# HALFWAY UP THE MOUNTAIN

Other titles by Mariana Caplan

*When Sons and Daughters Choose Alternative Lifestyles*

*When Holidays Are Hell…! A Guide to Surviving Family Gatherings*

UNTOUCHED: *The Need for Genuine Affection in an Impersonal World*

# HALFWAY UP THE MOUNTAIN

## The Error of Premature Claims to Enlightenment

Mariana Caplan

Foreword by Fleet W. Maull

HOHM PRESS
Prescott, Arizona
2001

Cover design: Kim Johansen
Layout and design: Visual Perspectives, Phoenix, Arizona

Library of Congress Cataloging-in-Publication Data

Caplan, Mariana, 1969-
 Halfway Up the mountain: the error of premature claims to enlightenment / Mariana Caplan
  pp   ca.
 Includes bibliographical references and index.
 ISBN 0-934252-91-2
 1. Spiritual life.   2. Spiritual formation.   3. Self-realization—
Religious aspects.   I. Title.
BL624.C346   1999
248--dc21                                                          98-45837
                                                                        CIP

07 06 05 04 03 02 01      7 6 5 4 3

HOHM PRESS
P.O. Box 2501
Prescott, AZ 86302
800-381-2700
http://www.hohmpress.com

Printed in the U.S.A. on recycled, acid-free paper, using soy ink.

For Robert Ennis (December 26, 1946–June 3, 1998), whose life and death offered an admirable example of integrity and commitment to this Great Work that we all share.

# Acknowledgements

Many esteemed spiritual teachers and masters, as well as scholars, therapists, and dedicated spiritual practitioners took time from the great demands of their lives to generously contribute interviews to this volume, as well as share their resources, suggestions, and heartfelt support and blessings.

The teachers contributing to this volume include: Andrew Cohen of the Moksha Foundation; Arnaud Desjardins of the Hauteville ashram in France; Robert Daniel Ennis of the Tayu Center; Robert Hall of the Lomi School; Joan Halifax of Upaya; Sensei Danan Henry of the Denver Zen Center; Jakusho Kwong Roshi of the Sonoma Mountain Zen Center; Judith Leif and Reggie Ray, teachers in the lineage of Chogyam Trungpa Rinpoche; Lee Lozowick of the Hohm community; Claudio Naranjo, renowned psychologist and teacher; Rabbi Zalman Schachter-Shalomi, revered Jewish mystic and leader; Robert Svoboda, Ayurvedic doctor and advanced Tantric practitioner; Llewellyn Vaughan-Lee of the Golden Sufi Center; and Mel Weitzman of the Berkeley Zen Center. The psychologists and scholars include: Christina Grof, Gary Mueller, Andrew Rawlinson, and Charles Tart. Among the many students who contributed to this volume are: Annick d'Astier, Marie-Pierre Chevrier, Gilles Farcet, Rick Lewis, Daniel Moran, Jai Ram Smith, and Purna Steinitz.

Furthermore, inspiration and extensive writings were taken from the following teachers and scholars: Charlotte Joko Beck, E.J. Gold, Carl Jung,

Roshi Philip Kapleau, Georg Feuerstein, and Chogyam Trungpa Rinpoche. The reference librarians at the Prescott Public Library were unwavering in their continual assistance and patience.

It was truly an honor and a boon for my own spiritual work to have the opportunity to sit in the presence of such greatness—to receive the impression of who these people are and what they stand for. I would like to express my sincere gratitude to these individuals and to my teacher for this rare privilege.

*Fool's gold exists because there is real gold.*

—Rumi

# Contents

Foreword     xiii

Introduction     xix

SECTION 1:    Enlightenment and Mystical Experience

CHAPTER 1     Presuming Enlightenment Before Its Time     3

CHAPTER 2     What Is Enlightenment Anyway?     33

CHAPTER 3     Motivations for Seeking Enlightenment     57

CHAPTER 4     The Beneficial Role of Ego     77

CHAPTER 5     An Overview of Mystical Experiences and
Their Relationship to Enlightenment     83

CHAPTER 6     Perspectives on the Value of Mystical Experience     105

SECTION 2:    The Dangers of Mystical Experience

CHAPTER 7     Spiritual Emergency     125

CHAPTER 8     Spiritual Materialism     141

CHAPTER 9     Getting Stuck: The Spiritual Cul-de-Sac     155

CHAPTER 10     Ego Inflation     187

CHAPTER 11     The "Inner Guru" and Other Spiritual Truisms     221

SECTION 3: Corruption and Consequence

CHAPTER 12    Power and Corruption                                   239

CHAPTER 13    Mutual Complicity                                      259

CHAPTER 14    The Consequences of Assuming a Teaching
              Function Before One Is Prepared                        289

SECTION 4: Navigating the Mine Field—Preventing
           Dangers on the Path

CHAPTER 15    The Three Jewels                                       313

CHAPTER 16    Testing Enlightenment                                  337

CHAPTER 17    Psychological Purification                             359

CHAPTER 18    Sadhana, Matrix, Integration, and Discrimination       373

CHAPTER 19    True Teacher—or False?                                 401

SECTION 5: Disillusionment, Humility, and the
           Beginning of Spiritual Life

CHAPTER 20    The Sadhana of Disillusionment                         441

CHAPTER 21    Enlightenment Is Only the Beginning                    483

Endnotes                                                             523

Bibliography                                                         539

Index                                                                545

# Foreword

Fleet W. Maull

What is enlightenment? Is it a continuous state of freedom and bliss, as most of us, at one time or another, have fantasized it to be? Does it bring an end to suffering, as we would like to hope? Is it an abiding non-dual context from which one can function with great skill and compassion, engaged in the manifest world of relative reality, while remaining anchored somehow in the formless Absolute? Or is it simply the capacity to awaken again and again, moment to moment, and actually be with what is? Although certainly representing one of the enlightenment traditions, my own teacher, Chogyam Trungpa Rinpoche, much preferred to talk about being awake, about being on the spot, about cultivating wakefulness and compassion in the midst of all our pain and confusion.

Upon my receipt of the author's request to write a Foreword for this very impressive work, which includes the contributions of so many truly accomplished teachers, practitioners, clinicians, and scholars, my mind produced several days' worth of heated confusion regarding my suitability for the task—all the usual self-conscious, self-depreciating, self-inflating, neurotic stuff. Even after some time on the path, even after we unavoidably stumble into a few of the more common meditative *experiences*, some of which may seem relatively illuminating and liberating at the time, the mind still does its thing, still produces this neurotic pain. For most of us, therefore, if we can claim any progress at all, it's that

maybe we have learned to deal with this habitual mind *stuff*, our own and others', with a little more humor and compassion.

The seemingly positive spiritual experiences—those illuminating, blissful moments of great clarity—are surely invaluable on the path, especially if we can avoid getting too caught up in the attachment and grasping they often generate. Yet, one of the immensely invaluable contributions of this book is to point to the possibly greater value of the seemingly negative, even devastating, experiences we encounter in life. Clearly, for me, the most powerful spiritual experiences have been those times when everything has fallen apart, when my whole world has collapsed. These seem to be the times when a real shift to a new level of work can occur. Apparently, only when our life somehow conspires to throw us into these "choiceless" confrontations with ourselves, our pain, with some kind of truth, are we able to effect real change.

Mariana Caplan has produced a comprehensive and exhaustive examination of the path of enlightenment and all the myriad pitfalls, dead ends, cul-de-sacs, and dangerous precipices where we can easily become lost in self-deception, or, worse, lead others with us into deception and all manner of corruption. I felt right at home in this material, as I'm sure I've been guilty of most of the distortions and self-delusions chronicled by the contributors. Fortunately for others, I've kept these mainly to myself.

I'm not just being self-depreciating here, not at all. It's just what the mind does. As Trungpa Rinpoche continually reminded us (and the sheer weight of the evidence in this book clearly confirms), it is not a question of *whether* we are involved in self-deceptions and spiritual materialism of all sorts. We are, constantly. It is rather a question of continually discovering *where*, *when*, and *how* we are doing it and being willing to immediately apply the appropriate correctives, to let go of the nonsense, come back to Reality, and proceed along the path. What's called for, as this work's many contributors convincingly demonstrate, is compassionate but rigorous and relentless self-honesty.

This, clearly, is much easier said than done; and, in fact, without some external source of clear and skillful feedback, it may be a hopeless project. The identity, security, power, and comfort-seeking reflex most commonly referred to as the *ego* by spiritual schools here in the West is a wily and

sophisticated foe indeed, and seems to be able to co-opt even the most "ego"-shattering or self-revealing awakenings and insights to its own ends.

The very notion of spiritual teachers, let alone spiritual masters and hierarchical lineages of wisdom transmission, runs contrary to our most cherished individualist, egalitarian, and democratic Western values. Nonetheless, it appears that authentic teachers in possession of personally-realized, authenticated spiritual insight and wisdom, and genuine spiritual schools and lineages are clearly necessary if one aspires to *real* spiritual work. The latter critically provide the necessary matrix or context for students' spiritual work and for the preservation and transmission of authentic wisdom teachings.

From ancient times the process of transmitting the authentic wisdom teachings and technologies for spiritual awakening was carefully guarded and contained within traditional spiritual schools and lineages in an effort to keep the corruption to a minimum. Casual interest and spiritual shopping trips were strongly discouraged. Commitment to rigorous training and the willingness to endure considerable hardship were required of all aspirants, and one who would become a teacher served a long and arduous apprenticeship under the thumb of the master. The whole process required tremendous patience, diligence, and humility.

Today, we are experiencing the radical reversal of this traditional approach on an unparalleled and almost unimaginable scale. The secret texts have all been published, and can be ordered with the click of a mouse on the Internet's World Wide Web. We have all but instant, total access to this once jealously-guarded treasure of "esoteric" knowledge. "Spiritual" teachers of every sort, from charlatans and the obviously shallow to the most profound and sublime masters, all advertise their books, programs, and retreats in the pages of the same New Age and contemplative-spirituality journals and magazines. Once-secret empowerments are now promoted and sold in the spiritual marketplace. Spiritual teachers are becoming celebrities; and, in some cases, celebrities are assuming the role of spiritual teachers. The traditional boundaries between the sacred and the profane, between spirituality and commerce, have all but dissolved as East merges with West in the high-tech marketplace of the late 1990s. Whether this is ultimately good or bad, or in what ways this

may ultimately turn out to be beneficial or harmful, is a hot topic of debate in spiritual circles. Regardless of what we may think or feel about all this, it is what it is—it is our present Reality. It is also causing tremendous confusion and making it harder than ever for students to find a genuine path and to connect with genuine, skillful teachers. The potential for self-deception and corruption has never been greater. Even experienced practitioners find the deluge of teachings and the crass marketing of "spiritual experiences" confusing and unsettling.

One of our critical liabilities as Westerners is our unfettered confidence and even arrogance vis-à-vis the assimilation of information from other cultures. We tend to feel free to pick and choose what we like and leave the rest behind, like so much dross or chaff. While it is true that the ancient spiritual traditions, both Eastern and Western, carry a certain amount of cultural "baggage," it is somewhat arrogant on our part to presume that we can easily distinguish between essential teachings and cultural baggage, or between such "baggage" and the crucial cultural matrix that provides the necessary container for the teachings and the critical context for real spiritual work.

It may, in fact, be neither possible nor desirable to assimilate a foreign or ancient cultural matrix. We may very well have to patiently build our own matrix for spiritual culture, a project that may take generations to accomplish. In the meantime, we need to have the humility to realize that the education, training, and wisdom realization required to genuinely represent and transmit the teachings, especially in the role of a lineage holder, is not just a question of how many three-year retreats, cycles of koans, or meditative experiences and breakthroughs one has accomplished, but is inseparably enmeshed in the cultural matrices that have supported these teachings and lineages for thousands of years.

The reader will almost surely be aware of the travails of the many teachers, both Asian and Western, whose lives and communities have imploded in scandal and corruption around the classic issues of power, money, and sex during the last several decades. While some of these scandals may have been instructive, and while, in the long run, some teachers and communities may grow in depth and wisdom through their journey of healing, the destructive and traumatic fallout for individuals and

communities, to say nothing of the negative impact on the traditions as a whole and their effort to preserve and establish genuine lineages of transmission, weighs heavily in the balance. The irony is that, in retrospect, most of these scandals appear preventable. Yet they continue to occur.

Clearly, the forces of self-deception, addiction, denial, and codependence are immensely powerful, calling for constant vigilance, relentless self-honesty, and fearless and open communication between teachers and students, and within spiritual communities and schools as a whole. *Halfway Up the Mountain*, destined to become a classic and a standard reference for serious students of the Way, offers us a blueprint for just this sort of self-examination and honest dialogue. It is highly recommended for all serious spiritual aspirants, but I would venture to say that it should be required reading for anyone taking on the profound responsibility of guiding others along the path. We can be very grateful that there are small, quality publishers like Hohm Press that are willing and able to support a project like this and to publish a decidedly noncommercial book of this length and depth.

*Fleet W. Maull, a long-time student of the Vidyadhara Chogyam Trungpa Rinpoche, is also an ordained Buddhist priest (lay monk) in the Zen Peacemaker Order, and a Ph.D. candidate in psychology. He is the founder of two national, non-profit organizations, Prison Dharma Network and the National Prison Hospice Association.*

# LIFE IN HELL

8-21-1998 ACME FEATURES SYNDICATE ©1998 BY MATT GROENING

**HEY, SWAMI!! JUST HOW STUPID DO YOU THINK I AM?**

**PRETTY STUPID, ACTUALLY.**

**ALL I HAVE TO DO IS WEAR THIS CAPE AND TURBAN, AND YOU TAKE ME FOR YOUR SPIRITUAL SUPERIOR.**

**YOU WANT TO BELIEVE SO BADLY THAT YOU COMPLETELY OVERLOOK MY OBVIOUS FLAWS AND HYPOCRISIES. I MOUTH TRITE PLATITUDES AND ESPOUSE EXOTIC SUPERSTITIONS, AND YOU, IN YOUR IGNORANT, DESPERATE STATE, JUST KEEP COMING BACK FOR MORE.**

**HOW THE HELL SHOULD I KNOW WHAT'S GOING TO HAPPEN AFTER WE DIE? FACE IT, PAL -- NO ONE KNOWS. BUT YOU CRAVE CERTAINTY SO MUCH YOU'RE WILLING TO SWALLOW ALL SORTS OF HOGWASH IN ORDER TO AVOID FACING YOUR FEARS.**

**WHICH IS LUCKY FOR ME -- BECAUSE I GET TO CHARGE GOOD MONEY TO TELL YOU SWEET HOLY LIES.**

**AHA! YOU JUST ADMITTED YOU'RE A FRAUD! SO WHY SHOULD I GIVE YOU ANY MORE OF MY MONEY, SMART GUY?**

**BECAUSE I'M JUST ABOUT TO REVEAL THE SECRET WISDOM OF THE ANCIENTS THAT WILL ALLOW YOU TO LIVE FOREVER.**

**HERE YA GO!!**

# Introduction

This book is not my book, or certainly not my book alone. What you will find within these pages is a comprehensive examination of the subject of "the error of premature claims to enlightenment," extracted from personal interviews with over thirty remarkable spiritual masters, lifelong spiritual practitioners, and esteemed scholars and psychologists, as well as research from the writings of dozens of other spiritual masters, both ancient and contemporary.

The reality of the present condition of contemporary spirituality in the West is one of grave distortion, confusion, fraud, and a fundamental lack of education. There exists no cultural context in the West by which to understand this great influx of spiritual information which crowds even the most popular newspapers, magazines, and television programs. Although the dramatic rise in popularity of contemporary spirituality in the Western world is introducing more people than ever before to spiritual ideas and ideals, the possibility for something other than a superficial affair with God has a very limited value if such ideas and ideals are not understood from a perspective that is educated, deeply considered, and carefully examined and checked.

Reflecting on this issue several decades ago, a time at which the situation wasn't nearly as critical as it is in the present day, Carl Jung wrote:

Spirituality in the Western world is in a precarious situation, and the danger is greater the more we blind ourselves to the merciless truth with illusions about our beauty of soul. Man lives in a thick cloud of incense which he burns to himself so that his own countenance may be veiled from him in the smoke.[1]

The subject of enlightenment itself is one of the biggest arenas of naivete, ignorance, self-deceit, and confusion in contemporary spirituality. A close second to enlightenment is the category of "mystical" or "spiritual" experiences. As a culture, we misunderstand what they are, what they mean, what they imply, and what one can rightfully presume about them. It is these subjects, and the great web of dharmic considerations which surround them, that are addressed within this book.

I consider the collective ignorance regarding the issue of presumed enlightenment to be a grave danger to those who sincerely long to deepen their connection to Reality. On one hand, there is no life-threatening danger for the majority of individuals engaged in the pursuit of Truth. There is the occasional Jim Jones, Charles Manson, or Marshall Applewhite (Heaven's Gate) who comes onto the spiritual scene and presents a physical danger to the very lives of the students whom they claim to be saving. But these instances are negligible in comparison to the majority of spiritual schools and teachers, who present no danger of physical harm to their students. Shy of the extreme of physical danger, however, there are many, many junctions on the path at which it is possible to get stuck at a certain level of spiritual development, trapped in both self-created and other-created delusions, and ultimately cheating oneself of one's own highest potential as a human being. People stay stuck at such junctions sometimes for weeks or months, and sometimes for years, a whole lifetime, or more.

Some people say that the psychological manipulation and emotional domination that so many so-called spiritual teachers exert over their trusting disciples is nothing but mere illusion and therefore not a subject we should attend to or be at all concerned with. "Why try to clarify a mirage?" they ask. But although the absolute may be true, the relative is where we live, and therefore there is great need for this investigation. In

addition, there is a whole series of moral and ethical issues surrounding this common circumstance that, although touched upon in this book, need to be thoroughly dealt with in another treatise.

Perhaps there is a big picture that says: "Everybody ends up where they belong, everything is a lesson, and all is as it should be." And it is probably so. But I believe that part of the "perfection" of the big picture includes the process of examining our areas of ignorance, misconception, and human weaknesses, and then taking the necessary steps to educate ourselves and each other about these areas. In so doing, we become responsible partners in our own awakening. As Tantric practitioner and Ayurvedic doctor Robert Svoboda says:

> The prevalence of half-baked teachers and misconceptions about enlightenment isn't a "problem" from my point of view. It is littering the landscape with a lot of unnecessary things. But if it is happening, it is reality. So we must first bow down to reality. Reality is great. "Thank you, Great Goddess, for sending us reality. However, it wouldn't disturb me if you were to alter your reality some." There's no reason you can't ask the Goddess to change things around. What is she there for? She is there to rearrange things.

It is with this yearning for clarity that I invoked the assistance of the individuals included in this book. Through a series of extensive interviews conducted in the offices, ashrams, homes, and spiritual centers of these individuals, and in a few cases over the telephone, I requested that they share their valuable time in the conviction that the wisdom they have won through years of personal struggle and discovery would provide invaluable help to those genuine spiritual aspirants who are in need of a body of knowledge that, with some exceptions, is rarely discussed in spiritual literature.

The individuals that were asked to participate in this project were asked to do so based on the integrity they have demonstrated in their lives, which I perceived through following their writings over many years, meeting their students, and in some cases as a result of ongoing personal

contact with them. All of these individuals have dedicated their lives wholly to Truth, whether they teach it, study it, or serve it. They were also chosen because they practice according to spiritual traditions that acknowledge the depth of struggle and contemplation that comprises the fabric of the human life and the quest for truth, and because the teachings that they represent are practical in their expression—accessible to responsible spiritual practitioners, and not woven into some other-worldly, cosmic framework. Printed sources of material are endnoted. If not noted as such, the material attributed to various teachers came from the interviews themselves and is unpublished elsewhere.

Frankly, I was humbled and often awed by the depth of knowledge that came across in the course of the interviews and research that is presented here. "Truth is one," it is said, but the expressions of Truth are limitless. Truth is also apparent, once rediscovered. I discoursed with the masters and sages of our day only to be able to present the reader with spiritual truths that are obvious, yet uncommonly realized. Each speaks to the same objective Reality, but of lessons learned as the result of each individual's own very personal, intimate relationship with that Reality.

It is important to pay attention to the distinction between those individuals included in this book who are masters and teachers in their own right, and those who are scholars and mature spiritual practitioners. At times the material shared by the students of the great teachers may be more easily understood and immediately applicable to one's own life than that shared by the teachers themselves, because the student is struggling with the same issues as the reader. Yet an important aspect of the teachings included here concerns discrimination, and learning how to pursue one's spiritual life with diligence and clarity. Thus, if one finds value in the words of the student of the great teacher and wishes to pursue further guidance on the basis of that discovered value, it is best to turn to the source of that student's knowledge—the teacher himself or herself—for further guidance.

The value of including so many perspectives in the book is that each spiritual master and each student has a distinct composition that predisposes him or her toward understanding specific aspects of Truth more readily when it is presented in a particular way and at the right time. The

teachings all point to the same Truth, undoubtedly, yet we study them in different forms and at different stages throughout our lifetime, hoping that at one point we will come to understand them not only intellectually, but to realize them wholly within ourselves. Therefore, included in the book are viewpoints on the subject of the error of premature claims to enlightenment presented from Jewish, Hindu, Buddhist, Baul, Catholic, and Sufi perspectives, to name a few, by those who consider themselves Masters, rabbis, teachers, guides, and disciples. My hope is that there is something in this book that strikes a chord of truth in each of its readers.

You will find a substantial body of data in this book from my own teacher, Lee Lozowick. My adherence in and respect for the body of teachings he represents has unquestionably shaped the context in which the brilliance of the words of the other teachers included in this volume is placed. I found his work only after years of disillusionment with a wide variety of pseudo-gurus, shamans, and mentors, as well as after studying with teachers who were sincere but could not offer the whole of what I was looking for.

Readers will also find themselves faced with differences in the way various teachers language their teachings and discrepancies in the way that each approaches this subject. In some cases, it is simply a matter of terminology (e.g., one teacher uses "enlightenment," another "liberation"; one talks about the "self" as being the ultimate, while another talks about the "self" as the ego). In others, there are clear differences in viewpoint. Many perspectives are presented here. Teachers and masters with decades of experience have shared their wisdom, and I have not tried to "correct" any seeming contradictions, only to present various angles on the topic of premature claims to enlightenment. The questions that will likely arise about views that at times may appear to be contradictory are important considerations for serious spiritual students, and to attempt to impose my answers to these questions on the reader would be a disservice.

This book is not one of answers. As you will likely discover for yourself, when daring a plunge into the murky waters of the presumption of enlightenment, we are faced with some big questions. To be understood clearly, the issue requires an investigation into a large framework of

knowledge and perspectives on spiritual development. To cover the breadth of the topic, I have divided the book into five sections.

Section One, "Enlightenment and Mystical Experience," provides a primary foundation for the consideration of this subject by looking at what is meant by ideas such as "presuming enlightenment," and the whole idea of "enlightenment" itself. It explores what motivates people to seek enlightenment and what is meant by the notion of mystical experience.

Section Two, "The Dangers of Mystical Experience," examines the tendency of ego to distort and misrepresent spiritual dharma and experiences. Topics considered include spiritual materialism, spiritual emergency, ego inflation, and mistaking mystical experience for enlightenment.

Section Three, "Corruption and Consequence," focuses on the nature of power and corruption. It examines the mutual participation of both student and teacher in creating a premature or false presumption of enlightenment and the consequences of assuming a teaching function based on such presumption.

Section Four, "Navigating the Mine Field: Preventing Dangers on the Path," presents a practical survey of how serious practitioners can learn to avoid the pitfalls of false enlightenment. Topics discussed include the testing of enlightenment, psychological purification, the process of integration, and the need for the Buddha's Three Jewels—the teacher, the teaching, and the spiritual community.

Section Five, "Disillusionment, Humility and the Beginning of Spiritual Life," considers what spiritual life really *is* about, the earlier sections having explored what it is *not*.

My purpose is to raise issues, not to solve them. The field of genuine spirituality is so multi-dimensional and multi-faceted, and the trappings so subtle and pervasive, that we can only aspire to dive deeper and deeper into our own spiritual practices with the protection offered by these questions themselves, considering what is offered to the degree we are able and applying it as best we can to our own lives.

Thus I present to the reader this collection of spiritual "nuggets," extracted directly from the gold mines of living spiritual wisdom that still

exist in bodily form, and set in a way that I hope will allow the reader to appreciate their preciousness and their value. It is the work of all of us, at whatever stage of spiritual evolution we find ourselves, to attempt to further open our eyes to the truth of our lives. In doing so, we take responsibility for the priceless gift that has been given to us by the fact of our birth and by our encounter with the great teachings of spirituality. We show gratitude for this gift by applying it in our lives and by letting the fruits of the transformation that results be of value to others.

Victory to the Master,
Mariana Caplan

# Section One
# Enlightenment and Mystical Experience

*Student: What is enlightenment?*
*Suzuki Roshi: What do you want to know for? You may not like it.*

What is enlightenment? What is the nature of the strong experiences that give birth to faith and inspire people to commit their lives to the pursuit of the spiritual? How does one know if the path he or she so passionately pursues is the highway to Absolute Truth, or a dead-end street? The essential questions that need to be asked in contemporary times are largely ignored, yet are presumed to be understood by people who lack the personal and/or cultural reference necessary to safely and effectively traverse the spiritual path. Although mystical experience, and even enlightenment itself, is the most natural thing in the universe, and although many curiosity seekers will be graced with experiences and phenomena which they presume to be enlightenment, the True Gift is experienced and lived only by those who make their very lives about the unfolding of the real questions.

This section sets the groundwork for the inquiry that is the subject of this book by (a) surveying the current spiritual crises arising from the premature presumption of enlightenment and (b) entering into a preliminary investigation of the meaning of enlightenment itself: why people pursue it and the nature of mystical experiences and phenomena.

# Presuming Enlightenment Before Its Time

*Today the name of the game is meditation. People of all ages are being duped into believing that enlightenment can be had, not through the long uphill route of the Zen masters but in twenty days of meditation, give or take a few days. And pleasantly, too. Snooze, snore, slump—meditate as you like, live as you please, because for sure you're gonna get enlightened. Then a medicine man comes along peddling another drug. "Three days to kensho!" he guarantees. Only a quack or a lunatic would make the brazenly preposterous claim that kensho—seeing into one's True-nature—can be realized by everyone in three days.[1]*

—Philip Kapleau Roshi

Sensei Danan Henry of the Denver Zen Center tells the story of how Philip Kapleau Roshi gave him a lesson about making immature and premature presumptions about enlightenment that would last a lifetime.

*I know all except myself.*
FRANCOIS VILLON

During my third sesshin I was working really hard. I had been miserable for so long, such an unhappy person during that period of my life. The pain was horrendous, just the physical pain of sitting. That kind of pain drives you to concentration.

All of a sudden, I felt a bliss like I had never experienced since childhood. The bliss of childhood when everything is brand new and alive from the tip of your toes to the top of your head. I was in a state of wonder and joy, oceanic bliss. I was so blissed out that I stopped my practice and just wallowed in tears of bliss and joy.

I went into the *dokusan* (interview) room to meet with my teacher, Kapleau Roshi. At first he was very patient with me. He said, "Well, that's good. That shows there is movement in your practice. How about *mu*, your koan?"

I said, "Mu-shmoo."

He said to me, "You must understand that because you concentrated so hard on *mu*, you let yourself go and began to feel some deeper levels of feeling. But when you stop working on *mu*, you stop the very process and work that is engendering this process of transformation." He was very kind, and said, "Just go back to your cushion and stick with *mu*."

So I went back to my cushion, worked very hard, and then it happened again. I was so blissed out. I went to dokusan again. Actually, I floated into dokusan. I said, "Mu! Roshi, that is nothing compared to what I am feeling." And he explained to me again what I needed to do.

He explained it to me three times.

The fourth time I went in, the same thing happened. But this time, he screamed at me. "All right! If you want to see the view from halfway up the mountain, that's your business. But get out of here! Do not come back to dokusan! Do not apply to another sesshin! You are taking the seat of somebody with true aspiration!" He screamed this loudly, and rang the bell that signaled me to exit. I got up and staggered out.

*Not even a King is immune from the rule that people jump to conclusions based on superficialities.*

IDRIES SHAH

Probably because I was more afraid of him than anything else—he was a very leathery warrior—the next time the bliss came up, and it did come up again, I stayed with *mu*. I just stayed and struggled not to get caught up in that.

Kapleau Roshi made it clear that bliss wasn't *mu*. So what was *mu*? I enquired into that, and with that there was a continued journey toward the ground of consciousness. If he hadn't corrected me, I don't know what would have happened. And so I consider that to be the greatest gift that he ever gave me.

*One who [thinks he] knows not, he knows; one who [thinks he] knows, he knows not.*
            GURU-GITA

Most people live at the bottom of the mountain. They make nice little villages there, even cities sometimes. They have families—and they love their families or they don't—they find work and friends, they're happy or they aren't, and they go to church or temple or they don't. And they die there.

Far fewer, though still a sizable population of individuals, live in the foothills. They still have their families and jobs and communities, but they strive to live by high moral standards, to treat others well, to learn and find meaning in their lives. They have some notion of God or Truth, and may even attempt to pursue that Truth in some way, perhaps even to serve it.

Less common still are those who live on the mountain, pitching their tents higher and higher up as they are able to adapt to the change in atmosphere. They often have families and friends, and consider life with them to be sacred. They strive to live lives of compassion. They recognize the value of the mountain, appreciate it, often devote their lives to ascending it, and do what they can to adjust to its ever-changing and ever-demanding circumstances.

Rare are those who have climbed the mountain. They often live alone in the perspective from which they perceive the world around them, though they may have dear ones who live near to them and wish to see as they do. They stand as an example that the mountain can be ascended. Some live active lives, receiving visitors, while others camp out and draw no attention to themselves.

Most rare are those who, having reached the top of the mountain, descend the other side, living a life of eternal ascent and descent, patiently and compassionately pilgrimaging from mountain to mountain, teaching the way of the mountain, helping others tie their boots, filling water bottles for them, throwing them ropes, helping them through mudslides, assisting them in scaling cliffs, encouraging them to proceed against all odds. They never stop to rest, but instead are always guiding others up the mountain.

True spiritual life is for the few. Many truth-seekers are sincere, earnest individuals, but the confrontation with ego that the path requires is more than most people are able, and willing, to undertake.

Jai Ram Smith, leader of spiritual groups for over twenty years and a long-term disciple of teachers E.J. Gold and Lee Lozowick, candidly speaks from his own experience.

> Stopping halfway up the mountain feels awfully good. Instead of looking up at climbing the rest of the way, you turn around to those climbing beneath you and say, "Thank you for following me. I'm here to tell you all about the mountain. You can see that I've climbed up a little further than you have." What could be more attractive to someone who has power and ambition as a modality? What also better fits the seeker who doesn't really want to make the climb, who is looking for spiritual comfort, than to have somebody else say, "Hey, I can answer those questions for you."

In spite of our view of ourselves as experienced mountain climbers, many spiritual practitioners, or whatever we fancy ourselves to be, are still living at the level of the foothills. Sincere about our wishes to ascend the mountain, we intuitively know the price that must be paid. Some of us fiddle with our shoelaces and run around purchasing fancy gear as a way of buying time while we wait to see if a cable car will magically appear to lift us up the mountain so we won't have to endure the climb. Others of us are climbing, picking our way rock by rock up the hills. Yet, as inexperienced climbers attempting to

*To be a warrior is not a simple matter of wishing to be one. It is rather an endless struggle that will go on to the very last moment of our lives.*

CARLOS CASTENADA

cross the entire Himalayan range without even a compass, we are eas-
ily mistaken in our estimation of where we are. We are also easily con-
vinced that we are farther along than we actually are and may start
guiding others before we are qualified to do so.

How do we know where we are on the mountain? Lee Lozowick,
Western Baul spiritual master, comments:

> Who defines the top of the mountain? Any of you who have
> ever climbed mountains know that when you're on the side of
> the mountain you can look up and see the top of the ridge and
> it looks like the top of the mountain. Because you can't see
> the ridge, you think, "Great. Another fifty yards and I'm
> there." Then when you get to the ridge, all of a sudden there
> is two-thirds of the mountain left. So we aren't the judge of
> where we are on the mountain. The judge of where we are on
> the mountain is someone who has climbed the mountain and
> who knows the territory and can tell us how far up the moun-
> tain we are. If we make that judgement based on our narrow
> view looking up, rather than on the view from the top look-
> ing down, which only someone who has been to the top has,
> in the majority of cases we'll be erring in our judgement, lost
> in the beautiful view from halfway up the mountain.

*Men suppose, fancifully, that they know Truth and divine perception. I<None>n fact they know nothing.*

JUZJANI

This book is not about how to get up the mountain and stay there,
because, as alluded to earlier, the real path apparently has no end. The
"end" of the path is not really an end, the top of the mountain not
really the destination. The great beings of past and present do not
stake their flags on the top of the mountain and relish the lovely
scenery, but instead lead a life of endless growth and service to others.
So rather than dwelling on the subject of how to get to the top of the
mountain, this book is a manual on how to avoid getting stuck halfway
up it and cheating ourselves out of the full journey. But in order to
learn not to get stuck halfway up, we must come to know the moun-
tain. Thus, the book is also about the mountain—about the spiritual
way—in its many aspects, traps, depths, and terrain. Better we come to

know the mountain well than worry about what it will be like to arrive at the top. As one dives into the consideration of being halfway up the mountain, it becomes clear that there is so much to learn about the way one ascends it that to talk about the top of the mountain itself can be not only presumptuous but an academic and irrelevant consideration.

## The Presumption of Enlightenment

/presume/ 1. to take for granted, assume, or suppose; 2. to assume as true in the absence of proof to the contrary; 3. to undertake with unwarrantable boldness; 4. to undertake without right or permission.

Ego, the construct created by psychology and primally defined by a series of reactions and defenses, is established during infancy and early childhood. This construct interprets reality according to its exclusive vision and creates function intended to maintain that vision, at all cost, in manifestation. It not only presumes enlightenment (as if ego knew what enlightenment was), it presumes *everything*. Ego presumes to know who I am, who you are, what is real, what is false, what a feeling is, what love is, and what truth is. It goes so far as to presume that *it* is who *we* are. Ego is presumptuous, and thrives on assumptions.

The odds of understanding *why* ego presumes everything it does, including enlightenment, are small, though it is very useful to understand *how* it does so and how to avoid having it so. In response to the question of why ego presumes enlightenment, it does because it does, and if we spend all of our energy trying to figure out why this is so— the implication being that we could somehow make it otherwise if we knew—we are less available to discover how to deal effectively with the reality of what is true concerning this very important issue.

Most human beings are *identified* with their ego. To be identified with ego means that who we think we are is linked with, and attached to, the egoic mechanism that functions within each of us. It means that there is no perceived separation between that mechanism and who we think of as "ourselves." As will become clearer throughout the book, this "ego" is a very powerful, highly persuasive mechanism. For most of us, it runs the show of our lives. It is the director, narrator, all

the actors, and the critic all in one. That is, ego runs the show until *who we really are* starts running it. This shift from being run by ego to becoming identified with that which *actually* runs the show is the process of genuine spiritual life.

In order to presume enlightenment, one must believe that one knows what enlightenment is, where one falls in relationship to it, and what its implications are. Most people believe enlightenment means that you can teach others, that people honor and respect you, that you have transcended death, that you have "arrived," and so forth; whereas although true enlightenment does exist, it exists entirely apart from the context of ego and the arena of presumptions. The enlightened state doesn't presume itself to be enlightened, *ego* presumes itself to be enlightened. And since most people are identified with their ego, individuals also presume themselves to be enlightened.

The problem with mistaking the fact of one's own enlightenment is that it negatively affects one's drive toward realization. It is an obstacle to the growth process. In every human being, there is a desire for evolution, God, Truth—whatever name we give it. There is also the egoic mechanism whose job it is to prevent that growth process from happening. Therefore, it could be said that we both want truth, and that we don't want truth. But the true heart always longs for truth, so although the ego may thrive on getting us stuck in false presumptions of our own spiritual progress, these presumptions are the actual enemy of liberation. In effect, the *presumption* of enlightenment blocks the possibility of *genuine* enlightenment.

*Study the assumptions behind your actions. Then study the assumptions behind your assumptions.*

IDRIES SHAH

## Who Presumes Enlightenment?

Most people think it is the charlatans, the techno-gurus, and the so-called masters who sleep with young girls who presume enlightenment. If that were the case, there would be no purpose for a book such as this, for those people would never read it anyway and, if they happened to, they would surely recommend it to several individuals *other* than themselves who they thought could use it.

The presumption of enlightenment is much more common than we think. Perhaps not in such obvious ways as the examples listed above, but in more subtle, though equally ubiquitous, ways. Ego is not only presumptuous, but exceptionally sly. Most well-educated, spiritual egos would not dare to call themselves "enlightened," especially to others, but either secretly or not-so-secretly assume a role such as spiritual guide, mentor, channeler, psychic, or spiritual friend and regard the skills they have acquired, or the knowledge they have gained, as having greater significance than they, in fact, have.

The notion of presuming enlightenment is a worthy consideration for anyone tempted to set themselves up in a position to teach or lead others, even a group of friends, based on what they presume to be a certain kind of wisdom or realization. Sometimes this happens within a very informal group—a therapy group, a community, a recovery group, or any group of people who get together with a shared aim—and other times it happens within larger "cultish" groups. Thus, this consideration applies equally to small-time community leaders and to those who place themselves in highly visible positions.

*What spiritual life should be about is a life of no compromise, a life of perfect singularity.*

ANDREW COHEN

A still deeper consideration is the tendency within all of us to make inaccurate presumptions. When we are committed to the spiritual path under wise guidance, we come to see that the tendency to aggrandize ourselves and our own attainments is more common than not. Everybody has an ego, and ego presumes everything, so why would anybody be exempt from such assumptions? Nobody is, but it is also not necessarily a problem. It only becomes a problem when we get carried away with it and are unable or unwilling to accept the necessary guidance that would place us back on the right track. We simply need to learn to work with such assumptions, and the first step in doing this is to acknowledge that this consideration is not about "the other" out there. It is about each one of us.

The flip side of presuming one's own enlightenment is presuming *another's* enlightenment. Some egos thrive on grandiosity, while others feed off of inferiority. Presuming another's enlightenment before its time is still the same presumption. Perhaps we have deemed ourselves unworthy of such a title, but we are still presuming to know what

enlightenment is and that "that person over there" has it. This is not to say that enlightened beings and great teachers do not exist, but that we can be equally mistaken in our presumptions about others as we are in our presumptions about ourselves.

## The New Age

A discussion of the presumption of enlightenment cannot be thorough without first clarifying the sharp distinction between home-grown New Age spirituality and the traditional, lifelong paths to liberation that are being addressed in this book. Most New Age philosophies and psychologies do not offer anything that resembles the path to liberation. They offer instead ways to be more comfortable in the dream of ego and teach us how to feel better within the illusion of our lives. What we need is education in how to pierce that dream. This point must be made clear because "spirituality" and "enlightenment" have become so popularized that most people assume that psychics, pseudo-shamans, and crystal healers are doing the same work as traditional Zen masters, Vajrayana Tantric teachers, and established Sufi sheiks, and group them all together under the umbrella topic of "spirituality." This is a great disservice both to these masters and to themselves.[2] As Robert Ennis, founder and former teacher of the Tayu Center, comments:

> This culture doesn't have enough experience in the area of spirituality to make any kind of distinctions. In our culture, if you have any access to spirituality, you think you have access to everything—there's no distinction between an entity that can demonstrate enlightenment in a body, and one that can only talk about it without a body. And those two are very, very different things.

The one notable misconception of the New Age that is worth addressing here to avoid unnecessary misinterpretations is the belief

*One of the greatest misunderstandings that people have is regarding the spiritual journey as a vacation trip.*
CHOGYAM TRUNGPA

that all of the new therapies, even the good ones, are a form of spirituality. People call themselves "spiritual psychologists," "meta-therapists," "spiritual counselors," and every other cosmic title one can think of. Call it what they will, there is a clear distinction between psychology and spirituality, and to fail to recognize that line is to once again fool ourselves into thinking that we are doing real spiritual work when we are not. Psychology deals with the human psyche, which is contained within the egoic structure; spirituality deals with that which is larger than the individual, the Reality which is our very essence and foundation, of which the ego and psyche are merely components. Author Georg Feuerstein writes:

> As in the case of most of the new religions, the humanistic therapy movement, as well as the therapeutic schools of transpersonal psychology, does not embody an adequate understanding of authentic spirituality. Self-development, self-improvement, and even self-actualization do not amount to spiritual life. In humanistic therapy, the self or ego remains intact as the guiding principle of existence, whereas in genuine spirituality it is transcended, not merely denied or negated. This all-important point must be fully appreciated.[3]

It can be difficult to distinguish psychological development from spiritual growth. Psychological breakthroughs can resemble spiritual insights. They can even *be* spiritual insights. Many of the fancy psychological techniques employed by the New Age are precisely designed to readily produce such visions and openings. However, we will come to see that such visions, revelations, and ecstasies are not the defining characteristic of either enlightenment or genuine spirituality. Kapleau Roshi observes:

> As for the new therapies, how many of these have actually brought about enlightenment? Individuals who claimed to have come to enlightenment through one psychological therapy or another have often asked me to test them. Of the

dozens of people tested, not one had had even a tip-of-the-tongue taste of kensho.[4]

Where psychology and spirituality converge is when an individual's psychological dynamic is effectively blocking his or her spiritual development. At such times, psychological work can be very helpful if it is done in the context of one's spiritual practice (a discussion of which can be found in Chapter Seventeen: "Psychological Purification"). However, even in these cases, psychological work is still psychological work, and spiritual work is still spiritual work, and each results in a radically different outcome.

Making a distinction between New Age spirituality and psychology and genuine spiritual paths is important to properly understand this consideration. Although both New Age gurus and practitioners of grounded spiritual disciples are prone to the presumption of enlightenment, to dissect the unwieldy and outrageous assumptions employed by the New Age is a subject complex and large enough to merit another book. There are unquestionably some dedicated and earnest spiritual practitioners wading through the shallow waters of the New Age on their way to the deeper waters of genuine spirituality, but, generally speaking, those whose spiritual practice is based on the idea of helping their ego feel better are not going to be interested in learning about the assumptions and presumptions they make and are going to misinterpret everything that is said about ego. The New Age itself *is* a presumption.

*This is not a journey for those who expect love and bliss; rather, it is for the hardy who have been tried in fire and have come to rest in the tough, immovable trust in "that" which lies beyond the known, beyond the self, beyond union, and even beyond love and trust itself.*

BERNADETTE ROBERTS

## Enlightenment Is Becoming Extinct

Whenever anything becomes as popular as enlightenment has become today, it must lose the essence of its meaning, because true spiritual principles cannot be communicated in mass form. Whereas New Age philosophies claim that we are in an era of evolution in which everybody can easily realize the enlightenment that was once available only to the rare few, this can never be so. At no time in his-

tory, including the present "New Age," have the masses ever been willing to undertake the required commitment necessary to fulfill the enlightened life.

Much like the term "love," "enlightenment" simply doesn't say very much anymore. We use "love" freely to describe a state of infatuation, our appreciation of ice cream, and our attitude toward our spouse or children, while most of us do not even know what real love is. The same has become true of enlightenment. The fact that the word is thrown around on popular talk shows, in the *New York Times*, *Time*, and *Newsweek*, as if everybody actually understands what it means, speaks directly to this erroneous, collective presumption about enlightenment that the whole Western world has fallen prey to. Jai Ram Smith suggests:

> By the time an idea or a concept in the Work [i.e., real spiritual work] enters mainstream America in the nineties, it's dead in terms of possibility. Enlightenment is all but dead when it is standing on the news rack, on the cover of the slickest, glossiest magazines. When it hits that level where it is in the mass market, the initial impulse of it has been reduced to a mechanical level. When everybody is running around and talking about enlightenment, it has a lessened meaning than something that is not spoken, that is not languaged. What kind of a culture do we live in, where people have the freedom on an almost recreational level to pursue the path of enlightenment? This is not a recreational product, so to see it packaged in a recreational guise, what does that tell you? What does it say about where we as a culture are in our quest for God? Where we are in our inner worlds? If the whole thing is mirrored out there in the newsstand, what does that say for what is inside?

According to Lee Lozowick, the reason the word enlightenment could be used in the ancient texts is that when those texts were written enlightenment meant something other than what it means today.

The *rishis*, or seers, had an understanding of what true enlightenment was, and so did the culture at that time, so they didn't have to compromise their language. The way the word is used today has implications that are based on gross ignorance of the actual nature of enlightenment.

An additional value the ancient texts had, aside from being written in the original, sacred languages and not translated into American English, is that they were not readily available in New Age bookstores as they are today. In order to access the teachings of enlightenment, one had to work with a teacher in an intensive course of spiritual study.

Sensei Danan Henry is highly critical of the way the New Age has taken up the use of spiritual terminology.

> I don't mind New-Agers doing all that silly stuff, but I do mind when they use terminology of the ancient traditions and insist they are talking about enlightenment. They are not talking about enlightenment. They are talking about a certain register of feelings and thoughts and sex. They have all of these good feelings and profound thoughts and they say, "That's enlightenment." Or they call it the "true self." They use words like "true self," and they're talking about having wonderful health and wonderful sex. I just can't stand it. They're so wrong they're not even wrong. They're not even in this ballgame as far as I'm concerned. This is where my intolerance comes out.

Sensei Danan's opinion is strong, but rightfully so. People like him who have devoted their lives to transmitting the Reality represented by words such as "enlightenment" are continually faced with having to untangle and dismantle the projections and expectations about spiritual life that their students have acquired through a cultural distortion and diminishment of sacred terminology.

"The more spiritual life becomes hip," comments Lozowick, "the more people seek it in their desire to be fashionable. The more that happens, the more every doodler gets to imagine themselves to be an

*I think that discussions about enlightenment are useless, and I think making enlightenment sacred is even more futile.*

JOHN WELWOOD

artiste." People pursue enlightenment not because they have any more genuine interest in spiritual life than they do in Pierre Cardin clothing but because it is the "in" thing to do. According to Colorado psychologist Gary Mueller:

*To an ass, a thistle is a delicious fruit. The ass eats the thistle. It remains an ass.*
HABIB EL-AJAMI

Spiritual development is now a trend. The identification with being enlightened is a trend, like a number of years ago channeling was a trend, and before that were the psychic trends, before that the fields of psychology, gestalt, transactional analysis. Often when we're on the bandwagon of a trend it feels like awakeness, but it has not much to do with awakeness. The trickery of ego is to fool oneself into thinking that we are awake.

Roshi Mel Weitzman, of the Berkeley Zen Center, recounts the scene surrounding a convention hall in the seventies, where one of the popular gurus of the time was speaking. Outside the convention hall, a woman was complaining to the ticket taker: "I paid a hundred dollars to get enlightened! I want my money back." Money doesn't buy enlightenment.

Yet to say that enlightenment has become extinct is not to say that that which the term represents in its purest form has become extinct. Enlightenment is neither more nor less common than it ever was. Truth has and always will exist, and it is always the rare few who are able to realize and live on the basis of that truth. Modern definitions and interpretations of enlightenment are critically debunked in this book in order to encourage people to not settle for a series of radical experiences and insights that may fit the textbook definition of enlightenment but that will cheat them out of still greater possibilities.

## Counterfeit Enlightenment

Because enlightenment is so costly, a fake has been produced. In the same way that replicas are made of any valuable substance—gold,

money, fine art—there exists the currency of counterfeit enlightenment. In many ways, the New Age is just that, an attempt to reproduce the copy without having to invest in the real thing. Jai Ram Smith explains:

*Real conscience is the beginning of real work.*

E.J. GOLD

> People want to create an imitation of enlightenment. The demand for an imitation is as great as the demand for the original product. In fact, the imitation has become more profitable. The knockoff is always more profitable. It's much cheaper to do the knockoff than it is to produce the real product. The real product is hand crafted, it takes time and energy. And there is a difference. Anyone who is a master of the craft knows the difference. But for most people, the knockoff is plenty good. That's how life is: the knockoff is good enough for most people. If you are a musician, you can tell when you are listening to a cheap instrument. But amateurs? It doesn't matter.

As Weitzman says, "People just want to have the thing. They don't want to do the work. They want to have the money to go to the store and buy the thing."

Real enlightenment definitely is not on sale at the corner store, doesn't contain preservatives, and isn't wrapped in plastic. Absolute surrender to God, or the Universe, is the greatest gift, the "pearl of great price," and it will never be cheap. That is why one should question the ersatz gems that pseudo-spiritualists so readily sell in their fancy packages. If one wants the real thing, one must learn about counterfeits; otherwise, one is showing off a rhinestone to God, convinced it is the Hope Diamond.

## A Lack of Spiritual Education and the Need for a Cultural Matrix

Because Western culture offers very little spiritual education to the majority of its inhabitants, people interested in spirituality lack

knowledge regarding how to discriminate between what is genuine and what is not. There is plenty of religion, and there was a strong cultural foundation for indigenous spirituality in North America and for the Celtic traditions in Europe, but by and large, the West is a desert in terms of educating its own about spirituality.

*In Tibet or Buddhist India, if you had a bad teacher, there would be good teachers right in the neighborhood, and people studying with those teachers. The environment itself would help to clarify issues. But this culture is not like that. People don't understand spirituality in general.*

REGGIE RAY

The reason that the West cannot offer a spiritual education is because it lacks a *cultural matrix*—a context within the culture itself that is created and sustained over time in order to provide a broad foundation for the members of the culture to perceive and experience spiritual understanding. A cultural matrix does not imply that everybody within the culture has a profound understanding of, or respect for, spirituality, but rather that there is literally an invisible, collective structure existing within the culture itself that serves as a spiritual resource and foundation of nourishment for those wishing to pursue spiritual development. (Detailed information about matrix can be found in Chapter Nineteen.)

Obvious examples of cultural matrix include India, Tibet (particularly prior to the recent Chinese invasion) and Israel, as well as many of the Buddhist countries such as Thailand and Vietnam. The cultures themselves *are* spiritual. Spirituality is not separate from life in these places; thus, the culture provides for those who wish to immerse themselves in the pursuit of God or Truth and provides, as well, implicit spiritual support for those who are less desirous of the mystical life, or able to engage it less intensely.

"I'm assuming that there are people all the time on this planet who become enlightened or 'wake up,' just by circumstance," says Smith. "But without training and a cultural context in which to place it, it's like starting a culture from scratch." The cultural matrix offers a context from which to understand spiritual awakenings and experiences, and also significant protection against the premature assumption of one's own enlightenment.

In *The Book of Enlightened Masters*, author and professor Andrew Rawlinson explains that it is only in the past century that Eastern religions have come to America, in the past fifty-five years that they have gained popularity, and the past ten years in which they have hit the

consumer mass market in America. "When you bring all of these ideas about enlightenment to the West, it's like throwing them into a culture that is, for the most part, totally at sea as to how spirituality works. What will happen is that there will be an awful lot of presentation of goods that are shoddily made."

Unfortunately, but inevitably, in the mass importation of Eastern spiritual traditions onto Western soil what has been imported are the visible, tangible practices and expressions of these traditions and not the cultural matrix from which they arose. It is impossible to import a cultural matrix, clearly, but when this factor is not taken into account, the result is a superficial and incomplete importation of the tradition.

Sensei Danan Henry discusses the difficulties in Zen Buddhism regarding transferring spiritual practices that originate from monastic life not only to a worldly setting but into a culture whose values are antagonistic to the culture from which the practices came.

We are taking monastic elements, but we are not a monastery here. All too often, people come to the temple, they sit in meditation, they put on their spiritual face (their Zen face, which is very self-contained, quiet, mindful), they learn all the forms that we do and they talk softly and kindly to one another. They may even demonstrate some real understanding. But they walk out of the temple and they run amok. There is no moment-to-moment invitation to practice, no religious truth outside. Not only is there no invitation, the world is totally nuts. The community at large is permeated with the most horrendous values of aquisitiveness, greed, hatred, anger, competitiveness—and it's championed! Not only is it there, it is what we champion and believe in, clawing our way to the top, doing anything that we need to do in order to succeed, doing as little work as possible to get as much recreation as possible. All of the values are totally crazy. We endlessly seek pleasure, endlessly avoid pain.

*After arranging the world in a most beautiful and enlightened manner, the scholar goes back home at five o'clock in the afternoon in order to forget his beautiful arrangement.*
CARLOS CASTENADA

*The conventional mind enter-
tains all kinds of misconcep-
tions and biases about spiritu-
ality. These wrong ideas often
lead to false approaches to
spiritual practice on the part
of those who dare to venture
beyond the seemingly safe
ground of exoteric religion.*

GEORG FEUERSTEIN

From Sensei Danan's explanation, it appears that not only is it dif-
ficult to transplant a tradition across the seas, but that Western culture
is so violent and antithetical to spiritual truth it is like trying to trans-
plant a rainforest fern into the Sahara desert.

Lama Thubten Yeshe says that Westerners, although they are very
intelligent and strong in their desire for "perfect wisdom," have a dif-
ficult time with spiritual *sadhana* (practice) because they simply don't
have the foundation for it. "When difficult circumstances arise, the
negative energy overpowers the positive because they have never built
up within themselves the force of good habits and because they lack
deep, internal understanding of the nature of karma, or cause and
effect."[5]

Furthermore, the profound esoteric exercises that are readily dis-
persed at weekend workshops were at one time given only to individ-
uals who had done years of foundational sadhana and who lived in
communities that could help them deal with the difficulties that often
arose as a result of engaging advanced practices. Rabbi Zalman
Schachter-Shalomi, author and religious pioneer in contemporary
Jewish mysticism, describes the danger of this very partial "transmis-
sion."

A lot of the spiritual stuff that's come from the East has been
imported. They didn't import the whole thing. What they
imported is refined stuff, and refined stuff can be a problem.
There's having a plain beer, or a glass of dandelion wine—
that's simple and easy, not such a heavy number; and then
there is high-grade whiskey, the refined stuff. The refined stuff
you have to watch out for. Another example that applies is that
of the coca leaf: If I have to do a hard day's work and I chew a
coca leaf, it will really help me to manage over the hump. But
by the time it gets to be crack, it's trouble. A lot of the spiritu-
al ways of the East have been refined out, so what they have
imported is the hot stuff, and what they have left out is the
whole bulk of folk ways. When you go to India, how many
things do people do there that are just part and parcel of the

path, but that never got transmitted to the United States? Do you see what I'm getting at? It's much easier to go wrong when you have that hot shot, refined stuff. That says, "This guy hasn't even gotten his crap together, but right away he wants to get shaktipat and kundalini up to the top." When that happens, and they haven't made vessels for it, it very often leads to these very holy special nervous breakdowns. The people don't have the vessels to contain the experiences in because they didn't take the path slow.  If you have experiences and then you reflect on them, and you take them in and ask what the action directives are, and you bring them into how you deal with your family, and the people with whom you work and so on and so forth, you build a very strong container. Then you get more experiences and build an even stronger container.

Reb Zalman's analogy of the coca leaf is a helpful one because it illustrates how a substance—in this case mystical experiences or advanced spiritual technologies—used in a particular form and context can be very helpful, whereas the same substance used in a different form and context can be dangerous, if not deadly. Lee Lozowick elaborates on this idea.

If you bring over some super technique to the West and you lay the technology on someone who is broken down, cruel and violent, and their kundalini opens and they become one with the universe, it could be very harmful because there is nothing in them that can hold that. Then it is their violence that gets released onto the innocent, not compassion or kindness. These teachers come over and awaken somebody's kundalini when they have no matrix to hold it, which is irresponsible at best and tragic and dangerous at worst. For the student, at best it doesn't stick, at worst it's very damaging. In India, for example, the practice of Advaita-Vedanta is one thing, because you grow up in an Advaita-Vedanta culture, but in the West if you take those ideas and try to live your life, you can't do it. You just get spaced-out and impossibly arrogant.

Eager spiritual teachers from the East, who understandably want to preserve their own dying cultures and help the West with their knowledge, have näively assumed that Westerners have the capacity to understand and make use of highly esoteric teachings. They often give them out flippantly and freely to anyone who will take them, so hungry are they either to spread the great teachings or to be considered great teachers. They fail to realize that their own understanding of and ability to work with the teachings is based on a cultural matrix that is so much a part of them they don't even know it is there. Particularly those teachers who are zealous in their mission to be great teachers, or urgent in their desire that somebody might carry forth the teaching, will, in their desperation, make compromises as to whom they are willing to teach and at what level. Considering this subject, Georg Feuerstein writes:

> Now what is interesting, when you look at the ancient literature, especially that of Yoga and Tantra, is that the qualifications required in order to be an aspirant or a neophyte are identical to those that characterize an accomplished adept. You are required to bring to your search everything that the adept himself or herself has achieved. This means that you have expectations placed on you that even in those days everyone knew they could not possibly meet. But these expectations were your guiding principles: you knew what the teacher would expect of you and would expect you to work on. Nowadays, though, teachers who are not following these more traditional ways have lowered their expectations to such a degree that they cater to the lowest common denominator and tend to attract, as a result, students who are not truly qualified for the spiritual path. And when, in time, such students are confronted with the real process of radical self-transformation, they collapse…Our moral and spiritual qualifications have slid down, as if in a big landslide, way to the bottom, and I suppose it is because most teachers take that into account that in their compassion they accept students that teachers in former days would not have accepted.[6]

Often, unbeknownst to the teachers themselves, their cultural matrix is an important part of what is protecting them. It is not uncommon for Eastern teachers who in their own culture were highly respected for their integrity in their teaching work to come to the West and not be able to withstand the challenges of teaching in a culture that does not have any matrix for or understanding of spiritual traditions. Unaware of the protection provided to them by their cultural matrix, they are easily swayed by the temptations of ego. Scientist Charles Tart, one of the forefathers of the consciousness movement in the United States, comments:

> We've had many instances of teachers who have come to this country from the East who, by the standards of their tradition, were relatively enlightened people, and yet after they've been in the West for awhile, they blew it. They come from a monastic tradition, and suddenly they are surrounded by beautiful women, and pretty soon they are sleeping with twelve-year-olds to reinforce their *prana*—things that seem pretty scuzzy but are highly rationalized. We have a basic personality formed within a certain cultural matrix, and that cultural matrix supports us in certain ways. Now if that cultural matrix has a place for being spiritual, and insulates you from a lot of ordinary things in the course of doing that, you may get some pretty fine development. But if you take the person out of their cultural context, and place them in a context where the culture doesn't protect them, they indeed may screw up.

*One attains to God by sticking to truth.*

SARADA DEVI

The cultural matrix offers further spiritual protection through the means of lineage. Most of the great spiritual teachers come from a long line of teachers before them and are solidly rooted in a tradition—that is why you will find less (though still plenty) of corruption in the lineages of tested and certified Zen masters or rabbis. In speaking about the cult leader Shoko Asahara, who was responsible for the 1995 Aum Shinrikyo tragedy that killed eleven and wounded 5500, professor of psychology and psychiatry Robert Jay Lifton said, "Because he didn't

belong to any reputable religious institution, he wasn't responsible to anybody or anything. You know, you can say, as many young Japanese do, that Buddhism in Japan lacks life. It seems deadened to them. But if you're a Japanese Buddhist and you belong to an institution, there are limits to what you can do. That's not so when you form you own religious organization that has no ties or requirements involving anybody else."[7]

Renowned author and scholar Ken Wilber suggests that if there is not a lineage to protect the teacher, "the individual teacher becomes the sole source of legitimizing power. Since individuals must have legitimacy . . . they will do or be whatever the legitimizing authority says—an invitation to problematic occasions."[8]

Reb Zalman illustrates how the Jewish cultural matrix protects people from getting carried away with inflated presumptions about their own spiritual stature.

*Western individualism is bad —up, down and all around. But there is one area that is really detrimental; the idea that each person is on their own and that you really don't need a community because everything is individualistically guided.*

REGGIE RAY

For the Jewish people, you wouldn't become a minister just by being a Bible thumper. You have to know a lot more. You have to know the original languages. There's a lot of study and a lot of mental stuff that goes along with becoming a spiritual leader. With Orthodox people, if a guy comes in off the street, he would have to be known to people from generations back— like he comes from such and such a family, he studied with such and such a Rebbe. If he wanted to come and preach and teach and they didn't know who he was, they'd just ignore him.

Neither the cultural matrix nor a spiritual education prevents assumptions and misunderstandings from arising, they simply create the possibility for the individual to not get stuck indefinitely. They serve as a foundation or internal access point to help us negotiate the gray areas of spiritual life. The individual who has received a strong spiritual education is not unlike the one who has been well educated in auto mechanics. It's not that every time the mechanic's car breaks down he instantly knows what the problem is and can fix it on the spot, but he knows where to look, how to diagnose the difficulty, how

to test his repairs. This is the value of education. It does not create realization, but it does provide us with necessary information.

"A lack of education is at the base of people getting scared away by mystical experiences, as well as deluding themselves into a sense of some kind of ultimate realization or arrival," explains a relatively new spiritual practitioner but one who has experienced ongoing and very strong mystical states.

The question then becomes: In a culture that is lacking in spiritual education, how do we educate ourselves? To educate the culture-at-large is unlikely, but there are spiritual schools and teachers whose work is precisely to serve this purpose. All of the teachers included in this book offer education to those who are really willing to learn. Of course, availability of a good teacher does not mean that one automatically learns. We can go to the best university in the world, but if we don't apply ourselves to a rigorous and intensive long-term course of study, we will leave empty-handed. We must apply ourselves to our education not only so that we won't cheat ourselves out of our own spiritual development but also to help raise the cultural standards of spirituality, to bring integrity to contemporary spirituality, and to preserve its essence in a time of great change.

*You have to pay with your ready-made theories, with your rooted convictions, with your prejudices, your conventions, your "I like" and "I don't like." Without bargaining, honestly, without pretending.*

JEANNE DE SALZMANN

Teachers and students alike are faced with the challenges posed by the lack of a spiritual matrix in their own culture, as well as with the difficulties that arise in pursuing a spiritual tradition that does have a cultural matrix but must be transplanted into Western culture. This subject will continue to be of increasing relevance and demand further enquiry as Eastern spirituality continues to be imported to the West and grow in popularity.

In spite of the dangers involved, Andrew Rawlinson, for one, is optimistic. He offers a refreshing approach to minds more wary than his own.

I'm very optimistic because I feel that the Westerners will keep on looking for something real. The fact that there is so much going on is actually a good thing, because it means that you can go down the road and check out other things. It is similar to periods in evolution where new species come up. It

is very exuberant: there is a lot going on, a lot of experimentation, and out of it comes up a few basic shapes that go on for hundreds and thousands of years. I think that we're in a situation in which there is a huge amount available, and a lot of things rising and falling. Just keep your eyes open, don't kid yourself, and explore—and be a good explorer. Don't go exploring in flip-flop sandals and with a small bottle of water and expect to get very far without blisters and getting hungry and thirsty and fed up. But it's not so difficult to learn.

## Many Gray Areas

*In terms of how we're doing in the contemporary spiritual scene, we're doing a whole range of things. We're doing wonderfully and we're doing terribly . . . Some people are getting more wise and compassionate, and a lot of others are exploiting people, are on ego trips, deepening our endarkenment and our samsara.*
CHARLES TART

Judith Leif, one of the eight *acharyas*, or teachers, selected to formally carry forth the work of the late Tibetan master Chogyam Trungpa Rinpoche, was speaking about the subject of the premature presumption of enlightenment in a culture that is not equipped to handle spirituality on a wide scale when she paused and said, "I hope that your book will bring out some of the complexities of this issue, because it isn't a black-and-white thing. Sometimes people just sort of slip into it."

Indeed it is not a clear-cut issue. The factors involved in a consideration of the presumption of enlightenment are endless. Each case is unique. Each circumstance is different. As Rawlinson reminds us, "It is one thing to say that someone's approach to liberation is incomplete, misguided, or incorrect; it is another to say that it is dishonest and hypocritical."[9]

Sometimes people are misguided, but sincere and even helpful. Sometimes there is great compassion without clarity of perception, while other times there is clarity without compassion. Some who have presumed their own enlightenment are open to being disproved; some are simply using it for power and fame; and some are so utterly unaware of their own unconscious dynamics that they are invulnerable to seeing their own weaknesses. Others do not make such claims but, because of the demand of students, are serving a teaching function, or are serving at the request of their teacher and under the teacher's direct guidance.

Purna Steinitz, who teaches in a spiritual community in Little Rock, Arkansas, comments:

> The teaching, the circumstances of the teaching, are situational. You can have one person doing something and it can look like the person across town is doing the exact same thing, and one person can be totally off and out of integrity and out to lunch, and the person across town can be really serving. And it might look very similar. So, we can't go on the appearance of things. You look at the person, the circumstances, at exactly what they're teaching, what they're doing, who they're working with, and then you put the whole package together. It's completely situational. There are no rules to that game.

## LLEWELLYN VAUGHAN-LEE: THERE IS NO REPLACEMENT FOR TRADITION

*Although many things can be adapted to make the traditions accessible to the Westerner, there are very basic precepts or spiritual practices that can't be adapted, that you have to do. Whether it is fasting, meditation, purification, or a certain attitude towards sexuality, you can't mess around with them because they belong to the tradition. You have to follow them. They, and your teacher, are the container to protect you, to keep you from getting inflated. That is why I am very doubtful about people who do it without the background of a tradition. I think it is far too dangerous, and sadly I've met people who have been "zapped out." You can't bring them back to earth. They don't want to come. Who wants to work on the shadow and look at their own darkness and failures and inadequacies when they can be off on a spiritual cloud nine?*

*Warriors have an ulterior pur-*
*pose for their acts, which has*
*nothing to do with personal*
*gain. The average man acts*
*only if there is the chance for*
*profit. Warriors act not for*
*profit, but for the spirit.*
CARLOS CASTENADA

## JAI RAM SMITH: THE LEARNING PROCESS OF BEING A STUDENT

*Am I really willing to go into the learning process of being a student? For me, that's the hardest question. I want to graduate already. I'm tired of going to school. But there is a learning process that is required. After ten years in the close company of my teacher, I realized that I had received maybe ten percent of what he had to offer. Ten percent. I had risked heavily, but I still missed ninety percent because of my inability to be a real student and to learn from the process of being a student. Its not that I didn't want to learn, but I had such a strong desire for things to be a certain way, and failed to understand what learning looks like.*

*Most students want to get to graduation way before its time. If you ask the question, "How long must you study in order to live responsibly from the state of enlightenment?" most people figure that they can do it within a few years, or if God blesses them within a couple of months. If it were up to us, every one of us would sign ourselves out way, way early on, I'm sure. If you told most people that it takes lifetimes, people would be crushed. They'd give up. If you told most people, "It may not happen in this lifetime," most people would give up.*

Charles Tart has been studying issues of consciousness, altered states, and enlightenment for over three decades from both an empirical and a personal perspective. Though he has drawn many hypotheses about consciousness studies and their implications, he returns to the recognition that, by and large, there is still much more that is unknown than known.

I wish I had answers to these questions, but I am more aware of the problems. I think if we stay aware of the problems, we have a chance of catching them and doing something about them. These are all terribly important questions, but by and large I think we don't know the answers. We just have to do what we can. If we get excited about the questions, then we have more of a chance at getting the answers.

We cannot draw quick conclusions about enlightenment: who is and who isn't, what are the signs of false enlightenment, and what are the signs of true enlightenment. Such conclusions will fail us. At the same time, we *can* become very knowledgeable about the pitfalls surrounding the issue of enlightenment and, in examining these tendencies within ourselves, come to understand them with enough clarity that we are able to apply them in specific circumstances in our own lives.

*Slowly but surely I began to realize that the whole question of Awakening is infinite in its subtlety and complexity.*
ANDREW COHEN

We are dealing with the mystery. We are studying the mystery, writing books about the mystery, meditating on the mystery, doing years of rigorous spiritual practice before the mystery, and still it remains the mystery. We must humble ourselves before this fact and remember it so that we do not get carried away by even our own wisdom.

## There Could Be Worse Things to Presume!

Joan Halifax, Buddhist teacher, lecturer, and anthropologist who has worked for over thirty years in the field of consciousness studies, death and dying, and who currently brings meditation practice into prisons, provides a radically alternative perspective from that of most of the other teachers included here regarding this issue. She reminds us that there are far greater horrors than the premature presumption of one's own enlightenment.

Better these people should think they're enlightened, which is a wonderful aspiration, than be robbing stores or taking

## ANDREW COHEN: "A CRISIS OF TRUST"

*Interestingly enough, it is only when a human being makes that critical decision to find the Truth Absolute, that the depth and complexity of compromise that had been the expression of a divided personality is revealed. This discovery is often shocking, for few human beings are prepared to come to terms with the enormity of the gap that is exposed between the way one imagines oneself to be and the way one truly is.*

*A passionate response to the yearning for liberation reveals that a divided condition is entirely volitional. In this revelation, the individual discovers for themselves the path to wholeness. That path is the sudden or gradual unwillingness to compromise in matters of the heart and ultimately in one's relationship to what it means to be a fully human being.*

*It is for this reason that I feel it is so essential that those individuals, who have been fortunate enough to have fallen into the miracle of transcendent spiritual realization, be able to demonstrate an attainment that clearly and unambiguously expresses the evolutionary potential of the race. For as long as this demand is not made, and those who are showing the way for others are allowed to demonstrate the very same schizophrenic conditional of contradictory impulses as everyone else, then the attainment of true simplicity and unequivocal victory over ignorance will remain a myth.*

*The magnitude of the implications inherent in this, what might not seem like such a crucial matter to some, is extraordinary. Without clear examples, the possibility of a collective evolutionary leap is unimaginable. That is why it is so destructive for the evolutionary potential of the race as a whole when those who have realized that transcendental spiritual perspective seem to be unwilling to go all the way . . .*

*The modern spiritual world has been plagued by countless shocking revelations of that vital discrepancy between word and*

*deed. This has created an air of cynicism and a crisis of trust. It should cause the independent thinker to question the ultimate validity of the attainment of those in whom these discrepancies have become painfully obvious. Yet I have been intrigued by the general lack of serious inquiry into this important question.*[10]

---

heroin or beating their wives or kicking their dogs. I think that one of the most wonderful things is the delusion of enlightenment, even if it is a delusion. At least it represents an aspiration that is better than an aspiration to be a murderer. I'm not going to do an enlightenment psychiatric evaluation of people. It's better to think that you're enlightened than a lot of other things. Even pretending to be enlightened is better than intentionally harming others. I also think it's a stage. It's kind of like when you were a little girl and you put on high heels and lipstick and you pretended you were your mother. In a certain way it is sort of sweet. I don't feel very condemnatory of anything because I work with people who kill people and I love them. People go through stages.

Purna Steinitz also suggests that the premature presumption of enlightenment is not necessarily bad: "Some people are calling themselves enlightened and it's not a problem. They're practicing, they're being responsible about their sexuality, learning to be kind and generous, becoming practitioners. And I would say, 'That's a pretty good person.'"

Halifax's and Steinitz's perspective is important. In ordinary life, let alone in prisons, people cheat, lie, steal, dominate and manipulate each other all the time without hesitation. Maybe people would be better off lost in visualizations and claiming to channel archangels if this meant they would cause less suffering to those around them. And as Steinitz suggests, there are people of great integrity and trustworthiness who are simply mistaken in their self-evaluation but are

*The less the wayfarer knows about his own spiritual progress the better . . In the journey toward annihilation and nothingness, it is best not to know where we are.*

LLEWELLYN VAUGHAN-LEE

*The veil is not in the mind, but in the heart. Only the heart will lift the veil.*

E.J. GOLD

nonetheless providing benefit to those around them. It is valuable to acknowledge this point of view, for it adds further dimension to this consideration.

On the level of the consideration of the evolution of consciousness, however, who knows what the implications are for the false presumption of one's own enlightenment? It might not be so harmless, particularly when those who have made false presumptions about themselves are affecting the lives of hundreds or thousands of disciples. (*See* "The Karmic Implications for Assuming a Teaching Function Prematurely" in Chapter Fourteen.) And, pragmatically speaking, for those individuals who have the possibility in this lifetime to do important purification work on the spiritual path and to serve humanity with their acquired knowledge, the false presumption of enlightenment is not an insignificant matter. It is a very real obstacle for many people, and one that requires careful attention in order to be sidestepped.

# What Is Enlightenment Anyway?

*Recognizing spiritual evolution and transformation as the struggle for a fully human condition makes it possible for anyone who is sincerely interested to come to an understanding of what real attainment is all about. As long as the meaning and significance of spiritual awakening is allowed to remain so shrouded in mystery, it will continue to seem beyond the reach of most to truly understand. There are many paths but the goal is one. This fact must be clarified in a simple and understandable way. Only then will many of us be able to grow up, and in doing so realize the profound independence that results from seeing clearly through eyes that have been freed from false and wrong views.*[1]

—Andrew Cohen

"What is enlightenment?"[2]—the great question, and the impossible koan, of contemporary spirituality. As we considered in Chapter One, the essential understanding of enlightenment is all but extinct. The word has lost its original worth as a result of being overused and has been desanctified by the misuse of those who think they know

what it means. On the other hand, it has not been replaced. There are options to the term "enlightenment," such as "awakening" and "liberation," and such terms are used somewhat interchangeably throughout the book, but each leaves us with the same confusion. Novices and long-term practitioners need a language in which to discuss ideas that represent their aspirations but must do so from a perspective that is hypothetical or, at best, intuitive.

In *The Progress of Insight: A Treatise on Buddhist Satipatthana Meditation*, Mahasi Sayadaw uses the following analogy.

*I don't have any pretension about knowing what is liberation, what is awakening. . . The only pretension I do have, and know something about, is saying "yes" to what is.*
DANIEL MORAN

Just as a very delicious, appetizing, tasty and nutritious meal can be appreciated fully only by him who has himself eaten it, and not without partaking of it—in the same way, the whole series of developments of knowledge described here can be understood only by one who has himself seen it by direct experience, and not otherwise.[3]

The main hazard of trying to define enlightenment is that we just add one more idea to our storehouse of concepts about what it, in fact, is. The principle benefit of attempting to define it is that since "enlightenment" does exist in the world as a concept, and we have no replacement for it as of yet, it is better to clarify it and broaden our perspective about it, rather than leave it in its decrepit state. Words are symbols, and often crude symbols at that, but they are one important form we use to attempt to share our experience. Thus, it is more beneficial to understand how confused we are about enlightenment and to attempt to clarify our uncertainty than to avoid the situation altogether.

## The Fantasy of Enlightenment

The main difficulty with trying to define enlightenment is that we do so from the bleachers, and not from the playing field. The same person who watches a football game on television and says, "If *I* were the quarterback, *I* would have made the touchdown," is the one who cannot

discipline himself to exercise three times a week and can't throw a football five yards. We try to define enlightenment from a subjective and conceptual perspective, but it lacks any objective or experiential reference. What we think of as "enlightenment" is an idea created by our imagination. Enlightenment is a fantasy.

"If we do not know the material with which we are working," says Trungpa Rinpoche, "then our studies are useless; speculations about the goal become mere fantasy."[4] He suggests that our speculations are based on the egoic desire to perceive the extraordinary and the dramatic, and that if our spiritual study is built on the foundation of a strong fantasy of enlightenment, this fantasy will become a large obstacle to recognizing and working with what is actually true of spiritual life. We will be so caught up in our ideas of how we would like enlightenment to be or how we think it should be that we won't be open to perceiving what it is. Trungpa Rinpoche further suggests that "It is destructive and not fair to people to play on their weaknesses, their expectations and dreams, rather than to present the realistic starting point of what they are."[5]

The most common, widely-held fantasy about enlightenment is that it is freedom from suffering, the transcendence of pain and struggle, the land of milk and honey, a state of perpetual love, bliss, and peace. Enlightenment represents the collectively-shared dream of an idealized and perfect world of pure beauty and joy. It is not only a New Age fantasy, it is the secret wish of all people. It is our shared dream of salvation. But it is only a fantasy. Lee Lozowick warns us:

> If you are holding out that once you are enlightened life will be some blissful, happy, pure, light state from then on, I wouldn't count on it. We live with this idea, "If I could just wake up, my problems would be solved." But that's not the way it is.

A twenty-year student of a Hindu teacher concurs.

> There is a universal view of spirituality that is supposed to "liberate" people. But what does this mean? Everlasting peace,

bliss, and joy? That's what we'd like to believe. That's the idea of immortality. But we are human. When will we get that "enlightenment" is not a thing to be owned, a kind of drug?

Jai Ram Smith tells the story of the loss of his fantasy of enlightenment that occurred during his training with contemporary spiritual master E.J. Gold.

At the time, my projection and my wish for whatever you want to call the awakened or the enlightened state was that it was a state of continuous unbroken and permanent bliss. That's what I thought my teacher had and what he was offering. So when he looked at me and said, "Hey, I gotta tell you, I'm not awake all the time," it was not only disheartening, it was confronting on a very deep level. Here was my master telling me that what he was offering wasn't permanent. He did tell me that at any time he needed to he could enter the awakened state in order to serve the Work, but that's not what I wanted.

*The first and biggest misunderstanding is the idea that the individual can free himself, can become free . . . It is only the consciousness that can become free of the individual, and not the individual who can become free of itself.*

DANIEL MORAN

Even the *possibility* that the great masters of our day may not be in this "enlightened" state all the time should present a sober challenge to all serious spiritual aspirants. There is a demand that we come face to face with our projections and fantasies about this mysterious "state" so that we can get on with our spiritual lives in a realistic manner. Even those who have studied and practiced spiritual disciples for long periods of time still hold to a fantasy of salvation—they know their ideas of enlightenment are illusory, but still, in some pocket of their mind, they hold out for the possibility of deliverance. To release the fantasy of salvation is a great spiritual challenge. Charlotte Joko Beck, presiding teacher of the San Diego Zen Center, says, "The most difficult, the most insidious, are the attachments to what we think are 'spiritual' truths. Attachment to what we call 'spiritual' is the very activity that hampers a spiritual life."[6]

## AN INITIAL ENCOUNTER WITH ENLIGHTENMENT

Recalling her initial years of spiritual work, a senior student who studies Advaita-Vedanta shares her initial encounter with what she believes to be "enlightenment."

*At the beginning of our work with our teacher, people were having very strong experiences. One night a few of us stayed up long into the night discussing the dharma with a teacher who had come to visit our community. We were flying high as a kite. Everything became crystal clear. We were not in time as we know it. The next day he left, and the three of us were in a very altered state. Everything was tacitly obvious to us. We looked at one another and said, "This is it. This is the end of the path and here we are."*

*The state lasted for almost two weeks in each of us, which is quite a long time for such experiences. I had had tastes of the experience when I was on drugs, but this was different because it was suspended. It lasted. I remember everything about those two weeks so vividly.*

*We were very excited and wanted to verify it, so we went to visit our teacher, who had just begun his teaching work, and he conducted some interviews with us to check our "enlightenment." He was very excited too and had various intelligent individuals who were well versed in dharma come to test us. All three of us passed. Our teacher said that it was quite possibly real, but while we were drawing all sorts of conclusions based on our state, he kept saying, "We'll see. Time will tell."*

*We all had jobs so we just maintained our ordinary schedules. Gradually, the experience started to become less. It was very difficult for me to watch it slipping through my fingers and not be able to do anything about it. It faded for all of us. Our teacher later told us: "It was just a blip on the screen of consciousness. If I were one of those 'flash in the pan' teachers I would have ordained you all and had you all out teaching."*

As we will see, our fantasies apply not only to enlightenment but to spiritual experiences, meditation, God, and so forth. When it was suggested to Reggie Ray, Buddhist teacher in the lineage of Chogyam Trungpa Rinpoche, that most of the world thinks meditation means cultivating a peaceful state of mind, he half-jokingly responded, "Well, those are people who don't meditate, obviously." It is essential that we acknowledge our fantasies so that we don't get carried away by our illusion of who *we are* based on our daydreams about enlightenment.

The fantasy of enlightenment is very difficult to let go of, for if we do, what do we have to hope for as a reward for our painstaking efforts? Perhaps not what we thought. Perhaps we are going to be faced with a reality that we have done our damnedest to try to believe is other than it actually is. Yet herein lies the possibility of discovering priceless riches other than those we have dreamed of. Lozowick hints at this other possibility.

> In the beginning, you think, "One or two years and I'm going to be enlightened. I'll have lots of disciples and travel around in a nice car with a chauffeur." Then fifteen years later you're still the same person. I find the investigation of these crises to be very useful for people. What is there to change?

## Contemporary Definitions

Despite the ambiguity of the term "enlightenment," a vagueness that was acknowledged by all of the teachers I interviewed (some would not even use the word), most were still willing to share their understanding of the concept.

There are many ways in which we try to speak of enlightenment, many angles from which we approach it. Different spiritual schools and spiritual teachers also have their own terminology, and definitions are often set in the context of how they relate to other definitions in the cosmology of the school. However, there also appear to be differences among teachers regarding their ideas of enlightenment, perhaps

pointing to the fact of a multifaceted reality or perhaps resulting from distinctions regarding the limitations of different spiritual schools. What follows are definitions and explanations of enlightenment from several perspectives as suggested by various contemporary teachers.

### Enlightenment is the shattering of mental constructs.
(Georg Feuerstein)

Georg Feuerstein describes the classic Advaita-Vedanta perspective on enlightenment by defining it as "the shattering of all mental constructs about existence, including the notions of voidness and chaos or fullness and harmony."[7] He further suggests that "Enlightenment is that condition of the body-mind in which it is perfectly synchronized with the transcendental Reality. It is identical with Self-realization."[8]

*From the Unreal lead me to the Real, From Darkness lead me to Light, From Death lead me to Immortality.*

BRHANDARANYAKA
UPANISHAD

### Enlightenment is responsiveness. (Reggie Ray; Joan Halifax; Andrew Rawlinson; Lee Lozowick)

According to Reggie Ray, in Buddhism enlightenment is total responsiveness. "It is being responsive to your world, and to be responsive, you actually have to have no agendas and no particular thing you are promoting or looking for. Responsiveness is being able to respond and interact with reality as opposed to one's projection of reality. Liberation is not something any human being can own, but it is a matter of how resistant you are to it. The more you go along, the less resistant you are, and the more responsive. The key issue for Buddhism is understanding that enlightenment is not a state."

Joan Halifax's perspective complements Ray's description when she suggests that enlightenment is "the capacity to really *be* with suffering and joy—directly and in an unmediated way."

"Enlightenment is a response—a response to the needs of beings," Andrew Rawlinson claims. "It is interaction with others, it's as simple as that. And you can't interact if you're floating, if you're out of it, if you're beyond reach. A whole aspect of human life is no longer available to you."

According to Ray and Rawlinson, then, enlightenment is the ability to respond to each situation. To be able to respond means one is not a slave to one's egoic expectations, projections, or need to manipulate. It is what Lee Lozowick means when he encourages his students not to "get" enlightened, but to be able to "do what is wanted and needed in each moment." By implication, these definitions bring enlightenment out of the astral plane and into everyday existence and the needs of the environment and of other people.

In a characteristically derisive tone, Lee Lozowick illustrates the importance of responsiveness by using the example of a revered Indian Swami, known as "Bench Swami," who lies on a bench either unconscious or in samadhi while visitors come and sit near him. "Let's say somebody came in and tripped on the floor—they could be dying and he wouldn't even know about it. If they get their enlightenment from him, they're going to end up like him, lying on a bench like a lump of clay. You don't save sentient beings by sitting on a bench. The idea of responsiveness is that you're responsive to your environment wherever you are."

**Enlightenment is a relaxed mind.** (Joan Halifax; Arnaud Desjardins)

Halifax talks about the importance of a relaxed mind.

> I was in Bhutan and speaking with a Rinpoche who was supposedly the debate champion of Tibet. He said to me, in a kind of adversarial way, "What is enlightenment?"
>
> I'm no fool, and so I said, "I don't know."
>
> He said, "Enlightenment is a relaxed mind."
>
> If you want something, your mind is not relaxed. It's spring now. We're sitting here in the garden, the tulips are coming up, as are the forsythias. Why would I want to force these flowers to bloom or to come out of the ground any faster than they're already present for? They have their own life. Our own life has its own life. If I'm sitting in the zendo trying to get something, I'm going to get exhausted is what I'm going to get.

Or I'm going to get inflated. Eventually you're just sitting to sit. Just serving to serve. Sitting with a dying person is not even serving, it's sitting with a dying person. It's not even practice.

Halifax's explanation of the relaxed mind is not unlike the teaching of French spiritual teacher and filmmaker Arnaud Desjardins, who continually asks his students to "accept what is" and "say yes to life." When he tells them to accept everything that *is* in the moment, as it is, without trying to change it, Arnaud Desjardins is speaking to the mind that is relaxed and spacious.

**Enlightenment is the knowledge that all things are transitory, including enlightenment.** (Lee Lozowick; Purna Steinitz)

"Enlightenment is the knowledge that all things are transitory, including enlightenment," says Lozowick. "In every moment, everything changes, so if you take *one* enlightenment experience and project it into the future, that doesn't leave the possibility for true enlightenment in *each* moment."

Steinitz, a long-term disciple of Lozowick, as well as a teacher in his own right, elaborates. "Enlightenment is not any one experience. It is the knowledge—not the intellectual or cognitive knowledge but the knowledge in the body—that all things are transitory, including enlightenment, and including that knowledge. It is living from, acting from, and making choices from that knowledge. If we were to call somebody enlightened, that would be somebody for whom the experience of enlightenment had shattered them such that even the fixation on experience had dissolved because that, too, had been shattered."

It can be confronting to ego to consider enlightenment as transitory, as it is generally used to refer to an abiding, permanent state that, once attained, remains unto infinity. Much in the way that E.J. Gold disillusioned Jai Ram Smith by telling him that he was not in the enlightened state all the time, to consider that even enlightenment itself is transitory challenges our commonly held ideal of enlightenment

*When a man's sleep is better than his waking—It is better that he should die.*
SAADI OF SHIRAZ

*The rose has gone from the garden; what shall we do with the thorn.*

HAKIM JAMI

as a permanent salvation, thus bringing us back to the vulnerability of impermanence, of not-knowing, of being unable to control life even in enlightenment.

Lozowick makes a further distinction between enlightenment as an experience and enlightenment as context, an entire perspective in which one can abide and in which all experiences arise and fade. To abide in the context of enlightenment suggests an irrevocable surren- der of oneself into a nondual context which is constant and inde- pendent of experience, including the experience of enlightenment itself. He says that whereas in the context of duality there can arise experiences of enlightenment that then subside, in the context of enlightenment any experiences of duality that arise will then subside back into the abiding context of enlightenment itself. This radical distinction defies all notions of enlightenment as any one state, by placing it in the domain of context.

**Enlightenment is an impersonal energy.** (Andrew Cohen; Carl Jung)

Andrew Cohen, founder of and teacher at the Moksha Foundation, describes the impersonal aspect of enlightenment as fol- lows: "The energy of enlightenment is an energetic movement in the universe that is the movement of evolution in consciousness. The movement of that energy is impersonal. It doesn't really care about you, doesn't really care about me. It has its own directive. It has its own business that needs to be accomplished, and your own particular situation or feelings as an individual are perfectly irrelevant to it because it has its own function, a function that is not conscious of you as an individual or your own psychological or emotional karmic cir- cumstance at any particular time."

In a manner similar to that in which Cohen uses the term "the energy of enlightenment," author Lee Sanella explicates Carl Jung's perspective on the kundalini. "Jung described the kundalini as an impersonal force," writes Sanella. "He argued that to claim the kun- dalini as one's own creation is perilous. It leads to ego inflation, false superiority, obnoxiousness, or even madness. For him, the kundalini is

an autonomous process arising out of the unconscious and seemingly using the individual as its vehicle."⁹

This definition suggests that enlightenment neither belongs to an individual nor is personal to him or her. One does not experience the energy of enlightenment because of one's good deeds or extraordinary nature. The movement of enlightenment is an unemotional force, indifferent to personalities and personal preferences, that uses the most suitable human vehicle to fulfill its needs.

Cohen goes on to make a distinction between what he refers to as "personal" and "impersonal" enlightenment.

> In the first [referring to personal enlightenment] the interest in Enlightenment is for personal gain. That means: I want to have a particular insight, a particular experience or a particular understanding, because I want relief from suffering or because it fascinates me. The second, impersonal enlightenment, refers to the discovery of an interest in Enlightenment for its own sake, not for your sake.
>
> In personal enlightenment the person doesn't care about anything because they have achieved a self-satisfied condition of freedom and personal liberation. But beyond personal liberation there is a profound discovery of something else. One comes upon a particular sense of urgency where one can't help but care. You have to go way beyond personal enlightenment to even begin to know what I'm talking about. Impersonal enlightenment is the discovery of a choiceless and absolute commitment to the realization of perfect purity in yourself for the sake of all beings—not for you."¹⁰

*The candle is not there to illuminate itself.*
NAWAB JAN-FISHAN KHAN

In his book *Enlightenment Is a Secret,* Cohen further explains, "The full realization of Enlightenment is the evolutionary leap to which all spiritual experiences ultimately lead. In deep spiritual experience a human being realizes that which is personal . . . Spiritual experiences and their results are not meant for the individual. They are for the whole race." He also says, "When you think about Enlightenment, it

is important that you include other people in that idea. Transcendence will be yours when you begin to accept responsibility for the condition of the whole human race."[11]

The majority of people who speak about enlightenment stop at what Cohen refers to as "personal enlightenment." Even for many people who have high standards of integrity, their goal of "enlightenment" refers to their own, personal breakthrough and is not connected to a larger vision. Other teachers do not refer to "personal enlightenment" as enlightenment at all, but rather a clear perception of reality that has not been integrated in the person. Some schools of spiritual thought and practice say it is enough to stop at "personal" enlightenment, while others say it is only the beginning of the beginning, and still others say it is not the point at all.

### Enlightenment is the realization of connectedness. (Joan Halifax; Christina Grof; Lee Lozowick; Daniel Moran)

Halifax defines enlightenment as "the realization that you're not alone. You're everything. Everything is connected. Everything is abiding in everything else."

The key word in Halifax's definition is "realization." It has become almost a cliché to say, "Everything is connected. We are all one." Yet there is a great difference between speaking these words and realizing them. Realization implies an integrated, bodily understanding of the reality of the connectedness of all things. This realization inspires a humility that an intellectual, or even intuitive, sense of it cannot. "There is a sense of humility in the face of knowing that you are connected to a larger whole," says author Christina Grof, president of the Grof Transpersonal Training Institute.

*I absolutely cannot see somebody else separate from me. It's impossible.*

DANIEL MORAN

Lozowick describes this realization of connectedness from the perspective of the illusion of separation which unawakened human beings live under. "The root of our suffering is the assumption of separation. We assume we are separate from the Divine—that we are independent and unconnected to everything else. Our entire relationship to life is based on that assumption, yet, essentially, separation is an illusion."

Most people unconsciously assume that they are not connected, and this assumption has significant implications. When we believe we are not connected, we have an adversarial relationship to the entire world and everything in it. We think in dualities: "me versus you," "me versus it," "everything exists outside of myself." When we believe we are separate from God or from Reality, we feel that we are not whole and not complete; therefore, we must take something from somebody to get that missing completeness. Aggression is based on a failure to realize connectedness.

Connectedness, according to Daniel Moran, assistant teacher to Arnaud Desjardins, "is erasing progressively and more perfectly the idea of the ego that says, 'I exist. I exist as a solid entity apart from the rest.'"

**Enlightenment is the realization that you know nothing.** (Mel Weitzman)

"Where people get off the path," says Mel Weitzman, abbot of the Berkeley Zen Center, "is that they think that enlightenment means that you know everything. So, ultimately, the greatest enlightenment is to realize that you know nothing."

**Enlightenment is more easily recognized through understanding one's endarkenment.** (Charles Tart)

To study one's own endarkenment—the illusion in which the vast majority of human beings are steeped to greater and lesser degrees— may be a more practical approach toward self-understanding than to try to assess one's own enlightenment. Charles Tart, an expert on altered states of consciousness, reveals his perspective on endarkenment.

I feel that I don't know what enlightenment is even though I am an expert on it. Both personally and professionally, I've studied endarkenment for almost sixty years now, so that I know when I'm deeper into my craziness and my distortions and cut off from reality. There have certainly been times when

*The spiritual journey has to do with really raw material, really confronting our fundamental ego-mania, our separation from our world. And, as such, it's a threat to accumulated habit.*

JUDITH LEIF

I've lightened up on the endarkenment, when I've actually listened to what someone was saying instead of hearing my preconceptions about what they ought to be saying. There are times when I've been able to be more helpful to people in that way, and I value those times, but they tend to be transient. I don't have any delusions that say, "Gee, I've become a really enlightened person." I know I haven't. I know I'm not as crazy as I was twenty years ago, and I'm glad of that. I can pay a little more attention. But compared to what I think is possible, I still have a long way to go. And even as I say this, I notice that there is a part of me that is proud of being so humble about enlightenment, so I better watch out for that part.

**Enlightenment is the exception to the rule.** (Jai Ram Smith)

"The thing about enlightenment," explains Smith, "is that it is the exception to the rule—it just is. It's the exception to the rule of ordinary life. Everything you hear about enlightenment is confusing to the mind. If I read one thing, I think, 'Oh, this is it,' and for a moment I am inspired by it. But then I read something else that some other teacher said, and I go into that mode. There are as many modalities as there are experiences."

Smith points to the subjectivity of our understanding of enlightenment. Not only are there many facets of Truth, but human beings on the spiritual path tend to be easily swayed by fancy definitions and ideas about it. Enlightenment is confusing to the mind because it does not exist within the context of mental constructs. By definition, it is other than that, and thus the exception to every rule of common understanding.

**Enlightenment has degrees.** (Arnaud Desjardains; Carlos Castenada; Andrew Cohen; Philip Kapleau Roshi)

Arnaud Desjardins proposes the following consideration regarding degrees of enlightenment: "Is there only one level of awakening or

enlightenment? Shall we say that either one is awakened or is not? Or can we say that one is more or less enlightened? My answer would be not that one is more or less naked but that one has more or less clothing. I am convinced the idea of gradual progress is much more helpful than expecting, waiting, for this sudden, complete awakening or enlightenment."

An avid follower of Carlos Castenada's work summarizes his perspective regarding this question of degrees of enlightenment. "Castenada says that people cross the line of enlightenment at different distances in terms of how complete their enlightenment is. People awaken to varying degrees. Some people awaken as virtually completed products, whereas some awaken still needing a great deal of assistance. They cross the line, but not to the degree of stability."

Cohen suggests, "Generally, the differences between the attainments of truly Enlightened individuals can be broken down into two categories: (1) *depth* of the attainment, e.g., the depth and breadth of the Enlightened vision and understanding, and (2) the *purity* of that attainment. That means: How untainted is the expression of that attainment? Is it tainted at all? And if so, to what degree?"[12]

The Zen tradition makes a clear distinction between "shallow" and "deep" enlightenment. It claims that while it is possible for the satori to penetrate individuals so profoundly as to produce a radical change in every aspect of their expression, often initial enlightenment is more "shallow" and must be deepened over time. Kapleau Roshi explains, "*The* satori person is an abstraction. There are only individual people of satori, or enlightenment, whose character and personalities vary according to the depth of their insight and practice."[13]

*When we think about enlightenment on a continuum, we can see it as a process, not just a final state.*

CHARLES TART

There are very different opinions among spiritual masters regarding the issue of "degrees of enlightenment." There are basically three perspectives on this issue. The first is that of "gradual enlightenment," in which the spiritual student gradually progresses along the path and becomes increasingly enlightened. The second is that of "sudden enlightenment," in which the individual practices and matures as a human being but the actual "enlightenment" is a radically marked moment not connected linearly to the gradual maturation that pro-

ceeded it. The third is that enlightenment has "degrees," but only *after* one awakens. In other words, there is a progression of increasing degrees and so-called levels of enlightenment, but they do not begin until after a radical shift of perspective has taken place.

Among those included in this book there was a great range of perspective regarding this question of "degrees of enlightenment," including, "Who cares to what degree you are enlightened? Just live your life in integrity, serve others, and don't worry about it!"

*Enlightenment is freedom from the spiritual path.* (Charles Tart)

> *The thrust of the warrior's way is to dethrone self-importance.*
> CARLOS CASTENADA

In an only half-kidding manner, Tart says, "Friends and I used to joke, 'Enlightenment is freedom from the spiritual path.' When you don't feel any need to be enlightened, that is very profound. Of course, the trouble is that you can also feel no need to be enlightened because you are totally lost in delusion. So it's a very tricky business: to be honest about enlightenment, but not to get twisted in an egotistical sense."

## The Preference Not to Talk About It

While many teachers will discuss the issue of enlightenment, there are others who will not talk about it or who will do so only with great reluctance. There are those who prefer to simply proceed with the practice of living an enlightened life; those who believe it is dangerous to discuss enlightenment because it further confuses people; and those who want their students to focus on living in a balanced and intelligent manner before concerning themselves with advanced considerations of enlightenment.

Most people who speak publicly about enlightenment are really speaking about their own fantasy, parroting an intellectual definition they once heard or maybe even experienced. This is a trap because the ego can all too easily enjoy the status of being one who "knows something about enlightenment." Another trap is assuming that everyone

in a lecture or a discussion, or everyone who engages spiritual life, has a shared understanding of what enlightenment is. Joko Beck recounts:

> Someone said to me a few days ago, "You know, you never talk about enlightenment. Could you say something about it?" The problem with talking about enlightenment is that our talk tends to create a picture of what it is—yet enlightenment is not a picture but the shattering of all our pictures. And a shattered life isn't what we are hoping for.[14]

It is interesting that so many of those whose lives seem to demonstrate anything *but* enlightenment easily lecture on, and profess, their own enlightenment; whereas those who, if not wholly enlightened themselves, lead lives of tremendous service and compassion and who are effective conduits for spreading spiritual teachings are insistent on their lack of enlightenment, and prefer not to discuss the subject. Joan Halifax, whose qualifications include ordination in three Buddhist lineages and serving as the director of a zendo and spiritual education center, states:

> I don't like to talk about enlightenment, because I myself feel like a Zen failure. I don't feel in any way enlightened. I feel I am constantly struggling with my own defilements and working with them. I feel the contraction in my own nature is quite strong, and the sense of self is also strong. So for me to talk about enlightenment is presumptuous. I am not enlightened. I have had tremendous vision on several occasions. Through the wear and tear of life, having made some really painful mistakes—for myself and others—I've learned some lessons. But in terms of enlightenment, no. Not this one. Not this one.

*Follow your soul and not your mind, your soul that answers to the Truth, not your mind that leaps at appearances.*

THE MOTHER

The tremendous presumptuousness and lack of humility in making the claim of being "The Enlightened One" stands in clear contrast to Halifax's insistence on her own lack of enlightenment. She recognizes and respects the magnitude of what is referred to as enlightenment,

and knows that even those of significant spiritual understanding and influence must be extremely wary of presuming themselves to be enlightened. Of course, there is always a danger that the ego that wants to be seen as humble will take on the disguise of "I'm not enlightened" and become even more proud of itself.

Chogyam Trungpa Rinpoche, who personally knew many of the great saints of our time, is said to have stated that he had met only three enlightened beings in his whole life. If his assessment was correct, or even nearly correct, and he knew only three enlightened beings on the whole planet of the hundreds, if not thousands, of masters he had met, it is certainly presumptuous for even talented spiritual aspirants to casually talk about enlightenment as if the experience of it was common. Judith Leif says, "We can talk about experiences that come and go, but enlightenment is much more than we can talk about."

*The really sincere act is the one which is known by no recording angel, by no demon to afflict it, nor by the self, to become prideful of it.*

IDRIES SHAH

Many teachers are far more interested in *demonstrating* enlightenment, and encouraging their students to demonstrate it, than in sitting around talking about it. Trungpa Rinpoche asserts, "One has to create the situation around one, so that one does not have to say, 'I am the Awakened person.' If one had to say such a thing and demonstrate it verbally, one would not be awakened."[15] Psychologist Gary Mueller agrees: "Enlightenment needs no announcement, or recognition. It is a natural process of the soul's evolution." In fact, excessive reflecting on who is and isn't enlightened, and evaluating every move to see if it is "enlightened" action or not, can be a distraction from enlightenment itself. Robert Svoboda observes:

> If you're enlightened, why not just sit quietly and be enlightened. It used to be that people were *swamis*. Then they became *bhagwans*. Now, so many people are *avataras*—incarnations of God coming down on earth. So where you see inflation, you have to think that the underlying currency is losing some of its value. So why start naming yourself anything? Why not simply go about your business like Kabir did? He didn't bother naming himself anything. He just sat, and he wove, and he wrote songs, and people came to him and he talked to those people. He

worshipped God and had a nice time and that was fine. He didn't make a big deal about anything. He enjoyed life.

People talk about enlightenment primarily because an everyday existence, full of the struggles and demands of ordinary life, sounds very painful in comparison to the enlightenment they dream of. Yet, Philip Kapleau asks:

> In what ways is an enlightened person different from one who isn't? Although they may ignore conventionality, the awakened do not flaunt their behavior. Neither do they put people into a bind by imposing shoulds and oughts on them. Their lives are simple and unpretentious. They are full of gratitude and compassion. Those truly enlightened do not boast of their enlightenment. Just as a truly generous person doesn't say, "I'm a generous guy, you know," so one who has integrated into life what she or he has realized in awakening will not wear enlightenment as a badge and shield. The fully awakened are modest and self-effacing. While they do not hide their light under a bushel basket, as the saying goes, at the same time they are not pushy or aggressively self-assertive. They know that in truth there's nowhere to go; they are already there.[16]

*Those who wish to progress should examine their assumptions.*

IDRIES SHAH

In the larger context of the demands of the true spiritual life lived in full, perhaps enlightenment is not what is referred to as "the pearl of great price." Perhaps enlightenment is something else. Perhaps it is just one more point, albeit a significant one, in the endless flow of service required by the enlightened life.

## If We Knew What Enlightenment Was, We Would Run from It

What could be so awful about enlightenment that it would make someone want to run from it? Only one who knows the reality of

enlightenment firsthand can adequately answer this question, but from the accounts of many, many of the great masters, Reality, or enlightenment, is not the heavenly salvation that most people hoped it would be. There is tremendous suffering in Reality in addition to the joy, and the enlightened vision sees all of it, as it is, unable to defend itself against any aspect of it.

In an interview with E.J. Gold, *Gnosis* editor Richard Smoley mentioned that he had always had the impression that enlightenment is a pleasant experience. Gold unapologetically contradicts this common and naïve assumption.

*We're all in the same boat, and half the time we're up shit's creek.*

ANONYMOUS

Every teacher, every schmuru I visited, I always asked the same question. "Do you ever feel afraid? Do you ever feel fear?" Not one of them said no. People tell me, "I've had a psychedelic, and it was so far out! I loved it! It was great!" I say, "You *loved* it? You want to take it again? What are you, out of your mind? You've never had a trip. You were never there! If you think it was a groovy place to go, and you want to go there again, you didn't get the point!" It's not a pleasant place to be; if it were a pleasant place to be, this universe would not exist.[18]

Lee Lozowick also talks about visiting saints around the world and points out that the true saints, although often radiant and capable of great joy, also suffer immensely. They bear the heartache that results from the clarity of their vision of the suffering of humanity. He goes on to suggest that "being an enlightened teacher" is not as glamorous as many imagine it to be.

Most of us think that if we do our spiritual work properly, all our problems will be taken away by the Master. However, the more successful we are, the bigger our problems become. The biggest problem the Master can give you is to ask you to teach, because you have to deal with untransformed individuals. Untransformed individuals are notoriously resistant to change, clinging to their own misery as if it were gold.

Vipassana meditation teacher Robert Hall notes, "I think if everyone understood what it meant to be a teacher, they wouldn't want to be teachers. It's not really all that wonderful." People often imagine the life of a guru to be one in which disciples sit humbly at their feet, bring them gifts, place flower malas around their neck, and offer them large donations. However, it may well be, if we can trust the testimonies of those who should know, that neither enlightenment nor the esteemed position of spiritual master are all that one imagines them to be. It is our assumptions about enlightenment, rather than our experience, that lead us to draw so many conclusions about it.

Generally speaking, most people have the idea of enlightenment backwards. If they understood that instead of swimming in an ocean of bliss their enlightenment would mean a life of heartbreak, service, and suffering on behalf of others, many would leave the path before they even began. That is why many great masters warn, "If you knew what enlightenment was, you'd run the other way." At the same time, it is the very teachers that tell people to run from enlightenment who simultaneously draw dedicated students to the path and do spiritual backbends and somersaults to get others to join them in the life that they themselves have committed to. They have seen Reality as it is and, knowing that no other real option exists, have committed their lives to serving it.

### VIMALA THAKAR: ENLIGHTENMENT CANNOT BE AN EXPERIENCE

Asked to teach by J. Krishnamurti nearly forty years ago, Vimala Thakar, a modest Indian teacher of unquestionable authority, has traveled the world teaching inquiry and meditation. The following excerpt comes from a letter that Vimala wrote from her home in Mt. Abu, in Rajasthan, India, as a contribution to this volume.

*Enlightenment is the consummation of human growth and maturity. It cannot be an experience. Experiencing is possible only on the mental plane. Mind is conditioned consciousness. It is conditioned through centuries by the total human race. Such conditionings, or sanskaras, are voluntarily accepted limitations for the sake of social life. Man is a social animal. The process of relationship presumes common conditionings which consist of organized thinking patterns and behavioral patterns, as well as the patterning of defense mechanisms. These patterns may be crude and uncultured, or they may be refined and sophisticated. They are, however, necessary requirements for the smooth running of a society.*

*The body-brain complex cannot be equated with the totality of our life. The conditioned consciousness cannot be equated with the totality of the energies moving and interacting within and around the field of our body and mind. The exploration of that which is beyond the reach of the physical senses, sense organs and the cerebral faculties can take place only in the unconditional abeyance of mental movement.*

*Experiences take place as long as the "I" consciousness, which is the monitoring agent of thought structure, is functioning. When the mind ceases to move, experiencing and experiences cannot happen. Enlightenment cannot be an experience.*

The mystical experiences can be the movement of a refined and sharpened body-brain complex. This organism is sensitized through refinement, and can assimilate impressions and vibrations contained in the emptiness of space. Such impressions and vibrations could be called "impersonal" in content, though they are localized in a particular individual's body. Obviously, the happenings on the vital or the subtle-most plane of consciousness have a different quality and feel than the sensory or ordinary psychological experiences. They have a uniqueness of their own. They confer upon the individual the splendor of sophistication, and yet they cannot be called the symptom of enlightenment.

The Supreme Liberation of moksha, as it is called in Indian terminology, has nothing whatsoever to do with ego-centered experiences or even happenings around the ego-field. Liberation is an entirely different dimension of Cosmic Energy. An individual may be visited by that unconditioned energy of Supreme Intelligence which causes a mutation in the whole being. The physical form may remain the same or might even go through some changes. The thought structure tethered to the total human past is rendered defunct. It no longer has any independent momentum of its own. It becomes operative only when the energy of Liberation requires its movement.

True spirituality is a mental attitude that you can practice at any time.

THE DALAI LAMA

# Motivations for Seeking Enlightenment

*Many so-called spiritual seekers are just Narcissus in drag.*[1]

—Bubba Free John[2]

Because there is so much confusion as to what enlightenment is, it is hard to know what we are looking for when we seek it. What we perceive enlightenment to be will dictate and influence the motivation toward its fulfillment. If one thinks they will "get" something from it, they might be motivated by greed or emptiness; if one thinks it will bring bliss, they might be motivated by unhappiness; if one thinks it will bring union, they might be motivated by separation, and so forth. In this chapter we will survey the range of motivations from which human beings seek enlightenment. More attention is given to the impure rather than the pure motivations for two reasons: one, the pure motivations need no clarification or examination—they are uncorrupted, untainted, and already serving their purpose; and two, given how "enlightenment" is used in contemporary spirituality, most people's motivations for seeking it are impure and in sharp need of scrutiny.

*Anybody or anything may stand between you and knowledge if you are unfit for it.*
IDRIES SHAH

## Pure versus Impure Motivations

According to the ancient scriptures, the knowledge of enlightenment is within every one of us, existing as our very nature. At the same time, the human being who is identified with the separative, egoic state entertains grave distortions about the nature of enlightenment. Therefore, within each individual there exists both pure and impure motivations for seeking enlightenment—the pure motivation stemming from the individual's true nature, the impure motivations arising from the egoic, separative state. While it is said that all human beings intuitively long for enlightenment, union, and Truth, and that this is the ultimate purpose for human existence, a cursory glance at the present state of humanity reveals that most people show no indication of this longing but, on the contrary, reveal a tendency toward widespread delusion. This is because most individuals are identified with their egoic, separative identity. They are identified with the illusion of their lives and not with their true nature.

*Typically, seekers do not really want to face mortality but rather subconsciously attempt to defer it by clinging to the notion of a progressive path of enlightenment.*

GEORG FEUERSTEIN

Before we delve into the issue of pure versus impure motivation, it is worthwhile to clarify those terms. "Pure," by definition, is untainted, uncorrupted, pristine, essential. A pure motivation for seeking enlightenment is a motivation that is uncomplicated and uncontaminated by the distortions of ego and illusion. "Impurity" can connote a Victorian ideal of something which is dirty, polluted, unclean—somehow bad or wrong—but in reference to one's motivation for seeking enlightenment, it instead suggests corruption and subjectivity in one's motivation. An impure motivation is an egoic motivation.

Charles Tart sheds some perspective on the issue of pure versus impure motivation by suggesting that pure motivation alone isn't the only factor to consider.

If I needed surgery, I'd rather have a surgeon who was really competent but had weird motivations than a surgeon who had good motivations but was incompetent. From the consumer's perspective, "doing the right thing" has a lot of value to it. Now in terms of the person themselves, if their motivations

and actions are at variance with one another, this is going to create a lot of internal suffering, and that is one of the problems they have to work on. Also, I don't really like the world "purity," because the Western mindset is that there is absolute purity and then there is sin. Most of the time we operate from mixed motives.

A spiritual aspirant who has impure motivations but acts with integrity might be better off than one who has a more pure motivation but no energy, ability, or skill to proceed. It depends entirely upon the circumstance. Ordinarily, if an individual with impure motivation continues to *act* as if their motivation is pure, the impure motivation rubbing against the purity of their actions will eventually produce insight and transformation.

"Motivation" is the driving force behind one's aspirations and actions. However, it is tricky to talk of motivation in regard to the issue of enlightenment because motivation implies hope, and enlightenment is about giving up all hope. In *Cutting Through Spiritual Materialism*, Trungpa Rinpoche says that an individual will suffer depression and failure to the degree that they search for the fulfillment of their imagined dreams. "This is the whole point. A fear of separation, the hope of attaining union, these are just manifestations of or the acts of ego or self-deception . . . Ego *is* the actions, the mental events. Ego *is* the fear . . . of losing the egoless state." [3]

One could say that any motivation, pure or impure—any attempt to "get" or "attain" something—is based in hope and in ego, because the egoless state does not strive to "attain" and is therefore not "motivated." It is true that the *dream* of enlightenment is the dream of ego but, at the same time, there is a force within us that moves in the direction of union, that reunites us with Truth. It is a force that is not motivated by ego but rather could be said to be "the self longing for the Self," or "God longing for God." Human beings are motivated in the sense that they are faced with the impetus to act in the life that continually unfolds before them. When this raw, life energy that prompts them becomes intentional and refined, the motivation becomes purified.

*The desire for an 'awakening' . . . may or may not be accompanied by the information and experience essential to precede this stage.*

IDRIES SHAH

*I think the point in spiritual work is to fulfill the time that is allotted in this earthly journey in some way that has meaning. Perhaps no more than that.*

ROBERT HALL

In every individual, there is a combination of pure and impure motivation. The pure motivation is always there, but in some it is buried very deeply and rarely shows its face, while in others it arises and subsides along with the arising of impure motivations, becoming refined often in ways that are imperceptible to us. Knowing that both pure and impure motivations exist within us serves as a reminder to continue to question ourselves and refrain from making assumptions about our own enlightenment.

## ANDREW COHEN: "PURE VERSUS IMPURE MOTIVATION"

*There are only two reasons why a human being would take the leap into enlightenment. One reason would be this: a pure-hearted individual, in whom the fire of liberation is burning brightly (there can also be a pure-hearted teacher in whom the fire of liberation is not burning brightly), if they had a very profound spiritual experience, would recognize very directly, very immediately that in the face of the Absolute they have absolutely no choice but to surrender everything without conditions. That is the famous war cry of surrender: "Thy will be done."*

*At that point the individual realizes that they have to give up their own will utterly and completely to the Will of the Divine, to the Will of the Absolute. They may actually have no choice but to do so because all they are interested in is that the truth become manifest in this world unadorned. There is an impersonal evolutionary imperative that functions in them that cares not about the ego or the personality of the individual who comes to them, but that only cares about the individual's true self. For a teacher like that, the ego is their enemy and they won't bargain with it and they won't pretend that it's okay.*

*A person who is not necessarily pure-hearted, but who has a lot of ambition, spiritual ambition, would be willing to take that same leap, which means they would be willing to leave the world behind and everyone in it, in order to be the One—the only One. So that individual*

would be willing to accept that kind of independence in order to be the Enlightened One, the only One, the One who stands alone. And so for that individual, their motivation is very different because they want to be special. Because they want to be the Enlightened One, they are willing to pay an enormous price.

You see, in these two cases the same leap has to be taken, which is leaving the world and everyone in it behind forever. But the motivation is completely different. The pure-hearted person does this because they have no choice and they're not trying to get anything in order to be someone; whereas the spiritually ambitious person would be willing to take that kind of risk in order to be The One Who Knows. It is a very delicate business.

Yet the quality of liberation in the two types of individuals is not the same. In the case of the pure-hearted individual there is no wanting for himself or herself, whereas in the case of the ambitious individual, what's fueling their confidence and their charisma and their independence is the desire to be the one who is worshipped, adored, and seen as being the Enlightened One. So the quality of the emanation and the transmission from these two types would be very, very different.

I've thought a lot about how these things work and tried to make sense of it all. This is as close as I've gotten. It's a very delicate business, but if you begin to understand how impersonal the movement of the enlightened energy itself is, what becomes obvious and apparent is that we as individual, conscious human beings have an enormous responsibility in all this evolutionary process.

The presence of the energy of enlightenment, or the energy of enlightened consciousness or grace, in and of itself is not enough. The enlightened consciousness, or enlightened energy in and of itself, free from the full-hearted participation of the pure-hearted and pure-minded individual, is useless. A lot of people think it is enough, but it's not because we have our own role to play. It has to go hand in hand with the cultivation of a pure vehicle, meaning our own self. So when these two things come together then something really remarkable, extraordinary and very significant happens.

## Pure Motivations

*We need hope, the powerful hope of attaining enlightenment in this lifetime. We need that hope because of having to relate with the constant chatter that goes on in our mind, the emotional ups and downs of all kinds that go on, the disturbances that we experience, the constant, ongoing processes taking place in our state of being.*

CHOGYAM TRUNGPA

Sometimes the pure motivation within the individual is conscious, and sometimes it is unconscious. Pure motivation exists within everybody as their birthright, and they will experience it either by the grace of good karma, and/or to the degree to which they consciously cultivate and nurture it.

Claudio Naranjo, psychologist, teacher, and long-term devotee of the spiritual way, says, "There is no way around it. Sincerity is required. To the extent that we fool ourselves, there is a dishonest intent." Naranjo points to the need for sincerity, not perfection. Just as impure motivation does not equal "bad," pure motivation does not equal "good" or "flawless." Instead it refers to that human longing which is motivated by one's innermost being.

One pure motivation for seeking enlightenment is that one has tasted or felt the suffering of humankind and feels they have no other choice but to seek to live from the enlightened perspective. They recognize that this is the only truly effective way they can be of help to others. They seek liberation in order to effectively serve that suffering. Andrew Cohen says, "Pure motivation means that you want to be free not for your own sake but for the sake of the whole."[4]

The other pure motivation for seeking enlightenment is that one is so humbled by having glimpsed the glory of God that they wish only to celebrate, praise, and serve that vision. Here, too, the wish is for service, but, instead of being motivated by the suffering of humankind, one is motivated by the glory and majesty of God or Truth.

## Impure Motivations

Acknowledging the impurity of one's motivations brings us face to face with the grueling task of understanding the ego's role in spiritual life. The recognition of our own impurity humbles us and our vision of the path in a way that allows for the possibility of seeing reality more clearly and objectively, instead of remaining steeped in the illusion.

Most people's motivations for seeking enlightenment (as well as for everything else they do in life) are unconscious. If the average beginning spiritual seeker in a big spiritual school was asked what motivates him or her, it is unlikely that he or she would have the clarity to respond with, "I'm afraid of dying," or "My mother didn't love me," or "I want to feel better."

Becoming aware of our motivations for seeking enlightenment and pursuing the spiritual path is part of genuine and uncompromised spiritual work. Awareness creates the possibility of not being a slave to those motivations, not mechanically acting in egocentric ways while sincerely believing that one's intentions are holy and selfless. Knowing our impure motivations for enlightenment makes us more real, humbles us, brings us closer to ourselves and to our own suffering, and therefore to the suffering of others.

*It is because any and every desire or motivation with any root in the personal will obscure the clear perception of that perfect order that it is imperative that every vestige of personal motivation be destroyed.*

ANDREW COHEN

## LLEWELLYN VAUGHAN-LEE: GOD'S DESIRE FOR YOU

*You see, what people don't realize is that, in the end, what takes you to God is your desire for God, which is His desire for you. And to live that, it doesn't matter if you make mistakes. I have made so many mistakes. It doesn't matter. What matters is your desire for truth, your desire to find what is real and not to be caught in outer appearances. And the teacher can be very deceptive outwardly, sometimes consciously and sometimes because that's just the way it is and the way it should be. But if you really desire it, if you really want it, if you really stick to it and stick to it and do the practices and work on yourself, bit by bit you surrender, bit by bit you create this inner container to be able to live in the presence of God, to be able to live a life of service to Him, to That, whatever you like to call it. And then, you know, enlightenment or not enlightenment, it doesn't matter.*

### Relief from Suffering

Human beings suffer, and seek relief from that suffering. When Buddha left the protection of the walls of the palace that had kept him sheltered from life and encountered the reality of suffering, old age, sickness, and death outside the gate, he declared the first noble truth: "Life is suffering." Buddha didn't say, "Joe's life is suffering," or "Anne suffers," and add that if they were good spiritual students they could be free of that suffering. He said that *life* is suffering. Human beings have great difficulty accepting this. In fact, all but a very few downright refuse to accept it. And understandably so, for to accept the reality of suffering implies that there is no way out. It also means that one begins to see the great lies and distractions that human beings have created in their world in an attempt to avoid the reality of their suffering.

Because human beings remain in denial about the fact of their suffering, the idea of "enlightenment" becomes the symbolic ticket out of it. Words associated with enlightenment that once carried with them tremendous meaning, words such as "transcendence," "freedom," and "going beyond" that were originally used by mystics, have been translated, reinterpreted, and set in an ego-centered context in a way that suggests to the suffering individual that "enlightenment" will remove their suffering. As Andrew Rawlinson suggests, "A lot of people are attracted to spiritual life who essentially want Father Christmas teachers: bliss-bestowing hands, laughing Buddha goes up to the mountains, makes his toys, gives them to everybody. Those people don't want to know about anything that looks dangerous or risk-taking."

Georg Feuerstein writes: "All too often neophytes suffer from the delusion that spiritual practice is supposed to be fulfilling. They expect to be made happy, to be relieved of their basic existential sense of dilemma, by their own efforts or by their teacher."[5]

Another twist on how people attempt to use "enlightenment" to relieve their suffering is by interpreting and manipulating the spiritual teachings in a way that justifies their own self-centered activity. In *Waking Up*, Charles Tart explains how this works.

If you haven't mastered various ordinary developmental tasks yet, these ideas provide glamorous and prestigious rationalizations for avoiding facing your shortcomings and working on correcting them. "I feel uncomfortable around ordinary people because they are asleep, just like Gurdjieff said, so why should a sensitive soul like me, a person on the Path, associate with them?" "I don't stay long in any job because I see the phoniness in mindless enculturation. I am above such common and degraded things as being a steady, mindless worker." At best, these ideas are fuel for pleasant daydreams about your situation, which you are not really intending to change anyway. At worst, they encourage you to let go of the few social skills you do have and contribute to further maladjustment to your culture.[6]

People believe that enlightenment will free them from the suffering of their own shortcomings and from having to face themselves both because they want to and because this is what those before them who have misassumed their own enlightenment claim to be true. Such individuals write about the bliss and everlasting peace of enlightenment, and those who long for reality to be different than it is read their writings and believe it.

On an objective level, there are not degrees of suffering—living in illusion is suffering—but there are gradations of awareness of suffering. If we are seeking enlightenment to be relieved of psychological discomfort, we will probably get superficial results, at least initially. Marie-Pierre Chevrier, an assistant teacher for Arnaud Desjardins, elaborates.

There is a confusion between a spiritual search and a psychological need to feel better. Once people have achieved a certain harmony on a psychological level and things are going a bit better, they may find that there is nothing more behind their desire. But as long as things are not going well and they are not feeling good, they mistake their search for happiness for a spiritual goal. It is important to feel better, but when people

*It all comes down to the fact that people want to be rescued from their suffering and their terror, and are willing to do anything to find that salvation.*

ROBERT HALL

wonder why they don't progress more than they do, it is often because of this confusion.

It is very important that people acknowledge and understand their impure motivations for seeking enlightenment so they can recognize the unrealistic expectations they have about spiritual life. Lee Lozowick comments:

> The typical psychological motive for coming to spiritual work is to be relieved from suffering, not because we want to serve God, though that may be somewhere in there. Because we want to be either free from suffering or safe in some way, we tend to view the effects of the work as having a kind of end result: if we do everything right, if we practice right, if we relate to the teacher right, if we pray right, then there's going to be a definitive end result which is salvation or safety.

Ego, in its belief that *it* can get *itself* enlightened, a subject that is further discussed in Chapter Seven, goes about trying to manipulate circumstances so that it will not suffer anymore. Ego (which we commonly consider as "ourselves") does not understand that it is not circumstance that creates suffering, but the identification with ego itself! As a result, the ego that seeks enlightenment as an escape from suffering is doomed to failure because it cannot escape from itself.

"Human beings are always looking for an oasis," comments Reggie Ray. "There are mundane oases—money or sexual pleasure or looking good or whatever—but also, in the spiritual realm, certain states of mind. Buddhism is always saying that enlightenment is not an oasis."

Enlightenment is not likely to relieve our suffering. In fact, many who seriously engage spiritual work claim that they experience more suffering as they progress along the path. As long as we have a human body, there will be suffering and there will be death. After we have realized that money, food, sex, vacations, and other worldly satisfactions provide no lasting relief from suffering, we fantasize that perhaps enlightenment will. Ironically, the belief that enlightenment will

bring salvation creates more suffering. By believing we can be "saved" from suffering, we end up continually resisting it instead of learning to move through it and benefiting from the lessons it provides.

There are those who say that suffering does change—that there is a shift from feeling one's own personal and psychological suffering to feeling the suffering of others, the suffering of the planet, of the cosmos, and ultimately the suffering of God. But those who make this claim also say that, while there is a certain freedom in no longer identifying with one's own suffering, to feel the suffering of God makes any personal suffering minute and insignificant by comparison.

If we truly understand suffering—even our own—our motivation to seek enlightenment for relief from it, although destined to fail, will be of tremendous benefit to us. Our suffering has to do with the intuitive awareness of the inevitable passing of all phenomena, including our very lives, and with our perceived separation from God or Reality. When we seek enlightenment to avoid our suffering, we are fleeing from the stark terror of accepting reality as it is—the stark terror that is beyond our ability to grasp but is always there. In other words, if we know we are seeking enlightenment because reality is so hard to bear, we at least have an intuitive sense of what we are fleeing from: a reality that has already begun to surface in our consciousness—a reality that our very seeking will eventually cause us to face.

The energy that comes from a conscious awareness of one's suffering, as opposed to denial of that suffering, is a powerful force that can propel us into real spiritual practice—practice that will eventually result in the ability to accept the truth of that very suffering. Our "impure" motivation to seek enlightenment as a relief from suffering can move us into spiritual sadhana that will expose the impurity of our motivation while simultaneously purifying it.

## Spiritual Ambition: The Search for Power and Control

Who would think that the imagined spiritual life—devoted to meditation and prayer, lost in the bliss of God, humbled in the face of truth—could be yet another cloak for dreams of power and success, or

*The mind has a way of tricking us into thinking that the way to not suffer is to get enlightened and have everything happen exactly the way we want it to.*

ROBERT ENNIS

a disguise for feelings of personal failure? Yet for many, it is just that. The fact is that the search for enlightenment is often a search for power, fame, prestige, or some other form of worldly success.

If an individual's modus operandi in life is to seek to be a "somebody," to be important (e.g., the CEO, the star athlete, the female corporate executive), and that person becomes involved in spiritual life, it is more than likely that the search for enlightenment will become linked with the search to gain power and fame in the spiritual domain. This is how ambition functions. An ambitious individual is not ambitious only in one arena but in all of life, including spiritual life.

If the individual suffers deep-seated feelings of loneliness and lack of acknowledgement, they think that perhaps a teacher, God, or "being enlightened" will finally gain them recognition. "This is the perennial human drama," says Andrew Cohen, "the desire to be someone. How much more special can you become in this world? Because the enlightened person is supposed to be One with that which is Absolute. So to the spiritually ambitious person, what could they desire more than to be the most special person?"

Some people want to be movie stars, some want to be enlightened. Some want to be movie stars and don't succeed so they figure enlightenment will "do it" for them. They want to "win." They may not know what they are trying to win (which is usually, at base, omnipotence, immortality, or the transcendence of suffering), or even that they want to win, but that is the unconscious game.

"The ego wants to be something," observes a long-term spiritual student and group leader. "It wants to be the one who has finally arrived and has gotten somewhere." The ego continually plays its games to try to distract us from ultimate reality and truth. Thinking that "it" is who "we" are, it imagines that enlightenment will finally give it the status it has longed for. It is yet another one of ego's ploys to assert its own dominance over that of God or Truth, a ploy that is doomed to failure from the start.

Human beings will do almost anything to avoid facing their own human weaknesses—anything, that is, except face themselves. The individual imagines that this "enlightenment" is an omnipotent state

in which they can not only dominate others but transcend or control all of their own human weaknesses and failings. What the ancient texts describe as the state of "perfect knowledge" gets interpreted to mean that a person will become their projection of what perfection is, and in doing so rise above human frailty.

Enlightenment can unquestionably provide illusory, or limited, power and control. Seekers look at those who have acquired certain *siddhis*, or powers—stopping their breath, materializing objects, levitating, or lighting candles through the power of their minds—and it appears to them that these individuals have tremendous power. It is easy to imagine that if one acquires the status of "enlightenment" or "spiritual teacher" one then will be able to control others and feel some degree of control over oneself. And perhaps they manage that—until they are in an automobile accident, or until their child becomes ill, or until their husband or wife suddenly walks out on them. It is the same illusory control as that of the CEO. Nobody would argue that he controls the hundreds or thousands of employees that work beneath him, but when an earthquake comes and reduces his building to rubble, or the stock market crashes, or he has a heart attack, then it becomes apparent how much control he actually has.

This kind of control is inconsequential compared to what is possible on the spiritual path—the power of self-surrender. Smaller spiritual powers are not only unimportant but can become a great obstacle on the path because they are so seductive. The fantasized enlightenment that is sought after in order to gain power and control is really not enlightenment at all but simply a collection of minor abilities that are easily learned by the common man or woman.

Spiritual development goes far beyond worldly power and control. Genuine spiritual teachers and those of profound realization rarely, if ever, view their lives from the perspective of being in control of themselves or controlling others. They know that life is full of wild cards and that although they may have influence in the lives of many people, even that influence is not really their own. They also recognize that the responsibility they have because of that influence is so enormous that any semblance of personal power or control they experience is dimin-

*There are two ways—the way of power and the way of peace. And the ego will easily dream of the way of power.*

ARNAUD DESJARDINS

ished in the face of their responsibility. (*See* "Teaching as a Process of Being Diminished" in Chapter Twenty.)

### The Survival of Ego Based on the Illusion of Separation

People seek enlightenment because they don't want to die. The translations of spiritual scripts speak of enlightenment as synonymous with "immortality," "transcendence," and the "deathless state"—very appealing notions to those who fear death. If one understands the context in which they were written, or if one studies the texts in their entirety, it is clear that they are not referring to the immortality of the ego or of the physical body. But human beings, desperate to find a way to avoid the imagined suffering of death, selectively gravitate toward some aspects of the teachings while avoiding others. They come to believe that enlightenment is the path to the eternal life of the ego, which they identify as "themselves," and not of consciousness itself, which is always, already, deathless. Reggie Ray explains, "People want to maintain themselves in some way. Basically, everybody is paranoid. We're fundamentally paranoid creatures. And we're very afraid. We're afraid of non-existence."

People seek enlightenment in an effort to survive because they live under the illusion of separation. Believing that they are separate from God and that they function independently of all other people, they unconsciously perceive themselves to be in an adversarial relationship in a world in which they must fight for survival. Enlightenment, the transcendent state, represents that survival.

Again, ego thinks that *it* is *us*. It is necessary to understand this, if only intellectually, in order to comprehend the nature of the illusion of separation. People believe that if the egoic structure is taken apart and loses dominance, as it does in genuine spiritual awakening as well as in death, that "they" will cease to exist. In order to prevent the apocalypse of true awakening, the ego decides that *it* will become enlightened and that *it* will become deathless.

At the same time, people intuit that the road to true awakening is the only way toward the "deathless state"—by coming to identify with

that which never dies, instead of with their small, separate egoic structure. When people realize that they are one with God, or Truth, or That, they recognize that they are already complete and whole, and do not have to try to "get" anything, including enlightenment. When people are no longer under the illusion of separation, they know that they are really a manifestation of the One, and that their ego-based identity will and must die, but that who they *truly* are cannot die. Ray advises, "You have to go toward non-existence. Because if you don't do that, you're not going to find out what you're afraid of, and whether that is true or not."

*In its own dualistic world, the ego will be ready to make efforts, to succeed, to obtain. If you meditate with strong concentration, if you go through some hardships, penance, it may give results. But it will not lead beyond, always beyond.*

ARNAUD DESJARDINS

## To Be Loved, Alas

We all seek to be loved, adored, cared for, respected, acknowledged—not recognizing that we are ultimately Loved, objectively.

People grow up feeling fundamentally either "loved," or "unloved," and most people in the Western world fall into the category of unloved through no fault of their own. Their parents did not know how to love them well, did not acknowledge them, did not validate who they were as individuals, and so they are left with a primal wound that is unconscious and deep. One doesn't usually walk around thinking, "Oh, I feel so unloved," but rather this feeling is implanted deep within the psyche, and the whole of one's life becomes a search to get the love one feels one never had. Robert Hall, founder of the Lomi School, refers to this desire to be loved as the need for "respect and acknowledgement."

I think the most common motivation to presume enlightenment is a desire to be respected and acknowledged. That usually is a strong desire in that personality that feels irrelevant and insecure at bottom. The family one grew up in, the media they cooked in, it all has a lot of influence. Many people were pressured to succeed and excel and to reach out and be more than who they were. That kind of person would feel the need to be seen as enlightened in order to justify their existence.

A forty-year-old man who has studied under three different contemporary spiritual teachers through two decades of spiritual sadhana observes:

> For many of us, a feeling of unlove is at the bottom of our aspirations. Perhaps not at the very bottom, but as a thin layer coating the very bottom. And we will do anything to be loved. To attempt to get love from a great teacher is a strong temptation. Even if the teacher isn't truly great, but presents themselves as such, if that teacher is willing to name us as "enlightened," we'll take it, because to be declared as such is a great validation—it is the validation of God's love. It is the rare student who is willing to stand up in the face of being declared enlightened—to question that, and to consider if there is somewhere further to go.

*What often imitates that extraordinary and profound surrender and renunciation necessary to truly destroy all false notions of self, which alone will result in true independence, is instead only the desire for validation of the personality.*

ANDREW COHEN

The individual who feels fundamentally unloved sees spiritual teachers with students crowded at their feet, adoring them, bringing them gifts, food, flowers, and they unconsciously think, "If I was enlightened, I would be loved like that." Some will go so far as to act enlightened, even to convince themselves that they are enlightened, just to get such love and validation. A former university professor shares the experience of her own temptation to get carried away by the possibility of validation and acknowledgement.

> I was teaching some courses at a university. Students would write me letters and poems expressing how much they felt they were learning from me and my classes. One day one of my students approached me and said, "There is a man who is moving out here from the East Coast because he heard about your teachings." Part of me was very incredulous and flattered—the part of me that believes it is separate from God and is desperate to be loved and acknowledged. Fortunately, I could see that it was a hungry child inside who wanted that, and so I didn't get carried away with it.

This need to be loved is a strong force. It could be said that it is a psychological expression of the illusion of separation. What people didn't get from Mommy and Daddy they try to get from the spiritual path or from the teacher. Perhaps what it represents, at its deepest level, is a longing for union with God, to know Truth, and the sense of being unloved is experienced as a separation from God or Truth.

The fallacy of seeking enlightenment in order to be loved is three-fold: one, the enlightened one doesn't collect love, he gives it; two, "enlightenment," by definition, means that one is no longer identified with the "I," and it is only that "I" who is seeking enlightenment in order to be loved; and three, there is already Love present always, irrespective of whether one is "enlightened" or not.

*We all need to be loved. We each have those heroes that were loved, so we try to be like them—like Jesus, or Buddha, or Krishna. Yet, the very act of "trying to be like" takes us farther away from ourselves. That's the paradox.*
GARY MUELLER

## To Find Meaning in Life

Faced with the mystery of life, human beings search out meaning. Having failed to find ultimate significance in career, family, hobbies, alcohol, drugs, and sex, many people hope that enlightenment will reveal the true meaning of their lives. Joan Halifax claims, "Human beings want something to live for. They want to live lives that are meaningful. They also like incentives, and enlightenment is a great incentive program. Saving all beings from suffering is a great incentive program."

Yet the question needs to be asked: "What is it within us that craves this meaning?" Llewellyn Vaughn-Lee, successor to Sufi master Irina Tweedie and teacher at the Golden Sufi Center, says it is the ego.

How many people I have coming who want to have a purpose, who want to have a spiritual mission. How many people confuse spirituality with their ego's desire to be needed, to be wanted, to have a goal, a spiritual purpose. This is one of the first things I have to take away from people—the desire to have a spiritual purpose. Because it's a big ego trip. Why should you have a spiritual purpose?

*The search for meaning and happiness, which occupies a growing number of Westerners, is the other side of their profound dissatisfaction with the prevalent values, attitudes, and forms of life.*

LEE SANELLA

One whose motivation for seeking enlightenment is to find meaning might find that the meaning they discover is that there is no meaning. The realization that one does not matter, and that nothing matters, often languaged as the realization of "emptiness," is an important step on the spiritual path. Whereas some (e.g., many of the great existentialists) stop their search at the realization of emptiness, others use this significant insight to deepen their spiritual understanding.

People can take almost any neurosis and use it to project onto the spiritual search illusory payoffs that are destined to disappoint them. However, these disappointments can be useful stepping stones on the path.

As one progresses along the spiritual path, one of the common initial insights is the discovery of the impurity of one's motivations. What most spiritual seekers don't know at this point, unless they have a good teacher to remind them, is that almost everybody who seeks enlightenment begins with impure motivations, at least on the surface. The fact that unliberated human beings are identified with their egos means that the ego will always attempt to manipulate life for its own benefit in *all* arenas, including spirituality.

The first step toward uncovering pure motivation within us, and it does exist beneath all of the overlay, is to admit that our motivations are impure. As Ray reminds us, "The whole emphasis in our traditions is one practice and on stripping away all of the agendas that we might bring to the spiritual path."

There are two things that can happen with impure motivation. One, it can lead to a thwarted growth, a "lopsided" enlightenment, as Robert Ennis calls it, because the impure motivation is never purified. Two, because pure motivation does exist within the individual, the force of that pure motivation (though it may be unconscious), combined with reliable help, will purify the motivation over time.

The great gift of any true spiritual path is that in spite of one's motivations, the path itself, assisted by the reliable guidance of a teacher, will transform the individual. God, or Reality, is always stronger than the ego, and in the long run—though it may be a very

long run—it will win out. The path and the teacher use the individual's weaknesses and ambitions to create lessons that eventually undermine those very weaknesses and ambitions, exposing them for what they are and slowly revealing the purity that lies beneath them. Still, we cannot sit around and wait to be transformed. We are an active part of the transformational work that is provided for us, and we can either resist and struggle against it or we can surrender ourselves to it.

Clearly, the ego is the key factor in our misperceptions and presumptions about spiritual life. On the other hand, this seeming villain can be valuable when given careful attention and placed in its proper context. Chapter Four reflects on the beneficial role ego plays in spiritual life.

*O Lord! If I worship you from fear of hell, cast me into hell. If I worship you from desire for paradise, deny me paradise.*

RABIA

# 4

## The Beneficial Role of Ego

*Many people make the mistake of thinking that, since ego is the root of suffering, the goal of spirituality must be to conquer and destroy ego. They struggle to eliminate ego's heavy hand but, as we discovered earlier, that struggle is merely another expression of ego.[1]*

—Chogyam Trungpa Rinpoche

There is great confusion in popular spiritual teachings concerning the nature of ego and what happens to the ego in spiritual development. This confusion is due in part to a general ignorance among casual spiritual students regarding the nature of ego, and in part to the fact that the various spiritual traditions use terms such as "ego," "ego death," and "transcending the ego," to mean very different things. One who studies these ideas outside of their proper context can easily draw incorrect conclusions from them. Seekers who jump from tradition to tradition pick up phrases such as "the ego must die" and immediately presume, most often incorrectly, that they know what this means.

The ego exists for a very specific purpose, its value often overlooked in spiritual schools that aim at transcending the ego and the world of duality. This book takes the view that the ego does not actually die in enlightenment, but rather that the individual ceases to

*Authentic discipleship paradoxically demands a mature personality with a strong ego.*
GEORG FEUERSTEIN

identify with it. Whereas ordinarily one identifies so closely with ego that one thinks of it as who he or she is, in enlightenment the ego is no longer the source of one's identity. It is a slave to the individual rather than being his or her master.

It is understandable that upon the initial discovery of the workings of ego within themselves zealous spiritual students would wish it dead or left behind, for it can be a tremendous nuisance and impediment on the path. They perceive ego as the great block between themselves and enlightenment, and so they set out to destroy it. However, their efforts are destined to fail, for it is the ego that is trying to destroy itself, rendering success an impossibility.

*If you have developed a perfectly functioning human organism, that's something to surrender. That is a worthy gift to God.*

ROBERT ENNIS

Seekers tend to struggle for many years against the ego, making it their arch enemy. When they can't destroy it, they try to transcend it with lofty thoughts, generally resulting in spaced-out, impractical, and even deluded spiritual students. In their attempt to transcend themselves, they push themselves further into denial regarding the ever-present dominance of ego. Even committed spiritual students who intellectually understand that they cannot effectively conquer ego continue to attempt to do so for many years, reluctant to face the reality of ego's existence and unaware of the gifts it can bring when properly respected and worked with.

To consider ego an illusion is another error common to spiritual students, and a very impractical approach besides. On one hand, it *is* illusory by nature—it cannot be measured, found, extracted. It is not a thing. On the other hand, it is fully operative in most, if not all, human beings and is as real as waking up in the morning. Thus, to say that ego is an illusion is to skirt the apparent reality of its existence. Georg Feuerstein writes:

> Many spiritual teachers—especially those from the East . . . tend to treat the human personality as an illusion that must not be taken seriously. But this is a profound mistake—from both a metaphysical and a didactic point of view. The ego, the sense of being a skin-bound island, is an immediate experiential fact for everyone except the rare enlightened being . . . Even if the ego

were a hallucination, it would still hold true for the hallucinating person. This fact should always be acknowledged and respected.[2]

Still another common error made by spiritual students is that they confuse a weak ego with no ego. It seems ironic that if one enters the spiritual path with an underdeveloped ego (i.e., low self-esteem, a lack of groundedness, clarity, and internal structure), a strong ego must actually be built before it can be diminished, but that is how it works. Individuals with weak egos do not have enough of a sense of themselves to observe their ego, to work with it, and to begin to disidentify with it. They are so fragile in their self-awareness that it is impossible to proceed with real spiritual work until they have built a stronger inner foundation. The act of disidentifying with one's ego requires tremendous strength, power, and clarity; thus, a strong ego is of great importance in the process of learning to let go of its dominance. A strong and capable ego demands an equal amount of strength to surrender it but is of much greater value to the Life force to which it is surrendered, as it can then be used as an effective servant of that force.

*The ego can't die.*
LLEWELLYN VAUGHAN-LEE

## The Value of Ego

The very ego that spiritual aspirants fight against so vehemently is the ego that allows them to survive and function in the most basic ways, that places them on the spiritual path, and that later helps them traverse it. The ego is what keeps us grounded in this world, what keeps our spiritual minds connected to the earth, our feet on the ground. Otherwise, we would be celestial bodies floating about and there would not even be the possibility of liberation in *this* world, in *this* life. Llewellyn Vaughan-Lee emphasizes:

You have to live with an ego, otherwise you can't function in this world. In those states where there is no ego, I am you and you are me, and I am also the floor, because there is a state of oneness. You go to the bank and you forget your name because

you don't know who you are because you are also the person in the bank. You can't function without an ego. There are many people who have had spiritual experiences and can't function after that. They start walking around on a sort of spiritual cloud.

Those who attempt to rid themselves of ego are in big trouble if they actually succeed. Instead, ego must be put in its proper place and respected for its abilities. Robert Svoboda asserts:

You don't want to lose your ego altogether. If you lost it altogether, how would you stay in one piece? You want to have it minimized, just like you would minimize a program on a computer screen.

*When people come to study, they need to have a strong ego, not no ego. They need to be formed. When they are formed, when their condition is strong, then they can also let go of it.*

JAKUSHO KWONG ROSHI

Another invaluable function of a solid ego is to assist the individual in living a life of maturity, integrity, and certitude. This alone is no small task. In his autobiography, *Memories, Dreams, Reflections,* Carl Jung shares the following realization about the value of a strong ego as a basis for further spiritual development.

It was only after the illness that I understood how important it is to affirm one's own destiny. In this way we forge an ego that does not break down when incomprehensible things happen; an ego that endures, that endures the truth, and that is capable of coping with the world and with fate. Then, to experience defeat is also to experience victory. Nothing is disturbed—neither inwardly nor outwardly, for one's own continuity has withstood the current of life and of time. But that can come to pass only when one doesn't meddle inquisitively with the workings of fate.[3]

In terms of spiritual life, the ego can paradoxically be useful in that it assists the spiritual aspirant in handling and assimilating the various "egoless" experiences that it so desires. It is the strong ego that provides the foundation and context to handle such experiences. Vaughan-Lee comments further:

There is this wonderful thing in mystical experiences that you get lifted out of your everyday consciousness and get taken to the level of the Self, which is wonderful, unbelievable bliss, joy, oneness. On the level of the Self, there is no problem, but often the ego has not been prepared as to how to deal with this experience.

A primary value of spiritual practice in relationship to the ego is that practice strengthens the ego and effectively trains it to be of service to enlightenment, rather than a hindrance to it. The ego is a mechanism almost unparalleled in its intelligence and complexity, second only to Truth, God, enlightenment. Thus, through time and the labor of spiritual practice, it is possible to first trick ego out of interfering with spiritual development, and then to teach it to actually assist in the process of dismantling itself. The fact that the ego can be trained to assist the individual in its own dethronement is a great and underappreciated miracle.

All practices in genuine spiritual traditions work with ego, but few do not scorn its existence. When the spiritual student is asked to "observe without judgment" the workings of mind, he or she is being called to come to know the ego for what it is, as it is. Judging the ego in effect only strengthens it, giving it more power than it already has and encouraging it to further assert itself. Observing the ego without judgment, and eventually coming to understand its impersonal, conditioned, and mechanical functioning, allows the individual to become less threatened by it, less dominated by it, and even, in some cases, to befriend it.

The few who come to know the ego so well as to befriend it can effectively learn to use what were once neurotic reactions in the service of enlightenment. For example, the ego that is greedy for money and possessions and fame can become greedy for God, never satisfied with less than the highest potential for fulfillment in God; the ego that is needy can become a source of tremendous longing for Truth, profound in its calling for what it perceives to be possible; the ego that is prideful can become proud not of itself but of the majesty of Truth and the marvel of the great Teachings.

Spiritual teachers can also take egoic personality traits and use them for greater effectiveness in their teaching. A teacher who developed charisma in order to manipulate disciples into following him or her can turn that charisma toward drawing others into following truth and participating in a life of practice and service; one who developed refined and elegant mannerisms in order to be respected and acknowledged may come to articulate spiritual teachings with great brilliance and clarity. In fact, every personality trait—down to the most disturbing in its unenlightened aspect—can be converted and used by the Divine in service of the individual's teaching work. Renowned psychologist and teacher Claudio Naranjo reflects on the process of transforming the ego into a servant of truth.

*It is necessary to learn how to become a properly functioning human being before one works on surrendering that. It is not real sacrifice unless you have something worth giving up.*

ROBERT ENNIS

There is a time when we reown character traits and hang-ups that we had left behind, but only seemingly so. It's not the same motivation. We reown abilities that the ego had developed, and we are more able to use them. We are on better terms with ourselves. We have reconciled ourselves to our karma, to the imprints of life on our being. We have "kissed our scars" so to say. And then the ego comes back, but it is not ego in the sense of a power over us. It is an island within the personality that is of service to the whole. When we become spiritually ripe our defects come back; it is as if we have gone back to the beginning and nothing has changed. Yet everything has changed because our experience is entirely different.

The goal is not to kill the ego—not only because it will not die anyway, but because it also informs us. We are trying to learn to live *with* ego. We are working to gain a mastery of its functioning so that we are not dominated by its genius. We want to befriend the ego, to know it for what it is—in all its horror and all its glory—so we can slowly begin to find within ourselves, and identify with, that which is not ego, the perception that arises outside of egoic functioning.

# Mystical Experiences and Their Relationship to Enlightenment

*Our normal waking consciousness, rational consciousness as we call it, is but one special type of consciousness, whilst all about it, parted from it by the filmiest of screens, there lie potential forms of consciousness entirely different. We may go through life without suspecting their existence; but apply the requisite stimulus, and at a touch they are there in all their completeness.*[1]

—William James

The field of mystical experiences and phenomena is the subject of volumes of literature. Human beings have been experiencing mystical states since the first day of human life, in all cultures, both within spiritual traditions and independent of them. Ordinarily, we perceive but a fraction of the reality that exists within and around us. Reality is vast, and the fact that ordinary, seemingly "unspiritual" individuals regularly experience such phenomena is not surprising.

However, in an age of spiritual depravity, such as the one in which we currently find ourselves, and at a time in which there is no appropriate cultural context, nor education about spirituality and

*Our mind clamours to be impressed at every turn by miraculous power and easy success and dazzling splendour; otherwise it cannot believe that here is the Divine.*
THE MOTHER

mysticism, psychic experiences are misunderstood more often than not, and conclusions are drawn from them that are subjective and incorrect. One of the most common, and incorrect, conclusions drawn on the basis of these experiences is that they signify enlightenment itself.

## Varieties of Mystical Experience

A painting contractor with no prior involvement in spiritual life shares this experience.

> I was driving in the middle of the night. I suddenly saw that everyone is enlightened, that there is no question of enlightenment, that enlightenment is only a question from this side of the fence. I saw that we are totally responsible for everything—whether you forgot it or not, or even knew it or not, it was irrelevant. I was experiencing these voids. It was like being an infant again. I was crying all the time.

Several varieties of mystical experience are reviewed here in order to provide the reader with a substantial enough overview of such phenomena to understand how and why they are so commonly misinterpreted and often lead to a premature claim to enlightenment.

### Kundalini

In his classic book, *The Chakras*, originally published in 1927, C.W. Leadbeater depicts the *kundalini* as follows.

> Kundalini is described as a devi or goddess luminous as lightning, who lies asleep in the root chakra, coiled like a serpent . . . The object of the yogis is to arouse the sleeping part of the kundalini, and then cause her to rise gradually up the sushumna canal.[2]

*Kundalini* is another term that is thrown around as easily as "love" or "enlightenment." Few people have any idea what it really is, and far fewer know how to properly make use of it. Many spiritual neophytes consider any strong sensation in the body to be kundalini, and they may even boast about "having very strong kundalini experiences."

Kundalini does exist, however, in everyone. It is a very real force, located at the base of the spine. Although the kundalini is often activated in the presence of intensive spiritual sadhana, or by the spiritual master, it can also arise seemingly at random. It can either be worked with intentionally under the guidance of a spiritual teacher or it can be left to circulate throughout the body on its own. In the latter case, if the individual does not know how to relate to it, the activation and circulation of this strong energy force may result in serious physical or mental crises. (*See* Chapter Seven: "Spiritual Emergency".)

Many people experience kundalini but don't know it. Sometimes it is felt as a strong current traveling up through the spine, but it has many more subtle manifestations that are imperceptible to the untrained observer.

## Body/Sensory

For most people, the expression of the Divine or the Infinite occurs within the body. Out-of-body experiences and astral travel do exist, but more commonly mystical experiences manifest through the body and its senses—both gross and subtle. As the Divine or the Infinite is unlimited by definition, so is the multitude of its expressions.

Examples of bodily, sensory-based experiences include: rushes of energy through the body—sometimes mild and sometimes so intense that the individual cannot sleep or eat; shaking; feelings of extreme heat and cold irrespective of environmental conditions; involuntary changes in breathing patterns; hearing sounds that others do not; tastes and smells arising irrespective of any apparent stimulus; the experience of physical touch—violent or gentle—though nobody is actually touching one. Mystical experiences often express themselves through vision: bright lights may flash either in one's inner or outer

*The messengers of the invisible world knock persistently at the doors of the senses.*
EVELYN UNDERHILL

vision; gods, goddesses, or deities may appear; frightening hallucinations may arise; or the individual may experience visual distortions. Such sensory experiences are infinite in their variety and expression and are more common than they are often believed to be.

## Bliss/Rapture

Many individuals report experiences of bliss or rapture. These, too, could be said to be perceived through the senses, but perception is usually through subtle, unordinary senses (as opposed to the five common senses). People often describe being "washed over" by a sense of ecstasy, or "overtaken" by rapture. They describe bliss as a simple, sweet, and humbling awareness that arises within them. A long-term spiritual practitioner reports:

> In the beginning, when I first met my teacher, I got pulled up by my bootstraps and lifted into states of ecstasy, wonder, bliss, expansion. This happens often when one first enters the aura of somebody who is charismatic. If you have any degree of sensitivity, you just get pulled right into their state. It doesn't take any skill or effort.

## Insight/Clarity

Mystical experiences can come in the form of sudden insight or clarity. The nature of reality becomes apparent. Truth is obvious. Life is simple, clear, uncomplicated. The illusion, the dualistic world, dissipates.

A practitioner relates:

> Everything became clear to me in a way that it never had before. I could see things I had never seen before. I had experiences of being on the Cross. I knew who Jesus was, who Buddha was. I knew everything. I understood the exact nature of all things. It was clear to me.

*Meditation can be so boring and so dull for quite awhile. So if some little thing happens—visions of this or that—or you regress and have past life experiences, you can stop transformation dead in its tracks.*

SENSEI DANAN HENRY

Sometimes such experiences arise out of deep meditation, other times they may follow a period of grief or loss, and at still others they appear seemingly out of nowhere. More often than not, they fade quickly. Occasionally these intense states are sustained for a longer period of time and people mistake them for enlightenment.

## Surrender

Some mystical experiences and phenomena result from a literal surrender of oneself to a reality greater than the separate self— whether that be God, a guru, or a higher power. A thirty-year student of a devotional path describes what happens when surrender occurs.

> Many of the phenomena arise when one's attention abandons the conventional idea of self. When that happens, one gets in touch with a larger picture, a picture which obliterates, anni-hilates, the standard boundary of who we think we are. At this point, there is literally an identification with a self which is so immense that the amount of energy that gets accessed cannot be contained or processed by the old body structure which is designed only to handle the energy patterns of a limited notion of self or of ego. The result is all sorts of reorderings that are necessitated by the upped amperage flowing thorough the old system. It has to upgrade, purify, and that process can be very extreme, even violent.

The influx of energy that is absorbed when one abandons oneself to a greater force can express itself in any number of manifestations, many of them listed previously in this chapter. In an interview with Sufi master Irina Tweedie conducted by Andrew Cohen, Mrs. Tweedie makes a distinction between mystical powers acquired through yoga, and those that are given through surrender.

> There are yogic powers and divine powers . . . Both outwardly look the same, but the one you acquire with your own effort,

the yogic power—and the divine power you receive when you surrender—it's a very different story. If you acquire it with the yogic power, at least some vestige of the ego remains.[3]

The same principle that applies to yogic powers applies to mystical phenomena. People can have all kinds of experiences through particular meditation techniques, breathing exercises, or visualizations. They aren't that uncommon. But those experiences that arise through surrender are of a different origin altogether, and are likely to have a stronger effect on the individual.

The influx of energy that comes with surrender can be overwhelming for some people, a subject that we will consider in Chapter Seven: "Spiritual Emergency." Like the kundalini, the energy of surrender is generally much safer and more useful when the individual is working under the guidance of someone who has a clear understanding of how to manage such energy.

## Different Realms of Consciousness

*Expansion of consciousness is a limited objective, for without awakening, such expansion is still within the bounds of ego; the dualism or fundamental neurosis of "myself and others" remains unaffected. Only genuine awakening can dissolve it.*

PHILIP KAPLEAU ROSHI

Many individuals are able to access different realms of consciousness. There is the common experience of contact with angels, channeling, dreams that have a particularly "real" and vivid quality. This is the aim of much shamanic work, vision quests, visualizations, and so forth. Lee Lozowick reports that while he was teaching Silva Mind Control a man came into his office limping as a result of being shot in the leg on the astral planes.

It is important to note that just because somebody thinks they have met an angel, or channeled a higher being, or traveled on the astral planes doesn't mean that it is necessarily so. Such realms are very real but can also be easily imagined and created. These experiences can also be interpreted as enlightenment, and are often sought after as the pearl of great price, though more often they arise in the field of duality and are not connected with enlightenment at all.

## Underworld Experiences

Most people do not tend to think of "dark," "terrifying," or "shattering" experiences which originate in the underworld as "mystical," but often they are just that. Frightening hallucinations, states of terror, profound and devastating grief—all are forms of altered states of consciousness. It is only our stereotypes and fantasies that tell us that mystical experiences are all bright, blissful, and ecstatic. Such underworld experiences are often accompanied by marked changes in one's bodily experience and can produce remarkable states of clarity. They may provide insight into suffering, impermanence, and death, among other things. The fact is that encounters with the underworld, and experiences of the pain and suffering of humanity, are not so different from other forms of mystical experience.

## Prayer

Those whose practice is prayer, or even those who pray at random, or who are brought to prayer by intense and sudden circumstances, may find themselves in altered states. Sometimes it is a state of humility (which is quite mystical for the otherwise arrogant individual), sometimes one's perception is altered, sometimes one becomes nothing in the face of the object of their prayer. True prayer, for those who live a mundane existence, often creates a profound state of openness and connectedness.

*The inflow of light and love is rhythmical, as is everything in the universe. After awhile it diminishes or ceases, and the flood is followed by the ebb.*
STANISLAV AND
CHRISTINA GROF

## Drug-Induced Experiences

The intake of psychoactive drugs (mescaline, LSD, psilocybin, MDMA) is a common and easy way to induce mystical experience and phenomena. Although each drug functions in a particular way, their common effect is that they alter the body-mind chemistry such that one is able to perceive states of consciousness, realms of reality, truths, visions, satoris, and so forth, that are normally inaccessible.

There is great variety in both the type and the depth of experience that such drugs produce. Some experiences are purely in the psychological realm, whereas others go beyond the psyche to the nondualistic realm. Visions and hallucinations, however, are not synonymous with enlightenment. Although such drugs were very popular in the sixties as an experiential aid to spiritual work, most contemporary masters do not advocate the use of drugs. A critique of drug-induced experiences in included later in this chapter.

### Mystical Experience As a Side Effect

*The truth that must eventually be learned or disclosed is that the divine is not an energy or power, and that none of our experiences of energy or power is divine.*
BERNADETTE ROBERTS

As the energies invoked either by spiritual practice or at random move through the many layers of the psyche, chemical processes are instigated that result in a variety of manifestations, some falling into the category of mystical experience or phenomena. Such experiences may arise as the side effect of a deeper, underlying transformative process that is occurring within an individual. Yet, as Robert Ennis points out:

There are mystical experiences that demonstrate transformation. That is, they are the result of a transformation that has already taken place. When people are ready, they have certain experiences, but the experiences are like icing on the cake. Having the experience does not create the cake.

Since many people think of the mystical experience as the goal of the spiritual path—the great cake itself—to consider that they are instead but a thin layer of icing is a challenge.

In his book, *A Path with Heart: A Guide Through the Perils and Promises of Spiritual Life*, Vipassana teacher Jack Kornfield discusses the principle that "All spiritual phenomena are side effects."

The Buddha often reminded students that the purpose of his teaching was not the accumulation of special good deeds and good *karma* or rapture or insight or bliss, but only the sure

heart's release—a true liberation of our being in every realm. This freedom and awakening, and this alone, is the purpose of any genuine spiritual path. The dazzling effect of lights and visions, the powerful releases of rapture and energy, all are a wonderful sign of the breakdown of the old and small structures of our being, body, and mind.[4] . . . These spontaneous bodily releases are neither enlightening nor harmful. They are simply what happens when the energy being generated in our practice encounters blocks and tightness where it cannot flow.[5]

## Mystical Experience As a Natural Part of Life

Mystical experiences are a natural part of human growth and development, the great evolutionary path that everyone is treading. When people don't recognize the naturalness of these phenomena, they draw all kinds of conclusions about them. Often they conclude that they themselves are somehow special because they have had such experiences, but it is not uncommon for a person to feel alienated and embarrassed, if not shattered by them. Because we live in a culture in which people are so cut off from their mystical senses, they believe that these experiences are indicative of either extraordinariness or abnormality. (*See* Chapter Seven: "Spiritual Emergency.")

In many cultures, mystical experiences are considered an ordinary part of daily life. Visions and dreams are discussed over breakfast or shared freely among friends. In traditional indigenous groups, adolescents were regularly sent out on vision quests, and as a result of the austerities endured through fasting, meditation, and sleep deprivation, they accessed mystical realms as a part of their initiation into adulthood.

These experiences are equally available to non-indigenous people—since on the level of basic humanity all people are the same. But when there is no cultural precedence for them, and no education about them, they tend to show up less. When they do, people often draw very unnatural conclusions about this very natural phenomenon.

*The greatest paradigm of holy experience in Judaism is only an experience.*

RABBI ZALMAN
SCHACHTER-SHALOMI

## A Critique of Drug-Induced Experiences

The influx of experimentation with drugs that arose beginning in the 1960s provided people with an experiential taste of a larger reality than they had ever known. This provocative taste brought many to the path. But to confuse drug experiences with what arises from a life-long commitment to spiritual life is to make a great error. Roshi Philip Kapleau expresses his cynicism about such drug-induced "enlighten-ment."

> While this madness for psychedelics was raging in our country I was living in Japan, totally unaware of the drug phenomenon. My first introduction to it came when a so-called "friend" sent me several xeroxed pages from Aldous Huxley's book *Island*. I say "so-called" because this extract did anything but spur me on in my training. The gist of what he sent was that the aspir-ing mystic need no longer undergo the exertion and hardships of the masters of old who sought Self-realization. All he had to do was first consult his psychiatrist to have the knots in his psyche untangled, then go to a knowledgeable chemist who would give him the proper drug or chemical to awaken certain age-old brain cells and expand his consciousness, and presto! He was a mystic: enlightened, awakened. God-imbued![6]

This was the popular notion of enlightenment: do some therapy, take some drugs, have a bunch of openings and insights, and declare yourself enlightened. Of course, this quickly proved to be untrue. Nonetheless, there are great individuals for whom, even though they knew the expe-riences that arose as a result of drug ingestion wouldn't provide lasting enlightenment, still considered them to be valuable for the inspiration they provided. In an interview conducted by *Tricycle* magazine, Ram Dass (Richard Alpert), founder of the Hanuman Foundation, recounts the observation of his teacher, the great Indian master Neem Karoli Baba, when Ram Dass provided him with significant quantities of psychedelics as an experiment. Neem Karoli Baba responded:

It's useful . . . but it's not the true *samadhi*. It allows you to come in and have the *darshan* of Christ, but you can only stay two hours and then you have to leave . . . You can't become Christ through your medicine.[7]

A similar observation is made by Aldous Huxley in his book, *The Doors of Perception.*

I am not so foolish as to equate what happens under the influence of mescaline or of any other drug, prepared or in the future preparable, with the realization of the end and ultimate purpose of human life: Enlightenment, the Beatific Vision . . . All I am suggesting is that the mescaline experience is what Catholic theologians call "gratuitous grace," not necessary to salvation but potentially helpful and to be accepted thankfully, if made available.[8]

Some of the more well-grounded and responsible drug experimenters found the experiences useful, while others did not, but one thing is clear: everything that comes up must go down. All experience fades, particularly that which is chemically induced and unintegrated. Joan Halifax knows this well.

*If all it took to be enlightened was experience, many individuals who took enough acid and psychedelic mushrooms under the right circumstances would be enlightened.*

LEE LOZOWICK

I was very involved in psychedelics in the 60s and 70s. I had incredible experiences, the doors of perception opened and my vision was cleansed. But when the drugs wore off, the world looked like hell.

Other spiritual masters were less tolerant of the introduction of psychedelic drugs into spiritual discipline, particularly when the teachers themselves were responsible for working with the students who used them. In his article "A History of Buddhism," Rick Fields shares this telling account of an incident that occurred in the center of Zen Master Eido Shimano Roshi.

In New York a student walked into the zendo on acid, sat on his zafu until he felt enlightened enough to get up off his cushion in the middle of zazen, then knelt in front of the teacher, Eido Roshi, rang the bell, and walked off nonchalantly into the small rock garden in back of the zendo. Eido Roshi followed, and the two stood locked eyeball to eyeball, until the teacher asked, "Yes, but is it real?" and the student, who seemed to have held his own till then, fled. After that, there was a rule that no one could sit zazen who used LSD in or out of the zendo.[9]

Regardless of one's perspective, all weathered spiritual practitioners and teachers agree that the mystical experiences obtained through the use of drugs must be integrated. The psyche of a human being is able to contain a certain degree of expansion, which, with time and practice, can stretch. Psychedelic drugs, however, artificially expand that consciousness, and without having completed the proper preparatory work, the individual cannot tolerate the degree of expansion and thus the experience cannot physically be sustained. (*See* "Matrix" in Chapter Eighteen.) Kornfield notes:

> You can take a very powerful substance and even if you are physically a wreck, you can touch deep places, but there will be a physical price to pay for it. When your body is in tune and open, you can open to deeper levels with much less physical disharmony. It also allows the experience to be integrated. Without preparing the body, one cannot hold those understandings.[10]

It is quite possible for the experiences induced by the intake of psychedelic drugs to be a detriment to spiritual progress. Besides the physical toll drugs take on a body that needs to be straightened and purified in order to contain increasing amounts of energy, drugs make a strong impression on the psyche. The ego witnesses the expansion that occurs, and the last thing ego wants is an expansion of consciousness, much

less enlightenment, for this would put it out of business as the boss of the show. Ego will often use what is discovered through these premature mystical experiences to become more rigid and sharp in its ability to protect itself from having the natural and essential enlightenment reveal itself. As a result, the individual ends up more constricted and more in the dark concerning what enlightenment is really about.

## Mistaking Mystical Experiences for Enlightenment

Georg Feuerstein claims, "The temporary experience of *unio mystica*, or ecstatic unification, is often confused with enlightenment."[11] Moments of unification, of ecstasy, none of it is enlightenment. If it was, almost everyone would be enlightened because almost everyone has had these experiences.

*It is common to mistake very powerful archetypal experiences for mystical experiences.*

LLEWELLYN VAUGHAN-LEE

Enlightenment is not an isolated experience. "It's like someone who gets stoned and has a really powerful experience and thinks they are permanently changed as a result," observes Robert Ennis. Mystics, saints, and spiritual practitioners have been producing altered states for thousands of years with fasting, extreme asceticism, breath, and different meditation techniques. To interpret these altered states of consciousness as enlightenment suggests a very limited definition of the term.

It is an easy jump from altered states of consciousness, or flashes of spiritual clarity, to the presumption of enlightenment. Robert Hall suggests:

> I think it's easy to confuse them because anyone doing spiritual practice seriously is hungry, starving for revelation. Therefore, the brief glimpses that come to us can be very convincing, and it isn't too difficult to imagine someone having had a glimpse and saying, "Oh, I've finally made it," and then to become inflated and to think "this is it." Also, we are all eager to get to the end of the journey, especially in our culture where we are all so goal-oriented that everyone wants to be finished.

Gilles Farcet, author, journalist, and teacher in the spiritual school of Arnaud Desjardains, reflects on the similarities between having a mystical experience and falling in love.

Mystical experience is in no way different from remembering that you were once passionately in love, and that you had a candlelight dinner with the person you were in love with, and that it was wonderful, and that you made love on the beach. When it is over, it is just a very pleasant memory. To pursue the comparison, the fact that you had this wonderful dinner and that you made love with such openness, and that you were able to feel such communion with another human being for a time, usually does not prevent you, the very same person, to then be very angry with, and maybe to be resentful of, that person, and to say horrible things to the person you once loved so much. So the experiences don't mean anything as far as your real ability to love is concerned. Similarly, a mystical experience is just an experience, but what could be called "awakening" or "enlightenment" is independent. It is not something which comes and goes.

*"Unusual experiences" can create an obstacle course of repeated difficulties and pitfalls in our spiritual journey.*
JACK KORNFIELD

Farcet's analogy is a useful one because most people can relate to it well. Anybody who has been in a long-term relationship probably knows the difference between falling in love and loving. For most people, falling in love is the easy part, as is having a mystical experience. Sometimes this "falling in love" fades to such a degree that it feels as if it is lost. This is comparable to somebody thinking they have lost the enlightenment they once had.

Those who have persisted with diligence in love relationships know that when the experience of falling in love fades, there begins the work of love, and that over much time and with much struggle there can arise a condition of loving—a context of love itself. This context of love is not dependent upon momentary of experiences of cosmic union and ecstasy. Love simply is.

### Charles Tart: The difference between being in a good mood and being a good person

*What is the difference between being in a good mood and being a good person? Everybody gets in a good mood sometimes, when their emotions take on a particular configuration. And they can be very nice to other people when they are in a good mood. If you feel good, you tend to treat other people pretty nicely. But that is not the same thing as being permanently biased toward being in a good mood. I know lots of people can have mystical experiences which may be relatively light or relatively profound. It may change them temporarily, but then it fades, because it is not part of their being. Gurdjieff talked about the difference between a state of consciousness and a state of being. A state of consciousness is relatively transient. You go into it, you're in it for awhile, and you come out of it. But a state of being is really talking about much longer-term changes.*

Of course, few people even in long-term love relationships are actually able to abide in the context of love that is being spoken of here. However, most people are able to understand this possibility, if not with a husband or wife, then with a child whom one loves unconditionally and independently of any temporary joyful or frustrating experience they share with the child at any given time.

*The ordinary lover adores a secondary phenomenon. I love the Real.*

IBN EL-ARABI

### There Is No Enlightenment in Duality

Enlightenment cannot exist in the context of duality. Therefore, those mystical experiences that arise in the world of duality—angelic realms, hell realms, high planes of consciousness—though remarkable in and of themselves, are not enlightenment. Similarly, if one returns to the dualistic state following the experience of enlightenment, which is often the case, one cannot be said to be abiding in the

enlightened context. Philip Kapleau Roshi explains this distinction in the following passage, where he uses the term "mind expansion" to signify mystical and altered states and the term *satori* to suggest abidance in nonduality.

> The difference between mind expansion and *satori* can be illustrated with a wristwatch. The watch face, with its numbers, hands, and movement, corresponds to relativity, our life in time and space, birth and death, cause and effect, *karma*. The reverse side of the watch, which is blank, corresponds to the changeless, undifferentiated aspect of our life. Of this absolute realm nothing can be posited. One whose understanding is on the level of the discriminating intellect is like a person who sees the face but is unaware of the back of the watch. Expansion of consciousness can be likened to enlarging the face; but no matter how much you enlarged it you would still be dealing with the face alone. Satori is like this [suddenly flipping over watch]. Now for the first time you realize that a watch actually consists of a face *plus* a back. In the same way, with awakening comes the understanding that relative mind and absolute mind are two aspects of our True-nature.[12]

*When someone has a mystical experience and thinks they are enlightened because of it, it's like someone who goes to England once and considers, "Oh, now I'm a world traveler." Seeing someplace does not mean that one is a citizen of that place.*

ROBERT ENNIS

In his book, *The Kundalini Experience*, Lee Sanella suggests that one can similarly mistake kundalini experiences for nondual reality, or God realization. He quotes the following explanation from an unpublished talk given by Adi Da:

> The way to God is not via the kundalini. The awakening of the kundalini and becoming absorbed in the brain core is not God-realization. It has nothing to do with God-realization. It is simply a way of tuning into an extraordinary evolutionary mechanism. The way to God-realization is the one by which that mechanism is understood and transcended completely.[13]

As long as there remains identification with the ego, experiences are still experiences. They may be archetypal experiences or psychic experiences, or profound experiences of kundalini; they may even be divine experiences. But all such experiences remain altogether distinct from enlightenment, and one must be vigilant in restraining oneself from considering them as such.

*With genuine enlightenment the notion of an ego-I is dispelled and the dualistic distinction of self and not-self is transcended. The consequences of this are enormous.*

PHILIP KAPLEAU ROSHI

## Mistaking Psychic Phenomena for Enlightenment

When one understands that there is a distinction between mystical experiences and enlightenment, and that enlightenment cannot take place in the context of duality, it becomes obvious that extraordinary psychic experiences may not signify anything at all about one's spiritual attainment. In *Zen: Dawn in the West*, Kapleau Roshi tells the following story of an American professor whom he met in Japan.

This professor had gone to India to find an enlightened master. One day in his search for the elusive guru he came upon a crowd in a small village. Edging his way toward the center he saw an ordinary-looking Indian giving a demonstration of psychic powers. Seeing the American, the psychic proceeded to give him a life reading, telling him things about himself and his wife and children that he could not have known beforehand. It was the professor's first direct experience with extrasensory perception, and he was dumbfounded. Another unusual thing happened: The psychic would not accept a donation from the professor as he had from others to whom he gave readings.

After the demonstration the psychic called the professor aside and told him the following:

"Have you not come to India to seek Self-realization?"

"Yes."

"You are different from most foreigners I have met in India, so permit me to give you some heartfelt advice. You were impressed by my power to know your past and present, but for me this is nothing remarkable. I have had these siddhis

[psychic powers] since I was a child, and my father before me had them. Believe me when I tell you that when I was a young man I had deep religious aspirations like yourself. But because people flocked to me for readings—and my father encouraged me to use my powers to help support our large and poor family—my yearning for spiritual liberation fell by the wayside. Now I am an old man and despite my natural psychic intuitions no closer to Self-realization than I was forty-five years ago."

In India you will find many psychics who pose as realized holy men, but you must not be deceived by them. The psychic has merely been in touch with the subtle manifestations of God's presence. The holy man has seen God himself.[14]

*On the path you can become a little bit more psychic, a little bit more open, and then you can begin to confuse things like psychic experiences and clairvoyant experiences for enlightenment itself.*

LLEWELLYN VAUGHAN-LEE

This story is powerful because it is about someone who, from his own life experience, genuinely understands the dangers of being seduced by psychic abilities.

Transpersonal psychologist and author Frances Vaughan explains that psychic abilities often arise as a by-product of spiritual work, and in no way can be assumed to confer spiritual understanding.

> Practicing consciousness disciplines that aim at control of the mind can . . . contribute to the development of psychic powers, those powers of the mind commonly called "extra-sensory." These tend to become available at transpersonal levels of development. However, the attainment of psychic powers does not ensure either ethics or spiritual understanding, and such powers may be abused by someone who has not yet transcended egoic identification. In many spiritual disciplines extra-sensory powers are considered by-products of spiritual work and are traditionally eschewed as traps that can lead a spiritual aspirant to ego entanglements in the domain of occult energies, or subtle realms.[15]

If one believes the fantasy that enlightenment bestows upon the individual special powers or *siddhis*, then the arising of such powers

and abilities within oneself will probably lead to the mistaken presumption of one's own enlightenment. Sensei Danan Henry pleads:

> Do understand that out-of-body experiences, paranormal psychology, and psychic phenomena have absolutely nothing, nothing whatsoever to do with spiritual enquiry and realization, the purpose of which is to find out what is what and who you are. Such phenomena happen to be by-products of spiritual exercises. If you concentrate real hard to settle the mind in order to realize what you are in your innermost identity so that you can live in that clear understanding for the benefit of not only yourself, but of an alien planet, you will experience such things because as the upper levels of the mind quiet, you'll begin to access all kinds of mind stuff that you're usually not aware of. But if you identify with any of that stuff, you'll stop your journey.

Everybody experiences psychic phenomena, but most people dismiss such experiences, attributing them to coincidence. Every time we receive a phone call from someone we were thinking about, or receive a letter from someone we planned to write to, we have had a psychic experience, in essence no different from that which Sensei Danan describes. He comments further on the ordinariness of psychic phenomena, which he experiences within himself all the time.

> Sometimes when people come into *dokusan* [interview with the Master], they speak in tongues. They are clearly speaking in a language from some other place. I don't deny that one can access past lives and all that sort of thing. I see channeling all the time. Every dokusan I see channeling. I sit there, let everything go, and respond to the situation. It's not "me" and my particular education that is responding, it's just that when "I" am not there, "it" comes out. But I don't need to channel someone who is 500 years old. The wisdom is here right now.

*True freedom must be won, by each and every individual through their own determination, clear intention, and perfect surrender.*

ANDREW COHEN

*A young man is walking by a river with his master and tries to impress him by running across the top of the river and back. The master says, "God, if I had known that you were that kind of person, I wouldn't have walked with you. You can cross at the ferry for five cents."*

ZEN STORY

To those who know what genuine spirituality is, even walking on water is unimpressive. They understand that to be fascinated by these seductions is to turn away from the genuine spiritual path. Although psychic abilities are not "bad" or "harmful" within themselves, and can even be helpful on occasion, they must be considered with great scrutiny and used with extreme caution. One must constantly question one's motivations for using them, and any conclusions one may be tempted to draw about oneself as a result of having them. It is too easy to think that one is extraordinary or important simply because such experiences have arisen.

When asked by a student if there were any dangers in trying to develop psychic powers, Roshi Philip Kapleau answered:

> People who strive to develop psychic powers often do so at the expense of other areas of their personality. They can become one-sided and conceited, feeling that because of their unusual and rare abilities that they deserve special recognition. Psychic powers are also seductive—the more one becomes involved with them the harder it is to become disentangled, until eventually one is caught in a net. Anyone who does zazen seriously will in time develop psychic abilities to one degree or another. The Buddha himself possessed numerous psychic perceptions, including the ability to recall past lifetimes, see into the future, and read others' minds. But never did he encourage his followers to develop psychic powers as a means to enlightenment, or to make a vain display of any that they already had.[16]

The subject of feeling special or important as a result of the acquisition of psychic powers will be dealt with more extensively in Chapter Ten: "Ego Inflation."

## EXPERIENCE VERSUS SURRENDER

A long-term practitioner of the bhakti, or devotional, path reflects upon the notable distinction between mystical or "enlightenment" experiences versus surrender.

*We think of enlightenment as a phenomenal, wonderful experience. We all hope that one day this experience called enlightenment will begin for us and fantasize how fantastic it will be, because built into our fantasy is that it never ends and it feels "good" and not "bad." The only reason we seek it is because we imagine that we will "feel good permanently," even though all the saints tell us that the desire to feel good permanently is our suffering. But then we take that and what do we do? We go to work on trying to eliminate desire itself, as if it existed, instead of inquiring into who is the one desiring, and addressing the real root of desire, the illusion that there is actually anyone there who could ever desire anything. We never give up the "I" which is the only actual desire there is, the desire to be separate.*

*I can say I have "experienced" the truth of there being no one there to desire anything, but I have not fully surrendered to the truth of that. Instead, I pick up my ignorance again and again, and keep wearing it day after day like a dirty, smelly, rotting blanket I've been latching onto since I left the crib and am terrified to let go of. So, personally speaking, mystical experience is the true booby prize, because I can look back at it and say, "Hey, look at the experience I've had," which means I'm not living it in the present.*

*It is very difficult for these experiences not to become ego's trophies. It takes tremendous vigilance, longing, intention, and sacrifice to keep throwing those trophies into the fire and instead say, "I want the truth now, not then, and I want it now so badly that I'll even refuse to reflect on the fact that the truth is present for me now." Because the moment I start reflecting on the truth I'm experiencing, what's next? What's next is patting oneself on the back about it, and what's next after that is the same old crap.*

*Anything that the mind can grasp, contain, conceptualize, or capture within the limits of itself is an experience. The mind cannot relate to what is not experiential, it cannot relate to things without limits, which is why the mind likes experiences which have a beginning and end. So the question of mystical experiences versus enlightenment strikes at the very core of the spiritual path. Maybe we could say that mystical experience is a dip into that which has no limit— Truth, Reality, whatever we call it—and enlightenment is permanent surrender to that condition.*

*So according to the dharma, not according to my experience, I'd say when there is no more desire and no further possibility of any desire for any particular experience, then this thing called enlightenment appears on the scene. But big deal—that's the dharma we've all heard many, many times, and anyone who's done a little reading can parrot it. But to get underneath that to where it lives in us is another story. I can attest to the fact that one can have extremely profound experiences of peace, bliss, and desirelessness and still not free oneself from suffering, ignorance, hostility, and so on.*

*When I start relating to these experiences I'm having as the goal, and on a subtle or not so subtle level start trying to keep them going, I lose the surrender that is sourcing the experience. When the surrender is being released into, then those mystical experiences start happening, and they come and go, and arise and pass, but all in the field of that surrender. So I would assume that continuous, constant, unbroken surrender would instigate all kinds of experiences, altered states of consciousness that would come and go, but what would remain and be consistent would be the surrender.*

*So not only is the quality of surrender distinct from the experiences, but they exist as two different components of the process that we're talking about that never mix or cross. Experience arises as something that has qualities against a background which has no qualities. This background of "no qualities" is essential to the perception of that which does have qualities. The background is surrender, the foreground is experience. The background is completely and utterly unqualified.*

# Perspectives on the Value of Mystical Experience

*There are some [voices and visions], experienced by minds of great power and richness, which are crucial for those who have them. These bring wisdom to the simple and ignorant, sudden calm to those who were tormented by doubts. They flood the personality with new light: accompany conversion, or the passage from one spiritual state to another: arrive at moments of indecision, bringing with them authoritative commands or counsels, opposed to the inclination of the self: confer a convinced knowledge of some department of the spiritual life before unknown.*[1]

—Evelyn Underhill

Mystical experiences and experiences can have tremendous value to the individual if related to properly. They shine as bright lights of inspiration on a path that is often difficult to see. But the fact that these experiences are brilliant to the eye and radiant to the senses does not necessarily imply that they transform the individual in and of themselves.

*The gods have their own rules.*

OVID

The attention given to the value of mystical experiences within this chapter stands in notable contrast to the dangers of such experiences that are detailed throughout the rest of the book. This is because whereas the value of such experiences is quite apparent, the dangers are often much less so. The experiences are valuable when left alone and appreciated for the gifts that they are. The dangers begin when the egoic mind enters the picture—usually about half-a-millisecond after the experience—and begins to play its undermining tricks.

## The Value of Mystical Experience

People find great inspiration in mystical experiences. For the one who lives an ordinary existence, distanced from the spiritual path, mystical experiences may stand out as the high moments of one's life; and for the one who walks the spiritual path, they may be the source of the faith that fuels the journey. If used properly, such experiences can provide solace and sweetness to an otherwise challenging course of life.

***Spiritual experiences provide an incentive through a taste of a greater reality.***

*For a long time I thought that spiritual experience had something to do with something outside myself, or bigger than myself. What I have realized is that it can be a result of a connection with something bigger than oneself, but not necessarily.*

CHRISTINA GROF

"I remember the first time I was meditating, when I was sixteen," says Llewellyn Vaughan-Lee. "Suddenly I went to a different plane of consciousness. I didn't know it then. I went into a state of total expansion and total contraction at the same time. That was a tremendous encouragement to start meditating."

Perhaps the most widely-shared view on the value of mystical experiences is that they throw open the doors to a greater possibility, creating a great incentive to embark upon the spiritual path. Vaughan-Lee continues, "In the beginning, momentary experiences can change your whole life. Suddenly you become aware of a different dimension, you tune into something else. They are tremendous encouragement. They open a door."

Gilles Farcet has a similar view.

Mystical experiences can be valuable insofar as they show you that reality is bigger than what your mind expects. They can enlarge the scope of your vision, and give you a sense of longing. It may be the beginning of your search, an incentive.

It will become apparent that such experiences are not the end of the path, and not even necessarily what the path is about at all. But most people have been raised in a culture devoid of genuine spirituality, and many have never even tasted an experience of reality greater than the K-Mart. In the beginning, a mystical experience can provide that sense of wonder and illumination that motivates and inspires an individual to move forward.

It is interesting, however, that for many people, especially those who are involved in spiritual traditions that do not stress the importance of mystical experiences as a sign of progress, the powerful experiences that frequently come at the beginning of one's entry onto the spiritual path are often not recognized for many years thereafter. Arnaud Desjardins observes:

> Sometimes at the very beginning of the way, there are extraordinary experiences which will not come again for years. I've seen sometimes when one tries to meditate for the first time, when one has never sat with the attention turned inwards. The very first day—unforgettable. And then it does not come for months or years.

Whereas one cannot presume to know the divine plan, perhaps one *needs* such experiences at the beginning of the spiritual path. Just as the experience of falling in love evokes a sense of genuine appreciation for love and for the other, which often inspires the commitment necessary to create a life of real love and intimacy, so mystical experiences create a sense of wonder and urgency to commit to the spiritual path. Once committed, individuals are then willing to pay the price and do the work necessary to discover the true spiritual life.

*The function of enlightenment experiences is like the carrot and the donkey—they motivate the individual toward continued and perhaps more rigorous practice. Spiritual practice. Actually putting time in.*

ROBERT HALL

*Spiritual experiences create and restore faith.*

Many people have never glimpsed God or Truth. When they do, if they are willing to acknowledge the validity of their perception, a long forgotten, or perhaps never before felt faith may arise within them. Of such experiences St. John of the Cross exclaims:

> Such is the sweetness of deep delight these touches of God, that one of them is more than a recompense for all the sufferings of this life, however great their number.[2]

Faith is a great gift amidst the struggles and suffering of daily life. If mystical experiences provide faith, their value is complete. The spiritual path could be a very desolate road to walk—with the hardships and the suffering that transpire upon it—were it not for such momentary glimpses, small signposts of reassurance that a greater reality exists. Vaughan-Lee shares how such glimpses of the Beloved would come and provide relief during the struggles he experienced during the early years of his spiritual work.

> I struggled and struggled, and I pushed myself. Sometimes I pushed myself too hard, made life unnecessarily difficult, but I pushed myself and pushed myself, and stuck to it and stuck to it. But after awhile something else took over. Then it doesn't matter. If you are given experiences you thank the Beloved. Sometimes He unveils His face a little bit—you can't see His entire face, the light would destroy you. The Sufi says no one knows God but God. You can't know God, but sometimes you get given a glimpse.

For Vaughan-Lee, the tenderness of such experiences humbles him such that the return of the ego is not so devastating. He continues:

> What I have found most wonderful is, even when the intense states have passed, to look within the heart and find the trace

of His presence in the sweetness of love. Then my lips will softly curl into a smile knowing that He whom I love has not deserted me . . . Coming out of these inner states one returns to the ego, which remains with its old failings, psychological problems, and inadequacies. But the difference is that they no longer matter; they are no longer seen as an obstacle, but are accepted as part of this world. Somewhere, something so precious has been given that one cannot ask for more, and the ego seems so insignificant.[3]

*Spiritual experiences leave an impression on the unconscious to which one is ultimately accountable.*

Spiritual experiences leave a memory or an impression on the unconscious. It is as if they temporarily "wake up" the individual, reminding him or her of a long forgotten knowledge that resides deep within. As we will see in Chapter Nine: "Getting Stuck," such memories can create great difficulty in spiritual students, for many grasp at them and try to force them to stay. But for others, the impression and memory of a mystical experience can be returned to again and again for inspiration. Arnaud Desjardins relates:

> Mystical experiences show that a completely different kind of feeling, or inner state, is possible. Sometimes it comes from a great guru, and the conditions surrounding the guru. When I was living with Ma Anandamayi, it happened once, twice, a third time—it was as if I had reached the goal. In fact I was far from it. Afterwards, it vanishes, but it may last two, three days—complete freedom. Complete freedom. Everything is perfect, nothing other than the here and now. And after a few days, it vanishes. But the memory is there. To my eyes, this is the value.

Andrew Cohen shares an insight on this subject that was related to him by a master whom he met in India.

*Mystical states indeed wield no authority due simply to their being mystical states. But the higher ones among them point in directions to which the religious sentiments even of non-mystical men incline.*

WILLIAM JAMES

A great master that I met in India said that the powerful experiences, like the ones we're speaking about, leave an impression on the unconscious. So even if we're not ready to actualize them in this life at this time, an impression has been made that ultimately won't be forgotten. It just may be that we are not ready to live up to it yet.

In *The Book of Enlightened Masters*, Andrew Rawlinson further illustrates this point by recounting a conversation between G.I. Gurdjieff and his student J.G. Bennet.

After discussing with Gurdjieff a very powerful experience that Bennet had had, Gurdjieff said, "What you have received today is a taste of what is possible for you. Until now, you have only known about these things theoretically, but now you have experience. When a man has had experience of Reality, he is responsible for what he does with his life."[4]

*People will often have some spiritual experience when they break through the layers of defense or woundedness within them, and are really able to tap into that place of wholeness, that spirit within them.*

CHRISTINA GROF

Of course, most people who have such experiences don't take full responsibility for them immediately. In some cases, the experience needs time to integrate, whereas in other cases the responsibility is just too much of a burden for the individual to carry. Thus, they tuck it away in their memory and set aside the felt experience of the truth of it.

In his years of research, Charles Tart has seen a wide variety of outcomes in his studies on the effects of mystical experiences.

I've heard people talk about a very wide variety of altered states they've experienced, some of which fit the traditional criteria for mystical things, and I see a tremendous variety of results from that. With some people, it has been an interesting experience that seems to have almost no long-term effect on their life at all. For others, it is an experience that does fade, but of which they can say, "I was given a glimpse of something really important. What can I do to try to make that

CHARLES TART: DIFFERENT STATES OF CONSCIOUSNESS
HAVE DIFFERENT FUNCTIONS

*When I popularized the term "altered states of consciousness,"
I tried to make it clear that it was a value-free term. An altered
state of consciousness meant that your mind worked in a different
pattern. That pattern might be better for some things and worse for
others. So, a state of consciousness that is good for going to church
may not be a good state of consciousness for balancing your check-
book. But in life we have to balance our checkbook as well as go to
church. I've seen people change their state of consciousness tem-
porarily a lot, and that is very good for some things and terrible for
others. To have a mystical vision of the oneness of the universe is
very maladaptive if you are crossing the street. If you are crossing
the street, you should recognize your biological vulnerability, and
when that truck comes roaring around the corner, you get the hell
out of the street and don't think about the oneness of allness, at
least not if you want to be around to do anything later on.*

glimpse a more permanent part of my life, to become a better
person, to get serious about it?" I know one person who had a
sort of permanent enlightenment experience where his con-
sciousness was changed forever after, but I think that kind of
person is relatively rare.

# Are Mystical Experiences Inherently Transformative?

To say that an experience is inherently transformative suggests that
it can and does create objective change in and of itself. Spiritual tradi-
tions generally adhere to one of two positions on this subject. The tran-
scendent school of thought suggests that it is very important to have

experiences of enlightenment, to transcend the small self, whereas the "immanent" school takes the opposite perspective. It says that enlightenment is expressed in daily life, not necessarily related to any particular set of experiences.

Most of the spiritual masters included in this volume lean more toward the immanent school of thought rather than the transcendent. In their years of experience, they have watched students go through thousands of experiences without necessarily transforming their lives. Cohen recounts, "When I first began teaching, I thought that all anybody had to do is have an experience and then they'd be free. I found out all it did was give them confidence."

Still, within the immanent approach, there appear at least three further perspectives on the value of mystical experiences: Some teachers say that these experiences have little or no value and are more dangerous than useful; others suggest that they are neutral—experiences just like any other—and have no particular meaning or significance; and still others say that their transformational value depends entirely upon how the individual relates to them.

Bernadette Roberts, author of several books on spirituality, is particularly wary of such experiences, more because of what human beings do with them than because of the experiences themselves.

> Because these experiences add nothing to the unitive state, they serve no real purpose in our spiritual life. We do not need them, desire them or cling to them; above all, we are cautious lest they become self serving instead of God serving. We have come too far to be attached to our "experiences." To get on with life is what the unitive life is all about; it is not about transient beatific or heavenly experiences, however wonderful these may be.[5]

Philip Kapleau Roshi is less wary.

> More often than not the ordinary mystical experience of expanded consciousness comes purely by chance, and since it

*What characterizes genuine transformation is some residual result of these mystical states that makes the particular human being more mature—meaning wiser, more serene, more able to respond to circumstances skillfully, more generous, more compassionate and so on.*

LEE LOZOWICK

is unconnected with a proven discipline, a discipline for sustaining and enlarging it, it effects little or no transformation of personality or character, eventually fading into a happy memory.[6]

Robert Ennis explains:

Experiences are simply another phenomenon on the path of consciousness. It's just like if you're driving along and there's an explosion on the side of the road. Well, it's dramatic, but it doesn't necessarily mean anything. Or if it means something, that meaning is ordinary. People used to have all kinds of experiences around Muktananda, and they weren't changed by it. It didn't mean anything, just another trophy on the wall: "See. I bagged that experience!" So if someone has a particularly dramatic spiritual experience, I encourage them to observe it and then move on. As one of my teachers, E.J. Gold, said, "The aim is to be neither attracted to nor repelled by the experiences of life." And that includes so-called spiritual experiences. It's simply something to observe and experience and move on.

*It's easy enough to generate some feeling of bliss or lightness in a room full of people who are supposedly working spiritually. It's even easy to generate ecstasy. But a few good beers, the right partner, and the Rolling Stones music for an evening can do that too.*

LEE LOZOWICK

Jack Kornfield expresses a similar viewpoint.

[Experiences] do not in themselves produce wisdom. Some people have had many of these experiences, yet learned very little. Even great openings of the heart, kundalini processes, and visions can turn into spiritual pride or become old memories. As with a near-death experience or a car accident, some people will change a great deal and others will return to old constricted habits shortly thereafter. Spiritual experiences in themselves do not count for much.[7]

As suggested in Chapter Three, human beings are meaning-making machines. We would like our experiences to have significance and

purpose. Perhaps they do have meaning, but they also may not. As Robert Ennis observes:

> One of the compulsions of the mind is that we have to cate-gorize, define, or place meaning on things. "Oh, this means this, or that means that." But everything has its own inherent meaning. We do not need to think about experiences at all. Our own internal guidance system will digest and integrate the meaning of every experience all by itself without any work on our part, as long as we are open to, and awake to, and recep-tive to experiences, no matter how powerful or dramatic.

The majority of people alive today have had some kind of mysti-cal experience, yet most remain untransformed in any significant way. It appears, then, that what gives an experience transformative value is not what meaning we place on it, nor how we attempt to control or manipulate it, but how we relate to it. Gilles Farcet comments:

> It's like anything: if you have the right attitude, the right rela-tionship to the experience, there is no problem. The experi-ences are what they are, intrinsically. So, in any experience, you have the positive value and the possible dangers. It all depends not so much on the experience itself, but on the way you relate to the experience. That's the whole point.

Cohen's perspective echoes Farcet's.

*Experiences can be transfor-mative in and of themselves, but if we don't make use of the transformation, it's an academic question.*

LEE LOZOWICK

It is not the experience of Enlightenment that matters. It is only the ego's relationship to that experience that has any meaning. Two different individuals could undergo the very same spiritual experience and the ego of one will relate to the event in one way and the ego of the other will relate to that event in a very different manner. The very essence of an indi-vidual is revealed in the way they relate to experiences of bliss, emptiness, insight and illumination. Revelatory experiences

themselves do not transform anyone. It is only the inherent readiness of an individual to accept what is revealed in these experiences that can truly transform them.[8]

The way to relate optimally to mystical experiences, then, is to utilize the insights such experiences provide to inform one's relationship to life itself. Zen Master Charlotte Joko Beck summarizes:

Now in many religious traditions, and particularly in the Zen tradition, there is great stock placed in having what are called "openings" or enlightenment experiences. Such experiences are quite varied. But if they are genuine they illuminate our being to our attention on that which is always so: the true nature of life, the fundamental unity. What I have found, however (and I know many of you have found it too), is that by themselves they're not enough. They can be useful; but if we get hung up on them they're a barrier. For some people these experiences are not that hard to come by. We vary in that respect—and the variation is not a matter of virtue, either. But without the severe labor of unifying one's life these experiences do not make much difference. What really counts is the practice that we have to go through moment to moment with that which seems to hurt us, or threaten us, or displease us—whether it's difficulty with our coworkers, or our family, or our partners, anyone. Unless in our practice we've reached the point in our practice where we react very little, an enlightenment experience is largely useless.[9]

*If our work is successful, it is not into another world to which we will return but into this world . . .*

E.J. GOLD

Andrew Rawlinson, too, calls into question the value of *kensho*, or enlightenment experiences, if they do not result in greater compassion and wisdom in the person who experiences them.

It seems . . . that it is possible to have genuine spiritual experiences and still act improperly. If this is so, then what is the value of *kensho*? I do not mean that it has no value—only that

it has to be put in the larger context of human relations. And it may be that *kensho* (which some people call enlightenment even if it isn't full enlightenment) does no in itself confer any real wisdom about what it is to be human, or any real compassion either. In other words, there may be a real insight into the human *condition* (in the large) which is essentially unconnected with *being* human (in particular).[10]

Rawlinson's suggesting the possibility that one can gain significant insight into the human condition without the realization of what it is to be truly human and to lead a compassionate life brings us back to the question of what constitutes enlightenment. Is seeing into the nature of reality, even sustaining that sight, equal to enlightenment? Is freeing *oneself* ultimate liberation? Or does genuine enlightenment go beyond that?

Marie-Pierre Chevrier says that a mystical experience is transformative when it goes beyond our personal desires and into the domain of surrender to that which is beyond ourselves.

*The real question is: Is the experience worth anything? Does it create greater necessity for us to take refuge in the Absolute, or does it satisfy ego in a way that dilutes that necessity?*

RICK LEWIS

Mystical experience is transformative when the experience leads to surrender, so that which is done happens through us, rather than it being "we" who do it. This is not to say that having lived through that kind of experience there are still not levels of resistance and work to be done with what remains, but after such an experience, there remains a real taste of what it is to surrender.

Llewelyn Vaughan-Lee further shatters the consideration of the personal value that mystical experiences have by taking them out of the context of self-reference and into the context of God-reference, or Other-reference.

The difficulty is, value to what and from where? We always see things from the point of view of our ego, of "me." "What do they mean to me?" One of the things Rumi says is that you

can't bring that level into your life, you have to go into that level. So yes, they have meaning. They are full of meaning. What do they mean to you? Who knows? Maybe it doesn't matter if they don't mean anything to you. Maybe they have a different purpose altogether.

*A mystical experience can be brief, like a flash of lightening, but the awakened state is a state of being that is permanent and irreversible. It is one's true nature.*

ANNICK D'ASTIER

## LLEWELLYN VAUGHAN-LEE: BEING A MYSTIC IS NOT FOR EVERYBODY

*To me, to be a mystic means to have both feet firmly on the ground, but with your head you support the sky. It's not for everybody. I'm sure many people have wonderful experiences that open them to a different level of reality, that enrich them, who aren't interested in really becoming a mystic, who aren't interested in going through the whole laborious way, to committing themselves to twenty years, to thirty years. Why should they?*

*Maybe they get a glimpse of something else. That's wonderful. It makes their life richer. People suddenly wake up and they hear beautiful music, or they become aware that there are angels, or that they have a guardian angel. All sorts of these experiences are wonderful, they are tremendously enriching. I don't think one has to point at them necessarily in a negative way, because these experiences are given. They can help people be aware that there is more to life than materialism.*

*But there is a great difference between those momentary experiences in and out of time, those momentary ecstatic experiences, and actually working on the container which gives birth to a way of learning how to dissolve in God.*

As human beings we reference ourselves as separate individuals who are fighting for survival. Everything that occurs in our lives is

interpreted as if it was created for us and about us. We think that mystical experiences are valuable if they make *us* feel better, or if they signify *our* progression on the spiritual path, or if they mean that *we* are wonderful people because we have them. This is how the unmasked ego perceives reality. This perception is subjective and neither "good" nor "bad," and is not in accordance with objective reality. Most people would not think to consider, as Vaughan-Lee does, that experiences can have their own—independent—value and that they can be transformative in a universal sense, altering and shifting forces that we cannot even imagine. These experiences do not "care" about us, and do not arise for our own personal benefit. We just happened to be the conduit. If such experiences are indeed transformative in and of themselves, it is plausible that we may never know what their value is, and it is quite likely that their transformational value lies beyond our self-referenced ideas about how the experience will make *us* better off.

## Capitalizing on Mystical Experiences and Phenomena: Letting Them Have Their Way

*If you are lucky, your experience will be so profound that it will result in your complete destruction.*

ANDREW COHEN

The nature of mystical experiences and phenomena is that they are outside the domain of ordinary human experience and control, out of our hands. Most mystical experiences arise when people let go, even for a moment, of their habitual forms of controlling their lives and allow something outside of this control to enter their field of experience. Yet, ironically, when such experiences do arise, the first thing people tend to do is to attempt to control them.

Reggie Ray explains:

We always want to control our experience, and we always want to get some kind of leverage on what we're going through. Even in terms of religious experience we want some kind of leverage or some kind of angle so that we can interpret it. But you know, experience is experience, and it's the ego that interprets it as being good or bad or transformative or

not. So I think as a meditator, basically you have to surrender. When you meditate in a serious way, you open your mind up and you explore all the realms: the hell realms as much as the god realms. All of them are a part of the journey and a part of our learning experience. But you can't really judge them. The minute you start judging them, that's ego coming and trying to figure it out, trying to create some kind of safe place for itself to get rid of the bad ones and hang on to the good ones.

Sensei Danan Henry suggests that we let go of controlling our experiences by simply experiencing them.

Experience is there and you experience it. If you're happy, then you experience happiness, but don't indulge it in your spiritual practice. Don't chase after it, continue it, wallow in it, try to hold onto it. It's just happy. Then the next moment you're sad. Okay, you're sad. Cry. You don't deny that, you don't push it away, nor do you wallow in it on and on with all your thoughts and ideas and justifications. Just cry, "Boo hoo." Experience it deeply and then go on with your life. Your life is whatever you are doing—you're making dinner or whatever. You go on making your dinner, and whatever arises, arises. In this way life becomes easier, and you experience everything more deeply even, not less deeply. If you experience bliss, you just say, "Yes, I just experienced that bliss." Let it be. Don't oppose it.

Judith Leif explains that the teachings of *Vajrayana* Buddhism stress the practice of "non-clinging" in relationship to experiences that arise.

In our teaching, there's a more fundamental emphasis on non-clinging. So whatever experience arises, the idea is if it is a good experience, not to hold onto it, and if it is a bad experience, not to run away from it. There is more of a sense of non-clinging and a certain equanimity.

*Most spiritual experiences contain a combination in various proportions of permanent changes, temporary changes, the recognition of obstacles that need to be overcome, and the lived realization of what it is like to exist at this higher level of integration.*

STANISLAV AND
CHRISTINA GROF

Convinced that they are maximizing their experiences by controlling them, most human beings not only short-circuit the very experience they claim to want to sustain, but they repress the full expression of *all* experience. If one is able to cease using all of one's energy to control one's experience, one frees up the energy and attention needed to experience *life* more deeply—not this kind of life or that kind of life. Drawing on his own discovery of this principle, a Buddhist practitioner eloquently articulates this realization of allowing mystical experiences to have their own way.

The best way to "manage" mystical phenomena is by not managing them. You leave the manifestations and phenomena alone, not assigning them undue meaning. In this way, attention is naturally drawn back to their source. Trying to manage what arises in us is what we are all about, normally. That's exactly what we're always doing, trying to manage the ebbs and flows of our psychology and physiology and circumstances and who we're relating to and how our relationships are going and everything else. To completely surrender, totally surrender, any management of that is the possibility that exists, and that is exactly where we lose it.

The ironic thing is that when I'm not managing myself, that's when things really start to happen. And as soon as things start happening, there is that tendency to grasp at it. "Oh, this should happen more. Let it keep happening. Let it not go away. What do I have to do to make it keep happening?" The other option is to surrender to exactly what is happening, which deepens *all* experience, the highs and the lows.

That is where our work lies—in recognizing and observing how we are always managing our experience. Once there is a taste of what it is like to *not* manage it, to really not manage it, then it gets easier because you start to get the knack of not managing. It is a knack, nothing you can muscle or force. It's nothing you could ever get from a book. It's nothing that you could ever get from anywhere except from a direct taste of

what surrender really is. When someone has a direct experience of what actual union is, then they will stop trying to create their *idea* of what it is. Any problem I have ever had comes from the ways that I try to create my experience.

## There Is a Lot We Don't Know

As much as we know about mystical experiences and phenomena, the reality is that there is a lot more we don't know. There was a recent incident of a contemporary teacher who had spontaneously "woken up" and begun to write and teach very inspirational spiritual dharma to close friends and students. Then, suddenly, at a young age, she was diagnosed with brain cancer and died soon after. Was her enlightenment real? Probably. Was the inspiration she provided useful? Inevitably. Did brain chemistry have anything to do with the whole experience? Who knows?

Lee Lozowick challenges the common assumption that people know what it is that creates mystical experiences and enlightenment.

Who knows if any mystical experience is any more than nerve-firing in the brain? Hit the right nerves, get the right euphoria—who knows? There certainly seems to be a category of experiences that we call mystical experiences that have to do with the unitive nature of reality, and with the whole concept of compassion and service. Typically, that's what we think of as mystical experiences. But it could just be a certain nerve channel in the brain: eat enough ice cream, or run enough and get exhausted enough. Who knows what? Put your finger in the right socket and there you go. All of a sudden you're God.

*All those so-called "hallucinations of the senses" which appear in the history of mysticism must . . . be considered soberly, frankly, and without prejudice in the course of our inquiry into the psychology of man's quest for the real.*

EVELYN UNDERHILL

Through his characteristically crazy-wise manner, Lozowick is demanding that people be humbled in the face of their egoically-based presumptions that they know where mystical experiences come from

and what they mean. One can and should study the great traditions and learn from the well-traversed territory of the great masters, but, standing before the great mystery that is *really* happening, who can ultimately say?

# Section Two
# Dangers of Mystical Experience

*Those who play at being angels, end up as animals.*[1]

—Blaise Pascal

The exalted experiences described in the scriptures, the poetry of the saints depicting the ecstasy of rapture in God and oneness with the universe, the wondrous visions and experiences that inspire one to seek Ultimate Liberation—any of these experiences may be the gifts of the gods, if not signposts of awakening itself. Or they may be the aspirant's demise, tempting ego to claim the experience for its own, thus preventing any genuine transformative value from occuring. The ego is *the* Master of Illusion. For this reason, mystical experiences need to be given room to flourish, while simultaneously being viewed with great caution. This section reveals the ever-illusory masks of ego and how it skillfully disguises itself in the name of genuine enlightenment and liberation.

# Spiritual
# Emergency

*Jodi had just come to California from Switzerland and was unfamiliar with any type of psychic or spiritual techniques. Suddenly she found herself immersed in the hub of New Age culture and started partaking of "the market." She began training in opening up psychic faculties, and at some point felt she had contacted a "guide" from another plane who was giving her direct information. She found herself in frequent communication with this guide, and more and more it began to consume her interest, resulting in her dropping out of graduate school and losing her job.*

*People began to visit her and pay her for the guidance she provided, and all was going seemingly well until she began to feel that she couldn't shut off this contact with her guide even if she wanted to. She started hearing information from the guide that disturbed her, and getting concerned and anxious. She went back to the people who had taught her to open to see if they could teach her to close herself, but they couldn't. At some point she got very frightened and wanted to stop the channeling but was unable to. Feeling particularly concerned about her one day, I went to her house to look for her, but she wasn't answering the door. I later got called and told that she had*

*stabbed herself through her ribs and had punctured her heart, result-
ing in open heart surgery. She lived through it but repressed the entire
experience afterwards and didn't want to speak about it.*

—Daniel Gottsegen, San Francisco psychologist

Jodi is a severe case in a spectrum of phenomena known as "spiri-
tual emergency." When novices who don't have the proper education
or guidance begin to naïvely and carelessly engage mystical experi-
ences, they are playing with fire. Danger exists on the physical and
psychological levels, as well as on the level of one's continued effec-
tive spiritual development. Whereas spiritual masters have been warn-
ing their disciples for thousands of years about the dangers of playing
with mystical states, the contemporary spiritual scene is like a candy
store where any casual spiritual "tourist" can sample the "goodies" that
promise a variety of mystical highs.

*You can get very high, but you
may fall.*

RAM DASS

Spiritual energies are a vast force. When an individual begins to
explore this arena, he or she imagines that mystical experiences will
lead to enlightenment. However, abiding enlightenment is only one of
many possible outcomes—one that usually results from a lifetime of
vigilant and disciplined spiritual practice conducted under the guid-
ance of a qualified teacher, not from sudden insights or temporary rap-
tures.

In their book *Spiritual Emergency: When Transformation Becomes a
Crisis,* Stanislav and Christina Grof, whose groundbreaking work cat-
alyzed the creation of the Spiritual Emergence Network,[1] describe the
various types of common spiritual emergencies, including shamanic
crises, the awakening of kundalini, communications with spiritual
guides and "channeling," and near death experiences.[2]

Italian psychiatrist Roberto Assagioli explains why the influx of
spiritual phenomena can create such difficulty in individuals.

[In some cases] the personality is unable to rightly assimilate
the inflow of light and energy. This happens, for instance,
when the intellect is not well coordinated and developed;

when the emotions and the imagination are uncontrolled; when the nervous system is too sensitive; or when the inrush of spiritual energy is overwhelming in its suddenness and intensity. An inability of the mind to stand the illumination, or a tendency to self-centeredness or conceit, may cause the experience to be wrongly interpreted, and there results, so to speak, a "confusion of levels."[3]

When faced with such an inrush of energy, an individual who has not been provided the proper context to allow the experience to be integrated may suffer a variety of undesirable consequences, including physical burnout, a radical misunderstanding of the experience, egoic inflation, or spiritual addiction.

## Physical Burnout

Anyone who has taken even a casual shopping trip to the spiritual market knows that the popular items for sale include "kundalini awakenings," "tantric openings," "shamanic journeys," "vision quests" and so on! What the naïve shopper doesn't know is that these practices may not be safe without proper supervision. Although they are generally harmless at the level at which they are taught (though rarely effecting the results they claim to), there exists the possibility that they will access forces within the individual that he or she does not have the proper foundation to assimilate. A discussion of the process of integration can be found in Chapter Eighteen: "Sadhana, Matrix, Integration and Discrimination."

In *The Face Before I Was Born*, the spiritual autobiography of Llewellyn Vaughan-Lee, he tells of engaging an intense macrobiotic diet and attending a Hatha-Yoga class as a young man—"straining my body to produce spiritual results." In addition to the spiritual highs and periods of clarity he experienced, he found himself suffering excess weight loss, intense energies circulating in his body, digestion problems, and physical weakness. He attempted to speak with his Yoga

*If the ego actually hit the enlightened plane of consciousness, you would end up in a mental hospital. Because the ego, what people think of as themselves, is a center of consciousness which is designed to function in this level of reality.*

LLEWELLYN VAUGHAN-LEE

teacher about the energetic phenomena he was experiencing, but she had no experience or understanding of what he was talking about.[4]

"She had no idea what to do," says Vaughan-Lee, "because she was just an ordinary Hatha-Yoga teacher who hadn't been trained what to do when the kundalini awakened. It's healthy to have a teacher who knows what they are doing, who has been there, who has really been trained properly in what to do in such an instance; or if they don't know, that they can refer the person."

Examples such as Vaughan-Lee's should alert the naïve seeker to proceed with caution as he enters the spiritual marketplace, where many so-called teachers offer techniques to awaken one's kundalini and bring one to permanent enlightenment and bliss, but few know how to handle the situation should they succeed in their aim. Contrary to how they are popularly treated, these energies should be regarded as sacred and respected as extraordinarily powerful. Aware of such dangers, C.W. Leadbeater, in his book *The Chakras*, cautions the casual practitioner about the power of kundalini.

> For the ordinary person it lies at the base of the spine unawakened, and its very presence unsuspected, during the whole of his life; and it is indeed far better to allow it thus to remain dormant until the man has made definite moral development, until his will is strong enough to control it and his thoughts pure enough to enable him to face its awakening without injury. No one should experiment with it without definite instruction from a teacher who thoroughly understands the subject, for the dangers connected with it are very real and terribly serious. Some of them are purely physical. Its uncontrolled movement often produces intense physical pain, and it may readily tear tissues and even destroy physical life. This, however, is the least of the evils of which it is capable, for it may do permanent injury to vehicles higher than the physical.[5]

Leadbeater's stern warning is backed by Robert Svoboda, who cautions individuals not to be naïve about the power of kundalini.

One definite, extremely undesirable conclusion that a lot of people have drawn about kundalini is that it is an on/off kind of thing, that it is either awakened or it's not awakened, when in fact it is very much a matter of how much it is awakened. Kundalini is called *ahamkara* when it is connected to the personality, physical body, and self-definition. Then kundalini starts leaving that definition and going toward being able to identify with something else, including the Absolute. But if you were to simply forget about yourself right now, and totally awaken your kundalini, it would be physically impossible for you to stay on the physical plane because there would be nothing for you to identify with. So even if your kundalini suddenly awakens to a substantial degree, it will probably fry your nervous system to such an extent that you'll either go insane, or it will simply wreck everything in your organism and you'll die after a period of time. So you want kundalini to get awakened slowly.

Warnings such as those of Svoboda and Leadbeater are not printed on the flyers that offer kundalini awakening in a weekend seminar. Whereas experimenting with higher spiritual energies does not commonly result in excessive physical danger to the body, it does happen, and being warned of this possibility should alert the spiritual seeker to the heat of the fire that he or she may be tempted to play with.

## Misunderstanding Spiritual Experiences

When one who is naïve about the nature of spiritual experiences attempts to find help in an environment permeated by the common cultural suspicion and antagonism toward such experiences, they may end up in very unfavorable circumstances. Christina Grof, who in her work with the Spiritual Emergence Network has encountered or heard about numerous situations of mystical experiences being misunderstood and mishandled, explains what can happen.

I have heard lots of stories of people who have had these kinds of experiences in a context in which those around them cannot accept it. They end up in a psychiatric hospital and are treated with drugs and psychiatric interventions that just aren't appropriate. One woman in one of our groups had an experience of walking along the beach and being aware of something much greater than herself. When she went home she was still in that state, and the people around her were scared. She ended up in and out of psychiatric hospitals for years.

We want structures and labels. When you are in such a state you are very vulnerable. If someone comes along and tells you that you are crazy, there is a part of you that really believes them, though for most people who have had this type of experience, something within them says, "This is important."

This is how I got interested in the whole idea of spiritual emergency. How can people who are going through a profound but shattering experience cope in a culture that doesn't know how to properly handle it? I've seen perfectly well-meaning, good people who are confronting family members who are having such experiences. Their cultures have told them that according to the medical model, when something so-called abnormal happens, you need to go to a doctor who will fix it.

*With respect to my own experience, it seems to me it is not so simple to know what part of it is genuinely mystical and what part of it just reflects my own mental pathology.*

DICK ANTHONY

There are also all kinds of apparent physical illnesses that doctors cannot identify that have the same symptoms as those associated with kundalini. More often than not, medical doctors and traditional psychologists misjudge spiritual experiences as psychological breakdowns, as they don't possess the necessary knowledge to make distinctions between physical, psychological, and spiritual symptoms.

Many spiritual crises arise because the individual does not understand his or her own experience and is overwhelmed by it. Jakusho Kwong Roshi of the Sonoma Mountain Zen Center in California says, "Anybody with a body and mind can experience realization. Often they don't tell anybody because they think it is strange. They either

keep it quiet, go crazy, or their search leads them to a teacher who can explain their situation."

Andrew Cohen observes:

Some people capitalize on experiences, but it seems equally common that people run away from them because they are too frightening. Often what happens is that people will run because they realize in the face of that kind of experience that what is being demanded from them by the unknown is everything that they are, and they suddenly recognize that it is too big. The idea of not surviving is too terrifying so they withdraw.

*I've met people who have had tremendous experiences of oneness, who weren't prepared for it. And they ended up going to the doctor and being diagnosed as manic-depressive and spending the rest of their lives on tranquilizers.*

LLEWELLYN VAUGHAN-LEE

Ego perceives that mystical experience and the clarity that results is the road to its own death. Unaware of the depth and duration of the process of genuine spiritual development, the individual imagines that to succumb to the experience would result in dramatic loss, pain, or a change in perspective that would be devastating. Danan Henry explains:

There is lots of pain involved in transcending oneself, in getting beyond oneself. Ego is not going to take this lying down. The ego is going to fight back. Finally, the ego is like a dog, a vicious animal in the corner. When it is cornered, it feels the demise of its dominant position, and all hell breaks loose.

Running from a spiritual experience and presuming one's own enlightenment as a result of an experience are two sides of the same coin. Both are means by which to avoid one's present reality and are based on incorrect assumptions as to what mystical experience means and what its implications are—assumptions that are more often than not incorrect.

Yet another scenario of spiritual emergency concerns those—including many great artists—who are so horrified by their sudden vision of Reality that they become alcoholics or entirely suppress the experience. "I hope that you talk in your book about how many people have seen Reality and then gone to pieces, who have become alcoholics,

been distracted in this way and that from what they know to be true, because what they have seen is too much to bear," comments Jai Ram Smith. These people assume that theirs is the ultimate vision and believe themselves to be incapable of handling it. Instead of pursuing effective spiritual guidance to assist them through their struggle, they escape from the intensity of their experience into some diversion or addiction. Lee Lozowick suggests that such a response is based on psychological tendency, and not on reality.

> Certainly to perceive the immensity of the nature of reality can be depressing if that's what we're resonant to. If we're basically a person that sees everything that's wrong with our lives instead of everything that's right with our lives, why would mystical experience make any difference? We would just see what was wrong with the world on a higher level.

> Reality *is* hard to face, but running from it doesn't change it.

## Ego Inflation

Ego inflation, considered in depth in Chapter Ten, is another prominent form of spiritual emergency and a common consequence of misunderstanding one's own spiritual experiences. There is the common process of inflation and misperception of one's own spiritual stature, which is bound to arise in the course of the spiritual journey, and there is a messianic inflation that manifests in very extreme ways— as the Jim Jones and the Marshall Applewhites of the world, as well as many other lesser known false messiahs. When the influx of spiritual energies comes suddenly to an unprepared individual, there may be extreme consequences. In *The Chakras* Leadbeater explains this phenomenon in terms of the kundalini.

> The premature unfoldment of the higher aspects of kundalini has many . . . unpleasant possibilities. It intensifies everything

in the man's nature, and it reaches the lower and evil qualities more readily than the good. In the mental body, for example, ambition is very quickly aroused, and soon swells to an incredible inordinate degree. It would be likely to bring with it a great intensification of the power of intellect, but at the same time it would produce abnormal and satanic pride, such as is quite inconceivable to the ordinary man. It is not wise for a man to think that he is prepared to cope with any force that may arise within his body; this is no ordinary energy, but something resistless. Assuredly no uninstructed man should ever try to awaken it, and if such a one finds that it has been aroused by accident he should at once consult someone who fully understands these matters.

Spiritual energies enter the individual and are perceived and manifested through the mechanism of ego. Thus, where there is an unstable ego and tendencies toward significant conceit and grandiosity, they become greatly magnified, and the ego inflation that results may be extreme in its manifestation.

*The ego cannot have a mystical experience. It can only carry the reflection of a mystical experience.*
LLEWELLYN VAUGHAN-LEE

## Spiritual Addiction

Spiritual addiction is just like any other kind of addiction, such as the obsession with drugs, alcohol, or food, only in this case the object of desire is spiritual practice and mystical experience. "There are people who have had direct access to mystical experience without having done preparatory work," explains Marie-Pierre Chevrier. "The danger is that this kind of experience can be used as an escape from who they are and from everyday reality. In fact, even without access to direct mystical experiences people use spiritual practices as an escape from reality."

Spiritual addiction becomes an emergency when the individual gets so far out, or so needy of their "fix," that they become irresponsible for their own lives and/or mislead others. The following letter to

the editor of the semiannual journal *What Is Enlightenment?* presents a revealing illustration of this principle.

> The driving force behind my seeking was, for many years, the bliss experience, and I would do anything and accept anything so long as I could get my fix. It is not difficult to see how, in such a case, discrimination takes second place to compromise and one is led inexorably toward those who would condone and perhaps even extol the seeds of my corruption. If I had to choose between standing alone at the possible risk of losing my channel to bliss on the one hand and staying with a teacher who allowed me to indulge but whose actions I found at times repugnant on the other, I was in little doubt as to which way I would turn. Moreover, what I really wanted was a fairy godmother who would do it all for me, taking away any sense of responsibility, while I could be left to immerse myself in spiritual good feelings!![6]

*Addiction to anything but God is a sure path to misery; addiction to God is the only path to happiness.*

THE AGHORI
VIMALANANDA

It is striking to see the resemblance between the letter writer's addiction to "bliss hits" and the support of his teacher for his spiritual highs, and the drug or alcohol addict's obsession with his or her substance of choice. When Christina Grof admitted herself into an alcohol and drug treatment center upon realizing that she had become an alcoholic in her efforts to escape the terror of the strong spiritual experiences she was having, she initially believed that she had a "higher" form of addiction than the others in the rehab program: "I was spiritually grandiose. I was someone who had done this and that, and thought that I was unlike the hookers and heroin addicts. I eventually realized that we were absolutely the same, and that maybe the heroin addict and the hooker had a whole lot to teach me at that point."

People become spiritual addicts for the same reasons they become addicted to any other substance. They are suffering, they are wounded, and they are looking for a way out—instead of through—their suffering. Grof comments:

One of the things that I have seen a lot in talking with people who have a history of trauma is that they often live in the spiritual, transpersonal realm. They learned when they were children that when they got hurt they could go somewhere else. They would go to a "safe place" where there were beings who would hold them, take care of them, and help them through what was going on.

Even people who don't have particularly traumatic histories still live in the same suffering as the rest of humanity, but are often in great denial about it. When they discover the bliss and ecstasies that are available through the various technologies and practices which are labeled "spiritual" (and mislabeled at that!), their denial finds yet a more sophisticated guise in which to continue its negation of reality. In *The Kundalini Experience*, Lee Sanella talks about this phenomenon.

Most people are "collapsed at the heart." They are in doubt of God, others, and themselves. Their feeling being is stunted. In their unhappiness, they search endlessly for ways to feel better. If they cannot console themselves with the usual pleasure of sex, food, or power, they look for other means by which to stimulate their nervous systems. They become "spiritual" seekers, exploring the potential of their own bodies and minds. And yet, their escape from the basic feeling of dissociation and contraction is destined to be futile. One cannot transcend what one does not recognize and understand.[7]

Arnaud Desjardins tells the story of a student, a medical doctor with five degrees, who went through a devastating situation in a love affair. The man would alternatingly write him desperate and then ecstatic letters, either saying that if he was brave enough he would commit suicide, or telling him about the profound peace he found in meditation. Reflecting on this situation, Desjardins commented:

*I think that there are a lot of really good-hearted people who are really looking for something, who are hungry for God, but who are also attracted to getting out of here.*

CHRISTINA GROF

This is my observation and my experience: Some people get "results" in meditation. Instead of struggling painfully not to identify with the chain of thoughts, they enjoy meditation very much—it is not too difficult for them to feel something. But it does not solve their true problems. Actually, it is a way to escape.

Lee Lozowick explains. "Mystical experiences show us the reality of other dimensions and other domains, but at the same time they can also get us fixated on subtle realms as a psychological methodology of avoiding our suffering—our suffering of here and now."

Of course, avoiding that "here and now" suffering is the payoff of the addiction, the very reason for its arising. Addicts don't quit their addiction because they receive benefit from it on some level. It does not remove their suffering, but the temporary escape from it is what compels indulgence. Even among serious spiritual students, the temptation to escape through spiritual experiences (if one happens to have access to them) is a strong pull.

One long-term student of a devotional path found herself in a period of sadhana during which she was prone to states of bliss and rapture, and very much wanted to stay in these realms instead of moving on as her teacher urged her to do.

It felt fucking great. No orgasm felt that good. It was addicting. People who are having such experiences often think that they are obsessed, but they are addicted. It's like a drug. I could have moved onto the ashram, meditated all day long, and become this renunciate idiot. People could have gotten something from me in that too. Even at the time people would come up to me and love to look at my face and my eyes. You're adored for this state that you're in. Why would you want to go elsewhere?

Of course many serious spiritual students do go elsewhere, leaving behind the bliss addiction, though often reluctantly. They go either because they are encouraged to do so by a respected teacher or because

they intuit that the arising of bliss does not diminish the reality of suffering and pain, either in themselves or in the world. They eventually recognize that their addiction only inhibits and prolongs their spiritual process. This student continues her story.

Where my awakening took me was back to my psychology. Before that, my mind was telling me that this was it, and that all I needed to do was meditate all day long. I would glow and look at my teacher and feel in love. In my dreams I would walk into my teacher and burst into flames. At the time I thought, "Who needs your husband and kids? I've gone beyond that." But my husband and kids were real, totally real. They were not an illusion. I took the awakening that happened to me and used it as an excuse to get away from where I really needed to be, and I paid for my mistakes. When these experiences happen to me now, I say to myself, "It's great, but it's no big fucking deal. What can I get from this and then move on?"

Weathered spiritual aspirants know, or learn through suffering, that if all they want is a spiritual high, they can go to channelers, psychics, pseudo-tantric teachers, or take psychedelic drugs. They also know that if a mystical state prevents them from serving their families and those around them, suspicion is warranted. One mother cautioned, "When I'm feeling that attached to an experience—so much that I don't want to tend to my child's needs—I miss the experience. I miss the enlightenment in it. When I am unwilling to show up when I'm called to serve because I'm attached to something about an experience, I miss the point."

No one can ultimately avoid their suffering. Just like any addict, the spiritual junkie requires more and more of his bliss fix to get high, and life simply will not provide an indefinite high. Eventually, the addict will crash. Sanella concludes:

No amount of mystical fireworks in the synapses of the brain can help overcome the crunch at the heart. Once the vision

*Instead of seeking for that realization that awakens the intelligence, most instead seek for a spiritual feeling that, like a narcotic, will hopefully relieve them of the burden of their existence.*

ANDREW COHEN

or experience of bliss is over, the person simply returns to his or her state of emotional distress. Then he or she will have to make renewed efforts to stimulate the nervous system or force the kundalini into higher centers in order to feel blissful again. In this respect, psychic or mystical experiences are little different from orgasms.[8]

## CHRISTINA GROF: DROWNING SPIRITUAL SORROWS IN ALCOHOL

*I am someone who is very stubborn and hard headed. I had had many spiritual experiences, both difficult and beautiful, but as a human being I was so shattered by a lot of what I had gone through in life that I had no ego boundaries to help me contain what was happening, and so it was leaking out everywhere. The experiences were happening but they intruded on my everyday life. Part of what I did in a sort of desperate attempt to calm the energy was to start drinking alcohol, at first just a couple of glasses of wine to calm things down. But I became an alcoholic very fast, and some of the symptoms of alcoholism began to mimic the kundalini rushes, hallucinations, visions. The experiences themselves became part of my denial symptoms. I'd think, "Oh, that's just kundalini."*

*Once I removed the alcohol, there were all the issues, all the things that the alcohol was hiding. I had been very comfortable in the archetypal realm, but in a sense it was very impersonal and transpersonal. For me, dealing with my biography, my own stuff, was more difficult. It has been very different to be forced to look at my own issues, knowing that I had to do that in order to ground the spiritual experiences and help me open back up to the world.*

## Proper Context Is Essential to Avoid Spiritual Emergency

The effective way to avoid spiritual emergency, or to attend to it when it arises, is to either establish the proper context within oneself regarding such experiences or to place oneself among others who have that context and can provide the necessary help during the crisis. Stanislav and Christina Grof suggest:

> The most important task is to give people in crisis a positive context for their experiences and sufficient information about the process that they are going through. It is essential that they move away from the concept of disease and recognize the healing nature of their crisis . . . Whether the attitudes and interactions in the narrow circle of close relatives and friends are nourishing and supportive or fearful, judgmental, and manipulative makes a considerable difference in terms of the course and outcome of the episode.[9]

Mystical experiences belong to the realm of the unknown. Though they have many origins, they are outside the domain of ordinary experience and should be shown respect by not presuming that one has control or mastery over these domains. As psychologist Daniel Gottsegen explains, "If you don't believe that there is something beyond, then spiritual emergency is no different than psychological emergency." If there is no respect for the beyond, and no understanding of the limitations of ego, then spiritual emergency will continue to be handled in the same way as any other psychological breakdown.

*It's not the experience of Enlightenment that matters. It is only the ego's relationship to that experience that has any meaning.*

ANDREW COHEN

Spiritual emergency and spiritual addiction represent the grossest level of the dangers of mystical experience. Each is based upon a series of assumptions and presumptions that are commonly held by the culture at large regarding the value, purpose, and meaning of mystical experiences. Whether they lead to the presumption of one's own enlightenment, or the perceived need to run away from such experiences, their objective purpose is neither of these. The following chapters explore

the more subtle dangers of mystical experiences as the individual progresses on his or her spiritual journey and the consequences of misunderstanding them.

## A LETTER TO PHILIP KAPLEAU ROSHI FROM A STUDENT

*Dear Roshi,*

*I feel that I have suffered a great deal in life and this suffering is what led me to Zen. I had many misconceptions as to what it would be like to be enlightened and I sought enlightenment as a means of alleviating this pain. I only worked on the koan Mu for about two months before coming to awakening. For the first six months I was ecstatic, and at the four-day sesshin I attended it reached a peak. Since that time I have slowly begun to realize that this shallow awakening is not the answer to life's pain. I will always do zazen, but I must know what lies beyond from one who has experienced greater depths of enlightenment.*

# Spiritual
# Materialism

*Spiritual materialism is an attachment to the spiritual path as a solid accomplishment or possession. It is said that spiritual materialism is the hardest to overcome. The imagery that is used is that of golden chains: you're not just in chains, you're in golden chains. And you love your chains because they're so beautiful and shiny. But you're not free. You're just trapped in a bigger and better trap. The point of spiritual practice is to become free, not to build a trap that may have the appearance of a mansion but is still a prison.*

—Judith Leif

A great danger of all mystical experiences—experiences of enlightenment, freedom, liberation, and so forth—is that they will get enrolled by ego itself and converted into material that will be utilized by ego for its own purposes. When the context of one's life is egoic self-reference—meaning that the identification is with ego as a separate unit—mystical experiences, moments of enlightenment, spiritual credentials, all become potentially dangerous assets. The "currency" of truth can quickly be exchanged for the currency of ego, and such experiences

*Spiritual materialism: using spirituality for the gratification of ego.*

Reggie Ray

readily become yet another one of ego's means to further its own leverage in its fight against true liberation.

*The ego is always behind every corner. You have to watch out!*

IRINA TWEEDIE

Ego can and will attempt to convert everything for its own use. That is why the domain of mystical experiences and experiences of enlightenment is so dangerous. It is precisely because their value is so high to the essential self that such experiences are so interesting, and threatening, to ego. Ego wants to strengthen itself, and also to effectively block the liberation which it perceives as its own death. Thus, becoming a "spiritual ego" is a brilliant disguise by which to infiltrate the individual's genuine spiritual life and seduce his or her attention away from Truth or God.

Whatever our hungers are, we transpose them onto the path. Those individuals who are lustful by tendency may, upon entering the spiritual path, attempt to acquire an array of bliss states and ecstasies, or use their spiritual "glow" to seduce potential sexual partners; those who are vain and showy in ordinary life may work hard to acquire fancy robes, spiritual titles, and sophisticated spiritual language by which to show themselves off to their fellow spiritual aspirants; the passive and lazy may find a spiritual school that tells them they are already enlightened and that they don't have to do anything.

One of the great dangers of spiritual materialism arises when spiritual experiences and practices are used to avoid the demands of real spiritual life. St. John of the Cross long ago informed us:

> Many of these beginners have also at times great spiritual avarice. They will be found to be discontented with the spirituality which God gives them; and they are very disconsolate and querulous because they find not in spiritual things the consolations that they would desire. Many can never have enough of listening to counsels and learning spiritual precepts, and of possessing and reading many books which treat of this matter, and they spend their time on all these things rather than on works of mortification and the perfecting of the inward poverty of spirit which should be theirs.[1]

The notion of using spirituality to avoid spirituality is not an idea that one would ordinarily entertain (unless one's ego were to do so in order to gain greater sophistication so it could convince both oneself and others that *it* was not doing this). It is precisely for this reason that spiritual materialism is so tricky. Unless one knows about it, and is serious about it, one would not think to question oneself in this way. Spiritual materialism is always around the corner spying for some sly new technique to use for its own advantage.

Spiritual materialism is nothing new. Chogyam Trungpa Rinpoche, who popularized this term in the West, recounts how the "hobby" of collecting spiritual transmissions has occurred over time and across cultures.

> Receiving abisheka (transmission) is not the same as collecting coins or stamps or the signatures of famous people. Receiving hundreds and hundreds of abhishekas and constantly collecting blessing after blessing as some kind of self-confirmation has at times become a fad, a popular thing to do. This was true in Tibet in the nineteenth century as well as more recently in the West. That attitude, which reflects the recent corruption in the presentation of vajrayana, has created an enormous misunderstanding. People who collect successive abhishekas in this manner regard them purely as a source of identity and as a further reference point. They collect abhishekas out of a need for security, which is a big problem.[2]

The contemporary version of what Trungpa Rinpoche is talking about is found in present-day "spiritual shopping sprees." People will go from their Tibetan Rinpoche to their Hatha-Yoga teacher to their transpersonal therapist to their meditation instructor, taking bits and pieces from each and thus establishing a great collection of spiritual blessings, techniques, tools, and methods. Trungpa Rinpoche continues:

> Jamgön Kongtrül the Great, a Tibetan teacher who lived in the nineteenth century, was raised and educated as an enlight-

ened student of vajrayana . . . but Jamgön Kongtrül had seen
that something was wrong with receiving a succession of
abhishekas purely as collector's items. He pointed out that
problem by saying that if we have no understanding of the
practicing lineage then we are just collecting piles of manure,
and there is no point in that. A pile of manure may be ripe,
smelly, and fantastic, but it is still a pile of shit. If we were
manure experts, we could utilize it. But when we are actually
collecting such manure to try to make it into food, that is out
of the question.[3]

In other words, if we want to write a book about contemporary
pseudo-spiritual technology, it may be useful to hop from teacher to
master to sheik to therapist to collect our data; but if we are genuine
spiritual students, this approach will only take us in circles around our-
selves.

Although spiritual materialism is nothing new, it has become a
remarkably popular fad in recent years. Because contemporary culture
is so entirely dominated by materialism, and because spirituality has
found its way into the mass market, the distortion of spiritual terms
and concepts, the need to dress and talk spiritual, and to think of one-
self as spiritual, is overflowing into the mass culture. One could say
that we are living in an age of widespread spiritual materialism. As Lee
Lozowick suggests, "In Western culture, where rationalism and materi-
alism are the core essences of our relationship to our world, spiritual
experiences tend to create more of the same."

Spiritual materialism also manifests itself when the individual
who has had mystical experiences or has received great blessings from
a teacher uses these experiences and blessings to separate themselves
from others as opposed to bringing them closer to others and to the
suffering in life. Lozowick explains:

The value of mystical experiences is that people get a glimpse
of the vastness of possibility and the unlimitedness of reality.
If they then infer that they are somehow special, that's when

the dangers begin. They start lording it over other people and using their experience to actually separate themselves more from other people, when all the actual implications of mystical experiences imply the unitive nature of all reality. It's amazing that people can have those experiences and actually become more separate. But that's what happens, typically.

Thousands of people have had such experiences, and instead of being more mature as servants of the relief of other people's suffering, they walk around with pyramids on their heads, and glasses with lights that flash and give you alpha rhythms. If people really want to know something about service, why don't they go to Calcutta and hold dying babies in their arms and comfort them instead of blathering on about serving the universe?

Spiritual experiences are about the continuum of life and about the oneness of all things. If we understand that, then obviously we would become more responsible for our actions in relationship to others and the world. Yet the opposite seems to be the case. People have these experiences and then go shopping and buy more clothes and make-up. Have you ever been to one of those New Age fairs? How could anybody possibly become more vain after having an experience which, if it was interpreted properly, would expose all vanity for its total emptiness and suffering?

*You may find after you've climbed to the top that your ladder is against the wrong wall.*

ANONYMOUS

The key to the answer to Lozowick's question is in the question itself, when he says, *"if [the experience] was interpreted properly."* Spiritual materialism is about the incorrect interpretation of spiritual ideas, ideals, experiences, encounters. The ego will not interpret experiences correctly of its own volition. This point cannot be overstated. People have wonderful experiences, and for a moment are "out of their own way," and then ego instantly comes in as interpreter, and the individual assumes that the interpretation is correct.

## The Spiritualized Ego

*The soul that is attached to anything, however much good there may be in it, will not arrive at the liberty of the divine.*

St. John of the Cross

One dramatic example of ego as interpreter can be found in the "spiritualized ego." Ordinary egos do the things that ordinary egos do: they think too much or too little of themselves; manipulate others and continuously try to gain the upper hand; act selfishly; lie, cheat, and steal a little. But spiritualized egos have their own game: they talk in a soft and spiritual tone; they create a certain facial glow or aura that they learn to emanate; they have "intense" experiences regularly; they know the dharmically-correct answer to every situation. Anyone with minimal intelligence can take the dharma spiritual teaching and manipulate it from an egoic perspective.

Llewelyn Vaughan-Lee recounts the demise of his own spiritualized ego.

> For many years it was so important to me that I was a spiritual seeker. This was my identity. One day I said to my teacher, Mrs. Tweedie, "Is this an obstacle?" She said, "Yes, my dear. It is a necessary crutch at the moment, and it will go." Then I had this vision of a coffin on which was written, "Spiritual Aspirant." That vision allowed me much more freedom just to be an ordinary, simple human being who loves God.

Seeker, finder, teacher, student, sage . . . the identity with any one of these roles is the same spiritual materialism. There are many people who function appropriately and effectively in these roles, but when the ego claims these identities for its own, and parades them around like a peacock, there is difficulty. Vaughan-Lee continues:

> One of the most dangerous things I have found are these spiritualized egos—people whose ego is no longer an everyday ego that likes a nice car, or getting a new dress or something, but has now become a spiritualized ego and is having spiritual experiences. You will see all the spiritual things these people know and are longing to tell you. If you look carefully you see

that they are a bit off balance. They are usually tremendously enthusiastic, and all of everything is coming out of them. They are substituting a spiritualized ego for a real spiritual experience, and it is very difficult for other people to tell the difference.

Ego does not realize that *it* cannot have mystical experiences or "get" enlightened, this being the primary cause for the arising of the spiritualized ego and spiritual materialism in general. Vaughan-Lee again:

> Many people actually have a momentary experience of one-ness and they come back to their ego, but the ego cannot have an experience of oneness because its very existence is that it is separate. It actually disturbs the ego very much when there are experiences of oneness because they begin to undermine the ego's belief in its own separate existence.

*Too often we think extraordinary phenomena are a gift from God when, more often, it is only the self masking as God, the self insuring its survival under a divine guise.*

BERNADETTE ROBERTS

The following dialogue between Philip Kapleau Roshi and a student illustrates this point.

*Questioner:* What is *satori?*
*Roshi:* When a Zen master was asked, "What is Buddhism?" he replied, "I don't understand Buddhism." Me, I don't understand *satori.*
*Questioner:* If you don't understand, who does?
*Roshi:* Why don't you ask someone who says, "I am enlightened"?
*Questioner:* Are you enlightened?
*Roshi:* If I say "Yes, I am enlightened," those of you who know will walk out in disgust. If I say, "No, I am not enlightened," those of you who misunderstand will walk out disappointed.[4]

Since ego cannot have mystical experiences or get enlightened, Kapleau Roshi cannot say that *he* is enlightened.

Vaughan-Lee describes a similar interaction between Irina Tweedie and Bhai Sahib.

> One day Bhai Sahib was telling somebody that he wasn't enlightened, that he hadn't realized the Self. When the person left, Mrs. Tweedie, who was standing next to him, got quite angry. She knew he was a tremendous sheik, a tremendous soul, and she said, "But of course you are! You have realized the Self. You are enlightened." And he looked at her and said that in those experiences the "I" is not there. "So 'I' have not realized anything," he told her.

The contemporary Indian teacher Vimala Thakar knows that the only "somebody" there is to get enlightened is ego. Of her own experience she describes, "The content of consciousness in Vimala's body is 'Nobodyness' and 'Nothingness.' How can there be any claim of being a genuinely enlightened person or teacher?"

"The true mystic knows," comments Vaughan-Lee, "that 'he,' 'you,' 'me,' 'we' can never be enlightened."

> One of the things people don't realize is that it is not the ego that has a mystical experience. Carl Jung beautifully explains that you must remember that the ego—or who you think of yourself as—is the manger in which the Christ-child is born, but it is not the Christ-child. There is a lot of misunderstanding of this. People think that they are going to become enlightened.

Trungpa Rinpoche said that ego wanting to experience enlightenment is like "wanting to witness your own funeral."[5] Yet try to convince ego of this! The ego is not only present for the experience itself, but the moment this essential experience fades, ego is all that is left. The implicit realization and recognition of something Other and Beyond, which was true of the experience, is no longer present as a realization, and the only thing left is ego, which proudly steps forth to take credit for the experience. Vaughan-Lee once again:

It's very, very subtle, the way that when you have an inner experience you can think, "Ah! I am now this spiritual person. I have had this experience." One friend of mine says, "Then the ego pulls you back to admire the experience." It's a very subtle process of having the experience and then realizing it isn't you that had the experience, and not letting the ego get attached to the experience.

One student describes this process of having the ego take credit for the mystical experience in the following way.

Personalizing the mystical experience and not acknowledging its source would be like a branch of an apple tree looking at itself and, as it was staring at its own beautiful leaves and flowers, deciding to cut itself off from the tree so that it could go travel and show the world its flowers. It is absurdly obvious given that kind of analogy that the flowers won't last long without the tree, but when it comes to ourselves we aren't so clear. The idea of having anything arise as a result of the connection to a greater source and then taking matters into one's own hands is ludicrous.

*Ego is extremely resilient and very quick to take credit for anything that arises that looks attractive or powerful.*
ANONYMOUS

Ludicrous as it may be, that's what ego does. "I often think of this song," recalls Vaughan-Lee. "'You can't get to heaven in a rocking chair, 'cause a rocking chair don't rock that far.' And you can't go to Reality through the ego, because the ego cannot go to a different plane of reality because it's designed for this plane of reality. The ego cannot have a spiritual experience. It can only carry the reflection of a spiritual experience, as the ordinary mind belongs to a level of duality."

Lozowick comments that even *after* that which he calls "the experience that instigated my teaching work," and what his students consider as his shift into the enlightened context, he still thought that it was somehow "him" who was radiating the teaching and benediction that was coming forth from him.

Ego says, "These people love me. These people want to give to me." I used to think, before I really connected with my teacher Yogi Ramsuratkumar: "I have this great radiance. I have this brilliant dharma." How foolish. It is never us, so you get in tremendous trouble if you start taking responsibility for the attention you're getting.

*If we think we have achieved something, that we have "made it," then we have been seduced by Mara's daughters.*
CHOGYAM TRUNGPA

It is difficult to not get seduced. The realness and authenticity of such experiences are striking. There is an expansion in them. There may be the realization that the entire universe is in your body, or you may experience the oneness of all of life. This is all very heady, and it takes a very strong degree of self-honesty and conscience to not take those experiences and use them to shore up ego, to make ego stronger. The more you are working with containing higher energies, the more dangerous it is for ego to identify with the process that you're being put through, which at some point you realize is not your personal process. It is a universal process that is so much bigger than anything we are identified with in this incarnation.

Although the ego can never get enlightened, or become "spiritually developed," the spiritualized ego readily fools both itself and others. To the untrained eye, its manipulations can appear seamless, and its radiance and apparent generosity are hard to question. The other aspect of the spiritualized ego that Llewellyn Vaughan-Lee emphasizes is that although ego cannot have true mystical experiences, it can synthesize its *own* brand of spirituality—imitations, if you will, of the real thing. In *Cutting Through Spiritual Materialism*, Trungpa Rinpoche explains:

> If you have learned of a particularly beneficial meditation technique of spiritual practice, then ego's attitude is, first to regard it as an object of fascination and, second to examine it. Finally, since ego is seeming solid and cannot really absorb anything, it can only mimic. Thus ego tries to examine and imitate the practice of meditation and the meditative way of life. When we have learned all the tricks and answers of the

spiritual game, we automatically try to imitate spirituality . . .
However, we cannot experience that which we are trying to
imitate; we can only find some area within the bounds of ego
that seems to be the same thing . . . [6]

Ego mimics spiritual experiences and gestures because it wants the
benefits that it imagines such experiences can bring, but is unwilling
to sacrifice its own ways. "We become skillful actors," says Trungpa
Rinpoche, "and while playing deaf and dumb to the real meaning of
the teachings, we find some comfort in pretending to follow the path."[7]
Jack Kornfield discusses this principle in terms of the Buddhist
teachings of the "near enemies."

> The near enemies are qualities that arise in the mind and mas-
> querade as genuine spiritual realization, when in fact they are
> only an imitation, serving to separate us from true feeling
> rather than connecting us to it. An example of near enemies
> can be seen in relation to the four divine states the Buddha
> described of loving-kindness, compassion, sympathetic joy, and
> equanimity. Each of these states is a mark of wakefulness and
> the opening of the heart, yet each state has a near enemy that
> mimics the true state, but actually arises out of separation and
> fear rather than genuine heartfelt connection . . . Each of these
> near enemies can masquerade as a spiritual quality, but when
> we call our indifference spiritual or respond to pain with pity,
> we only justify our separation and make "spirituality" a defense
> . . . If we do not recognize and understand the near enemies,
> they will deaden our spiritual practice. [8]

Individuals who have spiritualized their egos are in a very precari-
ous and unenviable situation, though they may fancy themselves the
belles of the spiritual ball. They have essentially used spirituality as a
defense mechanism to protect themselves from exposing themselves as
they actually are, which is what real spirituality is about. Their know-it-
all egos have become so well versed in spirituality and created such a

solid shell around them that there is almost no way for them to see that they have manipulated their knowledge to their own disservice. Since they know *everything*—every dharmic explanation, every meditative state—there is no genuine openness for them to see that their "knowing everything" is precisely what stands in the way of their spiritual life.

Gilles Farcet, one of the four teachers responsible for working with students under the guidance of spiritual master Arnaud Desjardains, shares his discovery of this aspect of spiritual materialism in his work with students.

> What I find dangerous over the years since I've been teaching has to do with certain people—usually very intelligent people—who pretend to know, and I would say "pretend" in a sincere way, because these people are deluding themselves. They relate to strict, ultimate, nondualistic teachings in such a way that they think they've got it. They don't go into their own psychology, nor examine their own behavior.
>
> This strategy can be very sophisticated. One man I worked with in a group was intelligent and sophisticated. I couldn't tell him what he was doing. When I even tried to allude to it, he covered it up with sophisticated dharma. It was impossible to pierce him. It was obvious that his whole strategy was of remaining in control. I've noticed that most of the people who use this strategy are people who have a lot to lose in terms of losing face if they are really confronted as to what is going on within them.
>
> These people usually have seen something. It's not totally false. They have sensed something, but precisely because they are so sensitive, they have taken recourse to spiritual teachings as a survival strategy. They haven't done the necessary work in order to face the truth about their own psychological mechanisms, and so they want to short-circuit them. I find that this type of strategy is far more dangerous than fancy mystical experiences which don't last. This type of person does a lot of harm to himself, and also sometimes to others.

One scholar and student of Advaita-Vedanta referred to the type of ego in Farcet's description as the "bulletproof ego." He suggested that when an individual does not have any context for understanding the nature of spiritual experiences and teachings (and even sometimes when they do), the ego takes the experiences and teachings it receives, reconstellates them, and orbits them around itself. It then assimilates them into a "bulletproof" ego. When the ego itself is comprised of the experiences and the teachings, nothing save a small miracle is going to be able to penetrate it.

All too aware of the insidiousness of ego, Llewellyn Vaughan-Lee is insistent that, for the sake of one's own spiritual work, the individual is better off with an ordinary ego rather than a spiritualized one.

> Again, the danger is always to spiritualize the ego, to become a "spiritual person." I always say that it is much easier if you have a good worldly identity because it is much easier to get rid of, but a spiritual identity is difficult to get rid of.

The possibility that ego is capable of such intricate tricks as elevating itself to high spiritual status is quite plausible to one who is familiar with its workings, but such a preposterous idea would never enter the mind of the ordinary spiritual sightseer. Until one's entire *context* shifts to that of Other-reference, or God-reference, the ego will always interpret spiritual experiences in ways which serve its own ends.

There is evidence of spiritual materialism in all traditions and in all cultures. Reclaiming the spiritual territory that ego has appropriated requires sharpening our ability to recognize when ego is running the show and being willing to question the assumptions that we make on the basis of ego's interpretations and agenda.

*Our vast collections of knowledge and experience are just a part of ego's display, part of the grandiose quality of ego. We display them to the world and, in so doing, reassure ourselves that we exist, safe and secure, as "spiritual" people.*

CHOGYAM TRUNGPA

# Getting Stuck:
# The Spiritual
# Cul-de-Sac

*When you awake, you have to awaken again. You try to understand this adversary. Make an effort, not struggle with him . . . but see what he is made of, what lies he tells, what insincerity . . . You have to understand and try to see how he has power over you. You need more moments of seeing. Wish to see him more, how he is connected within you, what wrong connections are.*[1]

—Lord Pentland

Imagine that you are attempting to drive to infinity, but on the way there you see a side street that is just too appealing to pass without taking a quick look. So you turn up the street, and at the end there is a cul-de-sac. You decide to take a fast drive around it, but by the time you do the scenery changes, and you figure that you better go around one more time just to make sure you took it all in. However, each time you get back to your starting point, the scenery changes again. And so you keep driving around—for hours—for years. Because the scenery keeps changing, you assume that you must be getting

*You must know yourself, know your weaknesses.*
E.J. GOLD

somewhere, and it is so colorful and interesting that you begin to forget that you even turned up a side street to begin with.

This is the way many people proceed on the so-called spiritual journey. Somewhere along the road, they get sidetracked. And because the scenery is so interesting (not always pleasant, but interesting)—a new guru, a psychological breakthrough, a fabulous job offer, two months of bliss and ecstasy, a divorce, a promotion to the status of meditation teacher—they figure they must be on the path. Things are certainly happening. After all, everybody is on the spiritual path, aren't they? And so they continue along, driving around the cul-de-sac of life, often forgetting where they were going in the first place but having an all right time, gaining lots of titles, promotions, experiences.

*You yourself are your own barrier—rise from within it.*

HAFIZ

"Looking good and going nowhere" is one way to describe this common phenomenon. The spiritual aspirant looks good: he or she has an important function and lots of friends in his or her spiritual community, is well-versed in dharma, has had a good share of experiences and breakthroughs. He or she has all the spiritual credentials— a flawless spiritual resume—and still is traveling on a dead-end road.

The entire spiritual path is full of fancy diversions, one opportunity after another to go down a side street and get distracted. It is as if a Divine Intelligence has placed all the diversions there in order to create discrimination and clarity in the serious aspirant who is willing to work to pass them up.

The first, and sometimes the last, place people get stuck is in the domain of mystical experiences and phenomena. Even the Buddha himself, when he was near to his final awakening, was tempted by a vision of the beautiful seductress Mara. Not only are we conditioned to believe that mystical experiences are what the spiritual path is about, but the experiences in and of themselves are so compelling, so outside the ordinary domain of human suffering, that they tempt us to stay there, with them, instead of moving on along our path. Ram Dass discusses how he and his peers were seduced by the rapture of mystical states when they began to get involved in spiritual pursuits.

Our practices and rituals affected us and we started to have many more spiritual experiences, leading to a time when everyone was in a state of spiritual bliss. We reacted to that experience by becoming enamored of all the phenomena that occurred as a result of our practices, meditation, and spiritual purification . . . The traditions warned us about this attitude; Buddhism, for example, cautions against getting stuck in the trance states, because you will experience omniscience, omnipotence, omnipresence. Buddhism advises that we simply acknowledge these states and move on. But the temptation to cling to such experiences as achievements persists.[2]

No one is exempt from such temptations, though some are more tempted than others and are seduced farther away for longer periods of time. Those who have not experienced the difficulty of the spiritual path first hand and acknowledged the depth of their own suffering should not assume that they, too, would not get stuck in the domain of mystical experience. As described in Chapter Three, most people are on the spiritual path because they want Truth or God *and* because they want to escape suffering. Suffering is the great sorrow of humankind, a reality that most people find impossible to come to terms with. Ecstatic experiences are moments of freedom from that sorrow, and thus it is understandable why one would choose to dwell on them rather than throw oneself into the unpredictable experiences that a life of surrender brings.

Understandable, but dangerous. Reggie Ray tells a chilling story about the dangers of getting stuck in one's attachment to mystical experiences and states of expanded consciousness.

*It's a universal truth: When people are stuck, their stuckness has to be theirs until such a point that they can come away from it, because people always come away a little bit. Absolute stuckness doesn't exist.*

ANDREW RAWLINSON

In Tibetan Buddhism, it is said that based on previous karma you can get into a state for a long period of time, a blissful, meditative state, and actually stay there. I once heard a Tibetan tell a story of going into a cave in Tibet that hadn't been used for hundreds of years and finding this little pulsating brain in the back of the cave. What had happened was

that the person had gone into a trance—such trances are well known—and had stayed there for hundreds of years. The brain had eaten up the rest of the body, until all that was left was this little brain. But in Buddhism they say that when you burn out from a trance state you go straight to the hell realm. So although it may feel good, it is not really a good idea, because you can wind up in a bad place if you try to hang out there.

This story is dramatic, but true. Although it is far beyond the danger that most spiritual aspirants will ever come near to, it is the continuum of danger that is being addressed here. Getting stuck is getting stuck, and while it has both mild and extreme forms, if one's goal is the Absolute, everything that is an obstacle to that is the same. Writer and spiritual aspirant John Groff warns spiritual students of the dangers of mystical experiences and powers.

I would offer here one final word about the *siddhis*, and in so doing add my voice to that of practically every spiritual teacher who has spoken on the subject. At one time or another during those two years [spent with the Sufi master], I saw all of these powers manifested in that garden: clairvoyance, levitation, materialization, dematerialization, bilocation. They are absolutely real and to the ego-mind absolutely fascinating. To beings whose spiritual work is to awaken, to realize that their essence is one with the Essence of God, these powers are also very dangerous, for the desire to master them and put them on public display can become the ego-aggrandizing work of an infinite number of incarnations.[3]

## The Child and the Butterfly

*One day, a young boy is playing out in the hills behind his house when he discovers a brilliant butterfly. He stands in wonder gazing at it, when he suddenly has the idea to catch it and bring it home as a pet.*

*He brings it to his room, secures it in a cage, and calls to his parents and brothers and sisters to come look at it. He invites his friends from school to come over and takes out the butterfly to show them. He even tries to train it. Moreover, he boasts of it to himself. As he walks to school, he thinks, "I have this beautiful butterfly at my house. I don't know anybody else who has such a butterfly." He admires it from all angles, and brings it special leaves and butterfly food to eat.*

*The child runs home after school to admire his beautiful butterfly, only to find that it has escaped through the bars of the cage. He is disappointed. Not wanting to admit that it is actually gone, he tells himself that it will come back later, that it is probably hidden somewhere in the house, and he sets out some nice green leaves to lure it back. Meanwhile, he goes out to play with his friends, figuring that the butterfly will come back, because who could resist such beautiful leaves?*

*A few days later, he finally admits that the butterfly is gone. It isn't coming back. It isn't in the closet, and it doesn't care about the pretty leaves or the gourmet butterfly meal that the boy put out for it. It has moved on, as it should.*

The story of the little boy and the beautiful butterfly is a useful way to understand the various stages at which individuals on the spiritual path can get seduced and even stuck by the temptations of mystical experiences and powers. The butterfly represents all the wonderful experiences and spiritual powers that have been discussed thus far in the book: it is the Buddha's Mara; it is the experience of rapture, bliss, clarity, oneness; it is the large and small powers of perception that often arise throughout a course of intensive spiritual practice.

Of course, the fact that a beautiful butterfly exists is not a problem. It is a natural part of the environment, pleasant to look at, neither bad nor good. Ordinarily, the butterfly comes out from wherever butterflies come from, flies about for a few moments, and continues along its way. The story changes, however, when the eager child decides to capture the butterfly for his own.

*The suffering on the path is the ego giving up its belief in autonomy, its belief that it is the ruler.*

LLEWELLYN VAUGHAN-LEE

## Capturing the Butterfly: Grasping at mystical experience

In the moment that he notices the butterfly and admires its bright colors, the child is free. We could say that it is a moment of "enlightened appreciation." However, the next moment, as always, arises. It is the moment when the mind enters the experience. Irina Tweedie says, "One has sometimes quite incredible experiences and then the trouble begins, because you don't know what to do with them."[4] In this case, it suddenly occurs to the little boy who is admiring the butterfly to catch it, take it home, and put it in a nice cage in his bedroom.

Most of us want to capture our mystical experiences with our mind, take them home with us, make them our own, and take them out to play with any time we want to. Trungpa Rinpoche suggests:

> Quite possibly, your first reaction after such an experience [of awakening] would be to write it down in your diary, explaining in words everything that happened. You would attempt to anchor yourself to the experience through your writings and memoirs, by discussing it with people, or by talking to people who witnessed you having the experience.[5]

*Oftentimes people will have a single insight and then proclaim, "I am the truth." Such a proclamation may indeed be true, but then again it may be another manifestation of ego.*
LEE LOZOWICK

> Speaking generally what happens is that, once we have actually opened, "flashed," in the second moment we realize that we are open and the idea of evaluation suddenly appears. "Wow, fantastic, I have to catch that, I have to capture and keep it because it is a very rare and valuable experience." So we try to hold onto the experience and the problems start there, from regarding the real experience of openness as something valuable. As soon as we try to capture the experience, a whole series of chain reactions sets in.[6]

First there is just raw experience. But if it is a positive experience, a reprieve from our suffering, we want to possess it, and so we capture it, put it in a cage, and mark it: "Mystical Experience I Have Had."

## Showing off the Butterfly: Spiritual pride

As the child is proud of the butterfly, so are we proud of our mystical experience. We take friends aside and want to tell them about this special experience we have had. When we read of the experiences of the great mystics, or listen to a spiritual discourse, we nod our head in that knowing way and look the speaker in the eye with great confidence. Just as the child thinks that the butterfly is his, as if he alone had created such a beautiful thing, we feel that this experience is of our own making, that it is because of who we are that we have had it. Gilles Farcet challenges that perception.

> The question is, How do I relate to this experience? Because if I say, "Ooh. This is it. This is it. This is it," then I grab it. The moment I grab it, it loses its integrity. The moment I grab it, it means that it is me grabbing it and thinking that I am the owner of this wonderful experience that nobody better take from me. The whole point is lost.

Like the child with the butterfly, when we show off a mystical experience we identify with it, as if it were our own. Yet the "butterfly"—the experience—is beautiful in and of itself. It is not beautiful because we "caught" it. It existed before we saw it, it was beautiful always, and it will continue to be equally beautiful even when it "escapes."

## The Butterfly Escapes: When experience fades

For many people, particularly those who are not familiar with the coming and going of mystical experiences through years of sadhana, it is devastating when a mystical experience or a period of enlightenment fades. It is so devastating that they try to hang on to every last bit of remaining insight, convincing themselves that it is not gone. Lee Lozowick comments:

Many people have an enlightenment "experience" in which they understand the nature of Reality. When the experience of that fades, the self-referenced individual will still remember it clearly, can speak about it, and may not even know that they are no longer operating from that experience. In the experience, they may have known, "I am God." So when the experience fades, ego thinks, "Well, I must still be God because that was true." And so they go around acting like they're God. Our task is to be human. Any human presuming to be "divine" is just ego dramatizing itself to the gaudiest degree.

It is necessary to make a distinction between experience and memory. When we experience something, it is in the present; it is alive, immediate. When we remember an experience, it is in the past, in the mind. Whenever we have had a mystical experience, but are not presently experiencing it, it is in the domain of memory. There is some middle ground in the sense that some experiences last over a period of time during which they may be stronger and weaker at different points, but there is a clear distinction between present and past. Most of the experiences that people parade around on banners to show what extraordinary individuals they are, actually are past events. They were real, and they may have a made a strong impression on the person's life, but they are in the past tense. Arnaud Desjardins observes:

> The danger is, "I must get back this experience. I must get back this experience." This turns into a desire among other desires, and this very desire will be an obstacle. I have known many people—men and women—for whom this grasping the past has been such a suffering: "I've lost this state. I've lost this state," they say. And it becomes a problem for them, seeing that this state, this status, can be lost.

The experience can be lost, and it most often is. And it is unpleasant. Like an enlightened hangover, ordinary neurotic consciousness comes back like a big headache. The child realizes that the beautiful

butterfly is gone. It was not there when he came back from playing with his friends, and it was not there the next day, nor the day after that. Reality hits hard. Jack Kornfield comments:

> Even those who have a natural ability to enter these realms discover that these experiences have their benefits and their limits. No matter how tremendous the openings and how strong the enlightening journey, one inevitably comes down. Very often in coming back down, layer by layer, one again reencounters all of the difficulties of the journey.[7]

Trungpa Rinpoche concurs.

> Once we come down from our "high," once we realize that we are still here, like a black rock standing in the middle of an ocean of waves, then depression sets in. We would like to get drunk, intoxicated, absorbed into the entire universe, but somehow it does not happen. We are still here, which is always the first thing to bring us down.[8]

Some children won't easily admit to the lost butterfly, particularly those who have told all their friends about it and have promised to bring it to school for show-and-tell. They insist, even to themselves, that the butterfly is not really gone. A similar dynamic occurs in spiritual life when someone has a significant mystical experience, claims "ownership" of it, and then loses their connection to the experience.

In *Cutting Through Spiritual Materialism*, Trungpa Rinpoche describes what this is like for the individual.

> He valued the experience highly and then communicated it to the ordinary and familiar world of his homeland, to his enemies and friends, parents and relatives, to all those people and attachments which he now feels he has transcended and overcome. But now the experience is no longer with him. It is just the memory. And yet, having proclaimed his experience and

*If your vision is fixated on the seduction, you will miss the Work. When you find yourself falling into the seduction, force yourself to lift your attention away and onto something else.*

E.J. GOLD

knowledge to other people, he obviously cannot go back and say what he said previously was false. He could not do that at all; it would be too humiliating.[9]

The proud child is embarrassed to have lost the beautiful butterfly. When other children at school ask him about it and why he hasn't brought it, he may even lie and tell them that the butterfly is sick, or that his mother wouldn't let him bring it in, but that it is definitely still there. Similarly, people who are very attached to their mystical experience don't want to acknowledge to themselves or others that it has indeed passed. They are unconsciously aware that if they cannot capture an experience of enlightenment, there may not be anything that they can capture. Andrew Cohen comments:

> So often the need to cling onto experiences long gone . . . seems more important . . . than the pursuit of the Truth un-adorned. Many seekers choose to lazily accept that which can-not bear too much scrutiny for fear of ultimately having to scrutinize themselves far too closely.[10]

Ego does not want to lose face. People do not want to lose face. The fading of mystical experience is a complicated issue because ego is a very complex mechanism. The ego does not want enlightenment, as it is a direct threat to its survival, but it does want to be "the one" who is enlightened, or who has had a fancy mystical experience. The fading of experience can cause a big uproar to ego, as Stanislav and Christina Grof point out.

> Experiencing the withdrawal of the transpersonal energies and the loss of one's exalted state of being is necessarily painful, and is apt in some cases to produce strong reactions and seri-ous troubles. The personality reawakens and asserts itself with renewed force. All the rocks and rubbish, which had been covered and concealed at high tide, emerge again. Sometimes it happens that lower propensities and drives, hitherto lying

dormant in the unconscious, are vitalized by the inflow of higher energies, or bitterly rebel against the new aspirations and purposes that are constituting a challenge and a threat to their uncontrolled expression. The person, whose moral conscience has now become more refined and exacting, whose thirst for perfection has become more intense, judges with greater severity and condemns his personality with a new vehemence; he is apt to harbor the mistaken belief of having fallen lower than he was before . . . It is as though he [the person who had an awakening experience] had made a superb flight to the sunlit mountain top, realized its glory and the beauty of the panorama spread below, but had been brought back, reluctantly, with the rueful recognition that the steep path to the heights must be climbed step by step.[11]

Some people take it harder, and some easier. Some people are just disappointed when the experience fades, while others end up with more difficulties in their spiritual work than if they had not had any type of experience to begin with. Annik d'Astier, assistant to Arnaud Desjardins, observes: "These experiences have value in and of themselves, but the consequences are often that the student then becomes irritated by the banality of ordinary life, and becomes lazy about the everyday work, which is not extraordinary and is not glamorous."

*As long as we continue to exist in this world, the expression of love and compassion is a million times greater than our transient experiences of another existence wherein this world is neither seen nor known.*

BERNADETTE ROBERTS

## Accepting That the Butterfly Is Gone: Coming to terms with reality

The child is going to have to accept that the butterfly isn't coming back, but there are different ways that individual children go about doing this. The first option for the child is to pout about the lost butterfly, talk about its wonderful attributes, perhaps even make a small look-alike model and pretend that it isn't *really* gone. The second option is that he could accept the fact that the butterfly is gone *and* the reality that he is struggling to accept this. The last option is to

accept the reality that the butterfly is gone and move on without looking back.

The process of accepting that a mystical experience has faded is different for different people, depending upon a wide range of factors. It is not unlike watching the various ways people die: some kick and scream all the way to the end; some struggle and accept the fact of their struggling; and some are able to let go easefully. Letting go of the glory of the mystical experience, which represented an escape from the reality of suffering, is like a small death to the ego.

The problem with clinging to mystical experiences is that it doesn't work. Eventually they will fade because that is their nature. If one responds to the fading of the experience by creating a big drama about the fact that it is gone, or by frantically trying to get it back, they will also be missing all of the experiences—ordinary or expanded—that are occurring in the present, as they are so caught up in the past. Trungpa Rinpoche refers to this as "self-deception."

> Self-deception, in this case, means trying to recreate a past experience again and again, instead of actually having the experience in the present moment. In order to have the experience now, one would have to give up the evaluation of how wonderful the flash was, because it is this memory which keeps it distant.[12]

Eventually, self-deception about one's mystical experiences catches up, but people can go on for a long time fooling themselves, and sometimes even longer fooling others. But no matter who one is fooling, the reality is that the experience is gone, and insisting on clinging to it is the very thing that inhibits the arising of any further experience. Reggie Ray shares his first-hand experience of this common struggle.

> Every time that some unusual experience has happened to me, I thought, "This is it! I've got to repeat this." It's not that I think I'm enlightened, but I think, "This is what I've been looking for. I want it again." And then you've got real problems,

because you begin to battle yourself. It doesn't really help you that you know that you're going to do it. It's like meeting a really beautiful woman that you fall in love with. People can tell you, "Well, you can't really have that," but you still want it. And you keep trying. In our tradition the whole path is that we meditate, we experience things, then we desire them, and then we have to work with the fact that we're trying to then reproduce the experience which is basically a memory. We are always trying to repeat something that happened, which we can never do. It's like a kiss. You can kiss somebody and feel, "That was so wonderful," so you try to repeat that kiss and you can't do it. And the more you try to repeat it, the more agony you're in. But when you're on retreat it is a good opportunity to work with this, because you go through a few days of torture and you finally realize, "I've got to give this up. This is not working."

For Reggie Ray, such struggle *is* the path. Some say that we can free ourselves of the struggle, but for most people, a large part of the path is a battle between attachment and letting go. Ray continues:

> This is the path. The path is trying to repeat things and realizing you can't do it. It's very ironic. People say, "How could I not try to repeat my experience?" You can't not do it. That's the human way. As long as we have karma, as long as we have egos, we're going to always try to repeat, and that's the path. The path is working with the agony of not being able to make something a certain way.

*What I'm interested in is the process of awakening, the long process of development, which may, or may not, have breakthroughs as a natural fruit.*

JOKO BECK

The whole of the path is the process of always chasing after that beautiful butterfly and never being able to claim it for one's own. The butterfly will always slip through the bars, and the path is knowing that it will always slip through the bars and trying to chase it down and keep it anyway . . . until, if ever, one doesn't.

If one engages the struggle of clinging and letting go, little by little letting go does become easier. It lessens up when the individual

struggles with attachment and loses so many times that letting go becomes the only possibility for "winning." Kornfield discusses this principle of letting go in terms of what he refers to as *pseudo-nirvana*.

> In pseudo-nirvana, students become stuck in positive states, trying to maintain them, grasping the clarity, power, or peace, using them to reinforce their subtle sense of being one who is awake, accomplished, free. The only release from this level of attachment is a radical letting go . . . At this point, we are awakened to the profound realization that the true path to liberation is to *let go of everything*, even the states and fruits of practice themselves, and to open to that which is beyond all identity.[13]

Recall Danan Henry's story about his teacher, Philip Kapleau Roshi, screaming at him that he was stuck halfway up the mountain, taking the seat of a serious student who wanted to go all the way up. When Henry then went back to his meditation cushion, he persisted. He persisted through the temptations of bliss and ecstasy and, after many years of further practice, found himself at the ground of consciousness itself. Every experience arises, remains for a time, and then fades in order to give rise to the next experience in life. Clinging to any one experience inhibits any further experience from arising. When Sensei Danan was denying the work with his koan *mu* in favor of the bliss he was experiencing, he was saying no to all experiences that were to follow *mu*, including the insight into the ground of consciousness itself.

Do we want to have a beautiful butterfly, or do we want reality? It is a hard choice, given that most people have no idea what it means to live in reality and that one cannot know what that would possibly imply unless they first gave up their attachment to the lovely butterfly.

Andrew Cohen encourages students to let go of all experience.

> You have to find the confidence to leave all experiences behind you. The deeper you dive into the Truth all experiences will start

to fade. Something else will begin to occupy you that has nothing to do with any event that could ever take place in time.[14]

There are different perspectives on what transpires when one releases the beautiful butterfly. Some teachers, like Cohen, suggest that there is something beyond, something profound, though they do not say what; whereas others, like Danan Henry, suggest that what is beyond is simply ordinary experience, arising and passing, but lived open-eyed and present. In the end, we will find out what ensues only when we release the beautiful butterfly. People can read books up to their ears about what has happened to other people when they let go of attachment to the beautiful bug, but it is all hearsay until they have done it themselves.

*If you're serious, you want to come to that point when there is no longer any distance created between you and reality as it is.*

ANDREW COHEN

The story does not have a "happily-ever-after" ending in the conventional sense of the term. The ending that the child, and that the sleeping world, wants is that the boy goes out in search of the butterfly and not only finds it but finds it hovering around several other cocoons, all future butterflies. He takes them all home and realizes that since the butterflies will always reproduce themselves, he can just go and collect cocoons the rest of his life and have beautiful butterflies forever after.

The ending for most people, however, is what Reggie Ray spoke of: The path is the continual struggle and movement between our wishes for reality, our attempts to manipulate reality, and accepting reality as it is. Thus, in the spiritual version of the story, happily-ever-after doesn't mean that the child finds a field of cocoons of future butterflies, but that he comes to realize that the butterfly was not his to begin with, and that he learns in time to appreciate the butterflies he finds and lets them go easily on their way.

## A Zen Buddhist Perspective: Philip Kapleau Roshi Speaks on *Makyo*

More than most traditions, Zen Buddhism provides an extensive set of teachings on the subject of mystical phenomena and the dangers

they present. The name Buddhists have given to these arising phenomena is *makyo*. *Ma* means "devil" and *kyo* means "the objective world." The literal translation of *makyo* is: diabolical phenomena that arise in the objective world.[15] Students are aided in working with the temptations of such phenomena by being educated about them from the start. Whereas such teachings don't prevent students from struggling with makyo, just as telling children that a stove is hot doesn't usually prevent them from touching it once or twice, the education does serve as a context from which to understand the experiences that arise within serious spiritual practice.

Roshi Philip Kapleau has spoken and written extensively on the subject of makyo, translating the traditional Buddhist scriptures in a manner that is more accessible to the Western mind. The teachings of makyo are presented here in order to provide the reader with another language, another perspective, by which to further understand the dangers of mystical experience and the ways that even serious spiritual aspirants get stuck in the traps of illusory phenomena.

Kapleau Roshi's understanding of makyo comes not only from his work with students, but from confronting it in his own practice. In *Awakening to Zen: The Teachings of Philip Kapleau*, he tells a story from his early years as a Zen student, a story that reveals the similarity between the lesson he received from his teacher and that which he later bestowed upon his student, Danan Henry.

> At the beginning of my own training in a Zen monastery years ago, I, too, went through a period of makyo, which were mainly visual. They grew from the paintings of Paul Klee, many of which I had studied earlier in my life. It was not merely the intensity of these fantasies that overwhelmed me. *I* was the cosmos dyed with unearthly colors of Klee. *I* was unity, *I* was love, *I* was joy incarnate. Utterly convinced that this was satori, I waltzed into my teacher's room at dokusan, elated and triumphant. Hardly had I begun my prostration when he rang me out of the room. After two such traumatic appearances, I humbly asked why I had twice been summarily

dismissed without having even been given the chance to describe my mind-state. "Too much ego," was the laconic reply. Even the ecstasy arising from feelings of oneness with my fellow man were dismissed by the roshi as nothing more than makyo. If I attached myself to them, he warned, they would block my progress toward true enlightenment.[16]

Kapleau Roshi continues with a description of the various ways in which makyo manifests itself.

> At one stage of practice the Zen student may experience illusory visions, fantasies and weird sensations. These are known as makyo . . . They may range all the way from simple, intensified visual and auditory sensations, feelings of sinking or floating, or experiencing of one's body as a melting substance, to penetrating insights, visions of God or Buddha, or clairvoyant powers[17] . . . These phenomena are not inherently bad. They become a serious obstacle to practice only if one is ignorant of their true nature and is ensnared in them.
>
> The word makyo is used in both a general and specific sense. Broadly speaking, the entire life of the ordinary man is nothing but makyo. Even such Bodhissatvas as Monju and Kannon, highly developed though they are, still have about them traces of makyo, otherwise they would be supreme Buddhas, completely free of makyo. One who becomes attached to what he realizes through satori is also still lingering in the world of makyo. So you see, there are makyo even after enlightenment . . .
>
> In the specific sense the number of makyo which can appear are in fact unlimited, varying according to the personality and temperament of the sitter. In the Ryogon [Surangama] sutra the Buddha warns of fifty different kinds, but of course he is referring only to the commonest . . . Besides those which involve the vision there are numerous makyo which relate to the sense of touch, smell, or hearing, or which sometimes cause the body

*It is imperative that the seeker of spiritual emancipation, once becoming a finder, i.e. arriving in heaven, not allow him or herself to take up residence even there.*

ANDREW COHEN

suddenly to move from side to side or forward and backward or to lean to one side or to seem to sink or rise. Not infrequently words burst forth uncontrollably or, more rarely, one imagines he is smelling a particularly fragrant perfume. There are even cases where without conscious awareness one writes down things which turn out to be prophetically true.

Very common are visual hallucinations. You are doing zazen with your eyes open when suddenly the ridges of the straw matting in front of you seem to be heaving up and down like waves. Or without warning everything may go white before your eyes, or black. A knot in the wood of a door may suddenly appear as a beast or demon or angel.

... In the *Zazen Yojinki* we find the following about *makyo*: "One may experience the sensation of sinking or floating, or may alternately feel hazy and sharply alert. The disciple may develop the faculty of seeing through solid objects as through they were transparent, or he may experience his own body as a translucent substance. He may see Buddhas and Bodhisatt-vas. Penetrating insights may suddenly come to him, or pas-sages of sutras which were particularly difficult to understand may suddenly become luminously clear to him. All these ab-normal visions and sensations are merely the symptoms of an impairment arising from a maladjustment of the mind with the breath."

Other religions and sects place great store by experiences which involve visions of God or deities or hearing heavenly voices, performing miracles, receiving divine messages, or becoming purified through various rites and drugs ... yet from the Zen point of view all are abnormal states devoid of true religious significance and therefore only *makyo*.[18]

Kapleau Roshi goes on to describe the essential nature of makyo.

What is the essential nature of these disturbing phenomena we call *makyo*? They are temporary mental states which arise

during zazen when our ability to concentrate has developed to a certain point and our practice is beginning to ripen. When the thought-waves that wax and wane on the surface of the mind are partially calmed, residual elements of past experiences "lodged" in the deeper levels of consciousness bob up sporadically to the surface of the mind, conveying the feeling of a greater or expanded reality. *Makyo*, accordingly, are a mixture of the real and the unreal, not unlike ordinary dreams. Just as dreams are usually not remembered by a person in deep sleep but only when he is half-asleep and half-awake, so *makyo* do not come to those in deep concentration or samadhi.[19]

Kapleau Roshi suggests here that makyo indeed convey a feeling of expanded reality, and also that they are not only unreal, but also real. Yet even the most real of the experiences are considered as makyo, to be left alone and not dwelled upon. It is very interesting to consider that although makyo may arise from a very deep part of the human psyche, they are not given any attention or importance. On the contrary, the Zen student is cautioned not to make any assumptions about their own spiritual development based upon such phenomena, and not to get stuck even in high places. Kapleau Roshi warns:

Never be tempted into thinking . . . that the visions themselves have any meaning. To have a beautiful vision of a Buddha doesn't mean that you are any nearer becoming yourself, any more than a dream of being a millionaire means that you are any richer when you awake. Therefore there is no reason to feel elated about such *makyo*. And similarly, whatever horrible monsters may appear to you, there is no cause whatever for alarm. Above all, do not allow yourself to be enticed by visions of the Buddha or of gods blessing you or communicating a divine message, or by *makyo* involving prophecies which turn out to be true. This is to squander your energies in the foolish pursuit of the inconsequential.[20]

*No matter what remarkable state arises, we must learn to allow it to come and go freely, recognizing that it is not the goal of meditation.*

JACK KORNFIELD

*The entire world of spiritual experience, with all its inherent conclusions, needs to be scrutinized very closely in order to ensure that a refuge for the individual has not been taken even in heaven.*

ANDREW COHEN

. . . Insights about oneself are valuable, of course, but your aim is to go beyond them. If you stop to congratulate yourself on your insights, your advancement toward realization of your Buddha-nature will be slowed. In the widest sense, everything short of true enlightenment is *makyo*.[21] Don't be enamored of them when they are pleasant, and don't become afraid when they are weird.[22] . . . [Even] what might be called "high level" *makyo*: regressing to past lifetimes, speaking in tongues, deep psychological or philosophical insights . . . are nothing to feel elated about. If you cling to them in the mistaken belief that you have experienced something of rare or permanent value, they will become an obstacle to awakening.[23]

. . . The crucial thing to remember when faced with *makyo* of any kind is not to get involved with them. *Makyo* are the magic of the ego, and without an audience this wily conjurer will take his bag of tricks and be gone. Or they are like uninvited guests—if you don't make a fuss over them, they soon leave. Entertain them, though, and they linger on . . . Above all, don't make the fatal mistake of confusing these mind states with actual awakening. Just put your whole mind into your practice! This is not easy when the *makyo* are vivid and strong. To avoid falling prey to them, you need determination when they are pleasurable and courage when they are frightening. More than anything else you need faith—faith in yourself, in your practice, and in your teacher.[24]

For most people, visions and prophesies are hardly "inconsequential." They leave a strong impression and perhaps even a heightened respect for the world of the mystical; but for the dedicated spiritual student, even these experiences are limited by comparison with the realization of the ground of consciousness itself.

It is also interesting that Zen Buddhism, as described by Kapleau Roshi, does not make a distinction between pleasant and unpleasant experiences—between visions of the Buddha and the devil; or between states of rapture and those of terror. In the common contemporary

spiritual perspective, not only is great importance given to experiences of bliss, ecstasy, vision and rapture, but experiences of terror, grief, sorrow, suffering and separation are often repressed and denied—very rarely, if ever, considered to be mystical experiences. Yet in terms of Kapleau Roshi's perspective on makyo, all are one and the same.

This challenging perspective leaves no room for serious spiritual students who study under the guidance of a genuine teacher to bask in the glories of their extraordinary, mystical powers of vision and perception. The reported experiences of both Henry Roshi and Kapleau Roshi suggest that students will still get carried away with such experiences, if only in the privacy of their own minds, but if they step anywhere near to the Master, the self-importance that has been created by such experiences is instantly shattered.

The Zen masters do not hope to teach their disciples to become clairvoyant, psychic, prophetic. They don't care if their students have special powers or not, and in some cases would even prefer that they not, as such powers can be an obstacle. These masters want no less than for their disciples to realize their own Buddha-nature, to abide in ultimate Reality, and to serve that Reality. From this perspective, even personal blessings of the Buddha are inconsequential. Why stop at receiving blessings from the Buddha when one can realize one's own Buddha-nature and help guide others to that realization?

There is a vast array of experiences and states of consciousness which are presumed to be equivalent to enlightenment. Whereas some people make the assumption that they are enlightened after their first experience of bliss, others wait until they have developed high levels of perception, vision, blessing power, insight, clarity. Yet Kapleau Roshi knocks down all these assumptions and presumptions with a single term: *makyo*.

## Spiritual Comfort

The notion of "spiritual comfort" refers to the danger of getting stuck on the spiritual path, even at very high levels of attainment

and/or renunciation, due to a certain degree of comfort and complacency. People seek out spiritual comfort because they unconsciously believe that such comfort will take away their own suffering. Few people do this consciously, but most do it unconsciously.

Spiritual comfort may occur on an exoteric level or on an esoteric level, and may be material or immaterial. As human beings, we try mightily to avoid the reality of our suffering condition, and we naturally seek comfort and security on any and all levels. To feel safe, a homeowner might purchase a house with a high fence, install a burglar alarm, buy homeowner's insurance and a watchdog. For the same reason, the spiritual seeker might seek status and position in his or her spiritual school—to be the "admired disciple" or even to be the actual teacher as a measure of safety and security. The difference between the homeowner and the spiritual student is that even the untrained eye can see what is motivating the homeowner, whereas in spiritual life, comfort-seeking often takes more deceptive forms.

*Our own comfort prevents us from seeing where we may work and serve. Comfort can be deceptive—it may be material, mental, spiritual.*

E. J. GOLD

On the exoteric level, spiritual practitioners can become comfortable in any number of ways. Some "old-timers" may feel comfortable in their popularity, or because they have prime office space on the ashram, or some leverage in decision-making. They may see these privileges as a sign of their spiritual development. Even students in less comfortable situations, living renunciate lives on an ashram, for example, may become comfortable in their routine, their job, their room, even if it is tiny and they share it with four others.

People can even seek comfort in *uncomfortable* situations: the individual with an austere and limited diet may be more comfortable with simple food than with having to be confronted with their own gluttony when faced with a grand feast; or the celibate monk may be more comfortable in his celibacy than having to deal with the issues of sexuality that would arise if he were a lay monk. "If you're looking for something to do it for you," explained one student, "then it's a comfort."

The notion of spiritual comfort applies to the esoteric, or inner planes, as well. There is a tendency for people to want to rest at a certain level. Perhaps they have attained some equanimity, or peace, or discrimination—some quality that is considered valuable in their

particular spiritual tradition. Maybe they have even reached a high level of attainment, equivalent to or beyond that of their own teacher. Or maybe they are abiding in a state of detachment, or they have learned to identify with the "observer." At this point it is a common trap for spiritual aspirants to convince themselves that since they have come such a long way in their work they are deserving of a rest instead of pushing ahead. Jai Ram Smith explains how one easily falls into this trap.

> One of the things about attainment is, you get to a certain point where you've put in a certain amount of time, you've got rank, and you've got tenure. There's no point in risking too much after that because you might lose what you've already got. Most people top off at that point. You have to have a willingness to be shook up at that point. It's a big trap. Perhaps you realize that you're already saved—that Jesus has already saved you. Why venture out to any further depth of exploration when you're already saved? Why risk?
>
> Comfort is a real nice thing. Comfort in spiritual life feels pretty good. If you look at different kinds of comfort, spiritual comfort is a very powerful product. So after a certain level of work, most of us feel that we've gotten a pretty good piece of the pie. Yet if you watch any real teacher, you don't see him or her resting on their laurels.

Lee Lozowick insists that "if you aren't moving forward, you're moving backward." This literally means that if we cease to proceed with our spiritual work, there is only backwards movement—there is no stagnancy, no waiting ground, no holiday. Lozowick further suggests that the backward movement happens much more quickly than the forward movement.

This notion doesn't mean that the individual must constantly be *wearing* signs of spiritual progress in visible or dramatic manifestations of change; rather, that he or she must not be clinging to certain states, nor even resting in them, but instead be always moving ahead. There

are periods of increased and visible movement on the spiritual path, and other periods of integration that are imperceptible to the untrained observer, but periods of less movement are not equivalent to "moving backward." An individual who is ruthlessly self-honest knows the difference, but self-deception comes very easily.

Joan Halifax is aware of this tendency for spiritual practitioners to deceive themselves through spiritual comfort.

> The tendency for many individuals to fall asleep is really great: getting cozy, finding a nice routine, going to the zendo every morning, feeling all comfortable and safe. I often say to people who come to sit, "It's not safe to sit. This is not about being safe. This is about really unpacking and peeling yourself layer by layer, and really deconstructing yourself."

Arnaud Desjardins is similarly concerned that his students don't fall into the trap of spiritual comfort. He says that when his students are sitting zazen, he tells them: "I wish you two things: that it may not be too difficult, painful, disappointing; and that it may not be too successful. If as soon as you sit and turn your attention inward, you feel peace, no thoughts, it will become a drug to stupefy the mind." Desjardins doesn't want his students to have limited success because he wants them to suffer but because he knows the danger of comfort. In fact, it is precisely because of his compassionate desire that his students not suffer ultimately that he wishes them less comfort in the immediate sense.

Even the desire to have a spiritual "rest," as Jai Ram Smith pointed out, can be dangerous. It is difficult to believe that even a small rest on the spiritual path—a few weeks off—can be a danger to one's spiritual work, but the most esteemed masters of our day all seem to agree on this point. Lozowick has said, "God doesn't give vacations." He tells the story that was told to him by a close student of G.I. Gurdjieff about a young man who was a student of Gurdjieff. He was in his late teens and, because of his intensive work with Gurdjieff beginning at a young age, he had not had the experiences so common to teenagers:

going to the beach, picking up girls, drinking, and so forth. At one point, he asked Gurdjieff if he could have a vacation. After much deliberation, Gurdjieff told the young man, "Okay, you can go to the beach . . . but be back in fifteen minutes!"

The energy of one's spiritual work accumulates over time and can also easily be leaked out or tossed away. One can do spiritual work at the beach, while picking up girls, or even in heaven for that matter—the actual setting is irrelevant—but here the "beach" represents time off from being conscious, an indulgence in distraction. The danger of the spiritual vacation is getting so lost in the comfort of the holiday that one forgets that one was ever doing spiritual work in the first place. Andrew Cohen explains:

> The natural inclination of most people is to want to rest. And when one rests, the next thing that might happen is one may get drowsy, and from there one may end up falling asleep once again. This is what happens most of the time when people for some reason or other stumble upon awakening. Just as easily as one can stumble upon awakening, one can stumble right back into bed.

*. . . Not to advance in the spiritual life is to go back.*
BROTHER LAWRENCE

The possibility that one can fall asleep even after awakening is uncommon knowledge among many spiritual students. Just as Jai Ram Smith was disillusioned when E.J. Gold told him that he wasn't in the awakened state all the time, most people tend to think of awakening or enlightenment as an "all or nothing" deal. But Cohen suggests that one can awaken and then fall back to sleep. In fact, Lozowick says, people wake up and fall back asleep all the time, only they are unaware of it.

Anything can be comfort. It all depends on our relationship to it. If we're looking toward something to alleviate the suffering in our life, even spiritual dharma can be used as a pill, as can anything that unconsciously buffers us from the responsibility we have for the naked reality that stands before us.

There is no rest on the spiritual path: no comfort, no security—not on any level.

## Getting Stuck Is Possible at All Levels

Spiritual comfort is available on *all levels*—even in heaven. Therefore, one should never consider oneself free from the need to be aware of all forms of seduction. As long as any traces of identification with ego remain, any state or attribute—including humility, generosity, service, and even liberation itself—can be a point at which the aspirant gets stuck. Further commentary on the subject from Andrew Cohen:

*Success as a practitioner is not necessarily being the perfect practitioner, but avoiding the traps at whatever level you are.*

LEE LOZOWICK

Too often without realizing it, freedom found becomes yet another object to be possessed and protected by the individual *for him or herself.* For even the revelation of emptiness, simplicity and love can become a refuge for the individual to stay safe within, rather than allow it to be only that indestructible ground upon which there is nothing to protect and nothing to fear. [25]

It is humbling to ponder the possibility that people seek safety and security even in emptiness and love. They do so because there is still an "I" left who seeks such security, even if its security is in "oneness" or "the essential self." As long as any traces of identification with the ego remain, there is always danger, and there is always danger *anyway* because it is very difficult for one to know that there are no traces of remaining identification with ego. It is all very subtle, very tricky, and freedom from such dangers cannot be presumed. Cohen continues:

Contemplation and direct Realization of the Absolute is the most demanding and all-consuming form of meditation that a human being can pursue. It is so dangerous, because of the perfectly immaculate nature of the Absolute Realization. Any

trace of self-interest of any kind in any form instantly corrupts that most perfect purity and automatically, although usually imperceptibly, taints its reflection. How to realize everything and remain untouched even by that? How difficult it is to remain free from all the temptations that direct Realization invites. Even those who do know and have Realized usually allow themselves to stop far short of that immaculate and perfect death that casts no reflection and recognizes only itself.[26] Any trace of self-infatuation, including even infatuation with Self, taints the possibility of the attainment of pure perception undefiled by any notion of Self. Infatuation with Self also indicates the likelihood of a subtle, yet profound, self-centered fixation on the Absolute, the existence of which obscures the perception of a vaster perspective of reality in which the Absolute serves as a foundation of perception and understanding rather than an end it itself.[27]

Precisely because there are so many almost imperceptible traps even in high levels of realization people get stuck, unaware that although they may be abiding in a very elevated level, they are still stuck. The question may be asked, Is it Realization at all if people can get stuck even there? And if not, what is Absolute Realization? This is a very useful question to ask for anyone who even subtly prides themselves on their level of attainment.

## Meher Baba's Masts

Ideally, states of absorption (in God or bliss or Truth) purify all the obstacles on the spiritual path that prevent us from developing into mature human beings. But sometimes people get stuck in states of absorption, unable to further evolve from their high state. This is true of a group of individuals in India known as *masts*. The great Indian saint Meher Baba made it an important aspect of his life's work to seek out masts and to serve them in an effort to shake them from their stuck state.

Masts often resemble madmen, and from a superficial glance it may be hard to tell them apart. They are often dirty, as they may not bathe or change clothes. They are not concerned with ordinary reality, and they may act in bizarre ways—uttering seeming nonsense to themselves, throwing things, yelling at others, and so forth. But there are significant internal differences between the mast and the madman. In *The Wayfarers*, Meher Baba himself writes:

> Masts are totally different from ordinary mad persons . . .
> Though both are far from perfection, and need correctives or
> healing, there is a vast difference in the nature of their inner
> mental states, and in the spiritual value of the results that are
> achieved by the application of correctives.[28]

In other words, aiding a madman in his craziness and serving a mast in his apparent craziness would lead to very different results. Meher Baba said that masts were very highly evolved spiritual beings—"God-mad" as he often referred to them. He said that they had the potential to be of much greater service to God than ordinary human beings, but that they were stuck on a very high plane of existence and were unable to proceed without the help of an exceedingly capable spiritual master. He explains:

> Some masts get stuck on the inner planes. They are overpow-
> ered by the onflow of grace and love, and get into a state of
> divine stupor. They are entirely absorbed in the "beatific
> vision." Some masts are completely stupefied by the psychic
> somersault precipitated by an entry into a new plane of con-
> sciousness, and cannot find their bearings in the midst of their
> new environment, new duties, and new powers. Some masts
> find their insurgent powers uncontrollable, and are faced by
> new and insurmountable temptations. They can make no fur-
> ther advancement through their own unaided efforts, and have
> to avoid the possibility of a precipitous fall through the indis-
> criminate use of occult powers. In short, in spite of having

attained a high spiritual status, many masts on the inner planes need real guidance and help from a Perfect Master . . . One of the most difficult things for a mast is to come out of the self-sufficiency of his state. He may be so immersed in bliss that he may experience no need within himself to get linked with any-one. He may have no wants, and need have none. Just as a mast becomes completely indifferent to his own body or to the physical conditions of his life, he can also become indifferent to the physical or spiritual conditions of others. When a mast gets walled-in by his own self-sufficiency and desirelessness, only the Master can draw him out of the isolation of his choice, by awakening within him an expansive love that breaks through all limitations, and prepares him for shouldering the important responsibility of rendering true service to others who are in need of spiritual help.[29]

Because Meher Baba knew that the masts could be of invaluable service, he took on the great work of intentionally seeking them out to draw them out of their isolation. He sent many of his close male devotees out in search of masts, often bringing them to his ashram and bathing and feeding them himself. He also traveled throughout India over a period of many years on "mast tours," visiting particular masts and mast ashrams in order to serve them. He could not wait for the masts to come to him, as they were often incognizant of their own state and unaware of its limitations. William Donkin, a close devotee of Meher Baba, says of the masts:

Saints who are consciously aware of their spiritual progress are, perhaps, not so hard to find, but great masts are gems wrapped in the rubbish of an outer packing of eccentricity and physical dirtiness, and it needs the skill and vision of the Master, not only to pierce the outer veil of trivialities, but also to separate the real jewels from plausible fakes.[30]

*This is indeed your bondage that you practice enstasy (samadhi)!*
*ASHTAVAKRA-GITA (I.15)*

## ARNAUD DESJARDINS: "THE GREATEST TREASURES"

*When I was young I was thinking, "Oh, if only I didn't have to work, if I could be meditating all day long, then I would change." But then I lived in India, and met people in well-known ashrams who surrounded very genuine masters and who meditated a lot . . . but who were fully disappointing: talking so much, criticizing each other, jealous. It was a great shock to realize that it is possible to meditate so much without any convincing change—convincing to me.*

*Of course with the sages, day after day one could not find any weakness, and my admiration for them was deepening—Ram Dass, Ma Anandamayi, the Tibetan Rinpoches, Sufi masters and so on. But there were so many differences between them and their follow-ers. Where were these differences coming from? Why was this one still proud? Reacting? Lost in likes and dislikes after so many years? And why was this one so loving, obviously wise, free, even if he or she had not reached the state of Ramana Maharshi himself? Then I found that kindness, good will, love, service—which are nothing especially esoteric and fascinating—were producing the greatest treasures. It was a great lesson . . .*

*Compassion. According to my feeling, this is one of the great-est teachings of Tibetan Buddhism: to insist upon compassion. Long ago I had the chance to meet some well-known Tibetan gurus. Still at that time, though not so much, I was dreaming of mysterious eso-teric teachings, occult powers. But I found these masters to be so simple, with such humility, even if their only teaching was compas-sion, compassion, compassion.*

Meher Baba revealed very little about the details of his work with masts. The encounters were often highly private, and although there are extensive journals documenting his trips and the few remarks that

were recorded from many of his visits with the masts,[31] much remains unknown.

Meher Baba successfully shook loose from the planes at which they were stuck many of the masts with whom he worked. Sometimes they went down, and sometimes they went up, but it didn't matter. What mattered was that they entered into the process of spiritual work once again. The example of the masts exemplifies the fact that those who stop evolving, no matter how high their state, are still stuck, and must release themselves, or be shaken loose by another, in order to proceed on the spiritual journey.

*Compassion is the essence of a spiritual life.*
THE DALAI LAMA

# 10

# Ego Inflation

*When a powerful illumination arises, the meditator thinks, "Such illumination never arose in me before. I have surely reached the path, reached fruition," thus he takes what is not the path to be the path and what is not fruition to be fruition. When he takes what is not the path to be the path and what is not fruition to be fruition, the course of his insight is interrupted. He drops his own basic meditation subject and sits just enjoying the illumination.* [1]

—Bhadantacariya Buddhagosa, *The Path of Purification*

Described by Carl Jung as that "which might be regarded as one of the unpleasant consequences of becoming fully conscious,"[2] and by E.J. Gold as the "Jesus complex," ego inflation is a process by which the perceived power of ego, already great in its unexpanded state, swells to such a degree that it floods the capacity for perception and clarity. Among individuals who have prematurely presumed their own enlightenment, there is most often significant ego inflation. Such individuals have a subjective and highly grandiose belief about their own spiritual stature and attainment. Inflation can be so commanding and so convincing that it consumes everything in its wake, including conscience, discrimination, and, at times, basic sanity.

*/in-fla-ted/ 1. puffed out; swollen, pompous; 2. bombastic; high-flown; 3. increased or raised beyond what is normal or valid.*

Ego inflation is often preceded by an experience, or series of experiences, of what has been referred to thus far as "enlightenment," mystical perception, or insight, which is then misinterpreted through the filters of ego. Although ego inflation manifests in individuals to greater and lesser degrees, the tendency toward a lopsided and subjective misperception of one's experience and spiritual progress is a phenomenon common to most serious spiritual students. The spiritual aspirant should consider it as always lurking nearby and ready to pounce if one loses vigilance for even a moment. Carl Jung, who studied the phenomenon of inflation extensively, describes it as follows:

> The state we are discussing involves an extension of the personality beyond individual limits, in other words, a state of being puffed up. In such a state a man fills a space which normally he cannot fill. He can only fill it by appropriating to himself contents and qualities which properly exist for themselves alone and should therefore remain outside our bounds. What lies outside ourselves belongs either to someone else, or to everyone, or to no one . . . The inflation has nothing to do with the *kind* of knowledge, but simply and solely with the fact that any new knowledge can so seize hold of a weak head that he no longer sees and hears anything else. He is hypnotized by it and instantly believes he has solved the riddle of the universe. [3]

The tendency toward egoic inflation not only arises in all spiritual disciplines and all cultures, but is in no way limited to the domain of spirituality. People fill their mundane existence with great amounts of money, or admiration for an ability they are able to manifest, and accept the breadth of their possessions or the fame they receive as if such things belonged to them; in spiritual life, people fill themselves with transcendental forces, powers, and visions, and accept the expansiveness of those qualities as though they "owned" these attributes.

"In the same way that people want to get power through money or through prestige," suggests Judith Leif, "spiritual traditions are fertile grounds for ego-mania." Popularly known as conceit, arrogance,

smugness, and self-adulation in the worldly sphere, egoic inflation is the same narcissism, or self-centered tendency to create oneself as larger-than-life and superior to others.

Gary Rosenthal, former Buddhist monk, notes:

> Inflation seems to be an occupational hazard of practically all social roles and professions, from parenting fathers who know best, to doctors with their supposed "God complex," or movie stars, politicians, athletes, even the foreman on the job. But . . . perhaps no "occupation" can offer us as much insight into the problem as spiritual teachers, or those who claim to be such, for they are the "professionals" who profess to know, to be able to guide. The very calling contains the scent of inflation—or as it is called in Zen, the "stink of enlightenment."[4]

*It's one of those paradoxes: You see that there is no self, and then you get arrogant about seeing that. When ego is not center stage, it's in the wings, waiting to jump in.*

DANAN HENRY

Ego inflation is common to all individuals because all individuals have an ego, most are identified with it, and the ego does and will swell at times. Although inflation is probably no more common in spiritual disciplines than in any other walk of life, it is particularly pronounced in spiritual traditions because work with the ego is a central focus of genuine spiritual development. Although the very calling toward spiritual leadership contains the "scent of inflation," as Rosenthal suggests, even the most modest of individuals is not exempt from its arising because of the nature of inflation itself.

Whereas in ordinary life the notion of ego is not even considered, and its dominance is actually celebrated to the degree that it is able to manipulate, swindle, and gain the upper hand, true spiritual evolution implies the undermining of such identification with ego. Because spiritual disciplines work so extensively with the ego, the ego is often intentionally expanded and deflated by the teacher and by the process itself. The ego will often become larger-than-life in the overall process of being eventually diminished, and it is part of the practitioner's "job" to learn to negotiate the relationship between ego and not-ego. Claudio Naranjo explains.

It is normal for the spiritual experience to take place in the context of ego. Ego does not die from one day to the other. The new self is born and co-exists with ego, and then the ego becomes a professional of spiritual things because that's the best thing it has. If I am a little enlightened, there's nothing that my ego feels more enlarged by than indulging that enlightenment and teaching enlightenment and identifying with the figure of enlightenment. The greater the ego the more it happens.

Ego inflation is to be expected and prepared for, but sometimes it will gain the upper hand. Thus, the fortress of the true self must be strengthened over time in its ability to manage inflated states of ego. Whereas in the ordinary world egoic inflation sustains the illusion by which one already lives, in spiritual life inflation that is unmanaged over time will stall and even retard any further spiritual development.

## The Masks of Inflation

*How rarely are we able to let anyone see us as we are, without donning a mask of some kind.*

JOHN WELWOOD

Inflation wears many different masks: a sense of superiority, vanity, self-satisfaction, a feeling of being special, an overestimation of one's spiritual development and capacities, pride in one's spiritual accomplishments and stature, aloofness, the feeling that no one is able to understand one's experience. Each of these is a mask of ego inflation, worn in delusion, with each wearer believing that his or her mask represents the true face.

As Andrew Cohen observed in Chapter Three, everybody wants to feel special, to be "the One." This comes not only from the dominant psychological wound that leaves children feeling that they are unloved and uncared for, but also from the intuited spiritual truth that we are nobody special, that we are in fact no-body. Ego, in its resistance to this fact, fights to be somebody. The great mystical vision or breakthrough experience that often precipitates ego inflation is a tease to the ego, which thinks that *it* has had the experience and is desirous

to be somebody special because of it. In their book, *The Guru Papers: Masks of Authoritarian Power*, Joel Kramer and Diane Alstad claim:

> Most people enjoy feeling special. One may be uncomfortable with this or dislike it, but that's a different issue. Adulation, the ultimate form of special treatment, has an addictive quality difficult to resist. Being the focus of such attention would activate the excitation levels of any sentient being on the receiving end of it. Whether for a guru or a rock star, this can be a more powerful experience than the strongest drug. It is also one of the great seductions of power.[5]

Such inflation is not limited to gurus, preachers, and charismatic leaders but comes up in small and large ways in all those who are eager for recognition and acknowledgement. The ego is seductive, and also persistent. Whereas sometimes a deeper force within the individual will create a crisis in order to alert the individual to the onslaught of inflation, other times the ego will not give in so quickly, and instead will blame the person or the situation that points out its error. St. John of the Cross writes:

> Sometimes, too, when their spiritual masters, such as confessors and superiors, do not approve of their spirit and behavior (for they are anxious that all that they do shall be esteemed and praised), they consider that they do not understand them, or that, because they do not approve of this and comply with that, their confessors are themselves not spiritual. And so they immediately desire and contrive to find someone else who will fit in with their tastes . . . Sometimes they are anxious that others shall realize how spiritual and devout they are, to which end they occasionally give outward evidence thereof in movements, sighs and other ceremonies; and at times they are apt to fall into certain ecstasies, in public rather than in secret, wherein the devil aids them, and they are pleased that this should be noticed, and are often eager that it should be noticed more.[6]

*To have an experience or realization of enlightenment is quite fine, legitimate. But it is usually a humbling experience. So when I see people who walk around proudly displaying their enlightenment, I don't see enlightenment. I see mostly ego.*

MEL WEITZMAN

*Ecstatic or pleasurable experiences by themselves are not transformational. They need to be integrated, digested and reanimated in a particular way in order to be useful.*

LEE LOZOWICK

Ego inflation can manifest blatantly, or it can show up subtly in a manner that is more difficult to detect. The individual who dances the "advaita shuffle" is an example of a more subtle expression of inflation—if they are sly enough they can cover their inflation with a flawless web of dharma that is impossible to penetrate. Another less obvious expression of egoic inflation is the individual who remains aloof in spiritual settings but internally is quietly superior, believing that he or she is beyond the unconsciousness and indulgent drama of others.

Still another common mask of egoic inflation is the messianic complex, a feeling of wanting to save the world or of being its savior. This type of inflation is common in all fundamentalist groups and is witnessed on street corners in small towns, on college campuses, in revivalist meetings. Although they may or may not believe themselves to be prophets, fundamentalists do presume to have found *the* way—the only way, in fact—and many feel so special and graced and important because of it that they want the whole world to benefit from the grand knowledge that they themselves possess. Often phrased in humble speech—"Jesus is the Lord, and I am only his son," or "The Great One came to me, His humble servant"—there is great pride in being the son, the servant, the "chosen one."

Although the masks are many, the face is one—the same ego whose goal is its own survival and that believes itself to be the sole dictator of the human being in which it has taken residence.

## How and Why Ego Inflation Occurs

Ego inflation is a mechanical process, not a mystical one. It sneaks up upon the individual in often unexpected and unforeseen ways because ego is slippery, not because it is a cosmic force. Whereas one is usually unable to catch the inflation before it happens, understanding how and when it is likely to occur can alert the individual to the possibility of its arising in certain types of situations. Thus one can be alert and prepared for its sudden arrival.

*Eagerness*

The simplest explanation, though perhaps overly simplified, as to how and why egoic inflation occurs is that individuals who experience expanded states are often naïve and eager to share their experiences and knowledge with others. The neophyte who has had little involvement in spiritual work and who suddenly comes upon a very strong experience often imagines that nobody else, or very few, have had such experiences, and he desires to broadcast it for all the world so that they, too, can partake of this glory. Christina Grof observes:

> It is very common that people will experiment with some spiritual technique and get a taste of, "Hey, I'm more than I thought I was," and not do any work around it but instead go out and try it themselves, becoming some kind of messiah.

An unseen world has suddenly been revealed, and the person is excited to share this "land of milk and honey" with all those whom they love and who are suffering. "Attempting to communicate the wonder of such experience to others is natural and understandable," suggest Kramer and Alstad. "The problem is that others who have not had similar experiences are prone to give such a person deference and special treatment. It is very difficult not to enjoy this, and thus subtly to reinforce whatever images others have of one's specialness—particularly since it makes people more apt to listen."[7]

Whereas the initial impulse to bask in one's experience and share it with others is quite innocent, the danger comes when other people who have not had such experiences naïvely overestimate their importance. At this point, the ego of the person who was innocently sharing his or her experiences notices the attention it is getting, and in its rapidly expanding state seduces the individual into a feeling of even greater specialness and self-importance, encouraging a savior mentality.

*Can we be undistracted by heaven and hell long enough to realize true emancipation from delusion?*

ANDREW COHEN

*Identifying with the Experience*

As should be clear by this point, mystical experiences and experiences of enlightenment take place outside of the mundane realm of consciousness—sometimes they are archetypal experiences and sometimes they come from the nondual reality. As Jung suggested, however, the ego very quickly identifies with such experiences and claims them for its own. According to Jung, one reason for this is because people do not understand the contents of their own consciousness.

> This grotesque situation [a great influx of energy] can, to be sure, occur only when the contents of consciousness are regarded as the sole form of psychic existence. When this is the case, there is no preventing inflation by projections coming home to roost. But where the existence of an unconscious psyche is admitted, the contents of projection can be received into the inborn instinctive forms which predate consciousness. Their objectivity and autonomy are thereby preserved, and inflation is avoided.[8]

Based on Jung's explanation, it becomes clear that when there is an understanding of the limited reality of ordinary consciousness and its standing relative to the unconscious, there can be an admission of, and respect for, other forms of consciousness whose source is beyond the ego and that should not be regarded as belonging to the territory of the ego, or ordinary consciousness.

The ego also identifies with the experiences that arise from outside of its ordinary consciousness because as the experiences arise egoic consciousness is also present. When the experience fades, or even as it is still occurring, ego presumes *it* is having the experience. In *The Bond with the Beloved*, Llewellyn Vaughan-Lee writes:

> We cannot escape the fact that as we progress along the path and have spiritual experiences the ego can identify itself with these experiences. Although our meetings with the Beloved

belong to the level of the soul, as we taste their sweetness it is only too easy for the ego to think, "I had a spiritual experience." Then the ego becomes inflated. Thinking you are progressing creates moments of elation, of greatness, fleeting feelings of divinity. Then you become unbalanced.[9]

This is the investment of ego. It so very much *wants* to have such experiences it presumes that it *has* had them. It is extraordinarily difficult to distinguish what is ego and what is Other. Given the hazy line, ego takes advantage of the opportunity to declare that it is indeed itself that was the source of the experience. In *The Atman Project*, Ken Wilber explains how this works.

> Every individual—every sentient being—constantly intuits .that his prior Nature is the infinite and eternal, All and Whole—he is possessed, that is, with a true Atman-intuition . . . Every individual *correctly* intuits that he is of one nature with Atman, but he distorts that intuition by applying it to his separate self. He feels his separate self is immortal, all-embracing, central to the cosmos, all-significant. That is, he *substitutes* his ego for Atman. Then, instead of finding actual and timeless wholeness, he merely substitutes the desire to possess the cosmos; instead of being one with God, he tries himself to play God.[10]

Claudio Naranjo concurs.

> There is a legitimate part to the messianic complex, but there is also a part that is a wrong interpretation of the divine within. It is true that we are divine, but not in the way that ego means it. The valid knowledge of the divine ground becomes a divinization of ego, a glorification of ego.[11]

The fact is, human beings are both ordinary *and* divine. The great mystics have all had the revelation that "I am That," "I am God," but

*There seem to be degrees to which people get stuck in the grandiosity; some live on it for the rest of their lives.*

CLAUDIO NARANJO

this is distinct from the revelation that "I *as ego* am That," or "I *as ego* am God." In the moment of revelation, the "I" which they refer to *is* That, and when the revelation has passed and they feel cold and want to get a sweater and don't like the way their wife cooked the steak, they are still divine, but also very ordinary. It is this ordinariness, the common frustrations of everyday life, that helps to keep ego from getting carried away with itself. It is more difficult (though many do so nonetheless) to rest in the revelation of "I am God" when you as God cannot control your temper and you yell at your kids or abuse your wife. Vaughan-Lee comments further.

> An ordinary person likes gardening—I like adventure movies —and just gets by and has all the everyday stuff. The other part is divine. The danger is that when you begin to have mystical experiences, you begin to touch this divine part of yourself, and you begin to say, "Oh, I'm God." This is very, very dangerous. You see, on one level, yes, you are God, we are all God, we are all part of God, we are all part of that tremendous Oneness. And we are also not. We are also everyday persons. If the ego hasn't done basic shadow work, it too easily identifies with mystical experiences, and then begins to say, "I am God." And you can become very charismatic when the ego thinks that the enlightenment experience—if you call it that—belongs to the ego. What happens is that you can get this energy of the higher self flooding the personality, and you can become a very "enlightened" spiritual teacher very quickly, and people recognize it because they feel the charisma, the energy, of the higher self.

The energy that comes through the individual is very real in and of itself, and others can receive a great deal from it—it is just not *personal* to the individual, and it becomes dangerous when this is not understood. As Naranjo says, "Spiritual capital gives the ego credit. The ego then, more than ever, lives on the strength of the real being."[11] Furthermore, since those who often perceive such energy and

charisma coming through an individual are also unfamiliar with their own egoic functioning, and are unable to make a distinction between the energy they are perceiving and the personality through which it is coming, it is all the more important for the individual to be responsible for their own tendency to identify with the experiences and energies that come through them.

Yet another favored ploy of ego is to not only identify with experiences but to then use them for its own means. Dr. Jacob Needleman, of the Department of Philosophy at San Francisco State University, clearly articulates this point.

> In every human being, there is this impulse to aggrandize through the ego, or in Ken [Wilber]'s terms, to take all spiritual or transformational communications and turn them into adaptive or selfish or egoistic implements. This is a fact of human nature. This is why man is what he is. Every great spiritual teacher understands this about human nature and has to take it into account. Anyone who doesn't understand that is underestimating the human problem. [12]

*These phenomena started to happen to us, and they scared or excited or trapped or enamored us, and we stopped to smell the pretty flowers. Many people brought their egos up with them when they went to experience this plane . . .*
RAM DASS

In other words, it is not only an innocent and uneducated misidentification with mystical experiences on the part of ego that creates inflation, but an intentional, purposeful process. When the individual perceives that people are paying more attention to them because they are a little bit psychic, or are fascinated with them because of their stories of journeys to other realms and their contact with alien beings, they are going to capitalize on it.

One could say that ego inflation happens consciously or unconsciously, but there are clearly unconscious manifestations that *could be* conscious if people were willing to see what is directly in front of them. They don't choose to see it because they are receiving egoic gratification from their abilities to manipulate and control others with their abilities. As Needleman says, anyone who doesn't understand this is "underestimating the human problem." Clearly those who

believe that all spiritual experiences are ecstatic, wonderful, and free of danger are definitely underrating the human problem.

An example of ego using its abilities to manipulate other situations and other people is shared by Colorado psychologist Gary Mueller.

> There were some points in my own career as a counselor and therapist where I got very good at eliciting a positive transference with people, and I found my ego swelling and that I was feeling special. Somehow I knew it wasn't right, but I couldn't help myself. Temptations were too strong. I would go out and do these talks and I had a way of getting people excited. At one point I was speaking in front of a thousand people and I found myself swell in that process and at the same time feel terrified. So in that journey of getting seduced by my own passions and ego self-centeredness, I created crisis in my life in many different forms.

Human beings living under the domination of ego—as many do in today's world—are highly self-centered, self-serving, manipulative, and outright dangerous. Those involved in spiritual work are no different, except that perhaps they have an intention—strong or weak—to see these dynamics within themselves and to not unconsciously manifest them by projecting them onto every individual and every situation that comes their way.

### A Great Influx of Energy

The archetypal realms, and certainly the domain of the Absolute, are sources of enormous energy—far more energy than ordinary consciousness is accustomed to. When the individual begins to receive such an influx of energy, the ego is often thrown off balance and sometimes into great confusion. Ego has lost its ground and, instead of releasing into the fullness of the great Unknown, it scurries about attempting to find a way to interpret what is happening and appropriate the energy

influx for its own domain so that it can maintain control. One way for it to do this is to presume that such energies belong to itself. Although the energies are unfamiliar, ego expands itself to fit them and thus becomes inflated. Italian psychiatrist Roberto Assagioli says, "Instances of such confusion are not uncommon among people who become dazzled by contact with truths too great or energies too powerful for their mental capacities to grasp and their personality to assimilate . . ." The influx of such energies, according to Assagioli, "may have the unfortunate effect of feeding and inflating the personal ego."[13]

Andrew Cohen adds an insightful perspective regarding how the influx of energy affects the ego.

*One experience is not enough.*
IRINA TWEEDIE

Energy in itself is wild. Let me put it this way: You have the energy of enlightened consciousness, and the energy of enlightened consciousness goes through a prism. The prism is the brain, the mind, and the heart of that individual. The brain, the mind, and the heart of that individual are suddenly going to become animated by the presence of this very powerful enlightened consciousness because the enlightened consciousness animates what is already there. So a very proud person with a very big ego who becomes animated with enlightened consciousness is going to become a very powerful person who seems to suddenly know a lot about enlightenment because the energy of that consciousness is now flowing through their cells. When that energy flows through the mind and heart of a person who does not have a big ego, then the expression of the effect of that enlightened consciousness is going to express the very condition of that individual.

The point of spiritual practice is to know the ego, to become intimately familiar with its workings, and to diminish or strengthen it as needed in order to be able to handle the power of the forces one is likely to encounter as spiritual work deepens.

### Insecurity Masking As Inflation

Egoic inflation also masks insecurity—not only psychological insecurity, but the existential insecurity of the illusion of separation, of the awareness of death, of the intuition that ego is not the autonomous, all-powerful being it thinks it is.

In the field of psychology it is well known that people who act in a grandiose manner, who boast, brag, and use their power to hurt others, are masking underlying feelings of profound pain, insecurity, and inferiority. In an ordinary life uninvolved with spiritual matters, a person might wear flashy clothes, show off his money and possessions, be very muscular, and perhaps own a gun—all in an attempt to feel worthy, important, strong. When this same insecurity is turned toward spiritual matters, this person may be excessive in giving dharmic discourses to others, insistent in correcting their mistaken spiritual beliefs, righteous in thinking that his own attainments are more than they actually are—all to convince himself and others that he indeed is spiritual, important, worthy.

Carl Jung wrote:

If we now consider the fact that, as a result of psychic compensation, great humility stands very close to pride, and that "pride goeth before a fall," we can easily discover behind the haughtiness certain traits of an anxious sense of inferiority. In fact we shall see clearly how this uncertainty forces the enthusiast to puff up his truths, of which he feels none too sure, and to win proselytes to his side in order that his followers may prove to himself the value and trustworthiness of his own convictions. Nor is he altogether so happy in his fund of knowledge as to be able to hold out alone; at the bottom he feels isolated by it, and the secret fear of being left alone with it induces him to trot out his opinions and interpretations in and out of season, because only when convincing someone else does he feel safe from gnawing doubts.[14]

Ego grasps and manipulates spiritual truths in order to create a scenario in which *it* can survive, in which there is no ego death, in which it can have its cake and eat it too, relishing all the wonders of God and Reality without cost to itself. Robert Hall articulates this principle.

> Ego thinks it is much more powerful than it actually is. In that way it defends itself against the realization of its true condition . . . which is fucked. It defends itself against the horrors of reality. The inflated individual has a sense of greater security and invulnerability which serves to mask the Truth.

All the great masters tell us that Truth consists not only of beams of love and radiating light but of pain and sorrow and heartbreaking compassion for the suffering world. Why would ego willingly submit itself to such a Truth when it has the option of thinking of itself as God, omnipotent, the creator Himself, the master of the human being? Ego not only does not submit itself; it shores itself up in any way it can, creating an ever more resistant fortress, even a spiritual fortress, to guard itself from the onslaught of Truth.

## The Dangers of Inflation

The story is told that when Carl Jung went through a crisis of inflation he actually had a pistol in his bedside drawer. He said that if he didn't resolve the crisis he was going to shoot himself. Carl Jung knew how dangerous inflation is.

*Satori is a wonderfully rubbery concept.*

ARTHUR KOESTLER

As Jung's experience suggests, and Gary Mueller's story—reported earlier in this chapter—confirms, the seductions of ego inflation are so sublime, so enticing, so intricate in their appeal that it takes far more than an intellectual understanding of what they are and how they work to overcome their temptations.

Ego inflation is a juncture on the path at which many get stuck in the mud. While experiencing inflation, one cannot proceed on the

way, for one is living in non-reality. Whereas some people move through inflation rather quickly, others stay stuck for weeks, months, years, or even lifetimes. The *Guru Gita* in the *Sri Skanda Purana* says: "Due to inflated ego and pride, [even] those equipped with the power of austerity and learning [continue to revolve] in the vortex of worldly life, like pots on a water wheel."

The ego is tricky, the workings of inflation insidious. Few can, like Jung, catch the process at work in themselves. Knowing this, it is safest to recognize that one may become inflated at any moment. Gary Rosenthal offers a cautionary note:

> It should be clear that one might suffer a transpersonal inflation and even pass it on to others without being aware that all this is occurring. Transpersonal inflations often tend to occur in people who are in many ways mature, accomplished, successful—and perhaps gifted with intuitive insight, creativity, and charisma. Yet it is the very giftedness or persuasiveness which may blind such people to their remaining distortions (such as inflation), just as it is their giftedness which often leads others to treat them as "special"—which can blind an individual all the more to an inflated identity or belief system.
>
> Unfortunately, the capacity for giving or receiving even genuine spiritual insight does not rule out the danger that one might also be inflated—in fact, the two often go hand in hand. There is, therefore, the ever-present risk of psychological exploitation by such a guide, in the sense that inflation may involve the manipulation of others in service of one's own grandiosity. This "unholy union" of the giftedness and the inflatedness, which can result from having access to transpersonal states, is a critical pitfall both for those who follow and those who guide others on the spiritual path.[15]

In other words, the presence of inflation doesn't preclude the possibility that the individual can provide genuine spiritual insight, or that the knowledge that comes to him or her is not accurate. It is again

a very precarious situation in which Reality and neurosis rest side by side, almost inseparable, and often imperceptible. As Rosenthal points out, inflation often arises in extraordinarily gifted individuals who are so perceptive and knowledgeable that they are able to fool both themselves and those around them.

Yet another danger of ego inflation is that the identification with the insights and experiences that lead to it will often separate the individual from others whom they perceive to be beneath them in terms of spiritual development. Identification with such exalted states implies a disidentification with "lower states" of consciousness. Jung warns:

> The man who has usurped the new knowledge suffers, however, a transformation or enlargement of consciousness, which no longer resembles that of his fellow men. He has raised himself above the human level of his age ("ye shall become like unto God"), but in doing so has alienated himself from humanity. The pain of this loneliness is the vengeance of the gods, for never again can he return to mankind.[16]

The whole purpose of spiritual work and the spiritual life is to bring about more unity and less suffering. States of inflation that separate the individual from others should be questioned as to whether or not the state is expanded at all. It may be simply another clever egoic disguise to create a false perception of one's own greatness and thus inhibit any real spiritual progress.

*Any sense of personal realization and personal functioning must disappear. Even the amazing experience of this body as Buddha must disappear.*

LEX HIXON

---

## ROBERT SVOBODA: THE MISUSE OF ACCUMULATED SHAKTI

*People want to teach because they want to feel like they know. The ego wants to be able to stand up and say, "I'm somebody. I know something." They want other people to appreciate them for*

their exalted, superior, remarkable, and praiseworthy qualities. People also like to teach because it is very difficult to digest knowledge.

My teacher, Vimalananda, always used to say, "Accumulating shakti (energy, the ability to accomplish actions) is not difficult. Any idiot can do that. All you have to do is have a certain amount of control over your senses." His point of view was that most people are leaking energy in all directions. So if you do nothing but stop all of the leaks, you will start accumulating shakti. So that's not the difficulty. The difficulty is how do you digest it and what do you do with it?

A person who learns a little bit will find that there is pressure on his tongue to let the shakti out. Shakti is looking for a way to move. If the person has already become very firm and stable in themselves, then the shakti can simply circulate inside the organism and there is no need for it to go anywhere else. But if the person is not very firm and very stable, then inevitably the shakti is going to be looking for some way out.

So you accumulate a little shakti and you're able to maintain your focus. You accumulate a little more shakti and you're starting to waver a bit. You accumulate a little more shakti and somewhere along the line you lose sight of where you were headed and you start to identify your own personality or whatever little kernels of it are still untransformed—your own preferences and disturbances—with the archetypal or the cosmic or the divine. If you have a lot of shakti and you are not quite at the point where you are completely dedicated to surrendering your shakti to the Absolute, then you start to get a swelled head, which is where the danger lies.

So a person who has a transformative experience while their ego is still fundamentally intact, and who develops a certain amount of shakti before being really able to digest it, can definitely create a situation in which the undigested shakti goes to nourish the parts of themselves that they really don't want to have nourished.

## Working with Inflation

In considering how to avoid or transform inflation, Robert Svoboda remarks:

> I don't think inflation is necessarily inevitable, though it is difficult to think of too many people, even the immortals, who have not made some mistake at one time or another. I think it is fair to say that there is a likelihood that everybody will experience some degree of illusion or inflation, but hopefully: (a) you have dedication and will be paying attention to what is going on and you'll be able to catch yourself before you've gone too far off the beaten path; (b) you'll have a good guru who will beat on you if necessary; or (c) your ego will be well enough under control that it will not identify itself so much with that delusion, so that you will eventually be able to tease the two things apart.

Inflation can be worked with because there are other forces besides the individual ego at play. Although the egoic mechanism within the individual expands, the Essence does not. It remains pure, whole, unchanged. Because the individual is identified with the ego, it appears as though he or she has personally expanded. But there is more to the person than the ego. This must be recognized and clearly understood, for if we are to effectively work with ego inflation, we must understand it as an impersonal, mechanical phenomenon, and one that can in many cases be addressed. While the inflation is going on, there is another aspect of the individual, though perhaps unconscious, that is simultaneously not inflated, and can be accessed.

The following suggestions can be employed in working with inflation. Whereas some of these approaches arise naturally, others must be pursued with great volition, and still others with outside help.

*From the position of egoic consciousness, unitive consciousness always appears to be quite supernatural, mystical or nirvanic, but once we get there, it turns out to be utterly ordinary.*

BERNADETTE ROBERTS

### Deflation

The greatest antidote for inflation is deflation. Deflation comes when the very life that lifted the person places them down once again. Although the felt experience of deflation can be truly hellish, it is a great gift, and those who experience deflation are far more fortunate than those who continue to ride on the illusory carpet of inflation. For although the experience of inflation is ecstatic, it is not the true heart's desire.

Still, to those who come down, the experience of deflation is rarely smooth. It has been described as similar to alcohol or drug withdrawal, or as a death, or as being jolted out of a beautiful sleep by a fire in one's bedroom. Gary Mueller shares his experience.

> The process of coming down was like dying. It was like surrendering to death. In my own journey there was a period where I was so identified with being swollen that to not be swollen felt like dying.

This description is not an exaggeration. During the period of inflation, one is so identified with the inflation that one really believes that he or she has finally found peace and is free, impervious to the suffering of life. Coming down from such ecstasy into the suffering of ordinary life can be depressing and even devastating.

For some, the experience of coming down is experienced as embarrassing, or even humiliating. They see where they have been, and are aware that others have seen it as well. E.J. Gold says that embarrassment is a positive experience because it is really the ego that one is embarrassed of, and the ego *is* embarrassing! Its antics are disgraceful and scandalous, and so when one comes down from soaring with the angels and realizes they were flying on toxic fuel and not on God's breath, embarrassment is a healthy response. Shame, however, is not, because once again it is not the essential self who inflates, it is a mechanical response of ego, and to feel ashamed is to take this mechanical response personally.

It is healthy to come face to face with deflation because, in the moment that one does, one can appreciate the insidious workings of the mind and recognize how easy it is to be fooled even by experiences that feel entirely real and true. The experience of inflation followed by deflation is necessarily humbling and brings the dangers of ego to one's doorstep, as opposed to being something that occurs "out there in the world."

What commonly brings people down is life itself. It is the law of *karma*, of cause and effect. Circumstances arise in life that command the individual to see what they are up to. Rosenthal comments:

> At a certain point the inflated system may begin to break down. The wandering elephants of reality may begin to knock over the fences. This process of "bumping against reality" may eventually become so uncomfortable and unavoidable that one begins to deflate, come down, and/or take another look at one's predicament.[17]

The circumstances that bring the individual back down to earth may be mild and ordinary. Arnaud Desjardins told Gilles Farcet, "Fortunately, I have my wife and my son living close to me who don't spare me. When they don't like something, they tell me very straightforwardly, and most people wouldn't do it because I'm the master. But he's my son, and she's my wife, and they just tell me, and it's good for me!" Many other teachers interviewed shared similar gratitude. Either a spouse, a child, an illness, or a small accident will give a warning sign when they are getting off track, even if they are not entirely "inflated."

*A crazy and a sage are pretty close.*
JAKUSHO KWONG ROSHI

Llewellyn Vaughan-Lee observes, "At these moments the conflicts and difficulties of our ordinary everyday life are invaluable: How can you be a spiritually advanced person when you get angry about a parking ticket? The world continually confronts us with our failings and inadequacies and thus protects us from the dangers of inflation. It presents us with our worldly shadow that we need for balance."

For others, who are perhaps more resistant to the subtler circumstances of life that call them down from their inflation, circumstances will be more severe. The students one has gathered will leave suddenly, or no one will listen to the inflated individual's expansive discourses, or one's inflation will become so obvious through messianic and self-righteous actions that they can no longer deny it. Maybe a grave accident will occur, or someone close to the individual will die, thus bringing them back to the reality of life as it is. Whereas some people continue to resist even such blatant feedback, others do eventually get the message. (*See* "Listening for and Respecting the Feedback of the Universe" in Chapter Sixteen.)

---

### LLEWELLYN VAUGHAN-LEE: BALANCE IS NECESSARY TO PREVENT INFLATION

*There has to be balance, otherwise there is inflation. One time, when Mrs. Tweedie was in India, she started to become clairvoyant. She began to see what people were thinking, to see their auras, and she really thought she was progressing spiritually: "This is what spiritual life is all about." But when her teacher, Bhai Sahib, discovered this, he took all these experiences, all the clairvoyance, everything away. She was quite affronted.*

*The ego has to be destroyed, has to become nothing, so it doesn't think that it is having the experience. That is why there is this whole very gradual process. For most people, it takes many, many years of annihilation, of the ego slowly being made less and less and less, so that you can contain these experiences without thinking that you are God. Then you can go into the states of oneness, you can go into the level of the Self, and then come out of them and get on with your ordinary, everyday life, and look after the kids and do the shopping.*

According to Rosenthal, deflation can lead to the "false belief of having fallen lower than before," often disillusioning people to such an extent that they remove themselves from spiritual pursuits altogether, at least temporarily. If the individual does not eventually return to spiritual practice, it must be assumed that his or her intentions were not very strong in the first place. The process of deflation and disillusionment is so inevitable and so necessary that if one cannot withstand it, one is probably not equipped to handle the strenuous demands of the genuine spiritual life. (*See* Chapter Twenty: "The Sadhana of Disillusionment.")

### Giving Credit Where Credit Is Due

The individual further learns to guard against the dangers of inflation by giving credit where credit is due, and credit is not due to the ego or the individual through which such forces pass. Credit is due to God, or Truth, or the impersonal force of consciousness that exists in the world, not the teacher. Reggie Ray reminds us:

> The fallacy is in thinking that you're something special. Thinking that somehow it's *you* that is actually presenting the teachings. That if you give a good talk that *you* gave a good talk, rather than that you are an occasion for something to happen that really needs to happen for the people whom you are speaking with. This is the Buddhist idea that the teacher is nothing. The teacher is like a crystal upon which the light shines and then is refracted in a certain way. But the teacher is nothing, and the more that I or any of us think that we're something, the less helpful it is.

Giving credit to the greater Source from which experience came is a very important, but difficult, thing to do. People who intellectually understand this problem but have not *realized* it may say things like, "Enlightenment is arising," or "A beautiful experience occurred through me," or they may begin their name with a lower-case letter to

*Let's not take ourselves to be the source and sole creator of this ongoing process.*
REGINALD RAY

demonstrate that they are not identified with the ego. Most of the time, these are simply more games of ego attempting to further fool oneself and others into thinking that identification has not taken place. The person would be better off admitting that they are arrogant *and* they think that they are enlightened than attempting to hide it under the table.

Disidentifying with the experience is a conscious, deliberate, and disciplined process. It begins with acknowledging that *we* are not the source of our experiences and, at the same time, admitting that we probably do not really know this and must be reminded of it again and again and again. It involves a conscious internal practice of not indulging in self-aggrandizement when one is praised or when one knows they have done a good job.

Compliments may be true, and insights may not be accurate, but it doesn't mean that ego is anything other than ego as a result of whatever experience has occurred. Christina Grof retells a story of Ram Dass going to the hospital to visit his brother, who had had a spiritual experience and believed that he was Jesus. At the time, his brother was clean shaven, had on a nice shirt, had short hair, and fit in well with the culture, whereas Ram Dass had long hair and a beard and looked a bit like images of Jesus. Ram Dass said to his brother, "So, you are experiencing that you are Jesus?" His brother said that he was. Then Ram Dass said, "Well, I experience myself as Jesus too, but I don't think I'm the only one."

Though Ram Dass acknowledged that he felt like Jesus, he was aware that, from one perspective, everybody is Jesus. In *The Psychology of C.G. Jung*, Jolande Jacobi writes, "The forces that have been activated in the individual by these insights become really available to him only when he has learned in all humility to distinguish himself from them."[18] Ram Dass knew that the experience of "Jesus" arose in him at times, and that he might at times identify with it, but that it was in fact an impersonal force that he best not take any credit for.

Individuals within theistic traditions may have an easier time working with ego inflation than those in nontheistic traditions or those who do not adhere to any tradition, because they give deference either

to God, Jesus, the guru, the elders, or some force or person beyond themselves. Many traditions that worship and praise the glory of God acknowledge that God exists in and as every individual but humble themselves before a force much greater than the common egoic identity, even if that force operates through them as well. Traditional Native American spirituality offers a prime example of this practice. Adherents recognize the dangers of ego and the limitations of the ordinary human identification, and allow themselves to be in awe and reverence in respect to the greater force that exists.

Of course, this perspective is not limited to theistic traditions. As Reggie Ray and others so clearly articulate, one can have respect and humility in response to the Buddha principle, or the scriptures and teachings of a tradition, or great teacher, or even Truth itself. The point is that one learns to disidentify with the experience by assigning the credit for such experience, insight, and wisdom to its true source instead of allowing ego to sign its name to it.

## Not Giving Experiences Too Much Attention

Another way inflation is worked with is by not giving too much attention to the exalted experiences that commonly proceed it. As Danan Henry learned from his experience with Kapleau Roshi, this is quite difficult to do for oneself, for the experiences are compelling, if not consuming. The ego would like to give such experiences great importance. This is a time when the help of a teacher is invaluable.

Andrew Cohen explains how he works with students who have experiences that could lead to ego inflation.

When I give retreats, people often have strong experiences. Sometimes people will describe very beautiful, very moving experiences of the Absolute, and sometimes I am very touched by what I am hearing. But usually my response will be, "Oh, that's very nice," or "Very good," whereas I know that in other circumstances these people would be told, "Oh, you're the most wonderful, most fortunate human being on the whole

*Rarely does a roshi say, "You are enlightened," or words to that effect, for such a pat on the back could reinvigorate an ego that has been merely dislodged but not wholly banished.*

PHILIP KAPLEAU ROSHI

planet." They would be affirmed in such a way that they would feel very special simply because they have tasted something. But just because we taste something doesn't mean there is anything special about us . . . How a teacher responds to these events has an enormous impact on the experiencer. So if someone has a very powerful experience and the response is, "Oh, that's very good," then it is unlikely that they are going to draw any lofty conclusions about themselves as a result of it. When they have some great experience and they are told that the most significant thing that has ever happened to anyone on the planet has just happened to them, it is likely it will go to their head.

*Do not try to be humble: learn humility.*

IDRIES SHAH

When Zen teacher Richard Clarke was asked by Gary Rosenthal how his teacher responded to his periods of inflation, or "Zen sickness," Clarke told him that he was "fundamentally ignored, allowed to stew in my own juices, or ridiculed."[19]

Whether a teacher responds to strong experiences and the tendency toward inflation in a subdued way, as Andrew Cohen does, in spite of being very moved by the experiences, or whether the response is based on the more absolute Zen approach that all such phenomena are makyo, both are geared toward not fuelling any of the already present tendencies of ego toward inflation. This is the principle pointed to by the famous Zen stories in which the student comes and tells the Master of his cosmic experiences of universal oneness, to which the Master responds, "And then what happened?"

Whereas most teachers are pleased that their students have such experiences, they are unlikely to give them very much attention, for the student's benefit. They are also more interested in how the individual lives as the result of such experience. Isolated experience has little value if it is not evidenced in the individual's life.

Andrew Cohen continues:

I wait and see what the result is. That is what I'm interested in. What is the result, or what is the impact of the experience?

That is a lot more important to me than the fact that the experience occurred at all, because I know that it doesn't necessarily mean anything. The experience should be affirmed, but within the context of that individual's actual relationship to life.

The spiritual student is less likely to become inflated as a result of mystical experiences if they are practicing in the context of a teacher and a body of teaching that does not place excessive importance on such experiences, but instead emphasizes how the individual is transformed in his or her life as a result.

## Keeping Quiet

Keeping one's experiences to oneself is a powerful way to guard against ego inflation, particularly if one does not have a teacher who can help one work with such experiences.

*Self-importance is man's greatest enemy.*
CARLOS CASTENADA

Keeping quiet about one's experiences is not a blanket approach to such phenomena, but rather an interesting experiment and a worthwhile consideration. For how inflated can an individual become about their experiences if nobody else knows they have had them? Of course there is still danger, for one can inflate within and for a time, even a long time, imagine oneself to be realized or special or beyond others. But for most individuals, if there is no one to feel special in relationship to, eventually such feelings of superiority subside.

As Robert Ennis pointed out in Chapter Six, experiences do not need to be talked about and acknowledged in order for them to be valuable. They leave an impression on the unconscious and are digested and internalized within the individual with very little, if any, conscious effort. Their higher purpose is not for display, but to transform the individual as is needed.

There are times to talk about significant spiritual experiences, but rarely are they when one is sitting in a special chair in front of a room full of hundreds of people, or writing for a magazine, or sharing in a personal growth seminar. In general, the value in talking about experiences or writing them down is to affirm the experience, ground it in

the body, and strengthen one's conscious awareness of it, not to boast, gain acknowledgement and validation from others, or even to create intimacy with others through the sharing of such experiences. These latter options are simply too seductive to the ego to play around with.

One senior practitioner encapsulates the entire consideration of keeping one's experiences to oneself.

> The question to ask oneself as a checkpoint is, "Regardless of what happens, no matter what experience I have, no matter how high I feel I've gone, am I prepared to live the rest of my life in obscurity and anonymity if that is the most beneficial use of this experience?"

This is a very healthy way to regard one's own spiritual experiences. Is the fact of the experience itself enough? Would one be willing to never speak about the experience—ever—if that was the most beneficial use of that experience? One who demonstrates in their life an affirmative response to these questions is the individual least likely to become inflated by extraordinary experiences.

### Intention

One of the most practical ways to guard against inflation in oneself is through the clear intention to not become inflated. In order to have a genuine intention to not become inflated (as opposed to being victimized by an internal spiritual dictator that says, "Inflation is bad. Don't get inflated. Don't get inflated.") one must have an understanding of, and appreciation for, the dangers of inflation. Carl Jung's intention to end his bout of inflation was demonstrated by placing a pistol on his bedside table. Charles Tart works with his own tendencies toward inflation by affirming his commitment to reality. He describes how intention works for him.

> I go out and give a lecture somewhere and a thousand people are applauding at the end. I like it. Luckily, it doesn't happen

too often, and I get off the stage quickly when they do that, because I don't want it to go to my ego. I have a very strong commitment to reality, and to trying to be of genuine service rather than just feeling good about myself. I love to feel good, but I realize that that is very seductive and I have to be very cautious about that sort of thing. Also, I have scientific training. I've been trained that the data are what is really important, not my feelings about it, not my feelings of cleverness or accomplishment. I keep coming back to reality, what is actually going on. That is the real test in the end. I also see that as a fundamental  principle on the spiritual path. You may think that you're terribly spiritually oriented and all that, but as soon as your preferences for feeling good, or defending your ideas, start to take preference over coming back to reality, you're not on a genuine spiritual path anymore. You are on an ego path, and it is a great danger.

*Remember that greed includes greed for not being greedy.*
IDRIES SHAH

Anyone who thinks they are not tempted by inflation is a likely candidate to become inflated. Inflation feels good, while reality doesn't always feel so good. Thus, the temptation is there; the question is simply whether or not one's intention is strong enough to stay steady in the face of its seductions.

## Help from the Tradition

The following account, shared by Llewellyn Vaughan-Lee, is a remarkable articulation of how the tradition itself can help guard its disciples from becoming inflated.

Our particular path has been carefully designed since the twelfth century to minimize the danger of the ego being gratified by spiritual experiences. There is a lovely story: There were these Sufis of Nishapur, a long, long time ago in the Middle East. At that time Sufis used to wear patchwork cloaks and everybody  knew they were dervishes. These Sufis of Nishapur

said, "Look, if you wear a patchwork cloak, everybody identifies you as being a dervish. Then you begin to think 'I am a dervish,' and the ego begins to have an identity. We don't want to do any of that. We just want to wear ordinary clothes." But then they said, "It is still a danger. When you go on the path you begin to have spiritual experiences and then you begin to think, 'Ah, I am a seeker, I have had spiritual experiences. I'm a spiritual person.' So that's also very dangerous." So on this particular path most of the experiences have been introverted to such a degree that for a long time you don't even know that you have them until those who look after you know that you aren't going to be swamped by them and the ego isn't going to get too inflated.

Each path, depending upon the needs of its disciples and the strengths and weaknesses of the tradition itself, provides distinct protection for its disciples. The Jewish tradition, for example, because of the still-recent impact of the Holocaust, is more focused on basic survival issues than on becoming inflated due to excessive immersion in ecstasies and raptures, though these are not the least bit uncommon among Jewish mystics. According to Rabbi Zalman Schachter-Shalomi:

We don't worry so much about inflation. First of all, we don't have such a big amount of personnel. We don't have so many folks out there doing the work. The problem for us is not so much that we get inflated, because as long as we stay in the system we aren't talking about our trip. We aren't telling other people what we think. We tell them, "The master teaches this, the Rebbe says that." Do you understand? So there is an important element of knowing who you represent. We don't come on saying, "I'm the Rebbe." We say, "I am one of the emissaries, a tentacle of the Rebbe." So on the one hand we could be very firm and strong by saying, "It's not that I'm doing my work. I'm doing the Rebbe's work." We also sometimes feel okay to say, "I can't say much, but I can say this: for what you are doing, and how you are doing it, you deserve the

Rebbe's blessing." And then we don't mind offering that bless-
ing in the name of the Rebbe.

Of course, one can also get inflated within such a tradition by dis-
playing pseudo-humility rather than being moved by genuine humili-
ty, but the Rebbe's point is that the ancient tradition in which they
work offers inherent protection against ego inflation.

From still another perspective, Reggie Ray suggests that the nega-
tive publicity their spiritual school received as a result of some of
Trungpa Rinpoche's outward behavior has served as an important pro-
tection for the school.

*Can you not see that all the
treasures in paradise would
not ever tempt me into your
wicked arms?*

THE HUNGER OF LOVE

> You need protection and you need to be somewhat anonymous
> in the kind of work that we do. I appreciate the negative pub-
> licity and I appreciate people not really noticing what we're
> doing. When you attract too many people, then you begin to
> attract people whose motivation is something other than spir-
> ituality, and that is not a good situation for a teacher.

The teacher whose spiritual shop is on Fifth Avenue is going to
attract casual spiritual shoppers who will blindly adulate the teacher
and thrive on any trace of mystical experience, whereas a spiritual
school that has a mixed reputation is going to quickly weed out those
who aren't willing to look beneath the appearance of things.

## Inflation Is Natural

Inflation is natural and should be expected to arise from time to
time. Claudio Naranjo explains how it occurs.

> I think it is possible to say that you can have spiritual experi-
> ences and at the same time undergo a psychological regression
> . . . [This happens in] people who really have a breakthrough
> that involves experiences which are very hard to label anything

*I think it is part of the natural process to be inflated, because if we are novices and have contact with something much beyond us, we will, necessarily, have a novice's interpretation of it.*

CLAUDIO NARANJO

other than spiritual, but who have not sufficiently transcended their ego, and their spiritual experiences are concomitant with an intensification of their narcissism. I think this is not exceptional, not an aberrant development. It would seem, on the contrary, that this is a common pattern . . . I tend to believe that all ecstatic religion is contaminated by the ego; that even in the best mystic, the ecstatic experiences are the reflection of true spirituality upon the imperfect mirror of the ego . . . It is as if the spiritual breakthrough or the dawn of spirituality must always get interpreted by a personality that has not matured.[20]

Naranjo neither rejects the contamination that the ego will always bring to the experience nor denies the truth of the experiences themselves. What is unique to Naranjo's perspective on this issue, a perspective gained from many years of personal experience and struggle with inflation (*See* Chapter Twenty: "The Sadhana of Disillusionment"), is his patience and his acceptance of the process. He suggests that since the underlying tendency toward inflation, or the "messianic complex," is already present, it is worthwhile to let it out of the cage and let it live a bit, to leave a little room for it.

If you are going to transcend the messianic complex, you have to clearly recognize it first. You have to live out your grandiosity, and therefore there is something functional in being a sorcerer's apprentice. Of course there is a danger of getting stuck, as well as a danger of misleading others, but it is as if there is a band or a level at which inflation is unavoidable, and also serves as a step to the next rung on the ladder.

Whereas those individuals with any degree of humility may have a firm suspicion that the tendencies toward egoic inflation exist within themselves, they will not know that they have transcended the fire of its seduction until they have allowed it to burn to some degree. Distinct from allowing oneself to manipulate and control others with one's increased charisma and abilities, allowing inflation to show itself and

throw its weight around a bit gives one the opportunity to recognize it and see it clearly, owning it and knowing first hand its dangers and implications. This knowledge may be the next step toward taking responsibility for one's spiritual work.

Lastly, Naranjo refers to the possible benefits of inflation when he says, "The narcissistic excitement of the person who is going through it doesn't go to waste either. It infects others and excites the process in others in a way that can be helpful to the work."

The point is not whether we become inflated, but whether we have the integrity and willingness to recognize ego inflation when it occurs and take responsibility for it. That means acknowledging it to the best of our ability when it is in process; inviting feedback and input about it from others; and not indulging it through excessive proselytizing and other forms of self-aggrandizement.

By effectively working with the dangers of inflation, we markedly minimize the possibilities of presuming enlightenment before its time.

The following chapter, "The 'Inner Guru' and Other Spiritual Truisms," explores another common form of self-deception on the spiritual path in which the individual manipulates spiritual truisms in an unconscious, ego-based attempt to sabotage an encounter with the Truth unadorned.

# The "Inner Guru" and Other Spiritual Truisms

*I am really terrified by what passes among us in these days. Anyone who has barely begun to meditate, if he becomes conscious of worlds of this kind during his self-recollection, pronounces them forthwith to be the work of God; and, convinced that they are so, goes about proclaiming, "God has told me this," or "I have had that answer from God." But all is illusion and fancy; such a one has only been speaking to himself. Besides, the desire for these words, and the attention they give to them, end by persuading men that all the observations which they address to themselves are the responses of God.[1]*

—St. John of the Cross

"The inner guru guides me." "Everything is my teacher." "It's all an illusion." "It's all one." These are statements frequently used by spiritual seekers to "jump the gun" and presume enlightenment long before its time. Each a vehicle for widespread and pervasive self-deceit, they are rarely understood and embodied as the Truths which they represent. Also falling into this category are the notions of inner guidance, channeled wisdom, the higher/inner self, following one's heart, hearing the voice of God, intuition, and so forth.

*The last thing you get is the guru within. Often what people think of as the "guru within" is the mischievous troublemaker within.*

LEE LOZOWICK

Ultimately, the "inner guru" refers to the reality that the guru is no different from the conscious self. "Everything is my teacher" means that it is possible to learn from all of life's circumstances. "It's all an illusion" suggests that life as perceived by the common ego is entirely illusory. "It's all one" is a statement of the nondual reality. All spiritual textbooks speak of these truths, and any intelligent seeker can grasp them intellectually, perhaps even experience moments of insight and clarity about them. But intellectual understanding or temporary insight is very different from permanent abidance in Truth or Reality.

## The Problem

*The path is narrow to the right madness. Be wary of trembling in the wrong places! The demons often disguise themselves as gods. And vice versa.*

SAM KEEN

The problem with playing around with high truths is that, once again, ego quickly adopts them, exploits them for its own purposes, and uses them to justify further illusion and distraction, as well as to manipulate others. These truisms—in all their fancy clothes—are used as justifications for inappropriate behavior, to avoid responsibility, and to fool us into thinking that we are more enlightened than we actually are.

### The Inner Guru

The concept of the inner guru is one of the most deceitful of all the popular truisms. Though the term refers to something ultimately real, of the many who believe themselves to be following this principle, only a rare few are able to do it effectively. A high degree of human maturity is required in order to consistently and clearly hear and follow the demanding guidance of the inner guru, a maturity that is earned through spiritual sadhana and not from reading a spiritual book or from hearing a New Age freedom fighter proclaim the message.

Georg Feuerstein approaches the phenomenon of the inner guru with suspicion.

As a first and common form of avoidance, seekers tend dexterously to replace the demanding external guru with the comforting and comfortable "inner guru." In other words, they succumb to the need to preserve their ego-identity. But as we have seen, the entire spiritual adventure is about sloughing the ego-identity. The inner guru to which so many seekers entrust their spiritual career is frequently only a figment of their imagination, a product of self-delusion.

. . . But how easy it is to deceive oneself! The ego is inherently conservative. It always seeks to maintain its position in the world. And consequently it will receive just those intuitions and "messages" from the inner guru that it likes to receive.[2]

One popular channel for such messages from the "inner guru" is the dreamworld. In guru traditions, it is said that if one dreams about the guru, it may in fact be a message from the actual guru. Upon hearing this, the ego, seeking confirmation of whatever illusion it is currently campaigning for, creates a dream in which it disguises *itself* as the inner guru, and confirms the desired wish. One woman who began an apprenticeship with a well-known Indian guru stopped her formal study when, in a dream, her guru came to her and said, "You don't need to come see me anymore. I am inside of you now."

Based on his own experience, Andrew Rawlinson strongly advocates a skeptical stance when questioning the inner guru.

When my master died, I lost something which I had taken for granted. I was used to seeing him quite often. Of course, I knew he was going to die, it was hardly surprising, and I had always thought, "The inner guru is the real guru anyway." But after he died, I was wanting to label anything as the "inner guru" because I missed the outer guru so much. I got more and more skeptical over the years. He's been dead for eight years now, and I've decided that I'm not going to say "This is the

*Try for a moment to accept the idea that you are not what you believe yourself to be, that you overestimate yourself, in fact that you lie to yourself. That you always lie to yourself every moment, all day, all your life.*

JEANNE DE SALZMANN

inner guru" unless I have no other alternative, which doesn't happen very often.

*Dead gurus can't kick ass.*

ADI DA

A close companion to the inner guru is the dead guru. Although there are many great living masters today (though few in comparison to the number who claim themselves to be), many people opt for a dead one. Why? Consciously, people say that there are no living masters who are comparable to their dead master, or that the dead guru was their true guru. Unconsciously, however, the reason many people choose dead gurus is because it is much easier to follow a dead guru than a living one. The dead master generally does not make demands, does not undermine the ego, does not question the disciple and show him where he has gone astray. It is very easy to get all kinds of ego-gratifying communications and directions from a dead guru that one wouldn't get from a living teacher. One feels loved and understood by their fantasy master and assumes that the relationship therefore is beneficial.

An interesting example of the preference for a dead guru exists at the present time in the vicinity of a great contemporary saint who lives in southern India. Nearby is the ashram of another rare and brilliant saint, one who has been dead for many decades. Many devotees of the dead guru claim to be in contact with him regularly, and say that they are empowered to bless others on his behalf. Yet these same individuals often act selfishly and aggressively, insisting on a nondualistic stance which they interpret as the license to do anything they want in the name of their teacher. Meanwhile, they reject the guidance of the master who lives just a few hundred meters away, but who would never support such ludicrous behavior. They justify their rejection of the living master by saying that even though their guru is dead, he is within them and is giving them ongoing feedback.

Although at an advanced state of spiritual life one does indeed follow the guru within, for the majority of spiritual aspirants this is not a safe bet. The guru stands for and is an expression of the Absolute, the Truth. The guru *is* no different than the conscious self, as the scriptures say, but whose "self" is conscious? If one has admitted to the

complexity of one's nature, dominated largely by ego, it is difficult to make the final assessment that "the guru within" has been effectively located. Individuals who have been profoundly wounded and disempowered in childhood are often so anxious to be through with their struggles, to avoid the heartache of healing, that they are quick to label the first spiritual experience or insight that comes to them as a direct message from the inner guru, and are often reluctant to question themselves further.

Some people are an exception to the rule, and do have a living relationship with a dead guru. In some cases these individuals have followed and worked closely with a living master for a number of years before the master died and have done enough spiritual sadhana so that their relationship with their dead guru is unobstructed by ego. Even more rare are those who have an immediate relationship with a deceased guru whom they never knew, as some devout practitioners of Christianity and Judaism have with Jesus or God. These individuals have undergone an intensive process of self-enquiry to the degree that they are able to maintain communication with, and receive reliable feedback from, their ultimate master, whom they experience within themselves.

### The Inner Voice and "Following One's Heart"

The inner voice certainly exists, but whose voice is it? People often fail to realize that although the "inner voice" does exist, *many* inner voices co-exist, each speaking from a different reality. G.I. Gurdjieff discussed the notion of the "multiple I's," or various "selves" that exist within the individual. Some "I's" sound very spiritual, some wicked, others compassionate. The point is that there are many of them.

Most people have been hearing inner voices all their lives but don't know it because these voices make up the fabric of ordinary thought: the complainer is an "I," anger is an "I," fear is an "I." But when "I's" with spiritual voices or messages start broadcasting, they are suddenly labeled as the "true" voice. Joseph Chilton Pearce, lifelong

*The path of seeking spiritual guidance, or becoming a student of one's own "heart" or "intuition," may risk a lesser chance of being manipulated by a spiritual authority figure, but does not minimize the possibility of being manipulated by one's own ego.*

IRINA TWEEDIE

spiritual practitioner who is recognized worldwide for his contributions to the field of human development, asked a zealous young spiritual seeker, "Why, if one really believes that everything is God, would one feel the need to label one voice 'the voice of God' over another?" Usually people claim guidance from the inner voice in order to get attention or recognition, or to feel special or important.

Llewellyn Vaughan-Lee exposes this common fallacy.

> The mind is a master of trickery. The mind knows exactly the spiritual tone to put on to make you convinced that you are being guided to do something. And there is really no guidance at all, it's that you want to do it. Rather than taking responsibility for your own desires, you put it into the voice of the higher self: "I am guided to go on holiday." Sadly, people don't take responsibility for what they want, and they have to be guided to do everything.

It is much easier to excuse something if one is "guided" to do it, because one can then avoid responsibility. If positive results come from the guidance, one becomes a hero for hearing and following the voice; if things don't work out, one is simply a victim of the inner voice's desires. Either way, the individual is not accountable.

A close relative to the inner voice is the notion of following one's heart. It is true that one must ultimately follow their heart, and that the True Heart doesn't lie. But how does one know when one is hearing this heart? Most individuals have no idea what their heart is, have never even felt it, have not heard it speak. The majority of messages they attribute to their heart are, in fact, coming from their mind, though it may well speak lovingly, tenderly, and even "heartfully."

Those who are willing to question the much-desired messages of the heart and inner voices often discover that they are not as they appear. The ego is endlessly clever, and if need be will speak its own wishes through the veneer of the inner voice or the heart.

## The Teacher Is Everywhere/Life Is the Teacher

The teacher *is* everywhere, but people rarely know how to perceive or interpret its teachings. Life *is* the teacher, but people are so busy trying to manipulate it and guard themselves from it, and are so mechanical in their relationship to it, that they rarely even experience it. The teacher is in all of life, but if people aren't changing dramatically as a result of the influence of such a broad and indirect teacher, perhaps they need to look elsewhere. Feuerstein remarks, "Looking for the teacher in all things can easily become a 'head trip,' an excuse for a casual approach to spirituality."[3]

If the teacher is in all things, and one is always learning from life, then we could say that we need do no more than wake up in the morning in order to progress spiritually. Perhaps this is so. Perhaps the alcoholic man who beats his own infant daughter *is* following the spiritual path and life *is* teaching him, and perhaps the murderer/rapist *is* a student of life, but if life is the teacher, then there are a lot of bad students.

## It's All an Illusion

The danger of saying "It's all an illusion," "It's all one," or "It's all a dream" is that this, too, can quickly turn into an excuse to do anything one wants and to indulge in any excess. If it is all an illusion, it doesn't matter if we harm others or if we destroy our bodies with drugs and alcohol because our bodies aren't real anyway. If life is but a dream, then why not take everything that we can get regardless of how many toes we step on to get it and how many others will have less because of our selfishness? If all is one, then there is no good and evil, right and wrong, so why not cheat, lie, and steal?

Those who indiscriminately use these absolute ideas do not understand that the absolute reality in no way negates the relative reality. Nonduality does not cancel out duality. Those who truly understand (as opposed to having had profound but fleeting insight into) the esoteric principles of "the inner guru," of "all is one," of "the teacher is

*I believe that because of their illusionist metaphysics, most Eastern or Eastern-type traditions have on balance failed to effect deep and long-lasting transformations in their Western adherents.*

GEORG FEUERSTEIN

everywhere" never boast such truths in reaction to any challenge to their psyche or psychology. They are instead humbled by the majesty of the reality they have glimpsed such that it propels them toward greater service to, and participation in, the very real world of duality, the world that we all live in. (*See* "Enlightened Duality," in Chapter Twenty-one.)

## Distinguishing the True Voice (the Guru, the Master, Reality) from Its Sound-Alikes

How does one discriminate the true voice from the false? This is a great question that cannot be answered in concrete terms. No formula will teach this ability, and there is no definitive test to show whether one's interpretation of the internal messages one receives is correct or incorrect.

*Until you can see yourself clearly and constantly for what you are really like, you have to rely upon the assessment of a teacher.*

IDRIES SHAH

The greatest help in learning to discriminate between real and false messages is to be continually aware of the fact of self-deception: how common it is, how it occurs at all levels of spiritual development in increasingly subtle ways, and how even the greatest masters can make mistakes. To be aware of self-deception suggests that one is constantly questioning oneself, never presuming that one is beyond error. One student who has learned lessons of self-deception from his own experience on the spiritual path comments:

> You can't rule out the possibility that we are fooling ourselves. The "feedback" that we often get internally can be real or imagined. It is only by paying careful attention at a feeling level that we can distinguish between inner voices that are psychologically generated out of neuroses, paranoia, delusion, or ignorance, and those inner voices that are genuine. All the voices are there. Anyone can go inside and get *any* message. It just depends upon what position they are looking to justify.

## ARNAUD DESJARDINS: REMEMBERING THE OUTER MASTER

*The "inner guru" is not just an empty term, but the physical master whom I have known, whom I have heard. Therefore, I must remember not only the inner master, but the outer master, even if the master is completely one with me at the level of non-dual relationship. I am talking about something very concrete and necessary for those who have not reached the highest level of awakening (and even all lamas are not one-hundred percent perfect Buddhas, even though they may be very useful to their students and great servants of truth).*

*So let us not dream. One who is not a Ma Anandamayi or a Ramana Maharshi and who starts teaching should remember the outer master—his look, his voice, his words . . . and question: "Am I faithful to him?" "If the master was here, now, looking at me, listening to me, would I be completely at ease—yes or no?"*

*But even in order to do this, the relationship with one's master must have been, and still be, very strong. It may take a long time to build this. If one has just been an ordinary student, it's not the same. Also, love and gratitude for one's master may be a great help. Sometimes, even if one has truly changed, understood and assimilated something, it is not completely purified and may come again suddenly: some trouble in relationship to a woman, or too much admiration, or someone famous and well-known who is interested by what you do. If this occurs, the connection with the master is fundamental.*

*I insist on remembering the outer master. If inside I forget who my master was, what he was teaching, and what he said, then I betray the master. According to my understanding, to my experience, which is what it is, this is so important.*

Given the degree of self-deception involved, and the fact that *anyone* can get *any* message and have it sound *exactly* like the inner voice, the process of learning to recognize the authentic inner voice does not come easily. Vaughan-Lee offers one method.

> In my experience, the best way to differentiate is to follow the voice of ego, thinking it is the higher self, and then fall in the mud. I've done that a number of times, and there's nothing that wakes you up more than your own mistakes . . . Eventually, you find that there is a different vibration to the voice of the ego and the voice of the higher self. The voice of the higher self has a certain clarity that the voice of the ego doesn't. For me, it comes out of a different space. But then again, the voice of the ego comes to each of us differently. You learn how to differentiate it. Also, usually from the voice of the higher self you have nothing to gain personally.

*We must first learn to distinguish between fantasy and reality, between our childish needs and neurotic desires and the genuine impulse to transcend the ego. Otherwise our spirituality is bound to remain a sad parody.*

GEORG FEUERSTEIN

Because the inner voice comes differently to each individual, and even within the individual may speak differently at various times, there is no blanket "test" for recognizing it. The clue that Vaughan-Lee offers here is that the voice of the higher self usually does not promote any personal gain. It rarely even refers to anything self-serving, and often makes suggestions that the individual would rather *not* comply with. The real inner voice tends to direct one toward the needs of others and the needs of life.

Those who are effectively able to discriminate between the true and false voices say that over time it becomes obvious when the true inner voice—or the voice of the master—is speaking. In *The Bond with the Beloved*, Vaughan-Lee writes:

> Gradually the mind becomes familiar with the way the Beloved speaks to the lover and learns not to interfere. The foundation of stillness enables the mind to function with a new-founded clarity, and it learns to distinguish the voice of the ego from the voice of the Self. When the higher knowledge of the Self

comes into consciousness the mind learns not to identify with it. Suddenly one knows something. It could be easy for the ego to become inflated, but it is usually so apparent that this knowledge comes from the beyond that the mind can recognize its origin. This knowledge has a quality that is different from ordinary knowledge—there is not a process of understanding something; suddenly the knowledge is there.[4]

## Case Study: The Advaita Shuffle—Glimpsing Nonduality Is Not Equal to Living It

A very interesting "case study" about self-deception is found in the behavior of certain teachers who manipulate the teachings of Advaita-Vedanta, or nonduality (i.e., "It's all One"), in order to further their actual separation from other people and from the divine life. Often it is the highly "spiritualized" ego that readily employs this tactic.

*My work is about realizing both the Relative and the Absolute.*

JOAN HALIFAX

This is the way it works. A spiritual teacher who is well seasoned in the dharma of nonduality and the workings of the human mind can easily induce an experience of nonduality in his or her students, and furthermore can teach students how to reproduce this experience within themselves.

In the contemporary spiritual scene in the West, there are several examples of very popular teachers who are employing this technique with their students. They provide students with the technology that will induce an experience of nonduality, and when the student experiences this state, which is easily misperceived as enlightenment itself, the teacher confirms that he or she is indeed enlightened. For many individuals, it is far more appealing to follow a teacher who pops out "enlightened" students weekly like a factory produces chocolate bars than to follow one who may not even think in terms of enlightenment. The consideration of what motivates these teachers to pursue this approach is not an easily answered question. But the fact is that it is not uncommon.

Advaita-Vedanta, or the teachings of nonduality, is a body of spiritual work that has been taught and practiced for thousands of years. The teachings boil down to the realization that the "I" does not exist as a separate entity and that "all is one." The same insight is regularly produced on LSD or through experiences of nature, but temporary realization—however it is induced—has little to do with a life in the context of an entire teaching on the subject, including all of its related subtleties and complexities.

Andrew Cohen is particularly outspoken and passionate in his viewpoint on the misuse of nondualistic teachings for personal gain and has appropriately named the phenomenon the "Advaita shuffle," referring to the ways in which people take the pristine nondualistic teachings of traditional Advaita-Vedanta and shuffle them around in order to avoid the real implications of nonduality.

The following selections are from an article entitled, "The Perils of the Advaita Shuffle," subtitled "These Days, Is the Absolute View Used As an Excuse to Avoid Waking Up Fully?" published in *What is Enlightenment?* magazine.

> Many mistakenly feel relieved from the burden of responsibility for their own behavior because of erroneous conclusions drawn from their spiritual experiences of no-separation. Realizing that "everything is the Self," they concluded that therefore there was nothing and nobody to be responsible for. In this way of thinking, responsibility implies duality, and any notion of responsibility is therefore seen to be an expression of ignorance. In this view almost any mode of conduct becomes acceptable—when one proponent was asked why he habitually acted rudely and with dishonesty, he said, "Oh, that's not real, that's just my personality." Another student said, "Nothing matters because it's all the Self." Others have answered with incredulity when asked about responsibility for behavior, "How can there be responsibility in Freedom? Who's responsible?" . . . Many people do have profound experiences when exposed to such teachings, but the teachings usually

have the effect of enslaving a person to a deluded view that they are completely free simply because they have had a glimpse of the fact that there never could have been a separate entity who could be bound in the first place. It is at this point that the Advaita view, as it is frequently proclaimed these days, becomes patently ridiculous. Such a view can make a person extremely confident, because any difficulty that one is faced with, from within or without, can be "Advaited" by saying that it is all unreal or all the Self anyway . . . However, this confidence becomes a form of arrogance, a form of self-delusion, when it is used to avoid one's own difficulties or areas of avoidance in order to obliterate the uncomfortable, dualistic facts of one's own personal situation. The Advaita view can paralyze a person and prevent him or her from sober self-introspection because to consider one's "self" is to entertain illusion, is to deny one's own realization, is to embrace the falsity of dualism. In this way, the opportunity to truly be free to face any difficulty or imperfections in one's own character is destroyed. Any desire to change anything, in this view, is seen to be coming from the ego, from ignorance, because change implies separation and only ego could want change.[5]

*It's the striving that separates us from who we are.*
JOAN HALIFAX

The spiritual slander described here is yet another masterful manipulation created by ego. Presumptions are layered on top of presumptions: the presumption that ego knows what enlightenment is; the presumption that the insight into non-separation means that an intellectual understanding is integrated into the whole of the individual; the presumption that there are no further insights than that of non-separation; the presumption that one (or, in this case, "no one") knows that their assumption that they are living in the nondual state is correct, and so forth!

Again, it is not the teachings themselves that are to blame. Such teachings were intended to be studied throughout one's lifetime under the guidance of a qualified spiritual master in a culture that has a

strong spiritual foundation, and to be practiced with diligence in the context of a broad understanding of the subtleties of ego and the whole of the spiritual life.

*I certainly hope that every-*
*body who claims to be enlight-*
*ened actually is enlightened.*
                ROBERT SVOBODA

Andrew [Cohen] does not deny that the Advaita teachings can liberate someone from the fundamental illusion of duality by revealing that there is indeed no separation between a person and what it is they are seeking. But the teaching, as it is so frequently taught, is fundamentally limited in that unless a person is perfectly, fully and finally Liberated by these teachings (a very rare event) their lives will be to some extent an expression of duality and an expression of ignorance.[6]

In other words, the teachings themselves are not responsible for the delusions perpetuated as a result of them; rather, when individuals presume that they are fundamentally and absolutely liberated based upon their understanding and experience of these teachings, they are ignoring the reality of the duality that remains in their lives. Nonduality is true of Reality, but so is duality. Most important, one must not presume that an understanding of nonduality—intellectual or experiential—is equivalent to a life that is a continual abidance in, and expression of, the nondual perspective.

In a public talk with Lee Lozowick in Boulder, Colorado, Cohen summarized his position on claims of living in nonduality. "It's so easy for people to say, 'Well actually I don't exist,' when whoever they are is sitting right there. We have to approach this matter with great care. Otherwise, we'll assume we know what it is we're talking about when actually we have no idea. What it actually means to not exist is a very delicate thing to understand."[7]

Ultimately, our goal is to live by the inner voice, the inner guru, to learn from all of life, and to dwell in the realization of the nondual perspective that "all is One." The fact that these realities are often manipulated and used in the service of self-deception does not negate

their value. The first step in moving toward an effective understanding of their true meaning is to expose the fallacies they are subject to.

## LLEWELLYN VAUGHAN-LEE: RECOGNIZING THE HIGHER MIND

*I'll tell you a very interesting thing: If you get a message from the higher Self, your mind knows that it isn't you. You get told something from somewhere else, and your mind instinctively knows that you didn't know it, because you are just sitting there and one moment you didn't know anything and the next moment you did. So the lower mind begins to recognize the higher mind, or the intuitional mind, or the part of the mind that is connected to the higher Self, and to know that it isn't oneself.*

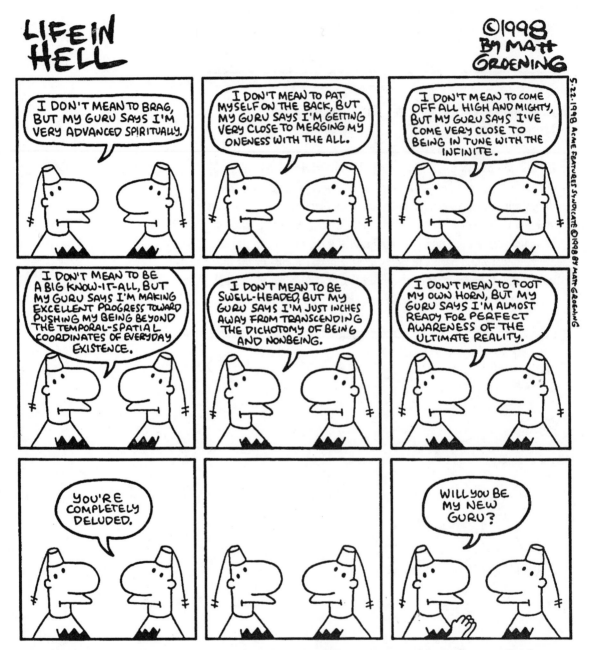

# Section Three
# Corruption and Consequence

*Why is there the possibility of distortion? Why is there the possibility of lack of purity? Why? If you really examine this, it should raise some strong questions. If people really questioned this, it would propel them into a higher standard for their own spiritual work. The fact that there is distortion, that there is the possibility of the production being phony, an imitation, should add an important element to one's spiritual work.*

—Jai Ram Smith

The dangers of mystical experience and of ego's tendency toward self-deception become magnified and have ever-increasing implications when one begins to interact with others on the basis of the presumption of enlightenment. This section examines the nature of power and corruption, and what happens when those with personal power—whether based on pure fantasy or on something genuine yet only partially developed—enter into the teaching arena.

# Power and Corruption

*Although God is the ultimate source of all energy, the self has a tendency to misuse it for its own ignorant purposes.*[1]

—Bernadette Roberts

"It's easy to be a monk on a mountaintop," it is said, and rightfully so. Alone on the mountain, one must wrestle only with one's own mind and inner forces. As long as the monk stays in seclusion—even if he presumes he is enlightened long before this is so—no harm is done, except of course to himself. But when he descends the mountain and re-enters the world of human relationship, all is manifest externally as well as internally. Each internal tendency toward the abuse of power—what we are calling "corruption"—has an external counterpart. Furthermore, the external world often does not bring clarity and truth, but instead mirrors the internal corruption. The inner and outer worlds are full of opportunities for corruption to manifest in the individual who has even the slightest unrevealed vulnerability to the seductions of power.

Power in itself is not a bad thing. It is only the truly powerful individuals who are able to effect positive change in others and in the

world. The great politicians, spiritual leaders, and lesser-known individuals who have touched and affected their environments are all powerful people. Power itself is a neutral, objective force that only becomes corrupt when it is used for self-centered or egoic purposes. For example, the power of the CEO is useful if he or she provides a healthy working environment for company employees, does not exploit human or material resources, and provides a necessary service to people. That power becomes corrupt, however, when it is used for purely self-centered purposes: to control others, to accumulate unreasonable storehouses of resources while others are struggling to make ends meet, to produce products that are harmful to, or taxing of, the environment.

Joel Kramer and Diane Alstad, co-authors of *The Guru Papers*, claim:

*The relationship between control (taking charge) and surrender (letting go) presents one of the deepest existential quandaries humans face.*
JOEL KRAMER
AND DIANE ALSTAD

The corruptions of power occur when maintaining power becomes central and more important than its effect on others. Although this danger is present within any human interaction, it is when power and position are linked that the possibilities of corruption are magnified[2] . . . Hierarchy and authority are part of the human landscape. Both become authoritarian when their main task becomes maintaining power.[3]

Most spiritual teachers hold an enormous amount of personal power, even if they are pseudo-teachers or not fully realized teachers. Many spiritual students also hold such power. This power in itself is neutral, a prerequisite for effectively guiding others. One must be vigilant, however, in noticing when ego and desire mix with that power to the degree that they dominate it.

One must also be vigilant about avoiding a moralistic stance in considering the issue of power and corruption. Yes, gurus who have sex with their disciples' twelve-year-old daughters (and sons) fall into a category far beyond the reaches of "wrong," but in terms of the ordinary, well-meaning spiritual teacher or spiritual student, the question is not one of ethics. The issue is one of learning to proceed most efficiently along the spiritual path with the fewest possible obstructions.

For even if one's own corruption never affects the masses of people, its effects have their greatest consequence on oneself.

Because we are considering not a moral but a spiritual issue, we need to avoid a moralistic, stereotyped definition of corruption, particularly when considering spiritual matters that are often outside the sphere of social morality. Reggie Ray encourages people to clarify their definition.

> We have to be careful what we mean by corrupt. There are teachers who act in an unusual way and are accused of being corrupt, and thus invalidated as a teacher. I would consider corruption to be when the teacher is really not acting in the best interest of his or her students.

## Power and Corruption

Everybody knows the taste of power. Those who do not experience it dream of it, and those who do experience it seek out more and more of it. Power is a great high. It is a Band-Aid on the wound of suffering. When one is soaring on the wings of power, one feels he has transcended suffering. Power can feel like immortality—the deathless state.

All the spiritual texts warn about the dangers of acquiring too much power too quickly. If one does not understand what power is and how to work with it, it easily becomes corrupt. Many traditions particularly discourage the development of psychic powers; or siddhis, because these small powers can be so attractive that one is easily seduced by them, forsaking the path to true power. Power easily plummets into the bowels of self-obsession, the ego becoming fat on its own glory.

The corruption of power occurs in all walks of life, spiritual life included. One who proceeds along the spiritual path learns quickly that just having a degree of attainment does not exempt one from any common human failing or weakness. As we suggested earlier, in our consideration of spiritual materialism, the drive for power and the tendencies

toward corruption that occur in ordinary life are directly transferred to the spiritual path. The same egos that run the armed forces engage spiritual life.

The seeds of corruption lie in each of us. We cannot be certain whether they will take root until we have been tested. Only one who has been given countless opportunities to be corrupted and has turned their back on all of them can say that they are likely to be trustworthy in the face of being given tremendous power.

Gilles Farcet suggests:

> Many people have small positions, a small life—they have their job, their house, their wife and two kids. That is what they can handle, and it's fine. But what if those people all of a sudden had the opportunity to rule over hundreds of people, to sleep with whomever they wanted to and get away with it? They may well become very horrible people all of a sudden.

Before assisting Desjardins with his teaching ministry, Farcet spent many years as a Paris journalist interviewing famous people. He says that one sees corruption everywhere, and that there is nothing extraordinary about it.

> When you're not famous, you're just a guy. Maybe you have a family, or lots of girlfriends, and you try to earn a living. But all of a sudden, you become famous and it is very difficult. The boundaries of your life expand and expand in a way that is very exhilarating. At the same time, if you're not very strong, and very mature, you get lost, because what do you do when you can do anything? You can screw all these women, buy fifteen cars, and fifteen houses, and go to New York for the day on the Concord. You have no boundaries anymore, and you get sort of mad. If you don't have the emotional equipment to face it, you become lost and trapped in your own game. This dynamic is not in itself special to spiritual people, it's just a dynamic in life.

Farcet elaborates by recounting a discussion he had with the producer for a very popular television station in Paris.

> She told me that for new sit-coms they always hire unknown actors, young actors. She said that the minute the show is going to be aired on television and the person is going to become famous and on the cover of the magazines, they know that this young man or woman, who is very sweet and kind and so happy to be hired, is going to change. Literally, from one day to the other, this sweet young man or woman is going to turn into the nastiest son-of-a-bitch you've ever seen. She had been in the field for many years and had *always* seen it happen, with maybe one exception. She said that these young actors and actresses can't control themselves, and that when their stardom starts to decline they just collapse. It's like a law.

Reggie Ray warns:

> All of us are a little bit corrupt. Part of what we are doing is for our own purposes or to reinforce our own ideas about ourselves. Nobody is outside of this whole question of corruption. If you realize this about yourself, then you can work with it. I think that the ego is inherently corrupt, and I think that to the extent that we have egos—and most teachers and students have some vestige of ego that they are still working on—then we participate in that.

*In total detachment from Buddhas and devils we must acquire the ability to say a great yes to the world of the absolute and the world of the relative, as well as to the Buddhas and also the devils.*

THE OX AND THE
HERDSMAN

The fact that everybody is corrupt to some degree isn't necessarily a problem. The tendency toward corruption seems to be a part of human nature, at the very least a part of contemporary Western human nature. There are degrees of corruption, however, and those who are most corrupt are least likely to be aware of the forces that run them. Kramer and Alstad suggest that "Dealing awarely with power involves guarding against its corruptions, instead of denying that one is corruptible."[4]

Not only is everybody corrupt to some degree, but everybody participates in the corruption around them by not doing anything about it. The most dramatic example in recent history is Hitler's Germany, where millions did nothing as other millions were murdered. Inadvertent participation in corruption happens daily as well. People are generally confused and have not come to terms with the corruption within themselves, making it easy to overlook a little in others.

Andrew Rawlinson discusses the human tendency toward corruption and self-deception that led to the suicides at Heaven's Gate.

If you bombard people with something enough, they'll take it on, as was true in the example of Marshall Applewhite from Heaven's Gate. Before he started preaching about the Hale-Bopp comet and the UFO that was flying behind it, he was called Bo and his companion was called Peep. They would stand on soapboxes on the University of California Berkeley campus, right alongside the Jesus freaks, and preach: "Hear this people! A year ago we were just lying quietly on our bed, and the ceiling rolled away, and we saw a UFO." They would share the teachings from the UFO for twenty-five or thirty minutes and then would say, "If you want to know any more about this, come up and see us." And people would come up, and they would tell them, "We're not going to tell you any more now, but if you go down near route so-and-so in southern Arizona, and go to such-and-such town, just outside the town you will find a public phone booth. If you look on the bottom left-hand corner, you will find a phone number. Call that number and the people will tell you something." People who had stopped to hear them at lunchtime didn't go home. They got in their car and drove to Arizona and called up and joined, just like that. They left their kids, their job, their home, after thirty minutes of exposure to something that they hadn't even been thinking about. If the plug is right, it just keeps the water in the basin. It happens outside of the spiritual sphere and inside it. Look at the First World War. English

mothers sent off their first son and their second son. And they would die. And then they would be proud to send their third, and their fourth, and they would all die. What is this?

This is the nature of corruption. This is the humbling reality that human beings, because they are suffering and confused, will—particularly when pressed into stressful situations or given the opportunity for power or fame—show an overriding tendency toward self-deception and corruption.

## Power Does Not Equal Enlightenment

Many people assume that charismatic and knowledgeable individuals—particularly those with a spiritual "glow" or a solid grasp of spiritual dharma—are in fact enlightened. But true power is not necessarily perceptible to the ordinary eye. There are many examples of great Zen masters who came to the West and worked in laundromats or donut shops for years before anybody recognized their powers; or of great saints in India who lived as beggars on the streets, enduring the disdain of the masses, before they were recognized for who they are. On the flip side, dramatic manifestations of power—such as the current craze of "firewalking," or the popular pseudo-tantric demonstrations—are not indicative of any genuine power.

*Self-justification is worse than the original offense.*
SHEIKH ZIAUDIN

Furthermore, even if one does have true power, this does not mean that the power of ego has dissipated. Andrew Cohen says: "Most people don't realize that ego and profound realization can coexist. It is for that reason that so many people have gotten into trouble."[5]

Profound—and even not so profound—realization is a tremendous source of power. It provides access to a domain far beyond ego, but also stimulates the ego. There are many concurrent truths about power and enlightenment, and many gray areas. In an article entitled, "Recognizing Authentic Paths to Transformation," transpersonal psychologist Frances Vaughan criticizes the display of power, particularly psychic power, as a means to control or manipulate others.

The display of psychic powers by one who has mastered them should not be considered an indication of spiritual mastery. On the contrary, the use of such abilities in the service of ego goals, such as attracting or intimidating followers, should automatically be suspect. A spiritual master who has truly transcended ego could be expected to disdain the use of special powers for purposes of manipulation and control.[6]

In spite of Vaughan's warning that the flashy show of powers should be suspect when used to seduce followers, many look for such power in teachers as a sign of their mastery. Spiritual seekers who have never allowed themselves to access experiences outside of the ordinary confines of ego (or who don't ever acknowledge such experiences when they do arise) are often over-impressed by the manifestations of psychic power, assuming such powers always indicate an enlightened state.

On the other hand, to say that enlightenment always manifests in the display of powers would be like saying that the only real peacock is the male because he is the only one who displays bright feathers, and that the female, because she keeps her power to herself, is not actually a peacock. Yet, like the male peacock, who uses his feathers for a purely functional purpose, the individual with true power uses that power only as needed, and would be equally powerful if they never displayed their power to others.

## Power and Corruption in Spiritual Life

We have seen that power and corruption are no different in spiritual life than in ordinary life. The same dynamic, the same egoic forces, are at play. However, because the context in which corruption occurs is distinct, the implications of the corruption will be different. Whereas in contemporary culture, power and corruption are not perceived as a problem (though few would openly admit to this), in spiritual life power is only genuinely beneficial to the degree that it is used

in the service of helping others, in generosity, in deepening one's understanding. And most people, even in spiritual life, do not use their powers to this end. Robert Hall, in his many decades of experience in spiritual work, has observed, "There are very, very few people who are the real thing. Most everybody is on some kind of power journey, inflated, or trying to make money."

There are many arenas in which power is turned corrupt on the spiritual path. On the crudest level, people who long to be powerful in a worldly sense but cannot manage it often attempt to find that power in the spiritual scene. New Age fairs are full of people using their intelligence and eccentricities to wield power over naïve spiritual seekers. Anyone with a sharp enough sense of marketing who shaves his head, wears the right robes, and talks the right talk can easily manipulate those on the path who have not learned discrimination and who are internally weak. There are also subtler manifestations of corruption on the spiritual path, as it is an arena rife with possibilities to either consciously or unconsciously abuse one's limited power. We will explore a few of them.

*One of the most embarrassing pieces of knowledge to have is to know when someone is doing something for his own entertainment, but is convinced that he is doing something for someone else.*

IDRIES SHAH

## Corruption Following an Experience of Awakening

Corruption in spiritual life commonly occurs after someone has had a sudden awakening or enlightenment experience. Because these experiences are so powerful and stand in direct contrast to that which the person has experienced up until that point, they begin to think, "*I* have found the key. *I* am God. People must hear what *I* have to say!" It is very easy to become corrupt at this point. If one begins to advertise one's newfound power and gets into a teaching situation, they could be headed for a fall. Claudio Naranjo found himself in precisely this position.

I was once at a point of having evoked in people enough willingness to hear or follow what I said, that I began to use my authority. I used it well at the beginning, and then not so well. My authority was very invited at the beginning, and very

*Disciples in power are less than children; Sages are like a firm wall.*

SAADI OF SHIRAZ

lightly used. The first things that I prescribed were very right-on. For instance, I remember saying to a certain person, "You should write the story of your life, and publish it." He eventually wrote an autobiography and it was a very fulfilling experience. Then I started to abuse that authority and to demand of myself that I have something to prescribe for everybody. I overdid it, and started to force things. I asked for things that were harder and harder to do.

I began to feel more insecure, more challenged, and I started to put down people who implicitly challenged me, and to invalidate them by pointing to their pathology. It may have been appropriate to some extent, and I think I did a lot of good, but there was a bad motive. The worse the motive got, the less that my prescriptions were good, until I put an end to the whole thing. I didn't feel the internal authority to be in that position.[7]

Naranjo's description will be elaborated upon in Chapter Twenty: "The Sadhana of Disillusionment."

### Corruption Following Burnout

Rabbi Zalman Schachter-Shalomi notes how power may be misused on the Jewish spiritual path.

Burnout is the first danger, because you wouldn't get to the place of mastery if you didn't have vision. And the bigger your vision is, the more tasks you see in front of you, and then all these tasks storm on you, and you want to do this and you want to that. You get impatient with yourself and with other people—that all of these things that need doing aren't happening, aren't unfolding as fast as they should. Sometimes people get sour and angry. It's not that they become suddenly sour and angry. It creeps up on you—the amount of work, not taking time enough out for the examination of conscience,

and to check out where you are and for whom you are work-
ing. If you don't have a certain ego strength, you can't get your
work done, but if the ego strength becomes too big, than it
can be egomaniacal, and that's not such a good thing either.
The master is so busy with things that need doing. Instead of
looking at the people who come to him and seeing himself as
the one who has to help them, he begins to see himself as the
one whom these people are coming to help. It's almost like
slave factories get created, to produce whatever needs to be
produced.

The form of corruption that Reb Zalman speaks of is similar to that
described by Naranjo in the sense that what begins as a genuine and
positive motive can easily get lost when one forgets the initial context
from which the motivation originally arose. Even the desire to serve a
great work can become the rationale for falling into corruptive actions.

### Corruption As the Result of Increased Levels of Seduction on the Spiritual Path

A common misconception about spiritual life is that the tenden-
cies toward power, greed, seduction, and so forth, decrease as one pro-
ceeds along the path. On the contrary, spiritual life often creates with-
in the individual the very powers that must then be reckoned with.
Knowing how one operates, and therefore how others operate, or gain-
ing special powers of perception may give one a disproportionate sense
of power.

Many teachers and advanced spiritual students argue that the
temptations of power and seduction actually *increase* as one proceeds
in spiritual life. Kramer and Alstad write:

*There's a sucker born every minute.*
PHINEAS TAYLOR BARNUM

The literature of Eastern spirituality is rife with warnings
about the dangers of the spiritual path. There is good reason
for this. Ironically, contributing to these dangers is the com-
mon and mistaken notion that the further along "the path"

one gets, the less one is likely to succumb to temptations—until one is fully realized, at which point one is no longer subject to the hazards of self-delusion. But in actuality the reverse is more often true, as the temptations get more insidious, powerful, and harder to resist. Seeing more deeply contains no guarantee against one's mind becoming concomitantly more clever at fooling itself."[8]

On the spiritual path the ego gets both strengthened and diminished. As the egoic mind becomes more powerful, it becomes increasingly clever at fooling itself. Increased power comes hand-in-hand with the increased possibility that that very power will become corrupt. But it is also true that as the seductions increase the ability to work with them increases as well. The pill gets bigger, but it also gets easier to swallow.

If ego gets empowered more quickly than it is gets diminished, one will likely fall into the traps of power and seduction. Llewellyn Vaughan-Lee elaborates:

You have to be very careful, and the more you go on the path the more careful you have to be. In some ways it gets easier, but in some ways it gets much more difficult, because there are more temptations, many more temptations. For example, my teacher said that she could make somebody fall in love with her. It's not difficult once you know how the human heart works. Also, people want to give you things. You can influence people. The danger is that you want to influence people for their own good. What right have you to influence people? Human beings should be left totally free. God is free. What right have you to not allow human beings to be free? Mrs. Tweedie said that even the desire to help somebody was a desire. She had to watch us get into absolute trouble and say nothing. She could have said just one word and we would have gotten out of trouble, but we had to discover it for ourselves, because it was our own evolution.

## JAI RAM SMITH: "I AM A FAKE TEACHER."

*I am a fake teacher. I am one. You're talking to one. I asked for power. I asked my teacher for a position of power, to lead others, and he gave it to me. When he gave that to me, I was as close as I have ever been to everything I have ever really wanted in this work. I was seeing through to the other side when I peeked through the little hole in the metaphorical fence.*

*When people started accessing me as a teacher—particularly the women—I got immediately thrust into wanting to be with all the women in the community. I wasn't able to take the energy and power I had and say, "This is something to be used for service. It doesn't have anything to do with me." When you get empowered, if you have a weak link in the circuit and you've got energy flowing into the circuit, it finds that weak link. That's the nature of power.*

*I actually couldn't see it at the time. It's like something that hits you in your blind spot. I really thought that the thing I had going with all the women was going to work out just fine. I had been trained in spiritual work and it was very clear to me that something very positive was going on. But there were other things working in the shadows.*

*A problem for spiritual students is that often they don't have a corrective function built in. You don't have a monitoring ability to know that just because spiritual work is happening there isn't a lot of subjectivity in your perception. A teacher is the necessary antidote for this type of self inflation.*

*In my own estimation, I failed at the task I was given. I didn't fail utterly, but I came up against something that I couldn't move against. I absolutely couldn't move without utterly redefining myself and my relationship to others. I wanted things to work in a certain way, and they wouldn't work that way and so I backed out. I said: "I can't do this. I can't make it happen given*

*Your medicine is in you, and you do not observe it. Your ailment is from yourself, and you do not register it.*

HAZRAT ALI

*the parameters. It is not going the way that I thought it would go or that I want it to go. I'm dying here."*

*My matrix was incomplete. I was not integrated yet. Sometimes the learning process is not about what you have. I think that most of the people around me know what I have to offer, and they also know what I'm missing. Much of deeper spiritual work is not about gaining in terms of what you already have, but about moving through an apprenticeship to what you're missing.*

---

Lee Lozowick cautions:

As a student, you can never get mature enough, or practice enough, to be able to rest on your laurels. As E.J. Gold has said, "Anybody can fall." He can fall. I can fall. Once one makes a little mistake, it can grow into a bigger mistake and, before you know it, you've got a huge mess! So never rest! Never stop practice. Never make assumptions about your level of practice!

## The Seeds of Corruption Were Always There

*Self-deception seems always to depend upon the dream world, because you would like to see what you have not yet seen, rather than what you are now seeing.*

CHOGYAM TRUNGPA

The possibility for power and corruption exists in all of us. It is only through a process of intensive purification and spiritual practice that one comes to terms with one's susceptibilities and, in some cases, overcomes them. When a teacher of seemingly great integrity suddenly acts in a corrupt manner, people are often shocked. "How could this have possibly happened?" they ask, as if some unprecedented and unusual event had occurred. Of course it is a painful situation, but, to one who understands their own tendency toward corruption, how it could happen is not a mystery. Andrew Cohen reflects on this point.

I don't believe that one goes from a state of purity to impurity. I think that if one may have appeared to have been uncorrupt but then proved to be corrupt, all the seeds for corruption were there from the beginning, and all they needed was a little water to come to fruition, the water being the temptation and the opportunity to manifest. But if the seeds aren't there from the beginning, they are not going to appear out of thin air. Either those seeds are there or they are not, and if they are there, they were there from the very beginning, they just weren't apparent.

It is too easy to take these words and assume oneself to be the exception, the incorruptible one. Thus, one's practice should be to assume that one *is* corrupt, and to be gracious if one is fortunate enough to never express it.

Describing another aspect of corruption, Cohen says, "I've seen people sabotage themselves many times when they are at that point in their own evolution where everything begins to come together, when their potential as a human being finally becomes actualized." When *real* power and responsibility are finally given to the individual, the ego is again cornered by the fear of its own death and rears its ugly head to fight for its own dominance. Cohen explains, "People in positions of power start out wanting truth and reality, but they get into a position of power and the forces of greed and wanting to be somebody special take over. They don't want to take responsibility for themselves. They say they want it, but when they get challenged they're not so sure."

In a meeting with Lee Lozowick in Boulder, Colorado, in 1998, Cohen described how, in his spiritual school, there had been twenty-one students in the past who had been empowered into leadership roles after demonstrating their abilities as strong spiritual practitioners. They were unable to maintain integrity in their positions and subsequently fell from power. One of the twenty-one was a man who exhibited dramatically inappropriate attitudes in relationship to his sexuality. Once confronted, this student went on a mission to destroy himself, and Andrew commented that there was nothing that he or

the others in the community could do: "I'm helpless to keep people from sabotaging themselves."[9]

Cohen's example provides an unsettling illustration of why it is absolutely necessary to become aware of one's own corruptibility—preferably *before* one finds oneself in a position of power. Although ego will devise ever more brilliant masks to disguise itself to the one it is sabotaging, the prepared student has the *possibility* to catch it when it sneaks up on them and avoid its traps.

## Avoiding the Pitfalls of Corruption in Spiritual Life

*Do not think your magic ring will work if you yourself are not Solomon.*

HAFIZ

One of the best protections one has against becoming corrupt in spiritual life is learning how to effectively manage corruption in worldly life. In spiritual life, everything is intensified. All tendencies toward the abuse of power and corruption become increasingly seductive, and the price for the abuse of such power becomes higher. Even one who can handle power in the worldly sense is going to be assaulted with yet another set of temptations when entering spiritual life. Gilles Farcet said that his teacher, Arnaud Desjardins, told him that one of Farcet's qualifications to teach was the lessons he had learned from working his way through the traps of worldly power.

> When you've dealt with the temptations of worldly power, you're not like a little kid who is able to be fooled by anything that comes their way. Arnaud told me very clearly on several occasions that one of the qualifications I had to be in a teaching position is that, although I am still quite young, I've had a rich life. I've been recognized in the world, I've had very interesting jobs, and I know, on my scale, what power is. I know what being successful is. I know what seduction is. I know what being able to fascinate people is like, and I know how to play the games of power and fame. It's on a small scale, but I know what it is. And I know what it is to make your way in the world. Arnaud said to me, "You're not here because you

couldn't do anything in the world and you had to compensate. You didn't just come here because of a spiritual awakening. You could have had power elsewhere, but you chose to dedicate your life to this path. That is a big qualification."

Arnaud was also recognized on television. He created films. He had admirers. He could have stayed on television and had a good job. He didn't need to have students. It is important to have had some experience in life. If you have a weakness with women as a man, which I certainly had, if you've gone through that reasonably, and you've learned from it—maybe you've had a few shocks, had to face the negative side of your weakness and see how it can hurt others—then you know better. You've been burnt, so you don't play with matches anymore. You can really settle into a relationship and not even have the idea of looking around and using your power, because you know what is going to happen if you play with fire.

Unfortunately, most spiritual students have not had extensive experience in dealing with the dynamics of power and corruption within themselves. Many find themselves on the spiritual path because the worldly life did not work for them, and they did not succeed in playing its games. Others who have had power in the world still struggle with similar issues in spiritual life, both because those tendencies are still strong within themselves, and because *having* power did not necessarily teach them how to *manage* it. Thus, they come to spiritual life and must learn it "on the fly," often through trial and much error.

---

## ANDREW COHEN: INTENTION AS PROTECTION

*One protects oneself from any distraction that would take one away from the possibility of perfect liberation through cultivating a very strong intention to be free no matter what. If our intention is very strong then we will never give in to the temptation to doubt,*

*and one expression of the temptation to doubt is the temptation to do anything that could or would in any way interfere with the possibility of our own perfect liberation in this life.*

*If we truly want to be free more than anything else, and we cultivate a very strong intention, it will be obvious to us before any action occurs that if we were to do this that it would inevitably and unavoidably endanger the possibility of our own perfect liberation in this life. It will be clear to us before anything happens that if there is something that needs to be avoided, what that thing is. But if our intention is not absolutely firm, then it will be possible for us to succumb to the temptation to doubt or to be deceived in some way without being aware of it. The reason we won't be aware of it is because still, fundamentally, we're divided—a large part of us wants to be free, but there is still another part of us that wants something else other than freedom, because our intention is not absolute and because we are not completely unified behind that intention.*

*Intention has the power to unify the movement of the personality. It means that I want to be free more than anything else. There is nothing else that I want. It therefore means that any choice that arises in consciousness or that life presents that would or could in any way defile or interfere with that one and only choice will be instantly and automatically be rejected.*

---

## Corruption Exists Because the Possibility of Purity Also Exists

Corruption exists on a wide scale. Unfortunately, for many people such corruption has left scars and produced cynicism regarding the value of spiritual community, spiritual practice, and the necessity of benevolent spiritual authority. People who have been "burned"—disillusioned either by spiritual authority or by their own understanding of the insidious dynamics of ego—often make blanket

negative assumptions about the possibility of purity and integrity in spiritual life. However, to make such assumptions is also to disavow one's own highest possibility for purity and integrity, and is a grave loss. In an article entitled, "Corruption, Purity, and Enlightenment," Andrew Cohen articulates the need to move beyond cynicism before we can discover the possibility for uncompromised purity and impeccability.

These days there is a strong current of cynicism about the possibility of purity in spiritual authority. Indeed, most authorities have failed to uphold or demonstrate perfection as any reliable possibility. Too many of those who have claimed Enlightenment have been found to be corrupt to some degree or other in spite of extraordinary spiritual attainments. This has been very destructive as it has created an atmosphere of disillusionment and skepticism.

People must be allowed to believe that it *is* possible for a human being to go all the way. This becomes a real possibility *only* when one who claims to have arrived is able to clearly explain and demonstrate that attainment. It is that individual's responsibility to prove that it is indeed possible to rise up out of the mess of corruption, compromise and ensuing confusion that is the norm in our time. But the burden of responsibility for corruption equally lies on the shoulders of those who claim to aspire to spiritual emancipation in this life. Only those individuals who are incorruptible in the purity of their desire for Liberation will prevent the continuance of the mess of confusion and corruption that is the norm in the spiritual world today. Those who would complain that hypocrisy and corruption in spiritual authorities is too easily accepted, tolerated and even condoned, must look deeply to find out what degree of compromise and confusion they are willing to hide behind in themselves.[10]

*As long as you want power, you can't have it.*

RAM DASS

*It is quite possible that if you assume that you are enlightened and you move in a positive direction that everything that is not transformed will get transformed anyway, but it may not.*

ROBERT SVOBODA

The teachers interviewed for this book demonstrate the possibility of integrity and virtue in spiritual life. The work that Kramer and Alstad have done in examining the dynamics of authoritarian power is included because of its thoroughness and clear understanding of the issues involved. However, the conclusion drawn here is entirely different from the one they reached: that because corruption is so pervasive and so deeply rooted in the human psyche, all spiritual authority should be avoided. Instead, it is suggested that corruption only exists in relationship to purity, to the possibility of rising above corruption. People become corrupt *because* the essence of the individual is immaculate. Thus, the realization of the dynamics of corruption in oneself and in the external world ideally serves as an inspiration to find in oneself and others that which is pure.

# Mutual Complicity

*It is not enough to see the corruption in teachers if one is not prepared to be brutally honest about one's own willing involvement in corruption. And once one has seen that, one can no longer claim ignorance nor can one authentically blame a teacher for one's own collusion.[1]*

—Paul Cheeseman

Mutual complicity is a sophisticated aspect of spiritual corruption in which both teacher and student participate, often unconsciously, in the co-creation of circumstances that are corrupt and impure, but also mutually beneficial. Although no one benefits from mutually complicit corruption in the long run, the egos of both the teacher and student are temporarily validated and satiated. Thus, one who prematurely presumes his or her own enlightenment will not get very far unless there are others around who are supporting that presumption; and one who assumes the stance of victim of a corrupt teacher must question their own involvement in the circumstance.

Corruption is ordinarily considered to be a one-way street—the bad, corrupt person violates innocent victims. Rarely do we ask what

*The minute you don't want power, you'll have more than you ever dreamed possible.*
RAM DASS

role those who are "victimized" play. Why do some individuals have a history of victimization, while for others it is a rare event? Whereas in worldly affairs one does not have a choice about whether one's town is bombed, or one's house robbed, the decision to engage spiritual life *is* a choice, in spite of the ignorance or naiveté of the one making it. Spiritual life demands tremendous personal responsibility because no one else can or will ultimately take responsibility for another's spiritual choices.

When one deeply examines the force of corruption in spiritual life, one comes to understand that it arises not as the result of a corrupt teacher alone, but as an expression of *the relationship* between teacher and student. For many people it is a startling discovery to realize that a situation that they imagined themselves to be a victim of was actually the result of their own making, at least in part.

The fact is, both teacher and student are 100 percent responsible in their relationship to one another. The teacher is 100 percent responsible to see that they do not create a corrupt situation in their spiritual school and with their students; and the student is 100 percent responsible to not tolerate, participate in, support, or consciously or unconsciously create any corruption in their relationship to their teacher and spiritual community. Each is fully responsible, and if either takes their responsibility seriously they provide a tremendous service to the other.

The reality of the existence of mutual corruption is important to know about, and it is also very good news. For although it can be disheartening to realize the degree to which one participates in the creation of the very circumstances that create so much difficulty and disillusionment in one's life, knowing the truth of this means that it is equally possible to create a situation that is healthy and mutually beneficial to both student and teacher.

A review of the psychological dynamics of projection and transference will help us to understand how mutual complicity comes about, how it is sustained, and how both teacher and student can guard themselves from involvement in it.

## Projection and Transference

Carl Jung clearly articulated the psychological phenomenon known as *projection*, the process by which the individual unconsciously creates the circumstances of his or her life based upon beliefs and expectations formed in childhood about the world and its people.

It is often tragic to see how blatantly a man bungles his own life and the lives of others yet remains totally incapable of seeing how much the whole tragedy originates in himself, and how he continually feeds it and keeps it going. Not consciously, of course—for consciously he is engaged in bewailing and cursing a faithless world that recedes further and further into the distance. Rather, it is an unconscious factor which spins the illusions that veil his world. And what is being spun is a cocoon, which in the end will completely envelop him.[2]

*Transference*, projection's companion, is the process by which one's projections are placed onto another individual, usually a perceived authority figure.

Projection is the source of much of our illusory world. Aspects of oneself that are either unconscious or denied get transferred onto an external circumstance or individual. The person who is projecting believes that his or her projection is true, and through the power of that projection can create a reality that didn't previously exist. When there is no mastery of one's mind, one can easily be fooled into believing that another's projected ideas onto oneself are actually true.

Robert Hall recounts his initial encounter with the projections of others onto him as a guru.

I was a young man—about thirty-five years old, and was just beginning to teach in Lomi school. It was back in the early seventies and a great number of people started collecting around me. I realized that I was scared and hadn't any idea what was happening, and also that I was surrounded by the

*It is necessary to make people realize the responsibility for their own lives and their own spiritual path. It is possible to accompany them, but not to travel in their place.*

MARIE-PIERRE CHEVRIER

potential of falling into grandiosity and inflation. The people turned over a lot of their personal, individual power to me. I fled the situation. I wasn't capable of dealing with it maturely.

Yet even when I fled, people followed, and the group I was working with began to set up training programs. But that kind of mentality—people who were seeking answers, seeking authority, and seeking gurus, was really frightening to me. I was very aware of not being able to fulfill that role. Eventually, I saw that I could teach them because I saw that their ideas about what they were learning were not inflated. They were interested in becoming better people, better workers. That was fine with me. They weren't seeking to be saved from themselves.

It was to the great benefit of Robert Hall and his students that he recognized the danger of the projections that were cast onto him. Eventually, he chose to teach the individuals he had fled from, though not in the function of guru and only after assessing the overall workability of the situation. His students were assisted in their work by virtue of Hall's not allowing them to project a distorted sense of authority onto him that he knew he was incapable of handling.

## The Value of Projection and Transference

Projections occur. Whereas in the ordinary unconscious life they are largely a hindrance, they can be of value at a certain point in one's spiritual work. Colorado psychologist Gary Mueller discusses the inevitability of projections.

It's part of the human psyche. With whomever we encounter, because we're in this human form, we're going to project aspects of ourselves. Sometimes those are divine aspects that we're afraid of in ourselves, and in that way the teacher can be a beautiful mirror. In that mirroring process the student can

discover that what they see in the teacher is an aspect of themselves that they can then begin to cultivate.

Projections and transference can be positive. People who don't have a thorough understanding of the nature of psychology believe that these dynamics are essentially bad and should never be allowed between people, but Llewellyn Vaughan-Lee explains their potential value.

People come to a teacher and they don't believe in themselves, but the teacher believes in something in them. The teacher sees a potential in them that they haven't yet realized. They don't even know it exists, or they feel it dimly. The teacher holds this projection of the higher self for the disciple. The teacher believes in them more than they believe in themselves. And this is the way it should be. What matters is that there comes a point when the teacher has to give it back. The disciple has to be thrown back upon themselves, to take responsibility for their own inner wisdom. What matters at this point is that the teacher has absolutely no interest in keeping the projection, in being this wonderful person for the disciple. You have to be able to cut it at the right moment.

As Vaughan-Lee suggests, projection and transference can be useful, but they are not always so. Not only can students get attached to their projections, but they present an obvious seduction for the teacher who is enjoying a projected divinity. Reggie Ray considers this dilemma.

It's a really hard thing to deal with, and it's hard to be skillful. You have to let people project because, obviously, it's a part of themselves that they need to work out. So there's something intelligent in it. But at the same time, how do you work with it so that you can move them along so they don't get stuck? This is the issue. If they practice long enough, they will eventually begin to have doubts about their own transference.

*Students create the master and project onto the master because they have something invested in it and they are going to get something out of it. The more they invest in the master, the more they are attached to him or her.*

JAKUSHO KWONG ROSHI

Lee Lozowick says that transference is really only valuable when the individual who is being transferred onto understands the underlying dynamics such that he or she does not take advantage of those dynamics to manipulate and dominate the person who is doing the transferring. As will become clear, if the object of transference cannot see it for what it is, then ego inflation and mutual complicity are likely to arise. Lozowick elaborates:

> If the person who is being transferred onto is as weak as the person doing the transference, a codependency develops, and then you have an unethical situation. Yet, if this is understood, then the situation can build trust because there is not a reciprocal game. The person who is transferring and projecting slowly comes to trust the integrity of the other person more than their own ideas of who the person is, because that other person isn't captured by the transference.

When Danan Henry was sanctioned to teach by Philip Kapleau Roshi, Kapleau Roshi came to Denver to do the ceremony. While out for a walk with Henry the morning that he left, Kapleau Roshi told him: "Remember, Danan, that your obligation is to protect your students from your influence."

Sensei Danan was being asked not only to avoid the traps of the transference that would be placed upon him by virtue of his position and influence over his students, but to protect his students from their own projections, transference, and displaced illusions about who their teacher was and what his function was in their lives.

### The Traps of Projection and Transference

The benefits and traps of projection lie very close together. Returning to the idea of mutual complicity, what tends to happen is that a student projects certain qualities or attributes onto the teacher, and the teacher's *ego* accepts these projections as though they were indeed true of *itself*. If the teacher does not understand what these projections

are and unconsciously accepts them, he in turn projects back onto the disciple qualities of inferiority, lack of divinity, and so forth—thus affirming the disciple's illusions about himself and about the teacher. In psychological terms, this is known as *counter-transference*. This cycle between teacher and student occurs unconsciously and results in a dynamic in which each must sustain their mutual projections in order to continue the relationship they have set up.

Judith Leif explains how easily a teacher can fall for the traps of the student's projections, in spite of the best of intentions.

> There is an incredible kind of power that comes with the student-teacher relationship. There are adoring students, and sometimes even people who start with good intentions, if they are not wary or well trained, can be swayed by the expectations of the students around them. They start believing everything that they hear about themselves whether it is true or not. It's not a bad guy or bad woman trying to pull the wool over people's eyes, it's not just self-deception—it's a mutual creation of the students and the teacher. It may start simply and then build. A person may be seduced by the power of inflated adoration and praise that is beyond what is appropriate for them. It's very seductive. I think it is very human.

Similarly, Gary Mueller suggests:

> The trap for the teacher is, "Ah. I'm being loved. I'm being admired." That is a very subtle trap because a lot of times we don't acknowledge that. But we have to watch that energy. The ego of the teacher begins to suck on the energy from the other—the admiration, the idealization. The ego swells and we can become addicted to the projections of others, and in our addiction we need others to be in that process with us. That's the real trap, for the teacher and the student.

Vaughan-Lee explains that the already charismatic teacher becomes even more charismatic because of the immense power of the psychic energy carried by the students' projections. This energy increases the vitality of the one being projected onto; thus, in the projected world co-created by students and teacher, the illusions appear to be even more real.

These examples all point to the danger that projections bring. The adoring students *and* the egoic forces in the teacher conspire toward the creation of a distorted situation, and it takes tremendous attention to counter those forces.

*When a nineteen-year-old woman who is in love with the dharma transfers it to the teacher, thinking that the teacher is God, and the teacher seduces her in return, she is helpless. I think that it is not fair just to say, "Oh, take what's good and don't worry about the bad."*

DANAN HENRY

Eventually, the idols of transference must be smashed. It is a very delicate thing to do, because there is a level of projection and transference which is valuable—maybe even necessary—and if you smash the idols too soon, you also smash people's chance of transformation. However, after a certain point even the smashing of idols becomes an element of the projected myth of the teacher.

Lee Lozowick illustrates this phenomenon by describing what happened with Werner Erhard when his students mythologized him.

Whenever he made a criticism of the audience, everybody cheered. That was part of the trip. People thought it was so cool that Werner would criticize them, but nobody took the criticism seriously.

His point is that once transference has gone too far, the teacher can do just about anything (physically or sexually abuse disciples, manipulate them, and so on), and everyone assumes it's a kind of "divine" abuse or manipulation.

## CHARLES TART: THE DANGERS OF TRANSFERENCE

*I had been in a number of Gurdjieff-oriented groups over the years, and at one point my teacher asked me when I was going to*

start my own group. I was quite surprised and told her, "I'm not qualified to teach a group. I am not an awake person." But then I was reminded of a similar encounter I had had with an Aikido instructor of mine.

I had been trying to get him to send somebody up to the town where I was living to teach an Aikido class, and he hadn't been able to find anybody. So he said to me, "Why don't you teach a class?"

I told him, "No. I only have a brown belt."

I knew how poor my Aikido technique was compared to the people who really knew something about it, but he said to me, "Yeah, that's true. But compared to the person walking in off the street, you know a lot." So I ended up teaching a very successful Aikido class. I knew how sloppy I was, but the students thought that I was incredible.

I then applied this reasoning to the request that I teach a Gurdjeiff group. I decided, "It's true. I don't know what really being awake means. I've never experienced it. I certainly know my faults, my daydreams, my delusions, my craziness. But I have been at it for awhile, and I do understand it intellectually, and I do have some skill in getting a little more present in the moment, so maybe for people just starting out on this, I can teach something useful."

I taught a group for a couple of years. I was ambivalent about teaching it because I knew that teaching a group can drive a person crazy. The students give you such positive feedback that it can be dangerous. But I thought to myself, "This is strictly a part-time activity for me: my wife will hit me in the head if I start getting my ego inflated, and my colleagues at the university will remind me that they don't think much of my work and that I am probably incompetent." I had a lot of grounding factors, and I had a few friends I could talk to about what I was doing who would be honest enough to tell me if they thought I was getting a little crazy.

After a couple of years I phased out. People learned a lot, and nobody got hurt, but I got scared when they projected too much authority onto me. They would ask me a question and I would say,

"I don't know." And they would think that that was a profound answer. And when I told them that it wasn't a profound answer— that I just didn't know—they would think that I was humble as well as profound. I could just see something in their eyes. They were putting a transference reaction onto me. I tried to get them to see it, but it was real hard to get people to see it.

I reached a point where I thought, "I've taught them all I know. I don't want to encourage this kind of transference reaction." We phased out the group and people went away happy without going crazy about that kind of thing.

I'm very concerned with being honest about what I know and don't know, and what my limits are. I also have other sources of ego satisfaction. I don't need to be some kind of group leader to make myself feel good. I have lots of things in my life that are satisfying, but a lot of people don't have that. If all you have is your status as a spiritual teacher, all that energy that students give you back can inflate you to no end.

At some level, we all have that yearning for the magic mommy and the magic daddy who will make things right, so it is easy for students to get a transference reaction that says, "The teacher is so wonderful, and the things that they say and do are so powerful and profound." But that kind of thinking is a very shaky foundation to build relationship on because none of us had perfect mommies and daddies, so there is also the possibility of a profound level of resentment. When people are very involved with a teacher and there is a heavy transference reaction as part of it, if the teacher suddenly does something that doesn't meet those buried psychological conditions, they think, "That bastard has been exploiting me the whole time! He's a charlatan!" The teacher suddenly becomes the terrible mother or the terrible father. So even if a person genuinely has something to teach, the transference reaction creates an unstable basis.

## The Teacher Exists Only in Relationship to His or Her Students

The "great saint" who sits alone on the mountaintop may indeed be a great saint, perhaps affecting universal cosmic forces, but he or she is not a teacher. In fact, the teacher and student are not separate in spiritual life, but become an interdependent organism whose highest function is to serve the transmission of the spiritual teachings. Teacher and student, or teacher and *sangha* (the community of students) together comprise the teaching situation, the spiritual school. Each needs the other. It is obvious that the students need the teacher to learn; but the teacher equally needs the students in order to fulfill his or her function, which is to teach. Each fulfills their own role, and each has an obligation to maintain integrity in the function they serve.

Everything happens in relationship to everything else. When one realizes the undeniable truth of this, it raises some real questions about corruption in spiritual life. When one really understands this principle, one can no longer place all the blame for corrupt circumstances on the teacher alone. "It's never like one person did it," explains Jakusho Kwong Roshi. "The teacher did it, but also the sangha is part of the teacher. We create each other."

Jack Kornfield makes a similar observation.

The problems of teachers cannot be easily separated from the communities around them. A spiritual community will reflect the values and behavior of its teachers and will participate in the problems as well.[3]

*Only a realistic relationship to a guru can possibly bear benign fruit.*

GEORG FEUERSTEIN

Students and teachers together create each other, the beneficial qualities of the resulting relationship depending upon how much vote their true hearts' desire has over the sum total of their egoic wishes. If the collective desire, including the unconscious desire, between teacher and student favors truth and bare reality over self-deception, then that is what they will ultimately create, although there may be many trials and tribulations along the way. If their egoic attachments

are too strong to allow the forces of truth to dominate them, then a corrupt circumstance results. Kwong Roshi has observed this phenomenon in his many years as spiritual leader of the Sonoma Mountain Zen Center.

> Students deserve the teacher that they get. Cosmic forces draw different people into different situations to go forward from, to stand on. You could say, "Boy, I really got ripped off." But that's the teaching. It sounds harsh, but we've been doing this a long time and you see so many different people with so many different teachers. The student deserves the kind of teacher they get, and the teacher deserves the kind of student they get. But also, if they are real seekers, they'll use everything and they'll grow from it.

Here Kwong Roshi goes out on a fragile limb, one that those who have been disillusioned by spiritual teachers are likely to avoid. But his point presents a healthy challenge to all teachers and students. His peers in the world of spiritual teaching have observed a similar dynamic. Claudio Naranjo maintains:

> In the spiritual path, as with marriage, you get what you deserve. You will find a real teacher if you are sincere, if you don't want to deceive yourself, if you put your thirst above everything. And if you learn as much as you can through the processing of your own experience and gaining insight into your own experience, you develop a good nose. You develop a spiritual eye, a clinical eye. Then you can perceive monsters for what they are, and you have enough contact with your own inner genius that you discover the genius of the other.

Marie-Pierre Chevrier claims:

> Before I used to think that it was the false teacher who was responsible and who should be condemned. But now I feel

that it is much more complex than that. It is not by accident that these things happen. The student is also attracted to the situation, if only by his own passivity and lack of self-confidence, and would in any event fall into similar traps and situations.

The teachers included here clearly place the onus for corruption on the part of the spiritual student. Of course the teacher is equally to blame, if not more so due to his or her position of power and ostensible clarity of understanding and depth of experience. But the current trend is to blame all corrupt teachers to the exclusion of considering the role their students have played in creating the situation. "It's hard to blame the teacher," Reggie Ray says. "The teacher is just doing their job. They have their own limitations, they're doing what they do. So how come people get into that kind of situation and can't get away?"

The point is that although situations of corruption can be difficult for the spiritual student to detect, and although the dynamics of projection are strong, nobody, or nothing, can screw up one's spiritual life when one is twenty or thirty or sixty years old. The adult spiritual aspirant, although he or she may be laboring under the vestiges of childhood dependency, is a responsible participant in the creation of the life circumstances in which they find themselves.

## The Paradox

The paradox of this situation is that while the student is clearly mutually complicit in the dynamic set up with the teacher, at the same time the teacher is unquestionably in a position of greater authority and power. It is to everybody's benefit if the teacher respects the fact that many students are veiled by psychological entanglements and self-deception through which they cannot, or will not, see.

Robert Hall, in response to the question of "Who's to blame?" for the dynamic of the false teacher, points out that this consideration can be addressed on various levels, and that each level demands a different response.

*There can't be a teacher without students, and it's hard to be a student without a teacher. You can't separate them out. It's an interdependent thing. Student and teacher have a mutual obligation to keep one another on track.*

JUDITH LEIF

I think that it depends on what level we are speaking. At a certain level both parties are participating in an interactive drama that they bear equal responsibility for creating. I think that's the highest level we are looking at: they are both dancing, participating in their karmic destinies together. There is another level on which to view it, and that is that at the social level the spiritual seeker is without information and without a certain level of intelligence about spiritual life, and a false teacher may have more information and more potential power and therefore bears greater responsibility because of that. What level do you want to talk about?

Charles Tart, while acknowledging the idea that "you get what you deserve," says that this perspective may be too absolute for fallible human beings who live in "the real world."

You could say that it is a flaw in the student's aspirations that led them to a false teacher, and that they get what they deserve; that if you're out to reinforce your illusions you'll align yourself with a teacher who will reinforce your illusions. But that's too absolute. It's like people who say, "If you get cancer it's your fault." That's laying too much responsibility on people. Maybe there is an absolute sense in which things like that are true, but back here in the real world, we make mistakes. Sometimes our intentions are good, but we don't fully understand something and we make a mistake. We need a little room for our humanity, a little kindness to ourselves. The idea is to learn to recognize when we've made a mistake, and not to be so hard on ourselves about it: "Okay, I've followed this teacher, and now I realize it is because it inflated my ego. Okay, now I've learned a little bit more about inflating my ego, and now I can back off and hopefully not make that mistake anymore."

Still another perspective on this issue is offered by Robert Ennis, who, while more uncompromising than Tart, suggests assuming an attitude of spaciousness and acceptance toward those students who indeed walk themselves into this trap.

In one sense, you can never give up responsibility for your own soul and so it doesn't matter what the teacher does, you're responsible. But on the other hand, it seems like it's a shame if people get spiritually raped, it's a shame if their path is made harder than it theoretically needs to be. So, there's no right or wrong about that. Some people will go to a false teacher and realize, "Hey, this is not quite what I wanted," and they'll learn something from that teacher and go on to look for a teacher who can teach them what they really need to learn. Other people will get stuck there. But in a sense they are choosing to get stuck there—they like the excitement of hanging around a teacher like that or they like the power that comes from being close to a teacher like that. And that has to be all right too.

*In Zen, if somebody gives you the teaching from the right, you must give the teaching to somebody on the left. If somebody gives you the teaching from the front, you must give it in the back. We are all in this together.*

DANAN HENRY

## Mutual Complicity Stemming from the Desire to Be Saved

There are many specific reasons why students and teachers enter into a mutually complicit situation. The first reason has to do with the desire to be "saved." As initially discussed in Chapter Three, the longing to be free of one's suffering, to be reassured that "everything will be okay," is a fundamental desire in human beings that stems from the illusion of separation. If they can't be ultimately saved, people want to be protected in the relative world, to find respite from the continual experience of human suffering. And people will go to great lengths in search of this. In her teaching work at Arnaud Desjardins' ashram in France, Marie-Pierre Chevrier has encountered many spiritual students who have found themselves in this dilemma.

I have had a lot of experience with people who come here who have been taken in by a pseudo-master, often in the context of Yoga, Tai Chi, or even astrology, in which the teacher has developed a real power over the students, and in which the students have come to feel that they are caught in a system in which they are going around in circles. These people often met their pseudo-masters at a critical moment in which they were needing reassurance, and they found it within the type of confidence that these so-called masters exude. What we see today is that there is a desperate lack of real reference points, and that people are searching anywhere they can find for some kind of solid ground on which to stand.

The pseudo-teacher gives the student the reassurance he or she is longing for. They may tell themselves that they are building self-esteem in the student. Or perhaps they adhere to an idealized philosophy that says that "Everybody is enlightened" or "We are all God." Meanwhile, the student, who suffers the universal human condition and who operates from a fundamental context of feeling unloved, finds this teacher (who they are unconsciously aware suffers the same unlove as they do and will therefore operate from the same context) and they enter into a co-dependent, mutual validation process. Andrew Cohen articulates this process.

The spiritually ambitious individual will attract people who want to be saved rather than liberated. If you want to try to save anybody, basically you have an arrangement with them: if they worship you, you will tell them that everything is okay. They give you what you want, which is to be adored; and you give them what they want, which is to be told that everything is okay as it is, which means that there is nothing left to change. The student then experiences tremendous emotional psychological relief, because in their eyes, you are the all-powerful and all-knowing one, and you are telling them that everything is okay. And because they put their trust in you, you're

telling them what they want to hear. I want you to understand that there is an arrangement here and both benefit.

Carl Jung also wrote about this tendency to seek refuge in, and associate with, an idealized teacher as a way to exalt oneself without bearing the burden and responsibility that the real teacher calls forth.

> Besides the possibility of becoming a prophet, there is another alluring joy, subtler and apparently more legitimate: the joy of becoming a prophet's disciple. This, for the vast majority of people, is an altogether ideal technique. Its advantages are: the *odium dignitatis*, the superhuman responsibility of the prophet, turns into the so much sweeter *otium indignitatis*. The disciple is unworthy; modestly he sits at the Master's feet and guards against having ideals of his own. Mental laziness becomes a virtue; one can at least bask in the sun of a semidivine being. He can enjoy the archaism and infantilism of his unconscious fantasies without loss to himself, for all responsibility is laid at the Master's door.[4]

Ennis says, "Those kind of students think, 'I'm with the one true teacher, the greatest teacher, and I am important because I am a disciple of the teacher.'" Such disciples take refuge in the teacher in the most superficial sense, and in doing so excuse themselves from proceeding with any *actual* spiritual work. On the other hand, Ennis suggests, there is an unexpected benefit from such delusional situations: "Teachers who allow that kind of thing to go on around them serve as a kind of filtering mechanism—they keep the people who aren't really interested in awakening away from real teachers."

Ultimately, the burden falls equally on the disciple who takes refuge in the false prophet and on the false prophet himself, for both suffer under illusions of protection and of spiritual greatness, and both are at least temporarily obstructed from genuine spiritual evolution.

These processes by which one seeks refuge in, or association with, the teacher as a way to avoid oneself, happen almost entirely unconsciously.

*Enlightened teachers who are not tempted by ingratiating students are rare, but childish seekers have always existed in abundance.*

GEORG FEUERSTEIN

No intelligent adult (which most people who enter into relationships of mutual complicity are) could consciously acknowledge their ulterior motives and then proceed in such a relationship with good conscience. It is all beneath the surface. The individual suffers a feeling of unlove so great that he or she will do anything to achieve the promised "transcendence" or "salvation" that the teacher offers. If the teacher pronounces them enlightened, they believe it. Since the underlying dynamics are unconscious, there is no reason to doubt or question the teacher's pronouncements.

Furthermore, in order to sustain the illusion of savior, the teacher and student must together believe that the teacher is greater and the student is lesser (as opposed to respecting the teacher's deeper knowledge in the field). According to Robert Hall, "The teacher-student relationship is an archetypal relationship that has psychological implications for both people, particularly in the area of domination and submission. Often the teacher psychologically needs to feel superior, while the pre-existing psychological tendency of the student is to feel inferior." In a similar vein, Gary Mueller suggests that students will often press the teacher to be superior because it justifies their role of inferiority and of not having to be responsible for their own actions and their own spiritual journey. In their mutual projections, they guard each other from the uncertain truth of the situation: that there is no superior or inferior, savior or saved.

Chogyam Trungpa explains that neurotically-based "refuge seeking" can never work.

> The refuge-seeker has no real basic strength at all, no true inspiration. He is constantly busy assessing greater and smaller powers. If we are small, then someone greater can crush us. We seek refuge because we cannot afford to be small and without protection. We tend to be apologetic: "I am such a small thing, but I acknowledge your great quality. I would like to worship and join your greatness, so will you please protect me?"[5]

As will become apparent, it isn't that people aren't capable of clearly seeing the fallacy in such situations; instead, their desire for comfort is so strong that they are willing to make compromises in order to temporarily feel better, more protected, saved, even though, just beneath conscious awareness, they know better.

## Mutual Complicity As Spiritual Codependency

Spiritual codependency is no different from ordinary codependency, only it usually manifests between a student, or a community of students, and a spiritual teacher. In a codependent relationship, or between parents and children, each behaves in a manner that serves to avoid confrontation with deep feelings of pain either within themselves or in the relationship, but in so doing perpetuates addictions, delusions, and other fallacies. Charles Tart explains the dynamic of ordinary codependency and how it applies in spiritual codependency.

> It is a crazy thing about human life. There is a built-in program in an infant that says that you have to love mommy and daddy. It doesn't matter how awful or klutzy or crazy they are. You love them. It's just part of being an infant. That gets transferred onto the spiritual teacher. So the spiritual teacher may have a hard time not only with their own psychological problems—admitting that they made a mistake, or that they didn't know, or that they goofed, or that they did something out of insecurity or anger—but their students also project this perfection onto them. In order to maintain their influence over their students, they tend to rationalize and accept the projections and this builds the delusion deeper for everybody and is very dangerous. Any spiritual teacher is in a really difficult position in this respect.

*Spiritual practice can never be fulfilled by imitation of an outer form of perfection.*
ST. JOHN OF THE CROSS

Tart's explanation of mutual codependency suggests why people so fear "cults," "brainwashing," and spiritual groups of any kind. They

intuit their unconscious tendencies to compromise themselves as a way of avoiding their own fears and weaknesses and think that the way around this danger is to avoid involvement in spiritual groups altogether.

Jai Ram Smith discovered how pervasive spiritual codependency is in his long-term work with groups.

> When I first started working with groups twenty years ago, it became very clear that real spiritual work was almost impossible because of the agreements that were made by people not to confront each other. The subtle, unconscious agreements that went on were pandemic. They were unconscious, but recognizable. It was a "taste" that revealed them. If you could take someone to an inner level and ask them what was going on, they could identify it, but that is very difficult to do. Only someone who has the capacity to break the pattern of codependency—which is what a teacher or leader will optimally do—can stop the pattern.

Unfortunately, many teachers do not have the conscious skills and integrity to stop the patterns of codependency, and many students are too veiled in their illusions to admit to what they perceive. It's not that each is not capable of greater clarity, they simply don't demand it of themselves because they are unconsciously aware that they are reaping tremendous benefit from the illusions that such codependency allows them.

A common scenario of spiritual codependency arises when people become addicted to the feelings or experiences they have around a particular teacher. For many people, a spiritual teacher is their first introduction to the experience of divine love, or to the opening of the heart, or to profound mystical experiences. For those who have led constricted and sheltered lives, simply being in the proximity of somebody who is more open than they are, and who gives them permission and encouragement to open up, can provoke a powerful experience, or opening, within themselves. This opening can be so exhilarating, so

liberating, that they become very attached to it and to the person who they believe to be responsible for it, and are then willing to overlook many things in order to stay connected to the perceived source of their opening. In an article entitled "Spiritual Slavery and Prostitution of the Soul," Andrew Cohen says that people are unwilling to question the perfection of their teacher's attainment for fear that this will threaten the link with the Absolute that their teacher represents.

Often when a person meets a teacher in whom the Absolute is manifesting to a powerful degree, their heart will open up unexpectedly. They may experience unusual insight and understanding just through mere association with this kind of extraordinary individual. After this kind of experience, it is easy to understand how one may get very attached to that individual. The bond that is formed through experiences like these runs very deep. Slowly, without realizing it, in order to protect the love and beauty of that precious event, the person starts to be willing to overlook things. The minute that begins, they become corrupt themselves.

The minute anybody allows themselves to tolerate corruption they become a part of it . . . The security of their spiritual well-being *depends* on the fact that no matter what, the actions of the guru are *never* questioned. Because their hearts are so invested in the guru, they will make almost any rationalization or justification for the guru's actions. They will do almost anything in order to protect that love that the guru has revealed to them. This is spiritual slavery and prostitution of the soul. In the weak-minded people the seal of enlightenment becomes a license for abuse.[6]

It is interesting that the object of the student's attachment and that which becomes the basis for their corruption is often an experience of a specific feeling state that is believed to be spiritual. We have seen that it is precisely the attachment to such states that is often the principle obstacle to one's genuine spiritual development. In other

*We are experience-starved. . . A person who has some attainment can "zap" people, and it is very seductive. It's like taking drugs. People want that hit again and so they hang around the teacher.*

REGGIE RAY

words, one becomes corrupt and forfeits one's conscience in order to protect an obstacle to one's spiritual growth. Tart wryly comments, "Illusions can give you energy, but illusions mean that you are out of sync with reality."

Spiritual codependency arises when either student or teacher slips in integrity and the other quickly follows. If the teacher demands integrity from the student, the student will struggle along attempting to rise to the demand. When the student demands this integrity from the teacher, the teacher must live up to it or risk the possibility of either losing his or her students or precipitating an overall breakdown in the spiritual school.

Jai Ram Smith shares his views.

When the demand of the student is not great, the teacher is also going to get sloppy. Everything fits perfectly together. Students are looking for the kind of teacher with whom the demand is not absolute. Students and teachers are going to match. At first glance, I would think that the responsibility for the codependent relationship would rest on the teacher, but the experiences I've had of spiritual schools that have broken down is that at some point the students have stopped demanding a certain level of integrity on the part of the teacher.

Thus, it becomes increasingly clear that the student is equally responsible with the teacher for the mutually complicit dynamic. Furthermore, if they want the kind of spiritual help that most individuals who come to a spiritual teacher claim to want, they are going to have to demand it from their teacher. They must, as well, watch vigilantly for the sprouting of their own seeds of corruption.

## The Difficulties of Disentanglement

In the same way and for the same reasons that people stay in bad marriages, they stay in spiritually codependent and mutually complicit

spiritual relationships. The complicity often creeps in so slowly and becomes so comfortable that it is very difficult to extract oneself from it. Although the relationship may be dead and lack integrity, it is, in its own way, workable. Self-deception, as we have seen, is very pervasive and can enshroud the individual in a hypnotic haze that requires too much effort and honesty to cut through. Reggie Ray believes that people are *able* to see through the haze, they just don't want to badly enough.

> I think people do see frauds, and they see them right off. The thing is that they don't realize that they see them. They don't trust what they see, and so they convince themselves that everything is fine. They do this because what they want and what the teacher wants is the mutual complicity. But they do see it. You talk to people after the fact and they say, "Well, actually I knew that the whole thing was completely screwed up, but somehow I couldn't admit it."

There is tremendous payoff in codependency. It may not be ultimately positive, but there is benefit. Furthermore, the mutually complicit relationship between student and teacher is usually just one more event in a long psychological history of involvement in such dynamics, often traceable back to one's parents and/or siblings, repeating throughout one's life in relationships with school teachers, boyfriends and girlfriends, bosses, and, ultimately, the spiritual mentor or even the spiritual master.

Not only are there payoffs in such relationships, but there is comfort. Many people are more "comfortable" in corrupt relationships than they are in healthy ones. Of course it may not always feel so great to be in a mutually complicit relationship, but the force of habit and early conditioning will often prompt one to choose it over a healthy relationship.

Andrew Rawlinson suggests that people will not give up their attachments to anything unless they have to, and if the attachment to an image of spiritual life or the spiritual master is strong enough, they

*If the guru is corrupt and you're intimately involved with the guru, you can't help but be corrupt yourself. It's unavoidable. By association it's an automatic result. It's a very delicate business.*

ANDREW COHEN

will maintain it under any circumstances. He provides a revealing illustration of this principle in his informal version of this true story.

> There was a classic example of this in the middle of the nine-teenth century. The man was an American, a Christian end-of-the-world-around-the-corner type. He had read Revelations and believed that the world was going to end on a particular day and time—let's say next Thursday at half-past three. He had followers, so they all went up and sat on a mountaintop, and when half-past three came around, nothing happened. So his followers asked, "What do we do?" So the guy went back, read Revelations again, and said that he was mistaken, that it was going to happen four weeks down the road, on a Wednesday at half-past three. The same thing happened again. Nothing hap-pened. So he said to the people, "I must have made a mistake about the end of the world happening." Upon his saying this, the people turned on him and said, "Get away. You aren't a real teacher." They *kept* what he had said, and got rid of the bloke who said it. They had to choose, and this is what they did. They were so attached to the notion of the "final end" that they wouldn't go along with the teacher himself saying, "I've made a mistake."

Over time, the lives of spiritual students and their teachers become deeply entwined, and situations develop that are difficult to get out of. Claudio Naranjo says that many teachers get stuck not in their illusions about themselves but in what they are doing and the way they are doing it. They generate a spiritual school, or even an institution, and create something that is genuinely difficult to extract themselves from, even though they may see through their own limitations. Such was the case for Claudio Naranjo.

It takes both great strength and enormous integrity to step out of a situation that is so well established. It involves enduring a tremendous loss of face. If accomplished, it can also be a great example for others, but that is often hard to see in the moment that one is struggling to

extricate oneself from a mutually complicit situation. Both the man mentioned in Andrew Rawlinson's story and Claudio Naranjo were able to extricate themselves from the empires they had built, but it is easy to see how tempting it would be to handle this type of situation with far less integrity than these men did.

Furthermore, it may be difficult to extricate oneself from the spiritually codependent relationship because it is not always a black-and-white situation. Rawlinson explains how this works by citing a familiar example.

> Let's take the relationship between fathers and daughters: daughters are bound to be very stuck to their fathers, even when they are maltreated at some level. They can't let go, and I can understand why that is. They are kidding themselves about who their father is and what their relationship to their father is, but there is something there. There's some loyalty there. It is mixed up with a lot of other things, but it's there. And there's some kind of gratitude, some kind of recognition of the man's strength, even if that strength was aggressive or negative. You can't tease the two out and have only the pure here and the impure there.

*When I began to plunge into the real nitty-gritty of the spiritual path is when the real obstacles came up.*
CLAUDIO NARANJO

The presence of mutual complicity does not controvert the fact that there are valuable aspects to the relationship and that often what initially drew the teacher and student together was something real. If there wasn't any inherent value in the relationship, the individual with enough strength would simply extricate themselves from it, but often they intuit that there is something genuine and true at its base that they do not wish to forfeit. Just as the couple who is deeply embedded in a codependent relationship usually attempts to work their way out of the codependency rather than break up, the spiritually codependent individual often prefers to try to heal the relationship rather than leave it.

### ROBERT SVOBODA: MUTUAL COMPLICITY RESULTING FROM MISINTERPRETED KARMA

*There are a lot of reasons why people with genuine spiritual aspiration end up in the hands of false teachers, but suppose it is simply because of the law of karma. Suppose that a person with genuine aspiration has a karmic connection to a certain individual. And suppose that they owe something to this person. Suppose that this karmic debt matures at a certain moment, and when that debt matures then automatically they are drawn to that individual to deliver them energy or money or something like that. Once that debt is paid back, if it is nothing more than a karmic debt, the person will automatically wake up and say, "Wait a minute! All I've done is deliver my shakti to this person and that is it. The best thing for me to do is simply wash my hands of the whole affair and go elsewhere!"*

*But then people get invested. They think, "How could I have wasted three years of my life with this teacher if he is false?" Then they start to think, "I can't have made such a terrible mistake, therefore my conclusion that he is false must not be right." Or they think, "I've made a terrible mistake, but now that I've made it, I'm stuck here. How can I go back? What face will I show to everybody?"*

*If you're a teacher, you end up with a big ashram. You're always trying to get more advertising to get more people, but basically you're just acting out of the inspiration of your karmic debt. Your karmic debt is pushing you along. So, you get paid back. If you're sensible, you'll recognize: "Okay. I've got payback. Now I can leave all of this and it will be nice and even." But it's difficult, once you're invested, to give things up.*

## Guarding Against Projection and Mutual Complicity

The only way that spiritual students and spiritual teachers can guard against the forces of projection and mutual complicity is through ruthless self-honesty, uncompromising vigilance, and a willingness to break habits and admit to mistakes.

Jungian analyst Marion Woodman says that reaching your human maturity means being able to withdraw projections. Thus, students who realize that they are involved in a mutually complicit situation withdraw the idealized projections that they have placed onto the teacher and replace this vision with a realistic perspective (and in so doing may find that the reality of the situation is far more rich and "ideal" than their projected image). Charles Tart encourages students to withdraw their projections not only because they are unreal, but also as a service to the teacher.

> We have to get more discriminating about what we expect and don't expect from a teacher. That is actually a gift to the teacher, because if you don't put unrealistic projections onto them, you're not giving them that energy to enhance their own craziness.

*Wonder is the beginning of wisdom, but not if it draws conclusions on the basis of insufficient data or pre-judgment of the facts.*

ASHLEY MONTAGU

The student helps the teacher to be a good teacher by being a good student, and helps them maintain their own integrity by not tempting them with excessive adulation and projections. However, there are potential traps even in this approach. Tart warns that the student must also be very careful that his or her "discriminating" is not just an excuse to disregard the actual wisdom and authority of the teacher. "It is a very dangerous psychological idea, because it is also a wonderful rationalization for only listening to what you want to hear of what the teacher says, and for not really changing."

While the student is withdrawing idealized projections (which, if they are not careful, can quickly turn to extremely negative projections), the teacher refrains from indulging those projections and with-

draws his or her own projection, or counter-transference, that the student is inferior, or less divine, or cannot live without the teacher's help.

Gilles Farcet shares his own experience in working with students' projections.

*Detect first what is false or obscure in you and persistently reject it, then alone can you rightly call for the divine Power to transform you.*

THE MOTHER

I try to deal with transference and projections in a very impersonal way. If someone is projecting onto me—whether it is negative or positive—I try to not take it personally. I think this is the key point. In this position of guiding others spiritually, I as an ego have no relevance whatsoever. People are not interested in my ego, even if Gilles's ego may be interesting because it has written books or whatever. This has no relevance. I may have a style of my own, colored by my own experiences in life, but that is not the main point. If someone has a projection towards me, it's just the person's dynamic. It has nothing to do with me. Or if it does have to do with me—the fact that my attitude is not always correct, or that I have made a mistake—then I have to see it, acknowledge it, and correct it. Otherwise, it has nothing to do with me. The projection of the person is just what it is in the moment, and I try to be one with what is and not get carried away with it.

If you're mad at me, you're mad at what you perceive, but it has nothing to do with me. If you're in love with me, it also has nothing to do with me—you're in love with your idea. So I shouldn't bother to identify with your idea. It doesn't make sense to. For example, here people pranam to the meditation instructor, so if I sit on the platform for meditation, of course people pranam, and I pranam as well, like Arnaud does. But if I stop for a second to think, "These people are pranaming to ME," it is very dangerous. They are pranaming to life, to the teaching; I pranam not to *them*, but to life, to the teaching. So there's nothing personal in it. It isn't that my personal dynamic doesn't try to interfere at some points—that's the mechanism of ego—but I have to relate to it in an intelligent way. Otherwise, it's madness.

Though others may language their work with projections and transference differently, Farcet's approach to working with them is the same as that used by all teachers of personal integrity.

Yet even the best of teachers cannot avoid all of the traps posed by their students' transference reactions. Steven Harrison, a teacher and author in Boulder, Colorado, summarizes it very simply when he says, "There is no perfect method."

Lee Lozowick comments:

I don't think it's possible to completely avoid all the traps. You can work so skillfully that you avoid many traps for many people, but you can't avoid all the traps for all the people. So any teacher worth their grain of salt—I guess these days any teacher worth their software or their hard-drive—would be actively adjusting their work in small ways and experimenting to see how to optimize the system in terms of helping the most people in the best way possible. You'll always lose some. Everybody loses some.

Finally, whereas teacher and student must be vigilant in regard to their own tendencies to project and to take on projections which culminate in a situation of mutual complicity, the ultimate protection against these forces is a sheer, uncompromising, unwavering intention to settle for nothing less than ultimate liberation, whatever that may be. Andrew Cohen beautifully summarizes this ultimate perspective, as well as the whole issue of mutual complicity.

*A sadhu must be always alert. His path is very slippery, and a slippery path has to be trodden.*

SARADA DEVI

Like attracts like. Corruption attracts itself. A seeker who is willing to settle for less than everything will seek a mentor who would need the shelter of that kind of corruption. A seeker who wants to go all the way, who cannot settle for less than everything, would never be able to bear shadows of impurity, just as a mentor who has truly gone all the way would never accept willingness to compromise in a seeker who claims, "I want to be free."[7]

Although both teacher and student are involved in the dynamic of mutual complicity, as one takes on greater and greater responsibility in spiritual life, they become exponentially accountable for their actions. Thus, one who functions as teacher is far more accountable to "the Work" than is a beginning student. The stakes become ever higher and the cost of unconscious errors increasingly expensive.

# The Consequences of Assuming a Teaching Function Before One Is Prepared

*The most dangerous man in the world is the contemplative who is guided by nobody. He trusts his own visions. He obeys the attractions of an inner voice, but will not listen to other men. He identifies the will of God with his own heart . . . And if the sheer force of his own self-confidence communicates itself to other people and gives them the impression that he really is a saint, such a man can wreck a whole city or a religious order or even a nation. The world is covered with scars that have been left in its flesh by visionaries like these.[1]*

—Thomas Merton

*Only the person who has unpacked his or her own experience can help other people unpack theirs.*

JOAN HALIFAX

Taking on the function of spiritual teacher should *never* be considered lightly. Unfortunately, in today's world many people quickly presume that they are qualified to teach others at the first sign of some kind of spiritual opening or awakening. Arnaud Desjardins has given the term "illegal wisdom teaching" to this phenomenon of teaching before one is legally prepared to do so in terms of universal law.

While it is entirely true that each individual is totally responsible for his or her own spiritual choices and cannot accurately blame the teacher for mutual complicity in their relationship, the teacher paradoxically has greater power and influence over the student. The student may have given this power to the teacher even though the teacher is undeserving of it, but if the teacher has accepted it, it is his. While the individual who makes poor spiritual choices suffers them alone, when the teacher is misguided, all of his students suffer his errors. Thus, the individual who chooses to take on the function of spiritual teacher should do so only with an open-eyed awareness of the implications of such a decision.

Gilles Farcet compares the teaching function to a precision tool.

To be in a position of teaching authority is like anything that is very efficient—like a tool or a weapon. You pay a dear price for a good weapon or a good tool. Actually it's priceless. But it is also very dangerous. If you mismanage it, if you don't handle it properly, it can destroy you. That's what a precision tool is.

Kapleau Roshi told Danan Henry that he must protect his students from his own influence because of this precise danger. Such influence is a tremendous source of power and, like any source of power, can be used to effect positive or negative consequences.

## Half-Baked Teachers

The Sanskrit term *ardha dagdha* means "half-baked." Robert Svoboda uses the analogy of a clay pot to illustrate what happens when a teacher is not fully prepared to begin teaching others. "If you have a clay pot that has been well fired, you can pour water into it and it can sit there until doomsday. But if you have a clay pot that you've fired only part of the way, if it is not completely cooked, the water will soak into it and eventually it will fall apart."

The baking in this equation is the slow process of transformation and preparation necessary to become a teacher. If the "water" of excess energy, projections, too much adoration, or demands that are too great to handle are poured into the half-baked pot of the untransformed teacher, the pot will break, the teacher will crash, the system will fail.

Although many people are eager for the transformational process to be quick, Svoboda says that it should happen slowly and thoroughly, so as not to leave the individual half-baked.

> You want the transformative experience to occur slowly. The danger arises when you have a mystical experience that is transformative, and you conclude that that is all the transformation that needs to happen. Or maybe you conclude that this is all the transformation that can happen. Then you're stuck. Then you continue accumulating shakti, and you continue reinforcing your worldview.

The phenomenon described by Svoboda is common. People do not have a solid education or foundation about spiritual principles and spiritual life and, instead of seeking that out, are quick to succumb to ego's conviction that upon the completion of a couple of years of meditation or a few visions of angels one has indeed "arrived" and is ready to start one's teaching mission.

*To imitate a saint is to ask for real trouble.*

ROBERT SVOBODA

The moment that these individuals begin to teach, the dangers to themselves and to their students increase exponentially. When one begins work with students, one enters into a field of tremendous energies, and not only positive ones. If the transformative process is not complete to the extent that the teacher is chemically and alchemically prepared to handle such energies, difficulties *will* arise, and it is lawful that this should be so. Svoboda explains this principle in terms of what happens to the energy of shakti when one begins to collect students.

> Most of these so-called gurus in North America go bad because they go over to India and think, "Yes, I've developed a lot of shakti." Then they return to the West and find themselves in

a totally different place—a place where their senses are being attracted by the media and various other influences all day long. They start being a guru and they accumulate a lot of people who are "shakti hina," or shakti-deficient, because they have been using up all their energy for enjoyment. Such students think, "Ah! The guru is now going to show me a way that I can have my cake and eat it too, while I'm meditating a little bit to keep him happy."

All these people begin to project their neuroses on the guru and the guru begins to have trouble. The students are extracting his shakti and paying him back in their polluted shakti. If the guru is a tough guy, it won't make any difference. He'll somehow deal with it. But if the guru is not a tough guy, what will happen is that little by little his mind will start to get distracted. It will generally happen so slowly that he won't even be paying attention to what is going on. As he gets distracted, he will move in the direction of whatever thing he is weakest at: he will start to eat too much, or he will start being attracted to all the young women in stretch pants in the ashram. He will indulge in some weakness because that is what diseases do: they go to the weakest part of the organism. Then he will begin to make justifications for himself because he cannot digest all these pressures. Digesting shakti is a difficult thing to do, especially if it is poisonous.

It should become clear that to take on a teaching function is a very serious affair, and that the long preparation that traditional spiritual schools require is not to hold the students back but to make them ready for the challenges they will be faced with. Corruption often sneaks in the back door, and teachers may be surprised to find themselves in a situation that they are not fully prepared to handle.

According to Marie-Pierre Chevrier, an example of this gradual corruption occurs when students begin to outgrow their teacher and want more than the teacher is honestly able to give.

The teacher starts sharing what they know and what they've experienced, but rapidly is induced to share what they *think* they know. Then what happens is that the students themselves will push the teacher with more questions to go further and further in that direction, and in so doing increase the power of the teacher. The danger is that it then becomes impossible for the teacher to turn around.

The teacher that Chevrier describes, who was never really prepared to call himself a teacher in the first place, does not want to lose face, or is enjoying others' projections, or imagines that he is more powerful than he actually is. At this point, the teacher either admits to himself that he is less qualified to teach than he imagined—which is a very rare occurrence—or, more often, he overlooks this fact and starts playing in water that is way over his head, justifying it with any number of dharmically-correct rhetorical responses, such as "I'm just following my heart," or "I received a 'message,' to teach," or "It is God's will for me to teach."

Svoboda challenges such justifications.

*But who is to guard the guards themselves?*

JUVENAL

The person thinks, "What is happening right now is the will of God, and I prefer for the will of God to happen because it is very sweet." If a person focuses first on what is the will of God, the will of Nature, and it is clear again and again that where the greatest sweetness lies is to go out and make promulgations and teach large numbers of people, then they should go ahead and do that. But I think that there are a lot of cases where in fact it is not so much God acting through that person and forcing them to do it, as much as that the person gets a little bit of enthusiasm that goes to their head and they conclude, "It must be the will of God because otherwise why would I be enlightened? Why would God have done this to me if I was not supposed to go out and teach?"

This raises the very complex consideration of what degree of enlightenment or what qualifications are necessary in order to teach. And who decides? In Chapter Nineteen: "True Teacher—or False?" the possibility of the "unenlightened" individual being able to teach effectively is considered, but here we will examine the prospect that the presumed "enlightened" teacher may not necessarily be qualified. When the whole notion of what constitutes enlightenment is thrown into question, one must be wary of assuming that any teacher who *presumes* enlightenment is in fact qualified to teach.

Roshi Mel Weitzman of the Berkeley Zen Center comments:

*I don't think that any of us has an infinite amount of time to make the right choices or the wrong choices. I think that this is something that has to be reckoned with if we're serious about spiritual life.*

ANDREW COHEN

That's why I say that enlightenment is not necessarily the end at all. That's why you have to be careful with enlightenment. A person may have some wonderful realization, but they are not complete, they are not well-rounded. That's why it can be dangerous. It's fine to have enlightenment experiences, but then you have to find out how to have a more well-rounded persona. There are things that have to be worked on. Forget about your enlightenment, just work on these things.

The individual has been partially baked. They have touched upon enlightenment, but, even so, they are not fully cooked. Even if they were, according to Bernadette Roberts, this would not necessarily imply that they should go out and proselytize to the world.

If, in its deepest aspect, mystical marriage has nothing to do with a transient, self-gratifying experience, we have been further misled by authors who give the impression that, once the soul enters the full unitive state, it becomes a charismatic being who goes forth to set the world on fire, or act as a light to all who are fortunate enough to draw near. This is not even the way it went with Christ. There is nothing about the unitive state that guarantees automatic recognition from others. [2]

Unfortunately, it is not the individuals who abide in the unitive state that most often presume a teaching function prematurely. It is those who have touched upon something of union, or even abide there from time to time, or who intellectually know very much about it, that tend to take on a teaching function before they are ready to do so.

## GILLES FARCET: "THE ILLEGAL PRACTICE OF WISDOM TEACHING"

*My teacher, Arnaud Desjardins, often uses an expression which in English translates as "the illegal practice of wisdom teaching." Just as there are quack doctors—charlatans who, though not qualified as medical doctors, pretend to be or remain vague about it, let themselves be called "doctor" and receive clients (though it is a serious penal offense liable to take you to prison)—you could say that there are people who, though they may know something about wisdom or even have had some degree of experience in the field of consciousness, let themselves be called "teachers" or "gurus" and take on the responsibility of students without being sufficiently qualified.*

*Of course, it's far easier to determine the degree of qualification and competence of a medical practitioner than of a spiritual instructor. If you go to an MD, he or she may be more competent or less competent, but at least you know that they have been through years of training in medical school, even more so if they are specialists, and have been certified. You have some guarantees. If you know you're going to have an operation, you will most certainly check the surgeon's reputation and background. But when it comes to spiritual work, people are so naïve and gullible as to pledge their body and soul to anyone who claims to have achieved something in the spiritual realm and who has sufficient charisma.*

## Half-Baked Teachers Produce Half-Baked Students

Andrew Cohen said that you can tell how somebody is progressing on the spiritual path by the tracks they leave behind them, and half-baked teachers generally leave a trail of half-baked students in their tracks. These students are often confused and may be as mistaken as their teacher regarding their own degree of spiritual development and their capacity to serve in a teaching function. Thus, there are not only consequences for oneself and one's students when a teacher chooses to teach prematurely, but even for one's students' students.

The half-baked teacher who presumes a fully-cooked state can do nothing other than produce half-baked students (with the rare exception of the student who transcends his or her master). Robert Ennis says, "What they have to transmit is limited and distorted, and is likely to cause students to either get disillusioned, to be abused in some way, or to imitate the teacher and go off and do the same thing." When the still-flawed teacher sees in his or her student the reflection, or transmission, of what they imagine to be their own perfection, they assume that the student, too, has become perfected. Furthermore, if the half-baked teacher wants to have enlightened students as evidence of his own power as a teacher, the students will often attempt to animate and/or imitate what they perceive to be the enlightened qualities they see in their teacher in order to satisfy both their master and their own egoic desires. Jack Kornfield comments on the futility of such an approach.

> Spiritual practice can never be fulfilled by imitation of an outer form of perfection. This leads us only to "acting spiritual." While we may be genuinely inspired by the examples of wise teachers and traditions, their very inspiration can also create problems for us. We want to imitate them instead of being honest and true in ourselves. Consciously or unconsciously, we try to walk like them, talk like them, act like them. We create great struggle in our spiritual life when we compare the images we hold of ourselves with our images of enlightened teachers, of figures like Buddha, Jesus, Gandhi, or

Mother Teresa. Our heart naturally longs for wholeness, beauty, and perfection, but as we try to act like these great masters, we impose their image of perfection on ourselves. This can be very discouraging, for we are not them.[3]

The student of the half-baked teacher does not understand that awakening is a *context*, and not the ability to deliver a series of dharmic speeches or exalted gestures, and thus he unconsciously sets out to imitate the apparent enlightened *manifestations*, and not the enlightened context.

While many masters and teachers say that enlightenment or liberation is not a prerequisite for becoming a spiritual teacher—particularly if the new teacher is operating under the guidance of his or her own master—Andrew Cohen makes a passionate defense for undefiled, utter, and complete liberation as the prerequisite for taking on the role of spiritual master. In *Autobiography of an Awakening*, he writes:

Even one speck of dust left on the mirror that reflects the Self will hinder and influence to some degree the perfect reflection of the Source of our being. The inherent danger of one who dares to bring others to Enlightenment, without having been utterly and absolutely consumed themselves, is that any traces of ignorance that may remain due to undissolved pride and desire will mar and influence the reflection of the Self and will defile the transmission of perfection. Most who dare to take on the role of Master—even though they may be Enlightened to some degree, and in some cases even to a very powerful degree—because of undissolved defilements have left a trail of misery, confusion and ignorance in their wake. The last twenty years has been wrought with this kind of confusion. The delicacy of this is beyond measure and it is indeed terrifying to perceive the karmic implications of what it means to claim Enlightenment, for if one would dare to do so, one must indeed be able to manifest and BE that perfection without hesitation and without fear . . . That is why it is not a

*My teacher was very real and he didn't talk a lot about enlightenment. When all the other teachers came to America, they were stressing kensho, but Suzuki Roshi would just say, "Practice your enlightenment, little by little. Don't try to force yourself into some great big experience. You can have enlightened experience moment after moment."*

MEL WEITZMAN

game and it is not a joke. That which is sacred is indeed sacred. No one is exempt from the absolute reckoning of one's entire being. Most of the world-renowned masters, gurus and prophets of our era have left a legacy of, at its worst corruption, and at its least confusion, only for this reason.[4]

Perhaps the most important factor in this consideration of the teacher who is not fully qualified to teach is the purity of his or her intention. Because every teacher will transmit *something* to their students, the question is: What will they transmit?

What Cohen calls "enlightened consciousness" can awaken in an individual with pure or impure motivations. Whether this enlightened consciousness can be equated with enlightenment itself is questionable but, as an impersonal force, it can and does enter individuals seemingly at random. When the individual discovers the power of this inner force, he or she quickly begins to attract followers, teaching them the principles of enlightened consciousness while lacking the proper context in which to understand and make use of its force. To consider these teachers to be even half-baked is a very generous assumption, and Cohen goes so far as to say that people are usually better off without the "enlightenment" that such teachers provide.

When there is impure motivation in the vehicle [the human being], but that vehicle is empowered by enlightened consciousness, what you get is a mess. It's not that there isn't a powerful result. It's not like these individuals are ineffectual people who don't know anything and don't have any power at all. People spend time with them and there is a result, but the results will usually be a clear reflection of where that teacher actually is. The results are usually unwholesome. As a matter of fact, I think people are usually better off before they get involved with people like this.

Half-baked teachers who presume to be fully cooked are in a precarious and problematical situation, for they have taken themselves

out of the transformational fire that would eventually burn their presumptuous ego to ashes. To be fully cooked is not to be a juicy, charismatic, plump pot roast—it is to be *nothing*—and many stop far short of this complete annihilation.

## Premature Teaching Inhibits Further Spiritual Development

"Once you become too well-known and too acclaimed, you actually can't do the work anymore," remarks Reggie Ray. "It's like winning the Pulitzer Prize or the Nobel Prize. You spend the rest of your life being the person who received the prize. I've read and heard so many interviews in which such people said, 'You know, I did no more serious work after I received that prize because I spent all my time being a famous person.'"

The initial enlightenment experience is accompanied by the realization that there is "nowhere to go, nothing to do." Thus the individual ceases to make further efforts. Cohen says, "When we're on the path and we still know that we're not there, there is humility; but when we falsely assume and presume that we have arrived at such a place and such a realization, then there is actually no longer anywhere to go and no longer anything to do." Whereas there is truth in such an ideal, it is also a very limiting perspective, causing the individual to stop far short of what is needed to serve as an effective teacher.

When one presumes enlightenment and then broadcasts that enlightenment by taking on the role of spiritual teacher or master, one risks confining one's enlightenment to a small box that is so nicely packaged and labeled that it is difficult to step out of. The individual has so much going for them that it becomes more and more difficult to keep growing and questioning themselves. Enlightenment is the Nobel Prize of spirituality. Just as it takes great humility and discipline for the Nobel Prize winner to not trade in his or her creative abilities for fame, it is the rare individual who is able to remain humble after an initial

brush with enlightened awareness and the premature self-declaration of the function of "spiritual master."

It is more difficult to clean out an infected wound once the skin has healed over, and it is more difficult to clear out and work with potential obstructions once one has declared oneself, or been "recognized" as, enlightened. Who would want to reopen a wound that was already healed over? Many would opt to ignore a minor infection rather than expose themselves to the pain of reopening the wound and the extended process of healing. The same is true of the semi-enlightened individual.

Ray's example of the Nobel Prize winners is so appropriate because the individuals who find themselves in a premature teaching function are often those who entered their spiritual work with great passion and innocence but got trapped in the understandably strong allure of egoic gratification.

Jai Ram Smith relates an account of watching the power of one of his own spiritual mentors be diminished in this way.

> I was with a spiritual mentor who I watched fall. In the end, he was undone by his own gap and weakness in the areas of sexuality and relationship. This person once had a very powerful spiritual impact on my life, and I watched that power be diminished. It wasn't even that it stopped. It would be one thing if the growth was arrested at a certain point, but it seemed to be actually retarded. He didn't understand that there is something bigger than the enlightened state itself. Once you get into the enlightened state, you feel like you are God, and all of a sudden, you're impermeable. E.J. Gold talked about the idea of the "enlightened idiot." The enlightened idiot is someone that even God cannot help. There is no access point to that person. There is no inroad. That can easily happen to somebody who awakens and doesn't recognize the need for help. This, to me, is a big trap.

It is a trap, of course, both for oneself and for one's students. It is an obvious trap for the teacher, and if one's students are not willing to go past their teacher's limitations, they suffer the same fate.

## The Karmic Implications of Assuming a Teaching Function Prematurely

The Aghori Vimalananda offered the following guidance to Robert Svoboda.

> I want you to remember one very, very important thing, Robby: Anytime you try to impose your will on the universe you run the risk of creating a new karma whose repercussions may follow you for years, or for lifetimes. When you fail to live with reality, reality in-evitably comes to live with you.[5]

*Spiritual life is not a game and I think that everything we do or don't do has an effect on the environment around us and also on ourselves.*

ANDREW COHEN

Whereas many of the masters and scholars included in this volume were reluctant to discuss the greater karmic implications of presuming enlightenment before its time, when it came to the subject of assuming a teaching function prematurely, the echo of the potential karmic implications—in addition to the very practical, imminent implications—could be heard loud and clear. Many of the teachers, including Robert Svoboda, Andrew Cohen, and Reggie Ray, adamantly declared that they would not wish to bear the consequences of an action such as the premature assumption of a teaching function.

The term "karma" is thrown around so flippantly that, like the word "enlightenment," nobody really knows what it means anymore. On the most basic level, karma, or the law of cause and effect, dictates that every action produces a reaction. The reaction may be immediate, it may be eventual, or it may even come in other lifetimes, but there will be a response. Andrew Rawlinson simplifies this principle by using the example of hot rod racing.

If you take on something too soon, it will roll you over, like you see in the races in England with seventeen-year-olds in hot rods. They roll them over. They go into corners too fast. They may even be good judges of the line they have to take, but they're going for something beyond their capabilities. If you say, "I will take this on," without acknowledging your own needs and weaknesses, it will always catch up with you, thankfully. The universe is too big a machine for you to escape it.

Reggie Ray was first warned about the potential karmic implications of assuming a guru function under false pretenses by his teacher, and then came to observe it in his own experience and in the lives of those around him. He comments:

I actually don't understand people who really just go with it and do this whole thing of becoming great gurus with people worshipping them and giving them all this money. I don't understand how they do it karmically, to tell you the honest truth. Trungpa Rinpoche used to say that if you try to do that, you'll be vaporized.

There are all kinds of built-in safeguards and protectors that you are bound to when you become a teacher; if you go off, you begin to get heavy messages. If you're willing to relate to them, the messages are very helpful, but if you try to do your own thing, they're not helpful. They nail you. If you don't listen to them, then really bad things happen. I know this from my own experience and from other people. For example, you have an accident, or you die—there have been people who have died. Or you go insane. You have to have consequences. There is a path that's laid out for you karmically and you have to walk on that path, and if you start to go off you get knocked down.

Lee Lozowick learned about karma prior to beginning his own teaching work through his studies with Jose Silva of Silva Mind

Control. Silva's healthy respect for karma provided a strong model for students like Lozowick and his peers who were concerned about pseudo-teachers stealing the methodologies of Silva Mind Control to use for their own purposes.

> There's no way around karma, you just can't predict the time in which it will happen. When people would steal the technology of Silva Mind Control and go out and start their own thing, Jose Silva used to say, "Well, if they're doing good work, and they bring integrity to it, never mind, let them have it; and if they aren't, they won't last long." All of us who were studying with him at the time wanted to sue these people, but he just said, "Don't worry about it. The field takes care of itself. Anybody without integrity will go down—it might take a few years, but they'll go down; and anybody with integrity, let them reach the people you're not going to reach. Let them have the technology and God bless them." It is a very healthy attitude.

Robert Svoboda, whose spiritual training emphasized a thorough education in the principles of karma, discusses the laws of karma in relationship to assuming the function of spiritual teacher.

> The word in Sanskrit that applies here is *adhikara*. A person who is "adhikara" is someone who is qualified to do something. Traditionally, in India, one becomes qualified to teach when the guru says, "You are now qualified to teach." Only when you have received this stamp of permission from your guru would you consider yourself ready to teach. For example, I practice medicine because I have the stamp from my guru who said, "You can go out and practice medicine." Otherwise, I would not want to deal with all the karma involved with medicine. You are taking money from people who are not in good shape. They come to you because they are desperate so they will have desperate money. Will you be able to digest it?

*The flaw with words is that they always make us feel enlightened, but when we turn around to face the world they always fail us and we end up facing the world as we always have, without enlightenment. For this reason, a warrior seeks to act rather than to talk . . .*

CARLOS CASTENADA

*A compassionate guru will try to experience the reactions of a lot of the karmas of his or her disciples, so that those disciples are not completely smashed into the mud as a result of their past actions.*

ROBERT SVOBODA

Questionable. But, if the guru says, "Go and do it," then it is the guru's responsibility. In Hindi, we say, "kitne pani mae tarte hai." It means, "How much water are you able to swim in?" If you are an Olympic swimmer, you can go out and swim the English Channel. If you've never swum before, you may drown in the baby pool. So if you've been well trained and your guru says, "Okay, you can go do the triathlon and the marathon swim," then you should go and do it. But if he doesn't give you the okay, then it's your responsibility.

If I take the responsibility of saying to the disciple, "Go out and teach," then I've taken responsibility for the disciple. It's like a pyramid marketing scheme. If the disciple goes out and does good things, then some of those good things will come back to me. If the disciple goes out and makes a lot of money in the name of teaching and seduces everybody in the neighborhood and murders a couple of people to keep them from getting at his money or his harem or whatever, then I'm going to pay for some of that, too, because it was my advising him that gave him that extra little push to go out and start. Had he done it of his own accord, he would have been enjoying all those karmas on his own.

If you decide on your own that you're ready to teach, it's your responsibility. When you say to someone, "I am your guru," if that person accepts you as their guru then a *sambanda*—a connection—has been established between you and that person. According to the Indian point of view, a guru is somebody whose energy travels with you from lifetime to lifetime, which means that if I take responsibility for you as my disciple, I have to wander around in the cosmos waiting for you to become enlightened, however long that might take. So, if you take responsibility for even one person, that could be a big problem, but if you start taking responsibility for ten thousand people, you're asking for a lot of trouble. Jesus himself only had twelve disciples. But even more than the karmic

problems, you've got ten thousand people whose disturbed, neurotic thoughts are going to be projected on top of you.

The system of karma is vast and intricate and operates according to its own laws—laws that transcend culture, tradition, religion. The implications of ego's seemingly harmless claims of identifying with the role of guru or spiritual teacher can have consequences that last life-times, and will probably also catch up with the individual in this life-time.

Svoboda continues his commentary on the complexity of the karmic connection that is formed in the guru-disciple relationship and the importance of being properly qualified to teach.

If you want to teach somebody, you should ask yourself whether you have the adhikara—whether you have not only the ability, but the license to teach—if you've been given the license to teach by your guru. And if you have been given that license, you still have to ask yourself, "Am I qualified to teach?" And if I am qualified to teach, who are the people that I am qualified to teach? Who are the people that I have the right rnanubandhana with—that I will not only be able to teach, but also who will be able to learn. There is no use in going out and preaching over everybody's head and expecting them to get something out of it. "Rnanubandhana" means "the bondage of karmic debt." A karma creates a *vasana*—a mental tendency that causes you to move in the direction of the reaction that the karma you have performed wants you to experience. So a rnanubandhana with somebody is a complex karmic web of actions and reactions between two people that is associated with vasanas that help predict the ways in which you are going to interact in this lifetime for either getting yourself deeper and deeper entangled with one another, or working out the entanglement.

*People think they're free after they leave the temple, but they're still in the stream of life and karma.*
JAKUSHO KWONG ROSHI

*Karma should not be under-stood in terms of a passive, static kind of force but rather should be understood in terms of an active process.*

THE DALAI LAMA

Svoboda's warning applies to the many popular spiritual teachers today who rapidly sanction their senior students to go out and teach. Even if the teacher who does so is not a formal guru, even if they only call themselves a "mentor" or "guide," they are weaving themselves into a complex relationship with the individual whom they send out to teach, taking responsibility not only for that person but for all of that person's students. A teacher in this position does not "decide" to take on this responsibility for their disciples and their students (and their students' students, and so on); it is simply what is because of the law of karma.

It would seem that understanding this law and respecting it would reduce some of the excessive pseudo-transmissions that run quite rampant in the contemporary spiritual scene, but it does not seem to, probably because people so easily deceive themselves about their degree of spiritual attainment. They encourage others to follow them because to the best of their knowledge—a knowledge that may well be only "half-baked"—they are enlightened.

Furthermore, in their incorrect assessment of their own spiritual development, as well as their misunderstood notions of karma, many believe themselves to be exempt from the karmic implications for their actions because they have been taught that once one is "enlightened" they are free from karma. Andrew Cohen is openly and outrightly critical of such thinking. He comments on the teaching of a popular charismatic teacher who said, "After enlightenment there are still very strong 'tendencies' that have to come out in order to 'burn themselves out,' and they will not create karma for the Enlightened person, because being Enlightened they will be free from the consequences of their own actions!" Cohen writes:

> This kind of thinking and this kind of teaching was and is the most dangerous and profoundly deluded misunderstanding of the teaching of Enlightenment. It means "I'm free so I can do whatever I want." How many gurus have gotten away with murder using this as a justification for doing whatever they felt like doing?[6]

Lee Lozowick exposes the problematic interpretations of Eastern thinking that say: "No behavior of the enlightened person is dangerous."

Whereas it may not be as dangerous to the enlightened person as it is dangerous to the student, nonetheless it also may be more dangerous to the teacher to feel that he or she is "above and beyond" all ethics and lawfulness. If you take a statement like that out of its cultural context it becomes an excuse for outrageous behavior. The enlightened person hurts and manipulates people and then says, "In my case, the behavior is just because I'm enlightened." I don't buy it.

The behavior of the enlightened individual not only has consequence, but may have even greater consequence than the behavior of the unenlightened person, both in the relative and ultimate scheme of things. Gilles Farcet suggests that the higher you go and the more responsibilities you have, the less patient the universe is with you, and Robert Svoboda unabashedly warns that even if one is teaching because they are *adhikara*, or qualified, they are still not exempt from the law of karma. When a karma is performed, somebody has to experience the reaction to it. Svoboda explains:

*All men, except for the learned, are dead.*
SAHL OF TUSTAR

The more shakti you have the more scrupulous you have to be since the karmic implications for any of your actions become graver and graver. You have to walk through the world like an elephant that is being chased by a yapping dog. The elephant knows that a single tap from his foot will be the end of the dog. But he refrains from squashing the dog because he knows that the dog does not realize the gravity of what it is doing.[7]

This story points to yet another level of consideration of karmic implications: consciously choosing to do something with a full awareness of the karmic implications for the action and the clear intention to pay the price. Svoboda said that Guru Maharaj (his guru's guru) wasn't deterred by his knowledge about the karmic implications for his actions

## ROBERT SVOBODA: THE NATURE OF KARMA

*The nature of karma is such that certain transactions have to occur. As an example, let's consider that one of these teachers who had decided to teach before he was qualified to do so was a sadhu in a previous birth, who came from a good family who gave him lots of money, and everything his family gave him he gave away. Quite naturally, all this money that he gave away has to come back to him. This is the nature of reality—you give something away, you do something, and the thing comes back, particularly if you gave it away without an absolutely perfect objectivity connected to it. But this doesn't have to be a problem.*

*So this sadhu is a very good person. He fed the poor and healed the sick. Now, in this time, all the people who were helped by him have to help him in return. And because he did some sadhana in the past, he has a little bit of shakti this time. The shakti comes to him and he thinks, "All these people are coming to me and I have all this shakti. It must be that I'm supposed to teach them." Why is he assuming this? Why should he not just be assuming, "They owe this to me. I will try to figure out what I owe to them. Then my karmic debt will be taken care of and they can go their way and I can go my way. My life will be simplified." They could think this way, but many of them don't.*

*If you want to be free, all you can do is use these teachers as hard as you can, and their karmic problems will remain their own. This is the secret you finally find out about teachers.*

RAM DASS

if he thought that any given action was what was needed in the particular situation. He knew that he wasn't exempt from the karmic payback, but would consciously choose to pay it given the necessary circumstances. Svoboda reports, "He would just say, 'All right. I will worry about the karma later. Right now, this is what I am going to do.' Then when the karma came, he would pay the reaction and say, 'Well, I'm miserable, but I wanted to do it and I did it. So I'm paying the debt.'"

Guru Maharaj's willingness to take total responsibility for the karmic implications of his actions illustrates the fact that even the one who understands the law of karma is not exempt from it, although that one accurately assesses the situation and chooses to suffer the rightful consequences.

## The Need for Strong Models of Spiritual Ingegrity

Perhaps the greatest consequence of assuming a teaching function before one is properly prepared to do so—or at least the consequence most relevant to the present spiritual crisis—is that in so doing one adds oneself to the long list of pseudo-teachers whose reputations and deeds have made many potential spiritual aspirants cynical regarding the possibility of finding real spiritual help.

Most people who prematurely assume teaching functions do so in ignorance and with good intentions. They are simply unwilling to bear the process of utter self-scrutiny necessary to expose the subtle egoic manipulations and corruptions that lie a hair's-breadth beneath their conscious awareness. In their unwillingness to expose themselves to the necessary process of ruthless self-examination, they allow others to suffer their tainted influence, and they become yet one more model of a contemporary spiritual teacher who lacked uncompromising spiritual integrity.

The decision to become a spiritual teacher or mentor is a very serious choice, but is often taken with extraordinary levity and veiled in a dense cloud of delusion and ignorance. To live in spiritual integrity means that one would choose to take on a teaching function only if that was the most optimal response to life itself, not only according to one's own evaluation of the situation but with qualified spiritual authority to back one's decision. If one's purpose is not to become a spiritual teacher, one can also live a life of inspirational spiritual integrity by quietly pursuing one's spiritual practice, studies, and service, "teaching" by the example of one's own life.

*The opposite of self-deception is just working with the facts of life.*

CHOGYAM TRUNGPA

*To copy a virtue in another is*
*more copying than it is virtue.*
                    IDRIES SHAH

Robert Svoboda suggests the following question for the serious spiritual aspirant or teacher:

> If I was going to die at this minute, would I be ready to die? Would there be things in my past that I would be embarrassed over? Would there be things that were tying me down that would be preventing me from dying? If you are promoting not only your disciples' liberation, but your own liberation, then you are probably moving in a positive direction; but if you are instead generating some kind of candy castle vision of something that is eventually going to collapse like a house of cards, the bill will arrive eventually. And you are going to have to pay it.
>
> You are going to have to pay the bill . . . and so will others.

# Section Four
# Navigating the Minefield:
# Preventing Dangers
# on the Path

*The Zen masters realize what a superlatively hard task it is to be a full-grown man, what heart-rending trials and backbreaking hardships, what gravelike loneliness, what strangling doubts, what agonizing temptations one must go through before one can hope to arrive at the threshold of enlightenment. That is why they have approached it with all their might, and have never been willing to stop short of their ultimate goal.*[1]

—John Wu

The spiritual path is like a minefield, with triggers set throughout. One must use all available maps and guides, and take each step with great vigilance and caution, in order to save oneself from disaster. Yet, in spite of the mines, there are individuals who cross safely, though rarely without an occasional scar or burn. Those who navigate their way successfully, avoiding the mines of stagnancy, ego, seduction, and self-deception, are the ones who have made it their life's work to study

and practice according to the wisdom of those who have crossed the field before them. They have earned their skills through hard work. They have not presumed the ability to cross the field simply because they had a dream of the map or because their psychic counselor told them how to.

This section sets forth the practical means by which the spiritual aspirant who is uncompromisingly dedicated to the fulfillment of his or her highest possibility can avoid the traps and seductions that are scattered across the minefield of spiritual life.

# The Three Jewels

*Without the Buddha, the dharma, and the sangha as sources of help, no matter how clear your perception is, you're really shooting in the dark. If you manage to get through life without getting into a lot of trouble, you're beyond lucky.*

—Lee Lozowick

The Buddha, the dharma, and the sangha—known in Buddhism as "The Three Jewels," and translated into common English as the ultimate teacher, the teaching, and the community—together comprise one of the most valuable protections against the dangers of the presumption of enlightenment. The Buddha represents God or Truth but is represented by the spiritual teacher or master in our discussion. In actuality, many Buddhists consider four vehicles: the Buddha, the dharma, the sangha, and the guru. Any guru who considered himself to be the Buddha would be considered quite mad. The *dharma* is the body of spiritual teachings, which in essence is the same teaching across all traditions, although languaged as a specific expression of the given tradition. The *sangha* is the spiritual community, comprised of practitioners who together study and support one another in their shared spiritual

*Your experience should be one of being met absolutely by the teacher, the teaching, the sangha, the environment.*
ANDREW COHEN

*The day is short, the labor long, the workers are idle, and reward is great, and the Master is urgent.*

MISHNA

aspirations. Traditional Buddhist practitioners consider these three jewels to be so invaluable that they ritually take refuge in each of them as part of their formal practice.

The three jewels can be found in all formal spiritual traditions, though they are often not pronounced as distinct elements, as they are in Buddhism, but are implicitly regarded as essential elements of spiritual life. For example, Rabbi Zalman Schachter-Shalomi says that in the Jewish tradition spiritual practitioners draw on the help of God (the Buddha) and the rabbi (the guru); the Torah, or Jewish mystical scriptures (the dharma); and the congregation or community that practices under the guidance of the rabbi (the sangha). In Hinduism, those who share a common guru form a community of students or devotees who gather together to worship and pray and to study the teachings prescribed by their teacher. These three jewels are found so widely across cultures and traditions because they are objective forms of sanctuary and protection for the serious spiritual aspirant.

The Buddha, dharma, and sangha together serve as a system of spiritual "checks and balances," each providing an invaluable perspective that complements and reinforces the others. "Some people like the Buddha, but they don't like the dharma or the sangha; or they like the dharma, but not the Buddha and sangha; or they like the sangha, but they don't like the Buddha or the dharma," explains Jukusho Kwong Roshi. The threefold system offers a complete system of support and allows for areas of greater strength of practice and attention while supporting the weaker ones.

The majority of people who are serious about spiritual life end up engaging the help of all three of these sources, although not always in a linear fashion. Even the matured spiritual practitioner or teacher may use the help of a teacher who is no longer living, continue to study spiritual materials that energize and support their practice, and draw strength from their connection with like-minded spiritual aspirants or teachers even if they don't live in close physical proximity. Not only is each of the jewels a manifest situation, each also represents a principle and an internal aspect of oneself. As with all aspects of spiritual life, there are many layers to this consideration.

## The First Jewel: The Buddha

The first jewel is the Buddha—symbolic of God or Truth—but represented here by the spiritual teacher or master. The Buddha is quoted as saying, "Be a lamp unto thyself." Whereas ultimately it is one's own True nature that is that lamp, the teacher shows the disciple how to hold the lamp and how to see correctly. Robert Svoboda explains: "The guru introduces you to ultimate, absolute consciousness, and that consciousness is the thing that runs your existence, instead of your own preferences running your existence." This idea of the teacher as the "tangent point for the divine" is eloquently expressed in Llewellyn Vaughan-Lee's autobiography in which he writes about his initial encounters with the Sufi master Irina Tweedie.

In the presence of Mrs. Tweedie, I felt both the path and my own need. I knew that she was a doorkeeper of the inner world, and that I would pay any price to go through. However low I needed to bow, even to becoming a speck of dust on the floor, the inner necessity to pass the barrier of the ego would push me down. Her presence, her inner state of surrender, was a living example of the process. The path and the goal had become a tangible reality.[1]

Andrew Cohen talks about the motivation that the teacher's very *being* inspires in the student.

In the reflection of the true teacher you see two things: one, you recognize who you really are—your own self—that self where there is no mind and there is no time, no notion of individuality or any separate self whatsoever. Also, in the reflection of the teacher's calm abidance in that natural state, one's own lack of naturalness, one's own pretense, fear, resistance, pride, ambition, selfishness, and impure motivation will stand out in stark contrast, and one will do whatever is necessary to destroy the gap between oneself and the teacher.

*The chances of someone awakening without a teacher are like the chances of getting pregnant without a partner. The spiritual teacher is the partner that is necessary for spiritual birth. Not too many immaculate conceptions happen.*

ROBERT ENNIS

Of the three jewels, the teacher is perhaps the most significant in terms of protecting the student from falling into the traps of ego inflation and the premature presumption of enlightenment. The teacher is the student's safeguard against his or her own ego. Purna Steinitz said that one needs the teacher because the ego won't orchestrate its own undoing.

There is a distinction between being a great spiritual technician and being awake. Ego will never, ever, ever allow its own undoing. We won't go there by ourselves. It is not a criticism, it's just the nature of the machine and the mechanics of ego. The teacher is the one who orchestrates that undoing in some way, shape, or form.

*Guru droha [offense or treachery against the guru] is so terrible because it is a rebellion against the authority of Reality.*
THE AGHORI
VIMALANANDA

The teacher is the director of ego's downfall and guards against digressions along the descent. Reb Zalman suggests, "As long as you stand in a living relationship with someone to whom you are answerable, the likelihood is that inflation isn't going to be such a great problem."

Joan Halifax explains that a skillful teacher is able to reflect back to students "their inflation, their neurosis to get something, their grasping, and their clinging." This is because the teacher is a living, breathing source of clarity who, assuming he or she is a genuine teacher, can provide personalized feedback to the student in an ongoing way with an objectivity that feedback interpreted through egoic filters can-not provide.

If we are not willing to accept help, our whole experience will be based on our own subjective view of reality, fabricated by ego and interpreted. Without a teacher as an example of active objectivity, the ego has free reign. A long-term spiritual student of a devotional path explains:

In any tradition you can have as many laws, rules, concepts, guidelines, and scriptures as you want, but what that looks like in human form is the part that truly concerns us and is where our work lies. Without a real human being who is manifesting

the intelligent and graceful embodiment of those guidelines, we simply can't know what it means to live in a proper context. We make it up, but it is a subjective adherence to the interpretation of doctrine instead of the living truth, the reflection of the Absolute.

When the teacher is the role model of the spiritual life of which they speak, their very existence serves as an inspiration, and even as one's own conscience. The example of living integrity they provide makes it increasingly difficult to live with one's own compromised integrity. Annick d'Astier, assistant to Arnaud Desjardins, suggests that simply working in such close proximity to her teacher is a safeguard against becoming too "big-headed." "His integrity in the role that he plays reminds us to continually be humble and simple."

When there is unwavering inner attention on the teacher, the chance of being derailed is safeguarded against. Students will veer off the track from time to time, perhaps often, but the teacher will eventually guide them back on course.

The teacher's job of keeping students on track is sometimes done easefully, but more often it is laborious work. In *Zen: Dawn in the West*, Roshi Philip Kapleau describes how he was kept on track by his own Zen masters.

> Before coming to Zen I was a self-indulgent, self-centered person. I did what pleased me, indifferent to the effect that my pursuit of pleasure had on the lives of others. Instead of being the master of my life I was its slave, and didn't know it. But my Zen teachers knew it and, keen judges of character that they were, they gave me precisely the kind of treatment I needed. Besides bringing home truths about myself never before realized, this treatment gave me a sorely needed measure of humility.[2]

As the seemingly innocent student gazes at the master and begs for help and teaching, the teacher is in spiritual warfare with his or her

*The master stands, literally, at the exact point where two worlds meet: the world of awakening and the world of sleep.*

PURNA STEINITZ

*The students need to relate with a spiritual friend . . . You cannot start even at the beginning of the beginning without relating with a person who has gone through this particular journey and achieved results.*

CHOGYAM TRUNGPA

students. The teacher is confronted with the need to find the skillful means necessary to work with and eventually undermine the particular style of egoic manipulation and domination in each student, and will do so even if they must say things or act in ways that would not conventionally be viewed as spiritual, or even moral.

Robert Svoboda says: "In Vimalananda's [Svoboda's spiritual mentor] opinion, the thing a good guru will do is make sure that your ego is pretty well flattened, well rolled out, ironed, and then fried—all to make sure that it will be under control."

Llewellyn Vaughan-Lee adds, "You need a teacher to say, 'That is not real. You are on a big ego trip.' You need somebody to guide you and tell you, 'Look, this is a problem; this isn't a problem,' or 'Look, you have totally inflated, you've gotten carried away,' or 'Don't worry.'"

Another one of the teacher's functions, according to Robert Ennis, is to feed positive impressions into the internal guidance system of the student.

> In our tradition, we say that people need to have certain impressions. If you think of our internal guidance system, or conscience, it functions something like a computer. If all you've had in your life is bad impressions, that will color your fundamental understanding of the nature of life. The job of a school or a teacher is to provide certain positive impressions to permit the internal guidance system to function properly. What a saint or a genuine spiritual teacher does is to provide powerful positive impressions of how it is possible to live a human life—impressions of love, impressions of compassion, impressions of non-selfishness. The nature of the internal guidance system is such that one positive impression will balance out a million negative impressions of the same strength. In other words, once the guidance system has correct data, it will throw out all the bad data. But finding those good impressions is very difficult in this society. Basically, the only way to harmonize the organism and to have a balanced awakening is to get those impressions.

While the true teacher provides ceaselessly for the student, he or she has absolutely no investment in receiving any form of self-gratification. Because the teacher is the only one in the student's life who is not trying to get something from him, and because their job is to serve the student's highest potential, they do not perpetuate or in any way feed into the student's mechanical, self-defeating illusions and presumptions. Of course, many teachers are fallible in this regard, but even a fallible teacher who is more dedicated to their students than they are to their own ego will be able to effectively, if not flawlessly, guide those students around ego traps that they could not otherwise avoid on their own.

Although there are various opinions regarding whether or not it is pragmatically possible to liberate oneself without the help of a teacher, it is clearly the exception. Students tend to declare their own liberation long before its actual time. Reggie Ray comments: "We have people like the Buddha, who basically did it on his own, but I have never met anybody else who could. The tendency for self-deception is so strong in all of us that it's pretty hard to get through—you get stuck somewhere or another."

It is rare to find a great teacher who was not once the student of another teacher. Just as one learns to fly commercial airplanes by taking lessons from a certified pilot, apprenticing to someone who has traveled farther along the spiritual path —even "just one step ahead" according to Vaughan-Lee—is going to assure a safer trip.

For ninety-nine percent of us, we need a teacher. We can't do it without a teacher. It doesn't mean that you can't do spiritual work without a teacher—you can prepare yourself. But you need a ferryman to take you across to the other side.

The specific role that the teacher plays varies from tradition to tradition, ranging from mentor or guide to guru or master, but the importance of the teacher in the life of the true student, and the respect and gratitude that naturally flow back to the teacher from the student, cross all cultures and traditions.

*The master-disciple relationship not only is an agreement between two individuals, it is the entrance into a lineage. It means becoming part of a whole much vaster than this particular relationship between two individuals.*

ARNAUD DESJARDINS

## ROBERT SVOBODA: WORSHIPPING GOD IN FORM

In India, when people are dealing with strong spiritual experiences, they generally either focus on the guru, or they focus on the ishta devata—their personal deity, or God with form. It is much easier to do things this way.

When your kundalini is awakening and has been associating with you as an individual with form, it is a lot easier to first transfer it onto another form before you try to get it to the formless. Transferring it onto form creates many fewer complications in your organism while you are trying to undergo this transformative, transmutational process.

In going through the process of taking away a little bit of your shakti from your self-definition so that it can be free to be attached to something else, if you have another image you can attach it to—like your guru or deity, or even just an image in your own consciousness—you can endow that image with the ability to take care of you. It can help to make sure that you move in the right direction and that your transformation happens at an appropriate, sustainable, and manageable rate of speed; to make sure that you don't go too far off the path. You can train your unconscious to do things for you in that direction.

You have an image, you have a belief system, you have something of which you can say, "This is the thing I have faith in." You don't just limit yourself to saying, "I have faith in this form," but instead, "I have faith in this form as the face of, or the mask of, the ultimate." And if you can say, "I can relate to this form very well, and I am worshiping the ultimate through this form," it can be very helpful. Most people who have gurus or worship deities are not idolaters. They know that there is an Absolute Reality, but they are using a form because it is easier to focus on and it is easier to develop a relationship with.

Spiritual discipleship is the deepest and most penetrating of all forms of human relationship.

DICK ANTHONY

It is curious to note that, of the respectable contemporary teachers of our time who say that it isn't necessary to have a teacher, nearly all have themselves been long-term students of other teachers—sometimes great, sometimes not-so-great. Whereas ultimately they realized that they don't need a living, external teacher in order to successfully travel the spiritual path, that realization came through years of rigorous sadhana under the guidance of a teacher or master.

It is precisely because the spiritual teacher is so invaluable to one's awakening, or to the fulfillment of one's highest potential, that students avoid getting into relationship with one. Although spiritual aspirants will give any number of excuses for why they don't need a teacher (e.g., "I follow the inner guru," "Everything is my teacher"), the fact is that the ego does not want a teacher because a teacher is going to put ego in the back seat. The presence of the teacher is going to continually nag the student's conscience, and the teacher is going to see past all of the student's clever forms of self-deception. The spiritual aspirant is comprised of both pure and impure motivations; of genuine longing for God and the genuine desire to manipulate God. The effective teacher will eventually expose all false motivations and claims and call the student to his or her highest possibility, a possibility which is full of demand, heartbreak, and responsibility.

In *Holy Madness*, Georg Feuerstein articulates the dilemma of the student and explains how the genuine teacher confronts this challenge.

*With a genuine spiritual master, surrendering means presenting oneself in a completely honest, naked way, without trying to hold anything back or maintain any façade.*

JOHN WELWOOD

> The spiritual seeker is always a troubled individual. He or she has become aware of the element of suffering in human life . . . The seeker hopes, secretly or openly, that the teacher will somehow alleviate that sense of dis-ease. But his hope will inevitably be frustrated. The guru may fill his or her disciples' minds and hearts with wonderful alternatives and even initiate them into all kinds of esoteric practices. But if the teacher is genuine, he or she will do nothing to remove the disciples' deep-seated aggravation about life. Indeed, the adept will, in numerous subtle and not-so-subtle ways, do his or her absolute best to fan their fire of frustration.

*It should be taken to heart that whatever the Spiritual Guide persuades his disciples to do and to practise, it is for the benefit of the spiritual disciple himself.*

MUINUDDIN CHISHTI

Gurus do this not because they are warped sadists who want to inflict pain on their disciples, but because they want disciples to understand that all their suffering is of their own making. They want disciples to bring real understanding, wisdom, to the situation. They want them to see that their spiritual quest is for the most part little more than a desire to escape from themselves, and they want them to begin to stand in place, to meet themselves face on.[3]

Functioning both internally as the disciple's conscience, and externally as his or her confidant, guide, and reference, the true teacher will not allow the student to get carried away in premature claims to enlightenment. This should be a great relief for students who recognize the degree to which they are run by mechanical, egoic functioning that ensures self-deception. The teacher may allow them a lot of rope, and even go so far as to let them make their own noose if that is necessary to create a valuable lesson, but if the disciples remain in cooperation with the teacher, the teacher will, in every way lawfully possible, prevent them from hanging themselves.

### The Need for a Teacher If You Are Teaching

Sensei Danan Henry shares his experience of the ongoing value that his teacher provides to his own teaching work.

I am kind of a weird one in this world of teachers. I am fifty-eight years old and I still study constantly with my teacher, doing koans and sweeping his house. I have seen people jump the gun. I have seen so much. The insistence in Zen on the enlightenment experience can cultivate arrogance, so I continue to study with my teacher.

It is humbling to discover that many of today's most esteemed teachers are still operating under the influence of their teacher—either directly, as Sensei Danan does; as a continual internal reference, as

Arnaud Desjardins suggests; or as some combination of the two, as in the case of Lee Lozowick and his teacher, Yogi Ramsuratkumar. (*See* Chapter Twenty-one: "Master as Disciple.")

Llewellyn Vaughan-Lee, who was asked by his own teacher to carry on her teaching work, says that he would not want to run the risks or bear the burden of teaching without help.

> Being a spiritual teacher without having a teacher is too much burden on the human being. People come to you with their aspirations, with their desire for truth, and that is the most important thing that exists within a human being. You see it in their eyes, this desire for truth, and this longing . . . Why should I trust my ego to help me guide them? I trust my teacher. I know that my teacher is looking out for me. If I am worried about something, I can go into meditation and ask, and I get help. You can't do it on your own. We are just fallible human beings.

*To go solo is hard. I think it's helpful to have somebody breathing down your neck or looking over your shoulder.*
JUDITH LEIF

As Vaughan-Lee explains, the task of trying to unite another human being with their longing for God or Truth against all odds is a monumental task. The true teacher is only able to effect the student's spiritual development to the degree to which the teacher is surrendered to some source of help.

---

## JAI RAM SMITH: THE TEACHER AS UNDERWRITER

*My teacher at the time, E.J. Gold, would take any tendency that a student had and stoke the fire until it burned out. He would empower any of the spiritual experiences his students had and entice them into a bigger scale of effort so that it was no longer a game that was being played for worldly stakes and ambitions. All of a sudden you were leveraged into playing for your life in the Work.*

*This could be a very dangerous approach, but it all depends on*

*your underwriter, who you're backed by. The underwriter is ultimately the manifest essence of the lineage in its purest sense—omnipotent, cellular, living, direct. The higher the level of teacher, the stronger the underwriting. E.J. called this "being bound in return." There can be very low-level teachers who take such a risky approach with their students and create very destructive results. But understand that the depth of the underwriting for E.J. was at such a level that the whole thing was cared for in a way that even the inevitable deviations became food for the transformational process itself—part of a necessary learning process. The things he would risk giving the student were underwritten in a way that there was a guaranteed bond of performance. He didn't have to worry, because who was underwriting the management of the situation was not going to let anything unlawful happen.*

*This "offering up" by the teacher of the student into the arms of the lineage itself lies in stark contrast to the path of power transmission in the worldly arenas of politics and religion. Underwriting is a bonding process and reflects an inner attunement and alignment. Lineage is not something that can be given, held, attained, or even asked for directly. E.J. often told us that if you knew what this work really meant you would never ask for it—so there is a skillful use of whatever your particular "carrot" of temptation is, in order to entice you through the doorway.*

*In my own case, one of the first things that E.J. told me is that I should be a teacher. He would tell me that there was only one difference between him and me—he was voluntary and I was still involuntary in manifestation. Now if you look at the effect of saying that on the state of someone like me at that time—who had had a few experiences, who wanted power and who had ambition, you can imagine what it did to me. It not only made me feel that I had found the teacher I had been looking for, but it began to swell a certain part of me. But because of his level of teaching and underwriting, that swelling or that tempting expansion was not going to cause damage to the real Work I was doing. Along with the swelling, there was a deep trick involved in what he was doing. He was also using that vein*

*to supply the bond for that level of work. So the expansion, disillu-
sionment, whatever was needing to be done to reformat the ego
structure was built in from the beginning. That's what I mean when
I say that it was underwritten in a very practical way.*

*So I would get expanded on one level, yet on another level I
couldn't possibly do anything that was out of integrity with the level
of Work being demanded. Another way of saying this is that he
would give you all the rope you wanted, but all the running you did
with the rope would just make you someone who knows about ropes,
whereas in a situation in which somebody has no reliable underwriter
and they are throwing out responsibilities left and right, there can and
will be abuses in the system. There are far, far more abuses in a sys-
tem where the underwriter is not reliable.*

---

Although some masters are able to have a very real and practical
relationship with the formless Absolute, maintaining a consistent,
clear relationship with one's teacher is the most practical means the
teacher has of accessing that help. Arnaud Desjardins suggests:

*There are very, very few
human beings who can do it
without a teacher.*

LLEWELLYN VAUGHAN-LEE

> I think that the problem with those who teach but still show
> weaknesses with their students in some areas has to do with
> the relationship with their own master, if their master was
> truly a master. When one begins to teach, to take responsibil-
> ity to share, to show the way, the inner relationship with one's
> own master—who may be dead physically—is so important.
> Always, always, remembering my master.

Buddhist practitioners take refuge in the jewel of the master because
they understand that there are very few sources of real help in an under-
taking as vast and immense as spiritual life, particularly the work of spir-
itual teaching. People from all traditions seek the help of the teacher
because they understand that their odds of success without such help are
insignificant, and they are looking for all the help they can get.

## The Second Jewel: The Dharma

The second jewel is the dharma, or teaching. The dharma is comprised of the specific body of knowledge of any particular school or tradition, as well as the scriptures and teachings of all the great traditions. It includes lectures given by the teacher, study groups, the contemplation of and writing about spiritual principles, and the questions one struggles with on the spiritual path. The value of a thorough spiritual education cannot be underestimated in terms of helping the aspirant to avoid the false presumption of enlightenment as well as other ego-created traps.

New Age idealists who talk about traveling through uncharted territory do themselves and others a disservice. While each human being is unique, the spiritual path is unchanging. Spiritual pursuit without study is like trying to cross the country without benefit of the maps that others, who have traveled it before one, have provided. One may get there, particularly with the help of a guide (the teacher) and traveling companions (the sangha), but it will be far quicker, easier—and safer—with the help of a map.

Another way to understand the importance of the dharma is to consider the "path" of becoming a skilled professional. If your goal is to become a surgeon, obviously you must study. It doesn't matter how much of a "natural" you are, or how much admiration you feel for the chief surgeon in the hospital, or how well you get along with the other surgeons. You still must undertake an extensive course of study in order to become knowledgeable about the complex and interconnected elements that form the human body. You will have to go to medical school, take examinations, ask questions, apprentice to other surgeons, prepare yourself for all the unexpected elements that may arise in surgery, practice steadiness in the face of great stress, and so forth.

Yet when it comes to spiritual life, people think they can do "open heart surgery" just because they've seen it done in a dream; or they think they have surrendered themselves to their teacher because they feel blissful in his or her presence—or that they have a thorough grasp of spiritual dharma because they have read a handful of books and can

parrot phrases like "God is the Self," "Be here now," and "There is no separation between anything." Such presumptions are the equivalents of the premed student attempting to do a liver transplant because he or she saw a video about it in an undergraduate science class.

A spiritual education is not only a necessity for the beginning spiritual student who is learning to avoid the most basic ego traps, but is an invaluable resource in assisting advanced spiritual aspirants to navigate the subtle distinctions that arise in the course of their deepening understanding. Joan Halifax said that one comes to "see oneself" in the teachings. The dharma is so precious that the Buddhists consider it a jewel and take refuge in it, the Tibetan monks spend hours each day memorizing and copying the sacred scriptures, and the Jewish people adorn their Torah, or book of teachings, in gold and guard it in a sacred ark, performing a series of rituals before they even open the scrolls. Until recent times, and still to some degree, the great esoteric teachings of all traditions have been guarded in secret and only shared with practitioners who have proved themselves to be worthy of them.

The spiritual scriptures of every tradition are encoded, multi-level teachings. The New Testament, the Old Testament, the Upanishads, the Koran, and even the writings of the great contemporary teachers are comprised of many layers, each only visible when one has deepened one's practice to the level at which one can understand them. That is why for some people the Old Testament is understood as a series of stories about an old man with a long beard who lives in the sky and is called "God," and for others it is a map of the psyche, a metaphor for the emergence of the Self.

*Generally speaking, the errors in religion are dangerous; those in philosophy only ridiculous.*

DAVID HUME

When one is thoroughly educated in the dharma not by having read ten books by great spiritual masters but by years and years of deepening study, questioning, discussion, and contemplation—one is safeguarded against not only premature claims of enlightenment but many of the pitfalls on the spiritual path.

The dharma educates one's conscience and not just one's mind. It is written from a deeper layer of consciousness than the common person ordinarily abides in; thus it informs a deeper layer of the human psyche. It plants seeds within the conscience of the individual that

germinate beneath conscious awareness and sprout when the student is ready to understand them.

For example, perhaps a beginning spiritual student reads a book by a great master that talks about ego inflation and how, when the spiritual student becomes a little bit psychic or has some mystical experience, they often become very grandiose and feel that they have reached enlightenment. Perhaps at the time the student thinks, "That's silly. I wouldn't fall into those traps. I want God, not a bunch of experiences." Then a couple of years pass and the student becomes frustrated with the slow progress of spiritual life. Having slipped into a rut of self-centered, spiritual depression, suddenly one day their kundalini awakens and they begin to experience enormous raptures and openings. They have access to all kinds of knowledge and information, bliss states, clarity. Whereas both the student who has received a solid spiritual education and the one who has not are likely to presume that they have reached a high state of being, the student who has been educated about the dangers to ego that are present in such states is more likely to be wary about the assumptions they make about themselves based on their present state. Their expanded consciousness may be floating off on a magic carpet, but their conscience will not be free of a nagging question. If the student is sincere and one-pointed about their spiritual path, they will inquire into themselves and seek guidance from their teacher instead of adding ego expansion to an already expanded consciousness, thus inflating themselves to the status of a messiah.

The dharma provides the foundation and framework from which we can understand our experience. The masters and sages of all traditions and over thousands of years have documented the stages of the spiritual path precisely for this purpose—so that students of all ages could navigate through them more easefully. Without a context for our experiences, we are likely to interpret them in whatever way is most suitable to ego: our spiritual experience means that we're special, or that something good has happened to us, or that we are some sort of high being or priestess.

Mystical experiences and the gradual expansion of consciousness create a certain clarity of perception, but that clarity can be applied to any domain of life, not necessarily spiritual. It can be used to make people fall in love with one, to make millions of dollars, to control a country, or to serve one's own surrender to Truth or God and all of humanity. The dharma grounds and directs the experience and arising power toward the fulfillment of a truly profound possibility.

Yet the dharma is not foolproof on its own (hence the need for the teacher and the sangha). In order for it to effect one's spiritual development, it must be rooted in personal experience and tested in the fires of daily experience to see whether one has understood it clearly and is able to apply what one has learned to life itself. For there are individuals who are highly gifted intellectually but who use their agility with dharmic concepts to buffer themselves from living their lives according to the truths they so easily proclaim.

In *The Tantric Path of Purification*, Tibetan teacher Lama Thubten Yeshe warns:

> Many scholars who can lecture at great length have reached nowhere. Therefore, I advise you to be careful. When you talk about the teachings it is not what you say but how you have gained your knowledge that is important. Your speech must carry the blessed vibration of personal experience and convey that energy to your listeners.[4]

The "blessed vibration of personal experience" that Lama Thubten Yeshe refers to only becomes blessed when one's continual flow of action is anchored in, and stems from, the context of the spiritual teachings. The dharma is not merely intellectual, but highly practical. It is a course of study that, if correctly applied, penetrates into all areas of one's life. It is like an insidious virus of conscience that infects avid spiritual students with their highest possibility and will not allow them to rest in self-centered, ego-gratifying interpretations of their own experience.

*The practice of Dharma, real spiritual practice, is in some sense like a voltage stabilizer. The function of the stabilizer is to prevent irregular power surges and instead give you a stable and constant source of power.*

THE DALAI LAMA

## The Third Jewel: The Sangha

The following conversation occurred between the Buddha and his closest disciple, Ananda, as recorded in the *Samyutta Nikaya*.

> The Venerable Ananda approached the Lord, prostrated himself and sat down to one side. Sitting there the Venerable Ananda said to the Lord: "Half this holy life, Lord, is good and noble friends, companionship and association with the good."
>
> The Buddha responded: "Do not say that Ananda. It is the whole of this holy life, this friendship, companionship and association with the good."

Like the Buddha and the dharma, the sangha is far more multifaceted than it appears at first glance, and organically functions to protect the individual against the dangers of self-deception and ego inflation that cause the premature presumption of enlightenment. The sangha provides help that is distinct from the help of the Buddha and the dharma. Joan Halifax, who leads a spiritual community in New Mexico, explains:

> Taking refuge in the sangha is the third way we work with inflation and temptations—being in a community where there is a kind of natural feedback, where there is a sense of reality, support, mirroring, building trust and of encountering difficulties in your experience with others and being able to sustain a relationship that will transform those difficulties into compassion and trust.

The sangha is the great stew in which the spiritual aspirant is slowly tenderized and flavored to perfection. While most people think of spiritual friendship as a group of people who get together and share their experiences and their interest in spiritual teachings, this is but a pleasant side effect. Real spiritual friendship, as the Buddha spoke of it, involves dedication to the fulfillment not only of one's own highest

potential, but also to the highest potential of those with whom one lives and practices. Spiritual friendship does not depend on personal liking or disliking, but rather rests in a mutual dedication among the sangha members to serve the spiritual life and development of all in the community.

The value of spiritual friendship in relationship to the tendency to presume one's own enlightenment is that sangha members, along with the teacher, are responsible for seeing that their sangha mates do not get off track and do not get carried away by their own subjective interpretation of their spiritual process. The members of the sangha protect one another from ego inflation, corruption, and the misperception of their experiences.

It is the natural function of a bonded spiritual community to keep one another on track. The bonded community functions like a body, and when the body is sick or has a virus, the available energy in the body works to heal itself. Reggie Ray explains how, in Tibet, even the teachers were protected by the sangha.

> In Tibet, even the tulkus—these very well-trained people—were surrounded by people who were watching them all the time. Even the ordinary village people knew what was appropriate behavior and what wasn't. If a guy went off, he'd be nailed. In this culture, people go off and become gurus. It's bad enough if they are trained—there's still not very much of a supporting network. You have to have a supporting network around you if you're going to do spiritual teaching. It's too dangerous otherwise. But when you think about people who aren't well trained . . . it just makes your hair stand on end to think what might happen.

The sangha and the teacher, together with the conscience developed by the dharma, serve as an ongoing feedback mechanism. The teacher, although an objective source of feedback, is, in form, only one individual, and often an individual who has more demands placed on him or her than it is possible to attend to in an immediate physical

*The side-effect that makes spiritual work most attractive is the possibility of developing compassion and the ability to love. I don't think it is to achieve enlightenment, whatever that is.*

ROBERT HALL

sense. The members of the sangha, though only wise to varying degrees, carry with them many of the elements of the teacher and the teaching. They provide one another with direct feedback, as well as with the subtler, ongoing feedback that occurs in their daily interactions with one another. For example, when a sangha member suddenly believes himself to be enlightened when it is clearly not the case, the sangha won't respond to his claims. As one simply moves about his or her daily life in the sangha, comments that are either self-aggrandizing or self-effacing are ignored or intentionally disregarded by fellow sangha mates whose desire for the discovery of truth is stronger than their desire to make one another feel good.

The sangha are the people with whom one lives—perhaps by sharing a household, perhaps just through regular interaction. Sangha members often know one another better than they know themselves and can reflect back to one another their areas of weakness. Lee Lozowick suggests that if one pursues spiritual practice outside of a sangha the possibility of moving through all the stages of spiritual life is negligible: "Without your peer group, you don't have a chance. It's so easy to slip—at first a little, then a little more, and a little more."

The sangha further functions to wear down the sharp edges of ego. Jakusho Kwong Roshi describes this process.

> The metaphor for the sangha is like rocks. You put all the rocks together, you shake the bucket, and the rocks rub each other and become smooth. If you don't relate to all three of the jewels, the rocks get sharper and sharper. We get smoothed out by the forms and the training. You won't become smooth without being rubbed. I started spiritual life when I was twenty-five years old. I'll be sixty-three. It's still a very short period. I've been here running our center for twenty-five years and this has probably been the hardest time of my sadhana. I raised four sons here. The rocks rub. I didn't expect that. Even after you're a teacher, the rocks rub.

The hardest period of Kwong Roshi's sadhana occurred after he became a teacher and began to live and raise a family in the company of the sangha—many years after he began his spiritual life. The sharp edges of ego's domination are only smoothed off through a process of continually rubbing up against other egos, which anyone who has lived in a sangha knows to be an unavoidable aspect of life in community. The sangha is further unnerving to ego because it demands relationship, and the vulnerability involved in real relationship promises to irritate ego's fragile sense of control.

One theoretically enters spiritual life because one wants to be free from the identification with ego. If what is needed to expose the fallacy of egoic identification and the premature presumption of one's own enlightenment is the very ordinary, unnerving, and disturbing friction of egos and personalities rubbing up against one another, then the sangha should be respected and appreciated for this service. For this reason, the sign above the entrance to the Study House at Gurdjieff's Prieuré read:

> Remember that you came here realizing the necessity of struggling only with yourself and thank anyone who helps you to engage this struggle.

Continual engagement in relationship with the sangha body promises to reveal the ego in all of its glory, and will not allow one to sustain an exalted sense of oneself. The sangha is a precious jewel. Few things can humble the individual to the degree that the sangha will, if given enough time.

Of course, the sangha can also lead one astray. If it is based on a false premise, if it is not sustained by the context of the teacher and the dharma, then the likelihood is that members will build and sustain a collective fantasy about whatever their beliefs are, and all of the feedback they provide will be filtered through that mechanism. Claudio Naranjo observes:

*To love God is so much easier than to love a human being.*
LLEWELLYN VAUGHAN-LEE

Sometimes the group is wrong, but that depends on the context and whether the group is led by somebody who is a good catalyst. The group energy has the possibility of seeing so clearly what the individual doesn't see in himself, and through gentle humor, or confrontation, or sometimes even without words, it comes across.

*Sooner or later on the spiritual journey one will come to a point where a leap of faith—a leap of trust—will be required.*
ANDREW COHEN

The possibility of the sangha being mistaken leads some people to question its value every time they get feedback they don't like. In so doing, however, they forfeit the value of the sangha as a source of help and protection against the fallacies of the ego and the premature presumption of one's own enlightenment. Therefore, one should take all the time they need to choose their teacher and sangha carefully. But after the choice has been made, one must take refuge in the sangha, giving oneself over to its wisdom, in order to optimally receive the help it can provide.

Over time, each of the three jewels becomes internalized. When one has been imprinted by the teacher, is highly familiar with the teachings, and has seen again and again how the sangha reacts to one's manifestations, one cannot act without a constant flow of internal feedback being provided by the three jewels. In this way the Buddha, the dharma, and the sangha become part of one's own conscience.

However, the internalization of the three jewels does not imply that one ceases to benefit from their external input. Spiritual life is a continual process of evolution. Trungpa Rinpoche has said that at each level of spiritual evolution new obstacles arise that must be worked through. Therefore, the teacher, the sangha, and the dharma continue to inform the individual throughout his or her lifetime of spiritual development.

The three jewels in themselves are continually checking, supporting, and affirming or disconfirming one's enlightenment. The teacher provides feedback and holds us to our highest possibility; the dharma strengthens our mental perception and awakens our conscience so that we cannot allow ourselves to indulge in unconsciousness and fallacies;

the sangha provides continual irritants that false enlightenment couldn't stand up to.

In addition to adherence in the three jewels, before making a claim to enlightenment, and even after a presumption of enlightenment has been made, responsible spiritual practitioners or self-proclaimed teachers will expose themselves fully to a process of thorough, rigorous testing that leaves no area of the psyche unquestioned. We will explore some of these testing methods in the next chapters.

# Testing Enlightenment

*Masters of old lashed out at those who claimed to be enlightened yet refused to be tested, calling them "earthworms living in the slime of self-validated satori."[1]*

—Philip Kapleau Roshi

Rabbi Zalman Schachter-Shalomi tells the story of a man who buys a little boat with a motor and a captain's cap, and comes home to his mother and says, "Mother, I'm a captain."

The mother says, "By me, you are always a captain. But by other captains are you a captain?"

The individual who proclaims his own enlightenment without having it tested or verified by his seniors on the spiritual path is like the man who believes he is a captain because he has his own boat and a cap to show for it.

According to author John Welwood, "The process of testing and transmission serves as a kind of 'quality control' to insure that a given teacher does not distort the teachings for his own personal gain."[2] The tradition of testing one's enlightenment is found in most of the great spiritual cultures across the world. In some traditions, like Zen, the

testing process has been refined and formalized through many centuries, whereas in other traditions that do not have so much emphasis placed on a definitive measure of "enlightenment," the testing of one's spiritual development is woven into the fabric of one's daily encounters and/or one's relationship with the spiritual teacher.

By contrast, most of the new spiritual traditions contain no such notion of testing enlightenment, and evade the issue with the excuse that one's "inner self" is the ultimate tester, or the pretext that contemporary spirituality has evolved beyond the need for hierarchical structures of testing. Charles Tart suggests: "A tradition has to be around for a long time and have a lot of people involved in it before you can build up an effective system of checks and balances. A lot of homegrown spirituality here—independent entrepreneurs—are certainly not a part of a system of testing."

*What seems to happen when we have spiritual experiences can only be known when that is tested. Otherwise we are likely to call ourselves a chef, open a fancy restaurant and promptly poison the clientele.*
LEE LOZOWICK

If one is not striving toward enlightenment in any form, and if one's ego is not tempted by the direct or even subtle implication that one is spiritually advanced, then there is no need for testing one's spiritual progress. But even the least presumption of one's own enlightenment that one is not willing to subject to formal or informal testing should be considered as questionable or as enlightenment lived in "the slime of self-validated satori," as the masters of old so wryly called it.

If one takes to heart the insights into the nature of ego shared by the great contemporary masters and teachers of our time, the possibility that one's enlightenment can and will be tested in a genuine spiritual tradition should be very good news. However, testing—particularly informal testing—will only be effective if one is responsive to, and able to objectively hear, the feedback offered.

## Traditional Forms of Testing

Traditional testing of enlightenment can still be found in some contemporary Zen schools in the West, although there are also many Zen schools that have either culturally "translated" their form of testing or informalized it. Although the ancient ways are sometimes viewed as

"harsh" or "severe," when carried out by a genuine teacher they are an objective means by which to dispel ego-based interpretations and illusions about one's own state of enlightenment. In *Awakening to Zen*, Philip Kapleau Roshi, a great advocate of traditional Zen practice in the West, describes the necessity for testing one's enlightenment.

> Zen teaching has always insisted that a purported enlighten-ment be tested and confirmed by a master whose own enlight-enment has in turn been sanctioned by an enlightened teacher. This is because of the great danger to personality resulting from self-deception. The truth is, it is all too easy for a novice to mistake visions, trances, hallucinations, insights, revelations, fantasies, ecstasies, or even mental serenity for satori . . . Since even a genuine enlightenment generates the subtle pride of "I am enlightened," the perceptive teacher's job—and it may be a long one—is to help the student wash away this "smell" of enlightenment through work on subse-quent koans or other practice.[3]

The process of testing is passed down from generation to genera-tion of teachers in order to help the student avoid the dangers of self-deception. Kapleau Roshi says, "Nothing can be more detrimental to one's personality than to believe one has had a valid enlightenment when in fact it is merely an insight, valuable though this latter may be on a psychological level."[4] Though a threat to ego, the testing process actually honors the individual's highest spiritual potential by clearing away the egoic desires to settle for less than the ultimate demand of liberation.

Kapleau Roshi further explains that there are specific modes of testing, each with their own purpose.

> One kind, for example, involves a student who insists that he or she has had an awakening and asks to be tested. "I've had an enlightenment experience. Please test me," such a one demands of the roshi. Although such an assertion already has a "smell" to

it, it cannot be safely ignored. One who has had a valid awakening, even if shallow, doesn't say, "I am enlightened . . . " Despite the student's attitude, the roshi will usually comply with the request; otherwise the student may believe that Realization has occurred when it has not . . . The testing questions a roshi uses to establish whether a student has had a genuine awakening are traditional, and there can be quite a few of them. A faltering, uncertain reply to any one of the questions or even a simple "I think" can vitiate an entire answer. To be acceptable, the student's response must be spontaneous, sure, and radiate understanding from the eyes and body as well as from the mouth.[5]

Jakusho Kwong Roshi of the Sonoma Mountain Zen Center brings to life the nature of the traditional testing procedure in the following two anecdotes from his own experience with students.

A person walked in to *dokusan* [an interview with the teacher, which may be used to test his or her spiritual progress] and said to me, "I'm nothing." I took my stick and hit him and the student yelped, "Ouch!" I said to him, "Well, what was that?" Another time a person came in and said, "I'm dead." I hit him with my stick and he screamed. So I said, "What's that? It's your body." Then you have a dialogue.

Kwong Roshi says that in the Rinzai school of Zen, where the teacher sees the student very often—up to three times a day—sometimes interviews are very short, even half a second; or that sometimes as soon as the student walks in the door the teacher will ring the bell to signify the end of the interview. "The teacher can tell immediately by the way the student walks in where he is at," he explains.

On the flip side, Kapleau Roshi says it can also happen that one is unaware of one's own enlightenment, and that the testing procedure can reveal this as well. He quotes the great Zen master Dogen as saying, "Do not think you will necessarily be aware of your own enlightenment."[6]

Kapleau Roshi further suggests that testing is vital in order to determine the depth and clarity of the awakening, as in Zen, as well as in all other traditions, there are both "shallow" and "deep" satoris. The recognition of the varying depths of enlightenment is a valuable consideration for practitioners in all traditions, as even the enlightenment that "passes the test" does not imply mastery or license to teach.

Lastly, formal testing serves to preserve the purity of the tradition and to avoid the dilution of the standards for enlightenment that have been upheld for thousands of years by the great masters. Traditionally, only a master who has been thoroughly tested by his master, who has been thoroughly tested by his master before him, and so on, is qualified to test a disciple. Even one individual who claims himself a master but has not been sanctioned by his own master can, through incorrectly sanctioning the "enlightenment" of his own disciples, dilute the strength and purity of a particular lineage.

*I have never seen a man lost who was on a straight path.*
SAADI OF SHIRAZ

## Non-Traditional Forms of Testing

Many respected spiritual masters of our day will say that there is no formal procedure for testing enlightenment or spiritual development in their schools—either because their tradition is relatively new and has not yet developed a system for testing disciples, or because the emphasis in the school is not on "enlightenment." They claim that the testing of one's spiritual development is woven into the teachings and the practices of the school. The teacher may be testing students' enlightenment by watching how they respond to a given task or exercise, or even to a question that they are asked in the most informal circumstance.

Teachers and students who live in close proximity with one another in a community setting report that the whole of their lives together presents one great arena of testing. Mel Weitzman provides an overview of this kind of informal testing from his years of living and working within the northern California Zen community.

Testing enlightenment comes through everyday practice. The students practice together for years. Everyone knows who everyone is. You don't have to test their practice or test their understanding because you are so close to each other. Testing is not something I think about doing because practice is always being tested. Everything is a test. Whatever you do, it's a test. So a good teacher can tell where the student is just by seeing the student—the way they walk, the way they eat, the way they perform their daily activities. You know where the student is. Sometimes you see a student and the moment you see that student, you know that they've changed—just by seeing them. If you're a painting contractor and you've been painting houses for years, when a painter comes walking up to you, you know exactly what their ability is, just by watching the way they walk. That's the way it is with Zen students too. You can tell where they are just by a glance.

Spiritual practice—or sadhana—is also a valuable means of testing enlightenment. The student works at increasing the integrity of his or her practice, and the teacher observes the student's process. As Weitzman suggests, a teacher who has spent a lifetime studying the ways of the mind and the tricks of the ego very often knows where a student is in their spiritual development by a mere glance, which is why the Zen master may ring the bell to signal to the student that their interview is over before the student has taken two steps beyond the door.

Rabbi Zalman Schachter-Shalomi describes how he was checked and informally "tested" in his apprenticeship to becoming a rabbi.

Apprenticeship of that sort is not easy because you get your rough edges knocked off by your Master. You also bring him your issues. In my situation, for a long time I sent my Master's son-in-law, the late Rebbe Menachem Schneerson, carbon copies of every letter that I wrote of a spiritual nature. So he was looking over my shoulder and correcting them, at times saying, "This is okay . . . This could have been done better in

another situation . . . " I would come to New York and give reports, and he would always ask questions—some of the questions made me cringe. It was not like an army sergeant who wanted to cut you down, it was a lot more like a loving teacher. When you stood and faced him and you knew that he was reading your soul and your guts, there wasn't anything you were going to hide. And so, if he pointed something out, it was something you wanted to know about yourself, rather than not.

In Arnaud Desjardins' school, people confirm their experiences through their teacher or one of his assistants. Marie-Pierre Chevrier explains:

> People mistake the fact of their own enlightenment because they have no other reference than themselves for their own experience. But what happens here is that people who have that kind of experience refer either to Arnaud or to one of his assistants, and that gives them a reference point, which, according to the confidence they have in the help, avoids confusion in these matters.

Some teachers, like Danan Henry, use a combination of formal and informal systems for testing their students.

> The koan system is the main testing system, but the other testing is just the raw material of life. Gurdjieff was the master of this. When I was studying the Gurdjieff work before studying Zen, one of my teachers had worked with Gurdjieff for many years. Although he was humble when I knew him, apparently he had been very arrogant. Every time Gurdjieff would talk to him, Gurdjieff would act outrageously condescending and arrogant. My teacher didn't get it at first, but then he saw that Gurdjieff was holding up a mirror to him over and over again. When he saw it clearly, he could see himself, and that helped him to undermine his own self-aggrandizement.

*Most of humanity do not know what it is in their interest to know. They dislike what would eventually benefit them.*

AL-NASAFI

Many spiritual masters continually test their students in informal ways such as this. In fact, life in the company of a genuine master could be considered to be an ongoing test.

The particular form of testing employed in any spiritual school is dependent upon what any given teacher considers to be the optimal expression of spiritual development, and clearly "enlightenment" means different things to different people (even among those who are widely agreed upon to be enlightened!). In some contemporary schools, a particular series of visions marks the progression of awakening; thus, a clear description of such visions might constitute enlightenment in that system. In another, understanding is demonstrated through the mastery of particular koans. In still another, one's willingness to demonstrate compassion in disagreeable situations is considered to be the true sign of enlightenment. We are once again faced with another gray area in terms of enlightenment and our assumptions and presumptions about it. There are differences in the language that great masters use to describe the same phenomenon, but there are also differences in perspective among teachers, which could suggest contradiction but could also point to the possibility of the existence of different facets or aspects of enlightenment.

## Peer Testing for Teachers

The Aghori Vimalananda, spiritual mentor of Robert Svoboda, was well learned in the ways of karma and also very passionate about testing and uncovering the falsity of saints and teachers who overestimated their own spiritual stature. Robert Svoboda reports, "Almost without exception, every time he ran across somebody who he thought was too big for his spiritual britches, he regarded it as being his responsibility to ensure that they came down towards earth, if not *all the way down* to the ground." The following story was told by Vimalananda to Robert Svoboda about how he "tested" an Indian spiritual teacher named Taat Maharaj.

I was hard on Taat Maharaj . . . One of my friends brought me to Taat Maharaj by telling me he could sit in samadhi for hours at a time while his followers sang and chanted. I didn't believe it, so I went to have his darshana (the viewing of a saint or deity). Sure enough, I could see that he was merely closing his eyes and fooling everyone. On top of that I was supposed to bow down to him! While I waited there I examined the room carefully and came up with a plan. Back at home I sharpened the point of a long iron nail until it was razor sharp. A few days later I returned to Taat Maharaj and got into the line to touch his lotus feet. When I got to the head of the line I bent down, raised the nail high above my head, and jabbed it into his foot. My God! What a howl came from that charlatan! His bellowings even drowned out the warbles of his singers.

"Wouldn't most people have responded to a nail in the foot even if they were in samadhi?"

No, not if the samadhi is genuine. A person who is in samadhi has no knowledge whatsoever of the outside world so long as he remains in samadhi. If Taat Maharaj had actually been in samadhi he would have felt nothing from that nail, not even a pinprick. But he was just pretending, so he felt it all. Everyone was so stunned that I had time to rush out the door to where an accomplice was waiting in the getaway car, and off we sped. I don't like to think about what might have happened to me had I been caught![7,8]

*One little satori and you think you're the avatar of the ages. But, when you are in a sangha where your peers know you, you can't mislead yourself because the system of feedback is absolute.*

LEE LOZOWICK

Of course, this humorous example (though not humorous to Taat Maharaj) is the *rare exception* to the rule of peer testing. Yet it demonstrates the principle that one's peers in the teaching world can help a teacher in a way that no one else is able to. Because of the dynamics of corruption and mutual complicity, in addition to the infallible slyness of the egoic mind, people who are in teaching positions need the help of others whom they consider to be their equals or seniors.

Charles Tart shares the following fantasy about a "spiritual teachers' club" that would allow for dialogue and provide grounds for mutual testing among peers.

I once had a fantasy that everyone who set themselves up as a spiritual teacher would also be a member of a special spiritual teachers' club where absolutely no students were ever let in. There they would sit around, drink beer, watch television, talk about what they were doing, and kid the hell out of each other: "You're having students do that?!" "That's the sickest idea I've ever heard!" It would be a place where they could get feedback from peers who know something about what they are doing. There's not too much of that, and we desperately need it. The principle of checking each other—collegiality— is very important.

*Question: Can one teacher learn from another?*
*Lee Lozowick: Not if they think they're enlightened.*

Reggie Ray and his peers, as it turns out, have made that fantasy a reality, in spite of living and working in different parts of the country. Ray and his colleagues, designated as *acharyas* ("teacher" in Sanskrit) by Sakyong Mipham Rinpoche, the son and successor of Chogyam Trungpa Rinpoche, stay in touch with each other and meet regularly for retreats.

Once or twice each year my peers and I get together and spend a week, practicing and talking. It is a very wonderful, very painful experience. When you're a teacher and you're with your students, it's one thing, but when you are with your peers and everybody is kind of—just what they are, there's something that reduces you to dust. It's a very good corrective when you're with your peers and they react when they see you're trying to make something out of anything. When you begin to think that you're somebody, your peers say, "Shut up!" It's good to have friends like that.

Reb Zalman shares a similar tradition of peer testing among rabbis in the Jewish tradition.

> There is the vertical check—the Master, and there's also a lateral check—your colleagues.  And your colleagues don't let you get away with stuff.  You meet them from time to time and you have some very good conversations—real heart-to-heart conversations, and sometimes they take you aside and say, "What you've been doing is not the way it should be done." So you hear that.  The other thing is also you hear from the people whom you're teaching.  You hear from superiors, you hear from equals, and you hear from people who are your students . . . The up side is that there's a peer system; the down side is that there's a lot of competition and backbiting.

For Ray, the peer group is a vital checkpoint. In response to a question about how someone could pursue teaching work without a teacher and without help from peers, he responded:

> I think it's very, very hard, particularly in America where there's so much emphasis on promoting oneself and setting oneself up. People sometimes say to me, "Why don't you teach on your own?" I always tell them, "No way! I'm not going to do that! That would be suicide!" It's dangerous enough, surrounded by everybody that I am surrounded by, but if I was out on my own? No!

*If teachers armor and insulate themselves from a peer group, and get stuck in the viewpoint that they've reached the top and there is no farther to go, they face a great danger because they cut themselves off from all sources of help, including the universe.*
LEE LOZOWICK

When we stay in relationship with those who have more stability than we have, we are fed and nurtured in a manner that actually protects us. We don't close ourselves off, defending ourselves with rhetoric and violence. The problem is that when someone feels all-important and transcendent, they allow this to separate them from everyone else rather than letting it move them into relationship with everything else.

Unfortunately, those teachers and students who are most resistant to relationship with their peers and seniors on the path are usually

those who need it most. They either consciously, or more likely unconsciously, know that their peers will see through their games and egoic manipulations. Therefore, while they may converse with peers or be "buddy-buddy" with teachers greater than themselves, they do not turn to them as a source of help and feedback regarding their own areas of weakness. Commenting on a situation in which a very popular spiritual teacher has isolated himself from relationship with his peers in the teaching world, Ken Wilber asks:

> What would the most enlightened World Teacher in history actually do in the world? Hide? Avoid? Run? Or would that teacher engage the world, step into the arena of dialogue, meet with other religious teachers and adepts, attempt to start a universal dialogue that would test his truths in the fire of the circle of those who could usefully challenge him . . . to step out in that fashion requires moral courage. It requires a willingness to engage and respond.[9]

## Can We Test Ourselves?

"I don't trust—and I don't advise anyone to trust—personal experience," commented E.J. Gold in an interview for the journal *Gnosis*. "I've had hallucinations and I know what hallucinations are and how powerful they can be. I've worked in the samadhi tank, so I've seen and experienced full-blown, three-dimensional, tactile hallucinations and I know how powerful they are. Therefore I can't say, 'I've met an angel!' Sure I have, but I've also had full-blown hallucinations, so what does that mean?"[10]

When one hears a warning like this from a master who has worked with students for over three decades, and who has experienced and witnessed as wide a range of mystical phenomena and spiritual awakenings as any contemporary master, it raises a strong question regarding trusting one's own experiences.

In response to the question of whether one can safely test one's own spiritual progress, Arnaud Desjardins cautions, "It needs so much honesty and desire for truth . . . and shame of untruth." Self-testing is dangerous territory when employed as the sole form of testing. The possibility for self-deception—even in the extraordinarily honest and sincere person—is simply too great to consider self-testing as the exclusive source of confirmation of one's enlightenment. Although the necessary testing doesn't always need to be formal testing from one's teacher, some form of objective feedback is necessary. On the other hand, individuals who use their teachers and peers as the only form of testing may wish to experiment with testing themselves in order to exercise and increase their powers of self-discernment, which they can later have affirmed.

When asked if an individual can create checks for themselves if they don't have a system of testing available to them, Reggie Ray responded, "I think that if you know that you need the checks, that is a really big step. I think it very well may be that the checks become available to you the minute that you really acknowledge that you need them."

Learning to test oneself is invaluable; it simply should not be considered the singular form of testing, or trouble *will* result. When one becomes familiar with the comings and goings of one's highs and lows, of the mystical, eventful periods of one's spiritual life and those that are dull, one needn't run to the teacher for confirmation of every small and large experience, nor presume that any experience is *the* experience.

*It is easy to question apparently irrational, funny or bizarre beliefs of others, but one's own are usually assumed to be true.*

FRANCES VAUGHAN

## Self-Checks

Although nearly all the masters and teachers included in this volume recommend using one's teacher or peers in the teaching field as a way to continuously check one's own enlightenment and spiritual progress, they also suggest that one might use certain guidelines for self-evaluation.

*The need to know everything is one of the signposts of incorrect awakening.*

Robert Ennis suggests that more advanced teachers not only do not have to know *everything*, they don't have to know *anything*. "They trust their own ability to deal with life as it comes along—there's no need to plan, no need to evaluate, no need to dwell on or criticize." If those who believe themselves to be enlightened cannot stand "not knowing," they should question their enlightenment. Enlightenment is not equivalent to omnipotence. Individuals who prematurely presume their own enlightenment often get themselves into trouble when they pretend to know more than they do because they think that will justify their enlightenment.

Lee Lozowick often opens his seminars by telling participants, "I'll do my best to answer your questions, and if I don't know the answer, I'll tell you." Many masters, when pressed with the difficult questions of life, respond by saying, "I really don't know. That's a very hard question."

*Dreams can be helpful, but also deceiving.*

One can look to dreams for confirmation, but one should also look to a teacher for confirmation of one's dreams! Reb Zalman shares a relevant story.

> There's a lovely story about this. A man came to the Kotzker Rebbe and said, "My father came in my dream and said that I should become a Master." The Kotzker laughed, so the man said, "Rebbe, why are you laughing? This is very serious." The Kotzker then said, "Meh, if your father had appeared in a dream to 300 or 400 people and said that you're their Master, I would have taken it more seriously. That you dreamt about it . . . so what!" In other words, that's your imagination, you don't have to take that seriously.

*"Be sure that you know that you're not enlightened."*

In some traditions it is considered important to know whether or not one is enlightened, whereas in other traditions it is relatively irrelevant. As a twist on the situation, Charles Tart, half jokingly and half not, suggests:

> In terms of enlightenment, the safest thing is to be sure that you know that you are not enlightened. Then you'll be careful. But as soon as you get that feeling that you are enlightened, you are not going to look for your faults. You are not going to ask for feedback. It's all self-validating, and very tricky.

Tart's suggestion is quite different from what the New Age guru will tell you! Andrew Cohen uses the phrase "leaning forward slightly off balance" to refer to this desired state of uncertainty, which not only deters one from ego inflation and spiritual smugness, but keeps one humble and ever looking toward further expansion. Uncertainty and awe of the mysterious nature of enlightenment may be more useful than confidence and charisma.

### How enlightened are you when hard times hit?

A superb test of enlightenment is to notice how enlightened one acts when in great pain, stress, or discomfort, or when things don't go the way one wants them to. Sensei Danan Henry observes:

> I'm all for people having enlightenment experiences, but what particularly makes a difference is what happens when circumstances are such that you can't be in a good mood: when people are coming on strong, when they are treating you badly, when things are confused, when you've got a cold. If your state of being doesn't reflect enlightenment, then you are going to become touchy and neurotic, sharp and defensive, whereas if

*It is only your behavior that expresses what you truly want, not what you think you want.*

ANDREW COHEN

enlightenment has transformed you, hopefully external circumstances won't affect you as strongly.

Many so-called strong dharmic practitioners are actually practitioners of convenience—we practice when it suits us, when we want to, when we feel like considering the principles and applying them. But if we get cornered, if our corns get poked at, or when a crisis happens that we are not prepared for, that's the test. If we think that we're enlightened and one dirty look or one snide comment from somebody can take that away, our "enlightenment" should be questioned. In fact, it is when others get really angry with us, misunderstand us, and treat us badly that we can see where we really are. Are we willing to practice under those circumstances? To apply practice and not just pay lip service to it?

**Am I free? Yes or no?**

From over fifty years of spiritual studies and teaching Arnaud Desjardins has formulated some important questions.

There are those who have studied, who have understood something, have had some experience, but who show weaknesses . . . There are those who speak convincingly, meditate beautifully, but who are not free. To speak about liberation with a capital "L" is difficult, but about inner freedom, yes. And that is the great question to ask oneself: "Am I free? Yes or no?" "Do I react? Yes or no?" "Am I one with the other, or are there still two?"

**Listen for and respect the feedback of the universe.**

Llewellyn Vaughan-Lee relates the following interchange:

Somebody said to Gandhi, "You say you are guided. Hitler also said he was guided. So how do you discriminate?" And Gandhi said, "You look at the results."

The universe will always respond. And if one cannot hear or understand the response of the universe clearly, they can ask others who live closely with them whether their experience is showing results—real results—with people, not with angels.

Jack Kornfield says that if you want to know about the Zen master, you should ask his wife or her husband. This is true not only of the Zen master, but of anyone who claims—outwardly or inwardly—to be spiritually advanced. Our spouses, children, close friends, and even work colleagues are continually giving feedback to us. The feedback of the universe does not come in cosmic visions, but in how our environment responds to us on a daily basis. Gilles Farcet comments on this ordinary, but precise, feedback mechanism.

> It's not dramatic. It's not like God descending to strike you, but it's very precise. You either get it or you don't get it, and if you don't get it, then your life is going to be hell because you will fall into the same trap again and again. Each time, the feedback of the universe is harder and harder and creates more and more difficulties with people. It's really very simple—nothing dramatic about it. But the fact that it is simple and not dramatic does not mean that it is not very precise and very sharp.

"Life itself is a fantastic feedback mechanism," suggests Lee Lozowick, "if we can read the signs. Life is always telling us when we're on and when we're off. Sometimes the signs are very obvious, but sometimes the signs are very subtle." If spiritual aspirants knew how to interpret feedback from the universe consistently and flawlessly, there would not be such an immediate need for external testing, but because of the egoic filters it is very difficult for most people to accurately and steadily interpret the feedback they get. Still, it is worthwhile to learn to interpret the messages that the universe is continually sending.

Feedback from the universe can come in the form of the response of the environment to one's actions, but it can also manifest as situations that arise for purposes known or unknown. For Reggie Ray, feedback

*Life itself provides the test. The way in which we live what life presents us with is an indication of where we are at.*
ANNICK D'ASTIER

and assistance have come in the form of illness. He explains the value of this seemingly undesirable source of help.

> If you're a teacher, you have things that can help you. In my case, for the last few years I've been sick off and on, and it's been very helpful and very necessary for me. I hate it. I hate being sick, but on the other hand, I appreciate it—for how do you stay grounded? How do you just keep your feet on the earth and realize the actual situation and not get so carried away with yourself?

Robert Svoboda discusses how one can learn to watch for the feedback of the universe—which he calls "nature"—in their own lives.

> Inevitably, whenever I've gone a little too far away, something traumatic will happen that will eventually wake me up sufficiently to guide me back in the right direction. You see, if you have really figured out what you need to do in cooperation with your dharma, you will find nature cooperating with you all the time—and that in itself is a good test. If nature is cooperating with you to do something, then you're moving in the right direction. If you are trying to do something and something gets in the way every time you try to do it, after the first one or two times you should be asking yourself, "Am I headed in the right direction or not?"
> For example, if you are thinking right now, "Madonna Ma is in town. She's supposed to be a great saint so I will go and see her," and if as soon as you have that thought you drop a rock on your toe, it is reasonable to conclude that this is the kind of omen that you might want to pay attention to. Because at the time when that thought came into your mind, you experienced something that was not of any particular benefit to you (unless dropping that rock on your toe happened to send some slug of shakti and enlighten you—that is a different

matter). But if it's an ordinary rock, dropping on an ordinary toe, that is something to pay attention to.

Again, the trick is correct interpretation, because it is equally common that some very ordinary event happens—someone drops a glass, or their car stalls, or they stub their toe—and somebody quickly suggests, "That's a sign . . . " So the universe gives feedback, *and* life is just life, and everything in life is not a sign of cosmic feedback. For this reason, a reliable source of *external* feedback (other than angels and spirit animals) is helpful.

## Time Will Tell

The great test for all spiritual teachers and aspirants—with or without formal or informal testing—is time itself. Few are those individuals, if any—even among those who manage to sustain their spiritual sand castles for decades—who escape the great test of time. Many can sustain exalted states for extended periods, but the grinding down process of daily life ultimately separates the true from the untrue. Years or decades are often necessary to see what will become of one's enlightenment.

In Chapter Twenty, Claudio Naranjo talks about how he was firmly established in a teaching function on the basis of his enlightenment before his clarity began to fade. The value of examples such as Naranjo's is that they serve as a warning not to presume enlightenment too soon, even after exalted, lasting experiences. All of the great masters have stories of their students who entered what they believed to be permanent enlightenment and eventually fell.

In fact, it is quite conceivable that "time will tell" only after decades or lifetimes. Robert Svoboda comments:

Vimalananda used to say, "The proof of the pudding is in the eating." So if a teacher goes out and starts to teach and gets good results and does not get either himself or his disciples

into trouble, we would think that things are moving in a positive direction. But we can't just think about that over a period of one year, or five years, or ten years. We really have to think of that over a long-term period. We have to see what happens in the long term.

Furthermore, one must look to the enlightened individual's actions—not superficial actions such as speech and an exalted gait or meditative bliss, but their ongoing relationship to life. Lee Lozowick observes that in the East there are many examples of great saints who left their wives, husbands, and children in search of God, and that Westerners often imitate such activity, presuming that it is the "enlightened" way. Yet, in truth, such activity may not only be unenlightened, it may be the expression of irresponsibility and the avoidance of real spiritual life. He comments:

*Do not think you will necessarily be aware of your own enlightenment.*

DOGEN

What defines enlightenment? One's ongoing relationship to life. If one's ongoing relationship to life continues to be self-centered, obviously you know that whatever the words are that come out of their mouth, something is wrong with all this magnanimous philosophy. But if someone's ongoing relationship to life—over time, years, is one of service, then you can say, "Well, even though they may take a vacation or whatever, maybe there is a stable relationship to the reality of non-separation." So in the moment you can't tell. In the moment you can guess. You can look at someone and say, "Well, my instinct is that this person is just having an experience," but you can't tell. You can only tell by observing the case, by watching their expression of whatever it is that they assumed happened to them.

Time *will* tell. One's enlightenment will be tested—whether one responsibly and willingly offers oneself to the formal or informal testing of the master and/or one's peers, or whether one waits for life to force itself through one's delusion and plant reality in one's lap.

## ROBERT SVOBODA: THE TEST OF AGHORI BABA'S STICK

*I should have known better when it came to the question of Aghori Baba's stick. Aghori Baba's stick had some definite shakti to it. It was the kind of thing that if you put it under the mattress of somebody who was about to die, it would prevent them from dying— at least temporarily. Aghori Baba's stick had been given to Vimalananda by Guru Maharaj when he came to Bombay. It had been sitting in the closet ever since then.*

*So one day, out of the blue, Vimalananda's foster daughter Roshni said, "What is the use of keeping Aghori Baba's stick around? We should take it back to Guru Maharaj."*

*I said to her, "What is the need of doing that? It is a powerful thing and it is sitting in the closet minding its own business. Why shouldn't it continue to sit there?"*

*Roshni said, "No, I feel strongly about this."*

*I told her, "Look. We're going to visit Guru Maharaj next week. If he mentions it, then we'll do something about it."*

*Guru Maharaj had not mentioned the stick for the past thirty years, but he mentioned it that day: "What have you done with that stick I gave you?"*

*Roshni said, "It's in the closet. Would you like it back?"*

*But once Guru Maharaj gave something to somebody, he never took it back. He said, "No, I don't want it back. Throw it into the ocean."*

*Roshni told him, "Well, I can throw it into the Ganges if you want to."*

*He said, "Throw it into the ocean. If I had wanted you to throw it into the Ganges I would have told you to throw it into the Ganges."*

*After he left, Roshni said, "See, I told you so."*

*I told her, "Look. He said to throw it into the ocean. The best thing to do is for me to take it to America. I am going to the United*

States next month, and I will have some time to experiment with it. Then I'll bring it back and before we come to visit him next year, I'll throw it in the ocean."

Roshni told me, "This is not a good thought to be having under his roof. This is not a good sign."

That afternoon, everyone took a nap. I had an unusual dream and woke up with a fever. In the afternoon Guru Maharaj came in and sat and he talked. While watching what was happening with me as my fever got higher and higher and higher, he said to us: "You know, I've been around for a long time. I've been able to achieve all the siddhis. There is no excitement in siddhis. What I am interested in achieving is the siddhi of when I do something for someone, if they don't admit that I've done it, something should grab hold of their throat and force them to do it. You see, right now I have to do it myself. I would rather have the kind of siddhi where it happens automatically."

I thought, "This is not a good sign. This is a bad sign."

Guru Maharaj left for the night and Roshni said, "See, I told you so."

I quickly repented and the fever went down. But I'm a very tamasic person, so of course as soon as the fever went down, I quickly unrepented. The fever went back up again. I repented again. The fever went back down again. I unrepented again. I said to the universe, "Look, I'll just use it for a few weeks in India. I won't take it to America." The fever went back up again. I kept negotiating until I went to Madurai and had my blood tested—everything was negative. There was no reason for me to be sick. So I finally realized that if I didn't cooperate with him, it might not be good for my continued existence. I finally decided, "All right. I will throw it into the ocean in Bombay." My fever went away and never came back. I did go to Bombay, but I didn't throw it in the ocean immediately. But it did go into the ocean finally.

# Psychological Purification

*Do not have unrealistic expectations: "Today I'm completely neg-
ative, tonight I meditate, tomorrow I'll be completely pure." You
cannot purify yourself overnight. Not only are such expectations
wrong, they themselves become obstacles.*[1]

—Lama Thubten Yeshe

Psychological purification is the cleansing and shedding of psy-
chological appendages that have been accumulated through a lifetime
of unconscious living, and of psychic debris that has amassed through
lifetimes of karma. Through this process of purifying and casting off
excess and incorrect understandings and perceptions, that which is
essential and always pure becomes conscious and manifest. Thus, as
one consciously engages the purification process, the false ideas and
presumptions, layers of obscurity, and neurotic perceptions that moti-
vate the false or premature presumption of one's enlightenment natu-
rally fall away. What is left is a clarity of perception that more accu-
rately perceives the distinction between mystical experiences and
abiding enlightenment, between pure and impure motivation,
between presumption and reality.

*If we have not been able to
make a relationship with our
suffering, frustrations, and
neuroses, the feasibility of
transmission is remote, ex-
tremely remote, for we have
not even made a proper rela-
tionship with the most basic
level of our experience.*

CHOGYAM TRUNGPA

Psychological purification tends to be the most commonly neglected aspect of the purification process among those individuals who prematurely presume their own enlightenment. These individuals are ready and willing to undergo austerities and deprivation, intense bodily sensations, visions, and fevers—which may or may not be symptoms of advanced spiritual purification. Yet they are often unwilling to engage the most basic level of psychological purification, which involves shedding the outermost layer of their self-denial and confronting those unconscious aspects of themselves that inhibit the clarity of perception that is vital to their spiritual progress.

The effect of a failure to engage psychological purification is exemplified by a Western *sadhu*, or renunciate, of Dutch descent who lives in southern India. Prakash, as he is called, has been living in India and doing sadhana as the disciple of a great master for over fifty years, although his master died years before he came to India. Prakash runs his own ashram, fancies himself a spiritual teacher, and rigorously engages intensive spiritual practice for many hours a day—praying, studying, chanting, serving. He is almost unparalleled among sadhus—Eastern and Western alike—in his knowledge and articulation of the dharma of all the great spiritual traditions. And yet, he has only one student and intuitively knows, though he is reluctant to admit it, that after more than five decades of valiant sadhana he has not reached his goal and very well may never.

As he enters his mid-eighties, Prakash cannot understand why he has not become enlightened. However, to those who know him, it is obvious where he is blocked, and it is also clear that if he cannot or does not address that blockage, enlightenment will never be his in this lifetime. Wise and learned as he is, this man was badly brutalized as a child—both by his parents and in Phillipino concentration camps. He carries with him a profound level of personal and psychological pain, as well as sexual wounding as the result of being raped in the camps, that effectively blocks any opening that would allow psychological healing, much less the energy of the unknown to consume him. He holds on so tightly to his childhood pain that he cannot let go into God.

Jack Kornfield explains the necessity for the spiritual student to disentangle himself from gross psychological and emotional blockages.

> When we have not completed the basic developmental tasks of our emotional lives or are still quite unconscious in relation to our parents and families, we will find that we are unable to deepen in our spiritual practice. Without dealing with these issues, we will not be able to concentrate during meditation, or we will find ourselves unable to bring what we have learned in meditation into our interaction with others.
>
> Whether our patterns of contraction and unhealthy sense of identity have their roots in our childhood or even in the more ancient patterns of karma, they will continue to repeat themselves in our lives and the lives of our children if we do not face them. It is simply not true that time alone will heal them. In fact, over time they may well become more entrenched if we continue to ignore them.[2]

*A person should not become dumber as a result of spiritual training.*

CHARLES TART

One cannot "skip" purification, though many have tried. One who stumbles upon something that could loosely be called "enlightenment" without proper purification is destined for continued difficulties in spiritual life, particularly in relationship to one's students if one should become a spiritual teacher. If we consider Andrew Cohen's perspective that the energy of enlightenment is impersonal and will enter through any human vehicle it can, the necessity to properly prepare that vehicle becomes obvious, as an impure vehicle carrying the great energy that many people mistake for enlightenment can be very dangerous. Proper purification on the spiritual path—particularly on the "lower" levels of psychological tendencies—greatly reduces the possibility that one will misperceive one's own enlightenment, and enhances the likelihood that one will be properly equipped to handle enlightenment responsibly when it does arise.

## The Need for Psychological Purification

We cannot be of practical value to God or Truth unless we understand the human condition, and the way we come to know the human condition is not by investigating our astral bodies and past lifetimes, but through learning about our own basic, mechanical, psychological functioning. Although our psychological functioning comprises only a fraction of who we are, our mistaken identification with it makes up the overridingly dominant aspect of who we know ourselves to be. Lee Lozowick discovered the importance of working with the psychological purification process as a part of spiritual development in his early years as a spiritual teacher.

> When I began my teaching work, people were having phenomenal experiences, but things weren't changing—their habits, their neuroses. It became clear that if people didn't work with their psychology, no matter how devoted and sincere they were, they were effectively blocked at a certain stage. If we don't efficiently deal with our psychology, we can forget spiritual work. Not that we can't have experiences, but we always come down from them.

*The more you are aware of suffering, the more you are aware of the true condition of birth, sickness and death, the more willing you are to take risks.*

ROBERT HALL

The premise of this book is that we are working toward an enlightenment that expresses itself not through living in a cave lost in bliss, but through service to others. In fact, to be consumed in ecstasy and soar with the angels is much easier than engaging the purification and discipline necessary to function in healthy relationship to others.

Psychological work is necessary, but psychological work is not spiritual work. This distinction is important, particularly during an era in which people are so quick to tag anything remotely transpersonal as "spiritual." The fact that psychological work can be of value to spiritual work does not make them one and the same. Psychological work is about the psyche and the psychology of the human being, and spiritual work is about God or Essence. They converge when the psyche is in need of psychological healing in order to proceed with spiritual evolution.

Bernadette Roberts clarifies this distinction in a letter she wrote regarding this volume.

> While the spiritual effects the psychological, the psychological can never effect the spiritual or bring it (the spiritual) about. Authentic spiritual development depends solely on grace which is God's doing and not ours. Grace is neither innate nor natural and even goes contrary to man's psychological nature. Thus, equating the psychological with (or as) the spiritual is not only misleading and false—a detriment to those seeking authentic spirituality—but is responsible for the contemporary confusion regarding the true nature of the spiritual journey.

*While healthy transpersonal development demands eventual transcendence of ego, the actual process of growth to higher, more subtle and complex levels of development does not necessarily ensure immediate transcendence of lower levels.*

FRANCES VAUGHAN

Just as psychological work does not replace spiritual work, spiritual work is not a substitute for psychological work in most cases. Many spiritual teachers have hoped that the purification process that is engaged in spiritual work would automatically take care of psychological purification. In some cases it does, but it cannot be assumed that it will. Deep-seated psychological knots have been known to emerge at very advanced stages of spiritual development.

Reggie Ray shares his thoughts on this issue.

> Many people of my generation have noticed that over the years we have tended to think that meditation is a substitute for actually working with our karma. That's not helpful. Sometimes people want to get into a certain state of mind and they're actually not engaging their neurosis and their confusion and their karmic situation. For that reason, I wouldn't dismiss psychological work. I think it's important.

Judith Leif suggests that thousands of years before the emergence of the formal field of "psychology," there were spiritual teachers who were effectively working with their students to purify those aspects of themselves that later came to be called "psychological." *Abhidharma,*

or Buddhist psychology, has been around for over two thousand years, but was considered as an inherent aspect of spiritual development that was not separate from spiritual life. It is based on the understanding that all levels of the human being must be dealt with in order to have a balanced spiritual development.

Gilles Farcet suggests that psychological work cannot be separated out from spiritual work when one is committed to a spiritual process: "It's all a unified whole. Arnaud always says that it's a life affair—you do it all your life. You do psychological work, and you work your way through life. It's all part of a learning process."

*He who has a pure mind sees everything pure.*
SARADA DEVI

Yet many respected spiritual teachers caution against psychological work because much of it aims at fixing up the psychology and making the individual feel better, while not catalyzing any genuine transformation. At times psychological work effectively retards spiritual progress by creating a fantasy of transformation when, in fact, it has only created a prettier illusion. "Psychological work has to be done in the right way with the right motive—the motive to destabilize yourself," comments Ray, "not to create another fortress that is a little bit more secure than the other one." Spiritual work is not about comfort. If comfort or charisma or talent happens to arise as a result of psychological work, it is purely a side effect. Spiritual work is about an increasing surrender to the presence of God or Truth in one's life.

Many "false" teachers have developed tremendously sophisticated psychological egos that are capable of demonstrating great power and charisma. They have manipulated their intelligence and their psychological understanding in the service of ego instead of in the service of the diminishment of ego that characterizes genuine spiritual development. Aware of this danger, Joan Halifax stresses the need—particularly for Western students—to do psychological work, but only in a context that does not strengthen the stronghold of ego. For her, this takes the form of Buddhist psychology.

Meditation itself and many of the practices we do as Buddhists are really not adequate to address psychological problems, as the sense of self is so strong in Western culture. I'm not so

interested in conventional psychology. Buddhist psychology is very different from Western psychology. It's not about a reification of the self. It's a realization of impermanence and interdependence and the capacity for freedom. It's very different from the psychology of pathology.

When psychological work is done for the sake of itself, it does not effect one's spiritual growth. However, when psychological work is used as a means of unraveling a psychological knot that is impeding spiritual progress by preventing balanced spiritual development, then it becomes an effective tool in the service of that development. Marie-Pierre Chevrier further clarifies this distinction.

> To really know oneself well, and to know the manner in which one functions—that is essential. It is not necessary to unravel one's whole history and every event that has happened, but to know how one functions. This work of knowing oneself leads to the spiritual search, whereas purely psychological work leads to more psychological work.

Psychological work, as it pertains to spiritual development, does not involve long, drawn-out therapy sessions about the inner child, or spending tens of thousands of dollars on psychoanalysis. Sometimes the psychological work that needs to be done will be done in a separate, therapeutic setting, and sometimes it is done as a part of the work of purification in the spiritual school. The value of doing psychological work in the spiritual school—when the psychological difficulties of the individual are not so extreme as to burden the collective spiritual work, and when the school is equipped to handle it—is that it is a natural process that is contextualized in one's overall spiritual development, and is less likely to become "psychology for psychology's sake." Robert Ennis comments:

*Self-knowledge as a psychotherapeutic measure frequently requires much painstaking work extending over a long period.*

CARL JUNG

> It should be possible to do the necessary psychological work in a school if the school is equipped to deal with that and willing

to deal with that. Some are and some aren't. But you can't go on until basic psychological issues have been dealt with.

There are many ways to do psychological work outside of a traditional psychoanalytic setting. Many spiritual teachers recommend transpersonal psychology, whereas others prefer more traditional methods. More important, however, than whether psychological purification happens within or outside of the spiritual school is that the therapist be effective, and that his or her intention be compatible with the intention of the spiritual practitioner, in spite of any differences in personal philosophies.

### Psychological Purification As Foundational Work for Teaching

Psychological purification, whatever form it takes, is necessary foundational work for anyone who wants to become a teacher. The unconscious oversight of the need for this type of purification has been the downfall of many teachers who have prematurely presumed their own enlightenment.

Spiritual teachers encounter every conceivable psychological manipulation—both from their own psyche and from their students. Students need a teacher with the skillful means to help them navigate their psychological labyrinth. The teacher must therefore be deeply familiar not only with his or her own psychological dynamic, but with *the* essential psychological dynamics that individuals in the culture manifest. This requires a tremendous amount of mastery and suggests why even many sincere and well-intentioned teachers are unable to effectively work with students. Rabbi Zalman Schachter-Shalomi elaborates.

If someone doesn't have insight into themselves, into their inner process and how they deal with people, and have a sense about what's appropriate and not appropriate, if they only see it from their own perspective, I think they will be a very poor teacher. People tend to generalize from their mind and body type for everybody, and the difference between someone who's

an amateur and someone who's really a pro is that a pro will check out the other person—what they need and where they are, before they prescribe. See, some people are buckshot people who say, "Everybody should do this and that," and they have only one recipe for everyone. I guess for some people, buckshot is a good thing. But I think a good teacher becomes a sharpshooter, and for that you need to have real good psychological acumen.

Ennis illustrates this same principle from the perspective of "harmonizing the organism."

Basic psychological work in terms of harmonizing the organism is necessary. You certainly should have harmonized your organism before you presume to teach other people how to harmonize their organism. You want each of your centers—the moving, thinking, and feeling centers—to be working properly. You want your relationship with your body to be functioning properly. You want your emotional center to be open and mature in terms of being able to deal with the full range of emotion without getting attached to anyone or paralyzed by anyone. You need to have access to anger, you need to have access to sadness, you need to have access to fear, so that not only will you have an accurate reading on life, but you will also be able to teach other people how to deal with those things. If there is an emotion you haven't ever dealt with, how can you teach someone else to deal with that? The same thing is true of the mind. The intellectual center has to be free to go anywhere; it has to be free to consider anything. There can be no taboo ideas, no taboo subjects, no banned books, as it were. A teacher needs to have full access to the full range of experience.

*The individual shadow is ineluctably tied up with the collective shadow. The integration of the shadow into consciousness is not a once-and-for-all event but a lifelong process.*

GEORG FEUERSTEIN

Jack Kornfield explains the need for teachers to undergo psychological purification by suggesting that because our awareness and

insight do not necessarily transfer from one dimension of life to the other, expansion in one aspect of life may still leave other aspects contracted. "Thus," he writes, "we encounter graceful masters of tea ceremonies who remain confused and retarded in intimate relations, or yogis who can dissolve their bodies into light, but whose wisdom vanishes when they enter the marketplace."[3]

If one is going to take up any type of spiritual teaching function (even if they refuse to be called a spiritual teacher but exercise similar influence over the lives of others), it is essential to have a thorough understanding of how human beings work. Perhaps this understanding is not necessary for an enlightened individual who works in a bakery or factory, but for one undertaking a teaching function, any areas of the psyche or the spirit that are left unexamined are eventually going to get in the way. Life is going to lead the individual who assumes a teaching function in every direction and into endless new situations. Although it is not necessary to have understood every past memory or minor trauma that one has ever endured, it is necessary to have a sense of one's own sexuality, one's own humanity, one's egoic tendencies, and one's relationship to children.

## Purification Through Darkness

*To become conscious of it [the shadow] involves recognizing the dark aspects of the personality as present and real.*
CARL JUNG

Psychological purification must eventually bring one face-to-face with one's own shadow—the dark, unconscious aspects of oneself that have been repressed and denied because they are thought to be "bad," or experienced as uncomfortable. Though most people resist intentionally engaging their own shadow, or underworld, it is a necessary undertaking for those who wish to purify themselves to a degree that the danger of a premature claim to enlightenment is greatly reduced.

An unexamined shadow is characteristic of charlatans and of seemingly solid teachers who, after a time, appear to "lose" their enlightenment or become involved in scandals and/or unhealthy relationships with their students. Arnaud Desjardins encourages his students to do serious work with their psychological dynamic. Gilles Farcet explains why.

When something has not been acknowledged, the shadow comes in and takes over. At some point, it is too late: the shadow has taken over. Since the shadow is proportional to the light, the more light there is, the bigger the shadow. And if you let the shadow take over, you're in for very serious trouble.

*[People] prefer to fight imaginary windmills rather than bravely stare the dragon of their own unconscious in the eye. They are scared of the sacred.*

GEORG FEUERSTEIN

Purification often happens through underworld experiences. Though people aspire to the freedom, bliss, and ecstasy of the upperworld, they are often unaware of and unprepared to undertake the journey into the underworld. They fail to understand that the dark side is as much a part of enlightenment as the light they so avidly seek. One does not come without the other, and if one refuses the dark, they simultaneously refuse the light.

The true nature of enlightenment is the marriage between enlightenment and endarkenment. You can't experience the heights of spiritual work unless you are willing to experience the depths. Carl Jung articulated this point when he wrote, "One does not become enlightened by imagining figures of light, but by making the darkness conscious. The latter process is disagreeable and therefore not popular."[4] Llewellyn Vaughan-Lee adds that shadow work—going into the depths of the unconscious and accepting and integrating the dark parts of oneself—is an important preparation for creating the pure inner space that allows for an experience of the higher self.

One senior practitioner whose sadhana has propelled her to frequently plumb the depths of the underworld shares her perspective on the value of the darkness.

Every upperworld experience has a parallel underworld experience. Each awakening is created to take you deeper. As high as you can go is as low as you can go. The underworld is the catalyst. It is the root and source of everything that goes on for us in the upperworld. The thing that catapults us into greater depths is the underworld. Upperworld experiences feel great but, for myself, I never feel as in touch with who I really am

when I'm in the upperworld, whereas in the underworld, I feel closer to myself. All the things in my life that I thought were irritants and problems were really catalysts that were challenging me to go deeper within myself.

*The shadow is a moral problem that challenges the whole ego-personality, for no one can become conscious of the shadow without considerable moral effort.*

CARL JUNG

Although difficult and challenging, the underworld is quite possibly a ticket into greater depths of self-understanding, humility, and compassion. Reb Zalman suggests:

Having a lot of light also brings the shadow with it. So the question is, "Have you learned how to deal with the shadow?" If we didn't have the shadow, we wouldn't want to work with other people either. We'd be content to be silent, quiet, God-realized beings who didn't need to make a fuss and go out in the world and teach . . . The shadow is also the dynamic part.

Teachers who are fully prepared to teach have acknowledged the shadow and in some cases made good use of their own work with their own underworld. The shadow will come out sooner or later, and it is much better to consciously purify it oneself than have it be the catalyst for confusing and otherwise avoidable difficulties in one's work with students.

## An Ongoing Work

The purification process is ongoing. As Charlotte Joko Beck describes, even *she*, an acknowledged master, continues to work with the desires for sensation, security, power.

Why even talk about enlightenment? When a person is ready, when that urge to know is strong, it's obvious to the teacher and student what to do next. We need to work patiently with our lives, with our desires for sensation, for security, for power—and no one here is free of those, including myself. So

I'm asking you to reexamine some of your thoughts about wanting to achieve enlightenment and to face this job that must be done with steadiness and intelligence.[5]

It seems ironic that the self-proclaimed, prematurely presumed, enlightened masters often describe themselves as having transcended all desire and attachment, whereas those teachers who have demonstrated their integrity over many years of stable and consistent work with students still claim to be ever-purifying themselves.

Robert Hall says that purification happens by trial and error: "When you learn that some kind of behavior produces suffering and then you decide not to continue that behavior—that's purification. Purification is not something you do, it's something you allow."

Individuals who aspire toward the great unknown enlightenment are responsible for continually observing their behavior and their mistakes and for letting go of those behaviors that do not serve their spiritual work. In this way, they allow themselves to be purified by forces greater than their own minds. To allow oneself to be purified is not a passive process that happens without any conscious intention, but a process that one opens to through clear and one-pointed attention and the willingness to learn from one's mistakes.

Purification is unceasing. Psychological layers of purification are at the base of the process, but the subtle levels of blockages and karma are endless. Particularly if one is serving in a teaching function in which one has obliged oneself to serve one's students, every last morsel of ego that has not been purified will show up.

In *The Lion's Roar*, Trungpa Rinpoche discusses how each level of spiritual practice both purifies neuroses and *creates* further neuroses that then need to be purified. The wisdom that is acquired alongside each successive layer of development also carries with it hang-ups that are particular to that layer of development. He concludes by telling a student, "There's no end. There's no end, my dear friend."[6]

*Ultimately, all you have to do is be willing to respond to the truth without hesitation.*
ANDREW COHEN

# Sadhana, Matrix, Integration, and Discrimination

*Resolve is possible. There is resolve for the suffering we feel. The answer is practice and practice is now. We should be thinking, "I need to practice. God needs me to practice. The universe needs me to practice. The guru needs me to practice. I need me to practice, perhaps most of all." Cultivate the view of practice as the solution, not awakening or enlightenment. Practice is now, not awakening some day.*

—Lee Lozowick

Sadhana, or spiritual practice, is the vehicle through which purification, the building of a matrix, and integration take place. Sadhana consists of all the formal and informal spiritual practices that a student engages under the auspices of a teacher as part of the training in a spiritual school. Matrix and integration are both aspects of and the fruits of sadhana. Building a matrix refers to the cultivation of a foundation, a context, a literal, subtle "structure" within oneself that can effectively contain and process spiritual knowledge and experiences. Integration

*It's not enough to come into the temple and divide your practice from your daily life, and then walk out.*

DANAN HENRY

is the process by which experiences and knowledge become assimilated into the being through the practical application of insight and experience in daily life. Sadhana, matrix, integration, and discrimination, together with purification, form an interconnected process, a great web of protection against the dangers of the mistaken perception of one's own enlightenment, as well as refuge from the other dangers of misperception common to spiritual life.

## Sadhana

Most people who make premature claims to enlightenment refuse to acknowledge the necessity not only for an extended period but for a lifetime of sadhana—a life of continual practice, study, and deepening of one's own understanding. These individuals convince themselves that they don't need to engage the rigorous efforts of sadhana by combining spiritual truisms such as "We're all already enlightened" with New Age philosophies that say we've leapt into a new time-space paradigm in which one can be enlightened without all the efforts required in previous times. They conclude that because they are so special and because they are living in this privileged time they are somehow exempt from the timeless responsibility of sowing the seeds from which the fruits of their own understanding will emerge. Georg Feuerstein comments:

> All too often, especially in New Age circles, people are so fascinated with the idea that enlightenment lies in the pathless "here and now," that they remain deaf to the countless traditional tales of struggle engaged by spiritual practitioners prior to their awakening. It is tempting and convenient to think that because *nirvana* (ultimate Reality) and *samsara* (conditional reality) are identical, we are already enlightened in our deepest nature and therefore need do nothing more, except perhaps to gossip about it.
>
> The ego does not want to know that the spiritual process, simple as it is, consists of a patient ordeal, a sometimes "bloody"

rite of passage, in which, ultimately, the ego is sacrificed. Thus the ego skillfully romanticizes spiritual life.[1]

Sensei Danan Henry discussed how, in reaction to the initial surge of monastic spiritual practice that characterized Western Zen in the sixties, the pendulum swung to what is referred to as "Budji Zen"—a philosophical Zen in which there is no real training or realization. Budji Zen, which is parallel to much of contemporary spiritual practice in all the new traditions, is self-directed practice. "You run the show," comments Danan Henry, "all day long, every day. You sit when you feel like it. You come to the temple when you feel like it. It is a practice directed by ego. The ego is always self-interested. If it is feeling a little nervous and uptight, it will do a little practice in order to feel a little bit calm. That's egotism—that's not practice, that's not relinquishment, that's not giving up the self." Budji Zen, as well as contemporary New Age spiritual practices, are sadhana of the ego. The ego directs them, the ego reaps their benefit, and the ego can feel secure in the fact that it is indeed practicing its way to the enlightenment which is already present anyway.

In *Eye to Eye: The Quest for the New Paradigm*, philosopher Ken Wilber denounces the notion that one can be enlightened by concepts and ideas about spirituality. He disputes and condemns the premise that learning a new paradigm can replace the efforts of purification and spiritual practice, and suggests that this should have been learned from our mistakes in recent history.

The notion was rapidly spreading that all you have to do to be a mystic is learn a new mental world view. If you actually think you can include the absolute Tao in a new paradigm—and get anything other than a mass of contradictions and paradoxes— then you foster the idea that by merely learning the new paradigm, whatever it may be, you are actually transcending—really transcending. I have actually heard that claim made. That is a disaster . . . But the fact that spiritual transformation takes years of meditative or contemplative practice, that it takes

*Everything that you encounter, everything you do from the moment you wake up to the moment you go to bed, is for the purpose of training and purifying the self—a seamless, uninterrupted practice from morning until night.*

DANAN HENRY

moral and physical purification, that it takes, or is helped by, direct contact with a living adept in divine realization, that it takes a direct opening of the eye of contemplation and has nothing to do with merely learning another mental paradigm—all of that was being left out. You know, we went through all this with Alan Watts. God knows nobody did more for mystical studies, especially Zen, than Alan, and I don't know a single person of my generation interested in transcendence who wasn't touched deeply by the man. Nobody could write like Watts, nobody. But it was just that—words. It was only at the end of his life that he rather surreptitiously began to admit that the core of Zen is, in fact, zazen. But by then, most of the people who began with Alan were now with Suzuki Roshi or Sazaki or Soen or Katigari or Baker—that is, they were actually practicing, actually working on spiritual transformation.[2]

*Practice should be so consistent that it looks like you're in nirvana already.*

LEE LOZOWICK

We keep hoping to be an exception to the rule of practice. Yet all the great masters and thinkers, as well as the great spiritual students who have tried to take the easy way out and failed, consistently call for the need for disciplined spiritual practice. "A great experience doesn't turn you into a saint," declares Rabbi Zalman Schachter-Shalomi. "Moral hard work turns you into a saint."

There are many teachers floating around with a clear perception of nonduality who insist that the laborious efforts of sadhana are unnecessary, as they themselves found a way to enlightenment without such painstaking exertion. One must question what kind of "enlightenment" one aspires to. If one is satisfied with the enlightenment they perceive in such individuals—the simple realization of nonduality—then they should discard the notion of sadhana and save themselves the struggle. It is only those who see this kind of "realization" as fast-food enlightenment, and who know that they will not be satisfied with anything short of the great feast, who need look further.

Reb Zalman says that in the Jewish mystical tradition practice involves everything that one does throughout the day.

In the morning you wake up and you say your prayers and study some. There are practices for alms giving, for helping other people—everything. Even how you treat your business—how much you may charge, and how you deal with your employees—all this is prescribed. It is all part of practice.

Danan Henry discusses the notion of practice in terms of aligning oneself to the Buddhist precepts. Whereas the precepts, as well as the Judeo-Christian "commandments" and the rules of any tradition, are often interpreted as regulations, they are in fact an expression of mature sadhana. One practices them in order to align oneself with the enlightened perspective, not for self-imposed moralistic or fear-based reasons.

*God who is purity itself cannot be attained without austerities.*

SARADA DEVI

The precepts in Buddhism (to not kill, or lie, or steal, and so forth) are not commandments. Buddhism, or any spiritual tradition, is not about self-reform, it is about living out of truth, and the precepts are just the way that the truly enlightened and developed person lives quite naturally. It is the behavior of someone who has reached complete Buddhahood. So we have to practice the precepts in order to continue to clarify the mind, which is not the same as imposing precepts. For example, when you see that there is no self, you understand the nature of the precept of non-killing because to kill is to postulate somebody separate from yourself. But you have to practice and practice and practice, and refine and refine, until you are truly living the life of enlightenment. You are living the precepts, and that is a testimony to your enlightenment, not to some self-imposed reform you are laying on yourself.

Another gift of spiritual sadhana is that practice itself protects one from the premature presumption of one's own enlightenment. Roshi Mel Weitzman shares a story about how Zen practice gently guided one zealous young man out of the illusion of his own enlightenment.

We get students every once in awhile who feel that they are enlightened. I remember one young kid—twenty-three or twenty-four years old—who believed he was already enlightened and tried to teach us all about enlightenment. I just humored him along and put him into the practice. The practice itself will straighten people out. We say that in order to straighten out a snake, put it into a bamboo tube. So let the student rant and rave about enlightenment, and then just put them into practice and the practice itself straightens them out.

*Don't relax practice, simply because you do not get his [God's] vision.*

SARADA DEVI

It is a great tribute to the universe that spiritual practice itself transforms the individual's perspective. Spiritual practices given by a teacher are empowered by a greater universal process and supported by thousands of prior years of practice by those who have traveled the path before one. The practices require work, but work that serves the individual's own spiritual development.

Lee Lozowick says that when one is in the midst of an experience of awakening, that is the time to solidify and objectify the significance of practice. At these times one can potentially gain a true appreciation for the value of practice and also use their temporary enlightenment to discover how to best proceed in order to sustain a life based upon that awakening. Unfortunately, most people get so carried away in the moment of awakening, realizing that there is "nowhere to go, nothing to do," or some other nondualistic insight, that they miss the opportunity to take something from that awakening that will feed their spiritual practice. That is why Kapleau Roshi advised Danan Henry to use his expanded consciousness to deepen his practice of *mu* rather than to languish in raptures.

One student shares her insights about the need for ever-increasing practice in daily life.

Practice is in no way a condition for experiencing grace, or for the existence of grace at all. Grace doesn't care at all whether anyone practices ever, or ever brings it into the world. It exists unconditionally and will always exist. But if we're concerned

with the evolution of this layer of reality that we live in, then practice is the duty we inherit along with that aim. Here we are. We're in the body and we have to work through the body in order to transform our lives. It is only possible through the body, through physical efforts, mental efforts, working with our emotions, feelings, and ideas about ourselves . . . I am beginning to see, through the mystical experiences I have had, that I have been waiting for a big experience to transform my life instead of taking responsibility for the effort that is required to bring my life into alignment with that which is revealed through the experience as "truth." The connection, or reconnection, to Source just ups the necessity for practice in ordinary life. In a way, the experiences do nothing but create greater necessity to practice. They just make me want to work that much harder because they increase the longing, the thirst. But it doesn't make the moment-to-moment effort any easier. Maybe it's even harder because it begins to dawn on you that it's all up to you to take responsibility.

Lozowick says that it is not the desire to realize God that motivates the individual to practice. The desire for God can take an individual to the path, but once on the path the desire for God often becomes vague and uncertain. "*Reality*," says Lozowick, "is the motivation to practice. Watching some skinheads who are so full of suffering and pain, so disaffected by life that they'll beat the shit out of someone—*that's* inspiration to practice." Practice itself reveals what Gurdjieff called "the horror of the situation." As spiritual practice strips away all the pretensions and presumptions that one carries around about oneself, God, Truth, enlightenment, and spiritual life, and reveals the destruction that the dominance of ego brings to one's own life and the lives of others, practice becomes the only viable option.

As with any other aspect of spiritual life, however, one must be very careful, for even in practice there are traps. Reb Zalman speaks of one.

*What genuinely concerns me is the necessity for a student to learn to be as awake as possible in each moment.*

JOKO BECK

The Jewish dharmic web is a very fine mesh, it covers so much. And the problem is that sometimes you can get so busy that you forget what you're doing it for or for whom you're doing it because you're so busy with it.

*The result of practice is that even if you want to act badly, you cannot. "It" will not allow you to act badly, because "you" are not the one practicing. And if you are practicing in every moment, than "you" have no authority, because "you" is your ego.*
LEE LOZOWICK

If the ego wants to be a martyr to attempt to prove its existence, then practice will become a tool for building martyrdom. If ego wants to avoid relationship, practice will become a noble excuse to avoid relationship. As we have seen, the ego can take *anything*, including the notions of practice, enlightenment, and spirituality, and use it to further strengthen its own fortress. Lozowick warns:

Most of our desire to do *tapas*, or spiritual practices, is a misguided heroism. We all want to go to India and sit in caves and meditate and get parasites. We want to make some kind of heroic gesture, thinking that it will attract God's attention. But those gestures usually don't mean so much. Tapas have to have a genuine purpose. It can't be a reaction against something, but instead has to be for deepening our practice. The point should be: What serves the path, the school, and the teaching most optimally?

Practice is yet another way that enlightenment is tested. The fruits of one's enlightenment can easily be seen in the way one practices in daily life, and there is no more demanding sadhana than to live consciously and intentionally. Roshi Weitzman suggests: "Practice will test you to your utter limits. This is the test. The practice will test you to your utter limits and you will have to bring forth something you didn't know you had."

Practice doesn't happen all at once, and one shouldn't expect to enter the spiritual path as a refined and advanced practitioner. Practice slowly builds the power to practice. Little by little the power of practice constructs a matrix, or foundation, within the practitioner that enables them to sustain the increasing benefits *and* demands that their own practice draws to them.

## Matrix

A matrix is a foundation, or energetic structure, that is slowly built through sadhana. It allows the individual to contain higher spiritual energies and processes and to integrate those into his or her daily life.

Bob Hoffman, founder of the Hoffman Quadrinity Process, says: "A lot of people who do spiritual work are putting whipped cream on top of garbage. The whipped cream is real, but the garbage will begin to stink through the whipped cream." The "whipped cream" of spiritual experiences, as Hoffman refers to them, are limited in their value, and can even be deceiving, if placed upon the garbage of the unpurified egoic structure. The exterior may look good, but if there is nothing solid beneath it, it will not hold up. Steady practice creates this solidity. The body is energetically strengthened to allow for a greater influx of transformational forces, and the emotional structure is stabilized so that one can remain steady in the face of the increased intensity of emotional activity that comes along with the purification process.

Llewellyn Vaughan-Lee shares the story of one woman's "enlightenment" experience.

> Recently a woman in our group had I suppose what you would call an enlightenment experience. (I don't like the word "enlightenment" because it is so often misunderstood.) She had an experience in which she died to her physical body and went out toward this center of light, pure light, a place where there was just pure consciousness and she had no physical body—there was just herself totally alone in the whole universe, nothing but her and this state of consciousness. Gradually she came back from there and said that for the next few days life was very, very strange. She looked at people in the street and they thought she was alive but she knew that she was dead somewhere, and where her heart was there was just a great, big empty black hole. It is learning to contain these kinds of experiences and allowing them to become part of a process that takes you somewhere.

"The work of the spiritual path," explains Vaughan-Lee, "is to be able to contain those experiences so they don't throw people off balance, because some of them can be very powerful." When mystical experiences arise and there is no matrix sufficient to hold them, one of three outcomes usually follows: one, they result in spiritual emergency; two, their value is misinterpreted and they cause ego inflation; or three, they fall away without catalyzing any transformation at all. Each of these three possibilities will be discussed in this section.

The Zen masters of old said that it is not the quality of the enlightenment that makes the person, but the quality of the person that makes the enlightenment. A solid matrix is formed through years of spiritual practice which mold, shape, and polish the individual character so that the quality of their personhood serves as a refined vehicle to contain the energy of enlightenment.

The matrix is the vehicle in which the energy of enlightenment, or God, or Truth is housed, and spiritual practice is the medium through which the house is cleansed (purified) and prepared. When the spiritual seeker does not do the necessary preparatory work, they invite God to move into an unkempt house that is unfit for majesty. Llewellyn Vaughan-Lee elaborates:

> You have to create a container within yourself in order to hold mystical experiences. Most of us are so cluttered by our problems, by our feelings of failure, of inferiority—all of the problems that we grow up with—that we clutter the room. If you imagine that the psyche is like a house, if the house is full up with all sorts of things and this energy of the higher self comes in, it bounces off all the furniture and causes absolute chaos. You can't contain it and you get very disturbed. I've met people who haven't had a container for their own experiences and have suffered as a result.

One practitioner of a devotional path—a thirty-four-year-old mother—suggests that we need to prepare an internal structure so that when the guest of grace appears we can properly host it.

My understanding of the practices is that if we work with them properly we can create a structure within which we can house grace once it appears on the scene, which could be at any point, unconnected to our efforts. If we are not practicing, when grace appears and we suddenly want a spare room for this guest, we've only got a heap of loose bricks. Practice creates a structure that can host grace, and this is the work: the process of integrating grace into our lives with the tools of our practice, so that grace can actually show up in this day-to-day reality we call "the world." The discipline of practice is also an anchor so that when grace streams in, instead of getting blown away and potentially becoming non-functional or unable to integrate it, there is a body of habits that is strong enough to handle the experience.

*If you do a lot of inner purification very seriously, that contains the ego. It actually creates a shell around the ego that stops it from being saturated by the spiritual experiences.*

LLEWELLYN VAUGHAN-LEE

It is said that if one were to see the full face of God one would be so overwhelmed as to perish before it. This is the kind of energy that naïve spiritual seekers are playing with. Without proper preparation, they may find themselves in situations they are not equipped to handle. Spiritual practice builds a new body of habits—conscious, intentional habits—that replace old neurotic habits and can function to contain and integrate higher energies. Vaughan-Lee tells another story of a young woman who did not have a matrix at a time when she naïvely invoked spiritual energies much stronger than she was prepared to handle.

I met this woman when she was in her late thirties. She said she had gotten married very young, and her husband was drafted to Germany. While in Germany, they found out about a spiritual teacher in England that they were both interested in. They were both very naïve, and he didn't realize that you can't just leave the army, so they went off to meet this teacher. He was captured for being absent without leave and was put in prison. She was terribly disturbed and upset. She didn't know a word of German and was alone in a foreign country and her

husband was in prison. She had recently read a book—I think by Ouspensky—in which he gave a meditation practice and talked about astral traveling. He said that if you did this meditation that you could travel on the astral planes. So she thought, "Wonderful. I'm going to do this meditation and go be with my husband in prison."

*Looking very objectively, the spiritual journey is more practical than esoteric.*
LEE LOZOWICK

She had never done very much meditation before, but she had so much longing, so much despair, that when she did this meditation she went much, much deeper than the astral plane. She went into the void, into the nothingness. She had been brought up with good basic values: the world exists, there is right and wrong . . . and she suddenly found herself in this place where there was no such thing as good or bad, and where nothing existed. She realized that everything she had been brought up to believe was a total lie, and that this universe was a total illusion. She eventually came out of it. I met her about twenty years later, and she was only just beginning to digest the experience. It threw her totally, because how do you digest an experience—not a dream, but an experience, in which you discover that this whole world is a total illusion?

A matrix is not only helpful in order to make use of mystical experiences, but in some cases it can be very detrimental *not* to have a matrix. "Some people have a tremendously deep experience at a very young age," explains Joan Halifax, "yet they don't have the emotional maturity to sustain it because the mental formations are so strong. The habit patterns are so strong that it is difficult to keep this vision awake. So for many people it's a downhill ride, with a tremendous amount of self-judgement, feelings of inadequacy, disappointment, a sense of betrayal, and so forth."

Vaughan-Lee says that the influx of spiritual energy that sometimes comes unexpectedly to beginning spiritual students, or even to those who experiment with drugs or come upon an experience by accident, literally vibrates at a frequency so high that an unprepared mind-body

cannot simultaneously contain both ordinary consciousness and expanded consciousness.

One reason the spiritual path takes a long time is that the mind has to learn to function in a different way, otherwise it gets shattered by a higher level of vibration of the self and becomes very fragmented. This is because the mind that is functioning in this level of duality, that knows I am separate from you, has to learn to function in conjunction with a sep-arate level of consciousness that knows that I and you are one, and experiences that I and you are one, and also experiences a quality of energy that, if people have a very structured mind, will begin to shatter it. This is one of the reasons that you need to spend many years meditating and doing spiritual prac-tices: to actually prepare the mind that you grew up with to learn to function in a different plane of reality, and to func-tion without interfering.

The Sufis of Nishapur, the lineage to which Vaughan-Lee belongs, were so aware of the necessity for a proper matrix to consciously con-tain mystical experiences that they designed their path over many centuries to introvert spiritual experiences to such a degree that the experiencer is not even aware of having them. They knew that the degree of consciousness and clarity required in order to make use of such experiences was more than the beginning spiritual student was prepared to sustain.

Another function of the matrix is to divert the dangers of ego inflation when strong mystical experiences arise. Because of the under-standing and strength that has been cultivated through sadhana, indi-viduals who have a strong matrix are less likely to allow mystical expe-riences to puff them up and can instead contain their energy in a way that creates real value and not just a brief egoic high. Lee Lozowick comments:

The average person does not have the work-muscle or the work-being to be able to have such experiences and not allow them to inflate them. Most of the people in my school who are having such experiences have been doing spiritual work intensely for some time. If someone comes to the school who has not had any work experience and all of a sudden they're having these wild experiences, my general response is to minimize it, to downplay it. If it is someone who has been here a long time, my tendency is to support, acknowledge, and encourage it, as long as that person has the depth and breadth to absorb the experiences in their proper perspective and not get all carried away.

In an interview with Zen teacher Charlotte Joko Beck for the Buddhist journal *Tricycle*, the interviewer inquired about Joko Beck's declaration that "breakthroughs aren't the point." She responded that Zen master Suzuki Roshi used to laugh when people asked him about breakthroughs, saying, "I've never had a breakthrough. I don't know what you're talking about." Joko Beck elaborated:

Until mind and body cease to want an ego-centered life, the openings and their teachings can be distorted into ego successes. It's only when mind and body are mostly free of reactivity (usually through years of patient practice) that it is possible to have a true understanding of life: not through a momentary breakthrough, but through an open and compassionate living in life.[3]

The matrix further functions to allow spiritual experiences to have a lasting transformative value. Without the matrix, experiences either fall far into the unconscious and are forgotten, or they are placed on the shelf to accumulate dust with ego's other trophies, effecting no enduring change in the individual.

At a public talk in Boulder, Colorado, Lozowick explained the necessity for a matrix in order to make use of the transformative possibilities that mystical experiences carry with them.

Many people feel that all they have to do is meditate or hyperventilate and have some experience and that that will imply some sort of transformation. All genuine spiritual work is built on a matrix. Probably three-fourths of the people in this room have had an experience that, if written up well, could compare to those of Meister Eckhart. But are you free from your suffering? From emotional recoil?

Without a suitable vessel to hold the kind of insight that may arise based on a great insight, that experience won't touch you. You may remember it, even for the rest of your life, but you won't be different because of it. Without a matrix to hold an experience—any kind of experience—it won't stick. It is not accessible, and your life doesn't reflect that experience. For your life to change from the way it is now, the experiences you have must be integrated into your life.

Jack Kornfield shares the perspective of many teachers and masters that to effect lasting transformation is a work that is far more laborious, and requires much more time, than most beginning spiritual students would dare to imagine. It certainly necessitates more than a few heady experiences.

*One does not become holy all at once.*
BROTHER LAWRENCE

My sense from my own Buddhist training and from teaching traditional practice for many years is that people underestimate the depth of change that is required to transform oneself in spiritual life. True liberation requires a great perspective—called a "long enduring mind" by one Zen master. Yes, awakening comes in a moment, but living it, stabilizing it, can take months, years, and lifetimes. The propensities or conditioned habits that we have are so deeply ingrained that even enormously compelling visions do not change them very much.[4]

Joko Beck further emphasizes this point.

> The capacity for a great satori—that's not going to happen to the average person. The person who has a great opening is somebody who has been almost selfless for years, and maybe that last little chunk drops off. I mean, great satori doesn't just fall out of the skies.[5]

New students regularly fall into the same pattern: they want liberation and freedom, but they don't want to practice and build the container to hold it. "People are so ill-established within themselves," observes Marie-Pierre Chevrier. "They try to go faster than one can really go and miss some essential steps in the process." Yet the process is known as spiritual *work* or spiritual *practice*, and not spiritual play or spiritual perfection, because it doesn't come easily. There is a high price for transformation, and the real goods only come to those who pay.

## Integration

*Many people have these moments of awakening, but how many people are prepared to have the diligence, the discipline, to do the work on oneself . . . in order, in the words of Brother Lawrence, "to be able to live in the presence of God," as a daily way.*
LLEWELLYN VAUGHAN-LEE

Integration is the process by which spiritual experiences and energies are slowly assimilated into the body, resulting in transformation. Whereas the mind tends to go in and out of enlightened states, abiding awakening is expressed in and through the body. Sensei Danan Henry explains the need for integration.

> Problems and difficulties—even among people of insight—can come about because seeing into the essential nature of reality, or even having the experience of it, does not of itself free one from habit forces created since time immemorial. You may know—from your experience of kensho or satori—that there is no abiding self, and that you are in fact no other than the phenomenal world. You may have had that and gone into the dokusan room and demonstrated that understanding, but you still have habit forces based on ignorance.

## ROBERT ENNIS: THE EFFECTS OF "CRYSTALLIZING ON A WRONG FOUNDATION"

Robert Ennis emphasizes that proper foundational work before awakening is necessary in order to effect a balanced enlightenment. He says that if one begins to function from Essence, or the context of enlightenment, without preparatory work, one's enlightenment will be lopsided and unbalanced. He explains that although realization is important, it is much more difficult to go back and make changes to the matrix once realization has been placed upon a lopsided foundation.

*In our tradition, foundational work serves to harmonize each of the centers, or bodies—the emotional body, the physical body, and the intellectual body. This is necessary so that when one is functioning from essence, that essence is balanced or harmonious. But it is possible to enter into essence without having done that. Gurdjieff called this "crystallizing on a wrong foundation." The result is that you have someone with power who doesn't have a very definite or real understanding of the nature of the universe. It's sort of like someone who is lopsided or missing an arm or missing an organ. These people have realized their self, but what they have realized is incomplete or imperfect.*

*It is much more difficult to make foundation-level changes later on. It is like when a tree is growing: it is relatively easy to make changes when the bark is soft and the tree is flexible, but once it becomes fixated in a certain position it's almost impossible to make changes. If you crystallize on a wrong foundation, on a lopsided foundation, eventually the part that is lopsided is going to trip you up. It's sort of like Russian roulette: you'll be fine for awhile, but then you'll come upon that one bullet. You're not prepared to deal with it because you didn't do the preparatory work properly. Usually it's the people who weren't prepared properly before they awakened that end up with problems.*

They are activated in your daily life, and so you still go on acting like a nerd. It can be painful. Many people have fairly deep insight and understanding, but they haven't continued to work properly and severed the habit forces and brought their daily life in line with their new understanding. This is the cause of a lot of problems.

It is possible for a sincere student to go into the zendo, in a sesshin, in a retreat, and to just concentrate on the koan or the breath, and then jump into the waking state. That is the isolated experience. Then they come back down. It is like having had a dream or a drug experience. They are not equipped in any way to integrate this experience into their life.

Through the process of sadhana, a matrix is built that can contain and integrate experiences and energies in a manner that effects transformation instead of feeding the tendencies toward inflation and misinterpretation. Without integration, suggests Vaughan-Lee, experiences never get grounded: "They are all floating around on cloud nine, and never get lived in the world, never get really integrated into people's daily lives."

*Even the extraordinary experiences are of no use, only something to let go of, unless they are connected with this moment here and now.*

AACHAN CHAH

A classic story of a successful, very high level integration is told about the famous Indian saint, Meher Baba. In *The God-Man*, C.B. Purdom writes that one night in January, 1914, at the end of one of Meher's regular visits to Hazrat Babajan—a great sage of that time—Meher kissed her hands and stood before her. Babajan then kissed him on the forehead, and shortly after he went home to bed. After just a few minutes, Meher began to experience "extraordinary thrills, as though he were receiving electric shocks; joy mingled with pain," and then he lost consciousness.

What followed this experience was a condition in which Meher was totally unresponsive and unconscious, sleeping and eating very little. Even medical treatment made no difference. Six months later he began to eat and speak some. His family thought he was "weak in the head, not the least in a high spiritual state." Every day he would knock his head against stones for hours at a time. Much later, he met another saint,

Upasni Maharaj, who upon meeting him flung a stone that hit him with great force and helped to bring Meher down into "gross consciousness" so that he could function in the ordinary world. It is suggested that hitting his head against stones, the final stone being that of Upasni Maharaj, was Meher's attempt to ground himself and assimilate his state of consciousness. Eventually, he became a great saint of India.[6]

Of course, for most spiritual aspirants neither the manifestation of spiritual energies nor the process of assimilating them will be as dramatic as it was in Meher Baba's case. Still, this story illustrates the fact that even great saints pass through years of assimilation and integration in their spiritual work. It took Meher Baba seven years to even be functional following Babajan's blessings, and his spiritual development certainly continued to develop subsequently. In fact, one could say that one is always in the process of integrating experiences, energies, and increasingly broader levels of consciousness.

"The ego has to surrender," says Vaughan-Lee, "because it is no longer in control of your life. It takes a long time for the ego to surrender so that the higher self really guides you and it isn't just the voice of your own spiritual fancies or desires. That all takes years and years of training."

Integration does not happen from one day to the next, as many would like to think. In fact, many people are either unaware of or choose to altogether ignore the necessity for integration, though it will eventually occur of its own nonetheless. They go straight from the enlightenment experience to teaching and proselytizing without realizing that their experience has not deepened, rooted, and been fully assimilated.

In *The Experience of No-Self*, Bernadette Roberts discusses the necessity for a prolonged period of integration and reflects on how this need is so often overlooked in spiritual literature.

> Following this first movement is an interval (twenty years in my case) during which this union is tested by a variety of exterior trials . . . Then, too, it is a period of becoming acclimated to the relative difference between life with the old, easily fragmented

*Integration happens through really tasting and feeling the experience, rather than thinking about or understanding the experience. You can see the degree to which you have understood and integrated your experience in the concrete examples of daily life.*

MARIE-PIERRE CHEVRIER

self, and life with a new self that cannot be moved from its center in God . . .

I might add that these intervening years between movements are also largely ignored in contemplative literature; their importance is highly underestimated due to the failure to realize that this interval is actually the preparation for a great explosion (a quiet one, however) that ushers in another major turning-point. It seems that at the end of this period a point is reached where the self is so completely aligned with the still-point it can no longer be moved . . . from this center. It can no longer be tested by any force or trial, nor moved by the winds of change . . . [7]

Kapleau Roshi suggests that until one's "awakening experiences are fully integrated into daily life so that one is living in accordance with the realization, that one could not be said to be truly enlightened."[8] He says that in the same way that one is not filled when one is hungry simply by reading about nutrition—that nourishment is extracted only after tasting, chewing, swallowing, digesting, and then assimilating the food—one is similarly not transformed by their awakening until they have integrated their understanding into their life.[9]

Vaughan-Lee reports that the Sufi master Bhai Sahib said that he could easily immerse people in mystical experiences, but that he largely refrained from doing so. "What use is it?" commented the master, "Because when they are not with me they won't be able to stay in that state." Experiences are not enough. It takes time and work to integrate into oneself the gifts of the gods. In *The Three Pillars of Zen*, Kapleau Roshi says:

Like a sprout which emerges from a soil which has been seeded, fertilized and thoroughly weeded, satori comes to a mind that has heard and believed the Buddha-truth and then uprooted within itself the throttling notion of self-and-other. And just as one must nurture a newly emerged seedling until maturity, so Zen training stresses the need to ripen an initial

awakening through subsequent awakening through subsequent koan practice and/or shikan-taza until it thoroughly animates one's life. In other words, to function on the higher level of consciousness brought about by kensho, one must further train oneself to act in accordance with this perception of truth.[10]

The illusion of duality must be pierced and understood to be false, but this understanding must then be integrated and expressed through action. Danan Henry argues this point.

Zen Buddhism is big on enlightenment experiences. Zen says that without that initial experience, without real, genuine personal experiences of the ground of being, that the tradition can be superficial. The main feeling in Zen is, "Just get the enlightenment experience, and everything else will take care of itself." That's not true! Everything else just doesn't take care of itself— we see this over and over again. Theravadan Buddhism, on the other hand, says, "Just live well. Be mindful. Live with meticulous effort. Keep the precepts, and enlightenment will take care of itself." It doesn't! Without deep realization and spiritual insight, there is no joy, no spontaneity. There is grimness. We are not here to lay trips on ourselves. We are here to touch others, to return to our true abode, to uncover our true nature.

*If a dervish remained in a state of ecstasy, he would be fragmented in both worlds.*
SAADI OF SHIRAZ

Lee Lozowick, also, is passionate about the need to integrate one's experiences into life itself, particularly because the state of the world is moving toward a potentially devastating condition. He explains that when one is experiencing great mystical states the tendency is almost always to want to absorb oneself in those states and "leave the world behind," but that instead the task is to remain functional in the world, which happens through work—concrete, ordinary, human work.

Because these mystical states are all-consuming, the thing I have said to everybody is, "You've got to keep working." Whatever work you can do—weed the garden, cook, go to your

job—the point is that you've got to stay functional. The purpose is not to get lost, but to allow the optimal purificatory force of the energies that are causing the bliss and mystical ascent and visionary experiences to affect your ordinary life in the world with people. The point is relationship—not just with people, but relationship with your world, so that you aren't adding to the destruction of the rainforests, and the genocide of tribal peoples, and the Westernization of indigenous cultures. Part of the wisdom of this purification is that you enter more deeply into relationship not just with your wife or your husband or your family, but with the world at large.

One of the points is to integrate this energy throughout the whole body so that it affects everything, rather than keeping it to the spinal cord and the brain, where it may have some effect on the mind but has little or no effect on the rest of the body.

If you have a support system, then someone can tell you, "Okay. Three hours of ecstasy in the morning, then work." It forces the energy—literally—to get into your hands when you're cooking, so when you're chopping vegetables you're not chopping up your fingers along with the carrots. The point is to bring your attention here, instead of allowing your attention to be wandering around the universe in some bliss soup.

It is through the process of integration—a process that happens only when one's spiritual life is based on a sound foundation of spiritual practice and when one does not jump the gun and make presumptions based on ordinary mystical experiences—that these experiences become assimilated to the degree that they effect transformation.

## Developing Discrimination

It is through sadhana, the construction of a matrix, and the process of integration that one begins to develop an increased sense of discrimination which includes: the ability to discern genuine thoughts

and experiences from egoically-based ones; the capacity to handle mystical experiences without getting carried away by them; the aptitude for self-honesty; and the ability to see clearly both oneself and other students and teachers.

"The individual who would aspire to claim enlightenment," asserts Andrew Cohen, "must be able and willing to discriminate. Without discrimination, a clear and unconfused understanding, untainted by contradiction, will be impossible to realize."[11]

Discrimination is not a linear process. Nor is it based on intelligence per se. There are many highly intelligent individuals who have very unintelligent discrimination when it comes to spiritual matters. With rare exceptions, discrimination must be developed over time, evolving through many years of spiritual practice and innumerable mistakes.

Claudio Naranjo comments:

> You shouldn't expect that discrimination comes only by itself. Discrimination comes from keeping watch over oneself by ongoing self study, ongoing reflection of one's experience, the intimate sharing of one's experience, and letting others in if you are part of a spiritual community.

Discrimination develops over time, but time alone clearly doesn't develop discrimination. Many students and teachers who have devoted their lives to the spiritual path still lack the ability to clearly see their own weaknesses, to find a true teacher, or even to know if they themselves are a real teacher! To become aware of the subtleties of the ground that lies between complete cynicism and ignorant naiveté requires work. It requires challenging oneself both internally and externally—applying the capacities of the mind, taking risks, and immersing oneself in the insecurity of spiritual life and of life itself. Most people want the easy way out. They don't want to do the work required for such self-honesty. But discrimination only comes through dedicated efforts of self-observation, self-questioning, and ruthless self-honesty.

*My crude law is that the day that man knows how to create spiritual shit he will become intelligent, because that day he will have rejected everything that is not necessary in order to go toward the spiritual.*

DANIEL MORAN

One of the advantages of having a trustworthy teacher is that the teacher trains the student in discrimination. Since discrimination is not a linear thing—there are no rules to go by and its application is different in each situation—students learn discernment by observing how their teacher embodies and expresses this quality. They can also test their own capacity for discrimination by questioning the teacher about how their ability for discernment has expressed itself in tasks they have been given, decisions they have made, situations they have responded to.

Lastly, discrimination tends to develop in proportion to the purity of one's intention and dedication to Truth or God, although it still may take time. Vaughan-Lee proposes:

> If you believe in oneness, if you believe in God, then you believe that your soul will guide you where you need to go. If you have the need to have an experience to learn discrimination, you have an experience. When one has integrated and purified enough so that their intention is even fifty-one percent stronger in favor of truth than it is of ego, then situations in life will provide ample opportunity for them to learn to see clearly, and to question and clarify their motivations, interpretations, and actions.

### Developing a Healthy Skepticism

Discrimination is cultivated by developing a healthy skepticism, not only toward oneself but toward spiritual teachers, toward mystical experiences, and toward one's expectations of what the spiritual path really implies and what "progress" on it looks like. Skepticism tends to carry with it a pejorative connotation, as if one is doubtful where one should be trusting, suspicious where one should be open-minded. Many people do fall into the category of righteous, fear-based skepticism, criticizing all elements of the spiritual path that involve risk because they are ultimately afraid of ego annihilation. But there is also a quality of skepticism that is necessary and rightfully due, considering

the prevalence of pseudo-masters and the insidious presence of ego in all spiritual matters.

In *Journey Without Goal*, Trungpa Rinpoche states:

> We need to encourage an attitude of constant questioning, rather than ignoring our intelligence, which is a genuine part of our potential as students. If students were required to drop their questions, that would create armies and armies of zombies . . . Preparing a beautifully defined and critical background for what we are doing to ourselves and what the teaching is doing to us is absolutely important, absolutely important. Without a critical background, we cannot develop even the slightest notion of the flavor of enlightenment.[12]

Skepticism is useful, especially for Westerners who as a whole lack an intelligent, critical foundation toward spirituality, easily falling prey to their own egos without any clear capacity for discernment. Andrew Rawlinson articulates the need to develop a healthy skepticism, and makes a distinction between higher and lower skepticism.

> Buddhism makes a distinction between two kinds of doubt: deep doubt and useless doubt. There is a distinction between useless doubt and the deep doubt which says, "What the hell is going on? I don't know what is going on." All the basic spiritual assertions and assumptions are deeply difficult to understand: commitment and faith, devotion and discipline. All of these assumptions can be trivialized.
>
> You have to keep asking yourself, "What is this devotion?" "What is this faith?" Of others, you can't ask, but of yourself, you have to ask. And you have to ask, "Am I kidding myself here?" The higher skepticism is protection. I've tried this and had my skepticism dissolve just like the sun on the mist in the morning. I've seen it go, and it's a great thing. Because if you've held the skepticism and then it is taken, you know that you're up against something stronger than you, as opposed to

*I am not more gifted than anybody else. I am just more curious than the average person and will not give up on a problem until I have found the proper solution.*

ALBERT EINSTEIN

you wanting something stronger than you and just making it up.

So there's faith and there's skepticism. I'm trying to put together deep skepticism, which is the tradition I was brought up in as an educated Westerner; and faith, which I have also experienced, which is something that was just given to me, dropped in my lap, the feeling of: "This is it."

I can't deny faith in the sense that my master was the truest thing that ever happened to me—more true than my wife whom I've been married to for thirty years, more true than the sun coming up, or certainly as true. And I can't abandon skepticism because I know that it can't go wrong if you are true to it.

So these two things are happening—one is a square and one is a circle. Faith is a globe, and when you're really in it you can never reach the edge of it because it expands in front of you infinitely. Skepticism is just the opposite: skepticism is like the diamond in the center of the sphere, and when you go back to it it's like you hit true metal.

*The spirit of a warrior is geared only to struggle, and every struggle is a warrior's last battle on earth. Thus the outcome matters very little to him.*

CARLOS CASTENADA

When one follows skepticism through to its end without falling prey to the traps of fear and doubt, that which is certain beyond scrutiny will reveal itself. Without applying skepticism, especially to ourselves, the allures of ego all too easily seduce us away from clear seeing and genuine insight.

Spiritual sadhana, the building of a matrix, and integration, combined with an increased capacity for discrimination, are all factors that determine whether or not the substance of mystical experience and technology is going to strengthen or weaken the individual. These means are empowered and strengthened significantly with the help of a spiritual guide. The spiritual teacher or master is the pivotal point in this formula, although clearly not every teacher will serve to correctly guide and protect the student because many teachers are themselves operating under the same mistaken presumptions about

enlightenment and spiritual life as their students are. Thus, it is vital to one's spiritual work to learn to discriminate between the true teacher and the false. In the next chapter, we examine this complex issue.

---

## ROBERT SVOBODA: TRAINING YOUR INTUITION

*Anything that you hear from anyone else, anything that you hear from yourself, any kind of information that comes to you is something that you have to evaluate. You can use a variety of techniques for training your intuition. Fundamentally, you have to rely on your intuition, but you have to be able to contact your intuition, and you have to make sure that when you are interpreting, when you are accessing your intuition, that you're doing it from a completely objective point of view, that you're not allowing yourself to get distracted by your preferences or your desires.*

*There is a difference between jnana and vidya. Jnana means "wisdom," but vidya means "body of knowledge." The vidyas are living bodies of knowledge. They are all goddesses. They're shaktis. A person who does medicine, astrology, music or something like that—a person who is really doing it—is not actually doing anything other than getting out of the way so that the vidya can act through him or her. So, as long as the vidya is acting through you, you can be a lot more confident that whatever is going on through you is something beneficial, because the vidya will be facilitating your intuition to work.*

*So if you're training yourself to be spot on, initially you may get results because your karmas are well aligned. But in the long run, especially when you have to do things, when you have to figure out things that may not fit with your techniques, then you have to rely on your intuition. If you rely on your intuition and you don't get good results, you can be fairly confident that something is wrong—not that your intuition is no good, but that you*

*are not accessing it properly. Or that you are accessing it, but that you are not interpreting it from the point of view that you want to interpret it from.*

*If you develop a healthy intuition, right away your intuition should start telling you things. It will be telling you, "This person is like this. This person is like that." As long as you have trained it so that you know you can rely on it, then it will give you reliable information. But even if your intuition is well polished, you can still create problems for yourself, because the world is a big place. If it just so happens that Saturn or Rahu or somebody is about to come down on your head and delude you, then that's what will happen. There are no free barbecues. Not in Texas. Not in Arizona. Not here in New Mexico. Nowhere.*

# True Teacher—
# or False?

*Buddha and the devil are never more than a hair's-breadth apart.*

—Buddhist expression

The true teacher is one's greatest protection on the spiritual path against all the dangers of self-deception, including being deceived about one's own enlightenment; the false teacher is one's greatest danger—as dangerous as having no teacher at all. The spiritual seeker who whole-heartedly aspires to the realization of his or her highest possibility in this lifetime must come face to face with two considerations: (1) whether or not they are going to have a spiritual teacher/master; and (2) how to find the true teacher amidst the masses of self-proclaimed charlatans, and even among the multitude of sincere but misguided teachers.

The term "true teacher" is used here to describe one who can effectively facilitate an individual's highest transformative capacity; the term "false teacher" refers to one who cannot, and who may even retard growth and evolution to a significant degree. But the issue is not clear cut. There are well-meaning but unprepared teachers, as well as corrupt, but highly functional and capable teachers, and every variation in between. Claudio Naranjo comments:

*No man is wise enough by himself.*
TITUS MACCIUS PLAUTUS

There are teachers on all different levels. There are fully realized beings, some great beings that we had not recognized to be so great. Then there are beings that make themselves big. And then there are beings who are quite sick, and still there is a spark of higher inspiration in them. And there are all kinds of combinations of the sublime and the ridiculous. All kinds of combinations of spirituality and pathology in which one feeds the other.

"When the disciple is ready, the master will appear," the saying goes. But the master doesn't always show up on one's front doorstep wearing a name tag. On the other hand, many a false teacher will gladly go to the effort of sitting on a potential student's doorstep and even wear a bright neon sign that reads "master" if they think that might get them the energy and attention they crave. Furthermore, one must be able to recognize the master when he or she does appear, or he or she will disappear just as quickly. One also needs to be able to see through the false master, or that teacher will follow one around for lifetimes.

While visiting a great saint in India, Daniel Moran, assistant teacher to Arnaud Desjardins, observed a close devotee of the master writing his name in her notebook and was told that the devotee does that twenty-four hours a day. Upon hearing this, he exclaimed, "She better hope when she gets to Heaven that God knows her guru's name!" The woman's practice was impeccable, and in this case so was her master, but Moran was alluding to the potentially enormous loss that one can incur if one devotes oneself wholly to the wrong teacher.

Carl Jung also comments on this principle.

I would not deny in general the existence of genuine prophets, but in the name of caution I would begin by doubting each individual case; for it is far too serious a matter for us lightly to accept a man as a genuine prophet. Every respectable prophet strives manfully against the unconscious pretensions of his role. When therefore a prophet appears at a moment's notice, we would be better advised to contemplate a possible psychic disequilibrium.[1]

When Ken Wilber asked Jacob Needleman what he meant by "false gurus," Needleman responded, "Well, somebody who picks up a great idea here and there, has a few mystical experiences and makes a career out of it. History is full of religious leaders whose spiritual authority is based on one big experience."[2]

False teachers run rampant. One has to apply profound skepticism when approaching a teacher—particularly in light of the overwhelming majority of false teachers traveling on the contemporary guru circuit. At the same time, one must be ever open to the discovery of the true teacher, because what that person can offer the genuine disciple is worth far more than the risk of incorrect guidance or even heartbreak that one may encounter with a false teacher.

"Maybe it's not negativity and backwardness that false teachers bring," suggests Lee Lozowick, "but a demand for students to clarify and make distinctions." Perhaps instead of discounting the possibility of finding a true teacher because one has been disillusioned by charlatans, one should sharpen one's discrimination in order to attract and/or find the true teacher once and for all.

## A Complex Issue

Finding the true teacher, and knowing when one has found him or her, is an issue of enormous complexity because forces far greater than one's own mind and body, including karma, influence one's relationship to the spiritual teacher. When teacher Purna Steinitz was questioned about who is responsible for a student finding a true teacher, he said, "God is responsible."

Arnaud Desjardins further exposes the complexity of this issue by suggesting that only the true disciple will find the true teacher, but that it is very difficult to be a true disciple. He says that those who cannot find a genuine teacher are not ready for the teacher. (*See* sidebar: "Am I a Disciple?")

*There are two very simple reasons why I teach. One is that I've suffered so much and I've been helped by teachers. The second is that I feel gratitude to those who have taken the time to teach me, and out of that gratitude I want to give away what I know to others.*

JOAN HALIFAX

Nonetheless, to the best of our capacity we are called to exercise the powers of discrimination that we do have in our efforts to identify the true teacher. This is complicated, however, by two principle issues.

The first is described by Dick Anthony, Bruce Ecker, and Ken Wilber in *Spiritual Choices*.

> It is impossible for one who is lodged in mundane consciousness to evaluate definitively the competence of any guide to transformation and transcendence, without having already attained to an equal degree of transcendence. No number of "objective" criteria for assessment can remove this "Catch-22" dilemma.[3]

No matter how it is phrased, the question comes down to: If enlightenment is beyond the scope of ordinary perception, how does one whose context *is* that ordinary perception evaluate the "enlightened one," who, by definition, abides outside of that context? Andrew Cohen writes:

> What makes this matter so confusing to so many is the fact that it is very difficult to ascertain the actual attainment of another as long as one is struggling within the initial stages of awakening oneself. It is because most of those who aspire to final liberation are precisely at that juncture in their own evolution that they usually feel insufficiently evolved to dare to assume such knowledge.[4]

Transpersonal psychologist Frances Vaughan acknowledges how difficult it is for the novice without training to assess the degree of mastery of a teacher.

> It is difficult for the untrained observer to distinguish a genuine spiritual master from a fraudulent one. Of course, anyone wishing to develop the necessary discernment through spiritual practice is free to do so, but the novice who has no training

in this area cannot be expected to make accurate evaluations of spiritual mastery, much as anyone who is not trained in science cannot adequately evaluate a scientific experiment.[5]

The second principle that makes it difficult to discriminate between the true teacher and the false is that ego does not want to find the true teacher—period. The true teacher is the ego's greatest enemy, a direct threat that ensures its eventual death. The ego wants a juicy, false teacher. As was made clear in Chapter Thirteen, on mutual complicity, the false teacher will validate the ego in a way that the true teacher never will, and thus the ego, often disguised as "my inner guidance" or "my spirit," will gladly crown the unqualified teacher as the true teacher, then lament its fate when it becomes disillusioned by some scandal or otherwise clear sign of the teacher's inability.

When somebody genuinely seeks a teacher with every cell in their body, it is not the ego crying out, but a deep, ancient longing for Absolute Reality. That person will find their teacher in due time. However, when one moves about from teacher to teacher, it is usually because there was some inner split between the true calling for the teacher and ego's attempt to sabotage that calling.

"Western disciples are notoriously fickle in their perception of the guru and in their commitment to the spiritual process," suggests Georg Feuerstein. "They are torn between the desire to catch a glimpse of Reality, or God, and the powerful impulse to affirm and assert themselves."[6] When the desire for a glimpse of Reality or God is the dominant force, the individual is capable of recognizing the genuine teacher, whereas when the ego's desire to assert itself is dominant, clarity is obscured. Feuerstein comments:

> Disciples of all eras have had to confront the possibility that their teacher may not be authentic or sufficiently qualified to guide them. But beyond any personal liabilities that a teacher may have, his or her very role is hazardous to the ego-personality that likes to dabble in spiritual matters but really resents and resists interference, divine or otherwise.[7]

*A learned man who has many friends may be a fraud, because if he were to tell them the truth, they would no longer be his friends.*

SUFIAN THAURI

## ARNAUD DESJARDINS: "AM I A DISCIPLE?"

*Gurus are not so common but disciples aren't either. And when we are considering the guru, we should also consider our own qualifications as a disciple. The question "What can I expect from the master?" inevitably implies another question—"What can the master expect from me?" We cannot consider the question of the master without reflecting on what a disciple is.*

*What is it we are asking for? Looking back I clearly see that I met Swamiji (Swami Pranjnanpad) when I started to really know what I was asking for, which meant many dreams and illusions had been destroyed over the years. This may be one meaning of the famous saying, "The master appears when the disciple is ready." Whenever I happen to give a seminar somewhere people tell me, "Ah, this saying isn't true, for me the master hasn't appeared." I do not have the cruelty to give them the real answer— "This saying is true but it is most probable that you aren't ready at all."*

*According to me, the guru must have time to guide me, to know me intimately, to give me private interviews. But what right do I have to demand that? Millions of people today have heard about gurus. Why on earth should a man who—through his own efforts and those of his master, through his personal karma and a whole set of circumstances—has solved his fundamental problems and reached liberation, why should such a man take particular care of me? Who am I, that destiny should grant me such unbelievable privilege? Life doesn't have to give it to you just because you desire it.*

*If, frequently enough, the question of the guru is not properly considered, it is because the question of the disciple is not properly considered. First the disciple, then the guru. If you do not have the being of a disciple, how can you hope to find a guru? And, taking into account who you are as a disciple, what type of guru can you legitimately hope to meet, and what are you then entitled to expect?*

*If you seek a teacher, try to become a real student.*

IDRIES SHAH

*Generally speaking, Westerners have a real lack of appreciation as far as the search for a master is concerned. Real appreciation has nothing to do with superficial judgment. If I show a child a precious round emerald and a multicoloured ball, he'll choose the ball which will impress his playmates. A jeweler, however, will know the difference. That's appreciation. We could say Westerners are not connoisseurs in this field. They want the cheap guru; they'd like to get an emerald for two hundred francs. It simply doesn't exist. One of the best allies of sleep in our Western world is our inability to evaluate the price of what is most precious.*

*This self-centered approach applied to the guru—"my guru, my guru"—is false. What you rather have to feel is, "I am his disciple." To be a disciple means to understand that this most precious among all relationships is not the relationship between an individual and an ego. It means to become part of a lineage which existed before us and will exist after us.*[8]

## Guru-Bashing and Spiritual Authority

To be clear about the necessity for a teacher in a culture full of charlatans, we must have some understanding of the current trend of guru-bashing and mass bias against all forms of spiritual authority, as well as of our own fears of spiritual authority and the reasons behind them.

It is interesting to ask why people who have no interest or involvement in spiritual life in any form have such a marked investment in "guru-bashing"—in tearing apart those who have, or who claim to have, some understanding of truth, reality, humanity. Is it simply that we are so terrified and repulsed by our own lack of understanding that we are envious of somebody else who appears to have it, and that we must make ourselves feel better by insisting that they are as ignorant as we are? Or is it that the possibility of a life of greater

*The popular mind does not care to distinguish between genuine spiritual teachers and fakes.*

GEORG FEUERSTEIN

integrity and truth is threatening to us because we don't want to leave our ignorance and sleeping state behind in order to do the work required by spiritual life? Or is it that spiritual authority is frightening to us because we were let down by the authority figures in our early lives and vowed to never allow anybody that power over us again? Or does it come down to the illusion of separation, the fear of death, and the fact that spiritual work nags at our false illusions of egoic autonomy and authority? Are we fighting the fact of our own ego death by resisting those who are trying to awaken from that illusion?

Most people who resist spiritual authority and denounce the value of the teacher have never deeply considered any of these questions. Others have been so burnt and disillusioned by false teachers that they have denounced all teachers in order to protect themselves from any further risk of pain.

"People who are unwilling to work with a teacher are basically resisting something," comments Purna Steinitz. "On some level, there is some nook or cranny of their consciousness that has been unexplored and not been freed, and they are unable or unwilling to free that up so that they can take advantage of the teacher/student relationship."

In an article entitled, "On Spiritual Authority," psychologist and writer John Welwood summarizes this dilemma.

*People think that a teacher should display miracles and manifest illumination. But the requirement in a teacher is that he should possess all that the disciple needs.*

IBN ARABI

To discount all spiritual masters because of the behavior of charlatans or misguided teachers is as unprofitable as refusing to use money because there are counterfeit bills in circulation. The abuse of authority is hardly any reason to reject authority where it is appropriate, useful, and legitimate. It is possible that in the present age of cultural upheaval, declining morality, family instability, and global chaos, the world's great spiritual masters may be among humanity's most precious assets. Glossing over important distinctions between genuine and counterfeit masters may only contribute further to the confusion of our age, and retard the growth and transformation that may be necessary for humanity to survive and prosper.[9]

## The Aghori Vimalananda: The Indulgent, Western Asuras

In this conversation between the Aghori Vimalananda and Robert Svoboda, Vimalananda discusses the weakness in the West regarding spiritual matters in a manner that may not be so appealing to the Western student.

"It is no surprise that Westerners mainly find false gurus. When you have cheated your own guru in the past why should you not be cheated in now? You get what you pay for; that is the Law of Karma."

"So why is this? Why do most of the people in the West want knowledge from the wrong motive, and get only cheats as gurus?"

"Why? Because most Westerners are asuras at heart. All the celestials, including the asuras, have to go somewhere when they fall down to earth. Many of the asuras—who are very fond of indulging themselves with meat, alcohol and sex, remember—have been born in the West, where they continue to indulge themselves. Occasionally one of them wakes up, a little; but because asuras are egotistical they conclude, as soon as they learn a little, that they know everything. Almost as soon as they learn how to meditate they start calling themselves gurus. But what do they really know of Indian wisdom? Nothing! They are still just probing our spirituality now. They will be learning spiritual things from us for the next 500 years. Even the dog of one of our Rishis could teach them for one hundred years and still have more to teach. Westerners are so far behind us in spirituality that to shine out among them is nothing. It is child's play for our so-called swamis to go abroad and try to impress all the monkeys over there with their so-called knowledge. I can tell you one thing: A real guru will come to the Westerners only when they decide that they are ready for real knowledge, and they invite Shukracharya . ."

"... *They won't need to search for him; when they are sincerely ready he will appear. They are his disciples, he is responsible for them. It is a great blessing to be guru or king to a bunch of asuras, because you are in a position to improve them. Unfortunately they tend to fall back into their old habits very easily, since their innate natures cannot change. Even Shukracharya tires of them now and again. I call people asuras when even though they have the desire for sadhana they cannot seem to follow the basic rules of discipline. I am willing to try to help such people out, but most of them are by no means ready for spirituality yet and I grow tired of them too.*"[11]

Whereas false teachers have helped to create and sustain this cultural bias, it is only the true teacher who can train his or her students to become impeccable teachers and individuals who model an integrity that stands in living contrast to it. If instead of blindly criticizing all teachers we learn to study what it is that creates false teachers and leads to their unwarranted presumption of enlightenment, we may glean some understanding of the way in which those same dynamics operate within ourselves so that we do not follow in the footsteps of the deluded.

Real spiritual authority, according to Llewellyn Vaughan-Lee, carries the stamp of freedom and not of the codependency and corruption that are so commonly associated with spiritual authority.

There has been much questioning and misunderstanding about the authority of the teacher and the disciple's need to surrender. In the presence of a real spiritual authority, this question did not enter my consciousness. I knew that the personality was not involved, and that there was no personal power dynamic. Real spiritual authority carries the stamp of freedom rather than the subtle or not-so-subtle patterns of codependency that are evident in any cult situation. This

authority does not come from any desire or egotistic power drive of the teacher, because a real teacher is one who has been made empty. If an individual feels the need to question the teacher's authority, he or she must be free to do so. In the Sufi tradition the seeker is initially allowed to test the teacher. But somewhere, on the level of the soul, the wayfarer instinctively bows down in the presence of a real teacher.[10]

## The Problem of Criteria

Concrete, fixed criteria for evaluating the mastery of any given teacher are limited, and at the same time can be very useful. The obvious limitation, as has been mentioned, is that to use criteria created in mundane consciousness to evaluate one who by definition is outside of that consciousness will pose difficulties. Imagine asking a baseball umpire who has never seen a soccer game to referee the World Cup.

"I don't think there are any hard and fast manuals," suggests Robert Hall. "Everybody is pretty much functioning at their own risk. It's not possible for most people to tell the difference between what you might call a genuine teacher and one who is a con artist. I don't believe it is something that can be taught."

In response to the numerous scandals and public disillusionments that have arisen in recent years, many respectable institutions and individuals have attempted to draw up lists of criteria for evaluating spiritual teachers. While they have raised some valuable points, if we rigidly stick to any set of criteria, however refined, for evaluating spiritual mastery, we may miss out on identifying some of the greatest masters of our time, as these masters often fall outside the domain of set parameters.

Reggie Ray is joined by many other contemporary teachers in his skepticism about using fixed criteria for judging spiritual masters.

It's not like having a scorecard of traits that you want in the person, and if they meet all of them then you decide you're

*If you're evaluating a gemstone, you want to look at it from a number of different perspectives.*

ROBERT SVOBODA

going to trust them and love them. If you're in that state of mind, you're not going to trust anybody. So I don't really understand this idea of criteria, which I know is very popular in American Buddhism: You have this scorecard with this list of traits that your teacher should have, and you check to see whether the person has it, and if they have it you decide you're going to trust them. I don't think that is psychologically accurate. I don't think that's how it works. I think it's much more out of control than that.

Spiritual mastery is far beyond ego's mastery. The criteria that are commonly used to evaluate spiritual teachers are highly conservative by nature. They are meant for the spiritual aspirant who wants to be totally safe and protected from any possible immoral behaviors on the part of the teacher, and guarded against any socially unacceptable means that a teacher may use in confronting the ego. However, as Ray alluded to, real spiritual work is not safe. It is very dangerous, and will never pass the safety standards of ordinary, linear thinking. Robert Ennis comments:

> I think it's pretty arrogant to think that you know how a teacher is supposed to act. I think you can only go by how a teacher feels, rather than how they act. The point of enlightened action is that it does not make sense logically. All of those Zen stories make no sense at all. Sufi stories make no sense at all—they're not logical. I don't think one should presume to judge a teacher based on logic or a list of standards of how a teacher should act. One should always trust one's heart. Of course, are you in touch with your heart? Well, that's another problem.

Claudio Naranjo and Andrew Rawlinson both suggest that criteria are limited in that those behaviors that demonstrate mastery in one teacher can be the very thing that reveal fraudulence in another. Naranjo explains, "Anything can be imitated. If you decide that a real

teacher is like this or like that, there will be fake teachers who appear to be like this or like that. You have to accept that a real teacher may be paradoxical. A real teacher may or may not appear like a real teacher according to any particular set of descriptors."

In talking about Freddie Lentz, the charismatic and questionable "teacher" who drowned himself in the ocean behind his house, Rawlinson comments:

> He was a charlatan. It rings true on every level. But everything he was accused of—charging a lot of money, having sexual relationships with disciples, starting his own tradition—every one of those things has been done by teachers whom I think people should take seriously. So you can't throw the whole thing out the window.

"There is no guarantee in writing a book and saying, 'According to this code, this person is a real teacher,'" explains Naranjo. "You can only point to inner realities that are immeasurable. You have to go through the subjective assessment. The real questions are: 'Is this person being a channel for the divine level?' 'Is this person connected to the divine level or the spiritual level?' 'How much impurity is there?' 'How much admixture is there of something else along with the spiritual gift?' Each of these things can only be perceived by a human subject. They cannot be discriminated by a computer."

A principal reason, if not *the* principal reason, that criteria are so limited is that concrete means are being used to evaluate context. It becomes increasingly clear that enlightenment is not a thing, is not a fixed state, is not comprised of a particular set of verbiage or a group of behaviors, but is a context. Thus, any deep and genuinely useful evaluation of the enlightened context would have to be a contextual evaluation, which is understandably difficult to do. An accurate contextual evaluation usually stems from an intuition that later proves itself correct. One can learn to develop this context, but usually only after a lengthy process of spiritual work. John Welwood cautions:

*Always discriminate.*
SARADI DEVI

We cannot rely on descriptions of external behaviors alone to distinguish between genuine and problematic spiritual teachers. Developing criteria for judging a teacher's genuineness by examining external behavior alone would, for one thing, neglect the context—both interpersonal and intrapersonal—from which the behavior draws its meaning; and for another, it would tend to identify one particular model of a spiritual teacher as being ideal or exclusively valid . . . [12]

Even if one could come up with the criteria to evaluate one's enlightenment, Charles Tart suggests, these would not necessarily represent the qualifications for spiritual teachership.

I'm also open to the idea that there may be some people who are very enlightened, but who are not very good teachers. In college we've all had teachers that we thought were brilliant because we couldn't understand them. They may have been brilliant in their field, but that doesn't mean that they were necessarily effective teachers.

In *Spiritual Choices*, Dick Anthony, Bruce Ecker, and Ken Wilber express a similar view: "There are people who have attained a great spiritual power but don't know how they got it and don't know how to give it to other people. And they make people think they're going somewhere, when they don't even know how they got there themselves."[13]

Lee Lozowick is uncompromising in his criticism of using criteria to evaluate something that is in fact far beyond the scope of the rational mind: "The need for criteria is the result of a lack of faith. As a general rule, if the teacher wants to sleep with your thirteen-year-old daughter, you should question that, maybe even run like hell as fast as you can. But if they don't steal, cheat, or physically abuse their students, investigate more closely." Like Reggie Ray, Lozowick suggests that what it takes to place oneself in the kind of relationship with a spiritual teacher that has the possibility to effect radical transformation

requires a leap of faith, an enormous risk, and a demand to depend on inner faculties that one may not even be able to access consciously.

## Criteria Nonetheless!

Criteria are problematical but can nonetheless be very helpful. Once again, spiritual life is full of paradoxes and uncertainties. Many of the same masters who criticize the value of criteria try, out of their compassion and understanding of the human predicament, to help seekers by providing them direction as to what to look for, and *how* to look, when considering entering into a teacher-student relationship.

In terms of criteria, most people who seek a teacher want to "see" evidence of their teacher's enlightenment. This is very tricky, for three reasons: (1) If we don't know what enlightenment is, it is very difficult to know what it looks like in someone else, and in fact it usually does not match up with our ideas about it; (2) Many respected teachers do not consider enlightenment a prerequisite to teach, a point that will be discussed later in this chapter; (3) As Tart has observed, even if one is enlightened, they might not be the best teacher.

Robert Hall and Andrew Cohen point students in the direction of looking at the teacher's life as an example of their enlightenment. Hall says that although there are no fixed criteria for judging spiritual teachers, perspective students should spend a long period of time observing the teacher in order to make sure he or she "walks the walk" and "talks the talk."

*A mature human being is someone who is purified of the motives towards grasping, greed, attachment.*

LEE LOZOWICK

Cohen expresses a similar idea in his book, *Enlightenment Is a Secret.*

If you decide to seek out the help of a spiritual teacher your first job is to scrutinize that teacher very closely over a period of time. You must find out if that teacher is Enlightened, and you must find out if the teacher's life is indeed a perfect demonstration of his teaching. If you find there is a gap between the teacher's words and actions you should leave him

behind. But if you decide that this person is in fact a true Master and that you want his help then you must decide to trust his intention to set you Free.[14]

What Hall and Cohen are referring to is often termed "enlightened action." Genuine masters exhibit enlightened action, and not just enlightened talk. However, enlightened action does not always match one's ideas about what it is. For example, let us say that "compassion" is an enlightened attribute. The common mind thinks that compassion is exhibited through a mirage of love and bliss that radiates off the teacher's face, or through feeding the poor, or through empathizing with the devotee's personal problems. However, compassion may manifest as a teacher severely reprimanding students, or giving them hard physical labor to do, or sending them away for a period of time. The difficulty, then, in attempting to view a teacher's actions as a sign of enlightenment is that one must have the eyes to know what one is seeing.

*You can learn more in half an hour's direct contact with a source of knowledge . . . than you can in years of formal effort.*

IDRIES SHAH

In crazy wisdom traditions (represented in this book by Chogyam Trungpa and Lee Lozowick), the teacher will purposefully act in paradoxical or nonlinear ways in their work with students. These teachers, who would easily "fail" on conventional lists of criteria, are exhibiting enlightened action but in a manner that is outside of the conventional mind set of enlightenment. Obviously, crazy wisdom can and has been used as an excuse for inexcusable abusive behaviors, but this is the risk one must take if one wants the teachings that unconventional masters have to offer.

When Lozowick was asked in a public talk how a student can "go about looking for a teacher," he responded:

1. If you aren't very serious about your desire to progress on the path, don't look for a teacher in the first place;
2. Don't be impulsive in signing up;
3. Study the teacher's body of students. How are the students, and how is the teacher with the students?

Other teachers expressed similar criteria. The first criterion needs no explanation: it's best to be honest with oneself about what one really wants from spiritual life so as not to get oneself in way over one's head. In line with Lozowick's second piece of advice to students, to not sign up too quickly, Hall observes, "I think it takes time and some critical judgment not to fall into a romantic swoon, or, if one does, to remember later that there is no hurry on this path."

Lozowick's third criterion—to "study the teacher's body of students"—is an invaluable piece of advice of which many seekers are not aware. Of course one must be careful about which students one examines, for there are blind followers and immature students on every spiritual path. But while it is difficult to judge the "enlightenment" of a master, one can see a demonstration of their work by closely examining and speaking with their long-term students. The students are not examined for their "enlightenment" per se, but in relationship to considerations such as: Do these students demonstrate qualities that I aspire to? Are they mature? Are they content with their teacher's work with them? Are they clear and centered within themselves, and not just mindless bliss-addicts who parrot fancy dharma?

Georg Feuerstein writes:

The question of a teacher's authenticity can be answered only when we see the gestalt of his or her work with disciples. It is not important whether a teacher can go in and out of mystical states at will, or whether he or she can perform all kinds of paranormal feats, or whether he or she can jolt the disciple's nervous system through the transmission of life-force, and so forth. It does not even make any difference whether a teacher has a splendid lineage or tradition to fall back upon, or whether he or she enjoys a large following. What really matters is whether a guru, in effect, works the miracle of spiritual transformation in others.[15]

When Claudio Naranjo asked spiritual teacher Oscar Ichazo if he should accept him as his teacher or not, he was told that he should

judge a teacher by the fruits of his involvement with him, by the results he got in following him, and by what growth he experienced through his involvement in his work and by being receptive to his indications. As a student, one can look to oneself as a meter by which to judge a teacher's work, but one cannot look superficially or in the short term. There also comes a time at which one must stop judging the teacher's abilities, and trust him or her wholeheartedly.

Humility is yet another characteristic that one may look for in a teacher, but it should not be judged superficially. The true spiritual teacher who abides in the context of enlightenment is humble to the degree that he or she no longer cares for the stature and power of the position. It is not a question of being able to *say*, "It doesn't matter to me that I am a master," but that it *really* does not matter. As in evaluating the crazy wisdom master, the tricky part of this is that it will not always be obvious. There are those masters who are humble but also confident, strong-minded, and outspoken, as well as those who use certain stylistic devices (e.g., humor or sarcasm) that superficially may not appear to be a manifestation of humility but are, paradoxically, an expression it.

Additional criteria for evaluating spiritual teachers were offered by other teachers and interviewees.

**Philip Kapleau Roshi:** *In his book,* Points to Watch in Buddhist Training, *written in 1235, Zen master Dogen defined a master as one who is fully enlightened, who lives by what he knows to be the truth, and who has received the transmission from his own teacher. By these criteria only a few roshis anywhere can be considered masters.*[16]

**Arnaud Desjardins:** Gilles Farcet, assistant to Desjardains, shared Desjardins' criteria.

*Arnaud says that in order to teach, one should basically be free of the four main areas of attachment: money, sex, power, glory. To be free of sex or money does not mean that you do not have sex or do not touch money, but that you are no longer liable to be carried away by those aspects—that*

*My humility is not there to impress you—it is there for its own reason.*

ANONYMOUS SUFI SAYING

*there is no risk that they will pollute your ability to serve, or interfere with your transmission.*

Farcet said that when asked about the qualifications of his assistants, who also serve in a teaching function, Desjardins replied: *These people have gone through tempests, storms, very concretely—not just mystical storms, like they've been through kundalini rising—nothing of that, but they've been through storms in their lives, and during these storms maybe they were really shaken but the mast didn't break. It stayed, and they were able to cross the tempestuous waters and come out of it alive.*

**Mel Weitzman:** *There is no step-by-step list of qualifications, but I have made a list of criteria necessary to give dharma transmission, though it's mostly subjective. It includes: good understanding, the ability to teach others, realizing that being a priest means to serve the sangha and not to promote yourself or try to gain anything, to not do anything that is done just for your own self-interest, and, of course, sincerity is very important.*

**Chogyam Trungpa Rinpoche:** *Finding a good teacher is not like buying a good horse. It's a question of relationship. If the teacher actually speaks in your style, connects with your approach, if what he says has some bearing on your own state of mind, if he understands your type of mentality, then he is a worthwhile teacher. If you can't understand what the teacher has to say, that's a lot of hassle at the beginning. Then, after he's said it, you have to try to interpret, and there's a lot of room for misunderstanding. So there should be a sense of the teacher's clarity and some kind of link between you and the teacher. The type of mentality and the type of style have to be synchronized.*[17]

**Andrew Cohen:** *The individual would have to have convinced you that they are a living example of what it is that you want to become. After scrutinizing them very closely, you would conclude that they are not struggling anymore in themselves to overcome impure motivation, that they are resting naturally in a state of pure motivation.*

In the journal, *What Is Enlightenment?* Cohen also writes: *There are some very basic, ethical laws that anybody who's not insane knows. They*

*One who doesn't have a sense of humor about what they are doing cannot possibly be awakened.*

ROBERT ENNIS

*are not esoteric.* When asked where the line is drawn, he responded: *The line is drawn where suffering is caused to other people due to selfish actions that stem from ignorance. That's where you draw the line.*[18]

**Robert Hall:** *I think it is necessary for a teacher to have a deep level of emotional maturity, sound judgment, to have a well-developed code of ethics, and to not be a person who finds psychological abuse attractive.*

**Georg Feuerstein:** *Accepting the fact that our appraisal of a teacher is always subjective so long as we have not ourselves attained his or her level of spiritual accomplishment, there is at least one important criterion that we can look for in a guru: Does he or she genuinely promote disciples' personal and spiritual growth, or does he or she obviously or ever so subtly undermine their maturation?*[19]

**Frances Vaughan:** *In order to choose a teacher or group with some degree of self-awareness, one could begin by asking oneself some questions. In considering involvement with a self-proclaimed master, for example, one might ask: What attracts me to this person? Am I attracted to his or her power, showmanship, cleverness, achievements, glamour, ideas? Am I motivated by fear or love? Is my response primarily physical excitement, emotional activation, intellectual stimulation, or intuitive resonance? What would persuade me to trust him/her (or anyone) more than myself? Am I looking for a parent figure to relieve me of the responsibility for my life? Am I looking for a group where I feel I can belong and be taken care of in return for doing what I am told? What am I giving up? Am I moving towards something I am drawn to, or am I running away from my life as it is?*[20]

**Gilles Farcet:** *It does not hurt to at first rely on very basic data, all the more so if you haven't yet developed a degree of experience and discernment in that field: Who was the teacher's teacher? What sadhana did this teacher do? Does he belong to a tradition, a lineage? How is he viewed by his peers? What about his students? What do his senior students demonstrate as far as basic human qualities and sensitivity are concerned?*

*Charisma is not a sign of enlightenment.*

In their exploration of criteria, several teachers called into question the whole issue of charisma as a quality of awakening or liberation. Jakusho Kwong Roshi was in a meeting with the Dalai Lama when His Holiness talked about this issue.

> We met with His Holiness the Dalai Lama at the first meeting of Western Buddhist teachers. He said that charisma is not a virtue for a teacher, or so-called teacher, but it fools people, and people look for charisma. In the Buddhist sense, it is not a spiritual quality, a spiritual virtue, but Westerners look for that quality. The Dalai Lama spoke about this issue because there have been a lot of scandals that have happened.

Whereas charisma happens to be an attribute of many great teachers, it is a by-product of their understanding rather than an expression of it. There are also many very powerful teachers who are not charismatic. Charisma is very seductive. It is such an inviting personality trait that we are often swept up in it before we even know what is happening to us. But we shouldn't assume that because an individual is charismatic, he or she is spiritual, much less enlightened. Spirituality often infuses one with a sense of presence and self-acceptance that is very compelling, but egocentricity and self-aggrandizement can produce a similar state. Charles Tart comments, "Certainly we're in a world that values egos—for a lot of people, the flashier the teacher, the better."

Gary Mueller warns about the dangers of charisma, and suggests that real charisma is naturally integrated into the personality.

> I don't really believe that a leader needs to be charismatic. In fact, I think that it is a seduction of ego. Real charisma is integrated into the personality. For people who are naturally charismatic, it becomes an emanation of their beingness. But when it isn't integrated, it feeds on dependency.

*Just as a truly generous person doesn't say, "I'm a generous guy, you know," so one who has integrated into life what she or he has realized in awakening will not wear enlightenment as a badge and shield.*

PHILIP KAPLEAU

### ARNAUD DESJARDINS: "WITH A TRUE MASTER, YOU CANNOT HELP BUT FEEL HIS LOVE"

When I was traveling alone in India in the Himalayas, I met not only very famous masters, but also masters who were not so well known, or known only by a few people. Some of them were genuine masters—there was no doubt—and year after year I was not disappointed by them. In other cases, it was obvious that there was something wrong, some ego left behind which had not vanished. And the proof of their falsity would come, and the people would be so disappointed.

It has been my good luck not to be cheated by fake masters, even when I was young and inexperienced, and very ready to dream. With a true master, you cannot help but feel his love. He gives so deeply, and he serves. Light radiates around him. Can you feel his love? His compassion? All masters—all of them—have this love. We could also call it "essential kindness."

One with open eyes and an open heart can feel and know this. The main point, as I said, is love, and kindness—with everyone. Even when the poor peasant, or the uneducated man or woman who had nothing to do with spiritual life would come to the ashram of Swami Prajnanpad, Swami would look at him or her with so much love and compassion and oneness. The question is not only "How is the so-called master with those admirers who do prostrations in front of him?" but also, "How is the so-called master with very ordinary people? With working women who have come to sweep the ashram, or to repair a wall that has fallen down?" I have seen Tibetan gurus looking at such a person in a way that was heartbreaking, with so much love. Therefore we can ask ourselves, "What is my love?" This standard is a good way to appreciate the differences between people.

Lee Lozowick makes a related observation: "Popularity is not necessarily a positive sign. To have many students is not a conclusive sign of a good teacher."

The perspective of these teachers is clear: There are many attributes of spiritual mastery, and charisma is not one of them. At best, charisma is a relatively random by-product of greater forces operating through an individual; at worst, it is an indication of psychosis. For example, many psychopaths are very brilliant individuals, and if they choose the field of spirituality in which to manifest their brilliance, they become extremely charismatic. One should be very careful to notice how much of one's attraction to a so-called teacher has to do with charismatic qualities that may have little or nothing to do with that individual's qualifications to teach.

*You would like to be one of those few people who have done something fantastic, extraordinary, super-extraordinary, one of the people who turned the world upside-down.*

CHOGYAM TRUNGPA

## Transmission

Chogyam Trungpa Rinpoche defines transmission as "the extension of spiritual wakefulness from one person to someone else."[21] According to many teachers, transmission is the primary criterion for assessing whether or not one is qualified to teach. Trungpa Rinpoche explains that the knowledge conveyed in transmission is not old or outdated, but living, wisdom. The teacher experiences the truth of the teachings and passes it down to the student as inspiration. The inspiration then awakens the student, who passes it on in his or her turn.[22]

Roshi Danan Henry explains the value of mind-to-mind transmission from master to disciple.

The whole idea of mind-to-mind transmission is that you have to show that you are the same mind as your teacher. You must show that, otherwise you'll never get transmission. If you are given transmission with anything less than that it undermines the entire system. In Zen, the teacher must validate the disciple's understanding—must. If that is not done, in one form or another, formal or informal, the whole thing unravels.

Rabbi Zalman Schachter-Shalomi said that a similar form of passing on the license to teach happens in Judaism, although there are some differences because full "enlightenment" is not a necessary qualification to become a rabbi in the Jewish mystical traditions.

> In the past, the question of succession and elevation to mastery has been dealt with in two ways: One way was when the master died, if he didn't have children who were prepared to step in his shoes, then various disciples who had gotten to the first rank became the masters. It then was up to the other devotees to choose one or the other and make their "hitqashrut"—the loyalty bonding with them.
> In other settings, people would come and study with a master and then he would say, "You guys are ready to go out to do it." Then there would be various forms in which the official crowning would take place. One such form of legitimization was to be called to the Torah with the new title. You see, on every Saturday seven people read from the Torah. The sixth reading represents the *Tzaddik*—the righteous one. If the master felt the disciple was ready to assume that leadership, he would personally call him to the reading of the Torah in the sixth place. Others would consider this to mean, "He's already it," and then they would relate to him that way.

Purna Steinitz is uncompromising in his stance that one must—in some way—have the teaching passed down to one in the form of the lineage.

> When people ask whose decision it is that I teach, I say, "It is the decision of my teacher." I would never, under any circumstances, ever, may I die in hell if I were to do this, may I be struck with lightning on the spot if I were to do this, go out and teach without my teacher telling me to do it, without his one-hundred percent blessing.

I also would not call anyone else a teacher who has not had the teaching passed down to him in some form of lineage. That doesn't necessarily mean that you're a Zen student, or that you're a Tibetan Buddhist. It doesn't have to be that formal. There are people out there who won't even acknowledge that something has been passed down to them in the form of a lineage. But if you really look closely, it has been.

The degree of profound understanding, practice, and impeccability necessary for receiving traditional transmission is often highly underestimated. It is told that Suzuki Roshi sat in a closet for three days literally bound forehead-to-forehead with his successor, Richard Baker Roshi, in order to provide him with full transmission. Many of the greatest masters say that if they can transmit their understanding to even *one disciple* they have completed their life's work, and many masters on their deathbeds have grieved their inability to do so.

"In Zen," explains Kapleau Roshi, " . . . a disciple is ready to teach when his teacher says he is. This naturally places a great deal of responsibility in the hands of the master. If he is wise, with high standards, his seal of approval is the public's safeguard."[23]

Reggie Ray comments:

In our tradition, what qualifies you to teach is if your teacher feels you are ready. It's not your own choice. I think if it's your own choice it's very, very tricky. If you begin to have these types of experiences and you think, "Well, now I'm ready to teach," I don't think that's a very reliable guide. We can deceive ourselves so well. We can mimic so much. So in our tradition, the teacher says, "Okay, now you go do it."

*Students and teachers have a mutual obligation to keep one another on track.*

JUDITH LEIF

If transmission were to be handled with as much integrity as these teachers suggest, spiritual aspirants would not have to worry so much about false teachers and charlatans. They would simply go to a teacher who belonged to a lineage and had been sanctioned by that lineage to

teach. But this could only take place in a culture in which there was a strong cultural matrix for spiritual understanding and practice.

The concept of transmission has been largely left behind in contemporary spiritual circles. Whereas many so-called teachers consider it to be outdated, or impractical in our day and age, the truth is that students and teachers alike—with their fast-food spiritual mentality—are *not* willing to pay the price of time, energy, and uncompromising effort that transmission requires.

Charles Tart comments on the cheapened notion of transmission and empowerments.

> I don't know what full spiritual transmission is. I've certainly been to very fancy Tibetan Buddhist transmission rituals. They bonk me on the head with a vase and chant the mantras. I appreciate their cultural integrity, but I don't know. Some people say afterwards, "Oh, wasn't that a wonderful empowerment?" I'm glad they liked it.

Jakusho Kwong Roshi laments the fact that everybody wants to teach but few are willing to do the work necessary to receive the quality of transmission that only comes through years and years of devoted efforts under the guidance of a genuine master.

> Everyone wants to be a teacher. Everyone wants to talk about the dharma, but no one realizes it. There have been people who have left here because they wanted to be teachers and I told them they were not ready, that they needed more training. In the old days people stayed with the master twenty, thirty, forty years. Yet for these people ten years seems like a long time. But something changes when you stay with a teacher. You can't help but go through different processes. But I think "teacher" in this country is a loose word. As I said, everyone wants to be a teacher, but in Zen, becoming a teacher occurs through a process of transmission. You inherit the lineage of the tradition.

Those who study with Zen Master Robert Aitken are not spared the payment of time and practice required to receive transmission. Sensei Danan Henry, who is a student of Aitken Roshi as well as being a teacher himself, elaborates.

> In Aitken Roshi's system, you finish the complete work, the complete koan syllabus, and any other training that you are doing with him at the time. Then, you *might* be given the status of apprentice teacher. You then do that for ten years under his supervision, continuing to go to private interviews with him. Then, if at the end of ten years things are working out fine, if he has confidence in you, and if the sangha feels right about you . . . then transmission takes place.

Of course, you get what you pay for. Although the West has cheapened spirituality and diminished terms like "enlightenment" and "transformation," one still gets what one is willing to pay for. Aitken Roshi's high demands are most certainly matched by an equally high quality of transmission.

## Must One Be Enlightened to Teach?

Most people imagine that the primary qualification to be a great spiritual teacher is enlightenment, yet a deeper look reveals that this is not necessarily so. Judith Leif says that in Trungpa Rinpoche's formal lineage, to which she belongs, nobody is considered enlightened. There are many exceptional students and teachers (including Trungpa Rinpoche himself, who never claimed that he was enlightened), but "enlightenment" is not the yardstick they use to evaluate the individual's teaching capacities. Leif elaborates:

*Surely it is not so much a matter of giving people what they want as giving them the best one has to give.*

ASHLEY MONTAGU

> As far as I know, in our school there is nobody who has been proclaimed as enlightened. There also isn't a sense that because you are teaching that means you are enlightened. But really you

don't have to be enlightened in order to be able to help people on the path. There are some basic things you do need: one is to have practiced and studied for a considerable length of time. You have to be an elder, to have been around, to have practiced, to have studied. Other qualities that are important are devotion, understanding, and that you are able to represent the conditions of the school truly, without distorting them in your own words, in a way that is not superficial but comes from a digestion process. Beyond that, it's a very individualized process. At various points people are asked to teach or are given the blessing to teach by the lineage holder. Sometimes there is some kind of ceremony or empowerment involved in which one takes an oath not to distort the teaching or misuse it.

*I think the foundation for my being a teacher is recognizing that I am in the same condition as everyone else . . . I just like to talk about it.*

ROBERT HALL

Arnaud Desjardins uses similar criteria to assess his students' abilities to serve in teaching functions. Annik d'Astier, one of Desjardins' four assistants, explains, "Arnaud looks to us in terms of our real capacities, not necessarily awakening or enlightenment, but a certain accomplishment in terms of how we live our lives in the light of the teaching."

"I think that the unenlightened person is capable of teaching," says Robert Hall, "as long as there is honesty—real emotional maturity. What matters is a kind of communion that takes place at a level of connection between me and the students, an open-hearted and compassionate relationship and atmosphere. That's what matters most, and that I get out of the way as much as possible to allow for something real to happen."

When Charles Tart was asked if he thought that an individual must be enlightened in order to teach, he responded: "I hope not, since full enlightenment is probably very rare but the need for teachers is very big. I'm willing to have a lot of partially enlightened people around teaching. I think we desperately need them."

Robert Ennis affirms this perspective by challenging students to reap the benefits of the knowledge that the teacher does have, instead of criticizing them for every inconsistent behavior and imperfection.

Normally we get to rely on the teacher's every action as being exactly appropriate, but we don't get to invalidate the teacher as a teacher, or invalidate our relationship with the teacher, if at some point they do something which we cannot quite reconcile. Even if they are only ninety-five percent perfect, that is quite a lot, and we can learn that ninety-five percent. We don't have to reject that ninety-five percent because there is five percent that we're going to have to work on ourselves later. But even if they only have sixty percent of the problems solved—hey, you can learn about those sixty percent, and don't go around criticizing them because they don't have the other forty percent.

*Liberation is not something any human being can own. It's a matter of how resistant you are to it.*

REGINALD RAY

Based on the comments and experience of these teachers, it appears that an individual can be effective in a teaching function—provided that the circumstances are conducive and hopefully with the teacher's encouragement—when their capacity to serve as an agent for the teaching outweighs the obstructions within them; and when they have become a clear enough channel for, and expression of, the teaching in a way that others may benefit markedly from time spent with them.

One senior practitioner of a Western Zen master explains that whether people are fully enlightened or not, and whether they profess themselves to be teachers or not, the one who has awakened to any degree *does* teach.

We may not be going out and doing teaching work, but when a part of you awakens, you do teach. When somebody comes to me in need, it pulls something from me that I can share. You do begin to teach, it just may not be that you go out as a guru or master. As these awakenings happen, you feel the need to serve. It happens on different levels, but it's all the same. I'm beginning to think that enlightenment is not one big bang.

Just as one need not be enlightened to teach, one who is enlightened does not necessarily teach. Lee Lozowick told a group of his

students that even if they were all to awaken fully and absolutely, per-
haps only a couple of them would go out and become teachers. The
rest would continue as always with their jobs, families, and ordinary
life, but do so from the awakened perspective.

A principle point to consider regarding the question of whether
one must be enlightened to teach is to be clear about exactly what it
is that one is teaching. Marie-Pierre Chevrier advises:

> What is important is to know where one is at, and to talk only
> about what one really knows and what one has really lived.
> That is all we can really share, and the only way in which we
> can help others.

Robert Ennis says, "As long as you're continuing to grow as a
teacher, your students will understand this from the beginning. As
long as you don't claim to be finished, that gives your students the data
that they need to observe and study with an open mind." However, he
also cautions that "the teaching is not words, and the teaching is not
techniques." He says that if one does not have a genuine sense of the
teaching they are communicating, it is like teaching people to garden
with dead seeds: "You can teach them all the techniques, but they will
never have the experience of something growing for them." One can
offer a great deal even if they have not attained perfect enlighten-
ment, but if one offers concepts and techniques instead of living expe-
rience, that's what their students will get.

"If you're not enlightened," Lozowick suggests, "you teach what
you know—that's all. And if you do that with integrity and commit-
ment to your path, you can be a source of transmission as much as any-
body else."

"Commitment to your path" are the key words here. Lozowick and
Chevrier, in their respective functions as teacher and teacher's assis-
tant, both belong to strong lineages of teachers, and rely on that
source itself for their abilities to teach. Lozowick says that in most
cases the ability to transmit takes place only when the person who is
teaching has a steady and committed relationship to a genuine

teacher: "If someone is established in relationship to someone who is enlightened, and their dedication to this relationship is reliable, then putting your spiritual life in the hands of that person is the same as putting your spiritual life in the hands of the enlightened person—but only in that circumstance." He notes that the possibility of being able to transmit independent of a teacher and lineage is extremely rare.

Marie-Pierre Chevrier, as well, maintains that the condition that makes it possible for one who is not enlightened to provide valuable help to others is that there is a reference to a figure who is on the other side of the barrier—the master. "In other words," she explains, "people who are close to the master can help others on the way on the condition that it is always referenced to the master and to the lineage."

Although it is possible to serve effectively in a teaching position if one functions always in reference to the master and the lineage, most teachers would agree that there is a distinction between teaching what one knows, or teaching under the direct guidance of a realized master, and taking on the function of master or guru—the One to whom one surrenders oneself entirely. Lozowick comments: "You can accurately pass on the teaching without being enlightened, without embodying it. However, to pass it on in a living way, you have to be a living demonstration of the teaching. There may be eccentricities and idiosyncrasies in such an individual, but you can't be confused by that."

A mature spiritual practitioner elaborates.

Someone who was very well educated about spiritual life, practice, spiritual traditions, and discipline could go out and teach that and prepare other people, giving them a certain level of grounding that could help them, once they really experienced grace, to meet that grace. But that person isn't going to give those students grace or act as the source of such Influence.

*The soul of a human being is contained within the energy of the tradition.*
LLEWELLYN VAUGHAN-LEE

## Can a Real Student Benefit from a False Teacher?

The other side of the consideration of whether one must be enlightened to teach is the question of whether or not a real student can benefit from a false teacher. The answer, by and large, is "yes." A real student *can* benefit from a false teacher, the key phrase here being "real student." And real students are very rare. A broader group includes those who would like to be real students—those who, though sincere and generally willing to learn from their experiences, are not absolute and uncompromising in terms of the purity of their intention and their willingness to do anything it takes to achieve their intended goal.

There is also the question of what exactly defines "falsity" in a teacher. If one encounters a teacher who is self-deluded, manipulative, psychotic, and abusive, one's chances of learning "are not better than anyone who just reads books and stuff," says Robert Ennis. But there also is a whole group of teachers who are sincere in their intent, and maybe even spiritually mature to a large degree, who range anywhere from slightly limited in their teaching capacities to grossly mistaken about their own abilities as a teacher. Sincere students do seem to extract enormous benefit from such teachers.

*For the mature disciple it should not even matter, in principle, whether or not the teacher is fully awakened.*

GEORG FEUERSTEIN

"If you want to learn to play the piano," suggests Robert Ennis, "you don't have to study with Rachmaninoff to learn it well. You could study with a gifted teacher, or with somebody who will eventually become a Rachmaninoff, and that is fine. That's all you need."

Hilda Carlton, a teacher in Manhattan who was very popular at the beginning of the teacher trend in the United States, used to tell her story of studying with a teacher who was a full-out charlatan. At the time she believed that he was the true teacher and that he could do no wrong. He was abusive and cruel, and would say horrible things about her. Instead of feeling abused or insulted, she would go into ecstasy because her guru was giving her attention. Because of the purity of her intention, the path later moved her on to people who could really be of help to her.

## GILLES FARCET: "WHAT IS YOUR QUALIFICATION?"

*People have asked me, "Why are you in this teaching function and what is your qualification?" Naturally, what is behind the question is always, "Why you and not me?"*

*Of course, the direct answer would be, "I don't know, but Arnaud knows, so if you consider that Arnaud is your master then you shouldn't even be asking that question because he decided it." But if I'm being more patient, I say, "I don't know. You have to ask Arnaud."*

*What I do know is that I'm here. I have my faults, and everybody knows about them. I don't pretend to be finished whatsoever. The only thing I can guarantee is that I'm doing my job with integrity. If there is something wrong with what I say or what I do, let's assume I'll see it very quickly and try to correct it and then be able to say, "I've been wrong here, and it's no big deal because everybody can make mistakes, and I won't let my personal dynamic interfere with the teaching." That is all I can say—that I'm doing my job with as much integrity as I can have, and all the rest is Arnaud's business, really, because he took the responsibility of putting me here.*

*The whole question of people guessing if Arnaud's assistants are enlightened and what if they're not . . . I can really understand it, because I would have had those thoughts before, but it is completely besides the point. As long as people are asking these kinds of questions, they are missing the essential point, which doesn't mean that there isn't a shift of context that can be very radical and very important, but this whole thing of giving marks—this one must have an "A" in enlightenment or this one a "B" or this one a "C"—it just reveals our immaturity.*

"If you're a good student, you could still be progressing in a school where the teacher is somewhat . . . we could say 'enlightenment-challenged,'" Lozowick playfully comments.

Not only can a real student benefit from a false teacher, but the necessity of the student can actually strengthen the teacher. The student can draw forth latent capacities in the teacher through the very strength of his or her need. Lozowick tells the story of Richard Baker, an American Zen master who studied for many years in Japan. At one time Baker was the student of a teacher who, while not a false teacher, was somewhat weak in his abilities. When Baker met a stronger teacher, he left the weaker teacher and went to him. He was criticized for his decision, and it was explained to him that what he had done was not the ethical thing to do in Japanese culture. In the Japanese culture, if you are a good student and your teacher is weak, you stay with your teacher to strengthen him.

This story illustrates an important principle. Whereas it seems that a student who realizes that he or she is with a weak teacher should seek out one who is stronger, this is a selfish perspective which does not take into account the work of the teacher and the student's capacity to serve the teacher. When asked if this principle transfers to Western spirituality, Lozowick responded:

Of course . . . if the teacher has integrity. If the teacher is a bad teacher, that's different. But if the teacher is a good teacher, but just weak or immature, it's worth extending every benefit of the doubt to such a person, because think of how wonderful it would be if they were to become strong. There is no such thing as a teacher in a vacuum. Every teacher is a function of relationship to their students. So if you're a good student with a weak teacher, then the strength of your practice demands that that teacher rise to the occasion. It is a very great service; whereas if you just switch teachers and go to a stronger teacher, the stronger teacher doesn't have to rise to the occasion because they're already there.

"We can get what we need from a lot of different circumstances," Purna Steinitz adds. "It may not be as comfortable, it may seem that another teacher has a lot more charisma, or that they are a higher ranking teacher, but it doesn't necessarily mean that the student will benefit more."

Lozowick makes a point when he says that although weaker teachers do not have as high a level of "skillful means," or as large a bag of tricks that they can use to facilitate their students' relationship to "the Influence" (sometimes called Reality or God), if they are really decent teachers they are surrendered to that Influence and can still be a source of blessing force.

Sometimes students find themselves in the hands of a teacher who they know is not the strongest that exists but with whom there is a certain resonance—a "rightness" in being with that teacher. Lozowick says that every student "belongs" to a teacher and a lineage, and therefore the weaker teacher still may be the most appropriate teacher for any given student.

In the final analysis, a real student can benefit from anything. "A good student is a good student," Lozowick says. "It is their quality of life and the innocence they bring to the work that matters."

His point is affirmed in the famous Hindu story about a student who, rejected by his master, found a rock in the forest and made an altar out of it and worshipped the rock as his teacher until he achieved liberation. Real students can make use of any situation. The purity of their intention alone will guide them. According to Arnaud Desjardins, the great Indian saint Anandamayi Ma said that it doesn't matter if the teacher is enlightened as long as the student is sincere, because what you're looking for in a teacher is your own higher self. If you are really sincere, you will be guided to what you need.

## Ultimately, We Must Trust Ourselves

All genuine teachers say that we must rigorously question ourselves, our motivations, our perceptions—both in seeking out a spiritual

*Sometimes it takes a misguided or a false teacher to create a wise student.*

JACK KORNFIELD

teacher and in all aspects of spiritual life. At the same time, we must ultimately trust ourselves because there is no other option. Karlis Krummins, long-time student of both E.J. Gold and Lee Lozowick, explains, "If you don't trust yourself, you may not be able to trust anyone. If you don't trust yourself, there is no foundation, nothing to stand on. Trust is based in self-honesty."

Reggie Ray says that although most people do know the difference between the true and false teacher, they often don't know that they know, or trust what they know.

> I think people do see frauds, and they see them right off. The thing is that they don't realize they see them. They don't trust what they see, and instead convince themselves that everything is fine. Even the most confused person has so much wisdom, actually. The confusion is that they don't realize how much they really see. So you can sit down with someone like that and you can be a person who everyone thinks is a sane, wonderful teacher, and this completely messed up, confused, neurotic person sees things very accurately.

*There are two conflicting things: one is to put aside my feelings and thoughts about everything; and the other is to ultimately rely on my own best judgement, my own deepest feelings.*

DANAN HENRY

Lozowick clarifies this point by saying that although we can tell the difference between the genuine teacher and the one that cannot be of help to us, our psychological identification and our allegiance to our own egoic needs often get in the way of that clear perception. We may not want to see what we see, or we may not have the strength to stand behind our knowing. He explains:

> I think it's fairly easy to tell the difference between someone who is psychologically disturbed and someone who may be intense and even have eccentricities in their behavior but who is free, liberated. We don't have training in personal integrity, so if we get caught in something that is not right, we don't have the strength to extricate ourselves until things get so extreme, and even then we can't always do it. A lot of

us are too weak in our psychologies to make clear distinctions and follow our intuitions.

There are teachers who have absolute integrity, and there are those who use their position to manipulate people, to dominate people; teachers whose advice is clearly misleading. Any intelligent adult should be able to make such distinctions, but obviously we cannot because many adults become disciples of such people. We find ourselves in this position often: our psychology is seduced and our essential wisdom is put into question because we are so identified with our psychology that we can't detach and observe. We act blindly based on our neuroses.

We must trust ourselves, yet, paradoxically, we are not trustworthy. And, says Charles Tart, we will make mistakes.

To some extent, we can judge. To some extent, we can say, "This doesn't feel right. It sounds good but it doesn't feel right." Or "This feels like what I need." But people do make mistakes. It's not like we have infallible judgement. That is why self-study and knowing yourself becomes all the more important.

One who is not enlightened oneself cannot definitively judge the enlightenment of another, and at the same time one must. One can not know definitively, but with enough purity of intention and self-scrutiny, one can make a good guess. There are no ultimate formulas, no scales, and there are traps at every juncture along the way. In the final analysis, one must be willing to risk.

"Our only protection is to get in touch with our own internal guidance system—with our heart, our conscience," says Robert Ennis. "It's our only real protection. And I don't know any way to safeguard anyone from making a mistake in that area."

To understand the power of self-deception is to understand that one cannot proceed without help at every level of spiritual development.

The individual who is truly serious about spiritual work will seek out these sources of help, even though this "help" represents death to egoic identification, spiritual stardom, pride, and power.

*"I'd read so much about it beforehand that I couldn't help being disappointed when I actually became enlightened."*

# Section Five
# Disillusionment,
# Humility, and the
# Beginning of Spiritual Life

*We, deliberately seeking for that which we suppose to be spiritual, too often overlook that which alone is Real. The true mysteries of life accomplish themselves so softly, with so easy and assured a grace, so frank an acceptance of our breeding, striving, dying, and unresting world, that the unimaginative natural man—all agog for the marvelous—is hardly startled by their daily and radiant revelation of infinite wisdom and love. Yet this revelation presses incessantly upon us. Only the hard crust of surface-consciousness conceals it from our normal sight.*[1]

—Evelyn Underhill

*We are all just disciples of God; sinners trying to do better.*

IRINA TWEEDIE

The real spiritual life is a secret that few ever come to know. It does not comply with our ideas of spirituality, our dreams of enlightenment, our hopes for salvation. It isn't cosmic and it isn't the freedom one imagines it to be. Freedom is freedom from illusion—not freedom

from sorrow, suffering, or humanity. Real spiritual life offers the dissolution of all of one's illusions and ideals about what it is so that the truth of it can be revealed, of which enlightenment is only the beginning. This section considers spiritual sadhana as a process of disillusionment and reveals the possibility of becoming fully human that rests at the core of real spiritual life.

# 20

## The Sadhana of Disillusionment

*Reality is hard and persistent and will knock you on your ass every time.*

—Werner Erhard

*You can't live in God's world for very long; there's no restaurants and no toilets.*[1]

—Sazaki Roshi

"As everyone, when I was young, I was dreaming of samadhi," Arnaud Desjardins recounts. "Afterwards, I understood that the most important is not to try to go so high, but not to go down so low. I stopped dreaming about exalted states of consciousness, and instead wished that in my worst inner moods—fear, anger, all kinds of weaknesses—that I should not fall so low. That all changed one day."

Disillusionment in spiritual life is the dismantling of all illusions. It is the humbling process in which one discovers not only that spiritual life isn't what they thought it was and that enlightenment isn't

what they believed it to be, but that their level of attainment isn't what they imagined it was and that they themselves aren't even who they imagined themselves to be. Disillusionment is not "bad" or "negative," but the necessary and inevitable process of dismantling the stronghold of ego.

From one perspective, all of spiritual life is a process of disillusionment—every inflated bubble of ego that bursts is disillusionment; every idea about enlightenment that proves itself to be empty is disillusionment; every false presumption of one's own enlightenment that gets exposed is disillusionment. In fact, every realization shared by the teachers in this book could be said to be a description of the fruits of disillusionment. We should consider ourselves fortunate if we are disillusioned countless times on the spiritual path, for otherwise we remain prisoners of unreality, and live and die under the same spell of illusion that has hypnotized all of the sleeping world, including its pseudo-teachers and pseudo-students.

In *The Kundalini Experience*, Lee Sanella tells the story of a young man who, in his teens, began to have out-of-body and other mystical experiences which culminated in an immense experience of "infinite peace in infinite space." A Zen master told him that during this period he was in a satori state, and he became very involved in an intensive yoga practice. Eventually, he became a student of a popular contemporary teacher. "He began to realize," writes Sanella, "that his intense yogic practice was born out of the terror of dying and an attempt to remove himself from the stresses of life. He no longer suffered from the delusion of being enlightened and also saw how he had not the slightest inclination toward surrendering the stronghold of the ego, which is the single most important precondition for enlightenment."[2]

This is a common story among ambitious spiritual neophytes, who, in spite of their naïve arrogance, stay committed to the spiritual path long enough to allow it to disillusion them. Whereas anyone can easily spew out the phrase "life is an illusion," what lies between the ordinary spiritual aspirant and that realization is the often slow, painful process of disarmament. The sadhana of disillusionment is the practice

of continually opening oneself to the deepening realization that things are not as they seem. This itself is sadhana, is spiritual practice.

Disillusionment is the way that all of the great saints, teachers, and practitioners have gone. It is the road to humility and to compassion that no amount of nondualistic insight can provide. You will often find teachers who have not undergone a penetrating process of disillusionment saying things like "God is bliss," "All is love," "Peace is eternal," whereas the teachers who have been ripened through disillusionment say things like "There is always more to learn," "There is no end," "There is no way to avoid pain," and "Spiritual life is a process of continual diminishment." While some claim that the perfection of enlightenment confers a state of all-knowing, disillusionment is about going from knowing to non-knowing. Whenever anybody asked a question of Mike, a janitor who worked after-hours in a New Jersey high school in the seventies, he would always tell them: "More and more, I know less and less."

Describing the process of disillusionment, Ray Bradbury suggests: "The first thing you learn in life is that you're a fool. The last thing you learn is you're the same fool. Sometimes I think I understand everything. Then I regain consciousness."[3]

It is true that life is an illusion, but we don't really know that. Human beings need to be disillusioned. Ego needs to be disillusioned. As long as there is any egoic identification, disillusionment is required because ego is based on illusion; it lives and thrives on illusion.

Reggie Ray articulates the unsettling need to realize that, from ego's perspective, things really aren't all right.

> If you think that you're doing okay, that's a big danger signal. If you're not sure if you're doing okay and if you feel like things are very shaky, that's good, that's fine. Then you're on the path. There is no way to actually make sure that everything is okay, because basically from ego's point of view, things are not okay, and they can't be okay, and they shouldn't be okay—in terms of spirituality.

*Ultimately, you have to trust your own journey, and struggle through the process. It is the dying and the birthing and the battle and surrender in which we eventually find ourselves.*

GARY MUELLER

The broad and sublime teachings of St. John of the Cross have much to offer in terms of understanding and valuing disillusionment. His writings in *Dark Night of the Soul* include several descriptions of the slow, grinding-down process in which the layers of illusion are revealed. In this piece, he compares spiritual life to a ladder and suggests that as necessary as the ascent is in order to experience the exaltation of one's love of God, the descent is what brings the humiliation that is needed to temper it.

*Most people don't want spiritual work because they don't want this slow process of being ground down. It's very unpleasant. Very painful.*
LLEWELLYN VAUGHAN-LEE

Even as the ladder has those same steps in order that men may mount, it has them also that they may descend; even so it is likewise with this secret contemplation, for those same communications which it causes in the soul raise it up to God, yet humble it with respect to itself. For communications which are indeed of God have this property, that they humble the soul and at the same time exalt it. For, upon this road, to go down is to go up, and to go up, to go down, for he that humbles himself is exalted and he that exalts himself is humbled . . .The reason for this [ascending and descending] is that, as the state of perfection, which consists in the perfect love of God and contempt for self, cannot exist unless it have these two parts, which are the knowledge of God and of oneself, the soul has of necessity to be practised first in the one and then in the other, now being given to taste of the one—that is, exaltation—and now being made to experience the other— that is, humiliation—until it has acquired perfect habits; and then this ascending and descending will cease, since the soul will have attained to God and become united with Him.[4]

True spiritual life is for the few. Many truth-seekers are sincere, earnest individuals, but the confrontation with ego that is required is more than most people are willing or able to handle. Disillusionment is not a sadhana that many willingly enroll in unless the strength of their inner conviction to do whatever is necessary propels them into it. But the individuals who resist disillusionment also have not tasted

its fruits. If one wants Reality, Truth, God, then one wants disillusion-ment, because there is no other way.

---

## CLAUDIO NARANJO: WHAT WE'VE LEFT BEHIND

*Years ago I was exchanging notes with a friend with whom I had a similar background . . . and looking back, we were saying things like, "Well, do I suffer less?" "No, really not, no. It's just a dif-ferent attitude, but I don't suffer less than before." "And what about virtue? Do you feel more virtuous than you were?" "Oh no, definitely not." "No, I don't either." . . . "And what about the quality of your experiences? Do you have richer, more profound experiences?" "No, I would rather say the opposite. In the begin-ning, my experiences seemed to be much deeper." There was noth-ing we could name that we were doing better at, but we ended up saying, "But I think I've come a long way." We were in agreement that we were evolving, but we couldn't point at anything in partic-ular. It was more a sense of evolving through the awareness of what we've left behind.[5]*

---

## A Stripping Away

The spiritual process is a literal stripping away of all the layers of falsity and illusion that cover, distort, and hide our understanding. We don't discover Truth or God somewhere outside of ourselves, but rather uncover it within. Whereas some aspects of this process may resemble a sensuous disrobing, other aspects are experienced as an actual skinning of human flesh, piece by piece. This stripping away is a bittersweet reality of spiritual life—often painful and excruciating but, as Trungpa Rinpoche says, simply "the way it is."

*The process is such that for every step you take, you seem to become a little bit more vir-tuous, and at the same time you become more aware of what a pig you are.*

CLAUDIO NARANJO

What is stripped away are the great egoic adornments—pride, vanity, illusion, confusion. In *Poems of a Broken Heart* Lee Lozowick writes of his own spiritual master, Yogi Ramsuratkumar:

*When you begin to recognize that suffering is grace, you cannot believe it. You think you are cheating.*

RAM DASS

He will destroy you if you let Him, and sometimes even if you don't know you're letting Him. What will be destroyed? Illusion. Ego. Misery. Blindness. Selfishness. Cruelty. Greed. And so on and so on.[6]

Although it is the very falsity and delusion that are at the root of our suffering that are stripped away and destroyed, even devoted spiritual seekers resist this process mightily. The ego does not want to surrender its autonomy, explains Llewellyn Vaughan-Lee.

Most people don't want spiritual work because they don't want the slow process of being ground down. It's very unpleasant, very painful. That's what the suffering on the path is, the ego giving up its belief in autonomy, its belief that it is the ruler, that it exists.

The pain that is felt is the shedding and skinning of ego's illusory layer of protection, a protection that has literally been grafted onto the soul for lifetimes, and that does not give easily. Reggie Ray says that in Chogyam Trungpa Rinpoche's tradition there is great importance placed on the process of "stripping away all the agendas that we might bring to the spiritual path."

In *Cutting Through Spiritual Materialism*, Trungpa Rinpoche writes that all agendas must be unmasked on the spiritual path.

Once we commit ourselves to the spiritual path, it is very painful and we are in for it. We have committed ourselves to the pain of exposing ourselves, of talking off our clothes, our skin, nerves, heart, brains, until we are exposed to the universe. Nothing will be left.[7]

"The affective presumption which they sometimes had in their prosperity," writes St. John of the Cross, "is taken from them; and finally, there are swept away from them on this road all other imperfections . . . with respect to this first sin, which is spiritual pride."[8]

The ego must be ground down. In order for the transformative process to enter the physical, psychic, and subtle bodies, there must be cracks made in the shell of ego that was once designed to keep dangerous influences out. Without this process of being cracked open, the student is not "workable"—he or she is like granite, instead of like clay, in the sculpting hands of the spiritual master.

E.J. Gold describes how new students inevitably go through a process of being "thoroughly mauled" before they are ready to engage in the type of spiritual work that he provides.

In the spiritual communities the first thing that happens is they get out there and they're hit by the spiritual hustlers. So after they're finished with all the hookers and the pimps and they're thoroughly mauled, they generally end up here. Broke, no front teeth, they've got holes in their sweaters, their soles flap, but they're *here* and they're ready to work. And that's when we usually get them, after they've been through all this stuff, and they've been stewed, screwed, and tattooed so many times by spiritual leaders and by spiritual groups. They end up here, crushed, broken, but still they're game and ready to work. It's at that point that I try to take advantage of them!

*You see the fact that your spiritual journey is an entirely different ball game than the path you thought you were on. It is very difficult to make that transition.*

RAM DASS

Gold's approach may appear harsh, but the goal of the most uncompromising of spiritual students should be to be "taken advantage of" in the way Gold speaks of here—to be taken advantage of by That which is beyond all egoically-conceived possibilities.

Trungpa Rinpoche says that the state of hopelessness that arises when all of one's egoic armor and agendas are left behind, when one has been broken by the shattering of one's illusions, is actually a very desirable situation, for even "hope" belongs to the ego, and spiritual life is devoted to the process of learning to bear true hopelessness.

In considering the implications of the process of stripping away, it is no wonder that even sincere spiritual aspirants shy away from it at the same time as they move toward it. Yet Lee Lozowick, backed by all the great saints and masters past and future, says that it is "unquestionably worth it."

*Sudden enlightenment comes only with exhaustion.*
CHOGYAM TRUNGPA

Is the ageless goal of union with God—which we might call the final and permanent shattering of the illusion of separation—worth the complete surrender, even the obliteration of all you now know, feel, think, and assume? Yes, and not just yes, but yes without question. What else is there to do?

Ray says that although it is a process of being "beaten down, beaten up," there is also confidence, and even joy, in being in a situation and being able to be destroyed. For again, even in the midst of the great pains of the destruction of ego, one must remember what it is that is being destroyed. "It's always the same question," remarks Arnaud Desjardins. "Ego or surrender?"

## The Way of Pain

The Sanskrit word *saha* means "to endure, to go patiently through hardships without rebelling."[10] The process of disillusionment is an unquestionably painful process at times. Genuine spiritual life has never been popular, and never will be, because most people are unwilling to open to and accept pain.

Ray says that the first time he ever heard his teacher talk, Trungpa Rinpoche spoke about suffering. "He was the first person I ever heard who acknowledged how bad things really are. And I thought to myself, 'That's it! That's what I want! I want to find out what is going on here and to explore it.'" According to Ray, their tradition places a great emphasis on the Buddha's first noble truth that life is suffering not because anyone wants to suffer, but because suffering is what is true of life.

"Your pain is the breaking of the shell that encloses your understanding," writes Kahlil Gibran. It is quite conceivable that not only is pain a necessary aspect of the spiritual process, but that to consciously enter into and experience suffering is the doorway to a more profound understanding of reality, something to even be sought after.

"The thing that many people would consider to be pain," says Ray, "—the thing they want to get rid of, that's demonic, that's the devil, that's their downfall—that's actually the only way out. There's no other way out." He suggests that the quality most people think of as pain is actually heat, a heat that is not pleasant but that represents reality.

In any situation or any state of mind you are in, there is always a point of heat, and we experience that as pain. But actually it's just heat, and that's what Trungpa Rinpoche calls the "Great Eastern Sun." It's the place where reality is coming up above the horizon where it is dawning, and that becomes our point of orientation. So I'm not saying to look for suffering, but I am saying that you have to look for the heat. There's a huge area of self-satisfaction and then there is an area where there is a crack in the door of ego. And there is a bright light coming in and it's very irritating and it's not pleasant, but that's what you have to look for. You are looking for it not because there is anything great about suffering, but because that's the way out.

I had a friend who was in a plane crash a number of years ago and she said that when the plane crashed it was pitch dark and the whole thing was on fire, and then somebody saw a crack of light and said, "The light is over here!" and that is how they saved themselves, because somebody saw this light.

That's what we have to do. We have to look for the crack in the shell of ego where there's a bright light coming through. It is too bright and it's irritating and it's painful, but that's the way out.

*There is an idea that with the spiritual life that there will be an increase in the amount of happy experiences and a decrease in the amount of unhappy experiences. The difference is in the way in which we live those experiences.*

ANNICK D'ASTIER

The very thing that spiritual aspirants, as well as all other people, seek to avoid is the exit which they so desperately claim to want to locate. "If you sit with an open mind," says Ray, "all of your shit is basically going to come up. And then the idea is not to go get out your broom and sweep it away, but to actually live through it. You have to live through your pain."

This pain is so crucial to one's spiritual understanding that Ray goes so far as to say that if one is not in touch with it their practice should be to intentionally look for and relate to the pain in any situation.

*We should feel grateful that we are in the samsaric world, so that we can tread the path, that we are not sterile, completely cleaned out, that the work has not been taken over by some computerized system. There's still room for rawness and ruggedness all over the place.*

CHOGYAM TRUNGPA

If you're in an environment that is ninety-nine percent bliss and one percent pain, the pain actually represents reality to you. You need to look for it and you need to find it. Most of the time, we're in so much pain that that's not an issue, but sometimes things go really, really well. In our tradition, we say that when you are in that kind of situation, you need to be aware of the whole situation and not fixate on the bliss or try to perpetuate it, but actually to relate to the pain in the bliss. It is said that there is no one-hundred percent happiness, that even in a so-called bliss state there is always a shadow. I know that anytime I've experienced something like that, that there is at least the fear of losing it somewhere on the periphery of that experience. In Buddhism you have to pay a lot of attention to the shadows in any situation you're in—not because you're torturing yourself, but because that represents the earth, that's the ground. In our tradition, pain is the vanguard of enlightenment. Pain is ego's response to Reality.

Pain is not only the way out, but the way in and down. Spiritual life can easily become imbalanced and fixated at a certain point if the bright aspect of Truth or God is not balanced with its shadow aspect. St. John of the Cross says that the principal value of the "dark night of contemplation" is to know one's own misery, which brings balance and humility to the exalted states of communion and abundance.

This is the first and principal benefit caused by this arid and dark night of contemplation: the knowledge of oneself and of one's misery. For, besides the fact that all the favours which God grants to the soul are habitually granted to them enwrapped in this knowledge, these aridities and this emptiness of the faculties compared with the abundance which the soul experienced aforetime and the difficulty which it finds in good works, makes it recognize its own lowliness and misery, which in the time of its prosperity it was unable to see.[11]

In his writings, St. John of the Cross eloquently describes how, once the student has experienced the sweetness and pleasures of meditation and prayer and found some degree of strength in their connection with God, "God desires to lead them further . . . wherein they can commune with Him more abundantly." He says that often when one is amidst the greatest pleasures, and when they believe that "the sun of Divine favour is shining most brightly upon them," God sets them down into darkness and shuts the door to the "source of sweet spiritual water which they were tasting in God whensoever and so long as they desired."

For as I have said, God now sees that they have grown a little, and are becoming strong enough to lay aside their swaddling clothes and be taken from the gentle breast; so He sets them down from His arms and teaches them to walk on their own feet which they feel to be very strange, for everything seems to be going wrong with them.[12]

The pain that God gives them is His gift, and not His curse, as it is so often felt to be. The practitioner *earns* the privilege of being placed down from the safe arms of communion with God into unbuffered reality so that he or she can learn to be held and to move from within.

One cannot have a full spiritual life if one has not come to terms with one's pain. Life is painful anyway. Pain can be temporarily evaded or drugged or resisted, but it cannot ultimately be avoided. There is pain in "neurotic suffering," which is the way we ordinarily think of

*There is no completeness without sadness and longing, for without them there is no sobriety, no kindness. Wisdom without kindness and knowledge without sobriety are useless.*

CARLOS CASTENADA

pain, and there is also the pain of "suffering for God," or suffering with humanity. They are very different types of suffering, but both are suffering; and whereas neurotic suffering only perpetuates itself, suffering for God, or enlightened suffering, serves all of humanity.

In order to serve humanity, one must know humanity. Ray explains that students in their tradition are encouraged to explore great depths of suffering so that they may know it as an important aspect of the totality of life. He shares how, through his teacher's example and guidance, he was shown the value of suffering.

*All men know the utility of useful things; but they do not know the utility of futility.*
CHUANG-TZU

You have the god realm, jealous god realm, human realm, animal realm, hungry ghost realm, and hell realm. The full range of possible human experience is included within those six realms. With Trungpa Rinpoche as a teacher, what we did was we explored the realms, and we're still exploring them. It's almost like he put a time bomb in us to explore those realms— all of them. Why? Because of the Boddhisattva vow to help sentient beings. We have to go through all of those experiences in order to be helpful to other people. If you can't be in a hell realm, if you've never been there, then you really can't help someone else who is there because you yourself are resistant to it. You are not willing to go there and so you can't be helpful. Trungpa Rinpoche was a very demanding teacher in that way. If you were looking for some kind of state of mind, or bliss state, or spiritual high, or charisma, or to be "zapped" in a certain way, he wasn't the teacher for you. Somebody once asked him, "Have you ever been in a hell realm?"

"Of course," he said.

"What did you do when you were there?" they asked him.

"Tried to stay there," he told them.

Now that is very different from the average guru, who is basically promising some kind of escape from reality.

Jai Ram Smith says, "You can attain liberation, and you can live there for an almost indefinite period of time through the grace of that

experience. You can earn that kind of karma. But sooner or later you have to come back to reality. So E.J. Gold's work with us was to take us into the hell realms and the bardos, because if you can awaken in hell, then you can work anywhere."

Traveling in the hell realms *is* certainly different from what the average guru promises, but most extraordinary teachers and practitioners do value the full spectrum of life, no matter what they call it, and encourage their students to do the same. Joan Halifax says that although divine mothers and saviors can be lovely and helpful, "that doesn't happen to be my job. I'm a sort of 'chop wood, carry water

*When you come to a spiritual teacher you have to be naked.*
BHAI SAHIB

---

### LLEWELLYN VAUGHAN-LEE: "SO FEW THINGS REALLY MATTER."

*It's such a relief. You know, so few things really matter—only to be with your Beloved, as He wills, not as you will. It's really all the grace of God, the experiences you are given. It's all because He wants to reveal a part of Himself. And sometimes you are allowed to witness a little bit of it, but mostly not. Mostly it would be too difficult. "There" there is so much love, so much intimacy, and then you wake up in the morning, and you have to go to work, you have to do your everyday things, to look after the kids, to be on time. "There" there is no time. "There" everything is given, you don't have to work for anything.*

*It's often funny that when you get too far in that direction, the world comes and knocks on your door. Suddenly you get a speeding ticket or something, just to bring you down. You are also an ordinary human being who has to accept that you live in this world with all of the limitations of this world. "There" you are so free, it is so limitless, and here if you get on an airplane you get jet lag, you have to rent a car, all of that business. It's not always easy.*

---

type.'" She then adds, "I like going to the hell realms. My job is the hell realms." Because Halifax has taken her decades of sadhana and brought them to high security penitentiaries in order to serve prisoners on death row, one can believe that she means what she says.

## The Way of Mistakes

The last thing that one who has prematurely presumed enlightenment wants to do is to make a mistake. On the other hand, those who really are what we might call "enlightened" know that they will always be making mistakes, always falling short of a higher possibility. "Authentic spiritual masters," writes Frances Vaughan, "unlike the mass leader who seeks an appearance of infallibility and cannot admit error, are not concerned with winning or losing. They have already won."[13] Or, as some masters would say, "They have already lost."

Mistakes are an inevitable aspect of spiritual life, a way in and of themselves. There are no great masters or great disciples who have not learned by trial and error, and often much error. In an interview published in the book, *Spiritual Choices*, Jacob Needleman describes what happens when an individual attempts to move toward spiritual realization using the full body of knowledge and teachings they have been exposed to.

*It may be that one always thinks that one is more awakened than one is. I'm always grateful when I realize what a bozo I've been, because then I have the opportunity of not doing that anymore.*

ROBERT ENNIS

What happens is this: We err, and frequently. In unnoticed, insignificant moments, again and again we err, or forget, or delude ourselves. Minutes or decades later, we may realize what has happened, become conscious of it, catch ourselves. At that moment, we experience a sudden, sharp awareness of our fallibility, our lack of attainment, our weak attention, the crudeness of our understanding. We sustain a humiliation and shock in these moments, making them unwelcome to the ego, skilled as it is at preventing such feelings from entering awareness. Frequent inner failures of attention and discrimination are inevitable; conscious recovery from them does not

automatically follow. The capacity to feel these highly instructive and corrective humiliations, and to allow them to inculcate a genuine humility, is in our view crucial to the practical art of spiritual inner development.[15]

The process of erring and becoming conscious of our errors *is* spiritual sadhana—in the same way that disillusionment and opening to pain are sadhana—it's just not what most people think of when they sign up for the spiritual path. And it could not be otherwise. Our illusory perceptions and fantasies become shattered through our increasing awareness of the mistakes that we constantly make.

*Failure is one of the simplest ways to destroy the ego.*

ANONYMOUS

We have to work for our wisdom—blood, sweat, and tears work. We have to want it and to be willing to make mistakes, to be willing to make wrong decisions, to be willing to pick wrong teachers, and to be willing to do this again and again and again until we have learned what we need to learn.

Everybody always talks about the importance of learning from their mistakes, yet most people don't learn from their mistakes, they keep repeating the same ones over and over. Therefore, we cannot assume that one learns from one's mistakes simply because one makes them, but rather that mistakes provide an increased possibility to observe the self-deception that lies at the source of the error.

If one has had a bad experience—either with a teacher or with one's own inflation or mistaken belief about one's spiritual progress—the way to make use of that mistake is to take responsibility for it and use it as a platform for further enquiry. In this way it becomes part of the foundation for the wisdom that is accrued throughout a lifetime. It is important to understand that all difficulties on the spiritual path, all seeming "failures," can be made use of. If placed in the proper context and respected for the experiential warning they are regarding the traps of spiritual life, they become fuel for deepening one's practice. If they are not used as such, they repeat themselves and become fuel for self-doubt, pity, and feelings of victimization.

Robert Svoboda quotes his teacher, the Aghori Vimalananda: "Everybody is going to make mistakes. The best thing to do is make

sure you always make different mistakes." Continually making different mistakes is evidence that we are learning something, but if we can't always make different mistakes, we can acknowledge our mistakes, consider them, and recognize how and why we refuse to act differently.

Being able to admit to mistakes is a very important skill for those who profess themselves to be teachers of any kind. Charles Tart is wary of those who cannot admit to their mistakes, and says that learning to do so is an important spiritual and psychological lesson.

> The big question I have is: Are people spiritually developed enough to admit that they've made a mistake? To try to make amends and learn what they need to learn? Or do they rationalize it? There are too many cases in which someone rationalizes, "I'm not seducing beautiful women. I'm helping transfer my spiritual energy."

> It's one of the spiritual lessons I've learned, and it's a psychological lesson too: the sooner I can admit to a mistake the better. The sooner I can say, "I don't understand," or "I did the wrong thing," the easier it is going to be. The longer you put it off, the more rationalizations you build up, the more excuses you make, the more you increase your illusion, the more you put yourself in samsara.

> You can deepen the illusion—you can make it more and more complicated, more and more emotionally driven, or you can start to lighten up on it and take a look around at what is actually out there. Part of being able to look at what is out there is the ability to learn to admit your mistakes. In fact, if anything, we should probably err in the direction of too quickly or too freely admitting a mistake, rather than covering it over.

*O you who fear the difficulties of the road to annihilation—do not fear. It is so easy, this road, that it may be travelled sleeping.*

MIR YAHYA KASHI

When mistakes are admitted to and used in the service of refining one's spiritual work, they are not a problem; even quite big mistakes are all right if one learns something from them and moves on. Andrew

Cohen once said that it is very important not to waste too much energy on the small mistakes one makes because in spiritual life one will inevitably make big mistakes, and it is better to save one's energy to deal with the big mistakes when they come up, and then to move on.[15]

"The aim is not the flawless performance," a dance teacher instructed her students, who could just as well have been spiritual students. "The indication of a fine dancer is when you have erred and made a mistake how impeccably you can recover." One can admit to their mistakes, learn from them, and move on with a hopefully sharpened awareness, or one can make a big, dramatic mess of them.

Robert Ennis says that the way to produce harmonious human beings is not by preventing them from making mistakes, but by allowing them to safely make all possible mistakes.

Only when you've made all possible mistakes can you genuinely choose a correct path without fear. It's like learning how to walk. You have to fall in every possible direction in order to know how to maintain your balance. And so, the harmonious development of a human being requires that one have permission to fall in all possible ways in order to reach a balanced state of centeredness and balance.

"Purification through putrefaction" is the term Claudio Naranjo uses to describe this process—a term his psychoanalyst friend Leon Lourie once used upon hearing of Claudio Naranjo's spiritual process.

We purify ourselves of some of our sick attributes by living them to the hilt. Letting them ooze out, being as crazy as we can be. Wisdom comes sooner in this way. You see your craziness for what it is only to the extent that you're willing to act on it. It's paradoxical—you have to make mistakes to heal your mistakes. You have to stray from the path to find the path.

*I ask myself questions like, "Can I be a little more open and intelligent and helpful today that I was yesterday?" That is a realistic goal for me to make. If I put it as, "Can I become fully enlightened today?," I guess not. I might as well go back and watch television.*

CHARLES TART

Reggie Ray tells the story that when he was teaching at Indiana University, Trungpa Rinpoche came to do a big event. At the time, Ray had only been a Buddhist for two-and-one-half years and was very much a novice. Yet Trungpa Rinpoche kept deferring questions to him so that he ended up doing the whole talk, and not entirely successfully. "In retrospect, it was ridiculous," recalls Ray, "but in another way, that is how he worked." He comments further:

*Ah, how sweet it is to suffer with God!*

BROTHER LAWRENCE

Obviously everyone has ambition, and when you let people act out their ambitions they learn so much. I did. I still do. So, I think that beyond the fact that they can handle it, it is also a wonderful thing for them, it's very generous that they can try it on and see what they can and what they can't do. Trungpa used to send people out on the road on teaching tours in the very early days. He would set people up and say, "You go out and give this talk and be my spokesperson." The person would go out and make a complete ass out of themselves, and it would turn into a very profound learning experience for everybody. So, we still do it that way.

Mistakes humble people. They are often necessary in order to break the cycle of egoic inflation or to place one back on track when one has strayed from integrity on the spiritual path. There is no wake up call like a fat, juicy mistake to jar us out of our illusory world. In *The Face Before I Was Born*, Llewellyn Vaughan-Lee writes, "Failure is one of the simplest ways to destroy the ego's desire for inflation, which can easily follow a spiritual experience."[16]

This doesn't mean that one prays to make mistakes, but rather that one desires to see clearly the mistakes that one is always already making, in order that one may possibly discover the false assumption that lies at the root of one's actions.

Everything has its lower and higher purpose, and mistakes can be recontextualized from being seen as errors to being seen as lessons. Judith Leif suggests that without obstacles there isn't any path. In her tradition (the lineage of Chogyam Trungpa Rinpoche), obstacles are

considered so valuable that practitioners make offerings to them. "Otherwise," comments Leif, "how do you learn? You don't learn so well when things are going easily, but when things go awful you learn really fast."

*The aim of practice is not to develop an attitude which allows a man to acquire a state of harmony and peace wherein nothing can ever trouble him.*

KARLFRIED VON DÜRKHEIM

## RABBI ZALMAN SCHACHTER-SHALOMI: A TOLERANCE FOR IMPERFECTION

*In Judaism, we have a greater tolerance for imperfection. It comes around the following way: When you speak of Jesus in Christianity, you see a flawless individual. When you talk to Moslems about Mohammed, peace be upon him, they'll say he was "in san al kamil"—he was the most perfect of human beings. But when you talk to Jews about Moses, they say, "Yeah, he also had flaws." So we don't get so excited over people's flaws. That's on the one side . . .*

*On the other side, most of our saints are not seen as archetypal saints. They're seen as accessible models. Do you know the difference between an archetypal model and an accessible model? With archetypal models, you think, "Who can be like that one? Ooh, he's so great." From that model you can understand how people should be. Then you have the accessible model: you see that he did it, and you can do it too. Ours is a lot more like the accessible model. Therefore, in terms of the issue of the flawed person, what else do you expect? Everybody has warts. A statement in the Talmud goes like this: "A person whose flaws are not hanging out, don't trust him, he shouldn't be a leader." In other words, when somebody comes as all virtue, and I don't know of any of the vices of that person, it doesn't pay to trust them so much. I need to know the vice/virtue balance in a person.*

## Teaching As a Process of Being Diminished

The ego dreams of becoming a great saint so that it can be exalted and glorified, yet Ray says that to be a teacher is to be minimized through the experience of teaching. "If a teacher becomes bigger through being a teacher, that's a bad sign. If a teacher becomes less, that's a good sign." An acknowledgment of the obligation that the teacher, as well as the student, has to the body of wisdom to which they have committed themselves can only humble them and never glorify them. Joan Halifax's description of practice is equally applicable to the process of teaching.

> Ultimately, practice is not about anything except for humility. It is not about being separate from others and walking into the penitentiary with purple robes on. It is to understand that we are all in the penitentiary. We are all murderers and rapists. We are all dying of cancer and AIDS. We all suffer. Practice is about living accordingly.

In a similar vein, Llewellyn Vaughan-Lee suggests:

*I will not serve God like a labourer, in expectation of my wages.*

RABIA EL-ADAWIA

> The teaching function is about being able to keep your own simple, individual humility as an ordinary person, no different from anybody else, not special—nothing; and at the same time to have access to this other dimension where "you" are not there.

The increasing depth of understanding and perception that evolves in teachers who dedicate themselves wholly to their students' growth will not allow them to be exalted or inflated by their work, but only to be diminished in the face of the immensity of the task that is before them. Lee Lozowick explains this process of diminishment from his own experience in over twenty years of teaching.

A real teacher is continually diminished and a false teacher is continually exalted. Because if you're a real teacher, working with students, the impossibility of transformation must diminish you. When you understand what it means to be responsible for a teaching position, you can't be inflated. You see yourself in relationship to the immensity of the universe and the impossibility of what needs to be done, and you can only be diminished. It must humble you more and more and more. You could not be anything but humble if you were looking at what you are up against as a teacher, because what you're up against is impossible. Nobody, no matter how brilliant or skillful, can master the physics of reality. One can master the physics of form—like Satya Sai Baba and Swami Premananda, who can materialize things. That can be mastered. But no teacher can master the physics of human nature.

*There is a fine old story about a student who came to a rabbi and said, "In the olden days there were men who saw the face of God. Why don't they any more?" The rabbi replied, "Because nowadays no one can stoop so low."*
CARL JUNG

From Lozowick's description, it becomes clear that even when one "arrives" at the status of teacher or master, the process continues to be one of disillusionment. Although he has functioned for many years as Roshi of the Denver Zen Center, Danan Henry says that he is ever-humbled by the mysteriousness of life, and that no difficulty, upset, or fall from grace would surprise him.

I know in terms of my own personal life, nothing would surprise me. I used to say and believe in a certain level of equanimity and personal strength, but I've gone through enough things, recently a divorce. I get up every morning and give it my best shot, and find over and over again that just by encouraging others, helping others, that I come to life. I experience wonderful joy, equanimity, and peace just going through the difficult times. I cry, and am upset, irritable, and angry at times, but I just move through these times without confusion, without fear. I also see wonderful changes in people. But if I were to suddenly fall flat on my face, it wouldn't surprise me. Not that I am looking for it or that I expect it, but life is just

too much of a mystery. I don't have very many expectations and ideas about what I am and what other people are, or about what I have attained. It's just a mystery. But I certainly do the best I can to live with honor and dignity.

We use the floor in order to get off the floor. If we don't fall down, we are not going to be able to practice. I feel too unnerved by life. My sister is incurably ill of cancer. That's very hard. We are just a bunch of fellow travelers to the grave. We just need to be good, to be nice to each other, and to be kind. Even if somebody has committed a hideous crime, I just can't muster up any personal animosity because I've seen enough about myself and my own failings and weaknesses.

> *A warrior has no honor, no dignity, no family, no name, no country; he has only life to be lived . . .*
>
> CARLOS CASTENADA

---

### JAI RAM SMITH: THE WORK AND THE WEAKNESS ARE BOUND TOGETHER

*E.J. Gold said that the Work and the weakness are bound together: shackled, two hands, like in handcuffs. And wherever the weakness is, the Work is always present in an equal amount at the same time. For example, let's say you are a teacher or a student and you're caught in power and ambition. The possibility of really working is just as present as the level of weakness manifesting. If you could only lift your gaze from the seduction for even a moment, you would see the Work which is always present in the moment.*

*Every person in a teaching position who is seduced by their weakness also has a strong possibility of doing the Work if they could only see it. The difficulty is that when you don't have the willingness to get input, you can't see it. As for myself, I don't like the input. I can tell you that it stings. It's like putting tequila on a cut. It hurts, because it does something to your structure. But you can't deny the value of it. You won't get that feedback if you are already assuming attainment.*

---

## The Denying Force

In the universe, there are impersonal forces that push one's spiritual development forward, and those that pull against it. Those that push are called affirming forces, and those that pull are called denying forces. The discovery of the denying force is another grand disillusionment with which many spiritual aspirants and teachers come face-to-face. As we have clearly seen, people want to believe that spirituality is all bliss and love, that God is always good-natured, that the world is just waiting to bestow upon us the great boon of enlightenment. Yet in every genuine spiritual tradition there are terms, symbols, and deities that represent the denying force: In Hinduism there is the goddess Kali. In Buddhism it is Mara who tries to seduce the Buddha away from his enlightenment. In many native traditions there is a *heruka*, who represents spiritual challenge.

Jai Ram Smith describes the denying force.

We have to look at the forces that we're up against. There is a big force that works against us that is very powerful and that leads to sleep and to what I'm going to call "The Big Lie." It creates the need for ego and everything associated with it. It's all a part of the picture. So I'm going to say that there is an actual force that would like to see this whole business of awakening destroyed and instead give rise to distortion and misrepresentation. The denying force has to be there, but most people won't tackle that level of inquiry about existence. But if you look around and ask, "Why am I here? What is this whole thing that is happening?" it can be startling. It is a rough game that is being played here. It's not unusual that all of us here are seeking relief from having to recognize this, and I think that most people who end up on the distorted end of "enlightenment" are insisting on negating the existence of this force.

*This may sound harsh, but just like not every acorn is going to grow into an oak tree, not every human being in any particular time period is going to awaken. Only those who have exactly the right combination of circumstances, experiences and make-up are going to awaken.*

ROBERT ENNIS

Most people don't want to accept the reality of the existence of the denying force. Once it is admitted to, it can't be negated, and to recognize it implies the further deconstruction of many of our illusions about spiritual life and of the still-hoped-for fantasy of heaven. Georg Feuerstein comments on that aspect of the denying force that shows up within the individual in the form of resistance.

> Perhaps it is safe to say that wherever there is great spiritual force there is also great resistance. The enlightened adepts of humanity represent a principle that runs counter to conventional life. Their very existence is a threat to the ordinary person, who has no time for spiritual matters and spiritual masters but rather seeks egoic autonomy. Let it be stated, however, that even a faithful disciple is subject to bouts of resistance, which can at times be quite dramatic. The ego-personality habitually resists transformation. Yet the disciple is committed to freeing the energy frozen in such resistance and turning it to better use.[17]

*When a man suffers, he ought not to say, "That's bad! That's bad!" Nothing God imposes on man is bad. But it is all right to say, "That's bitter! That's bitter!"*

THE DALAI LAMA

The immensity of our resistance may be uncomfortable to acknowledge, for it is much easier to feel like a victim than to realize that it is oneself who is resisting that to which one claims to aspire. However, having knowledge of one's own personal resistance, as well as of The Great Resistance in the universe, is useful because if one is aware of it, then there is an opportunity to know it for what it is and to begin to learn to live and work with it.

In *Enlightenment Is a Secret*, Andrew Cohen writes:

> The mind will try to pollute anything and everything. Even the most sublime realization, the mind will try to corrupt, taint and destroy. This is not the mind's fault. It can't help it. It doesn't know how to do anything else. Unfortunately, most people unwittingly participate in this process. It is because of this that they get lost again and again.[18]

It should be clear by now that on the level of the personal, the ego itself is the denying force. This personalized, custom-designed ego that attempts to deny the possibility of enlightenment in a manner tailored to the individual's particular denial system is really The Ego—the one ego. It appears specific to the individual but is, in essence, a collective denying force that stands as the polarity to any awakening, anywhere in the universe, at any time.

The question of *why* the denying force exists is a worthwhile enquiry for any serious spiritual student. While it may appear to be an evil force, it is also lawful. In some indigenous groups, those who work against the force of awakening are called "contraries." According to Lozowick, the denying force is not only natural but necessary in order to maintain balance in the universe. Everything seeks balance, and the universe is no different.

*I do not pray that you may be delivered from your pains; but I pray God earnestly that He would give you strength and patience to bear them as He pleases.*

BROTHER LAWRENCE

Since reality includes all possibilities, if you get too imbalanced on the side of one possibility—even if it is a positive possibility—then somehow reality is not existing as it is in fact. It is important for all things to arise in the natural balance of their energetic dynamics. On the one hand, there is a dimension of reality that is evolutionary; on the other hand, there is a dimension that is entropic. If we leave the universe to itself, then all things balance out. The denying force is just a name that we have given to one of the natural forces of the universe, of creation. Creation is always moving in harmony within itself, internally. If there's too much goodness, then there's more badness. If there's too much badness, then the Avatar comes. And then when everybody has remembered the nature of truth, the devil comes. It's the natural state of affairs—there is nothing unnatural about it.

"If you study what we're up against," observes Smith, "it seems perfectly obvious to me that there should be fake enlightenment all over the place, and that somebody who is on the journey should have to

discriminate between what is real and what is not. It goes with the territory. It has to."

---

## LORD PENTLAND: "WHEN YOU AWAKE, YOU HAVE TO AWAKEN AGAIN"

*Every effort we make in life we expect to be paid for. All that is different in this work. This effort is for yourself—there is no reward—just so that you can be awake. Go on working at this. There will be times . . . when you really do have a wish to awake. You may see to some extent. What will you see? Resistances, adversaries—it takes the form of myself as I picture myself to be— I see I am too young, too ill, to busy to understand. It takes many different forms.*

*After the ecstasy, the laundry.*
ZEN SAYING

*What I really want to say is that you have to see more after you have seen. When you awake, you have to awaken again. You try to understand this adversary. Make an effort, not to struggle with him, but see what he is made of—not resist, but see beneath, how false he is. Try to realize when you are asleep more deeply. See the face of the false man—not try to rout him out or trace back where he came from. Instead, try to see what he is made of, what lies he tells, what insincerities.*[19]

---

Because the denying force is natural and will always exist as a lawful aspect of the universe, it is useless to put one's energies and attention into trying to destroy it. However, as it seems that at this point in evolutionary history sleep and ignorance are more than adequately represented as one aspect of universal balance, one might put more energy into seeking the enlightened aspect.

## The Long, Slow Road

It is a long, slow road, any way you look at it. Those who say that it comes instantly, easily, and to many are talking about a different enlightenment than is being spoken of here. Quick satoris and swooning ecstasies can be bought at the five-and-dime store, but that which is real is never cheap, never quick, and never easy.

The necessity to travel the long, slow road, as opposed to taking the satori shortcut, is beautifully illustrated by Llewellyn Vaughan-Lee in a story about Irina Tweedie and her teacher.

> One time, when Mrs. Tweedie was in India, she started to become clairvoyant. She began to see what people were thinking, to see their auras, and she really thought she was progressing spiritually. She thought that this is what spiritual life was all about. When her teacher, Bhai Sahib, discovered this, he took it away. She was quite affronted. He took away all the experiences, all the clairvoyancy and everything. He said, "Well, my dear, you are getting tremendously puffed up."
>
> The ego has to be destroyed, has to become nothing, so it doesn't think that *it* is having the experience. That is why there is this whole, very gradual process. For most people it is very gradual. It takes many, many years of annihilation, of the ego being slowly made less and less, less and less, so that you can contain these experiences without thinking that you are God.

It takes time, but few are patient. Robert Svoboda observes:

> Most Westerners today believe that all their desires . . . should be gratified immediately. But there is nothing speedy about refinement; it takes time and restraint. Refinement occurs automatically in all aspects of life . . . if you just slow down. Westerners think the spiritual urge can be gratified in the same way that they gratify their sex urges.[20]

*It takes time to make a soul pregnant with God.*

BHAI SAHIB

## LEE LOZOWICK: LIFE AS IT IS

*When we start the path we think that after ten years we'll be kings of the universe. Sometimes, however, ordinary life is just stable and reliable. We're just satisfied as we are—imagine that! Life is just satisfying. We're not creating great art, starring in some movie, being anybody special.*

*Everyone wants to be special in some way. What if life was fine the way it was? Everyone can't be a famous artist, or a famous spiritual teacher. What if life for each of us was just what it was? What if there was nothing else? What if it was our unavoidable and undeniable destiny for the rest of our lives to be just how we are right now—kinky hair, big nose, a little extra weight? What if in each moment who we were was our destiny—absolutely perfect, and we had no choice but to accept it? That's the way it is actually, but we keep thinking we have a choice—that if we don't like it we can somehow be somebody else. But we can't be, so why don't we just accept it . . . whoever we are?*

*That is the practice, and it's the same practice for the greatest artist or philosopher as for the most ordinary person whose name no one knows. Accept what is, as it is. There is no payoff, no prize for practicing. You don't make a business arrangement with the spiritual master. The master doesn't say, "If you practice and accept what is, I will make sure your life changes—you'll be wealthy, healthy, beautiful, happy in every moment." What do you get for practicing? You get to see life as it is, clearly, and that's great.*

*Ego wants some kind of advantage—to be stronger, better than everyone, secure. Ego wants to be protected against death, pain. Yet, at the level of Reality, all the differences between us are illusory. You get to see that you're all right as you are—no problem. Just imagine if, in this moment, who you were right now was all right with you. If everything about you was fine with you—your body, your hair, your personality. What would you do with all the*

*energy that that freed up? We devour a tremendous amount of energy being unhappy with how we are in the moment, struggling to be someone else, when we can't be any other way.*

---

It is the collective neurosis of the Western world to believe itself superior in all areas of life, including enlightenment. Because Westerners can get almost anything they want with a plastic credit card, they assume enlightenment should be the same. The sadhana of disillusionment is the discovery that there is no easy way out, no fast train. There is only the work of diligent practice, prayer, service, humiliation, continual loss of face, disillusionment. It cannot be any other way.

*The sorest afflictions never appear intolerable, except when we see them in the wrong light.*
BROTHER LAWRENCE

## Stories of Disillusionment

Some of the most inspiring stories told by spiritual teachers and devotees are not tales of great raptures and fireworks, of visions and divine revelations, but accounts that describe heartbreak and frustration and the slow growth of wisdom through trial and frequent error. Ordinary mortals not only identify with the seeming failures of those who travel the spiritual path more easily than they relate to testimonies of everlasting peace and bliss, but these stories resonate with what people know to be deeply true about life. They tell the truths that the missionaries for enlightenment have never admitted to: that the path does not lead to the kind of enlightenment the ego tried to fool us into thinking it would; that shattering enlightenment experiences are not the end of the road and hardly even the beginning; that the spiritual path is destined to take us closer to our own humanity rather than beyond it.

In this section you will find stories of disillusionment by three highly respected contemporary spiritual figures. Claudio Naranjo's tale

is of particular relevance because he is an example of someone who lived in a luminous, enlightened state for some years and had become an established teacher before this clarity faded. When Richard Alpert became Ram Dass, spiritual groupies wanted him to be a guru so much that they conspired with his own unconscious in masking an awareness of how he was using his radiance and wisdom to escape a deeper experience of his own humanity. Arnaud Desjardins spent many years of impassioned searching and rigorous sadhana, only to have his guru hardly even acknowledge the great shift in him when it finally came. Disillusionment came in a different way to each of these teachers, but in each case it resulted in a deepened understanding and appreciation of what real spiritual life is about.

## I. Claudio Naranjo's Story: Sacrificing Enlightenment for the Sake of Enlightenment

*When one has nothing to lose, one becomes courageous. We are timid only when there is something we can cling to.*
CARLOS CASTENADA

I became a teacher in 1971, after what I could technically call my "spiritual birth" experience in the desert in Arica in the north of Chile, where I had been sent on a forty-day retreat. It was the aftermath of the death of my eleven-year-old child. What happened in the desert was like an internal, subtle birth. I underwent what you could call a temporary enlightenment: there was a sharp transition, like a quantum leap that gave me a new focus. After that I had a higher self that I could intermittently access. The state lasted for about three years and I started to teach a small group.

I was functioning as a guide who operated through his own inner guidance. I didn't know from moment to moment what I would do. It was my own improvisation. I trusted that I would have enough connection to be effective, besides trusting that through the experiences and training I had had, I had something to offer. I acted on an assumption that if someone did what I did, saw what I saw, understood what I understood, that they would get to the place where I was. I went on that impulse and on that faith.

It was as if I was channeling a higher level. I was inspired by something that was beyond me, but my ego was very happy about being such a channel, and so there was an investment in having my hands full. I was once a child who didn't feel sufficiently appreciated by my mother, like most mortals feel in relationship to one parent or the other. Therefore, there was a strong desire in me to be special in order to be loved and appreciated and valued, and to value myself through others' acceptance of me. I thought that I had left behind the drive to be somebody special when I ripened spiritually. I had indeed thrown my old life overboard in some sense, but, of course, the same old desire found a new way of living on and nourishing itself from the state of heightened inspiration. At the time, I was very excited by my own inspiration and my ability to help others. I was excited about teaching, about being somebody able to teach, about having some understanding and some wisdom. For some people, I was a very effective teacher. My impact on people's lives was speeding up their process a lot. They became seekers. Something significant happened in their lives.

Yet, it was as if I still hadn't opened my eyes. I was not really in the world. Something wasn't working. When I realized what was going on, I experienced a drastic loss of excitement and motivation. After realizing that I was not compassionate enough to do it *just* for others, searching became heavy rather than exciting. It was like squeezing out the last drop of something. I went more and more into meditation as a way of arresting what I sensed as a continuous fall. Yet meditation was effortful, and decreasingly successful. I was falling further and further away from the mountaintop of revelatory experience and advancing more and more into the desert, in spite of my efforts in wanting to recapture an experience that was becoming less and less accessible. I was reaching from the bottom up.

*. . . From the aridities and voids of this night of the desire, the soul draws spiritual humility, which is the contrary virtue to the first capital sin . . . spiritual pride.*

St. John of the Cross

During this time I wrote very little, although writing was my work. I *told* myself that I was writing, but I was not coming up with anything significant. I gave talks at conferences and was invited here and there. Such stimulation kept me going, but my real life became more and more focused on internal work—not at the psychological level anymore, but mind training. Developing attention. Developing the ability to practice. My life became something like a sedentary pilgrimage.

My experience of the "dark night" was not unlike that described in *The Tibetan Book of the Dead*. First I visited the realm of the Gods, becoming a God-like spirit: there was much joy, abundant grace, great spiritual satisfaction. I then moved into something a little less high: still a high consciousness, but more like the consciousness of the *Asuras* than that of the *Devas*. One of my students pointed out that I had become a "wrathful deity"—striving and struggling, trying to be God. I was still a very effective teacher at this point. I would cut people into pieces and that was very useful, for sometimes it is not so useful to be too forgiving, too accepting.

Then I became a hungry ghost. The thirst for the experience I had just lost became very, very great. I went into intense deficiency motivation and, in spite of much meditating, proceeded on to hell. I was very much in touch with a sense of wrongness inside. I felt as if I had not taken even one step on the spiritual journey. I was lower than I had ever been. I had known depression, but I had never known this kind of meta-depression, of being so much in touch with the monstrous internal side. Sometimes I felt like a complete fool, like an idiot—which caused me much embarrassment.

I did not know that there could be such a thing as a very dramatic experience of spiritual breakthrough that seems definitive, but may then be lost. But then I became more familiar with the Christian tradition and the Christian mystical history, and saw how regular a feature it is that after an

*Through . . . humility, which is acquired by the said knowledge of self, the soul is purged from all those imperfections whereinto it fell with respect to that sin of pride, in the time of its prosperity.*

ST. JOHN OF THE CROSS

early stage in spiritual development that is like a honeymoon, there comes the "dark night of the soul." I became something like a student of the dark night through my own experience.

This "dark night" was the very opposite of when I had felt wise, and I think it was Grace that brought me to that state. Feeling like an idiot is very important. It is important to feel stupid, to feel bad, to feel that you have nothing to give, that you're pure ego. When you see that thoroughly enough, then you won't buy your own lies. What seemed to be love begins to be seen through, like in my work when I had thought that I was guided by a compassionate motivation and then began to see how much narcissistic contamination there was. It is a process of gradual impoverishment. It's a *learning* to be poor— poor of all that which were your riches but became spiritual materialism.

It is important not to let ego take credit for virtue or to let the shadow side take credit for your spirit. Life is for itself, and out of itself there is a generosity. But to the extent that there is a mind parasite, or ego in us, this parasite reaches for that energy and uses it for its own grandiosity.

Fortunately, many good teachers were around at that time, so I had good influences to soak in at a time when I was at the low ebb. I remember Oscar Ichazo telling me early in our contact, "You have to lose the experience, and then come to it again, with the keys in your hand, in order to work most effectively with others. Otherwise, you'll be like some Indian *babas* who have attained a high level of realization but cannot pass it on."

If the experience is really a revelatory experience of a high order, I think there may be a choice of staying there, in which case the spiritual experience becomes encapsulated: it is not lost, it does not decay, but it is not integrated either. The other possibility is that if you're willing to let go of it the experience dies, but in the way that a seed dies and then becomes a plant. You let go of it, instead of enjoying the spiritual seed

*Misery is only the gift of God. It is the symbol of His compassion.*

SARADA DEVI

and holding onto it, ecstatically announcing to the world that you are in contact with God, and helping people get some kind of contact high from you instead of deep transformation.

You can use the light of an experience to see your darkness. The experience is being lost only to the extent that it is being reinvested in yourself. The light you receive mixes with your own darkness, and then it is not light anymore, but neither is the darkness so dark anymore. Your being is transformed.

I had a lot of aspiration, so I was willing to let go of a season in heaven. I was willing to sacrifice what I had; to sacrifice everything to get to the real thing. I was willing to plunge into space, to throw myself into the abyss, come what may, and to digest whatever came. It had to do with sacrificing enlightenment for more enlightenment instead of holding onto enlightenment. I think that decision comes from some measure of clarity, of intuition, and a motivation to not be content with less.

Meanwhile, I had been reinforced in continuing to teach. Trungpa in particular told me, "Beware of confession." To confess would have been to say: "Oh, I am not as mature or as complete as I thought I was. I am not enlightened, and therefore I quit." Or to say, "Oh, I have been playing the teacher when I should not have been." There was an appropriateness to what I was doing and I had something to teach, but only if I didn't make myself into something bigger or higher than I was. I had to begin to speak in a language a little different from the language I had spoken during the period of time in which I thought I was so special—there was the voice of "little me" again, who would sometimes get the gift of inspiration.

Then it happened that, little by little, regeneration started coming. A new springtime began to come into my life. A love affair had something to do with it—falling more deeply in love than I ever had before. It made me feel more deeply than before that I was lovable, and it healed some of the childhood issues that were still behind the problem. Also, at

*We never consider that the sacrifice required for liberation may be liberation itself.*

LEE LOZOWICK

## BERNADETTE ROBERTS: THE MOST HUMBLE MAN I EVER MET

*I knew a priest who was in the unitive state. He had been through the night of the spirit, but after all the wonderful experiences, he came upon a certain let-down, and seemed to have a difficult time reconciling himself to the utter "ordinariness" of the state. For this reason he was bewildered and humbled, he felt perhaps he had lost something, that somehow he still had a long way to go—but go where? He took for granted that he had not been given the graces of the saints; in a word, he had about him the air of humble disappointment. Though he had the unitive secret deep within, he otherwise had a poor image of himself. I always remember him as the most humble man I ever met. I was very young at the time—he was the only spiritual father I ever had—and, for a while, I too wondered what had gone wrong. But many years later I realized that in this priest I had met the living reality of the unitive life in all its simplicity, humility, humor, discernment, depth . . . when I think of it, he was "ordinary"—but extraordinarily so.*

*The sense of a falling-off or of encountering a "wasteland" that sometimes occurs after emerging from the cocoon, is actually the butterfly leaving the chrysalis behind as it flies into the unknown where "there is no path." It is the onset of a life of selfless giving and yet a further stage of death to the self. This is where the contemplative may feel lost and wonder what has happened to all his former experiences, and wonder, too, if something has not gone wrong. Also he may still be waiting for the experiences of the saints, and possibly a share in their renown. From here on, the glory of the unitive life can only be known in its fearless exercise, which means the full acceptance of our humanity and selfhood. Here we must literally lay ourselves and our unitive life on the line, as if daring the forces of hell to separate us from God. This alone is the way forward to the final emptying, to the loss of everything that can be called a self.[21]*

*To venture into that terrifying loneliness of the unknown, one must have something greater than greed: love.*
CARLOS CASTENADA

one point something was triggered in my body—another level of kundalini experience, but a much more tactile, more physical process that started in my skull and went downward. I would say that that was the beginning of my journey of return.

There came a time when people asked me where I was in my journey and I said, "I cannot say it is the dark night of the soul anymore." I am back in the world. It is like coming back from a pilgrimage. I am doing something good. I have cleaner and more wholesome relationships and, at the same time, I cannot say that it is the same spiritual connection that I have known and that I knew in the beginning.

It has been a very good period, and at the same time I am waiting for greater spiritual fulfillment. Not pushing for fulfillment, but knowing that this is the fulfillment I am heading toward, and trusting that I am moving toward it although I'm not pursuing it in the way I used to pursue it. I am allowing it to come in its own time, as I just continue to do what I need to do.

Perhaps a story I can tell that not many others can is that at a certain time I was willing to say, "Okay. I had my baby. Now it's time to get back onto the dry dock. I am not meant to be teaching others now; instead, I am meant to come back to working on myself."

### II. Ram Dass's Story: A Ten-Year Perspective

Ten years ago I was very caught in specialness. I was what I now would call a "phony holy." I was busy trying to be high for me and everybody else. I assumed that everybody wanted me to be high all the time so I would prepare myself to be high in front of everybody. There's a certain way you are when you're high. You smile a lot, you're very benevolent—it's the holy man role. I took all the parts of me that didn't fit into that role and shoved them under the rug so that I could be who everybody wanted me to be. I wanted to be that, too. I really wanted to be Ram Dass.

You see, I had what was called vertical schizophrenia. I even had a name to go with each of my personalities. Dick Alpert and Ram Dass. Ram Dass would sit in front of a group of people and look out and maybe just love everybody and want nothing. Dick Alpert was counting the house. Worse than that, Dick Alpert was impersonating Ram Dass. Somebody would come up and say, "Oh, Ram Dass, thank you for your writings!" and I'd hear Ram Dass say, "Wouldn't you like to come up and see my holy pictures?"

Well, that may seem funny to you, but what I felt was just a tremendous amount of hypocrisy, being what everybody wanted me to be. You see, what happened was that the spiritual identity played right into my hands psychologically. Psychologically there were whole parts of my being that I was afraid of and didn't accept. I had a justification for getting rid of them by becoming holy, and I was using my spiritual journey psychodynamically in order to get free of things that I couldn't acknowledge in myself.

But after a while I began to feel as if I was standing on sand. I had to live with my own horror, and the predicament was that I was trying to live in the projection that other people were creating for me. But every now and then I had to be alone, and when I was alone I'd go into very deep depressions, which I hid.

My theory was that if I did my Sadhana hard enough, if I meditated deeply enough, if I opened my heart in devotional practices wide enough, all that unacknowledged stuff would go away. But it didn't, and it has taken me years to understand what the teaching was in all of this. I was busy going from the two into the one . . . from dualism into nondualism, from multiplicity into unity. All yogic techniques are designed for that purpose: Yoga means union. I could huff and puff in pranayam, control my breath to go into a trance state, and in that trance state all of Dick Alpert would be gone completely. But I always came down again, and down had a pejorative connotation for

*As you progress in the Work, your chief weakness doesn't go away, it actually becomes stronger. It is the grain of sand in the oyster around which the pearl is coated.*

E.J. GOLD

me. I kept wanting to get high. I didn't want to come down. But I indeed did keep coming down, even with Yoga techniques.

Somehow being human meant less than perfect. Even though I intellectually knew that "form is no other than formless and formless is no other than form," I knew that the manifestation was God made manifest. Everything was perfect out there except me. But original sin was going to have a last stronghold right here with me. Now I had steeped myself in a Hindu tradition of renunciation, which could produce liberated beings, but often just produces horny celibates, and it kept reinforcing my denigration of personality.

I'd already figured out that as long as I pushed anything in the universe away I wasn't going to be free. I also saw that the game wasn't just getting high; the game was to be free, and free included the highs and the lows. Free included it all . . . "all and everything" as Gurdjieff would say. There is also that lovely line of G. Manley Hall— "he who knows not that the Prince of Darkness is but the other face of the King of Light knows not me."

The problem that I ran into for some years was that the doorway to the intuition is through the human heart, and I was trying to leap into cosmic love without dealing with emotionality because emotionality was a little too human for me. What I experienced was that I had pushed away my humanity to embrace my divinity. When I wanted to be intuitive, the intuition, the impeccable warrior intuitive action, had to come from a blending of humanity and divinity. Until I could accept my humanity fully, my intuitions weren't going to be fully in harmony with the way of things. When I went into my sixth Chakra, everything looked absolutely perfect. I could look at suffering and see the way in which it was grace. I could see death as grace. It was a place that was clear, but with that clarity there was no warmth. If someone fell down in front of me I could say, "karma." But when I came down into my

*All that majesty, ecstasy, and wonder doesn't change the way things are.*

LEE LOZOWICK

human heart, it would hurt so bad because I opened to the suffering of the universe. The easiest way to handle it is to go up. It's much harder to stay down and stay open. It's excruciating.

I began to feel that my freedom was going to lie in the creative tension of being able to see simultaneously perfection and also to experience pain; to see that there was nothing to do and yet work as hard as I could to relieve suffering; to see it was all a dream and still live within the reality of it. My present work is to get into the fullness of the human heart. People used to say, "We love you and we think you're beautiful and very clear, but we don't trust you." They would say they didn't trust me because they couldn't feel my heart, my humanness. There's an image of a Buddha statue with a tiny smile at the edge of the lips and it's known as "the smile of unbearable compassion." It's a way in which you can open to the horrible beauty of it all. You can bear it, not by deadening yourself, but by balancing. It's a big one, embracing humanity—not embracing humanity. Embracing my humanity.

Almost ten years ago I met this Tibetan rascal named Chogyam Trungpa Rinpoche. I knelt in front of him and he looked at me and said, "Ram Dass, we have to accept responsibility." What would you do with an opening gambit like that? So I said, "What responsibility? Rinpoche, God has all the responsibility. I don't have any responsibility. Not my but thy will, Oh Lord." He said, "You're copping out." Then we turned to other conversation, but that statement stuck in my craw.

I was busy holding on to a myth about myself, a scenario about myself: "Dick Alpert thrown out of Harvard, drugs, Yoga, Guru games . . ." what will happen next? It's very "somebody-ish." So I went into nobody training, giving lectures, "Nothing New by Nobody Special." I was going to be nobody special like the big boys. But there's a sneaky "somebodiness" in there.

Ten years ago I used to be counting, "How soon 'til I get enlightened?" Now I've developed patience. It's not despair.

*If you are just having unusual experiences and feeling special—especially if you feel better than everybody else—I think that is a dangerous thing.*

CHARLES TART

It's patience. It's rooted in hopelessness. My attachment to where I was going was getting in the way of being. The third Chinese patriarch says, "Even to be attached to enlightenment is to go astray."

No longer am I trying to imitate anyone else. I'm Dick Alpert and I'm a perfect Dick Alpert. I listen from moment to moment, and what I hear changes, and I find that I can't be afraid of being inconsistent if I'm going to listen to truth and allow my uniqueness to manifest. Now I listen and I do what intuitively I must do. I begin to trust myself to find the unique way that I'm going to manifest this year, in this world, which has never been like this before, with this body that is totally unique, with this mind, with this childhood, with this set of experiences. The rule book isn't going to be good enough—no matter how fancy its covers and how august its authors.[22]

### III. Arnaud Desjardins' Story (as related by Gilles Farcet): A Sober, Down-to-Earth Attitude About Enlightenment

*Spiritual life lived in earnest should be intensely nourishing and intensely gratifying, even if ultimately challenging.*

ANDREW COHEN

When I was very young on the path, I thought, "Arnaud is enlightened. He is in that elated state." I had all kinds of fantasies about that, which is very normal. Yet when I had opportunities to talk to him about it, he always had a very sober, down-to-earth and even disappointing attitude about it. On one hand, he distinctly said, "Yes, there has been a shift of context." But once acknowledging that, he would say things like: "But then I had to practice, and I saw the mechanisms coming back, and I had to be very vigilant, very careful." Or he would say, "I think I really started to practice when I opened my first ashram—Le Bost." At the time, this was very disturbing to me because I thought, "I don't understand. If he's enlightened, what does he mean about mechanisms coming back? I thought he was supposed to be free of those mechanisms. What does it mean when he says that he really started

to practice when he opened his first ashram? He was already enlightened, already a guru."

I was really disturbed by all of that, but the more time went on, and the more I was on the path and spoke with him about this, the more I realized that his attitude is very true and very important. Arnaud had a shift of context, but this shift was a crystallization of efforts done over years—very rigorous sadhana under the guidance of one singular guru after years of intense efforts and search and facing the truth about himself in very concrete terms.

Once I went to him and asked him what his teacher, Swami Prajnanpad, said to him when his shift of context occurred. I imagined that he had gone exalted to Swami Prajnanpad and said, "Now I've got it!" and that Swami Prajnanpad embraced him and all that. But, to my surprise, Arnaud said, "We didn't talk about it. I had an interview one day, then this thing happened, and then I went on with my interviews as usual in the following days. Swamiji certainly noticed that my questions had changed a little bit, my perspective had changed, and that I wasn't protecting myself anymore, but that was all." Arnaud said that it wasn't until two years later, in an informal conversation, that Swamiji said something like, "Mmm, Arnaud, you've changed. You've changed. No doubt." And that was all. And then they started to plan for the first ashram, and Swami Prajnanpad told him, "I don't think you should remain in an administrative job on television. Your job is to teach." But otherwise, nothing else was said.

I've also noticed over the years that when people ask Arnaud questions about his enlightenment, he says things like, "Ooh. Wait a minute. What I've achieved is nothing compared to what Ramana Maharshi achieved." Or he says, "There's a progression that goes on after." Even recently he told me, "Fortunately, I have my wife and my son, who are living close to me and who don't spare me. When they don't like something, they tell me very straightforwardly, and most people

*If you are becoming a kinder, more intelligent, more compassionate person as a result of what you are doing, I think you are doing something right.*
CHARLES TART

wouldn't do that because I'm their master. But she's my wife, and he's my son, and they just tell me—and it's good for me!" He also told me that something unpleasant had happened to him recently and that he had felt that it had been an opportunity to practice more and to deepen his practice. I was very touched by this, and thought, "He doesn't consider that he doesn't have a practice anymore." He seizes every opportunity, while at the same time acknowledging very clearly that he's not a false teacher and is not practicing what he calls "illegal wisdom teaching." I've learned a lot through this very sober attitude.

*We are all just disciples of God; sinners trying to do better.*

IRINA TWEEDIE

You will find a story of disillusionment behind every great disciple and every great teacher. The ego never starts out humble and free of illusion. The very ego that often tricks one onto the path is the ego that, once fully committed to the path, begins to get tricked by a process greater than itself. The truth itself that ego claims to aspire to begins to grind and strip the individual down to a living experience of reality in order that the individual may serve that reality. As will be discussed in the final chapter, even enlightenment itself is not the end of the path. It is the beginning of a path that has no end. Spiritual life both demands and provides an opportunity far different, and far greater, than any kind of enlightenment that the ego once dreamed of. It opens the way to the natural life, the simple life, the fully human life.

# Enlightenment Is Only the Beginning

*When ordinary things become extraordinary, and extraordinary things become ordinary, then enlightenment has been glimpsed.*

—Lee Lozowick

"After you've climbed the hundred foot pole, you have to jump off the hundred foot pole. That's the next step," states Jakusho Kwong Roshi in classic Zen terminology. Enlightenment, touted to be the pinnacle of all spiritual life, may well be only the beginning of it. Of course, whether or not enlightenment is the ultimate expression of spiritual life depends entirely upon how one defines enlightenment. There were masters of old whose understanding of enlightenment was so broad that it included a mature expression of that enlightenment in the finest details of life and a full openness to continually expanding and deepening their enlightenment; but almost without exception, in contemporary times, enlightenment is considered to occur when one breaks through dualistic perception into the nondual, egoless state.

Bernadette Roberts explains that one reason that the egoless state, or the realization of nonduality, has been mistaken for the end of the

*The spiritual path is a process, a journey, and I don't think anyone who is really at ease with himself or herself would assume that the journey is completed. It's an ongoing process.*

ROBERT HALL

*The Path is not other than the service of the people: It is not the rosary, the prayer-rug and the dervish robe.*

SAADI OF SHIRAZ

path is that ego death brings with it a sense of ending and completion. It is only when one looks beyond this apparent death that one discovers it is simultaneously the birth of a new potential.

The egoless condition has been mistaken for the end of the journey for a number of reasons. One is that the final revelation of the divine center and true self has a definitive sense of ending as well as a sense of a new beginning. This end, of course, is the ending of the egoic state and the beginning of the unitive state. From this particular position we do not see anything further to be attained in this world; nothing else is wanting. With the divine we have everything; we are home free. So what do we do now? The path ahead is to live this egoless condition to its fullest unitive potential, a potential we cannot know until it has been lived.[1]

Reggie Ray tells the story of someone asking Trungpa Rinpoche: "What happens when you become a fully enlightened Buddha?"
"That's just the beginning," Trungpa Rinpoche responded.
"The beginning of what?"
"The beginning of the spiritual journey."

Philip Kapleau Roshi shares a parable from the Sutras that brings to light this relationship between awakening and post-awakening.

In this story enlightenment is compared to a youth who, after years of destitute wandering in a distant land, one day discovers that his wealthy father had many years earlier bequeathed him his fortune. To actually take possession of this treasure, which is rightly his, and become capable of handling it wisely is equated with post-kensho zazen, that is, with broadening and deepening the initial awakening.[2]

"People have big egos," comments Kwong Roshi. "They think that even a glimpse of emptiness or their first realization is the end of the

road. And people hang onto those things and feel that they are ready to teach. But little do they know that that is just the beginning. They've convinced themselves that they're ready and that there's no more to learn."

Many highly respected teachers, including Trungpa Rinpoche, Jakusho Kwong Roshi, and Lee Lozowick, agree that the individual doesn't even *begin* to do spiritual work until he or she has had a profound shift of context and a deep and abiding realization of the nondualistic perspective. While many spiritual schools define enlightenment as the piercing of the illusion of nonduality, Lozowick says that he would not say that such individuals are enlightened: "I would say that they had touched the beginning of enlightenment. Unless that enlightenment was mature, I wouldn't consider it enlightenment."

Jai Ram Smith says that we find so many "messy situations" in the spiritual scene because individuals presume themselves to be fully enlightened when they have only just begun. He compares spiritual aspirants with a fresh insight of nonduality to children in a sandbox: "The kids in the sandbox have new toys. Powerful toys. And they have influence. They have influence over others and they have influence in an energetic sense, but they are still only in a sandbox. It is said that enlightenment is like kindergarten. It is just the beginning of spiritual work."

Whereas Smith compares enlightenment to the kindergarten of real spiritual work, Robert Ennis and Gilles Farcet scale up the educational analogy. "We tell people that awakening is like getting your college diploma," explains Robert Ennis in his characteristically humorous style. "Awakening is the beginning of your real life, it's not the end of your real life."

Gilles Farcet reflects on the progression of his own education.

When I finished high school and passed the exam, it was a big deal! But then it was over. I had passed it. So then I went on to university, and when I was there I thought, "How great it would be to have a bachelor's degree." I looked at people in their third year and thought, "Ooh. How exciting." But then

*A Master says, "You have entered the way but you are not truly enlightened. Step forward from the top of a hundred foot pole, and the 10,000 things become your body."*

ZEN PARABLE

I got my bachelor's degree and it was behind me. Then I went on to get a master's degree and then a doctorate, and once I had the Ph.D., that was also behind me. I had to go on with my career. I couldn't spend the remaining thirty years of my career saying, "I got the Ph.D.! I got the Ph.D.!" "I'm Gilles, Ph.D., Gilles Farcet, Ph.D. Call me 'doctor' please." No, I had to go on with my career, find a job.

You can't spend all of your life saying, "Ooh. I've achieved this shift of context," or even more sophisticatedly saying, "'It' has been achieved, the 'I' has disappeared." You have to go on with your life and your teaching, and you have to demonstrate what this change has done and what its implications are in your daily life, in your way of relating to yourself and everyone else.

*The path is the goal, and everybody is on it one way or another—even the most neurotic, messed-up materialist is on the path. They are at some point on the path, and in their suffering people are getting transformed. Some people are on a more gross, fixated level because of their karma, but everybody is on the path.*

REGGIE RAY

Kapleau Roshi says that in the Zen tradition, as well, even the "graduation certificate" for enlightenment doesn't mean that the work is through or even that one is ready to teach.

There is a calligraphic acknowledgement that a master gives his student when he sanctions his enlightenment, but that can hardly be called a teaching certificate, because real Zen training begins after enlightenment. Students who complete work on all the koans prescribed by their teacher receive what is called *inka,* but inka in itself does not make one a qualified teacher any more than graduation from medical school makes one a full-fledged doctor.[3]

Gilles Farcet tells the story of a time when Arnaud Desjardins was conversing with Swami Prajnanpad about the Swami's disciples. Swamiji [the personalized form of "Swami"] cut him off and said, "Swamiji has no disciples."

"What?" asked Arnaud.

Again Swamiji said, "Swamiji has no disciples."

When Arnaud asked him what he meant, Swami Prajanapad gave the sobering reply, "Swamiji only has candidates for discipleship."

Although spiritual seekers routinely make high claims either about their advanced discipleship or their status as enlightened beings, Swami Pranjnanpad's response suggests that even the most senior practitioners are usually only candidates for discipleship. "Even the greatest teachers I've met," reports Reggie Ray, "say: 'Well, I'm just beginning really. I'm just starting. I feel like a baby taking my first steps.'"

The great masters know from their own experience, and from witnessing the evolution of their students, that the initial experience of enlightenment is definitely not the end of the road. Nor does initial enlightenment—whether it is considered to be a glimpse or even a relative abidance in the nondualistic perspective—confer that all neurotic and/or egoically referenced actions have been purified. In *Autobiography of an Awakening*, Andrew Cohen writes:

*Spiritual life is full-time work, twenty-four hours a day. This is why most people don't want to do it.*
LLEWELLYN VAUGHAN-LEE

> My Teacher always said that someone was "Enlightened" after this initial glimpse into their true nature. I soon realized this wasn't true. If a person was "enlightened," to me that meant that they had to be able to manifest and express that realization in their outer lives. It seemed that in spite of "Enlightenment," much neurotic and conditioned behavior remained . . . What did all this mean? It meant that Enlightenment was only the beginning. It meant that the realization of one's ultimate potential was the beginning of the path. It meant that indeed the beginning of the path was the end of all seeking, but not necessarily the end of realization.[4]

Kapleau Roshi further debunks the myth that initial enlightenment confers "perfection" in the ordinary sense of the term. When a student asked him if enlightenment removes personality imperfections and flaws, Kapleau Roshi responded, "No, it shows them up!" He explained that before one is enlightened, one can overlook or intellectualize such flaws, but that after enlightenment, they cannot be hidden. With enlightenment, however, a strong desire to purify imperfections arises and, for this reason, ongoing practice and training is

necessary so that one's behavior can eventually become congruent with one's understanding.[5]

According to Bernadette Roberts, the early stages of enlightenment are marked by great insight and ecstatic experience, and provide excitement and grandeur to those aspects of the ego that remain unintegrated, as well as to eager followers. However, the deepening of that early enlightenment into what she calls the "unitive state" may not be expressed in such a flashy or seductive manner. She suggests that it is important to make a distinction between the set of experiences and insights that arise in conjunction with the initial experience of enlightenment, or the "cocoon stage," and those experiences that arise as an aspect of the life of a mature butterfly. She also says that there is a need to hear about the life experiences of the mature butterfly, about what happened after the great emerging from the cocoon.

*I think anybody who is enlightened is kind of ordinary.*

JOAN HALIFAX

If, as soon as we emerge, we write up these transforming experiences, publish them, and hand out the good news, we are only generating premature excitement based on the newness of the state . . . Let us hear instead from those who have lived twenty to fifty years in this state, and we may hear a different story; now something will have to be said about "what happened next." We need to hear about this, we need to hear about the ordinary life of a mature butterfly.[6]

She further writes: "Until and unless he [the butterfly] lives this condition in the ordinary world, all he can tell us is how he became a butterfly; he cannot tell us about the life of a butterfly. In fact, until it dies, all the data on the life of a butterfly is not in."[7]

Some paths end where the butterfly emerges, while other paths insist that this end is merely a signpost marking the beginning of the way. Lee Lozowick clarifies this point by suggesting that different spiritual paths have different aims and different goals in terms of what it means to fulfill the highest possibility of that path. Speaking with a group in Koln, Germany, he explained that although liberation is a

necessary realization along the path, it is not the aim of the Tantric work which he teaches.

> For Advaita-Vedanta and similar schools, liberation is the point; for Mahayana Buddhism, service is the point; for Vajrayana Buddhism (Tantric schools), adoration—objective adoration of Reality—is the point. Adoration is about worshipping life as it is. From the tantric perspective, liberation is a stage: not the final goal, but a halfway step toward adoration.

This discrepancy in perspective concerning the ultimate objective of the spiritual path accounts, to some degree, for the widely-held assumption that enlightenment is the end of the path. For there are traditions in which the teachings do not extend beyond the notion of nonduality, as well as teachers who are not aware that there is more to enlightenment than the experience of oneness. Thus, they lead students to believe that the beginning of the road is, in fact, the end of the road.

## No Top End

"This work is ongoing, long-term, never-ending," says Sensei Danan Henry. "They say that the Buddha is only halfway there. The Buddha is up in the *tashida* heavens, practicing away." Not only is enlightenment only the beginning, but there is no end, ever, anywhere, to one's evolution, growth, enlightenment. This presents a sobering, if not daunting, contemplation for the average spiritual seeker.

"Ooh, but after enlightenment it just gets better and better as one expands infinitely," says the naïve and hopeful aspirant. Perhaps this is so, but those who have traveled far beyond the point where most ever get say that the work is ever-demanding, ever-challenging, and, for many, ever-heartbreaking. While it is true that one is more prepared to handle these greater challenges, the work increases in proportion to one's capacity to handle it.

*Continuous practice over many years is a much more powerful way of purifying negative actions and much better for you than impulsive, emotional bursts of meditation in solitary retreat.*

LAMA THUBTEN YESHE

There is unquestionably a shift in context, or initial "enlightenment," that irrevocably changes the individual's perspective. The error is to then mistake that shift for the end of one's path. A discussion group leader observes: "Looking at it from one angle it seems to be a continuum, but from another standpoint there is a radical and sudden shift in context that is quite distinct, that stands out from that continuum."

Danan Henry quotes Dogen as saying, "No beginning to practice and end to enlightenment; no beginning to enlightenment and end to practice." Sensei Danan says that it is impossible to find an end to enlightenment because purification goes on eternally, and that is simply the way it is. "We never arrive, ever," he says, and, at the same time, we are always there.

Kwong Roshi explains the process of enlightenment as a circle which is ever broadening, but always moving back into itself.

*There is no need to know that one is identical with Buddha when Buddha is truly Buddha, for a truly enlightened Buddha expresses his Buddhahood in his daily life.*

JIYU KENNETT

Enlightenment is more like a circle: enlightenment, then delusion, then enlightenment again, then delusion again. We become enlightened by delusion and then we're deluded with our enlightenment. Then we are again enlightened by our delusion. There is no beginning and end. So the adept, or the true seeker, will always continue.

Andrew Rawlinson says, "It is a cardinal tenet of Zen that *kensho* is never final but can be deepened and refined without end."[8] Because of the law of impermanence, everything does and must change. It is only and always process, and never completion. Enlightenment, no matter how high it is, must continue to grow and refine.

The Sufi master Bhai Sahib, in discoursing about *Brahma-vidya*, the knowledge of Brahma, said: "Thousands and thousands of years are not enough, because it is a continual process."

Llewellyn Vaughan-Lee, quoting Bhai Sahib, comments, "This is something I love about spiritual life: one is always beginning. You never say, 'I have arrived,' and sit back. Instead you see your horizon expanding even more, the consciousness expanding more."

There is always more to do. After enlightenment there is simply more practice, greater skillful means, and more working out of karma without incurring a greater volume of new karma. "I had this idea about spiritual work that the more you let go, the less there was to let go of," shares a ten-year student who has been experiencing strong spiritual phenomena, "but I'm finding it to be just the opposite. The more you let go of, the more you're given back, and you then need to let go of *that*."

"No top end" means no final salvation. No freedom from suffering. It implies that we are going to walk this spiritual path into eternity and never get "there." It also implies that there will never be any rest. There may be some significant landmarks, such as the initial shift of context, but the road won't end. The aspirant's last holdout for ever-lasting bliss is annihilated in the recognition that one will always be moving. For those who insist on the illusion that they will find eman-cipation from suffering if only they can get enlightened, this is bad news. Llewellyn Vaughan-Lee warns:

> One of the dangers of this whole thing about enlightenment is that people imagine there comes a point when you feel you've arrived. You've done it. You've gotten there. Maybe some people have arrived, maybe some people have gotten there, but to me it's just a deepening process of surrender which you try to live more each day, according to His Will in His Presence. It's full time work, twenty-four hours a day. This is why I think most people don't want to do it.

For some, the endlessness of the path is too overwhelming, too dif-ficult. Yet for others, this is good news, as Ennis suggests. While "no top end" does mean that there is no rest for the weary traveler, it also means that there are no limitations, ever, not even the limitation of enlightenment.

As Kwong Roshi says, "As long as we have a mind and body, enlightenment continues to go on. There's no place to rest." Life goes on, and so does the work of the enlightened one. There is no end to

*He has established himself upon a mountain So he has no Work to do. A man should be in the market-place While still working with true Reality.*

SAHL

enlightenment, as the potential to deepen and surrender into God or Reality is truly infinite.

## Enlightened Duality

*Enlightenment from the Buddhist perspective is not just the moment of awakening in which the mind becomes fundamentally relaxed, clear, mirror-like, luminous and spacious. It's about seeing the Dharmakaya [the transcendental reality] in this very world.*

JOAN HALIFAX

Enlightened duality is a re-entry into the world, following an experience of nonduality, in which one functions in the world on the basis of one's realization. One who lives in enlightened duality has already realized nonduality, and with that realization present has then willfully descended back into the realm of duality, bringing with them the enlightened perspective in order that it can be lived in duality.

The Zen Oxherding pictures offer a clear illustration of this matured expression of enlightenment. Each of the ten pictures is portrayed with a circle, and each represents one of the various stages of "capturing" the wild mind, depicted as an ox. As the pictures progress, a man catches the ox, and even becomes one with the ox, represented by an empty circle. But the pictures do not end there. The final pictures show the man leading the ox by a rope back into the marketplace, signifying the need to bring one's realization back into the world. Commenting on the pictures, Kapleau Roshi writes: "The Zen man of the highest spiritual development lives in the mundane world of form and diversity and mingles with the utmost freedom among ordinary men, whom he inspires with his compassion and radiance to walk in the Way of the Buddha."[9]

The caption under the tenth and final oxherding picture, entitled "Entering the Marketplace with Helping Hands," written by Zen poet and mystic Kuo-an Shien reads:

> Bare-chested, barefooted, he comes into the marketplace.
> Muddied and dust-covered, how broadly he grins!
> Without recourse to mystic powers,
> Withered trees he swiftly brings to bloom.[10]

Bernadette Roberts expresses the need to bring one's experience of union back into the marketplace in her book, *What Is Self?*

> The unitive state is not an end in itself; rather its purpose is authentic human existence, for it is only by living a mature existence that we can make our way to a far greater end or destiny. We do not know this great end ahead of time (though we may have glimpses of it), nor can we come upon it until the unitive condition has been exhaustively exercised and tested in the marketplace . . . Having finally arrived at the mature human state the immediate goal is not to die—as if there were no further to go—but to live the human experience as fully as possible.[11]

Enlightenment in the marketplace is not so appealing to ego as enlightenment on a throne or in a fancy turban or with groupies in white bowing at one's feet. One who lives from the perspective of enlightened duality may serve a formal teaching function or may not, but regardless, their attention is on life here and now, and on the unquestionable necessity for enlightened ordinariness. Vaughan-Lee says, "I am a great advocate of the whole Zen thing of 'chop wood and carry water': before enlightenment, chop wood and carry water, after enlightenment, chop wood and carry water, but something changes inwardly. The external life may be totally the same—nobody notices, and why should they? It's your business, your relationship with God."

When students come to Charlotte Joko Beck and want to tell her about the fabulous breakthroughs they have had, she tells them, "I'll give you one minute to tell me." And after their minute, she asks, "And how are you and your wife getting along?" "Their little moment," she comments, "simply means that they are beginning to be able to be present, if only for a few seconds, but it doesn't necessarily mean that they now know how to be present with the criticism of a wife or anyone else."[12]

The point is to live enlightenment here and now. We keep thinking that we are going to find it somewhere besides here, somewhere besides in the pain and suffering and joy and passing of our very lives. But it is never found there. We would all like to stay in ecstatic states, but it is

*If the enlightenment is true, it wipes out even clinging to enlightenment, and therefore it is imperative that we return to, and live in, the world of ordinary men.*

JIYU KENNETT

*Kensho is the moment of awakening, but the Dharma-kaya [transcendental reality] is in this very world. You can't function in everyday existence in the relative world with a chronic state of the moment of awakening.*

JOAN HALIFAX

not natural. There are the rare few whose enlightened destiny is to travel the cosmos, but organic, human life is generally not about sitting in a cave for thirty years being eaten up by ants and feeding off subtle nutrients in the air, so deep in meditation that we can't even feel our bodies. *Kaya* sadhana is the sadhana of the body, and what satisfies the body is human relationship, felt through all the senses of the body.

Joan Halifax, who was very involved in the shamanic traditions before pursuing sadhana in the Zen tradition, drives this point home.

> The recognition of being a reborn Tulku or an enlightened being is not going to absolve us from right here and now. Even though I've been very involved in shamanism, I don't think magically. I'm very concrete. I'm a woman. I'm very practical and I've seen the fruits of romanticism—of romantic spirituality—hurt many, many people.

She continues, "*Who you really are* is not to be blown out of your mind, but is to just be in this everyday world with a kind of beginner's mind."

Both Arnaud Desjardins and Andrew Cohen insist on the importance of recognizing the *reality* of this world, whether or not it is ultimately illusory. For all practical purposes and for everybody who lives in it, it is real. Thus, they say that enlightenment must be expressed in action, in the world. A close student of Andrew Cohen's writes:

> In Andrew's experience, real Enlightenment brings one to an even more acute awareness of the laws of human existence and thus to a deeper consciousness of the effects of one's actions in the world . . . With Enlightenment, the relative does not go away. Like it or not, a person who is realized still does exist in space, in time, as a human being in this relative universe! Andrew's whole emphasis is that the depth of a person's Enlightenment is revealed in how they relate to this fact. Andrew feels passionately that Enlightenment is not a ticket into a realm where nothing matters anymore and one can do

whatever they feel like doing, because the Enlightened one is *more* aware of the consequences of his or her actions in the world.[13]

Cohen himself writes that "there is no spiritual experience, feeling or insight that can free us from the burden of actuality, the burden of life *as it truly is*."[14] The point of enlightened duality is to integrate and apply the most profound of our insights, the truest of our feelings, and our full attention to the life in front of us, and to live there.

Desjardins says that it is very difficult to accept the often painful reality of duality fully instead of taking refuge in a nondualistic perspective that may be true of the realizer, but is not true of the world.

It is not so easy to bring great experience into daily life—they are too different. So my conviction is: take daily life, here and now. Not what it should be, but what it is, now—to accept duality fully, and not to dream too early of a nondual state where there is no "I," no doer, and only the shakti working through one. There is a kind of forced, fake, nonduality of the ego, a caricature of the highest truth that thinks: "Only myself. And if the world does not obey my wishes, then there is something wrong." Swamiji used to say that the ego is the seal of the "I" imposed on the "not I."

At this level of reality, there are two: myself, with my fears and desires, here and now; and the other. And the other is another. The ego does not accept this law of difference. The ego thinks, "In *my* world . . . " No, not in *your* world, but in *the* world. One cannot be free of the world. If it rains, it rains for the sage as well as for the green earth. When the communist party took over in Afghanistan, the most convincing Sufi masters were killed. It was very sad, but it was like that. When the Chinese invaded Tibet, some great Tibetan sages were killed. So one cannot be free of *the* world, one can only be free from *one's* world. So I believe in simple practice—day after day, hour after hour, second after second.

*Until you can step back into the phenomenal world, and experience it from the vantage point of that place of eternal serenity, that place which is unborn and undying; until you can live your life out of this understanding, it is not enlightenment.*

DANAN HENRY

Lee Lozowick describes enlightened duality as "living God." He explains this notion in terms of differentiating between "infinity" and "divinity," a distinction first made by Meher Baba, and not unlike Jack Kornfield's earlier descriptions of the immanent and transcendent schools of Buddhism. *Infinity*, Lozowick says, is the transcendent perspective. It is the impersonal nature of God. In this realization of non-duality, God is an energetic phenomenon that responds to change but doesn't "care" about anybody personally, doesn't know their names, and so forth. *Divinity*, on the other hand, is the immanent perspective. It is the personal expression of God. Lozowick explains:

---

### THE AGHORI VIMALANANDA: TO BE TRULY AWARE

The Aghori Vimalananda explained to Robert Svoboda: *You know, Robby . . . all these swamis talk about samadhi as the highest goal, but I think they are fools. What is the use of these spurting samadhis, anyway? Fine, you go off into a trance, but when you drop back down to earth you are just as you were before. That sort of samadhi state stays separate from the normal waking "you." I think it is much better to retain consciousness on this plane even while you shift your main focus to other realities. Here I am playing chess with you, but as I play I can go to America to check on how your parents are doing, or I can visit Patalal (the underworld), or the planet Venus, or my Guru Maharaj, or wherever I please, and still sit here acting as if I know nothing. To be truly aware you have to know what is happening far away today, what has happened here long ago, and what is going to happen anywhere in the cosmos during the coming decades. But all the while you continue to function effectively in this time, space and causality. Awareness on all levels at all times—that sort of enlightenment has some use.*[15]

---

God has two faces. In the immanent expression, we, as awakened beings, would demonstrate in the world how God would be if God were personal. The ideal demonstration of the Bodhisattva is the demonstration of the personal divine in the world. If God were incarnate, God would be kind, generous, compassionate, affectionate, "magical." At the level of divinity, there are no needs, but expressions that are lawful and natural. In enlightened duality, we don't have needs like we do at the level of ego, but we demonstrate a certain lawful relationship to life that is characterized by care, compassion, ardent idealism. We find ourselves in circumstances of love and affection, and yet those things are not needs, but the demonstration of the enlightened state in the world. Great realizers have no needs, but they demonstrate tremendous states of clarity, heartbreak, affection, joy, rage.

Still another possibility that exists in the domain of enlightened duality, which does not exist in other expressions of enlightenment, is that of "loving God" as the personal Beloved. Nontheistic traditions, such as Buddhism or Advaita-Vedanta, do not use the language of "loving God," but many of their great masters and devotees manifest an equally profound expression of worshipping and surrendering to the Absolute Reality.

In order to love God, one must be separate from God. A student who is passionate in her desire to love God in this way writes:

Union is not the key, but love in separation. Enlightened duality is about objective relationship with the world. By definition, there is no relationship in the realization of nonduality because there is no "other" with whom one would relate. There is only union with the Divine, which is all and everything, including emptiness. Where can one go from there?

This realm of relationship is not the same kind of worldly relationship that we entertained before the realization of nonduality, which is motivated by the grasping, needy struggle to

*I had always thought that hell would be a blazing inferno where only dragons, serpents, and scorpions could survive. But now I see that Hell for me is separation from you.*

THE HUNGER OF LOVE

alleviate the suffering of separation. The opening of the heart leads to the highest relationship of all: to the Divine in relationship with Itself through the devotee, through the Lover of God.

Devotees of God or Truth abide in the dualistic perspective, albeit an enlightened perception of it, so that they can love God and adore God; whereas when one lives in nondualistic consciousness, there is no one to adore and nothing to adore, and God cannot be loved as Lover. Ego can still do something with the feeling of "I am one with the universe" that it can't do in a state of self-effacement in love. The experience of loving God leaves one in such a state of humility, wonder, awe, and longing that the ego has no place.

The possibility of loving God in this way is indeed a radical perspective, and a rare fruit that sometimes hangs from the tree of enlightened duality.

## Practice As Enlightenment

"Practice is a form of enlightenment," says Joan Halifax. "It is being determined to live the life of a Buddha, of an awakened being, of a person who fundamentally vows not to harm other beings or oneself." The notion of considering practice as enlightenment is an uncommon perspective on sadhana. While clearly one isn't enlightened simply because one practices, a life of practice that is impeccable in its refinement, intentionality, and reliability is an expression of enlightenment.

Most teachers included in this volume agree that a body of practice that expresses the enlightened perspective is more desirable than an experience of enlightenment that is not accompanied by ongoing practice. "I don't care how enlightened my students are," says Roshi Mel Weitzman. "It's fine to be enlightened, but it's still just enlightenment. One really has to go beyond enlightenment to see how one actually acts in the world." Enlightenment without practice tends to

*I never particularly cared about enlightenment that much. I was always interested in reality, but I never worried much about whether or not I was going to get enlightened. I thought in terms of finding what is real, practicing what is real, and finding my teacher.*

MEL WEITZMAN

express itself in the world as laziness or indulgence, backed by dharmic rhetoric such as "There's nowhere to go, nothing to do" to justify the lack of practice; whereas impeccable practice, even without enlightenment, manifests as humility, intentionality, and an openness to further development.

Weitzman encourages his students to place their attention on practice as an expression of the awakening they seek, rather than dreaming of an obscure enlightenment.

In our practice, we say that practice itself is enlightenment. Enlightenment itself is not experienced, it is experienced as practice; and practice is experienced as enlightenment. But if you try to understand what enlightenment is, or to grasp it, then it's not enlightenment. But if you sincerely practice, then enlightenment is there. We get greedy for enlightenment. We want to grasp this thing called enlightenment so that we have something.

When I hear people talk a lot about enlightenment, and getting some experience, I'm always very wary. People reach out for this thing that is called enlightenment and they ignore what they are actually doing. They ignore what is under their feet. They sacrifice this moment's activity for some enlightenment in the future, instead of just being rooted where they are and being totally aware of what they are doing right now in the simplest way. That is why, for us, all of our daily activities are practice, which means selfless activity. When you have selfless activity, enlightenment is always there.

*Enlightenment is not difficult, keeping your practice pure is difficult.*

MEL WEITZMAN

To strive to express enlightenment in this moment through practice is a worthwhile endeavor. In *The Joy of Sacrifice*, E.J. Gold drives this point home by suggesting that not only is there no reward aside from one's actions in and of themselves, but that humanity will even attempt to sabotage and destroy such efforts, as well as the one who is intending them.

You must not perform these obligations with the expectation of reward or merit. The Work is its own reward for those with conscience. In the Work one receives his reward from the moment in which he takes action and is present. Humanity cares nothing for your efforts, and in fact will not only do nothing to assist you in carrying them out, but will, through ignorance and fear, try to destroy you and your work . . . Your devotion, your efforts and your constant and unfailing sacrifices for the common good will go unheeded in Heaven and on Earth.[16]

*Discipline, if it is authentic, is the practice of enlightenment, that is, of magnifying our intuition of what is prior to the ego-contraction. Discipline is realizing the enlightened viewpoint under all circumstances, until that realization becomes full and permanent.*

GEORG FEUERSTEIN

If there is no such thing as a future enlightenment, then those who are serious about their spiritual practice are forced by necessity to seek gratification in their present actions, actions that must express enlightenment if they are to provide fulfillment. Enlightenment must then become a conscious expression of moment-to-moment activity, which is no different from practice itself. Jack Kornfield quotes Suzuki Roshi as saying, "Strictly speaking, there is no such thing as an enlightened person. There is only enlightened activity."[17]

Joko Beck responds to a question regarding the importance of daily practice.

It isn't something that we want to do. But that's what keeps you getting more porous. A lot of people, though, even though their practice is going well, will read a book, and say, "You know, Joko, in the three or four years that I've worked with you, everything in my life has transformed. I have a happy marriage now, I'm getting along at work, everything is totally different and I feel much freer. But what about the real thing?" They mean, "When do I get enlightened?" And of course, they are walking the path of enlightenment—non-reactivity—but their understanding is partial. In time, they'll see that the process itself is the real thing; it is the gateless gate.[18]

It is interesting to note—as we have seen thus far in the cases of Danan Henry and Arnaud Desjardins—that even those who are

considered "masters" continue to practice throughout their lifetimes. Their practices may be similar or different from those of the aspirant who is still searching, but their life is a continual, unbroken chain of practice. And even when the master abides in a domain of surrender from which he or she has no choice but to practice, the practice is still challenging, requiring great energy and effort, and often going against the grain of those personal tendencies that remain.

Sensei Danan comments, "At first we have to take ourselves in our own hands and make the practice happen. However, at a certain point the practice practices itself, but there is still practice going on. It is a matter of ongoing practice, perfection of character. The person who manifests this in their everyday life—only such a person can be called a master."

*The secret of Sufism is that it has no secret at all.*
SUFI PARADOX

If there is no top end, then there is no point at which one can afford to not practice.

## The Practice of Presuming Enlightenment

The practice of presuming enlightenment is an advanced consideration of the notion of practice as the expression of enlightenment. Whereas the premature presumption of enlightenment is the manifestation of weakness, the practice of presuming enlightenment is an expression of enormous strength and dignity. The practice of presuming enlightenment is a very high-risk and demanding endeavor that is dangerous to the undeveloped ego. Although it can be contemplated and flirted with by anybody, it is the rare practitioner who is able to successfully fulfill this practice.

The purpose of the practice is to rest in the reality of the wakefulness that is present when one is not caught up in the veils of the illusion of separation. The way it works is this: When one glimpses the enlightened state, if one does not exploit the possibility of languishing excessively in raptures and visions, one can instead allow that temporary awakening to ascertain what would be necessary to sustain that realization. When that temporary or shallow enlightenment fades, the

individual then proceeds to practice, or act, in accordance with what one perceived while in the enlightened state. Thus, all of one's actions become an expression of enlightenment, even if the internal state does not match up.

The koan, then, that lies at the base of the practice of presuming enlightenment is: If one continually acts from the perspective of wakefulness, even while asleep, can it really be said that one is asleep?

In *Spiritual Choices*, Dick Anthony, Bruce Ecker, and Ken Wilber write, "The practice is necessary, but it can be done from *being* enlightened, rather than *getting* enlightened. When you do the practice from *being* enlightened, then each one of the steps becomes a step in the *expression* of enlightenment."[19]

Rabbi Zalman Schachter-Shalomi explains this process in terms of "pretending," which is distinct from imitation and self-deception.

*Inner progress is measured by the quality of my internal relationship to the moment, and outer progress is measured by the way I relate to people and situations in the moment. Inner and outer are just one.*

GILLES FARCET

I like the word "pre-tend," because that means I get there before I'm there. I think every attunement calls for some kind of pre-tending. How do I become a saint? I pretend to be a saint. I don't mean I pretend socially to be a saint to the people in the world, but I say, "The next half hour I will live in my best understanding of how a saint lives." It's not that I have achieved that state already, but I'm making the template of my consciousness and my experience fit that ideal that I understand. The likelihood is that when I get there I'll still get some surprises and I'll have to adjust my expectations of what saintliness is.

One of the great possibilities of the practice of enlightenment is that the ego gets put to a severe test. The individual who practices the presumption of enlightenment chooses to act against the egoic tendencies of ego moment after moment. The ego kicks up its heels, digs them in, scratches and bites to try to drag the person back down to the level of mechanical, survivalist functioning. But if the ego's efforts to regain control are defeated by the strength of the enlightened practice, the possibility exists that the ego, like a mad dog behind bars that gets

tired of fighting, will step down from its position, deferring to an enlightened disposition which, at that point, may be no different from enlightenment itself.

Although many serious practitioners throughout the course of history have contemplated and experimented with the practice of presuming enlightenment for greater and lesser periods of time and to greater or lesser degrees of intensity, there are rare situations which call for certain individuals to not only presume enlightenment, but to presume the role of spiritual teacher. Claudio Naranjo's life, as we saw in the previous chapter, provides an uncommon example of one who has consciously and intentionally experimented with this practice *following* a period in which he lived and functioned from the awakened state. Prompted by his teachers to continue to teach after he had attempted to step down from the teaching function, and increasingly asked by students who attend his seminars to take the "guru seat," he has deliberately engaged the practice of presuming the function of Master or Teacher.

There was a time when I definitely felt that I was doing no service to people by placing myself above them on a high, comfortable chair, and when I felt it necessary to remind my students of my imperfections. When I came back to teaching, over ten years ago, I was not pretending to be an enlightened guide. I came with the attitude of: "I'll do what I can to help you. I'll use the abilities I have."

Then people began to call me "Master," to regard me as a teacher with a capital "T." The part of me that had stepped down from that role was tempted to stay down and say, "Hey, it's just us chickens here." But then I made a decision. I felt that now it was wrong to insist on a humble position and tell them, "You're wrong. Don't take me to be an enlightened teacher."

It was not honoring people to invalidate them for putting me in the position of teacher, and it seemed like the thing to do was to take on the function that was being asked of me—to accept the "high seat" that I was being offered and the respect

*If you understand spiritual practice in its true sense, then you can use all twenty-four hours of your day for your practice.*

THE DALAI LAMA

*Essentially, the result of the most profound and sacred spiritual work is not an exalted state of consciousness, but a state of consciousness in which one is completely responsive to reality. That's what God-realization could be said to be.*

LEE LOZOWICK

that I evoked without intending it. I allowed people to perceive me in the way that I came across to them in their experience, while at the same time not holding onto that position or developing a position of authority around that role in the service of ego. I do take some authority because it makes sense to do so in some situations.

I started to be acknowledged from the outside, but it was not like the earlier times when I was in love with my own beautiful words. I did not feel brilliant. I did not feel self-admiring. I was doing what I could, responding spontaneously to situations according to my experience and my talent. And I felt that I could help people better than ever. This was helpful not only for others, but for myself as well. It was necessary for me to get beyond the compulsive humility that was always part of my personality, which is somewhat aligned with the practices of "guru yoga" and "Buddha pride." In the first, one is encouraged to identify with one's guru, and in the second, one imaginatively takes on the position of enlightened radiance. Yet, I am still a beginner in the sense that I haven't come to the goal, which is not the promised land but the rebuilding of the temple. I haven't come to the King Solomon stage in my own life. I'm still waiting. Instead, what I share with others is my activity, the fruit of my intuition and cumulative understanding.

Naranjo's story is an exacting illustration of the challenging practice of presuming enlightenment. It shows clearly why the beginning practitioner could not responsibly handle this practice, as there are far too many opportunities and invitations inherent within it for self-deception. Naranjo is able to fulfill it only because of the inner strength that he earned through the years of disillusionment, frustration, and deception he incurred throughout the course of his sadhana.

The dangers of the practice of presuming enlightenment should be obvious. There is a difference between "acting is if" one is enlightened, and imitating enlightenment; between the *practice* of presuming enlightenment, and the unconscious and self-deceptive presumption

of enlightenment. "Assuming the position of enlightenment can be productive or counter-productive," says Naranjo, "depending upon whether it stems from conscious choice or self-delusion."

The key to this delicate practice is to always remember that one is acting *as if*. The moment one forgets that one is practicing and presumes that one's actions are an expression of a shift that has already taken place instead of a shift that one is aspiring toward, one has taken the bait of ego and fallen into the trap of self-deception. The presumption of having already integrated that which one is practicing will inevitably lead to arrogance and inflation.

However, it is still possible to experiment with "acting as if" without making oneself into a guru. One can simply go to one's job and say to oneself, "For today, I'm going to try to act as if I were enlightened, and do all the things that an enlightened person would do." Attempting this exercise for even one day is bound to be revealing.

Lastly, it is helpful to test oneself by finding out if *others* experience one's actions as enlightened. For the practice of presuming enlightenment will not be successful if one does not have enough clarity about the context of enlightenment to know how to act in the first place.

## Becoming More Human

The collective voice of the contemporary masters and sages included in this volume suggests that spiritual life is about becoming human—and then becoming more human still. When one comes to a spiritual master in search of the highest enlightenment and bliss possible in the universe and is told by the master that he simply wants one to become a human being, it can be a great shock—one that may not be understood for years. This is precisely what happened to Irina Tweedie with her master, Bhai Sahib, who told her that she must become less than the dust at his feet—that she must rid herself of all pride, vanity, selfishness, and, beyond that, become *nothing*—before she could be a human being. In *Daughter of Fire*, the diary of her years with her teacher, she writes:

*Awakening is not inhuman or non-human or superhuman. Awakening is . . . ultra-human.*

ROBERT ENNIS

His face was severe. He was half listening, half in Samadhi. I
had the feeling that I was boring him. He lifted his head and
looked me straight in the eyes:

"Why don't you become a human being? Why don't you
try to become less than the dust at my feet?" I stared at him;
it seemed like an unexpected attack.

"Am I not a human being?" I was amazed and felt forlorn.

"What you are I don't know, but a human being you are
not," he drawled, and it sounded like a growl. "Only when you
become less than the dust at my feet will you be balanced, and
only then can you be called a human being!"[20]

*Whereas I once thought enlightenment meant being up there somewhere, free and off the wheel of birth and death, free of all fetters, one with the experience of love . . . all that has changed. It is now about: What do I do with what is present for me now, using the tools I have been taught?*

CHRISTINA GROF

"I am already human, how can I become human?" one may ask, as
Tweedie did. But perhaps what one is is not truly human. Perhaps to
become truly human is to be stripped of the illusion of separation that
keeps one functioning from ego, and to then be released into the raw
vulnerability of human suffering and human life.

Reggie Ray said that when people would project high states of
being onto Trungpa Rinpoche, as they do to all great teachers, he
would respond: "I am a human being. I'm more human than the rest of
you. This is what it means to be a human being. What we're trying to
do here is become ordinary, naked human beings." Trungpa Rinpoche
also told his students, "I have less going for me than any of you"—and
he meant it. He had nothing. The brilliance of the realness that
Trungpa Rinpoche was, recounted Ray, was too much for most people
to handle, and so they rejected him in one form or another, buffering
themselves from an encounter with that much reality.

Becoming human is the answer to egoic pride and inflation. To be
truly human is to be humble. Tweedie describes how she came to
understand that what Bhai Sahib was teaching her was humility. She
said that at a certain point in a disciple's training, he or she is bound
to realize their divine origin, at which time they will become inflated
with the belief: "I am God."

It is then that one needs a Teacher. And the Teacher will say: no, be careful, with those lips not yet pure, with the heart not yet as limpid as the Waters of Life, it is a blasphemy to say that you are God! But a Great Teacher does not say it so directly— he simply teaches humility: "Become less than the dust at my feet." How can the inflation arise if one is made to be so humble? But this is not all. From my own experience I know that the nearer one moves towards the Reality, the more one realizes the absolute oneness of all and everything. And if I am part of something so Great that my mind cannot even conceive it, of something which fills me with awe, where is the pride? And those two processes—the inner realization of absolute oneness and, on the other hand, the Teacher pushing one's nose into the dust, to put it figuratively—they protect the disciple from the greatest danger: of himself being inflated like a balloon and bursting with pride.[21]

*Awakening brings us closer to life, more in contact with life, more sensitive to everything that everyone else feels, not less sensitive, not cut off, divorced or detached. The difference is that with awakening it becomes not only acceptable, but joyful to experience both the joys and the sufferings of the world.*

ROBERT ENNIS

In *Enlightenment Is a Secret*, Andrew Cohen writes of the humility that is necessary in order to embody a "precious and rare" expression of transformation.

The more genuine humility there is in a human being the deeper the impact the initial experience of Enlightenment is going to have. People who are very proud may have powerful experiences but the understanding that results from those experiences will be short-lived. A proud person will soon be left with only a memory of the great event. When profound humility is present the transformation will remain, and that human being's behavior will demonstrate something very precious and rare.[22]

Whether one is humbled through the guru or through one's own understanding and insight, this humiliation wears down pride and conceit, and allows the individual to express a more fully human condition.

### Robert Svoboda: "All You Need Is Faith."

*All you need is faith. Faith is the one thing you require, and faith is the one thing that you cannot obtain from any store—not from Albertsons, not from Wild Oats, or from the Institute of Ayurvedic Medicine here, or any other place. You cannot obtain it by trying to obtain it. It is something that has to come by your allowing yourself to be open to it.*

*So when you're patient, when you're humble, and when you bow down to Reality, Reality eventually will deliver you some faith that will allow you to create a connection with that Reality, and that Reality will act as a guide wire along which your shakti will move. And the more it moves in the right direction, the more you can be sure it is moving in the right direction. There will always be times when you will become confused, because that is the nature of human life. But if your shakti is moving strongly in the right direction, you won't stay confused for very long.*

## Master As Disciple

*Now that they are called masters, [they] are ashamed again to become disciples.*
        Tommaso Campanella

The true master is a master to his students, but to himself he is always a disciple. As His Holiness the Dalai Lama says: "I am just a simple monk." Although he is a political and spiritual leader for the Tibetan people as well as an inspiration to much of the world, to himself he is a monk. In front of his "boss"—the Universe Itself—he is not "His Holiness," but a servant of the Great Work.

Most of the teachers included in this volume are disciples as well as teachers and masters. If they are not disciples of a teacher, then they consider themselves to be disciples or servants of God, or Reality, or humanity.

To be a disciple is to be humble in the face of a force greater than oneself, to be responsible to something or someone for whom one has great respect. When a master thinks, "I am God. I have the power," he defers to no one. There is no higher conscience and no living demand for continual evolution and deepening surrender. There is only oneself, and it is dangerous to travel alone, even for a god.

All of the great saints of the past: Jesus, Rumi, Moses—as well as the more recent saints: Swami Papa Ramdas, Shirdi Sai Baba, Anandamayi Ma, Meher Baba—all were disciples of great masters, even if that master was God or Reality Itself. Their surrender to their master gave them tremendous force and benediction to give to others and guarded them from heavenly isolation.

*It is not so difficult to see if one is always first—before being a master—a disciple.*
ARNAUD DESJARDINS

Teachers or masters are much safer from the dangers of all presumptions and assumptions that may lead to arrogance and an eventual downfall if they maintain focus on their discipleship instead of on their mastery. Their time and outward attention is placed on their function as master, but inwardly they are focused on their discipleship. Arnaud Desjardins cautions:

Better a genuine disciple than an insufficiently prepared master. Better a genuine disciple, whose bond and relationship with his own master is very deep, than someone who claims to be a master in his own right but who has not gone to the end of the way. A master is a servant—a servant of his own master, a servant of the teaching and of the dharma.

Although he serves as spiritual master to thousands of disciples, Desjardins says of himself, "Though I am acting as a master, and fulfilling the job of master, I'm a disciple. My relationship is that of a disciple to his master and to all the masters I've met and trusted."

"Many people nowadays are prone to claim the highest attainments for their teacher," comments Gilles Farcet. "They say that he's an *avatara*, or that he's 'beyond the beyond,' and so forth; whereas the appropriate question may be, 'Is he a disciple?'" After a respected master came to visit Arnaud Desjardins' ashram for the first time, Farcet

said that Arnaud praised the teacher by saying, "He is a disciple, a wonderful disciple." "For Arnaud," Farcet says, "that meant much more than saying, 'He's a great teacher.'"

The true disciple is turned to his or her master in an act of ongoing surrender, a feat much greater and a labor of love more demanding than proclaiming one's own mastery. In *Aghora III*, Robert Svoboda shares the blessing and insight that the Aghori Vimalananda gifted him with at the end of his life.

*At first, you are not worthy of the robes and implements of the Sufi. Later you don't need them. Finally, you may need them for the sake of others.*

IDRIES SHAH

Spiritual development occurs as Kundalini relinquishes her hold on the limited self and, turning her face toward her Lord, begins to act not from desire for personal gain but for the greater glory of That Which is Real. This creates true happiness. So long as I continue to realign my own Kundalini toward that soul I know that someone will correct every mistake I make and, dragging me out of whatever ditch in which I may have dropped, will return me to the path. This was the parting blessing of my friend-philosopher-guide, the token of his Aghori's love, the benediction he could bestow because he had so utterly devoted himself to offering himself to his Self.[23]

There is no top end for the master who is also a disciple, no self-satisfaction or self-centered absorption in one's own divinity or position. If one has one's attention on and is always serving something higher than oneself, one is protected from the powers of seduction and ego and is more available to be of service to others. "One is safeguarded by realizing that one is a servant, rather than that he or she serves themselves," proposes Annik d'Astier. "I believe it is possible for someone to have a relationship with the divine and to live as a servant."

## Surrender and Service

Most of our ideas about surrender are just ideas, not lived sacrifice. Those who do not know surrender can only talk about surrender, intu-

it surrender, and pray for surrender. They certainly should not assume that they *are* surrendered simply because they can speak about it elegantly, or because they once had an insight about it.

One is more likely to awaken through surrender than through seeking to awaken. The effort to awaken is the effort of ego, whereas to surrender is to give up all efforts and to place oneself in the hands of a vast force that is more powerful than any realization of nonduality. Lee Lozowick asserts: "You can come up with a very clear and concise articulation of nonduality, and you can speak of it over and over again, and you can attempt to align your activity to that articulation. But in fact, organically, unless you've surrendered to the Will of God, which is movement but in the domain of nonduality, any state of nonduality is not mature."

While contemporary notions of enlightenment consider it to be a state of oneness, Reggie Ray says that from the Tantric perspective the basic teaching of non-ego is surrender.

It is simply that we can surrender, we can give in, we can relinquish all of our hold on reality. We don't have to hang onto things, we don't have to maintain ourselves, even spiritually. The teachings are that reality is so good and that there is so much blessing in the universe that we can actually surrender to what life is and we don't have to have all of these techniques and tricks to try to keep ourselves afloat.

Enlightenment is commonly believed to be a state of "all-knowing," whereas surrender is relinquishing oneself into the *unknown*. One senior student describes surrender as "devastation, annihilation, utterly and totally disappearing." One cannot surrender oneself, but can only *be* surrendered by a greater force.

Llewellyn Vaughan-Lee shares a moving account of his own relationship with God, hinting at the possibility of surrender and "not being."

*A final and complete loss-of-self is not achieved by ecstasy, spiritual marriage, or by any such comparable experience, but rather by years of such selfless living that, without satisfaction accruing to the self, the self must die.*

BERNADETTE ROBERTS

To me, this is what mysticism is about. You have a relationship with God that is more and more part of your life until there comes a time when you can't imagine what it's like not to have relationship with God. How do people live? On what basis do they make decisions when all that matters is to be of service to your Beloved? To be available to your Beloved? Sometimes He graces you with what the Sufis call states of nearness, when you are near to him, and your heart is soft, and there is tremendous love and tremendous intimacy, and moments of oneness, and moments of bliss, and moments of not being.

*He who does not know about service knows even less about Mastership.*

TIRMIZI

In the end, you know, it is such a relief not to be. You can finally relax when you go into that space when you are not, when you take off the clothes of this world that are so burden-some—the burden of your own identity and of what people project onto you and all of that. You can step outside of that and just dissolve, not be. It is such a relief. It is such a burden to have to carry this identity around with you all the time, to prove yourself, and all of the games that people play. It is such a relief just to be empty, to be nothing, to be lost in God.

When one finally gives up one's futile attempts to make reality conform to one's own wishes, and allows it to unfold on its own terms, all the energy that was tied up in foolish attempts to manipulate the universe is freed up. If the giving up is partial or shallow, one may end up simply content or smug, but if the surrender is deep, there is noth-ing left to do but to serve others from the fullness of oneself. Mahatma Gandhi said that when people die to themselves, they immediately find themselves at the service of all living things.[24]

A beautiful example of this principle is seen in the life of Zen mas-ter John Daido Loori, recounted by Danan Henry.

At one point, the son of Daido Loori, a great Zen teacher, was diagnosed as having severe brain damage. Daido Loori was devastated. When he walked into dokusan with his teacher,

he was in a lot of turmoil and self-pity. But that quickly changed. He told me: "I don't even remember what Maezumi Roshi said. He just started screaming and yelling at me and putting me down. All I know is that when I walked out of there, I was ready. I was aroused like a lion and was ready to do whatever I had to in order to help my son, to accept it if he died, and to accept and provide for him for the rest of his life is he were a vegetable. That was his gift to me."

Surrender and service are closely linked. Those who are surrendered serve. The Reality they are surrendered to, either directly or through the lineage of masters before them, cannot do anything but serve, and thus they too must serve. A life of service to others is one evidence of abiding enlightenment, but may take many forms, including serving one's family and children, and should not be judged superficially. When the renowned Zen teacher Issan Dorsey said that being a true Bodhisattva is nothing more than being an impeccable housewife, he was intentionally broadening his students' scope of the possibility of service. Service is much broader than counseling, teaching, or feeding the poor. It is all the actions that are the natural outcome of enlightenment, of surrender.

Charles Tart shares a story that was told to him by the Tibetan teacher Sogyal Rinpoche, who was once the translator for the Dalai Lama. The Dalai Lama said that he would really like to have time off to go on lots of meditation retreats and to practice and to become an enlightened person, but that obviously he didn't have time to, as he had all the work of being the Dalai Lama. But then he thought, "If I did get enlightened, I'd spend all my time working to help other sentient beings be happier. And what am I doing now? I am spending all my time working to help other sentient beings be happier. So I guess it's not important to get enlightened."

"I don't give a flip about enlightenment," shares a longtime devotee. "That's not what I really want. I want to serve—that's who I want to be." The Bodhisattva vow is traditionally the vow to forego one's own enlightenment until all sentient beings have been saved, but

*Our problem is that we don't want to surrender what we can surrender, and we do want to surrender what we can't surrender.*

DANIEL MORAN

Judith Leif says that a radical interpretation of the vow is "renouncing the whole notion of enlightenment as any kind of clinging to individual salvation as separate from the interdependent web of the whole enchilada." In other words, if one is not ultimately separate from anyone else, then there can be no personal salvation until all sentient beings have been saved. It is all or none.

Joan Halifax sees her own path as the path of service.

> I go to the Zendo several times a day, and I sit sesshin and all that, but really where I learn most truly is by going to where suffering is deep and not experiencing myself as separate from those who are suffering. And if I do see myself as separate, which of course I do frequently, my practice is being aware of that and seeing why my fear is present in the situation.

Service is the direct outpouring of surrender, or "the unitive condition" in Bernadette Roberts's terms. She says that the unitive condition engenders such immense love and generosity that "this love is too great to be kept within or solely for oneself" and that it naturally moves out to embrace all of existence.

*Sahaja means literally "together born" or "coemergent." It signifies the idea that freedom is not external to us but our very condition; that the phenomenal reality (samsara) arises simultaneously with, and within, the transcendental Reality (nirvana); and that the conditional mind and enlightenment are not mutually exclusive principles.*

ENCYCLOPEDIC
DICTIONARY OF YOGA

> This love finds no outlet for its energies in the mere enjoyment of transient beatific experiences. In fact, so great is this love, it would sacrifice heaven in order to prove and test its love for the divine in the world.[25]

Bodhisattvas, the true servants of God, are born from their surrender. They have dared to not stop even at enlightenment in their movement toward the fulfillment of the highest possibility for their existence.

## Sahaja: The Natural State

Sahaja is the natural state. A life of service and surrender *is* the natural state. That which the term "enlightenment" points to *is* the

## REB ZALMAN: TO DO KRISHNA'S WORK

*There's a lovely story that comes from Hinduism. A man comes to Krishna and says, "Lord Krishna, who is your best devotee?" The man figured that he was, because the whole day he kept saying: "Hari Rama, Hari Krishna," and because he thought of Krishna all the time.*

*Krishna answers: "The guy down the road."*

*So the man goes and checks out the guy down the road, and watches him. This guy gets up in the morning and says, "Good morning, Lord Krishna," and he goes to bed at night and says, "Goodnight, Lord Krishna."*

*The man thinks: "Krishna says he's the best devotee. How do you figure that?"*

*So he goes back to Lord Krishna and says, "Lord Krishna, why do you say that this person is the best devotee of yours? I chant your name all the time, and all he does is say, 'Good morning, good night.'"*

*So Krishna says to him, "Fill up a glass of water." The man does it right away. Krishna then tells him, "Now I want you to run around the table as fast as you can seven times without spilling a drop of water."*

*"Yes!" the man says, and he runs around, runs around, and comes back to Krishna and says, "Yes, I've done it!"*

*Lord Krishna then asks, "How many times did you chant my praises?"*

*The man says, "Lord Krishna, I was so busy doing what you told me to do."*

*"Ah ha, see that?" says Krishna. "This guy wakes up in the morning, goes to bed in the evening, and the rest of the time he is busy doing Krishna's work."*

natural state. Enlightened duality *is* the organic state of being. "Sahaja" represents a relationship to life which is easeful and natural.

In *Obscure Religious Cults*, Shashibhusan Das Gupta refers to sahaja as "of the nature of supreme love,"[26] and as "an intuition of the whole, the one underlying reality pervading and permeating all diversity."[27] He quotes the *Sahara-pada*:

> Sahaja cannot be heard with the ears, neither can it be seen with the eyes; it is not affected by air nor burnt by fire; it is not wet in intense rain, it neither increases nor decreases, it neither exists nor does it die out with the decay of the body; the Sahaja bliss is only a oneness of emotions,—it is oneness in all.[28]

*Finally, everything that we've said here is just the bubble that pops, and all that remains is just to be here at one with the here and now, with one's self in a clean way, and be open to the whole, without asking ourselves whether this gives us pleasure or not—simply being one.*

DANIEL MORAN

Georg Feuerstein says that *sahaja-samadhi* is equivalent to "liberation while being alive"; and that the yogin who lives in *sahaja-samadhi* "lives as it were in both worlds (the dimension of unqualified existence and the dimension of relativity)."[29] Lee Lozowick describes *sahaja-samadhi* as "open-eyed satori, in which satori is every moment and not just a blast of clarity during a retreat." Sahaja is living liberation: where all realities meet in human form, on the earth, living the Absolute, natural state, which is also the most uncommon experience known to human beings.

The question then arises: If sahaja is the natural state, what is everything else? Everything else is not what it appears to be, including enlightenment and mystical experiences. Everything else is the play of ego, the great illusion of separation and the workings of karma that give continual rise to human suffering. Sahaja is the state of one who is truly human, freed from the entanglements of one's own greed, selfishness, hatred, confusion.

Everything that is not sahaja is an altered state—an "experience" outside the domain of ordinary reality. When we run about from teacher to seminar to fancy technique, what we are really asking for is a more *pleasant* altered state, when the one thing we should be asking for is the natural state, free from all alterations, buffers, deception,

manipulation. Enlightenment is a non-altered state—it is living right here, in life, as it is.

Sahaja, the perfected state we all dream of, appears to be an "altered" state precisely because it is different from anything that we have consciously known. Those who have found their way there, even for moments, experience it as tremendously altered from the reality they have known, but also strangely familiar, right, and natural. What they are recognizing is their own organic innocence, the Reality that is always present beneath the many veils of illusion. Those who abide in sahaja also say that the extraordinariness quickly turns to ordinariness. Because it is such a natural state—in fact the *only* natural state —it takes only a period of acclimation to experience sahaja as that which is already true of oneself. Jakusho Kwong Roshi says, "It becomes more ordinary. In the beginning it's a big experience, but when you have many experiences of it, it becomes ordinary, everyday." Bernadette Roberts concurs.

> In itself this new consciousness is not spectacular, it is only in contrast with our former consciousness or self that we know it as a more mature state or level of consciousness . . . From the position of egoic consciousness, unitive consciousness always appears to be quite supernatural, mystical or nirvanic, but once we get there, it turns out to be utterly ordinary.[30]

"It is very hard to understand," says Ram Dass, "that spiritual freedom is ordinary, nothing special, and that this ordinariness is what is so precious about it."[31]

Those of us who proclaim our longing for enlightenment often long for everything but the very thing that would truly fulfill us. We chase our own tails and complain that we aren't getting anywhere while doing all we can to avoid the annihilation that is necessary to bring us to our rightful place. We exhaust ourselves with our search— which is the design and purpose of the search—until we see clearly the price we must pay for that which we claim to desire so intensely. Once we see it, we either pay it, or we do not.

*The work is very basic and natural—not about these great pillars of light exploding in your mind, walking on water, raising the dead. Raising yourself is enough, without worrying about the dead!*

LEE LOZOWICK

## The Price

The price for what is being spoken of in this final chapter; the price for the possibility of "no top end"—for an infinite expansion into the absolute highest possibility for human existence on this earth; the price for clarity, for the ability to be kind, generous, compassionate—a real human being capable of serving and loving; the price of *sahaja*—is no less than *everything*. Absolutely everything.

The surrender that is demanded is exactly that: the complete abandonment of our entire identity, everything we know to be true about ourselves and our world, all of our emotional attachments. *Everything* must be given over, even if it is then given back. "You have to risk everything," says Robert Hall, "even who you think you are—most of all who you think you are." Everything must be given, and as Jeanne de Salzman says, it must be paid in advance to have even the possibility of receiving the Great Gift, although even then there are no guarantees.

*Your attitude toward the world and toward life is the attitude of one who has the right to make demands and to take, who has no need to pay or to earn. You believe that all these things are due, simply because it is you! All your blindness is there!*

JEANNE DE SALZMANN

One pays with oneself. Mahatma Gandhi says, "God demands nothing less than complete self-surrender as the price for the only freedom that is worth having."[32] To surrender oneself entirely means that the individual that one "knows" oneself to be will not be there when the great prize comes in. The prize is freedom from the limitations of ego, but ego can no longer be there to enjoy its own freedom. This is God's great play: The one who signs up for the spiritual journey does not get to complete it, and one cannot *really* understand this until the moment that it has become true of them.

"To live in the simplest strata of yourself," says Llewellyn Vaughan-Lee, "costs no less than everything. One must learn to live in a state of tremendous vulnerability, a vulnerability that many people cannot cope with, in order to live the true mystical life."

In *The Way of Transformation*, Karlfried von Dürkheim writes:

Only to the extent that man exposes himself over and over again to annihilation, can that which is indestructible arise within him. In this lies the dignity of daring . . . Only if we

venture repeatedly through zones of annihilation can our contact with Diving Being, which is beyond annihilation, become firm and stable. The more a man learns wholeheartedly to confront the world which threatens him with isolation, the more are the depths of the Ground of Being revealed and the possibilities of new life and Becoming opened.[33]

Most people either cannot, or will not, pay the price for the gift they have requested. It is the ultimate risk, and the stakes are too high. Andrew Cohen writes:

> So few seem to have the willingness to abandon absolutely every and all thought formation and subtle concept in the pursuit of that Perfect understanding. It is so easy to get stuck even in imperfect Enlightenment. It may indeed be that one's very life, as one has known it, may need to be questioned in its every aspect to such an extraordinary degree that it may literally dissolve into emptiness before one's very eyes—if one truly wants to go ALL THE WAY.[34]

Everyone wants to be enlightened, but no one wants to pay. They don't want to pay *anything*, much less *everything*—save perhaps an hour of meditation in the morning and refraining from a bad habit or two. Thus they wander the spiritual circuit for twenty years complaining of disillusionment, giving up on spiritual teachers who ask too much and give too little, writing off their once-true aspirations for fulfillment, while never realizing that it is they themselves who will not give. Georg Feuerstein writes, "Typical seekers come to spiritual life and the teacher with open hands but a closed heart, expecting to be given something without giving something (i.e., themselves) in return."[35]

The other great play of God in the spiritual bargain is that once you receive the Great Gift you cannot keep it for yourself. In order to keep expanding into ever higher possibility, you are obliged to give and give and give—the way the Bodhisattva gives, the way one gives who cannot hold onto anything because their hands are so hot and

*How can you overcome your weakness if you don't have the will to overcome your weakness? I will give you an answer to that question too: you must love the Work more than you love your own life.*

E.J. GOLD

their heart is so full that they would burn the gift to pieces if they did not give it away.

Jai Ram Smith describes how E.J. Gold instilled into his students' conscience the responsibility of giving and serving that awakening implies, should one happen to be graced with this gift.

*You must pay dearly . . . pay a lot, and pay immediately, pay in advance. Pay with yourself. By sincere, conscientious, disinterested efforts. The more you are prepared to pay without economizing, without cheating, without any falsification, the more you will receive . . .*

JEANNE DE SALZMANN

Part of the way E.J. taught was to temper one's enthusiasm to be in the awakened state with the knowledge of the corresponding responsibility of what it means to be given this gift, and the conscience to know what it was for. Because once an individual awakens in this way, there should be an immediate turning toward one's responsibility in relationship to existence. E.J. called this responsibility "The Work."

In other words, you can't get the prize. Imagine it this way: You're working to win the lottery. You have a very strong intention to win. But you are going to give all the money from the lottery to a noble charity. You're not going to keep one dime for yourself. Do you see how that changes the structure of your mood toward winning? You are still paying for it out of your own pocket, you are still taking the time to go down and get the ticket, but you aren't going to take a dime. If you can get an image of what that feels like, you can begin to understand how E.J. worked with this. He let you know ahead of time that you were never going to take a dime for yourself. You were going to invest everything you wanted from this experience for the benefit of others.

One has to choose this option. There has to be the choice. But if your conscience is developed, then it's the choiceless choice. Once you have an objective grasp on things, you don't have any other real choice. If you tried to make another choice, you would be going against something so strong that you would wish you had never tried. By the time you got access to the awakened state, you couldn't party with it. You couldn't use it for your own self-aggrandizement. You had to use it to serve.

Smith's description provides an immediate illustration of what it means to be asked to give everything and to keep nothing, and to even pay with one's very life to be able to give in this way. Gold himself emphasized this point in an interview with *Gnosis* magazine.

There's the kind of school where you arrive saying, "What can I get?" or "How is this any good for me?" You see, I had workshops—I figure I must have had 20,000 people through my workshops in 37 years. Most of the people asked, "What is this going to do for me?"

My answer is always the same. "This is not for you; it's not for your benefit; you're not supposed to get anything out of this at all. If you do, you'll be very fortunate, because I never have. All you do is give. That's the whole thing. You just give and give and give. And it costs you to give. You even have to pay to give. And in the end you have nothing. Just nothing. Now if you can handle that, you belong here."[36]

*You will see that in life you receive exactly what you give.*
JEANNE DE SALZMANN

This is the price for the real spiritual life. It is a far call from the fantasies of those who seek out enlightenment for power, recognition, or to be free of their own suffering. The real spiritual life is nothing anybody ever spoke of. It is something that those who go to church or synagogue or even meditation retreats for a whole lifetime may never discover in the lines of the sacred texts. And of those who do dare to read of it, most are either so disturbed that they refuse to think about it and quickly dismiss it, or assume—mistakenly—they know what it means and likewise quickly dismiss it. There are also those who do have a sense of what true spiritual life is and, through the strength of their own self-honesty, admit that it is too much for them to bear, yet respect those who are willing to submit to such a life.

Enlightenment is not what it was ever imagined to be by the ego. It is nothing, non-existent, an empty term used by those who aspire toward something beyond the ordinary while those who are truly liberated simply encourage others to live deeply and fully and with compassion in this moment. *Sahaja* is the perfected reality which is the

birthright of everyone, the only natural state—the "pearl of great price" that costs no less than one's very life. This is the real spiritual life: the life of total annihilation and the return to just what is.

# Endnotes

## Introduction

1. Carl Jung, *The Portable Jung*, ed. Joseph Campbell (New York: Penguin Books, 1971), 473.

## Chapter One - Presuming Enlightenment Before Its Time

1. Philip Kapleau, *Zen: Dawn in the West* (New York: Doubleday, Anchor Press, 1978), 87.
2. In this volume, the terms "teacher" and "master" are used somewhat interchangeably to describe respected spiritual leaders of our time, although the term "master" is used only in association with those individuals whose teaching expertise is widely regarded as demonstrating a very high degree of attainment.
3. Georg Feuerstein, *Holy Madness* (New York: Paragon House, 1990), 193.
4. Kapleau, *Zen: Dawn in the West*, 86-87.

5. Lama Thubten Yeshe, *The Tantric Path of Purification* (Boston, Mass.: Wisdom Publications, 1995), 9.

6. Georg Feuerstein, "To Light a Candle in a Dark Age," *What Is Enlightenment?* 12 (fall/winter 1997): 37-8.

7. Robert Jay Lifton, "From Mysticism to Murder," *Tricycle* (winter 1997): 54-59.

8. Ken Wilber, "The Spectrum Model," in *Spiritual Choices: The Problems of Recognizing Authentic Paths to Inner Transformation* (New York: Paragon House Publishers, 1987), 257.

9. Andrew Rawlinson, *The Book of Enlightened Masters* (Chicago, Ill.: Open Court, 1997), 218.

10. Andrew Cohen, "A Crisis of Trust," *What Is Enlightenment?* 5 (spring/summer 1996): 31.

## Chapter Two - What Is Enlightenment Anyway?

1. Andrew Cohen, *An Unconditional Relationship to Life* (Larkspur, Calif.: Moksha Foundation, 1995), 45.

2. The terms "enlightenment," "awakening," and in some cases "liberation" are used interchangeably throughout this book. Although for most people who use these terms there are slight variances in meaning, there is nothing close to a uniform understanding among individual spiritual schools and teachers, rendering it impossible to define their subtleties of meaning when collectively considering input from such a broad range of spiritual teachers and teachings.

3. Mahasi Sayadaw, *The Progress of Insight: A Treatise on Buddhist Satipatthana Meditation*,  English trans. by Nyanaponika Thera (Kandy, Ceylong: The Forest Hermitage, 1965), 26.

4. Chogyam Trungpa, *Cutting Through Spiritual Materialism* (Boston: Shambhala, 1973), 121-122.

5. Ibid.

6. Charlotte Joko Beck, *Everyday Zen: Love and Work* (San Francisco: Harper & Row, Perennial Library, 1989), 188.

7. Feuerstein, *Holy Madness*, 215.

8. Georg Feuerstein, *Encyclopedic Dictionary of Yoga* (New York: Paragon House, 1990), 109.
9. Lee Sanella, *The Kundalini Experience* (Lower Lake, Calif.: Integral Publishing, 1987), 18.
10. Andrew Cohen, "Two Dialogues on Impersonal Enlightenment," *What Is Enlightenment?* 1, no. 1 (January 1992): 6-7.
11. Andrew Cohen, *Enlightenment Is a Secret* (Corte Madera, Calif.: Moksha Foundation, 1991) 260; 263.
12. Andrew Cohen, "Enlightenment Is Neutral: A Dialogue," *What Is Enlightenment?* 1, no. 2 (July 1992): 8.
13. Philip Kapleau, *Awakening to Zen: The Teachings of Philip Kapleau* (New York: Scribner, 1997), 135.
14. Beck, *Everyday Zen*, 173.
15. Chogyam Trungpa, *Meditation in Action* (Boulder, Colo.: 1969), 16.
16. Kapleau, *Awakening to Zen*, 173.
17. E.J. Gold, "All That Glitters: An Interview with E.J. Gold & Co.," *Gnosis*, no. 47 (spring 1998): 61.

## Chapter Three - Motivations for Seeking Enlightenment

1. Bubba Free John, *The Method of the Siddhas* (Middletown, Calif.: Dawn Horse Press, 1978), 137.
2. Bubba Free John has many names, including Da Free John, Da Love Ananda and, currently, Adi Da.
3. Trungpa, *Cutting Through Spiritual Materialism*, 69-70.
4. Andrew Cohen, unpublished meeting, March 13, 1998.
5. Feuerstein, *Holy Madness*, 106.
6. Charles Tart, *Waking Up* (Boston, Mass.: Shambhala, 1986), 172-3.

## Chapter Four - The Beneficial Role of Ego

1. Trungpa, *Cutting Through Spiritual Materialism*, 153.
2. Feuerstein, *Holy Madness*, xxi-xxii.

3. C. G. Jung, *Memories, Dreams, Reflections* (New York: Vintage Books, 1961), 297.

## Chapter Five - Mystical Experiences and Their Relationship to Ego

1. William James, in *Spiritual Emergency* (Los Angeles, Calif: Jeremy P. Tarcher, 1989), 109.
2. C. W. Leadbeater, *The Chakras* (Wheaton, Ill.: The Theosophical Publishing House, 1927, 1985 [Fourth Quest Book]), 115-6.
3. Irina Tweedie, "A Sufi Should Never Give a Bad Example," *What Is Enlightenment?* 1, no. 1 (January 1992): 9.
4. Jack Kornfield, A *Path with Heart: A Guide Through the Perils and Promises of Spiritual Life* (New York: Bantam, 1993), 129.
5. Ibid., 123.
6. Kapleau, *Zen: Dawn in the West*, 85-6.
7. Ram Dass, "The Roundtable with Ram Dass, Joan Halifax, Robert Aitken, Richard Baker," *Tricycle* (fall 1996): 102.
8. Aldous Huxley, *The Doors of Perception* (New York: Harper & Row, 1970), 73.
9. Rick Fields, "A High History of Buddhism," *Tricycle* (fall, 1996): 50-52.
10. Jack Kornfield, "Domains of Consciousness: An Interview with Jack Kornfield," *Tricycle* (fall 1996): 37.
11. Feuerstein, *Holy Madness*, 138.
12. Kapleau, *Awakening to Zen*, 57.
13. Quote from an unpublished talk by Da Love-Ananda [currently Adi Da] on July 8, 1978, in *The Kundalini Experience* (Lower Lake, Calif.: Integral Publishing, 1987), 122.
14. Kapleau, *Zen: Dawn in the West*, 56-7.
15. Frances Vaughan, "A Question of Balance: Health and Pathology in New Religious Movements," in *Spiritual Choices*, 272.
16. Kapleau, *Zen: Dawn in the West*, 57.

## Chapter Six - Perspectives on the Value of Mystical Experience

1. Evelyn Underhill, *Mysticism* (London: Lower & Brydone, 1967), 269.
2. St. John of the Cross, in *Zen and Zen Classics* (New York, Vintage Books, 1978), 73.
3. Llewellyn Vaughan-Lee, *The Face Before I Was Born* (Inverness, Calif.: The Golden Sufi Center, 1998), 279-80.
4. Rawlinson, The Book of Enlightened Masters, 184.
5. Bernadette Roberts, *What Is Self?* (Austin, Tex.: Mary Botsford Goens, 1989), 34-5.
6. Philip Kapleau, *The Three Pillars of Zen*, 25th ed. (New York: Doubleday, 1989), 200.
7. Kornfield, *A Path with Heart*, 129.
8. Cohen, *Enlightenment Is a Secret*, 204.
9. Beck, *Everyday Zen*, 170.
10. Rawlinson, *The Book of Enlightened Masters*, 171.

## Section Two - Dangers of Mystical Experience

1. Blaise Pascal, in *The Ascent to Truth* ( New York: The Viking Press, 1951), 110.

## Chapter Seven - Spiritual Emergency

1. The Spiritual Emergence Network (SEN) is a worldwide organization that supports individuals in spiritual crises, provides them with information that gives them a new understanding of their process, and advises them on available alternatives to traditional treatment. SEN can be contacted at (415)648-2610.
2. Stanislav and Christina Grof, *Spiritual Emergency: When Personal Transformation Becomes a Crisis* (Los Angeles, Calif.: Jeremy P. Tarcher, 1989), 13-14.

3. Roberto Assagioli, "Self-Realization and Psychological Disturbances," in *Spiritual Emergency: When Personal Transformation Becomes a Crisis* (Los Angeles, Calif.: Jeremy P. Tarcher, 1989), 34-35.
4. Vaughan-Lee, *The Face Before I Was Born*, 11-14.
5. Leadbeater, *The Chakras*, 81.
6. Letter to the editor, *What Is Enlightenment?* 2, no. 1 (January 1993): 5.
7. Sanella, *The Kundalini Experience*, 121.
8. Ibid.
9. Grof, *Spiritual Emergency*, 192.

## Chapter Eight - Spiritual Materialism

1. St. John of the Cross, *Dark Night of the Soul*, ed. Allison Peers (New York: Doubleday, Image Books, 1959), 44.
2. Chogyam Trungpa, *Journey Without Goal* (Boulder, Colo. and London: Prajna Press, 1981), 89.
3. Ibid.
4. Kapleau, *Zen: Dawn in the West*, 48.
5. Trungpa, *Cutting Through Spiritual Materialism*, 63.
6. Ibid., 7.
7. Ibid., 13.
8. Kornfield, *A Path with Heart*, 190-91.

## Chapter Nine - Getting Stuck: The Spiritual Cul-de-Sac

1. John Pentland, *Exchanges Within* (New York: The Continuum Publishing Company, 1997), 34.
2. Ram Dass, "Promises and Pitfalls of the Spiritual Path," in *Spiritual Emergency*, 180.
3. John Groff, "The Sufi and the Zen Master," *Gnosis*, no. 47 (spring, 1998): 38.
4. Tweedie, "A Sufi Should Never Give a Bad Example," 9
5. Trungpa, *Cutting Through Spiritual Materialism*, 65-6.

6.  Ibid., 67.

7.  Kornfield, *A Path with Heart*, 154.

8.  Trungpa, *Cutting Through Spiritual Materialism*, 70-1.

9.  Ibid., 66.

10. Cohen, *An Unconditional Relationship to Life*, 48.

11. Grof, *Spiritual Emergency*, 39-41.

12. Trungpa, *Cutting Through Spiritual Materialism*, 67-8.

13. Kornfield, *A Path with Heart*, 147.

14. Cohen, *Enlightenment Is a Secret*, 251.

15. Kapleau, *Three Pillars of Zen*, 41.

16. Kapleau, *Awakening to Zen*, 133.

17. Ibid., 132.

18. Kapleau, *Three Pillars of Zen*, 41-43.

19. Ibid.

20. Ibid., 43-4.

21. Ibid., 106-7.

22. Ibid., 108.

23. Kapleau, *Zen: Dawn in the West*, 98.

24. Ibid., 99.

25. Andrew Cohen, "Come Together: Who Has the Courage to Stand Alone/Together in the Truth?" *What Is Enlightenment?* 2, no.2 (July 1994): 4.

26. Cohen, *Enlightenment Is a Secret*, vii.

27. Andrew Cohen, "Personal Enlightenment vs. Impersonal Enlightenment," *What Is Enlightenment?* 2, no. 1 (January 1993), 10.

28. Meher Baba, quoted in *The Wayfarers* (Maharashtra, India: Adi K. Irani, 1948), 3

29. Ibid., 8-10.

30. Ibid., 146.

31. Records of these visits can be found in *The Wayfarers*, by William Donkin, and stories about Meher Baba's work with the masts are included in various books about the teachings of Meher Baba.

## Chapter Ten - Ego Inflation

1. Bhadantacariya Buddhagosa, *The Path of Purification [Visuddhimagga]* (Boston, Mass.: Shambhala, 1976), 740.
2. Jung, *The Portable Jung*, 104.
3. Ibid.
4. Rosenthal, "Inflated by the Spirit," in *Spiritual Choices*, 307.
5. Kramer and Alstad, *The Guru Papers*, 112.
6. St. John of the Cross, *Dark Night of the Soul*, 40-1.
7. Kramer and Alstad, *The Guru Papers*, 111.
8. Jung, *Memories, Dreams, Reflections*, 347.
9. Vaughan-Lee, *The Bond with the Beloved*, 20-1.
10. Ken Wilber, *The Atman Project* (Wheaton, Ill.: Theosophical Publishing House, 1980), 102-3.
11. Claudio Naranjo, "An Interview with Claudio Naranjo," in *Spiritual Choices*, 205.
12. Jacob Needleman, "When Is Religion Transformative?" in *Spiritual Choices*, 333.
13. Roberto Assagioli, "Self-Realization and Psychological Disturbances," in *Spiritual Emergency*, 35-6.
14. Jung, *The Portable Jung*, 87.
15. Rosenthal, "Inflated by the Spirit," 317.
16. Jung, *The Portable Jung*, 104.
17. Rosenthal, "Inflated by the Spirit," 317.
18. Jolande Jacobi, *The Psychology of C. G. Jung* (New Haven, Conn. and London: Yale University Press, 1973), 126.
19. Rosenthal, "Inflated by the Spirit," 311.
20. Naranjo, "An Interview with Claudio Naranjo," 204-205.

## Chapter Eleven - The "Inner Guru" and Other Spiritual Truisms

1. St. John of the Cross, in *Mysticism*, 449.
2. Feuerstein, *Holy Madness*, 127-8.

3. Ibid., 129.
4. Vaughan-Lee, *The Bond with the Beloved*, 109.
5. B.R., "The 'Advaita Shuffle,' Part 1: The Perils of the 'Advaita Shuffle' or These Days, Is the Absolute View Used As an Excuse to Avoid Waking Up Fully?" *What Is Enlightenment?* 1, no. 1 (January 1992): 12.
6. Ibid.
7. Andrew Cohen, public talk with Lee Lozowick, Boulder, Colo.: March 13, 1998.

## Chapter Twelve - Power and Corruption

1. Bernadette Roberts, *The Path to No Self* (Albany, N.Y.: State University of New York Press, 1991), 174.
2. Kramer and Alstad, *The Guru Papers*, 12.
3. Ibid., 18.
4. Ibid., 106.
5. Cohen, "Enlightenment Is Neutral," 8.
6. Vaughan, in *Spiritual Choices*, 272-273.
7. Naranjo, "Interview with Claudio Naranjo," in *Spiritual Choices*, 206.
8. Kramer and Alstad, *The Guru Papers*, 107.
9. Unpublished meeting between Andrew Cohen and Lee Lozowick, Boulder, Colo.: March 13, 1998.
10. Andrew Cohen, "Corruption, Purity and Enlightenment," *What Is Enlightenment?* 1, no.2 (July 1992): 1.

## Chapter Thirteen - Mutual Complicity

1. Letter to the editor, *What Is Enlightenment?* 2, no. 1 (January 1993): 5.
2. Jung, *The Portable Jung*, 147.
3. Kornfield, *A Path with Heart*, 255.
4. Jung, *The Portable Jung*, 120.

5.  Trungpa, *Cutting Through Spiritual Materialism*, 27.
6.  Andrew Cohen, "Spiritual Slavery and Prostitution of the Soul," *What Is Enlightenment?* 1, no. 2 (July 1992): 9.
7.  Cohen, "Corruption, Purity and Enlightenment," 1.

## Chapter Fourteen - The Consequences of Assuming a Teaching Function Before One Is Prepared

1.  Thomas Merton, in *A Path with Heart*, 268.
2.  Roberts, *The Path to No-Self*, 206.
3.  Kornfield, *A Path with Heart*, 161.
4.  Andrew Cohen, *Autobiography of an Awakening* (Lenox, Mass.: Moksha Foundation, 1992), 84-5.
5.  The Aghori Vimalananda, in *Aghora III: The Law of Karma* (Albuquerque, N. Mex.: Brotherhood of Life, 1997), 311.
6.  Cohen, *Autobiography of an Awakening*, 107.
7.  Robert Svoboda, *Aghora III: The Law of Karma* (Albuquerque, N.Mex.: Brotherhood of Life, 1997), 103.

## Section Four - Navigating the Minefield: Preventing Dangers on the Path

1.  John Wu, *The Golden Age of Zen* (New York: Doubleday, Image Books, 1996), 202.

## Chapter Fifteen - The Three Jewels

1.  Vaughan-Lee, *The Face Before I Was Born*, 37.
2.  Kapleau, *Zen: Dawn in the West*, 63.
3.  Feuerstein, *Holy Madness*, 112.
4.  Yeshe, *The Tantric Path of Purification*, 16.

## Chapter Sixteen - Testing Enlightenment

1. Kapleau, *Awakening to Zen*, 133.
2. John Welwood, "On Spiritual Authority," in *Spiritual Choices*, 290.
3. Kapleau, *Awakening to Zen*, 133.
4. Ibid., 162.
5. Ibid., 163.
6. Ibid., 162.
7. Svoboda, *Aghora III*, 262-3.
8. When Robert Svoboda asked Vimalananda if there was not karma involved in this testing, Vimalananda replied, "There is karma involved in every activity, but this karma was worth it to me to see that imposter unmasked. I do have certain advantages in this department (the advantages of knowing my own karmas and rnanubada-hanas), and I can assure you that he deserved what he got from me. Unless you know your runanubandhanas, though, and know how to negate your karmas, never try any stunts like this!" Svoboda said that Vimalananda was never afraid of suffering or causing others to suffer when he thought that it would be useful to teach somebody a lesson.
9. Ken Wilber, "The Case of Adi Da," Oct. 11, 1996. From *Ken Wilber Online* [a letter taken from the Ken Wilber Forum on Shambhala Website].
10. Gold, "All That Glitters," 62.

## Chapter Seventeen - Psychological Purification

1. Yeshe, *Tantric Path of Purification*, 5-6.
2. Kornfield, *A Path with Heart*, 249.
3. Ibid.
4. C.G. Jung, *Collected Works* (London: Routledge & Kegan Paul), vol. 13, para 335.
5. Beck, *Everyday Zen*, 38.
6. Chogyam Trungpa, *The Lion's Roar* (Boston, Mass.: Shambhala Publications, 1992), 186.

## Chapter Eighteen - Sadhana, Matrix, Integration, and Discrimination

1. Feuerstein, *Holy Madness*, 110.
2. Ken Wilber, *Eye to Eye: The Quest for the New Paradigm* (Boston, Mass.: Shambhala, 1990), 198-199.
3. Joko Beck, "Life's Not a Problem," *Tricycle* (summer 1998): 37.
4. Kornfield, "Domains of Consciousness," 36-7.
5. Beck, "Life's Not a Problem," 37.
6. C.B. Purdom, *The God-Man* (Crescent Beach, S.C.: Sheriar Press, 1964), 20-25
7. Bernadette Roberts, *The Experience of No-Self* (Albany, N.Y.: State University of New York Press, 1993), 12-13.
8. Kapleau, *Awakening to Zen*, 247-8.
9. Kapleau, *Three Pillars of Zen*, 200.
10. Ibid.
11. Cohen, "Corruption, Purity and Enlightenment," 6.
12. Trungpa, *Journey Without Goal*, 49.

## Chapter Nineteen - True Teacher—or False?

1. Jung, *The Portable Jung*, 119-20.
2. Needleman, "When Is Religion Transformative? 343.
3. Dick Anthony, Bruce Ecker, and Ken Wilber, *Spiritual Choices: The Problems of Recognizing Authentic Paths to Inner Transformation* (New York: Paragon House Publishers, 1987), 6.
4. Cohen, *An Unconditional Relationship to Life*, 48.
5. Vaughan, "A Question of Balance," 275.
6. Feuerstein, *Holy Madness*, 247.
7. Ibid.
8. Excerped from Arnaud Desjardins, "Am I a Disciple?" in *Death of a Dishonest Man* (Prescott, Ariz.: Hohm Press, 1998), 43-59.
9. Welwood, "On Spiritual Authority," 299-300.
10. Vaughan-Lee, *The Face Before I Was Born*, 36.

11. Svoboda, *Aghora III*, 175-6.
12. Welwood, "On Spiritual Authority," 293.
13. Anthony, Ecker and Wilber, *Spiritual Choices*, 343.
14. Cohen, *Enlightenment Is a Secret*, 112.
15. Feuerstein, *Holy Madness*, 144.
16. Kapleau, *Zen: Dawn in the West*, 31.
17. Chogyam Trungpa, *The Path Is the Goal* (Boston, Mass.: Shambhala, 1995), 143.
18. Cohen, "Spiritual Slavery," 9.
19. Feuerstein, *Holy Madness*, 143.
20. Vaughan, "A Question of Balance," 275.
21. Trungpa, *Journey Without Goal*, 52.
22. Trungpa, *Cutting Through Spiritual Materialism*, 17.
23. Kapleau, *Zen: Dawn in the West*, 30.

## Section Five - Disillusionment, Humility, and the Beginning of Spiritual Life

1. Underhill, *Mysticism*, 449.

## Chapter Twenty - The Sadhana of Disillusionment

1. Sazaki Roshi, in *Inside the Music: Conversations with Contemporary Musicians about Spirituality, Creativity, and Consciousness* (Boston, Mass.: Shambhala, 1997), 201.
2. Sanella, *The Kundalini Experience*, 63-65.
3. Ray Bradbury, in *A Path with Heart*, 230.
4. St. John of the Cross, *Dark Night of the Soul*, 164-166.
5. Naranjo, "An Interview with Claudio Naranjo," 200-201.
6. Lee Lozowick, *Poems of a Broken Heart* (Madras, India: Sister Nivedita Academy, 1993), iv.
7. Trungpa, *Cutting Through Spiritual Materialism*, 81.
8. St. John of the Cross, *Dark Night of the Soul*, 82.

9. Lozowick, *Poems of a Broken Heart*, iv.
10. Svoboda, *Aghora III*, 180.
11. St. John of the Cross, *Dark Night of the Soul*, 76-77.
12. Ibid., 62-63.
13. Vaughan, "A Question of Balance," 274.
14. Needleman, "When Is Religion Transformative?" 206.
15. Cohen, unpublished talk, San Rafael, Calif.: March, 1996.
16. Vaughan-Lee, *The Face Before I Was Born*, 295.
17. Feuerstein, *Holy Madness*, 160.
18. Cohen, *Enlightenment Is a Secret*, 247.
19. Pentland, *Exchanges Within*, 33.
20. Svoboda, *Aghora III*, 178.
21. Roberts, *The Path to No-Self*, 211-12.
22. Ram Dass, "A Ten-Year Perspective," in *Journal of Transpersonal Psychology* 14, no.2 (1982): 171–183.

## Chapter Twenty-one - Enlightenment Is Only the Beginning

1. Roberts, *What Is Self?* 30.
2. Kapleau, *Three Pillars of Zen*, 200-201.
3. Kapleau, *Zen: Dawn in the West*, 30.
4. Cohen, *Autobiography of an Awakening*, 56.
5. Kapleau, *Zen: Dawn in the West*, 31.
6. Roberts, *The Path to No Self*, 210-11.
7. Roberts, *What Is Self?* 30.
8. Rawlinson, *The Book of Enlightened Masters*, 355.
9. Kapleau, *Three Pillars of Zen*, 313.
10. Ibid.
11. Roberts, *What Is Self?* 29-30.
12. Beck, "Life's Not a Problem," 37.
13. B.R., "The Advaita Shuffle," 15.
14. Cohen, "The Paradox of the Fully Awakened Condition," *What Is Enlightenment?* 2, no. 1 (January 1993): 6-7.

15. Svoboda, *Aghora III*, 157-58.
16. E.J. Gold, *The Joy of Sacrifice* (Prescott, Ariz.: IDHHB and Hohm Press, 1978), 34-37.
17. Suzuki Roshi in *A Path with Heart*, 269.
18. Beck, "Life's Not a Problem," 37.
19. Anthony, Ecker and Wilber, *Spiritual Choices*, 116.
20. Irina Tweedie, *Daughter of Fire* (Inverness, Calif.: The Golden Sufi Center, 1986), 378-379.
21. Ibid.
22. Cohen, *Enlightenment Is a Secret*, 235.
23. Svoboda, *Aghora III*, 316.
24. Mahatma Gandhi, in *Spiritual Emergency*, 185.
25. Roberts, *What Is Self?* 35
26. Shahibhusan Das Gupta, *Obscure Religious Cults* (Calcutta, India: Firma K.L. Mukhopadhyay, 1969), 145.
27. Ibid., 83.
28. Ibid., 82.
29. Feuerstein, *Encyclopedic Dictionary of Yoga*, 297.
30. Roberts, *What Is Self?* 28.
31. Ram Dass, "Promise and Pitfalls of the Spiritual Path," 180.
32. Gandhi, in *Spiritual Emergency*, 185.
33. Karlfried von Dürkheim, *The Way of Transformation* (London and Boston, Mass.: Mandala Books, 1971, 1980), 82.
34. Cohen, *Autobiography of an Awakening*, 128.
35. Feuerstein, *Holy Madness*, 109.
36. Gold, "All That Glitters," 57-63.

# Bibliography and Recommended Reading

Aitken, Robert. *The Mind of Clover: Essays in Zen Buddhist Ethics.* Berkeley, Calif: North Point Press, 1984.

——. *A Zen Wave.* New York: Weatherhill, 1978.

Anthony, Dick, Bruce Ecker and Ken Wilber. *Spiritual Choices: The Problems of Recognizing Authentic Paths to Inner Transformation.* New York: Paragon House, 1987.

Beck, Charlotte Joko. *Everyday Zen: Love and Work.* San Francisco: Harper & Row, Perennial Library, 1989.

Blyth, R.H. *Zen and Zen Classics.* New York: Vintage Books, 1978.

Buddhaghosa, Bhadantacariya. *The Path of Purification* [*Visuddhimagga*]. Boston, Mass: Shambhala, 1976.

Cohen, Andrew. *Autobiography of an Awakening.* Lenox, Mass.: Moksha Foundation, 1992.

——. *Enlightenment Is a Secret.* Lenox, Mass.: Moksha Foundation, 1991.

——. *An Unconditional Relationship to Life.* Lenox, Mass.: Moksha Foundation, 1995.

Das Gupta, Shahibhusan. *Obscure Religious Cults*. Calcutta, India: Firma K.L. Mukhopadhyay, 1969.

De Ropp, Robert. *The Master Game: Pathways to Higher Consciousness Beyond the Drug Experience*. New York: Delacorte Press, 1968.

Desjardins, Arnaud. *The Jump into Life*. Prescott, Ariz.: Hohm Press, 1989.

———. *Toward the Fullness of Life*. Putney and Brattleboro, Vt.: Threshold Books, 1990.

Donkin, William. *The Wayfarers*. Maharashtra, India: Adi K. Irani, 1948.

Feuerstein, Georg. *Encyclopedic Dictionary of Yoga*. New York: Paragon House, 1990.

———. *Holy Madness*. New York: Paragon House, 1990.

Glassman, Bernard and Rick Fields. *Instructions to the Cook: A Zen Master's Lesson in Living a Life That Matters*. New York: Bell Power, 1996.

Gold, E.J. *The Joy of Sacrifice*. Prescott, Ariz.: IDHHB and Hohm Press, 1978.

Grof, Christina. *The Thirst for Wholeness*. San Francisco: HarperSan Francisco, 1993.

Grof, Stanislav and Christina. *Spiritual Emergency*. Los Angeles: Jeremy P. Tarcher, 1989.

———. *The Stormy Search for the Self*. Los Angeles: Jeremy P. Tarcher, 1990.

Halifax, Joan. *Shaman: The Wounded Healer*. New York: Crossroad, 1982.

———. *Shamanic Voices: A Survey of Visionary Narratives*. New York: Dutton, 1979.

Hixon, Lex. *Living Buddha Zen*. New York: Larson Publications, 1995.

Jacobi, Jolande. *The Psychology of C. G. Jung*. New Haven, Conn. and London: Yale University Press, 1973.

James, William. *Writings 1902-1910*. New York: Literary Classics of the United States, 1987.

Jung, C. G. *Memories, Dreams, Reflections*. New York: Vintage Books, 1961.

——. *The Portable Jung.* Joseph Campbell, ed. New York: Penguin Books, 1971.

Kapleau, Roshi Philip. *Awakening to Zen: The Teachings of Roshi Philip Kapleau.* New York: Scribner, 1997.

——. *The Three Pillars of Zen.* New York: Doubleday, 1980.

——. *Zen: Dawn in the West.* New York: Doubleday, Anchor Press, 1978.

Keen, Sam. *to a dancing god.* New York: Harper & Row, 1970.

Kennett, Jiyu. *Selling Water by the River: A Manual of Zen Training.* New York: Random House, Pantheon Books, 1972.

Koestler, Arthur. *The Lotus and the Robot.* New York: The Macmillan Company, 1961.

Kornfield, Jack. *A Path with Heart: A Guide Through the Perils and Promises of Spiritual Life.* New York: Bantam, 1993.

Kramer, Joel and Diane Alstad. *The Guru Papers: Masks of Authoritarian Power.* Berkeley, Calif.: Frog, 1993.

Leadbeater, C. W. *The Chakras.* Wheaton, Ill.: The Theosophical Publishing House, 1927, 1985 [Fourth Quest Book].

Lozowick, Lee. *The Alchemy of Transformation.* Prescott, Ariz.: Hohm Press, 1996.

——. *Death of a Dishonest Man: Poems and Prayers to Yogi Ramsuratkumar.* Prescott, Ariz.: Hohm Press, 1998.

——. *Hohm Sahaj Mandir Study Manual —Volumes I and II).* Prescott, Ariz.: Hohm Press, 1996.

——. *The Only Grace Is Loving God.* Prescott, Ariz.: Hohm Press, 1982.

Merton, Thomas. *Mystics and Zen Masters.* New York: Farrar, Straus and Giroux, 1967.

Naranjo, Claudio. *Enneatypes in Psychotherapy.* Prescott, Ariz.: Hohm Press, 1995.

——. *The Healing Journey.* New York: Pantheon Books, 1974.

——. *Transformation Through Insight.* Prescott, Ariz.: Hohm Press, 1997.

Needleman, Jacob and George Baker, eds. *Gurdjieff.* New York: Continuum, 1996.

Ornstein, Robert. *The Psychology of Consciousness*, 2d ed. New York: Harcourt Brace Jovanovich, 1977.

——. *The Roots of the Self: Unraveling the Mystery of Who We Are*. San Francisco: HarperSan Francisco, 1993.

Pentland, John. *Exchanges Within*. New York: The Continuum Publishing Company, 1997.

Purdom, C. B. *The God-Man*. Crescent Beach, S.C.: Sheriar Press, 1964.

Rawlinson, Andrew. *The Book of Enlightened Masters*. Chicago, Ill.: Open Court, 1997.

Roberts, Bernadette. *The Experience of No-Self*. Albany, N.Y.: State University of New York Press, 1993.

——. *The Path to No-Self*. Albany, N.Y.: State University of New York Press, 1991.

——. *What Is Self?* Austin, Tex.: Mary Botsford Goens, 1989.

Ross, Nancy Wilson. *The World of Zen*. New York: Random House, 1960.

Sanella, Lee. *The Kundalini Experience*. Lower Lake, Calif.: Integral Publishing, 1987.

Sayadaw, Mahasi. English transl. by Nyanaponika Thera. *The Progress of Insight: A Treatise on Buddhist Satipatthana Meditation*. Kandy, Ceylong: The Forest Hermitage, 1965.

Schachter-Shalomi, Zalman. *Fragments of a Future Scroll*. Germantown, Penn.: Leaves of Grass Press, Inc., 1975.

Schachter-Shalomi, Zalman and Ronald S. Miller. *From Age-ing to Sage-ing*. New York: Warner Books, 1995.

Schneider, David. *The Life and Work of Issan Dorsey*. Boston, Mass.: Shambhala Publications, 1993.

Schwartz, Howard. *The Dream Assembly: Tales of Rabbi Zalman Schachter-Shalomi*. Nevada City, Calif.: Gateways/IDDHB, 1989.

St. John of the Cross. *Dark Night of the Soul*. E. Allison Peers, ed. New York: Doubleday, Image Books, 1959.

Svoboda, Robert. *Aghora*. Albuquerque, N. Mex.: Brotherhood of Life Inc., 1986.

———. *Aghora II: Kundalini*. Albuquerque, N. Mex.: Brotherhood of Life Inc., 1993.

———. *Aghora III: The Law of Karma*. Albuquerque, N. Mex: Brotherhood of Life, 1997.

Tart, Charles. *Open Mind, Discriminating Mind*. San Francisco: Harper & Row, 1989.

———. *Transpersonal Psychologies*. New York: HarperSan Francisco, 1992.

———. *Waking Up: Overcoming the Obstacles to Human Potential*. Boston: Shambhala, 1986.

Trungpa, Chogyam. *Cutting Through Spiritual Materialism*. Boston: Shambhala, 1987.

———. *Journey Without Goal*. Boulder, Colo. and London: Prajna Press, 1981.

———. *The Lion's Roar: An Introduction to Tantra*. Boston: Shambhala, 1992.

———. *Meditation in Action*. Berkeley, Calif.: Shambhala, 1970.

———. *The Path Is the Goal*. Boston: Shambhala, 1995.

Tweedie, Irina. *Chasm of Fire*. Inverness, Calif.: The Golden Sufi Center, 1986.

———. *Daughter of Fire*. Inverness, Calif.: The Golden Sufi Center, 1986.

Underhill, Evelyn. *Mysticism*. London: Lower & Brydone, 1967.

Vaughan-Lee, Llewellyn. *The Bond with the Beloved*. Inverness, Calif.: The Golden Sufi Center, 1993.

———. *The Face Before I Was Born*. Inverness, Calif.: The Golden Sufi Center, 1998.

———. *The Paradoxes of Love*. Inverness, Calif.: The Golden Sufi Center, 1996.

Von Dürkheim, Karlfried. *The Way of Transformation*. London and Boston, Mass: Mandala Books, 1980.

Wilber, Ken. *The Eye of Spirit: An Integral Vision for a World Gone Slightly Mad*. Boston: Shambhala, 1997.

———. *Eye to Eye: The Quest for the New Paradigm*. Boston: Shambhala, 1996.

——. *No Boundary*. Boston, MA: Shambhala, 1985.

——. *The Spectrum of Consciousness*. Wheaton, Ill.: The Theosophical Publishing House, 1977.

——. *Up from Eden: A Transpersonal View of Human Evolution*. Boston: Shambhala, 1983.

Wilber, Ken, Jack Engler and Daniel P. Brown. *Transformations of Consciousness*. Boston: New Science Library, 1986.

Wu, John. *The Golden Age of Zen*. New York: Doubleday, Image Books, 1996.

Yeshe, Lama Thubten. *The Tantric Path of Purification*. Boston: Wisdom Publications, 1995.

# Index

## A

*abhidharma* (Buddhist psychology),
   363–64. *See also* psychology
*abisheka. See* transmission
Absolute, the, xx, 30, 60, 68,
   129, 181, 198, 211, 224, 279,
   325, 405
absorption, in God, 181
acceptance, 41
*acharya(s)*, 26, 346
addiction, spiritual, 133–38, 277–
   80. *See also* codependency
*adhikara*, 303, 305
Adi Da, 98
*Advaita* shuffle, 192
*Advaita-Vedanta*, 21, 37, 153,
   231–33, 489
aggression, 45
Aghori Baba's stick, 357–58
Aghori Vimalananda, *See*
   Vimalananda, Aghori
*ahamkara*, 129. *See also kundalini*

Aitken, Robert (Roshi), 427
alcohol/alcoholism, 138
Alpert, Dick (Richard), *See* Ram
   Dass
Alstad, Diane, 191, 193, 240, 243
Anandamayi Ma, 108, 229, 435
Applewhite, Marshall, xx, 132
Asahara, Shoko, 23
*ashram*, 273, 284
Assagioli, Roberto, 126–27, 199
*asuras*, 409–10, 472
attainment, 59, 241, 509
Aum Shinrikyo tragedy, 23
authority, spiritual, 256–57, 407–11
*avatar(a)*, 50, 345, 465, 509
awakening, 34, 96, 137, 140, 419,
   421, 466, 505, 520, 524n2.
   *See also* enlightenment; liber-
   ation
   corruption following an experi-
   ence of, 247–48

# B

Baker, Richard, 434
balance, 208
*bardos*, 453
Baul, 7
Beck, Charlotte Joko, 36, 115, 370, 386, 388, 493, 500
Beloved, 108, 194–95, 512
"Bench Swami," 40
Bennet, J.G., 110
Berkeley Zen Center, 16, 294
Bhai Sahib, 148, 392, 467, 490, 505, 506
*bhakti*, 103
bliss/rapture, 4, 86, 95, 113, 119, 134, 136–38, 157, 192, 362, 393
*Bodhisattva*, 497, 513, 514, 519
　vow, 513–14
Bradbury, Ray, 443
brain, 54, 55, 199
Buddha, 90–91, 102, 156, 313, 315–19, 321–22, 330, 463, 490. *See also* master(s); teacher(s)
　four noble truths of, 64, 448
Buddhism, 39, 66, 157, 158, 402, 450, 492
　American, 412
　in Japan, 24, 434
　Mahayana, 489
　Theravadan, 393
　Tibetan, 157–58, 184, 426
　Vajrayana, 119, 489
　Zen, 19, 169–75, 393. *See also* Zen

Buddhist practitioners, 325
Buddhist precepts, 377, 393
Buddhist psychology, 363–65
Budji Zen, 375
burnout
　corruption following, 248–49
　physical, 127–29

# C

Caplan, Mariana, xiv
Carlton, Hilda, 432
Castenada, Carlos, 47, 301
*The Chakras* (Leadbeater), 84, 128, 132–33
charisma, 82, 196–97, 266, 421, 423
charlatans, 9, 368, 413. *See also* false gurus; teacher(s), true/authentic *vs.* false/fake
Chevrier, Marie-Pierre, 65–66, 116, 133, 270–71, 273, 292–93, 343, 365, 388, 430, 431
Christianity, 377, 472
Clarke, Richard, 212
codependency, 264, 274, 283, 410
　in groups, 278
　mutual complicity as, 277–80
Cohen, Andrew, 33, 42–44, 46, 60–63, 68, 109–10, 112, 114–15, 131, 164, 168–69, 179–81, 199, 211–13, 232, 234, 245, 252–57, 274–75, 279, 287, 296–99, 306, 315, 361, 395, 404, 415–16, 419–20, 456–57, 464, 494–95, 519
comfort, spiritual, 175–80

commitment, 405, 430–31. *See also* devotion

communion, 428, 450

communities, spiritual, xv, 447. *See also sangha*

compassion, 26, 184, 185, 331, 344

connectedness, 45

conscience, 17, 248, 321, 327–28, 331, 334

consciousness, 28
  altered states of, 111, 157–58, 203, 516–17
  enlightened, 298, 504
  realms/plains of, 83, 88, 385

context, 42, 139, 297

control. *See* power, and control

corruption, 23, 134, 239. *See also* ego, corruption; mutual complicity; power; sexual seduction and transgression
  avoiding, 254–56
  defined, 241
  ego and, 253, 254
  following an experience of awakening, 247–48
  following burnout, 248–49
  mutual, 260, 281. *See also* mutual complicity
  and power, 241–45. *See also* power
  in spiritual life, 246–47
  in relation to purity, 253, 256–58
  responsibility for, 260, 270–73, 288
  seduction on spiritual path, 249–52

in spiritual life, 254–55
in teachers, 259
tendencies exist in everyone, 242–45, 252–54

counter-transference, 265, 286

crazy wisdom, 416

cults, xx, 10, 23, 277–78, 410. *See also* Aum Shinrikyo tragedy

cultural matrix, xvi, 17–26

culture, xvi
  Japanese, 24, 434
  Western, xiv–xvi, xix–xx, 14, 17, 22, 25–26, 144, 397, 407, 409, 467, 469

## D

Dalai Lama, 185, 306, 421, 464, 508, 513

"dark night," 472, 473

*Dark Night of the Soul*, 444, 473, 476

darkness, 368, 369, 474. *See also* endarkenment; underworld

Das Gupta, Shashibhusan, 516

d'Astier, Annik, 165, 317, 428, 510

death, 58, 70, 310. *See also* ego death

deathless state, 70–71

deception. *See* self-deception

deflation, 206–9. *See also under* ego inflation, working with

delusions, xx, 234. *See also* self-deception

Denver Zen Center, 3, 461

denying force, 463–66

depression, 206, 328, 472, 477

Desjardins, Arnaud, 40–41, 46–
47, 107, 109, 135, 152, 162,
178, 184, 207, 229, 254–55,
325, 349, 352, 403, 418–19,
422, 428, 435, 442, 486, 509
story of, 480–82
devotion, 397, 428, 499–500. *See
also* commitment; discipleship
devotional path, 103
*dharma*, 37, 146, 245, 267, 313,
326–29, 352, 419, 499, 509
*Dharmakaya*, 492, 494
dharmic web, xx, 380
disciple(s), 248
master as, 508–10
discipleship, 77, 320, 406–7,
486–87, 509–10. *See also*
devotion; student(s)
discrimination, 134, 247, 285, 374
developing, 394–96
disillusionment, 209, 256, 266,
270, 296. *See also* ego infla-
tion, working with
the *sadhana* of, 442–43, 469
stories of, 469–82
as a stripping away, 445–48
Divine Intelligence, 156
divinity/divine, 90, 496
*dokusan* (interview), 4, 101, 340,
512
domination, emotional, xx
Donkin, William, 183
Dorsey, Issan, 513
doubt, temptation to, 255–56
dream(s), 91

of enlightenment, 28, 59
self-deception through, 350
drug-induced "enlightenment," 92
drug-induced experiences, 89–90
critique of, 92–95
drugs, psychoactive/psychedelic,
89–90, 92–95, 232
duality, 42, 45, 88, 149, 227, 234,
385, 495. *See also* nonduality
enlightened, 492–98
enlightenment cannot exist in
context of, 97–99
illusion of, 393

## E

eagerness, 193
Eastern teachers, 22, 23. *See also
specific teachers*
Eastern traditions, importing,
19–21, 25
Eckhart, Meister, 387
ecstasy. *See* bliss/rapture
education, spiritual. *See also* stu-
dent(s); teacher(s)
lack of, 24–25
and need for cultural matrix,
17–26
ego, xiv–xv, 374–75, 380, 405,
465, 468, 482–84, 502
attempts to destroy, 78, 79
balance as preventing, 208
beneficial role of, 77, 79–82
cannot have mystical experi-
ences or get enlightened,
147, 148, 150

corruption, exploitation, and manipulation by, 10, 66, 68, 74, 141–42, 146, 225, 233, 318

and corruption, 253, 254

defined, 8

developing (a strong), 80

identification and disidentification with, 8, 66, 79, 99, 100, 180, 196, 197, 333, 443

illusory nature of, 78, 123, 146–51

learning to live with, 78

mechanics of, 8, 164

as (mis)interpreter, 145–46, 153

presumptuous nature of, 8–10

spiritualized, 142, 146–53

and surrender, 88

takes credit for mystical experiences, 149–50, 153

ego death, 70–71, 77–80, 131, 148, 206, 455, 511. See also ego inflation, working with, deflation

ego inflation, 10, 68–69, 132–33, 187–90, 262, 272, 458. See also deflation; grandiosity

balance as necessary to prevent, 208

dangers of, 201–3

how and why it occurs, 132–33, 192–201, 264, 265

influx of energy during, 198–99

insecurity masking as, 200–201

masks of, 190–92

as natural, 217–19

working with, 205, 214–15

deflation, 206–9

giving credit where credit is due, 209–11

help from the tradition, 215–17

keeping quiet, 213–14

not giving experiences too much attention, 211–13

egoless state, 483–84

emotions, 127. See also specific emotions

endarkenment, 45–46, 369

energy, 55, 61, 87, 126, 127, 132–33, 383

enlightenment as impersonal, 42–44

influx of, 384–85

during ego inflation, 198–99

enlightened action, 416

enlightened persons vs., 39, 500

enlightened consciousness, 298

enlightened duality. See under duality

enlightenment, 1, 369, 483–89. See also premature claims to and presumption of enlightenment; testing enlightenment; unenlightened

becoming extinct, 13–16

cannot be an experience, 54–55, 147

contemporary definitions, xiii, 14–15, 33–34, 38–39, 356

enlightenment [*continued*]
  as consummation of human
    growth and maturity, 54
  as exception to the rule, 46
  as freedom from the spiritual
    path, 48
  has degrees, 46–48
  knowledge that all things are
    transitory, 41–42
  as realization of connected-
    ness, 44–45
  as realization that you know
    nothing, 45
  as relaxed mind, 40–41
  as responsiveness, 39–40
  shallow and deep, 47
  as shattering of mental con-
    structs, 39
  counterfeit/imitation, 16–17.
    See also mystical experi-
    ence(s), mistaking for
    enlightenment; *specific topics*
  demonstrating, 50
  dream(s) of, 28, 59
  evaluating, 7, 50
  as experience *vs.* context, 42
  fantasy of, 34–36, 38
  gradual vs. sudden, 47–48, 448
  hazards/difficulties of defining,
    16, 34–35
  as impersonal energy, 42–44
  initial encounter with, 37
  misconceptions about, xxi,
    35–36, 52, 53, 57, 66–67,
    140, 147–48

  motivations for seeking, 57
  Andrew Cohen on, 60–63
  to be loved, 71–73
  to find meaning in life, 73–75
  pure *vs.* impure, 57–63, 74,
    298, 315, 321, 359, 361,
    419
  relief from suffering/salvation,
    64–67
  spiritual ambition, 67–70
  survival of ego, 70–71
  as natural states. *See sahaja*
  as necessary in order to teach,
    427–31
  personal *vs.* impersonal, 42–44
  qualities of, 50–51
  recognized through understand-
    ing one's endarkenment,
    45–46
  reluctance to speak about,
    48–51
  sacrificing enlightenment for
    the sake of, 470–74, 476
  as trend, 16
*Enlightenment Is a Secret* (Cohen),
    43, 415–16, 464, 507
Ennis, Robert, 11, 74, 90, 95,
    113, 114, 273, 275, 296, 318,
    350, 365–66, 389–94, 428,
    430, 432, 437, 457, 491
Erhard, Werner, 266
Essence, 205
  of God, 158
ethics, 240. *See also* conscience;
    morals

# F

faith, 320, 415
  as all that is needed, 508
  spiritual experiences create and
    restore, 108–9
false gurus, 228, 230–31, 274,
    403, 409. *See also* charlatans;
    teacher(s), true/authentic *vs.*
    false/fake
false messiahs, 132
false prophets, 275–76
fantasies, 38
Farcet, Gilles, 96, 106–7, 114, 152,
    161, 242–43, 254–55, 286,
    290, 295, 307, 353, 364, 368–
    69, 420, 433, 485–86, 509–10
fear of separation, 200
feedback, 314
  internal, 224, 228, 331. *See also*
    internal guidance system
  of others, xiv, 267, 316,
    330–32, 334, 338, 345, 349
  of universe, 352–55
Feuerstein, Georg, 12, 39, 64,
    78–79, 95, 222–23, 227,
    321–22, 374–75, 405, 417,
    420, 464, 519
Fields, Rick, 93–94
freedom, 36, 101, 256, 352, 439–
    40, 518. *See also* liberation

# G

Gandhi, Mahatma, 352, 512, 518
generosity, 247, 473
Gibran, Kahlil, 449

God, xix, 98, 100, 108, 181, 182,
    221, 226, 321, 451, 496
  desire for people, 63
  Essence of, 158
  identification with. *See* ego
    inflation
  longing for, 59, 321, 323
  loving, 72, 497–98
  relationship with, 511–12
  suffering of, 67
  union with, 448. *See also* uni-
    tive state
  vs. separation from, 73. *See also*
    separation
  will of, 60, 293, 511
  worshipping, in form, 320
goddess, xxi, 399, 463
Gold, E.J., 6, 36, 41, 52, 179,
    206, 300, 323–24, 447, 453,
    462, 499, 520
good mood *vs.* (being a) good
    person, 97
Gottsegen, Daniel, 125–26, 130
grace, 363, 378, 446, 452–53, 473
grandiosity, 134, 195, 262. *See
    also* ego inflation
Great Eastern Sun, 449
greed, 215
Grof, Christina, 44–45, 126, 129–
    30, 134–35, 138, 139, 164, 193
Grof, Stanislav, 126, 139, 164
Grof Transpersonal Training
    Institute, 44
Groff, John, 158

groups
  Gurdjieff-oriented, 266–67
  spiritual codependency in, 278
Gurdjieff, G.I., 97, 110, 178–79,
    225, 266–67, 343
guru yoga, 504
guru(s), 406–7. *See also* false
    gurus; inner guru; New Age
    gurus
  bashing, 407–11. *See also*
    authority, spiritual
  dead, 224
  New Age, 13, 351

# H

habits, 20, 285, 362, 383, 387,
    410
"half-baked" students, 296–99
"half-baked" teachers, xxi,
    290–99
halfway up the mountain. *See*
    mountain metaphor
Halifax, Joan, 29, 31, 39–41,
    44–45, 49–50, 93, 178, 316,
    330, 364, 384, 453–54, 460,
    494, 498, 514
Hall, Robert, 53, 71, 95, 201, 247,
    261–62, 271–72, 276, 371,
    411, 415, 417, 420, 428, 518
hallucination, 86, 89, 90, 121,
    172, 348
Hazrat Babajan, 390
heart, following one's, 225–26
heartbreak, 53, 469, 489, 497
heaven, 180, 474, 514

Heaven's Gate, 244–45
Henry, Danan, 3, 15, 19, 20, 101,
    119, 131, 168–71, 211, 264,
    290, 322, 343, 351, 375, 377,
    378, 388, 393, 423, 427, 461,
    489, 512–13
Hinduism, 435, 463, 478, 515
Hoffman, Bob, 381
honesty. *See* self-honesty
human, becoming more, 505–7
human beings, mechanical nature
    of, 81, 322, 362, 502
humility, 44, 212, 217–18, 418,
    471, 472, 475, 506–7. *See also*
    ego inflation
hungry ghost, 472
Huxley, Aldous, 93

# I

Ichazo, Oscar, 417, 473
idealization. *See under* teacher(s)
illegal wisdom teaching, 289, 295,
    482
illusion, xx, 69, 227–28, 266, 280,
    456
  of separation, 70–71, 448, 516
immanent school/approach, 112
immortality, 241
imperfection, tolerance for, 459
impermanence, 42, 365, 490
India, 99–100, 181, 320, 390–91,
    409
indigenous culture, 91, 394, 465
infinity, 496
inflation. *See* ego inflation

inner guru, 221–25, 227–29, 234
  problems with, 222–25
inner voice, 234, 289. *See also*
  internal guidance system
  and "following one's heart,"
  225–26
  recognizing/distinguishing,
  225–26, 230
insight/clarity, 86–87, 222, 232, 368
  spiritual, 12
inspiration, 46, 105–7, 109, 121,
  123, 276, 284, 296, 309, 315,
  317, 379, 402, 423, 471, 474
integration, 373–74, 388, 390–94
integrity, spiritual, 257, 258, 280,
  287, 425, 437. *See also* cor-
  ruption
  need for strong models of,
  309–10
intellect, 247, 364
intention, 209, 214–15
  impure, 296, 298, 432, 435, 437
  as protection, 255–56
  pure, 63, 214, 272, 287, 296,
  298, 309, 432, 435, 437
internal guidance system, 318,
  437. *See also* inner voice
intuition, 100, 225
  training one's, 399–400

## J

Jacobi, Jolande, 210
James, William, 83
Japanese culture, 24, 434
Jesus Christ, 210

Jewish cultural matrix, 24
Jewish mystical traditions, 216,
  376–77, 380, 424. *See also*
  Schachter-Shalomi
Jones, Jim, xx, 132
Judaism
  testing enlightenment in,
  342–43, 347
  tolerance for imperfection in,
  459
  transmission in, 20, 424
judgment, 81
Jung, Carl Gustav, xix, 42–44, 80,
  148, 188, 194, 200–202, 261,
  275, 369, 402

## K

Kali (Hindu Goddess), 463
Kapleau, Philip (Roshi), 3–5, 12,
  46, 47, 51, 92, 98, 99, 102,
  112–13, 147, 168, 170–75,
  211, 264, 317, 337, 339–41,
  378, 392, 418, 425, 484, 486,
  487
karma, 20, 207, 284, 301, 303–8,
  359, 409. *See also under* teach-
  ing, before one is prepared
karmic connection, 305
karmic web, 305
*kensho*, 13, 115–16, 490, 494. *See
  also satori*
knowing everything, need for,
  152, 350
*koan*, 168, 343, 344, 393, 486, 502
Kongtrül, Jamgön, 143–44

Kornfield, Jack, 90–91, 94, 113, 151, 163, 168, 269, 296–97, 353, 361, 367–68, 387
Kotzker, Rebbe, 350
Kramer, Joel, 191, 193, 240, 243
Krishna, Lord
work of, 515
*kundalini*, 21, 84–85, 98, 132–33, 138, 320, 510
defined, 42–43
power of, 128–29
Kwong, Jakusho (Roshi), 130–31, 270, 314, 332, 333, 340, 421, 426, 483, 485, 490, 491, 517

# L

Leadbeater, C.W., 73, 84, 128, 132–33
Leif, Judith, 26, 50, 119, 188, 265, 363, 427–28, 458–59, 514
Lentz, Freddie, 413
letting go, 119. *See also* surrender
mystical experience and, 118–21, 166
liberation, 34, 55, 61, 62, 90–91, 123, 142, 255–57, 310, 352, 387, 429, 452–53, 474, 524n2. *See also* enlightenment; freedom
Lifton, Robert Jay, 23–24
lineage, 319, 341, 420, 425, 428, 431
longing
for Absolute Reality, 405
for God, 59, 321, 323

Loori, John Daido, 512–13
losing face, 152, 164, 282, 293, 469
Lourie, Leon, 457
love, 14, 96, 97, 331, 422, 476
falling in, 96, 107
need for, 71–73
loving God, 72, 497–98
Lozowick, Lee, xxiii, 6, 7, 14, 15, 35, 38–42, 44–45, 52, 66, 88, 121–22, 132, 136, 144, 149, 161–62, 177–79, 252, 253, 264, 287, 302–3, 307, 313, 332, 350, 353, 362, 373, 378, 380, 385–87, 393, 403, 414, 416, 417, 423, 429–31, 434–36, 446, 448, 460–61, 465, 468–69, 488, 496–97, 511, 516

# M

Maharaj, Guru, 307–9, 357, 358
Maharaj, Taat, 344–45
Maharaj, Upasni, 391
manipulation, psychological, xx. *See also* corruption; ego, corruption, exploitation, and manipulation by; seduction
Manson, Charles, xx
master(s), xxii, 183, 402, 523n2. *See also* Buddha; teacher(s)
as disciple, 508–10
*masts*, 181–85
matrix, 252, 373, 381–88
contains spiritual experiences, 384–85

cultural, xvi, 17–26
defined, 381
as protection from ego infla-
tion, 385–86
Maull, Fleet W., xvii
*mayko*, 169–75
meaning, search for, 73–74
meditation, 3, 53, 135, 384
Buddhist, 3
Meher Baba, 181–85, 390, 391
memory *vs.* experience, 162
Merton, Thomas, 289
messianic complex, 132. *See also*
false messiahs
mind. *See also* ego
recognizing the higher, 235
"mind expansion," 98
mistakes
"the way of," 454–59
value of, 455–59
Moksha Foundation, 42
monastic life, 19
morals/morality, 240–41, 370,
376. *See also* conscience;
ethics
Moran, Daniel, 44–45
mountain metaphor, 3–8, 239
Mueller, Gary, 16, 50, 198, 201,
206, 262–63, 265, 276, 421
mutual complicity, 259–60, 264,
287
arising from projection and
transference, 261–66
compared with parent-child
relationship, 283

defined, 259
disentangling/extricating one-
self from, 280–83, 285
guarding against, 285–88
the paradox of, 271–73
payoff of, 259
resulting from misinterpreted
karma, 284
as spiritual
codependency/addiction,
277–80
stemming from desire to be
saved, 273–77
mystery, the, 29, 73
mystical experience(s), 55, 83
attempts to control/manage,
118–20
letting go of, 119
benefits of, 43
leave impression on uncon-
scious, 109–11
provide incentive, 106–7
clinging to, 119, 157–58, 160
containing. *See* matrix
dangers of, 106, 123, 141. *See
also mayko*
fading away, 161–66
fleeing from, 131–32
getting stuck in, 133–37. *See
also masts*
grasping at, 160
identifying with, 194–98
as inherently transformative,
111–18
letting go of, 166

mystical experience(s) [*continued*]
  letting them have their way,
    118–21
  losing, 450
  misinterpretation of, 145. *See
    also* ego, as (mis)interpreter
  mistaking for enlightenment,
    87, 88, 92, 95–102
  misunderstanding, 129–32
  as natural part of life, 91
  out-of-body, 85, 101
  personalizing, 132
  as side effects, 90–91
  talking about, 132
  value of, 106, 144–45
    creating and restoring faith,
      108–9
  varieties of, 84–85, 87–89. *See
    also* bliss/rapture
    body/sensory, 85–86
    drug-induced, 89–90, 92–95
    insight/clarity, 86–87
mystical phenomena, 90–91. *See
  also* psychic phenomena

# N

Naranjo, Claudio, 62, 82,
    189–90, 195–96, 217–19,
    247–48, 270, 282, 333–34,
    355, 395, 401–2, 412–13,
    417, 445, 457, 505
  stories of, 469–74, 476, 503–4
narcissism. *See* ego inflation
"near enemies," 151
necessity (in student), 434

Needleman, Jacob, 197, 403, 454
Neem Karoli Baba, 92–93
New Age, 11–16, 247, 374, 375
New Age gurus, 13, 351
nirvana. *See* pseudo-nirvana
"No Top End," 489–92, 518
nonduality, 42, 98, 227, 376, 489,
    492, 495. *See also* duality
  glimpsing at *vs.* living, 231–34
  realization of, 376, 483–84

# O

omniscience. *See* knowing every-
  thing
oneness, 511. *See also* unitive
  state
  experience of, 147, 180
"openings," 115
ordinary life, 31
ordinary reality, 516
Oxherding pictures, 492

# P

pain. *See also* suffering
  the way of, 445–54
paradigm, 374, 375
path. *See* spiritual path/search
Pearce, Joseph Chilton, 225–26
pearl of great price, 88, 522
Pentland, Lord, 466
power, 239–40, 257. *See also*
  corruption, and power
  and control, 240
  search for, 67–70, 152
  dangers of, 240, 241

does not equal enlightenment, 245–46
seduction of, 191
powers, 69
extrasensory, 99
psychic, 100, 245–46
dangers of, 100, 241, 245–46
yogic, 88
practice, spiritual, 107, 252, 373, 376, 378, 380, 383, 388, 459, 460, 468, 489. *See also sadhana*; work
as enlightenment, 498–501
of presuming enlightenment, 501–5
purpose of, 501
Prajnanpad (Swami), 422, 481
Prakash, 360
prayer, 89
precepts (Buddhist), 377, 393
premature claims to and presumption of enlightenment, 3–5, 8–11, 24, 26, 32, 95, 100, 131, 297, 316, 322, 333, 377
genuine enlightenment blocked by, 9
not necessarily bad/worse things to presume, 29, 31–32
presuming another's enlightenment, 10–11
pretending, 502
pride, 81, 113, 133, 161, 181, 200, 202, 297, 339, 446, 447, 471, 472, 504, 506–7

projection, 260–62. *See also* transference
guarding against, 285–88
Jung's views on, 261
traps of, 264–66
value of, 262–64
withdrawing, 285
working with (for students), 286, 287
working with (for teachers), 287
prophets, 275–76, 402
pseudo-nirvana, 168
pseudo-teachers, 274. *See also* false gurus; teacher(s), true/authentic *vs.* false/fake
psyche, 12, 90, 194, 382
psychiatry, 130. *See also* therapy
psychic phenomena. *See also* mystical phenomena; powers, psychic
mistaking for enlightenment, 99–102
psychological breakthroughs, 12
psychological purification, 13, 359–61. *See also* purification
defined, 359
failure to engage, 360
is not substitute for spiritual work, 363
need for, 362–66
as ongoing work, 370–71
and premature presumption of enlightenment, 360, 366
within spiritual school/work, 366

psychological purification [*continued*]
  for spiritual teachers, 366–68
  through darkness (shadow work),
    368–70. *See also* underworld
psychology, 365
  Buddhist, 363–65
  as distinct from spirituality, 12,
    13, 65
  as related to spirituality, 12
  transpersonal, 12, 366
Purdom, C.B., 390
purification, 59–61, 383, 415,
    457, 487. *See also* psychologi-
    cal purification
purity, 376. *See also under* enlight-
    enment, motivations for seek-
    ing; intention
  corruption in relation to, 253,
    256–58

# R

Ram Dass (Richard Alpert), 92,
    156–57, 210, 470, 477, 479-
    80, 518
  story of, 476–80
Ramdas (Papa), 509
rapture. *See* bliss/rapture
Rawlinson, Andrew, 18, 25, 39, 40,
    64, 110, 115–16, 223–24, 281,
    283, 301, 397–98, 413, 490
Ray, Reginald, 39, 40, 66, 70, 74,
    157–58, 166–67, 169, 209,
    211, 217, 243, 263, 271–73,
    281, 299, 302, 319, 331, 346,
    347, 349, 353–54, 363, 364,

411–12, 425, 436, 443, 458,
    487, 506, 511
Reality, xxi, xxii, 374, 379
  coming to terms with, 165–69
  commitment to, 214
  connection to, xx
  perception of, 52, 53
realization, 130–31, 180–81, 340.
    *See also* awakening; enlight-
    enment; liberation
  God, 98
religion, 172, 210. *See also specific
    religions; specific religions and
    aspects of religion*
resistance, 39, 463–66
*rnanubandhana*, 305
Roberts, Bernadette, 112, 294,
    363, 391, 475, 483–84, 488,
    493, 514, 518
Rosenthal, Gary, 189, 202, 203, 207

# S

sacrifice, 470–74, 476
*sadhana* (spiritual practice), 20,
    72, 85, 136, 161, 321, 333,
    342, 360, 373–81, 390, 398,
    454, 455, 470, 498
  of disillusionment, 442–43, 469
  *kaya*, 494
*sadhu*, 287, 360
*saha*, 448
*sahaja*, 514
  as natural state, 514, 516–17
  the price of, 518–22

*sahaja-samadhi*, 516. *See also samadhi*

saints, 356, 459, 509. *See also specific saints*

Sakyong Mipham Rinpoche, 346

salvation, 42, 66–67, 491
    fantasy of, 36, 273, 276

*samadhi*, 345, 496, 516

Sanella, Lee, 98, 135, 137–38, 442

*sangha*, 269, 313–14, 330–35
    creates useful friction, 333
    as protection from inflation, 330
    provides feedback, 314, 330

*satori*, 47, 98, 147, 201, 337, 338, 341, 345, 388. *See also kensho*

Sayadaw, Mahasi, 34

Sazaki Roshi, 376

Schachter-Shalomi, Zalman [Reb Zalman], 20, 216–17, 314, 316, 337, 342–43, 347, 350, 366–67, 370, 376–77, 379–80, 424, 459, 502, 515

sects, 172

seduction, 156, 180, 263, 265, 266
    of ego, 142, 421
    of power, 191, 246. *See also* power
    of the spiritual path, 249–52

self. *See* ego

Self, higher, 148

self-centeredness, 64

self-deception, xiv, 30–32, 166, 228, 230, 245, 250, 252, 271, 437, 503–5. *See also* corruption
    "case study" about, 231–33

through dreams, 350

self-honesty, 436

separation
    assumption of, 44
    fear of, 200
    from God, 73
    hell as, 497
    illusion of, 70–71, 448, 516
        survival of ego based on, 70–71
    from others, *vs.* connection with others, 144–45

service, surrender and, 510–14. *See also* surrender

*sesshin*, 4, 390, 514

sexual seduction and transgression, 23, 142, 251, 266

shadow, 367–70. *See also* darkness; underworld

*shakti*, 291, 292, 307, 320, 508
    misuse of accumulated, 203–4

shamanism, 88

Shien, Kuo-an, 492

*siddhis*, 69, 100, 158, 241. *See also* powers

Silva, Jose, 302–3

Silva Mind Control, 88, 302–3

skepticism, cultivating healthy, 396–99

skillful means, 435

Smith, Jai Ram, 6, 14, 17, 28, 36, 41, 46, 131–32, 177–79, 251, 278, 280, 300, 323–24, 452–53, 462, 465–66, 485, 520

Smoley, Richard, 52

soul, 50, 146, 195, 294, 396, 431, 444, 451
spiritual cul-de-sac, 155–58
spiritual development, 16, 69, 279, 437
　teaching before one is prepared as inhibiting, 299–301
Spiritual Emergence Network (SEN), 126, 129
spiritual emergency, 125–27, 131, 139, 382. *See also* burnout
　proper context as essential to avoiding, 139
*Spiritual Emergency* (Grof and Grof), 126
spiritual experience. *See* mystical experience(s)
spiritual materialism, xiv, 142–45, 163, 241
　defined, 141
spiritual path/search, 33, 48, 107, 156, 215, 321, 446, 484, 489
spiritual practice. *See* practice; *sadhana*
spiritual pride. *See* pride
spiritual schools. *See* communities
spiritual seeker, 321
spirituality, 11–12. *See also specific topics*
　Eastern, 25. *See also* Eastern traditions
　Native American, 211
　Western, xx, 434. *See also* Western traditions
"spiritualized ego," 142, 146–53

St. John of the Cross, 108, 142, 191, 221, 444, 447, 450, 451
Steinitz, Purna, 27, 31, 41–42, 403, 408, 424, 435
student(s), xxii, 22. *See also* devotion; disciple(s)
　"half-baked," 296–99
　learning process of being a, 28
suffering, 39, 52, 144–45, 157, 362, 446, 448–49, 451–52, 458, 464, 473. *See also* pain
　enlightenment and, 62, 63, 140
　relief/freedom from, 64–67, 136, 137, 203, 273, 491
　roots of, 44, 66
Sufis, 184, 510, 512
　of Nishapur, 215, 385
Sufism, 411, 501
surrender, 17, 60, 63, 69, 78, 82, 87–88, 167–68, 321, 511, 518. *See also* letting go
　ego and, 88, 391
　*vs.* enlightenment, 103–4
　and service, 510–14
*sutras*, 171, 484
Suzuki Roshi, 376, 386, 500
Svoboda, Robert, xxi, 50–51, 80, 128, 203–5, 284, 290, 291, 293, 301, 305–8, 310, 315, 318, 320, 344, 354–58, 399–400, 467, 508, 510

**T**

Tantra, 11, 22, 489, 511
*tapas*, 380

Tart, Charles, 23, 28, 45–46, 48, 58–59, 64–65, 97, 110–11, 214–15, 266–68, 272, 277, 285, 338, 346, 351, 414, 421, 426, 428, 437, 456, 513

*tashida*, 489

teacher(s), xv. *See also acharya(s);* corruption; guru(s)
as archetypal relationship, 276
assessing the mastery of, 228, 404–5
criteria for evaluating, 411–21, 423–27
difficulties of being a, 52–53
exists only in relationship to students, 269–71
"half-baked," xxi, 290–95
produce "half-baked" students, 296–99
idealizing, 261–63, 265. *See also* projection; transference
is everywhere, 227
life as the, 227
not belonging to school or institution, 24–25
provides impressions, 318
qualifications for being a, 295, 433. *See also* purification enlightenment, 427–31
teachers' need for, 322–23, 325
true/authentic *vs.* false/fake, xv, 251–52, 270–72, 274, 364, 401–7, 410–11, 422. *See also* charlatans; false gurus; prophets

students benefiting from false teachers, 432, 434–35
trust in. *See* trust
as underwriter, 323–25

teaching, 26–27. *See also dharma*
illegal wisdom, 289, 295, 482
before one is prepared. *See also* illegal wisdom teaching
as inhibiting further spiritual development, 299–301
karmic implications of, 301–9
as process of being diminished, 460–62

testing enlightenment, 337–38, 380. *See also* feedback
in Judaism, 342–43, 347
life itself as, 344, 351–53, 355, 356
non-traditional forms of, 341–44
peer testing for teachers, 344–48
self-testing/checks, 348–55
time as, 355–56
traditional forms of, 338–41
in Zen tradition, 337–42

Thakar, Vimala, 53, 148

therapy, 12–13, 365–66

three jewels, 313–14. *See also* Buddha; *dharma; sangha*
as protection, 313, 314, 316

Tibet, 18, 331. *See also* Buddhism, Tibetan

tradition, 27
importing, 19–21, 25
transplanting, 20, 25

trance, 157–58, 339, 477

transcendence, 276, 363, 404
transference, 260–62. *See also*
    projection
    traps of, 264–68
    value of, 262–64
transformation, 447, 507
    mystical experience and,
        111–18, 387
transmission, 143, 359, 423–27
    in Judaism, 20, 424
    mind-to-mind, 423
    partial, 20–21
trauma, persons with history of, 135
true self, 15
Trungpa Rinpoche, Chogyam,
        xiii, xiv, 26, 35, 38, 50, 59,
        143, 150–51, 160, 163–64,
        166, 217, 276, 334, 371, 397,
        419, 423, 427, 445–48, 458,
        474, 479, 484, 506
trust, 13, 264
    crisis of, 30–31
    in self, 289, 435–38
    in teacher/guru, 53
Truth, xxii–xxiii, 46, 103, 141, 157,
        168, 201, 211, 219, 224, 379
    wanting *vs.* not wanting, 9, 81
truth-seekers, 444
*Tulku*, 331, 494
Tweedie, Irina, 73, 87–88, 146,
        148, 208, 250, 315, 467, 505

**U**

unconscious/unconsciousness,
    109–11, 278, 334, 369

Underhill, Evelyn, 105, 439
underworld, 89, 368–70
unenlightened, 294, 428
unitive state/unity, 73, 95, 121,
        203, 488, 493, 514. *See also*
        oneness
"unlove," 71
Upasni Maharaj, 391

**V**

Vaughan, Frances, 245, 404–5,
        420, 454
Vaughan-Lee, Llewellyn, 27, 63,
        73, 79–81, 106, 108–9, 116,
        117, 127, 128, 146–48, 153,
        194–95, 207, 208, 215–16,
        226, 230, 235, 250, 263, 315,
        323, 352, 369, 381–85, 392,
        396, 410, 446, 453, 458, 460,
        467, 491, 493, 511–12, 518
victim/victimization, 259–60
Vimalananda, Aghori, 204, 301,
        318, 344, 409–10, 496, 510
Vipassana, 53
visions, 90, 91, 132, 344. *See also*
        mystical experience(s)
von Dürkheim, Karlfried, 518–19

**W**

Watts, Alan, 376
weakness, as bound together with
        the Work, 462
Weitzman, Mel (Roshi), 16, 17,
        45, 294, 341, 342, 377–78,
        380, 419, 498, 499

Welwood, John, 337, 408, 413–14
Western individualism, 24
Western teachers, 231, 409–10.
    *See also specific teachers*
Western traditions, xiv–xvi,
    xix–xx. *See also* culture,
    Western
Wilber, Ken, 24, 195, 197, 348,
    375
will of God, 60, 293, 511
wisdom, crazy, 416
wisdom teaching, 295
    illegal, 289, 295, 482
Woodman, Marion, 285
Work, the, 462, 477, 519. *See also*
    practice

# Y

Yeshe, Thubten, 329, 359
yoga, 22, 477
    guru, 504
    *hatha*, 127–28
    mystical powers acquired
        through, 87–88
Yogi Ramsuratkumar, 150, 446

# Z

Zalman, Reb. *See* Schachter-
    Shalomi, Zalman
zazen, 173, 376, 484
*Zazen Yojinki*, 172
Zen, 47, 212, 273, 377, 486, 490,
    492. *See also* Budji Zen;
    Oxherding pictures
    in the West, 338, 375
*Zen: Dawn in the West* (Kapleau),
    99
Zen Buddhism, 19, 169–75, 393
Zen failure, 49
Zen masters, 175, 245, 311, 317,
    340, 342, 382, 387. *See also*
    *specific masters*
Zen schools, 338, 340
Zen sickness, 212
Zen teaching, 339
Zen tradition, testing enlighten-
    ment in, 337–42
Zen training, 392–93

# Text Credits

# ADDITIONAL TITLES FROM HOHM PRESS

## THE ALCHEMY OF LOVE AND SEX
by Lee Lozowick                                    Foreword by Georg Feuerstein, Ph.D.

Lozowick recognizes the immense confusion surrounding love and sex and tantric spiritual practice. Preaching neither asceticism nor hedonism, he presents a middle path grounded in the appreciation of simple human relatedness. Topics include: • what men want from women in sex, and what women want from men • the development of a passionate love affair with life • how to balance the essential masculine and essential feminine • the dangers and possibilities of sexual Tantra. . .and much more. The author is an American "Crazy Wisdom teacher" in the tradition of those whose enigmatic lives and teaching styles have affronted the polite society of their day. Lozowick is the author of 14 books in English and several in French and German translations only. " ... attacks Western sexuality with a vengeance." —*Library Journal.*

Paper, 312 pages, $16.95                          ISBN: 0-934252-58-0

• • •

## THE ALCHEMY OF TRANSFORMATION
by Lee Lozowick
Foreword by: Claudio Naranjo, M.D.

A concise and straightforward overview of the principles of spiritual life as developed and taught by Lee Lozowick for the past twenty years in the West. Subjects of use to seekers and serious students of any spiritual tradition include: • From self-centeredness to God-centeredness • The role of a Teacher and a practice in spiritual life • The job of the community in "self"-liberation • Longing and devotion. Lee Lozowick's spiritual tradition is that of the western Baul, related in teaching and spirit to the Bauls of Bengal, India. *The Alchemy of Transformation* presents his radical, elegant and irreverent approach to human alchemical transformation.

Paper, 192 pages, $14.95                          ISBN: 0-934252-62-9

• • •

## ENNEATYPES IN PSYCHOTHERAPY
by Claudio Naranjo, M.D.

World-renowned Gestalt therapist, educator and Enneagram pioneer Dr. Claudio Naranjo conducted the First International Symposium on the Personality Enneagrams in Pueblo Acantilado, Spain in December 1993. This book derives from this conference and reflects the direct experience and lively testimony of notable representatives of a variety of therapeutic disciplines including: psychoanalysis, Gestalt, Transactional Analysis, bodywork, and others. Each writer describes how the Enneagram holds invaluable keys to understanding personality and its relevance to those whose task is helping others.

Paper, 160 pages, $14.95                          ISBN: 0-934252-47-5

## TO ORDER PLEASE SEE ACCOMPANYING ORDER FORM
## OR CALL 1-800-381-2700 TO PLACE YOUR ORDER NOW.

# ADDITIONAL TITLES FROM HOHM PRESS

## *FACETS OF THE DIAMOND: THE WISDOM OF INDIA*
by James Capellini

Anyone who has ever felt the pull of India's spiritual heritage will find a treasure in this book. Contains rare photographs, brief biographic sketches and evocative quotes from contemporary spiritual teachers representing India's varied spiritual paths—from pure Advaita Vedanta (non-dualism) to the Hindu Vaisnava (Bhakti) devotional tradition. Highlights such well-known sages as Ramana Maharshi, Nityananda, and Shirdi Sai Baba as well as many renowned saints who are previously unknown in the West.

Text in three languages—English, French and German

Cloth, 224 pages, $39.95, 42 b&w photographs          ISBN: 0-934252-53-X

• • •

## *THE JUMP INTO LIFE: Moving Beyond Fear*
by Arnaud Desjardins
Foreword by Richard Moss, M.D.

"Say Yes to life," the author continually invites in this welcome guidebook to the spiritual path. For anyone who has ever felt oppressed by the life-negative seriousness of religion, this book is a timely antidote. In language that translates the complex to the obvious, Desjardins applies his simple teaching of happiness and gratitude to a broad range of weighty topics, including sexuality and intimate relationships, structuring an inner life, the relief of suffering, and overcoming fear.

Paper, 216 pages, $12.95          ISBN: 0-934252-42-4

• • •

## *TOWARD THE FULLNESS OF LIFE: The Fullness of Love*
by Arnaud Desjardins

Renowned French spiritual teacher Arnaud Desjardins offers elegant and wise counsel, arguing that a successful love relationship requires the heart of a child joined with the maturity of an adult. This book points the way to that blessed union. Topics include: happiness, marriage, absolute love, and male and female energy.

Paper, 182 pages, $12.95          ISBN: 0-934252-55-6

**TO ORDER PLEASE SEE ACCOMPANYING ORDER FORM
OR CALL 1-800-381-2700 TO PLACE YOUR ORDER NOW.**

# ADDITIONAL TITLES FROM HOHM PRESS

**THE WOMAN AWAKE:** *Feminine Wisdom for Spiritual Life*
by Regina Sara Ryan

Through the stories and insights of great women of spirit whom the author has met or been guided by in her own journey, this book highlights many faces of the Divine Feminine: the silence, the solitude, the service, the power, the compassion, the art, the darkness, the sexuality. Read about: the Sufi poetess Rabia (8th century) and contemporary Sufi master Irina Tweedie; Hildegard of Bingen, and the Beguines of Medieval Europe; author Kathryn Hulme *(The Nun's Story)* who worked with Gurdjieff; German healer and mystic Dina Rees...and many others. Includes personal interviews with contemplative Christian monk Mother Tessa Bielecki, artist Meinrad Craighead and Zen teacher and anthropologist Joan Halifax.

Paper, 518 pages, $19.95, 20+ photos        ISBN: 0-934252-79-3

• • •

**UNTOUCHED**
*The Need for Genuine Affection in an Impersonal World*
by Mariana Caplan        Foreword by Ashley Montagu

The vastly impersonal nature of contemporary culture, supported by massive child abuse and neglect, and reinforced by growing techno-fascination are robbing us of our humanity. The author takes issue with the trends of the day that are mostly overlooked as being "progressive" or harmless, showing how these trends are actually undermining genuine affection and love. This uncompromising and inspiring work offers positive solutions for countering the effects of the growing depersonalization of our times.

"To all of us with bodies, in an increasingly disembodied world, this book comes as a passionate reminder that: Touch is essential to health and happiness."—Joanne Macy, author of *World as Lover, World as Self*

Paper, 384 pages, $19.95        ISBN: 0-934252-80-7

• • •

**SIT:** *Zen Teachings of Master Taisen Deshimaru*
edited by Philippe Coupey

"To understand oneself is to understand the universe." – *Master Taisen Deshimaru*

Like spending a month in retreat with a great Zen master, SIT addresses the practice of meditation for both beginners and long-time students of Zen. Deshimaru's powerful and insightful approach is particularly suited to those who desire an experience of the rigorous Soto tradition in a form that is accessible to Westerners.

Paper, 375 pages, $19.95        ISBN: 0-934252-61-0

## TO ORDER PLEASE SEE ACCOMPANYING ORDER FORM
## OR CALL 1-800-381-2700 TO PLACE YOUR ORDER NOW.

# ADDITIONAL TITLES FROM HOHM PRESS

# ADDITIONAL TITLES FROM HOHM PRESS

## *RUMI — THIEF OF SLEEP*

*180 Quatrains from the Persian*
Translations by Shahram Shiva; Foreword by Deepak Chopra

This book contains 180 translations of Rumi's short devotional poems, or *quatrains*. Shiva's versions are based on his own carefully documented translation from the Farsi (Persian), the language in which Rumi wrote.

"In *Thief os Sleep,* Shahram Shiva (who embodies the culture, the wisdom and the history of Sufism in his very genes) brings us the healing experience. I recommend his book to anyone who wishes *to remember.* This book will help you do that."—Deepak Chopra, author of *How to Know God.*

Paper, 120 pages, $11.95                    ISBN: 1-890772-05-4

**TO ORDER PLEASE SEE ACCOMPANYING ORDER FORM
OR CALL 1-800-381-2700 TO PLACE YOUR ORDER NOW.**

# RETAIL ORDER FORM FOR HOHM PRESS BOOKS

Name _____ Phone ( ___ ) _____

Street Address or P.O. Box _____

City _____ State _____ Zip Code _____

| | QTY | TITLE | ITEM PRICE | TOTAL PRICE | |
|---|-----|-------|------------|-------------|---|
| 1 | | THE ALCHEMY OF LOVE AND SEX | $16.95 | | |
| 2 | | THE ALCHEMY OF TRANSFORMATION | $14.95 | | |
| 3 | | ENNEATYPES IN PSYCHOTHERAPY | $14.95 | | |
| 4 | | FACETS OF THE DIAMOND | $39.95 | | |
| 5 | | HALFWAY UP THE MOUNTAIN | $19.95 | | |
| 6 | | IN THE FIRE | $9.95 | | |
| 7 | | JUMP INTO LIFE | $12.95 | | |
| 8 | | RENDING THE VEIL | $27.95 | | |
| 9 | | SIT | $19.95 | | |
| 10 | | TOWARD THE FULLNESS OF LIFE | $12.95 | | |
| 11 | | UNTOUCHED | $19.95 | | |
| 12 | | THE WOMAN AWAKE | $19.95 | | |
| 13 | | THE YOGA TRADITION — Paper* | $29.95 | | |
| | | | SUBTOTAL: | | |
| | | | SHIPPING: (see below) | | |
| | | | TOTAL: | | |

## SURFACE SHIPPING CHARGES

1st book ............................................................$5.00
*Please add $7 for shipping on each *Yoga Tradition*
Each additional item ...........................................$1.00

## SHIP MY ORDER

☐ Surface U.S. Mail—Priority      ☐ UPS (Mail + $2.00)
☐ 2nd-Day Air (Mail + $5.00)      ☐ Next-Day Air (Mail + $15.00)

## METHOD OF PAYMENT:

☐ Check or M.O.   Payable to Hohm Press, P.O. Box 2501, Prescott, AZ 86302

☐ Call 1-800-381-2700 to place your credit card order

☐ Or call 1-520-717-1779 to fax your credit card order

☐ Information for Visa, MasterCard or American Express order only:

Card #_____–_____–_____–_____ Expiration Date _____

*Visit our Website to view our complete catalog: www.hohmpress.com*

***ORDER NOW! Call 1-800-381-2700 or fax your order to 1-520-717-1779.***
***(Remember to include your credit card information.)***